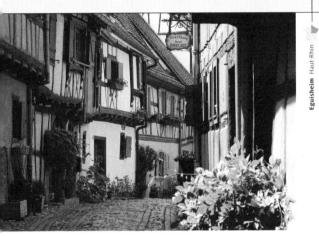

Local Specialties

Food and Drink Pretzels - Poin d'épice (spice cake) -Mushrooms - Alsatan charcuterie -AOC Alsace wines and Eichberg and Pfersigberg grands crus. Art and Crafts Artist's studios - Art gallery - Painting -Upholstery and decoration

★ Events

July Equiverm wines were and "Nuit des Grands Cus" wine festval (and fortinght). August: Discovery Day, Parc & Cigognes (sis Sunday, guided wine tasting (sis week), Fed ed Vignerons, winegrowers' (estival (last weekend)) September: Fed ed Vin Nouveau, new wine (estival (last weekend)) October: Fed ed u Vin Nouveau (sist weekend), Fed du Champignon, mushroom (estival (last weekend)) November and December: Christmas market (dally forthe four weeks of Advert)

W Outdoor Activities

Discovery of the village by microlight • Standard and electric bike rental • Walking 12 marked trails • Segway rides

🕊 Further Afield

 Hautes Vogges, region Munster Valley, Col de la Schlucht (3–19 miles/ 5–31 km)
 Colimar (3) rmiles/55 km),
 Alsace wine route Turckheim (5 miles/ 8 km), Rouffach (7 miles/11 s km),
 Kayesroberg (8 miles/12 km),
 Riguewin (11 unies/12 km), see pp 76–77, "Hunawhfr (21 miles/13 km), see pp. 66–67, Guewiller (13 miles/2 23 km),
 Château du Hohlandsbourg and Five Castles Route (5 miles/8 km),
 Neufefisnach (13 miles/8 km),

I Did you know?

Here, if stores could speak, they would tell the story of the illustrious family of the courts of Eguishem, into which was born a certain Bruno, son of Hugh VA high-ranking nobleman, he was called to papal office. Bruno went to Rome on foot, stok in hand, cape on his shoulders, just as he is depicted in his statue on the Place du Chateau. On his sarrival, he was acclaimed by the people of Rome and enthmond as Proce Leo IX.

63

Local Specialties

tisanal produce and local delicacies; afts and artistic activities in the village.

Events

arkets and key events in the village lendar (fetes, festivals, exhibitions, etc.).

Outdoor Activities

cursions and activities in the open (walking, watersports, mountaining, etc.).

🕊 Further Afield

Tourist attractions, towns, and other Most Beautiful Villages of France (marked with an asterisk before their name) within a thirty-mile (fifty-km) radius, or a one-hour drive.

Did you know?

An anecdote, historical detail, or cultural particularity of the village.

The villages are arranged by four geographical regions

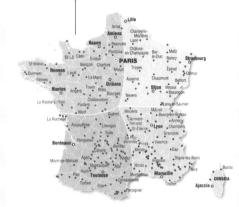

A map introduces each geographical region

Northwest: pp. 16–55 Northeast: pp. 56–83 Southeast, pp. 84–155 Southwest, pp. 156–263

All of the villages are listed alphabetically in the index pp. 270–71

CALGARY PUBLIC LIBRARY

JAN 2017

The Official Guide to the Most Beautiful Villages of France

Design Concept: Audrey Sednaoui Layout: Serge Bilous

English Edition Editorial Director: Kate Mascaro Editor: Helen Adedotun Editorial Assistance: David Ewing Translated from the French by Kate Ferry-Swainson and Anne McDowall Copyediting: Penelope Isaac Typesetting: Thierry Renard Proofreading: Samuel Wythe

Color Separation: IGS, L'Isle d'Espagnac Printed in China by Toppan Leefung

Originally published in French as Les Plus Beaux Villages de France: Guide officiel de l'Association Les Plus Beaux Villages de France © Flammarion, S.A., Paris, 2016

English-language edition © Flammarion, S.A., Paris, 2016

All rights reserved. No part of this publication may be reproduced in any form or by any means, electronic photocopy, information retrieval system, or otherwise, without written permission from Flammarion, S.A. 87, quai Panhard et Levassor 75647 Paris Cedex, 13

editions.flammarion.com

16 17 18 3 2 1

ISBN: 978-2-08-020266-6

Legal Deposit: 05/2016

The Official Guide to the Most Beautiful Villages of France

Les Plus Beaux Villages de France association

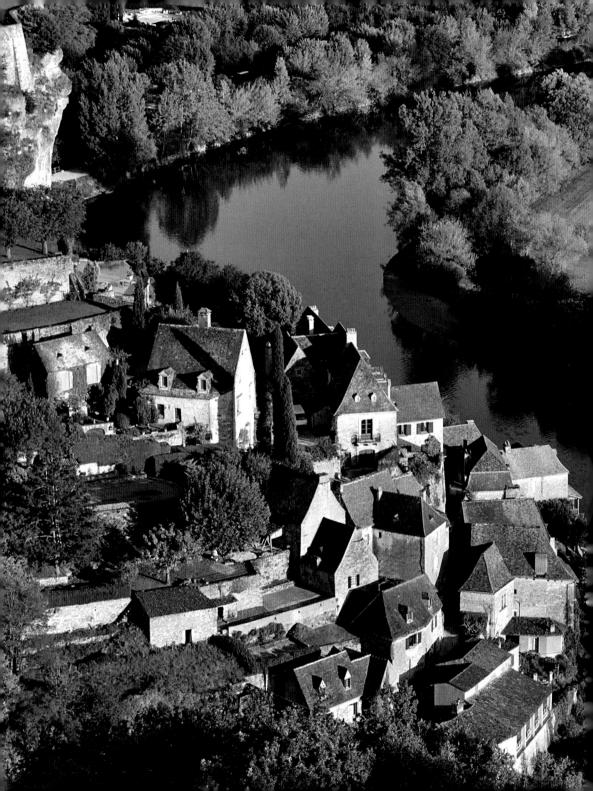

Preface

Come and discover, explore, wonder at, and stroll through The Most Beautiful Villages of France. Listen to the stones tell their story, linger on a café terrace, feel the cool water of a fountain run between your fingers, marvel at the skills of artists and craftspeople, fall asleep in a fairy-tale castle or dovecote, follow delightful walking trails, share in local celebrations and festivals, sample all the regional delicacies, and bring home choice items from the village market.

The Official Guide to the Most Beautiful Villages of France invites you to experience both simple and extraordinary pleasures, in exceptional locations that will awaken all your senses. More than 150 distinctive destinations—boasting a wealth of outstanding heritage and architecture, and buzzing with the vibrant energy and enthusiasm of their inhabitants—celebrate the French way of life, in all the diversity of their regions: from Alsace to the Basque Country, from Brittany to Provence, from Picardy to Languedoc, via Corsica and even the overseas department of La Réunion.

Whether you are seeking a short break or an extended vacation, whatever the season or occasion, this guide is the perfect traveling companion to help you enjoy these magical places to their fullest and to organize your stay with ease. If you are longing for a memorable rural getaway, The Most Beautiful Villages of France are ready to welcome you.

Maurice Chabert

President of Les Plus Beaux Villages de France association, Mayor Emeritus of Gordes, in the Vaucluse

The Most Beautiful Villages of France

Inside story

The association of Les Plus Beaux Villages de France was founded in the early summer of 1981 when one man encountered a certain book. That man was Charles Ceyrac, mayor of the village of Collonges-la-Rouge in Corrèze, and the book was Les Plus Beaux Villages de France, published by Sélection du Reader's Digest. This book gave Cevrac the idea of harnessing people's energy and passion to protect and promote the exceptional heritage of France's most beautiful villages. Sixty-six mayors signed up to Charles Ceyrac's initiative, which was made official on March 6, 1982 at Salers in Cantal. France.

A network and a strategy

Today, the association is a national network of 153 villages extending across the 14 newly created administrative regions of France and 68 of its départements. Represented by either its mayor or an elected individual from the local council, each member village contributes to the financing of the

association by paying an annual subscription fee of €3 (about \$3.40/£2.35) per capita, capped at 2,000 inhabitants. Since its creation, the association of Les Plus Beaux Villages de France has established a strategy around its motto, "Ouality, Reputation, Development." The aim of this topical mission statement is to preserve and enhance the heritage of these exceptional locations in order to increase their reputation and aid their economic development.

How to become one of The Most Beautiful Villages of France

Rigorous selection procedure

In the first instance, the village must submit an application showing that it meets the following three preliminary criteria: - a total population of no more than 2,000 inhabitants;

- two protected sites or monuments (historic landmarks, etc.);

- proof of mass support for the application for membership via public debate. If these three conditions are met, the application is accepted. The village then receives a site visit, in which twenty-seven criteria are used to evaluate its patrimonial, architectural, urban, and environmental attributes as well as municipal initiatives to promote the village. The results of the site assessment are put before the association's Quality Commission, which alone has the power to make decisions on the inclusion, or not, of a village. On average, 1 in 5 applications is successful.

(Italy) in 2001; and The Most Beautiful Villages of Japan in 2005. Through the federation of The Most Beautiful Villages of the World, the five pioneer associations that made their collaboration official in 2012 (France, Belgium, Canada, Italy, and Japan) are now taking their particular expertise to emerging networks in Romania, Saxony (Germany), Spain, South Korea, and Russia.

An honor and a commitment The accreditation of a village is not the end of the story. Its listing is made official by the signing of a quality charter in which

the village makes a commitment to pursue

its efforts to protect and promote. In

addition, the association makes regular

site visits, the results of which can range

from straightforward recommendations or

a caution to the decision to delist a village.

This process of selection and continuous

quality control creates just the right

visitors the excellence they expect

from the label The Most Beautiful

A concept that

Issues of preserving and enhancing rural heritage transcend national boundaries,

and several initiatives in Europe and across

the world have given rise to other "Most

Beautiful Villages" associations based

on the French model: Les Plus Beaux

Les Plus Beaux Villages de Québec

Villages de Wallonie (Belgium) in 1994;

has traveled

the globe

Villages of France.

dynamic and competitive spirit among

the villages of the association to guarantee

loin us on www.facebook.com/ beautifulvillagesoftheworld

To read more about the association, visit www.france-beautiful-villages.org/en

villages in japan

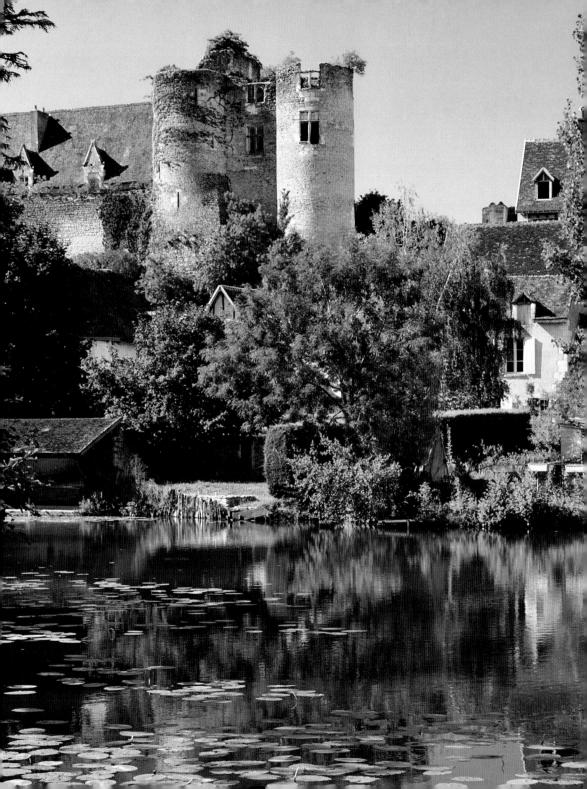

Find us online

Go online at www.france-beautifulvillages.org/en to get the latest news and events, enjoy virtual sightseeing, share photos and itineraries, and choose your next destination.

Website and newsletter

Visit our website **www.france-beautifulvillages.org/en** for tempting weekend breaks, news of recently listed villages, photo galleries, events, and our online shop. Francophones can also sign up for our free newsletter, *Vivons l'Exception!* And make sure you don't miss any of our 153 fabulous locations on your trip by using the mobile website on your smartphone, with its GPS capability. Scan the QR code below to access the mobile website directly (available in French only).

Social media

Our presence on social media means that you can post about your favorite village, share photos of your latest trip, and stay in touch with what's new in the villages. You can find Les Plus Beaux Villages de France on Facebook and Twitter.

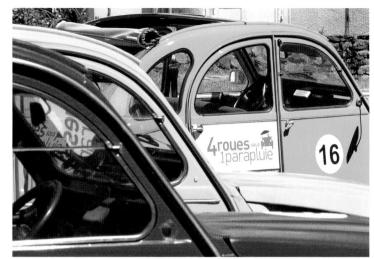

Create your own adventure

The Most Beautiful Villages of France are even better in real life! Whether you're seeking a bespoke or a package vacation, you'll receive a warm welcome in 153 outstanding villages just waiting to give you a wonderful experience.

Book online—new!

The website of Les Plus Beaux Villages de France now has a dedicated online booking system that is compatible with smartphones and tablets. It's very easy to use: select your destination, the type of accommodation or activity you want, your vacation dates, and choose from the options available. (Available in French only at the time of publication, but an English-language version is forthcoming.) www.france-beautiful-villages.org/en, click on "Short Breaks."

Become a member of the association

Play your part in safeguarding the heritage of French villages and receive a VIP welcome in these 153 remarkable locations by becoming a Friend of Les Plus Beaux Villages de France. In return for your membership, you will receive special privileges, gifts, and discounts when you stay in the villages with the association's label. Participating establishments are marked with a ♥ in this guide. Find membership details at the back of this book. www.france-beautiful-villages.org/en, click on "Friends of the Association."

Take "La Route des Villages Paris-Cannes"®

In 2011, the company 4 roues sous 1 parapluie (4 wheels under an umbrella) devised a brand of tourism that celebrates the 2CV car, and, in partnership with the association, created an exceptional car rally through The Most Beautiful Villages of France situated between Paris and Cannes. Each May, participants spend a week in the iconic French convertible, taking part in an original treasure hunt, during which they discover the rural heritage of France through a series of charming overnight stays.

4 roues sous 1 parapluie: +33 (0) 800 80 06 31 www.4roues-sous-1parapluie.com

Save the date

Get to know The Most Beautiful Villages of France from every angle heritage, cuisine, craftsmanship and in every season, by taking part in events aimed at those who enjoy the finer things in life.

Journées Européennes des Métiers d'Art® (European Festival of Arts and Crafts), 1st weekend in April

This is the perfect festival for those seeking artistic inspiration. There is a growing number of artists and craftspeople settling in The Most Beautiful Villages of France, since they provide the ideal setting for them to work their creative magic. Each year. in collaboration with the Assemblée Permanente des Chambres des Métiers and the Institut National des Métiers d'Art. the association harnesses the creative skills within the villages to host its European Festival of Arts and Crafts. Events include open studios. demonstrations, workshops, exhibitions, and art and craft fairs. Heritage and craft come together over the course of a weekend to create many varied opportunities for visitors.

www.journeesdesmetiersdart.fr (in French only)

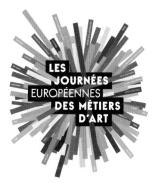

Marché aux Vins des Plus Beaux Villages de France® (The Most Beautiful Villages of France Wine Festival), 2nd weekend in April

In addition to being rich in heritage. The Most Beautiful Villages of France are also hotspots for French cuisine and flourishing vinevards of renown. Since 1998, the village of Rodemack in Moselle—which borders Luxembourg, Belgium, and Germany—has hosted The Most Beautiful Villages of France Wine Festival. During this event, local wine producers welcome you to their vinevards and their village, to sample and purchase the local produce. Tourist information—Communauté de Communes de Cattenom et Environs: +33 (0)3 82 56 00 02 www.tourisme-ccce.fr

Journées Européennes du Patrimoine® (European Heritage Festival), 3rd weekend in September

This festival has become an unmissable event for anyone who is passionate about heritage and history, and it is undoubtedly one of the best times to discover The Most Beautiful Villages of France. Whatever the theme, each year numerous establishments offer visitors fascinating programs of activities, including guided tours, exhibitions, special openings of historic buildings, and talks. A cultural break made all the more pleasant by the pastoral beauty of fall!

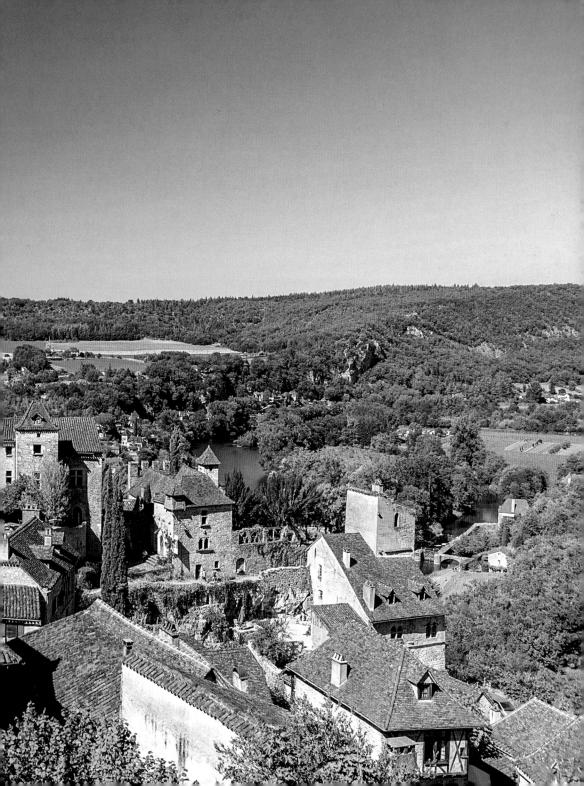

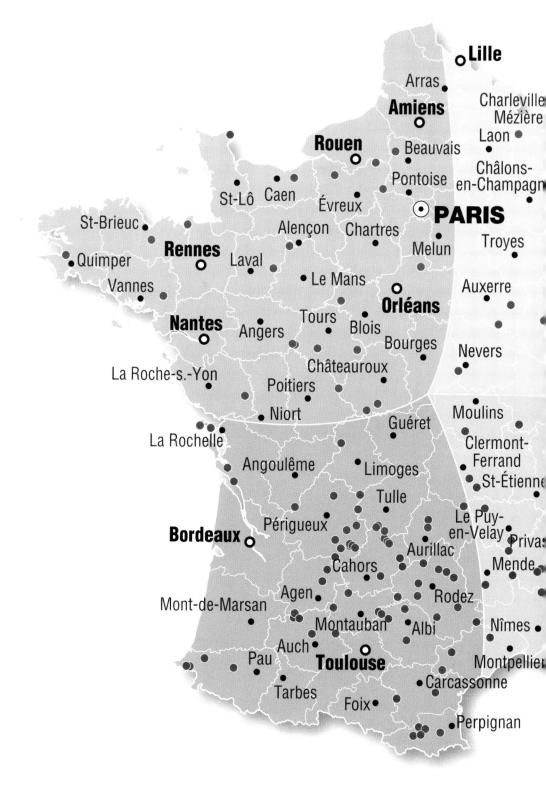

The 153 Most Beautiful Villages of France by geographical region

Northwest pp. 16–55

Northeast pp. 56–83

Southeast pp. 84–155

Southwest pp. 156–263

La Réunion pp. 266–67

Strasbourg

Colmar

Metz

Nancy

Épinal

Vesoul

Bourg-en-Bresse

Grenoble

Besançon

Lons-le-Saunier

Annecy
 Chambéry

Belfort

ar--Duc

naumont

ion

îcon

.yon

Valence

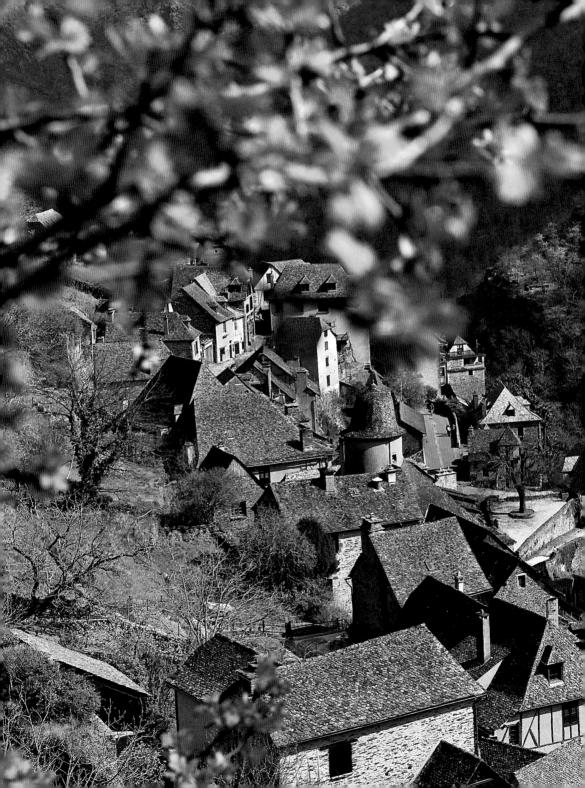

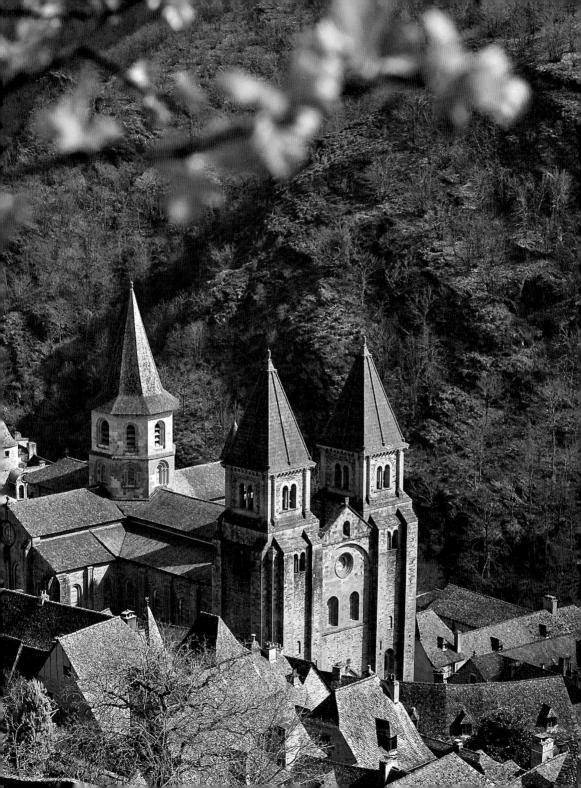

UNITED KINGDOM

No. Contraction

English Channel

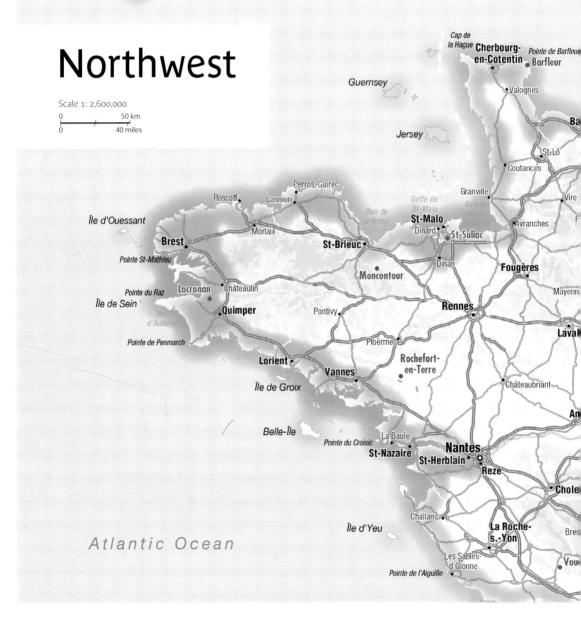

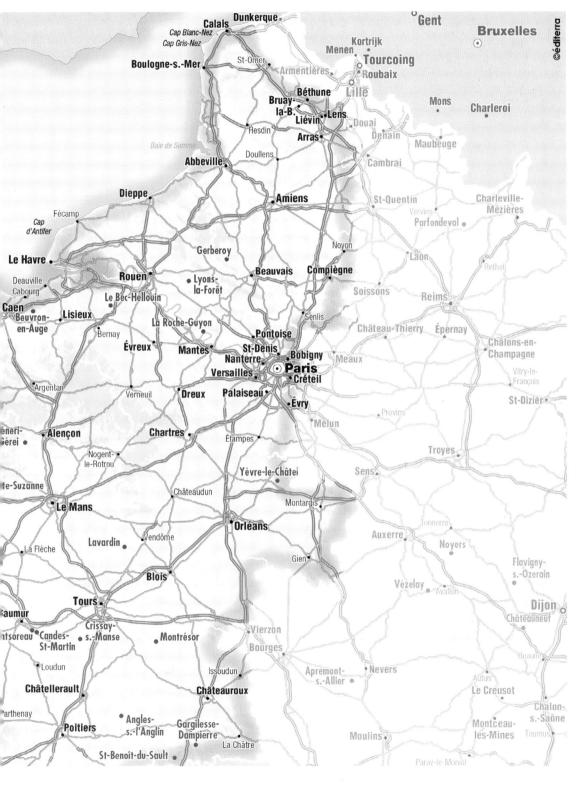

Angles-sur-l'Anglin Traditional skills and ancient wall carvings

Vienne (86) • Population: 385 • Altitude: 331 ft. (101 m)

The *jours* (openwork embroidery) of Angles is a traditional skill that is still practiced in this village on the banks of the Anglin.

From the top of the cliff, the ruins of the fortress, built by the counts of Lusignan between the 11th and 15th centuries, overlook the river. At the top of the village, the Église Saint-Martin, with its Poitiers-style Romanesque bell tower, stands next to the 12th-century Chapelle Saint-Pierre. The "Huche Corne" offers a magnificent view of the lower part of the village, where the Chapelle Saint-Croix, an old abbey church with a 13th-century doorway, faces the river, which is bordered with weeping willows. With its old bridge and its mill wheel, this romantic environment is the perfect spot for providing artists with inspiration. Several lanes—les Chemins de la Cueille, le Truchon, l'Arceau, and la Tranchée des Anglais—run from top to bottom of the village and are lined with pretty pale stone houses. Nearby, the site of the Roc aux Sorciers (Sorcerers' Rock) houses a Paleolithic frieze carved into rock 15,000 years ago, which is now protected.

Angles has been famous for its *jours* for 150 years. Threads are drawn from fabric (such as linen or cotton) using very fine and sharp scissors, and the openings are then embellished with embroidery. Angles has for many years provided Parisian department stores with luxury lingerie.

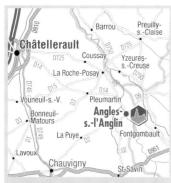

By road: Expressway A10, exit 26– Châtellerault Centre (22 miles/35 km). By train: Châtellerault station (21 miles/ 34 km); Poitiers TGV station (31 miles/ 50 km). By air: Poitiers-Biart airport (37 miles/60 km).

(i) Tourist information: +33 (0)5 49 48 86 87 www.anglessuranglin.com

Highlights

• Forteresse d'Angles (July and August): Remains of the fortress built in the 11th-15th centuries: +33 (0)5 49 48 86 87. • Maison des Jours d'Angles et du Tourisme: Demonstration of the *jours* technique and sale of embroidered linen. Further information: +33 (0)5 49 48 86 87. • Village: Guided tour Friday at 11 a.m. and 3 p.m. and Saturday at 3 p.m. for individuals; groups by appointment only: +33 (0)5 49 48 86 87.

Accommodation

Hotels

Le Relais du Lyon d'Or***: +33 (0)5 49 48 32 53. **Guesthouses** Artemisia***: +33 (0)5 49 84 01 83. Le Grenier des Robins: +33 (0)5 49 48 60 86. La Ligne: +33 (0)6 18 34 17 96. Lorna and Tony Wilkes: +33 (0)5 49 48 29 85. **Gites and vacation rentals** Further information: +33 (0)5 49 48 86 87 www.anglessuranglin.com

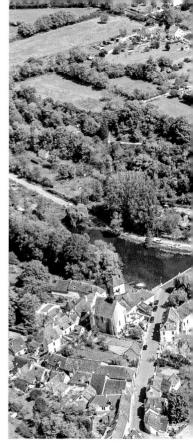

T Eating Out

Café de la Place, brasserie: +33 (0)5 49 84 18 37. Crèperie d'Angles: +33 (0)5 49 48 95 53. La Grange des Dames: +33 (0)5 49 84 54 78. Le Marsala, pizzeria: +33 (0)5 49 48 65 44. No. 15, tea room: +33 (0)5 49 91 01 25. Le Relais du Lyon d'Or: +33 (0)5 49 48 32 53.

Local Specialties

Food and Drink Broyé du Poitou (butter cookies). Art and Crafts Antiques • Secondhand bookstore, traditional bookbinding • Jours (openwork embroidery) • Artists • Cross-stitch, lace, gifts • Custom clothing, hats, and accessories • Wood carving.

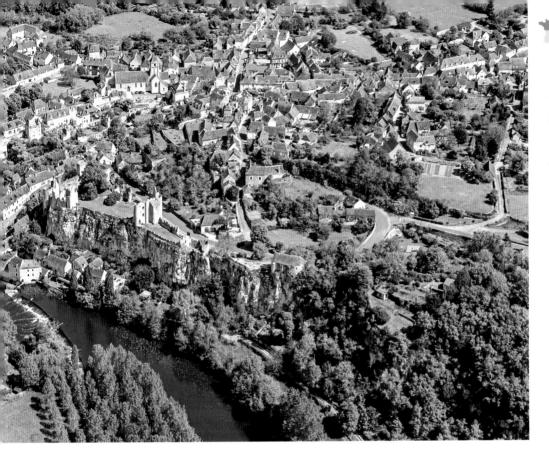

★ Events

Market: Thursday and Sunday mornings. May–October: Exhibitions. June: Journée du Patrimoine de Pays, local heritage day. July: Medieval crafts days (weekend of 14th).

August: firework display with music (1st Sunday); "Des Livres et Vous," book festival (week of 15th).

W Outdoor Activities

Canoeing • Rock climbing • Fishing in the Anglin • Walking • Mountain-biking • *Pétanque.*

🕊 Further Afield

- Abbaye de Fontgombault (5 ½ miles/9 km).
- La Roche-Posay (7 ½ miles/12 km).
- Abbaye de Saint-Savin (10 miles/16 km).
- Le Blanc (11 miles/18 km).

- Archigny: Ferme Musée Acadienne (15 miles/24 km).
- Chauvigny (16 miles/26 km).
- Futuroscope, theme park
- (30 miles/48 km).
- Poitiers (31 miles/50 km).

I Did you know?

The village takes its name from the unruly Germanic tribe of the Angles, who invaded Britain in the 5th century and whose name forms the basis of the word "England." Four centuries later, Charlemagne led descendants of this tribe who had remained in Germania to the banks of a river—a tributary of the Gartempe called the Angle and later the Anglin—where they settled, hence the name Angles-sur-l'Anglin.

Barfleur A port facing England

Manche (50) • Population: 600 • Altitude: 10 ft. (3 m)

In the Middle Ages, Barfleur was the principal port on the Cotentin Peninsula, and the village's history is tied to that of the dukes of Normandy and England.

It was a man from Barfleur named Étienne who, in 1066, carried William on the longship Mora to conquer England. In 1120 William Adelin (heir to King Henry I of England) and Henry's illegitimate son Richard perished when the White Shin ran aground at Barfleur Point, In 1346, at the beginning of the Hundred Years War, the English returned to the port, which they looted and burned. The 11thcentury Romanesque church, which occupied the present-day site of the lifeboat station, was replaced by the Eglise Saint-Nicolas, built between the 17th and 19th centuries. Surrounded by its maritime cemetery, the building contains-by way of an ex-voto-a threemasted whaleboat, offered at the birth of the artist Paul Blanvillain (1891-1965). The Chapelle de la Bretonne, built in 1983 by the people of Barfleur in honor of the beatification of Marie-Madeleine Postel. features some remarkable stained-glass windows tracing the life of the saint, as well as numerous statues adorning its walls. Alongside humble fishermen's cottages surrounded by pretty little gardens, the opulent-looking houses of the Cour Sainte-Catherine (15th century), facing the fishing port and marina, are built—like those of the Bourg, La Bretonne, and the old Augustinian Priory (18th century)-from the gray granite that is part of Barfleur's austere charm.

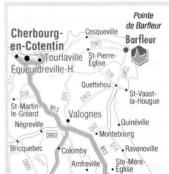

By road: N13, exit Valognes (16 miles/26 km); expressway A84, exit 40–Cherbourg (66 miles/106 km). By train: Valognes station (16 miles/26 km); Cherbourg station (17 miles/ 27 km). By air: Cherbourg-Maupertus airport (11 miles/ 18 km).

(i) Tourist information: +33 (0)2 33 54 02 48 www.ville-barfleur.fr

Highlights

• Église Saint-Nicolas: Built in the 17th– 19th centuries on a rocky promontory at the center of a maritime cemetery, it is in the classical style and contains a superb Visitation by the Flemish school of the 16th century, which is listed as a historic monument.

• Old Augustinian Priory (18th century) and its garden.

• Chapelle de la Bretonne: Listed stainedglass windows tracing the life of Marie-Madeleine Postel.

• Cour Sainte-Catherine: The remains of a former mansion (late 15th–early 16th century).

• Lifeboat station: The first lifeboat station to be built in France, in 1865, modeled on English ones.

• Village: Guided tour in summer. Further information: +33 (0)2 33 54 02 48.

Accommodation

Le Conquérant**: +33 (0)2 33 54 00 82. **Guesthouses, gîtes, walkers' lodges, vacation rentals, and campsites** Further information: +33 (0)2 33 54 02 48 www.ville-barfleur.fr

I Eating Out

Café de France: +33 (0)2 33 54 00 38.

Chez Buck, crêperie: +33 (o)2 33 54 o2 16. Le Comptoir de la Presqu'île: +33 (o)2 33 20 37 51. La Marée: +33 (o)2 33 20 81 88. Le Moderne: +33 (o)2 33 23 12 44. Le Phare: +33 (o)2 33 54 10 33.

Local Specialties

Food and Drink Shellfish and fish. Art and Crafts Antique dealer • Decoration • Art gallery • Ceramic artist.

★ Events

Market: Tuesday and Saturday in summer (Saturday off-season), 8 a.m.-1 p.m., Place Henri-Chardon.

June-August: Painting and sculpture exhibitions.

Late July to early August: Été Musical de Barfleur, classical music festival. August: Village des Antiquaires, antiques fair (3rd or 4th weekend).

W Outdoor Activities

Walking: Route GR 223; hiking and mountain-biking trails. Watersports: Sailing, kayaking, diving.

🕊 Further Afield

• Barfleur Point (2 miles/3 km).

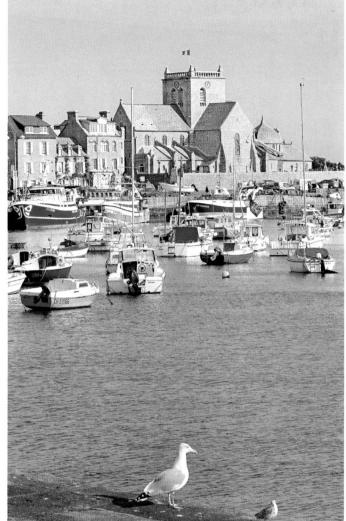

• Montfarville: church and its paintings (2 miles/3 km).

- Gatteville lighthouse (2 miles/3 km).
- La Pernelle: viewpoint (4 ½ miles/7 km).
- Saint-Vaast-la-Hougue: Vauban towers (9 ½ miles/15.5 km).
- Valognes, "the Versailles of Normandy" (16 miles/26 km).
- Cherbourg; Cité de la Mer, science park (18 miles/29 km).
- Château de Bricquebec (24 miles/39 km).

I Did you know?

Some come here just for the Barfleur "Blonde." This wild mussel, from natural beds near the port, is fished by professional fishing boats equipped with a mussel dragnet, and is best eaten between June and September.

Le Bec-Hellouin

Spiritual resting place in the Normandy countryside

Eure (27) • Population: 419 • Altitude: 164 ft. (50 m)

Between Rouen and Lisieux, this typical Normandy village takes its name from both the stream that flows alongside it and the founder of its famous abbey. The abbey at Bec was founded in 1034, at the time of William the Conqueror, duke of Normandy and England's first Norman king. Its first abbot was Herluin (Hellouin), knight to the count de Brionne Both Lanfranc and Anselm followed Herluin into the abbey and were trained by him: both left their mark on Western Christianity. Lanfranc was a scholar and teacher who developed the abbey school: he served as archbishop of Canterbury in England from 1070 to 1089, Saint Anselm, philosopher and theologian, succeeded Lanfranc as prior of Bec Abbey and became abbot on the death of Herluin in 1078. He also became archbishop of Canterbury (1093-1109). Destroyed and rebuilt several times. Bec Abbey fell into ruin during the French Revolution and Napoléon's Empire. The only remaining part of the medieval abbey complex is the tower of Saint-Nicolas (15th century), which still dominates the site. In 1948 new life was breathed into the abbey by the arrival of a community of Benedictine monks. While Le Bec-Hellouin certainly owes its reputation to the religious prestige of this remarkable building, the village itself is also well worth visiting, with its half-timbered houses and flower-decked balconies nestling in the heart of a verdant landscape of woodland and fields.

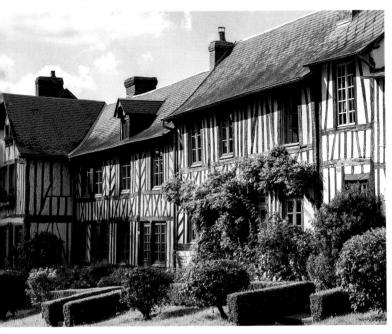

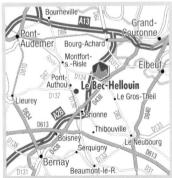

By road: Expressway A28, exit 13– Le Neubourg-Brionne (3 ½ miles/5.5 km). By train: Brionne station (4 ½ miles/7 km); Bernay station (16 miles/26 km). By air: Deauville-Saint-Gatien airport (5 miles/8 km).

Tourist information—Pays Brionnais: +33 (0)2 32 45 70 51 www.tourismecantondebrionne.com www.lebechellouin.fr

Highlights

• Abbaye de Notre-Dame-du-Bec: Maurist (Congregation of Saint Maur) architecture of 17th and 18th centuries; abbey church, cloisters. Further information:

+33 (0)2 32 43 72 60.

• Église de Saint-André (14th century): Important 13th–18th-century statuary.

Accommodation

Auberge de l'Abbaye***: +33 (o)2 32 44 86 02. **Gîtes and vacation rentals** Le Petit Moulin***: +33 (o)2 32 35 40 22. Au Chant des Oiseaux: +44 (o)1386 765972. La Maison du Bec: +33 (o)6 14 20 12 22. La Parenthèse: +33 (o)2 32 45 97 51. **Campsites** Camping Saint-Nicolas*** (March 15–October 15):

+33 (0)2 32 44 83 55.

T Eating Out

L'Archange, crêperie: +33 (0)2 32 43 67 64. Auberge de l'Abbaye: +33 (0)2 32 44 86 02. La Crêpe dans le Bec, crêperie: +33 (0)2 32 47 24 46.

Au Relais du Bec Fin: +33 (0)2 32 44 82 95. Restaurant de la Tour: +33 (0)2 32 44 86 15.

Local Specialties

Food and Drink Organic produce. Art and Crafts Art and antiques • Monastic crafts.

★ Events

April: Plant market (last Sunday). July: General sale (closest Sunday to 14th) and "Gourmand'Art," outdoor produce market (Sunday after the 14th). July–August: Exhibitions of painting and sculpture (village hall).

W Outdoor Activities

Horse-riding • Fishing (Bec stream) • Walking (3 marked trails) and green route (27 miles/43 km) of multi-trail paths along the former railway line (walking, cycling, roller-skating).

🆗 Further Afield

Brionne: keep, former law court, watersports on the lake (3 ½ miles/5.5 km).
Harcourt: castle, arboretum (8 miles/ 13 km).

• Sainte-Opportune-du-Bosc: Château de Champ-de-Bataille (8 ½ miles/13.5 km).

• Le Neubourg: Musée de l'Ecorché d'Anatomie, museum of anatomy (11 miles/18 km).

• Pont-Audemer, "the Venice of Normandy": Musée A.-Canel, museum (12 miles/19 km).

• Bernay: museum, abbey church (14 miles/23 km).

• Beaumesnil: museum, castle (24 miles/39 km).

• Évreux: cathedral, Gisacum religious

- sanctuary (27 miles/43 km).
- Rouen (27 miles/43 km).

I Did you know?

In 1232, excavations at the abbey unearthed the body of the Empress Matilda, daughter of King Henry I of England and wife of Henry V. Wrapped in cowhide, according to medieval custom, she had been buried in 1167 in front of the altar of the Virgin, beneath a marble slab.

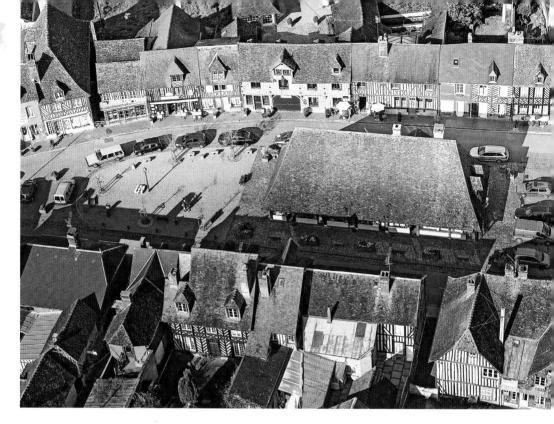

Beuvron-en-Auge

The flavors of Normandy

Calvados (14) • Population: 246 • Altitude: 33 ft. (10 m)

Nestled between valleys dotted with apple trees and half-timbered farmhouses, Beuvron, centered around its covered market, is a showcase for the Pays d'Auge.

In the 12th century, Beuvron consisted of only a small medieval castle and a church. By the end of the 14th century, however, reflecting the fame of the resident Harcourt family, the town was in its heyday. This Norman family with royal connections helped establish the town's commercial activities right up until the French Revolution, and built the present church and chapel of Saint-Michel de Clermont overlooking the Auge valley. The façades of the wooden-frame houses recall the four golden centuries of the village: decorated in rendered plaster or pink brick, with vertical or diagonal timbers, they are bedecked with geraniums. Previously thatched, the steep roofs are now covered with slates or tiles. The houses and businesses huddle around the magnificently restored covered market. On the edge of the village, farms, manors, and stud farms stretch out into the woods and farmland, keeping alive the region's local traditions and specialties.

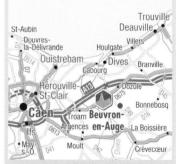

By road: Expressway A13, exit 29–Cabourg (4 ½ miles/7 km). By train: Lisieux station (18 miles/29 km); Caen station (19 miles/31 km). By air: Caen-Carpiquet airport (26 miles/22 km).

() Tourist information: +33 (0)2 31 39 59 14 www.beuvroncambremer.fr

Highlights

• Church (17th century): 18th-century main altar, stained-glass windows by Louis Barillet, pulpit in Louis XVI style.

• Chapelle de Saint-Michel-de-Clermont (12th–17th century): Statues of Saints Michael and John the Baptist.

• Stud farm Haras de Sens: Visit a stud farm that breeds, raises, and trains horses; groups by appointment only: +33 (0)2 31 79 23 05.

• Espace des Métiers d'Art: In the former school are five art and craft studios, and a multipurpose exhibition space. Further information: +33 (0)2 31 39 59 14.

• Village: Guided visits for individuals in summer, and for groups by reservation. Further information: +33 (0)2 31 39 59 14.

Accommodation Guesthouses

♥ Le Clos Fleuri ***: +33 (0)2 31 39 00 62.
 Aux Trois Damoiselles:
 +33 (0)2 31 39 61 38.
 M. and Mme Pierre de La Brière:
 +33 (0)2 31 79 10 20.
 Domaine d'Hatalaya: +33 (0)2 31 85 46 41.
 Manoir de Sens: +33 (0)2 31 79 23 05.
 Le Pavé d'Hôtes: +33 (0)2 31 39 39 10.
 Le Pressoir: +33 (0)6 83 29 42 52.
 Gites

M. Patrick De Labbey***: +33 (0)2 31 79 12 05. La Maison du Haras: +33 (0)6 98 25 51 84. **RV parks** Further information: +33 (0)2 31 39 59 14.

T Eating Out

Le Café du Coiffeur: +33 (o)2 31 79 25 62. Le Café Forges: +33 (o)2 31 74 01 78. La Colomb'Auge, crêperie: +33 (o)2 31 39 02 65. L'Orée du Village: +33 (o)2 31 79 49 91. Le Pavé d'Auge: +33 (o)2 31 79 26 71.

Local Specialties

Food and Drink Cider AOC, Beuvron cider • Calvados. Art and Crafts Antique dealers • Artists' studios • Fashion

designer • Painter • Sculptor, *Santon* (crib figure) maker, animal painter.

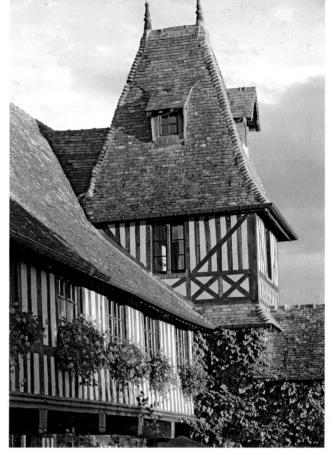

★ Events

April: Boogie blues at Sens stud farm. May: Geranium fair. July: Antiques fair. July–August: Art and craft exhibitions. August: Grand flea market. October: Large market and traditional cider festival, boogie-woogie at Sens stud farm. December: Christmas market.

W Outdoor Activities

Fishing • Walking (one marked trail).

🕊 Further Afield

- Manor houses and castles in the Beuvron region (1/2–6 miles/1–9.5 km).
- Cambremer (6 miles/9.5 km).
- Côte Fleurie, coast in bloom
- (9 ½ miles/15.5 km). • Caen (19 miles/31 km).

1 Did you know?

The covered market in Beuvron's main square is not as old as it looks. It was actually built in 1975 on the site of the previous market building, using materials recycled from farms and granges set to be demolished when the Normandy expressway was being built.

Candes-Saint-Martin

Bright reflections where rivers meet

Indre-et-Loire (37) • Population: 224 • Altitude: 131 ft. (40 m)

Built on a hillside. Candes gazes at its own reflection in the waters of the Vienne and Loire. Springing up where two rivers merge, Candes was for centuries a village of barge people, who contributed to the busy traffic on the Loire and the Vienne by selling local wines. plum brandies, and tufa stone from their toues (traditional fishing boats) and barges on the Loire. Indeed, the striking whiteness of tufa stone beneath the dark slate and tiled roofs still brightens the houses and the imposing collegiate church in the village. Built between 1175 and 1225 and fortified in the 15th century, the church is dedicated to Saint Martin, the bishop of Tours, who brought Christianity to Gaul. One of its stained-glass windows recreates the nocturnal removal of his body by monks from Tours. More than sixteen centuries after his death. Saint Martin is still revered through legends of his many miracles. Undoubtedly the best tells the story of how, when his remains were taken by boat to Tours on November 11, 397, the banks of the Loire burst into unseasonal summer blooms. This was the first ever été de la Saint-Martin-also known as an Indian summer.

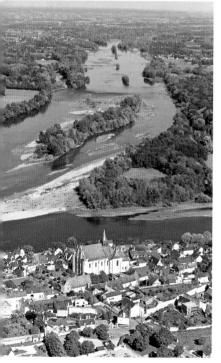

Highlights

• Collégiale Saint-Martin, collegiate church (12th and 13th centuries): Plantagenet Gothic style, fortified in the 15th century. • Comptoir du Confluent: Find out about the area's river heritage (conference, crossings, exhibitions) in July and August: +33 (0)2 47 95 93 57.

• Village: Guided tours to the village and/or the collegiate church given by the Association des Amis de Candes: +33 (0)2 47 95 90 71.

✓[★] Accommodation Guesthouses

La Fontaine**: +33 (0)2 47 95 83 66. La Basinière: +33 (0)2 47 95 98 45. **Gîtes and vacation rentals** Le Château de Candes**** and ***: +33 (0)2 47 58 88 88. Le Gîte de la Confluence****: +33 (0)2 45 95 87 12. Le Logis de la Renaissance***: +33 (0)2 41 62 25 21. Le Moulin Saint-Michel: +33 (0)2 41 51 18 23. **Campsites** Camping Belle Rive: +33 (0)2 47 97 46 03.

T Eating Out

La Brocante Gourmande, bookshop and tea room: +33 (0)2 47 95 96 39. L'Onde Viennoise, brasserie: +33 (0)2 47 95 90 66. La Route d'OI: +33 (0)2 47 95 81 10.

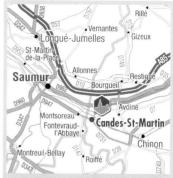

By road: Expressway A85, exit 5–Bourgueil (6 miles/9.5 km). By train: Saumur station (8 ½ miles/13.5 km); Saint-Pierre-des-Corps TGV station (42 miles/68 km). By air: Tours-Saint-Symphorien airport (43 miles/69 km).

(i) Tourist information—

Pays de Chinon: + 33 (0)2 47 93 17 85 www.chinon-valdeloire.com

Local Specialties

Food and Drink AOC wines from Tours, Chinon-Tours, and Saumur-Tours. Art and Crafts Ceramic artist • Antiquarian books •

Silver- and goldsmiths • Lamp-maker.

🖈 Events

Country market: Saturday mornings, 9 a.m.-1 p.m., east car park. Throughout the year: Concerts: +33 (0)2 47 95 90 61. July and August: "Flâneries Piétonnes" (village closed to traffic, various activities): Sundays 2–6 p.m. August: Fête des Ricochets, stoneskimming contest; Fête du Village (and Sunday); concerts (end of August).

W Outdoor Activities

Bathing: Confluence beach (no lifeguard) • Fishing • Boat trips • Walking: path along the Loire via Sancti Martini • Cycling: "Loire à Vélo" trail.

🖗 Further Afield

- *Montsoreau (½ mile/1 km), see pp. 41–42.
- Abbaye de Fontevraud (4 ½ miles/6.5 km).
- Seuilly: la Devinière, Rabelais's house (9 ½ miles/15.5 km).
- Chinon (11 miles/18 km).
- Châteaux of the Loire and Indre (12–23 miles/ 19–37 km).
- *Crissay-sur-Manse (24 miles/39 km), see p. 27.

Crissay-sur-Manse

Renaissance charm in the Touraine

Indre-et-Loire (37) • Population: 116 • Altitude: 197 ft. (60 m)

A former *crisseium* (Latin for "where a fortress stands") in the 9th century, Crissay has retained its castle, its houses, its gardens, and two washhouses bordering the river Manse, which meanders beneath the poplars.

Originally a castellany belonging partly to Île-Bouchard, a large town at this time, and partly to the archbishopric of Tours, Crissay became the stronghold of Guillaume de Turpin and his descendants for nearly five centuries. The Château de Crissay was built on the foundations of the fortress in the 15th century. Of this seigneurial residence, which was never completed nor lived in, there remains only the main building, the keep from the 11th and 12th centuries, and underground shelters. Built in 1527 at the instigation of the Turpins, the church contains two 16th-century wooden statues representing Saint John and the Virgin, a piscina with floral *rinceaux* in the chancel, and the tomb of Catherine du Bellay, a cousin of the poet Joachin du Bellay (c. 1522–1560). On the upper square, the 15thcentury houses recall Crissay's golden age with their mullioned windows and ridged dormers.

Highlights

• Castle (15th century): By appointment only: +33 (0)2 47 58 54 03. • Église Saint-Maurice (16th century): 16th-century statues. • Village: Guided tour by appointment: +33 (0)2 47 58 64 99.

Accommodation

Hotels L'Auberge de Crissay: +33 (0)2 47 58 58 11. Guesthouses M. Guérin: +33 (0)2 47 97 07 81.

Gîtes

La Chaume: +33 (0)2 47 97 07 33. Les Rageaux: +33 (0)2 47 58 54 26. Rochebourdeau: +33 (0)2 47 95 23 84.

T Eating Out

L'Auberge de Crissay, wine bar/restaurant: +33 (0)2 47 58 58 11.

Local Specialties Food and Drink

Goat cheeses • Honey • Chardonnay, vin de pays, and AOC Chinon wine.

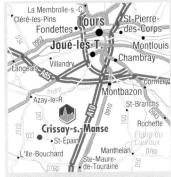

By road: Expressway A10, exit 25–Saint-Maure-de-Touraine (7 ½ miles/12 km). By train: Noyant-de-Touraine station (6 miles/9,5 km); Tours station (29 miles/47 km); Saint-Pierre-des-Corps TGV station (30 miles/48 km). By air: Tours-Saint-Symphorien airport (31 miles/50 km).

(i) Town hall: +33 (0)2 47 58 54 05

\star Events

April: Walk (3rd Sunday). Pentecost Sunday: Foire aux "Vieilleries," rummage sale. July and August: Classic and modern theater in the castle courtward (and

theater in the castle courtyard (2nd fortnight of each month).

W Outdoor Activities

Walking: 2 marked trails.

🕊 Further Afield

• Roches-Tranchelion: collegiate church (1 mile/1.5 km).

- Vienne valley: from Île-Bouchard to Chinon (4 ½–14 miles/7–23 km).
- Azay-le-Rideau: castle (12 miles/19 km).
- *Candes-Saint-Martin (24 miles/39 km), see p. 26.
- *Montsoreau (24 miles/39 km), see pp. 41–42.

I Did you know?

The so-called Huguenots' Fountain lies just outside the town. In 1562, according to local legend, some Huguenots were trying to transport a huge church bell, but the cart carrying it foundered in the marshes and the bell sank without a trace. This natural spring produces water at a constant temperature, but is said to be fated to ring out its anger every hundred years.

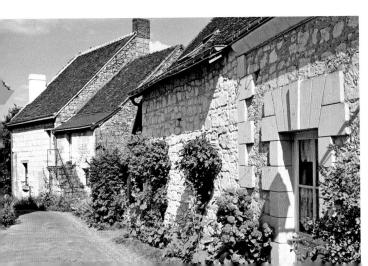

Gargilesse-Dampierre Inspiration for a novelist

Indre (36) • Population: 325 • Altitude: 476 ft. (145 m)

This romantic village, with its harmonious houses overlooked by the château and church, stretches out over a sloping headland rich in vegetation. In 1844, novelist George Sand discovered this village. whose "houses are grouped around the church, planted on a central rock, and slope down along narrow streets toward the bed of a delightful stream, which, a little further on and lower down, loses itself in the Creuse." Only a postern and two round towers survive of the medieval castle, the rest of which was destroyed in 1650 during the Fronde (civil wars, 1648–53) and the extant château was built on its ruins in the 18th century. The 11th-12th-century Romanesque church, with its fine white limestone stonework. adjoins it. Its nave houses a set of capitals decorated with narrative scenes, including the Twenty-Four Elders (Revelation 4:4) at the crossing and scenes from the Old and New Testaments in the apses. The crypt is decorated with 12th- to 16th-century frescoes of rare beauty, representing the instruments of the Passion and various scenes from the lives of Christ and Mary. Following in the footsteps of Claude Monet, many artists-such as Paul Madeline (1863-1920) and Anders Österlind (1887-1960)—have been inspired by the charm of the village.

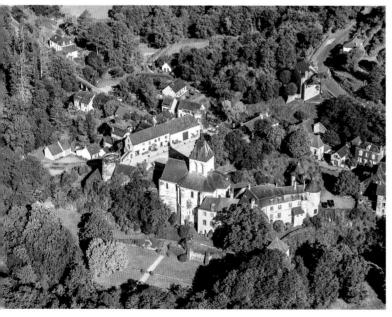

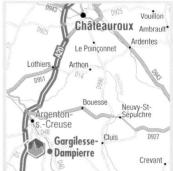

By road: Expressway A20, exit 17– Argenton-sur-Creuse (11 miles/18 km). By train: Argenton-sur-Creuse station (8 miles/13 km); Châteauroux station (25 miles/40 km). By air: Limoges-Bellegarde airport (62 miles/100 km).

() Tourist information: +33 (0)2 54 47 85 06 www.gargilesse.fr

Highlights

• Château (18th century): Art gallery: +33 (0)6 81 19 65 53.

• Romanesque church (12th century): Capitals decorated with narrative scenes, including the Twenty-Four Elders from Revelation and scenes from the Old and New Testaments; crypt, 12th- to 16th-century frescoes representing the instruments of the Passion and various scenes from the lives of Christ and Mary; painted wood Virgin (12th century); guided tour daily in summer: +33 (0)2 54 47 85 of.

• "Villa Algira," Maison de George Sand: Collection of the author's personal effects in her former vacation home: +33 (0)2 54 47 70 16.

• Musée Serge Delaveau: Collection of works by the painter who lived at Gargilesse. Further information: +33 (0)2 54 47 85 06.

Accommodation

Les Artistes: +33 (o)2 54 47 84 05. **Guesthouses** Le Haut Verger: +33 (o)2 54 60 16 54. **Gîtes** Further information: +33 (o)2 54 47 85 06 www.gargilesse.fr **Municipal campsite and chalets** La Chaumerette**: +33 (o)2 54 47 84 22.

Y Eating Out Les Artistes: +33 (0)2 54 47 84 05. Auberge La Chaumerette: +33 (0)2 54 60 16 54. Café de Dampierre: +33 (0)2 54 47 84 16. Le George Sand, in summer: +33 (0)2 54 47 83 06.

Local Specialties

Food and Drink Goat cheese (*Gargilesse*). Art and Crafts Picture framer • Metalworker • Art galleries • Pottery • Soap-maker • Jewelry • Sculptor • Antiques.

★ Events

May: Flower and farm produce market (2nd Sunday).

June-September: Concerts and exhibitions.

August: Free art exhibition in the street (Sunday before the 15th); harp and chamber music festival (3rd week). September: Journées du Livre book fair (last weekend).

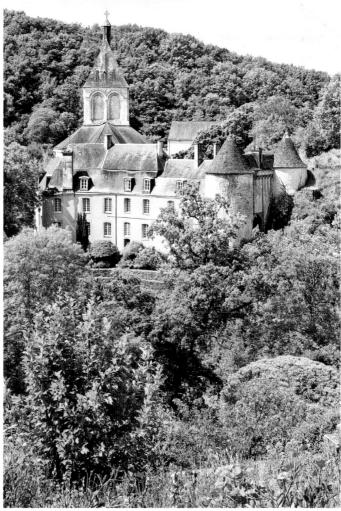

W Outdoor Activities

Swimming • Fishing • Walking: Routes GR Pays Val de Creuse and 654, Chemin de Compostelle (Saint James's Way), and marked trails.

🕊 Further Afield

- Gorges of the Creuse (1 mile/1.5 km).
- Lac d'Éguzon, lake (7 miles/11.5 km).
- Argenton-sur-Creuse (8 ½ miles/13.5 km).
- Crozant (11 miles/18 km).
- *Saint-Benoît-du-Sault (15 miles/24 km), see p. 49.
- Nohant-Vic (24 miles/39 km).

I Did you know?

George Sand wrote of Gargilesse, where her dry-stone house, Villa Algira, provided a contrast to her grander mansion at Nohant: "While waiting for fashion to extend her scepter on this rustic solitude, I am careful not to name the village in question: I simply call it my village, as one might speak of one's discovery or one's dream."

Gerberoy The roses of Picardy

Oise (60) • Population: 88 • Altitude: 617 ft. (188 m)

On the border between two villages that were once rivals, the houses in Gerberoy combine Normandy and Picardy traditions, featuring wattle-and-daub half-timbering and brick slabs.

The village, on the edge of the Pavs de Brav, acquired a castle in 922 at the instigation of the viscount of Gerberoy. His son and successor completed the structure with the addition of a keep, a hospital, and a collegiate church in 1015. Given its strategic position at the crossroads of two kingdoms, the village of Gerberoy was soon coveted and contested. The fortified town belonged to the lords of Beauvais, then was successively besieged by John the Fearless, the Burgundians, and the Catholic League. The square tower that controlled the curtain wall is the only remnant of the castle that once adjoined the collegiate church of Saint-Pierre. Rebuilt in the 15th century after having been burned by the English, the latter still contains treasure in its chapter house. From the tower gate can be seen, down below, the paved courtyard and house that hosted Henri IV in 1592 after he was wounded at the Battle of Aumale. Captivated by "the silent Gerberoy." the postimpressionist painter Henri Le Sidaner (1862-1939) created beautiful Italian-style gardens here that are visible from the ramparts, and helped to make Gerberov a village of roses, which have been celebrated every year since 1928.

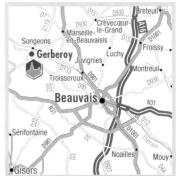

By road: Expressway A16, exit 15– Beauvais-Nord (12 miles/19 km); expressway A29, exit 16–Hardivillers (20 miles/32 km). By train: Marseilleen-Beauvaisis station (6 miles/9.5 km); Milly-sur-Thérain station (7 miles/11.5 km); Beauvais station (14 miles/23 km). By air: Beauvais-Tillé airport (16 miles/ 26 km); Paris-Roissy-Charles de Gaulle airport (63 miles/101 km).

(1) Tourist information—Picardie Verte et Ses Vallées: +33 (0)3 44 46 32 20 0r +33 (0)3 44 82 54 86 ot.picardieverte.free.fr / www.gerberoy.fr

Highlights

• Collégiale Saint-Pierre (11th and 15th centuries): 15th-century stalls.

 ♥ Jardins Henri Le Sidaner: Designated a "remarkable garden" by the Ministry of Culture; terraces of the old fortress transformed into 1-acre (4,000 sq.-m) gardens by the artist Le Sidaner; artist's studio/museum: +33 (0)3 44 82 36 63.
 Musée Municipal: Archeology, crafts,

and paintings and drawings by Le Sidaner. • Village: Guided tour for groups all year round by appointment only: +33 (0)3 44 82 54 86 or

+33 (0)3 44 46 32 20.

Accommodation

Guesthouses Le Logis de Gerberoy****: +33 (0)3 44 82 36 80.

T Eating Out Les Jardins du Vidamé, bistro: +33 (0)3 44 82 45 32. Le Vieux Logis, restaurant and tea room: +33 (0)3 44 82 71 66.

Tea rooms

Ambassade de Picardie: +33 (0)3 44 82 16 50. L'Atelier Gourmand de Sarah: +33 (0)6 73 19 02 06. La Terrasse: +33 (0)3 44 82 68 65.

Local Specialties

Food and Drink Rose products (soaps, preserves, candles).

★ Events

April-September: Art and crafts exhibitions. June: Moments Musicaux de Gerberoy music festival; Fête des Roses (3rd Sunday).

W Outdoor Activities

Walking: Route GR 125 and 3 marked trails.

🕊 Further Afield

 Songeons; Hétomesnil; Saint-Arnoult; Vendeuil-Caply (6–25 miles/9.5–40 km).

- Pays de Bray, region: Gournay-en-Bray;
- Saint-Germer-de-Fly (8 miles/13 km).

• *Lyons-la-Forêt (22 miles/35 km), see pp. 35–36.

Lavardin Grottoes and Gothic architecture

Loir-et-Cher (41) • Population: 220 • Altitude: 262 ft. (80 m)

This village, near where the poet Ronsard was born in 1524 (the Promenade du Poète that runs along the Loir river is named after him). bears the marks of centuries of occupation, from prehistoric cave complexes to the Renaissance and beyond. Lavardin became famous when it withstood Richard the Lionheart's attack in 1118, thanks to its castle's tiered defenses. However, the lords of the region were not in a position to fight back when they faced Henry IV-the king of Navarre-and his troops. Furious when his subjects refused to convert to Protestantism, the young king and the duke de Vendôme destroyed the fortresses of Montoire, Vendôme, and Lavardin. Today, the castle ruins command the village from the top of a limestone cliff. A tufa-stone Gothic bridge with eight arches spans the Loir. Standing tall at the heart of the village is the Romanesque church of Saint-Genest, whose nave and choir are decorated with murals from the 12th and 16th centuries. Almost every period of history has left its mark on Lavardin, which blends troglodyte, Gothic, and Renaissance houses. White facades rub shoulders with half-timbered houses topped with flat tiles. Larvardin also boasts the only grottoes in France in which, according to a widely held legend, a powerful druidic sect indulged in bloody sacrificial rites.

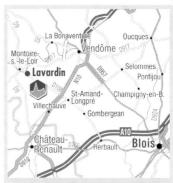

By road: N10 (7 miles/11 km); expressway A10, exit 18–Château-Renault (21 miles/ 34 km). By train: Vendôme station (16 miles/26 km); Vendôme TGV station (19 miles/31 km). By air: Tours-Saint-Symphorien airport (32 miles/51 km).

① Tourist information—Montoiresur-le-Loir: +33 (0)2 54 85 23 30 Town hall: +33 (0)2 54 85 07 74 www.lavardin.net

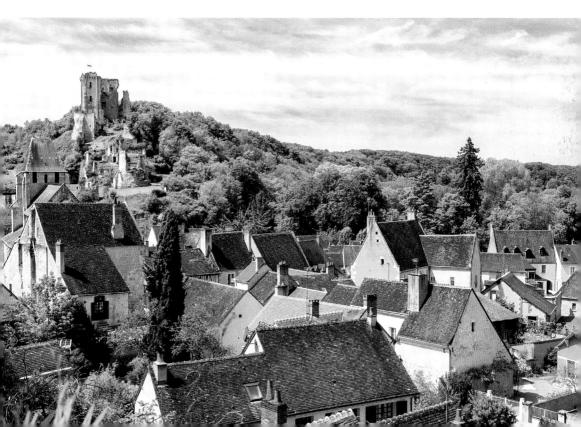

Lavardin Loir-et-Cher

Highlights

• Castle (11th and 14th centuries): Lodge, outbuildings, drawbridge, grand staircase, guardroom, keep. Open May-September: +33 (0)6 81 86 12 80.

• Église Saint-Genest (11th century): Wall paintings from 12th and 16th centuries, representing Christ's Baptism and Passion: +33 (0)2 54 85 07 74

• Musée de Lavardin: Village history and castle heritage. Open May-September.

Accommodation Guesthouses

À la Folie: +33 (0)2 54 72 60 12. Gîte de l'Arche: +33 (0)6 21 21 78 36. Gîtes

À la Folie: +33 (0)2 54 72 60 12. Gîte de l'Arche: +33 (0)6 21 21 18 36. Les Roches Neuves, cave-dwellers' gîte: +33 (0)2 54 72 26 56.

T Eating Out

Le Relais d'Antan: +33 (0)2 54 86 61 33.

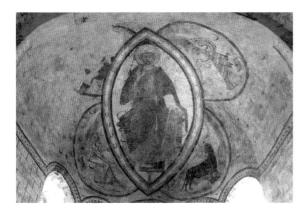

Local Specialties

AOC Coteaux du Vendômois wines • Regional produce (honey, goat cheese, charcuterie, mushrooms, cider, ice cream).

★ Events

January: Fête de Saint-Vincent. March: World Chouine (traditional card game) Championships, (1st Sunday). Ascension: "Peintres au Village" painting contest. June: "Feu de la Saint-Jean," bonfire.

July: "Embrasement du Château," celebration with fireworks. December: Christmas market (1st weekend).

W Outdoor Activities

Walking: Routes GR 35 and GR 335, and 3 marked trails.

🕊 Further Afield

 Troo: collegiate church, cave-dwellers' settlement; Couture-sur-Loir: Ronsard's manor (5-9 ½ miles/8-15.5 km).

· Thoré-la-Rochette: tourist train; Vendôme (6-12 miles/9.5-19 km).

I Did you know?

Each year Lavardin hosts the world championships in chouine, a card game that has been played since the 16th century.

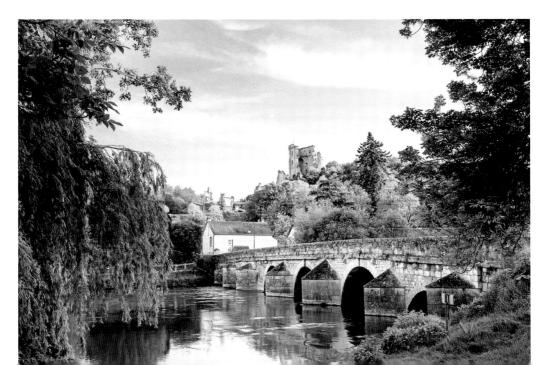

32

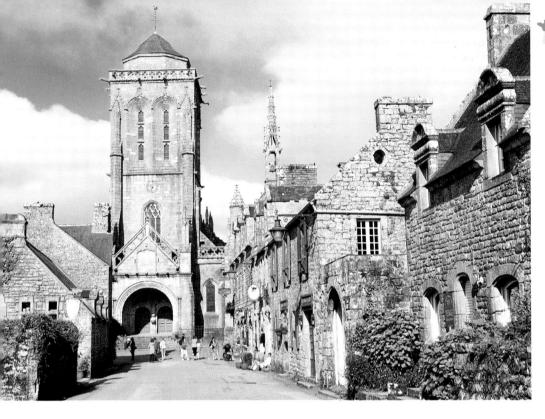

Locronan

Thread and stone

Finistère (29) • Population: 800 • Altitude: 476 ft. (145 m)

A historic weaving village dominated by granite, Locronan owes its name to Saint Ronan, the hermit who founded it.

In the 6th or 7th century, while still haunted with memories of druidic cults, the forest of Névet became home to the hermit Saint Ronan. In the 15th century, thanks to the dukes of Brittany, Locronan became one of the jewels of Breton Gothic art. The priory church was built between 1420 and 1480, while the Chapelle du Pénity (15th-16th centuries), next to the church, houses Saint Ronan's recumbent statue. During the Renaissance, the village became famous for its weaving industry, providing canvas sails for the East India Company and the ships of the French Navy. The East India Company's offices still stand on the village square, as well as 17th-century merchants' dwellings and residences of the king's notaries. Locronan's Renaissance granite buildings regularly provide movie backdrops, for productions such as A Very Long Engagement (with Audrey Tautou and Jodie Foster) and Tess (directed by Roman Polanski). In the old weaving quarter, the 16th-century Chapelle Notre-Dame-de-Bonne-Nouvelle contains stained-glass windows by the abstract painter Manessier.

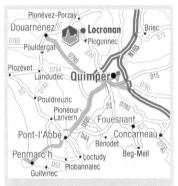

By road: N165, exit Audierne-Douarnenez (3 miles/5 km). By train: Quimper station (11 miles/18 km). By air: Quimper-Cornouaille airport (11 miles/18 km); Brest-Guipavas airport (39 miles/63 km).

Tourist information: +33 (0)2 98 91 70 14 www.locronan-tourisme.com

Highlights

• Église Saint-Ronan (15th century): 15thcentury stained glass, statues, treasure, • Chapelle du Pénity (15th-16th centuries): Recumbent statue of Saint Ronan in Kersanton stone (15th century). Chapelle Notre-Dame-de-Bonne-Nouvelle (16th century): Modern stainedglass windows by Alfred Manessier; cross and communal washing place. • Musée d'Art et d'Histoire: "L'Industrie de la toile" (the work of an 18th-century weaver, traditional costume collection) and "Locronan, Étape de la Route des Peintres en Cornouaille" (collection of paintings by 50 early 20th-century painters), Breton headdresses and costumes, reconstructed Breton interior. • Village: Guided visits for groups or individuals. Further information: +33 (0)2 98 91 70 14.

Accommodation Hotels

Latitude Ouest***: +33 (0)2 98 91 70 67. Le Manoir de Moëllien***: +33 (0)2 98 92 50 40.

Le Prieuré**: +33 (0)2 98 91 70 89. Guesthouses

Mme Camus***: +33 (0)2 98 91 85 34. Mme Douy: +33 (0)2 98 91 74 85. Mme Le Doaré: +33 (0)2 98 91 83 97.

Vacation rentals

Further information: +33 (0)2 98 91 70 14 www.locronan-tourisme.org

Campsites

Camping Locronan***: +33 (0)2 98 91 87 76 or +33 (0)6 28 80 44 74.

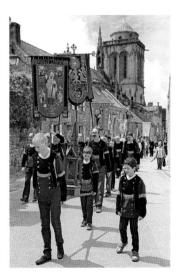

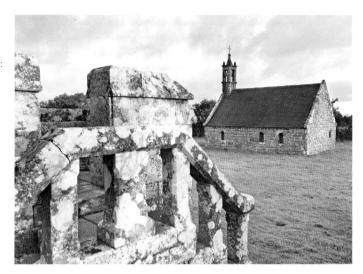

T Eating Out

Au Coin du Feu: +33 (0)2 98 51 82 44. Le Comptoir des Voyageurs: +33 (0)2 98 91 70 74. Le Grimaldi: +33 (0)2 56 10 18 37. Le Prieuré: +33 (0)2 98 91 70 89. Créperies

Breiz Izel: +33 (0)2 98 91 82 23. Chez Annie: +33 (0)2 98 91 87 92. Le Temps Passé: +33 (0)2 98 91 87 29. Les Trois Fées: +33 (0)2 98 91 70 23. Ty Coz: +33 (0)2 98 91 70 79.

Local Specialties Food and Drink

Galettes • Breton cake • Kouian amann (buttery cake).

Art and Crafts

Watercolorist • Antiques • Ceramic artists • Leather and tin worker • Bronze worker • Leatherworker • Painters • Art photographer • Glass-blowers • Weavers • Wood sculptors · Marriage-spoon sculptor.

★ Events

Market: Every Tuesday morning, Place de la Mairie. May: Flower market. July: Pardon de la Petite Troménie, procession (2nd Sunday). July-August: "Les Marchés aux Étoiles," evening craft and local produce market (Thursdays, mid-July-mid-August);

concerts (Tuesdays); flea markets and antiques fairs. December: Illuminations and Christmas market.

W Outdoor Activities

Walking: Route GR 38 and marked trails (Névet forest, circular walk; wheelchair accessible) · Mountain-biking (Névet forest).

W Further Afield

- Douarnenez (6 miles/9.5 km).
- Châteaulin; Nantes-Brest canal (10 miles/16 km).
- Ouimper (11 miles/18 km).
- Audierne (19 miles/31 km).
- Crozon peninsula (19 miles/31 km). · Pays Bigouden, region; Pont-l'Abbé (24 miles/39 km).

I Did you know?

Locronan is one of the few Celtic settlements still to have a nemeton in the landscape. This large rectangle of land (making a circuit of 7 ½ miles/12 km) contains 12 markers corresponding to the 12 months of the Celtic year. It had a sacred purpose: to represent on earth the passage of the stars in the sky. Every six years, the Grande Troménie religious procession takes place in honor of Saint Ronan, and the inhabitants of Locronan walk this sacred path.

Lyons-la-Forêt

Eure (27) • Population: 759 • Altitude: 312 ft. (95 m)

Standing in the middle of one of the most beautiful beech groves in Europe, in Normandy's largest forest, Lyons's attractive halftimbered buildings are typical of the Normandy style of the 17th and 18th centuries.

Gallo-Roman in origin, Lyons-la-Forêt stretches along the Lieure river. The church of Saint-Denis (12th–16th centuries) and the historic Benedictine and Cordelier convents look down over the river. Right at the heart of Lyons-la-Forêt, the village center encircles the remains of the castle, where Henry I of England, son of William the Conqueror, died—supposedly from a surfeit of lampreys—in 1135. The village also clusters around its 18th-century market hall, in a triangle bustling with all the shops and businesses you'd expect from the region's county town. Built of colored cob, bricks, or halftimbers, the houses are bedecked with flowers. The Vieux Logis (coaching inn), the Sergenterie (sergeants' residence), the house of Benserade (a poet at Louis XIV's court), the Fresne (where Maurice Ravel composed), and the former bailiwick court (now the town hall) are the main attractions.

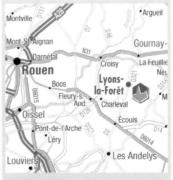

By road: Expressway A16, exit 15–Beauvais centre (37 miles/60 km); expressway A13, exit 20–Criquebeuf (21 miles/34 km). By train: Rouen station (21 miles/34 km). By air: Rouen-Vallée de la Seine airport (17 miles/27 km); Beauvais-Tillé airport (34 miles/55 km); Paris-Roissy-Charles de Gaulle airport (71 miles/114 km).

(1) Tourist information—Pays de Lyons: +33 (0)2 32 49 31 65 www.paysdelyons.com

Lyons-la-Forêt Eure

Highlights

• Hôtel de Ville: Prison cell and 18thcentury law court: +33 (0)2 32 49 31 65. • Village: Guided visits for groups by appointment only: +33 (0)2 32 49 31 65.

Accommodation Hotels

♥ La Licorne****: +33 (0)2 32 49 62 02. Le Grand Cerf ***: +33 (0)2 32 49 60 44. Les Lions de Beauclerc: +33 (0)2 32 49 18 90. Country inn Le Domaine Saint-Paul***: +33 (0)2 32 49 60 57. Guesthouses L'Escapade de Marijac: +33 (0)2 32 49 96 62.

Le Vieux Logis: +33 (0)6 80 40 00 40. Gîtes

Further information: +33 (0)2 32 49 31 65/ www.paysdelyons.com

Campsites

Saint-Paul***: +33 (0)2 32 49 42 02. Le Bois Mareuil, naturist club: +33 (0)6 63 98 00 45.

T Eating Out

Le Commerce: +33 (0)2 32 49 49 92. Le Domaine Saint-Paul: +33 (0)2 32 49 60 57. Le Grand Cerf: +33 (0)2 32 49 60 44. La Halle: +33 (0)2 32 49 49 92.

La Licorne Royale, gourmet restaurant: +33 (0)2 32 49 62 02. Les Lions de Beauclerc: +33 (0)2 32 49 18 90. Le Petit Lyons: +33 (0)2 32 49 61 71.

Local Specialties Food and Drink

Local Normandy produce. Art and Crafts Antiques • Gifts • China • Stringedinstrument maker.

* Events

Market: Thursday, Saturday, and Sunday 8.30 a.m.-1.00 p.m. 1st May: "Foire à Tout," general sale. Pentecost: Craft fair. July: Fête de la Fleur, flower festival (1st weekend). October: Fête de Saint-Denis (mid-October). December: Christmas market.

W Outdoor Activities

Arboretum • Horse-riding • Walking • Cycling.

W Further Afield

· Abbaye de Mortemer; castles at Fleuryla-Forêt, Heudicourt, Vascoeuil, and Martainville: Abbave de Fontaine-Guérard: Musée de la Ferme de Rome (3-12 miles/5-19 km).

 Château-Gaillard; Château de Gisors; Rouen (12-22 miles/19-35 km).

• *Gerberoy (23 miles/37 km), see p. 30.

I Did you know?

Lvons-la-Forêt has twice been the location for film versions of Madame Bovary by Gustave Flaubert. The first was filmed in 1933 by Jean Renoir. The second was made in 1991; directed by Claude Chabrol, it starred Isabelle Huppert.

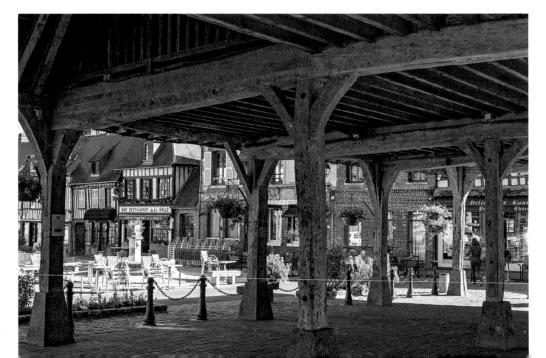

Moncontour A product of revolution

Côtes-d'Armor (22) • Population: 957 • Altitude: 394 ft. (120 m)

In a spot where two green valleys meet, Moncontour is girdled by its imposing medieval ramparts.

The village was founded in the 11th century as part of the defenses for nearby Lamballe, capital of Penthièvre. Despite being damaged in numerous clashes during the Middle Ages and partly dismantled during the French Revolution by order of Richelieu, the walls still boast eleven of its original fifteen towers, together with the Porte d'en-Haut and Saint Jean's postern. From the 18th century until the Industrial Revolution (and echoing its Finistère neighbor Locronan). Moncontour developed around the production of *berlingue* (canvas and linen cloth), which was exported to South America and the Indies. In this granite-and-slate world, the grand mansions, the town hall, and the Église Saint-Mathurin are reminders of this prosperous era. The Maison de la Chouannerie et de la Révolution reveals how the republican General Hoche established his headquarters in a mansion on the Place de Penthièvre during the French Revolution.

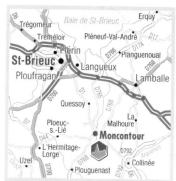

By road: N12, exit Moncontour (8 ½ miles/ 13 km). By train: Lamballe station (10 miles/16 km); Saint-Brieuc station (16 miles/26 km). By air: Saint-Brieuc airport (22 miles/35 km); Rennes-Saint-Jacques airport (60 miles/97 km).

(i) Tourist information: +33 (0)2 96 73 49 57 www.tourisme-moncontour.com

Highlights

• Église Saint-Mathurin (16th and 18th centuries): Listed 16th-century stained-glass windows: +33 (0)2 96 73 49 57.

• Maison de la Chouannerie et de la Révolution: Permanent exhibition about the Chouan guerrilla movement of the 19th and early 20th centuries: +33 (0)2 96 73 49 57.

• Théâtre du Costume: Permanent exhibition on knights in the Middle Ages, and costume from Louis XII (1498–1515) to 1900. Further information: Carolyne Morel, +33 (0)6 81 87 33 40.

• Village: Heritage walk, "The medieval fortress" (90 mins). Guided tours available for individuals in summer (Thursdays), and throughout the year for groups by appointment; themed guided tours in summer; carriage rides Mondays in summer: +33 (0)2 96 73 49 57.

Accommodation

Hostellerie de la Poterne**: +33 (o)2 96 73 40 01. Guesthouses À la Garde Ducale***: +33 (o)2 96 73 52 18. La Vallée**: +33 (o)2 96 73 55 12. Gîtes and vacation rentals Mme Georgelin**: +33 (o)2 96 73 44 24 or +33 (o)6 71 20 13 72. Mme Leroux** : +33 (o)2 99 64 52 28 or +33 (o)6 87 48 30 21.

M. Ruffet**: +33 (0)2 56 26 91 05 or +33 (0)6 33 38 37 18. Moncontour Cité Médiévale : +33 (0)2 96 61 46 85. Mme Picard: +33 (0)2 96 61 46 85 or +33 (0)6 61 94 38 45. Campsites La Tourelle**: +33 (0)2 96 73 50 65 or +33 (0)6 76 74 85 04.

T Eating Out

Adana Kebab: +33 (0)2 96 76 02 72. Au Coin du Feu, crêperie/pizzeria: +33 (0)2 96 73 49 10. Le Chaudron Magique: +33 (0)2 96 73 40 34 La Mulette: +33 (0)2 96 73 50 37. La Poterne: +33 (0)2 96 73 40 01. Les Remparts: +33 (0)2 96 73 54 83.

Local Specialties Art and Crafts

Ceramic artist • Dressmaker and hatter • Beadmaker • Stylist • Costume designer • Painter • Stained-glass artist • Résidence des Arts (exhibitions and residencies by artists and craftspeople).

* Events

Market: Local produce, Monday evenings. Pentecost: Pardon de Saint-Mathurin procession, Pentecost festivities. July-August: Sporting and cultural activities (daily).

August (odd years): Fête Médiévale, medieval festival (1st Sunday). September: "Journée des Peintres" painting contest; Festival Dell Arte, street art (1st weekend). December: Ménestrail, cross-country trail.

W Outdoor Activities

Walking, horse-riding, and mountainbiking • Nordic walking • Fishing.

🕊 Further Afield

- Plémy (3 miles/5 km).
- Hénon, Quessoy, and Trébry: parks and residences of Ancien Régime notables (3 1/2-5 miles/5.5-8 km).
- Saint-Glen: Village des Automates, clockwork and robotic toys (July and August) (6 miles/ 9.5 km).
- Lamballe (10 miles/16 km).
- Saint-Brieuc (16 miles/26 km).
- Loudéac (17 miles/27 km).
- Quintin: castle and Musée Atelier du Tisserand et des Toiles, working weaving museum (18 miles/29 km).
- Le Foeil (20 miles/32 km).

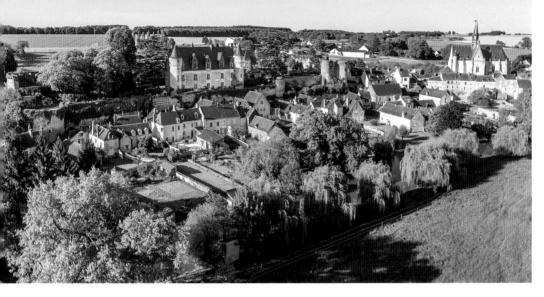

Montrésor In the heart of the Loire valley, on the banks of the Indrois

Indre-et-Loire (37) • Population: 341 • Altitude: 328 ft. (100 m)

Montrésor get its name from the Treasurer (*Trésorier*) of the chapter house at Tours Cathedral, which owned this area in the 10th century.

In the early 11th century, the powerful count of Anjou, Foulques III, nicknamed "Nerra" (the black), began to build a fortress at Montrésor in order to defend the approaches to the Touraine. Remains of the double ring of defenses are still visible. Inside its wall, at the end of the 15th century. Imbert de Bastarnay (advisor to the French kings Louis XI. Charles VIII. Louis XII. and Francois I) built the present castle in the Renaissance style. He is also responsible for the collegiate church of Saint-Jean-Baptiste, which houses an Annunciation painted by Philippe de Champaigne (1602-1674), as well as tombs of members of his family. In 1849, the castle became the property of Xavier Branicki, a Polish count and friend of Napoléon III. He restored it and filled it with many works of art: sculptures by Pierre Vanneau, and Italian Renaissance and Dutch paintings. Count Branicki also gave his name to one of the streets cut into the rock, where halftroglodytic houses and half-timbered ones rub shoulders. Cardeux Market, once the wool market, has been restored as a cultural center and permanent exhibition space, and recalls village life in bygone days. The 16th-century Chancelier's Lodge, which has a watchtower, houses the present town hall. The riverside walk, "Balcons de l'Indrois," provides wonderful views of the village from the footbridge to Jardinier Bridge, which was built by Eiffel's workshop.

By road: Expressway A85, exit 11–Bléré (17 miles/27 km); N76 (17 miles/27 km). By train: Tours station (34 miles/55 km); Saint-Pierre-des-Corps TGV station (34 miles/55 km). By air: Tours-Saint-Symphorien airport (42 miles/68 km).

(i) Tourist information:

+33 (0)2 47 92 70 71 www.tourisme-valdindroismontresor.com www.village-montresor.fr

Highlights

 Castle (11th-15th centuries): "Musée d'Art Polonais": +33 (0)2 47 92 60 04.
 Collegiate church of Saint-Jean-Baptiste (16th century): Alabaster tomb with three recumbent statues, Annunciation by Philippe de Champaigne.
 Cardeux wool market: Permanent

 Village: Guided tours for groups only and by appointment: +33 (0)2 47 92 70 71.

Accommodation

Guesthouses Le Moulin de Montrésor***: +33 (0)2 47 92 68 20. La Grenache: +33 (0)2 47 92 71 39. Gites and vacation rentals Further information: +33 (0)2 47 27 70 71.

T Eating Out

Montrésor Café: +33 (0)2 47 92 75 31.

Local Specialties

Food and Drink Montrésor macarons • Montrésor rillettes. Art and Crafts Local crafts (Maison de Pays shop) • Painter.

★ Events

July–August: "Nuits Solaires" evening festival; Painters' fair (August 15). December: Christmas market.

W Outdoor Activities

Boules playing field • Fishing • Walking: 2 marked trails • Cycling.

🕊 Further Afield

- Loches; Indre valley (11 miles/18 km).
- Château de Montpoupon; Cher valley: Chenonceaux; Loire valley: Amboise (16–28 miles/26–45 km).
- Château de Valençay (19 miles/31 km).
- Tours (31 miles/50 km).

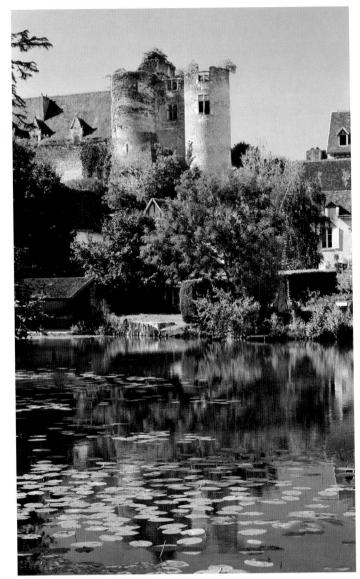

I Did you know?

According to legend, the young Gontran, who became king of Burgundy from 561 to 592, fell asleep in his equerry's lap on a riverbank and dreamed of treasure hidden in a cave. The equerry saw a small lizard run over Gontran's face; it dashed toward a nearby hill and returned covered in gold. When the king was told this vision, he quickly had the hill excavated and discovered enormous wealth there. But the chronicles of the Middle Ages reveal that this estate belonged to the Treasurer of Tour Cathedral's chapter house. This explains why during the 10th century it was called Mons Thesauri (mount of the Treasurer), which later became Montrésor.

Montsoreau

Maine-et-Loire (49) • Population: 431 • Altitude: 108 ft. (33 m)

Montsoreau sits between Anjou and the Touraine. in a land of history. sweetness, and harmony.

Lying between the Loire and a hill, and very close to the royal abbey of Fontevraud, Montsoreau grew up around its 15th-century castle. The village draws a rich heritage from the Loire river and Montsoreau's lady, Françoise de Maridor: Alexandre Dumas wrote tales about her passionate and fatal love affair with Bussy d'Amboise. There is something for everyone here: wander the village's flower-lined paths that climb toward the vineyards, and admire its white tufa-stone residences and immaculately tended gardens. Stroll the courtyards and alleyways, beyond which the Loire stretches into the distance: roam the Saut aux Loups hillside, where historic cave dwellings nestle. Taste some famous Saumur-Champigny and Crémant de Loire wines at a local vineyard.

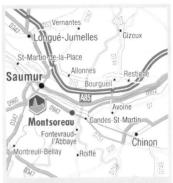

By road: Expressway A85, exit 5–Bourgueil (7 ½ miles/11.5 km). By train: Saumur station (8 miles/13 km). By air: Angers-Marcé airport (39 miles/63 km); Tours-Saint-Symphorien airport (45 miles/ 72 km); Nantes-Atlantique airport (110 miles/177 km).

() Tourist information: +33 (0)2 41 51 70 22 www.saumur-tourisme.com www.ville-montsoreau.fr

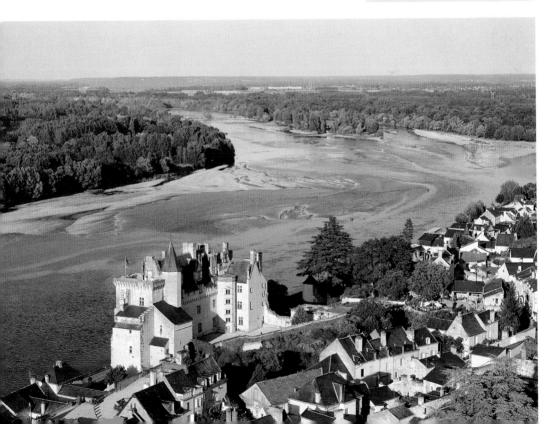

Highlights

Castle (15th century): Further information: +33 (0)2 41 67 12 60.
Église Saint-Pierre-de-Rest (13th-18th centuries): +33 (0)2 41 51 70 15.
Le Saut aux Loups mushroom farm:

Within a group of 15th-century cave dwellings, now used as a mushroom farm, a reconstruction of an early 20th-century mushroom farm: sculptures, exhibition, geological collection: +33 (0)2 41 51 70 30.

• Maison du Parc Naturel Régional Loire-Anjou-Touraine: Permanent fauna and flora experience, exhibitions, shop. Further information: +33 (0)2 41 38 38 88.

• Vins de Loire market: In a cave dwelling, experience the wines of the Loire valley in 10 stages from Nantes to Sancerre: +33 (0)2 41 38 15 05.

• Village: Guided tours. Further information: +33 (0)2 41 51 70 22.

Accommodation

La Marine de Loire****: +33 (0)2 41 50 18 21. Le Bussy***: +33 (0)2 41 38 11 11.

Guesthouses

La Fauvette: +33 (0)6 08 93 85 61. La Forge: +33 (0)2 41 52 35 47. Juliette: +33 (0)2 41 51 75 70. **Gîtes and vacation rentals** Further information: +33 (0)2 41 51 70 22 www.ville-montsoreau.fr **Campsites**

L'Isle Verte****: +33 (0)2 41 51 76 60.

T Eating Out

Aigue-Marine, floating restaurant: +33 (0)2 41 38 12 52. La Cave du Saut aux Loups: +33 (0)2 41 51 70 30. La Dentellière, crèperie/salad bar: +33 (0)2 41 52 41 58. Diane-de-Méridor, gourmet restaurant: +33 (0)2 41 51 71 76. Le Lion d'Or, crèperie: +33 (0)2 41 51 70 12. Le Mail, brasserie: +33 (0)2 41 51 73 29. Le Montsorelli: +33 (0)2 41 51 70 18. Le P'tit Bar, brasserie/grill: +33 (0)2 41 51 72 45.

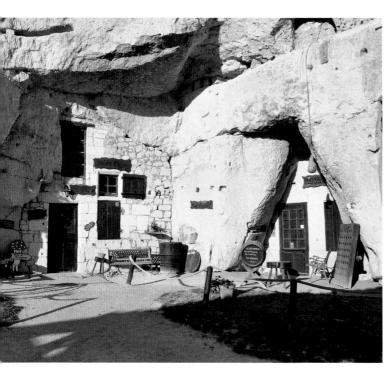

Local Specialties Food and Drink

Mushrooms • Organic apples and pears • AOC Saumur, Saumur-Champigny, Crémant de Loire wines. Art and Crafts

Antiques dealers and art galleries.

\star Events

Market: Sundays, 8 a.m.-1 p.m., Place du Mail. July-August: Les Musicales de Montsoreau music season at the castle and church. Throughout the year: Montsoreau flea market (2nd Sunday of each month).

W Outdoor Activities

Pony trekking • Mountain-biking • Loire river cruises • Fishing • Watersports on the Loire • Walking: Route GR 3, 1 marked trail (11 miles/18 km), and "Au Temps des Mariniers de Loire" heritage trail from Montsoreau to Candes-Saint-Martin • Cycling: "Loire à Vélo" trail.

🕊 Further Afield

• *Candes-Saint-Martin (½ mile/1 km), see p. 26.

- Abbaye de Fontevraud (2 ½ miles/4 km).
- Saumur (7 ½ miles/12 km).
- Chinon (12 miles/19 km).

• *Crissay-sur-Manse (24 miles/39 km), see p. 27.

I Did you know?

A unique location at the heart of the village continues the ancestral tradition of the *boule de fort*, designated a Loire heritage game by the French Ministry of Culture. At the Société l'Union in Montsoreau's old market is a circular pitch on which players, who must wear slippers, roll *boules* of 6-in. (13-cm) diameter with flattened sides; the balls must get as close as possible to the *maître*, the smallest boule at the center of the pitch.

Rochefort-en-Terre

Morbihan (56) • Population: 710 • Altitude: 164 ft. (50 m)

Halfway between the Gulf of Morbihan and "Merlin's Forest" (Brocéliande Forest), this village was once a *roche fort* (stronghold), which controlled the trading routes between land and sea.

A medieval village that dates back to the 11th century, Rocheforten-Terre is one of the oldest fieldoms in Brittany. Its location, on a rocky outcrop surrounded by deep valleys, gave it a strategic position and a leading role. Traces of this rich history can be seen in the upper village—a legacy of a prosperous past linked to the exploitation of slate quarries—with its old covered market, 12th-century collegiate church, ruins of the medieval castle of the counts of Rochefort, and the 19th-century château, as well as the 16th- and 17th-century mansions with their richly embellished granite and shale façades. Rochefort-en-Terre became an artists' town in the early 20th century, thanks to the American portraitist Alfred Klots, and has retained its pictorial as well as its floral tradition.

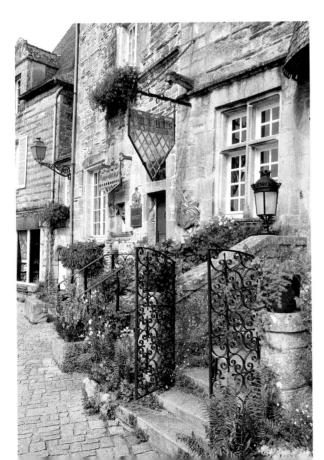

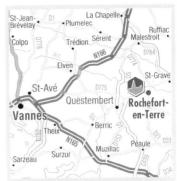

By road: N166, exit Bohal (9 ½ miles/ 15.5 km); N165, exit 17–Marzan (14 miles/ 23 km). By train: Questembert (6 miles/ 9.5 km), Redon (16 miles/26 km), Vannes (20 miles/32 km) stations; Rennes TGV station (62 miles/100 km). By air: Rennes-Saint-Jacques (60 miles/100 km), Nantes-Atlantique (62 miles/100 km), Lorient-Lann Bihoué (64 miles/103 km) airports.

(i) Tourist information: +33 (0)2 97 26 56 00 www.rochefort-en-terre.bzh

Highlights

• Parc du Château: View of the ruins of the medieval castle and of the 19th-century château built on the site of 17th-century stables. Collegiate church of Notre-Dame de la Tronchave (12th-14th centuries). • Village: Sightseeing tour of the Petite Cité: guided tours all year round for groups, booking essential; every Tuesday and Thursday morning in July and August, and Fridays and Saturdays in December when the Christmas lights are on, for individuals: +33 (0)2 97 26 56 00. · Naïa Museum: Contemporary, fantastic, digital, and kinetic art museum; Parc du Château: +33 (0)2 97 40 12 35/ www.naiamuseum.com

Accommodation

Hotels Le Pélican**: +33 (0)2 97 43 38 48. Holiday village VVF Villages Le Moulin Neuf: +33 (0)2 97 43 35 50. Aparthotel Domaine Ar Peoc'h: +33 (0)2 97 43 37 88. Guesthouses François Pinat: +33 (0)2 97 43 30 43. La Tour du Lion: +33 (0)2 97 43 36 94 or +33 (0)6 63 34 77 27.

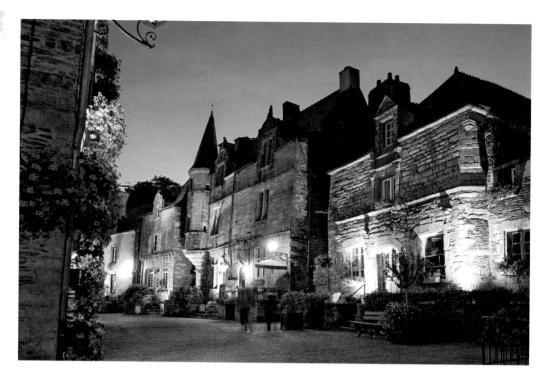

Gîtes and vacation rentals

Further information: +33 (0)2 97 26 56 00 www.rochefort-en-terre.bzh

Campsites

Camping Au Gré des Vents: +33 (0)2 97 43 37 52 or +33 (0)6 23 32 51 53.

T Eating Out

L'Ancolie: +33 (0)2 97 43 33 09. Les Ardoisières: +33 (0)2 97 43 47 55. Freine le Temps: +33 (0)2 97 43 31 63. Le Local des Saveurs, pizzeria: +33 (0)2 97 47 57 85. Le Ménestrel: +33 (0)2 97 43 38 33. Le Pélican: +33 (0)2 97 43 38 48. Crêperies

Le Café Breton: +33 (0)2 97 43 32 60. La Crêperie du Puits: +33 (0)2 97 43 30 43. La Petite Bretonne: +33 (0)2 97 43 37 68. La Tour du Lion, crêperie/brasserie: +33 (0)6 63 34 77 27.

Local Specialties Food and Drink

Breton shortbread, kouign amann (buttery cake) • Pain d'épice (spice cake) • Galettes bretonnes (butter cookies) • Honey • Chouchen (type of mead) · Cider · Apple juice.

Art and Crafts

Wooden handicrafts • Metal handicrafts • Slate handicrafts • Handmade candles • Embroidery • Jewelry and sculpture • Textiles • Leather craftsman • Artists • Mixed media artists · Soap-maker.

★ Events

June-September: Temporary exhibitions of work by artists, painters, and sculptors. July: Potters' market.

August: Medieval fair (around 15th): Pardon de Notre-Dame de la Tronchaye procession (Sunday after 15th); music festival;

Les Loustiks de l'Akoustic festival (end of August).

July and August: Concerts at the Café de la Pente (every Thursday) and at the Salle de Spectacle at the Étang Moderne. December: Christmas lights.

W Outdoor Activities

Walking: Route GR 38 and marked trails around Rochefort.

W Further Afield

 Malansac: Parc de Préhistoire de Bretagne (2 ½ miles/4 km).

 Caden: Musée des Maquettes de Machines Agricoles, museum of models of farming machinery; arts center (6 miles/9.5 km).

• Questembert: 16th-century covered market (6 miles/9.5 km).

• Malestroit (10 miles/16 km).

 La Gacilly: handicrafts, Végétarium Yves-Rocher, photography festival (11 miles/18 km).

• La Vraie-Croix: 13th-century chapel (11 miles/18 km)

· Le Guerno: Branféré animal painter (12 miles/19 km).

• La Roche-Bernard (12 miles/19 km).

 Forêt de Brocéliande, forest (22 miles/ 35 km).

• Vannes (22 miles/35 km).

 Gulf of Morbihan: Île d'Arz, Île aux Moines (25 miles/40 km).

I Did vou know?

In 1911, four years after buying the castle, the American painter Alfred Klots created a floral window display competition to brighten up the village's old houses, offering each inhabitant some geranium cuttings to bedeck their windows. The floral-decoration tradition has continued, earning Rochefort high honors in this area.

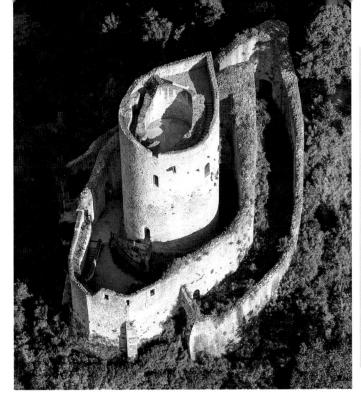

La Roche-Guyon

Val-d'Oise (95) • Population: 520 • Altitude: 394 ft. (120 m)

In a bend of the Seine carved into cliffs of chalk and flint, La Roche-Guyon mixes Île-de-France architecture with Normandy halftimbering.

The village, which was originally troglodytic, consisted of *boves*: dwellings cohabited by animals and men that are now used as outhouses. The 12th-century keep is surrounded by a curtain wall and linked to the castle by an impressive secret passage more than 330 ft. (100 m) long. Built in the 13th century and rebuilt in the 18th, the castle has retained its corner pepperpot turrets from its feudal past. The main building was completed with corner pavilions and terraces during the reign of Louis XV. Located on the main road between the castle and the Seine, the castle's kitchen garden, created in 1741, was restored in 2004 following the original 18th-century plans, and provides a setting for artistic creations by sculptors and landscape designers. The village's old streets invite one to stroll around and to follow the Charrière des Bois or de Gasny to the banks of the Seine. The village forms part of the regional nature park of French Vexin and of the Coteaux de la Seine nature reserve.

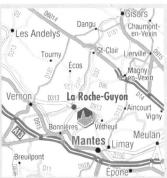

By road: Expressway A13, exit 14–Vernon (7 miles/11.5 km) or exit 11–Mantes-la-Jolie-Est (11 miles/18 km). By train: Vernon station (8 ½ miles/13.5 km); Mantes-la-Jolie station (10 miles/16 km); Paris TGV station (47 miles/76 km). By air: Paris-Roissy-Charles de Gaulle airport (55 miles/ 89 km); Paris-Orly airport (56 miles/ 90 km).

(i) Town hall: +33 (0)1 34 79 70 55 www.larocheguyon.fr

Highlights

• Castle (13th-18th centuries): Themed tours (medieval route, salons route, keep and chapels route, bunker and *boves* route), kitchen garden; activities for children; cultural events:

+33 (0)1 34 79 74 42.

• Église Saint-Samson (15th century): Marble statue by François de Silly, who owned the castle in the 17th century: +33 (0)1 34 79 70 55.

Accommodation

Les Bords de Seine**: +33 (0)1 30 98 32 52. Guesthouses M. Buffet: +33 (0)1 75 74 41 85. Gîtes

Le Logis du Château: +33 (o)6 98 70 58 77. Walkers' lodge Further information: +33 (o)1 34 79 72 67

or +33 (0)7 63 16 31 14.

T Eating Out

Les Bords de Seine: +33 (o)1 30 98 32 52. La Cancalaise, crêperie: +33 (o)1 34 79 74 48. Casa Mia, pizzeria: +33 (o)1 34 79 70 73. Le Relais du Château: +33 (o)1 34 79 70 52.

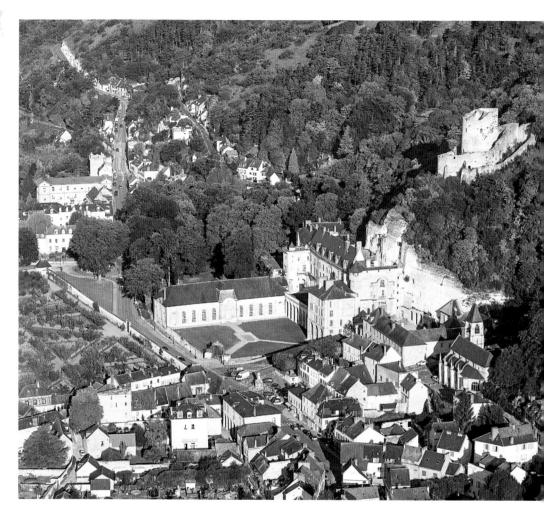

***** Local Specialties

Food and Drink Cookery and patisserie lessons. Art and Crafts Metalworker • Mosaic artist • Artist • Potter • Weaver.

★ Events

May: "Plantes, Plaisir, Passions" plant festival (1st weekend). June: Country market (2nd Sunday). Ascension: Big flea market. July 14: Citizens' banquet. November: Wine fair (2nd weekend) and Advent market (last weekend).

W Outdoor Activities

Walking: Marked walks in the forest and village (topographic guide from the town hall) • Mountain-biking.

🕊 Further Afield

• Route des Crêtes, scenic drive; Route GR 2, hiking trail (1 mile/1.5 km).

- Haute-Isle: underground church (2 miles/3 km).
- Vétheuil (3 ½ miles/5.5 km).
- Giverny: Claude Monet's house and gardens (5 ½ miles/9 km).
- Chaussy: Château de Villarceaux; golf course and manor house (6 miles/9.5 km).
- Vernon (8 miles/13 km).

- Mantes-la-Jolie (10 miles/16 km).
- Les Andelys: Château-Gaillard (19 miles/31 kn

I Did you know?

In February 1944, Field Marshal Rommel set up his headquarters at the castle. Opposed to Nazi theories and eager to end the war, he made contact with the German Resistance. The castle became the setting for secret meetings to negotiate peace with the Allies, while he tried to persuade Hitler of the futility of his fight and of the likelihood of imminent defeat. Rommel did not have time to execute his plans: the Allies landed on the Normandy beaches on June 6, 1944.

Saint-Benoîtdu-Sault

A priory on the edge of Limousin

Indre (36) • Population: 615 • Altitude: 722 ft. (220 m)

Built on a granite spur, the village of Saint-Benoît-du-Sault overlooks a broad bend of the Portefeuille river.

Enclosed by partially intact double ramparts. Saint-Benoît has preserved its medieval past in the form of a fortified gateway, a 14th-century belfry, and an old wall-walk. At the tip of the rocky promontory, a Benedictine priory offers a view over the valley. The church, majestic and sober, from the first Romanesque period, contains carved capitals and an 11th-century baptismal font. At the heart of the village, 15th- and 16th-century houses line the narrow, often steep streets: the Portail and Maison de l'Argentier, with its carved lintel, are the most remarkable. Walking trails invite visitors to explore the village, built in the shape of an amphitheater, and the priory, which is reflected in the water below. The priory is due to be restored soon and will house a cultural and tourist center.

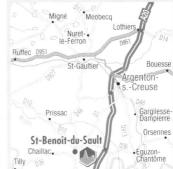

By road: Expressway A2o, exit 20–Saint-Benoît-du-Sault (5 miles/8 km). By train: Argenton-sur-Creuse station (13 miles/ 21 km). By air: Limoges-Bellegarde airport (50 miles/80 km).

(i) Tourist information: +33 (0)2 54 47 67 95

www.saint-benoit-du-sault.fr

Highlights

• Church (11th, 13th, and 14th centuries): Stained-glass windows by contemporary master stained-glass maker Jean Mauret. • Priory: Open to the public for

exhibitions.

• Village: Guided tour on Wednesday and Saturday: +33 (0)2 54 47 67 95.

Accommodation

Le Centre: +33 (0)2 54 47 51 51. Guesthouses

La Châtille***: +33 (0)2 54 47 50 12.

Le Portail***: +33 (0)2 54 47 57 20. Outre-l'Étang: +33 (0)2 54 24 83 97. La Treille: +33 (0)9 60 02 10 50. **Gîtes**

M. Level: +33 (0)2 54 24 89 16. Walkers' lodge

La Maison des Voyageurs: +33 (0)2 54 47 51 44.

T Eating Out

L'Auberge du Champ de Foire: +33 (0)2 54 27 43 77. L'Entrecôte, pizzeria/steak house: +33 (0)2 54 47 66 82. Hôtel du Centre: +33 (0)2 54 47 51 51.

Local Specialties

Art and Crafts Publisher of artists' and poetry books • Engraver and painter • Photographer • Angora wool dyer and designer.

★ Events

March: Festival de Ciné-concert (movies with live music, late March). April: Pays de la Loire wine fair. June: Contemporary art exhibition. July: Flea market (13th). July and August: Theater, concerts. August: Inter-regional ram show (4th), local saint's day (13th), cattle show (last week). December: "Foire Grasse d'Oies et Canards de la Région de Brive," goose and duck produce fair.

W Outdoor Activities

Fishing • Tennis • Walking trails.

🕊 Further Afield

• Dolmens of Les Gorces and of Passebonneau (1–2 miles/1.5–3 km).

- Roussines: church (2 ½ miles/4 km).
- Parc Naturel Régional de la Brenne,
- nature park (3–31 miles/5–50 km). • Château de Brosse, ruins (6 miles/
- Chateau de Brosse, ruins (6 miles/ 9.5 km).

• Creuse valley; Musée Archéologique d'Argentomagus; Lac de Chambon, lake; Crozant: ruins (11–17 miles/ 18–27 km).

• *Gargilesse-Dampierre (15 miles/ 24 km), see p. 28.

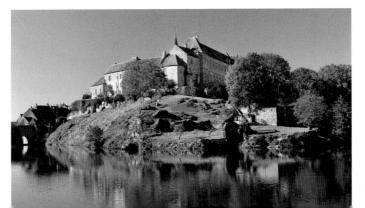

Saint-Cénerile-Gérei A painter's paradise

Orne (61) • Population: 140 • Altitude: 417 ft. (127 m)

At the heart of the Mancelles Alps, Saint-Céneri-le-Gérei combines water, stone, and wood.

The village, which nestles in a bend in the Sarthe river, was founded by Saint Céneri, an Italian-born monk who created a monastery that was later burned by the Normans. A church was built on the site in the 11th century. Today, topped with a saddleback roof and a tower adorned with columns and belfry openings, it emerges above the trees. Inside, it houses recently restored 12th-century murals and a ceiling that is unique in France. The village's old houses surrounding the church have been preserved. Below is a charming 15th-century chapel. On the opposite bank is the miraculous spring created by Saint Céneri in 660, which, according to popular belief, has the power to cure eye problems. Over the years, the village has charmed many famous painters, including Camille Corot (1796–1875) and Eugène Boudin (1824–1898), and at the Auberge des Sœurs Moisy, which they frequented, you can still see charcoal portraits of artists and villagers sketched by candlelight.

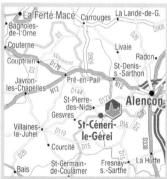

By road: Expressway A28, exit 18– Alençon centre (12 miles/19 km), N12 (7 ½ miles/12 km). By train: Alençon station (12 miles/19 km). By air: Caen-Carpiquet airport (83 miles/134 km).

(i) Tourist information—

Alpes Mancelles: +33 (0)2 43 33 28 04 or +33 (0)2 33 27 84 47 www.saintceneri.org

Highlights

 Église Saint-Céneri (11th century): Murals, Stations of the Cross.
 Chapel (15th century): Statue of Saint Céneri.

• Auberge des Soeurs Moisy: Museum of 19th- and 20th-century painters.

• Village: Audioguide tour (www.saintceneri.org).

Accommodation Gîtes and vacation rentals

La Cassine: +33 (0)2 33 26 93 66. Chez Martine: +33 (0)2 33 32 23 93. La Giroise: +33 (0)2 43 33 79 22.

T Eating Out

Auberge des Peintres: +33 (o)2 33 26 49 18. Auberge de la Vallée: +33 (o)2 33 28 94 70. Lez'Arts à Table: +33 (o)2 33 81 91 21. Le Petit Caboulot: +33 (o)2 14 17 65 04. La Taverne Giroise: +33 (o)2 33 32 24 51.

Local Specialties Art and Crafts

Marquetry • Restoration of paintings • Artists • Painter-sculptor.

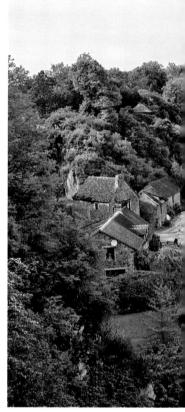

* Events

Pentecost: Artists' event. July: "Saint Scène" (music). August: Open-air rummage sale (1st Sunday).

W Outdoor Activities

Canoeing • Fishing • Walking: Route GR 36, several marked trails via the Normandie-Maine regional nature park and the Chemin des Arts toward the Mont des Avaloirs • Mountain-biking • "Monts et Marche" (signposted walk).

🕊 Further Afield

- Saint-Léonard-des-Bois (3 miles/5 km).
- Alençon: Musée de la Dentelle,
- lace museum (9 ½ miles/15.5 km). • Mont des Avaloirs (9 ½ miles/15.5 km).

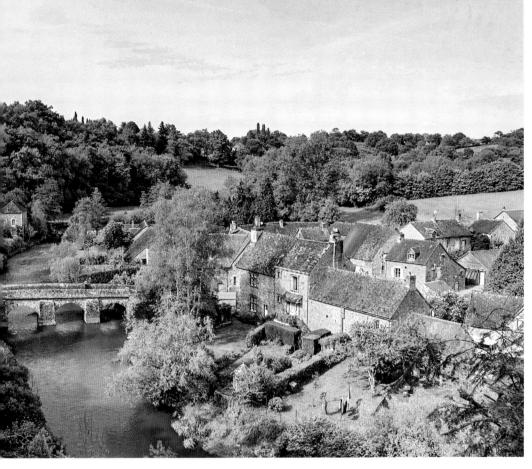

- Forêt d'Écouves, forest; Château de Carrouges (12–19 miles/19–31 km).
 Parc naturel régional Normandie-Maine, nature park; Carrouges (19 miles/31 km).
 Bagnoles-de-l'Orne (25 miles/40 km).
- Haras National du Pin, national stud (34 miles/55 km).

I Did you know?

In the 15th-century chapel built on the site of the Saint Céneri hermitage, there is a statue of the hermit and a granite stela, said to have been used by him as a bed, and believed to heal incontinence. Legend has it that, if young girls pushed a needle into the feet of the saint's statue, they would be able to find a husband.

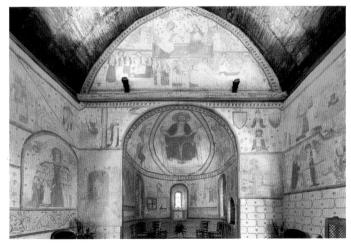

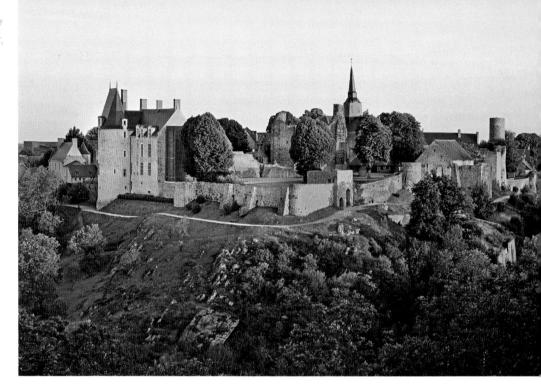

Sainte-Suzanne

Beauty and rebellion

Mayenne (53) • Population: 1,008 • Altitude: 525 ft. (160 m)

This medieval village, the "pearl of Maine." perched on top of a rocky peak dominating the Erve valley, resisted attacks from William the Conqueror.

When relics of Saint Suzanne (patron saint of fiancés) were brought back to Saint-Jean-de-Hautefeuille from the Crusades, the village was renamed in her honor. The medieval village was fortified in the 11th century; both beautiful and rebellious, it proudly resisted William the Conqueror, but had to surrender to the English during the Hundred Years War. Atop a mound opposite the village, the site of Tertre Ganne, occupied by the earl of Salisbury's troops during the 1425 siege, offers a fabulous view of Sainte-Suzanne's striking profile. The keep partly survived this tumultuous period, but the double wall of 12th-century ramparts owes its present appearance to Guillaume Fouquet de La Varenne, comptroller general of posts, who also built the Renaissance lodge and took over ownership of the citadel from Henri IV. The hamlet of La Rivière, where the "Promenade des Moulins" path winds, offers the loveliest vistas toward the medieval village.

By road: Expressway A81, exit 2–Sablé (12 miles/19 km). By train: Évron station (4 ½ miles/7 km); Laval station (21 miles/34 km). By air: Angers-Marcé airport (45 miles/72 km).

 Tourist information—Coëvrons: +33 (0)2 43 01 43 60 www.coevrons-tourisme.com www.ste-suzanne.fr

Highlights

• Castle (17th century): Centre d'Interprétation de l'Architecture et du Patrimoine de la Mayenne, visitor center; exhibitions and activities: +33 (0)2 43 58 13 00.

• Romanesque keep (11th century): Self-guided visit (interior staircases and gangways).

• Musée de l'Auditoire: History of the fortified village: +33 (0)2 43 01 42 65. • Grand Moulin: Former communal mill belonging to the lords of Sainte-Suzanne,

with an *à l'anglaise* (English-style) mechanism. Possibility of guided tours or partially guided tours, educational workshops: +33 (0)2 43 90 57 17.

• Camp des Anglais: Fortified camp, William the Conqueror's base during the siege of 1083–86, military fortifications: +33 (0)2 43 01 43 60.

• Dolmen des Erves (2 miles/3km): 6,000-year-old megalith.

• Village: Various guided tours available. Further information: +33 (0)2 43 01 43 60.

Accommodation

Hotels Hôtel Beauséjour**: +33 (0)2 43 01 40 31. Guesthouses Côté]ardin****: +33 (0)2 43 98 93 66. Gîtes Les Fiancés de Sainte-Suzanne****: +33 (0)2 43 53 52 43 or +33 (0)6 09 11 40 70. Le Passe-Muraille****: +33 (0)6 42 78 11 71. Les Remparts****: +33 (0)6 42 78 11 71. Le Grand Moulin***: +33 (0)820 153 053. La Patache***, fishing gîte: +33 (0)2 43 90 65 55 La Forge** at "Pont Neuf": +33 (0)2 43 53 58 82. Farmhouse accommodation La Sorie, equestrian farm: +33 (0)2 43 01 40 63. Vacation villages VVF-villages "La Croix Couverte"***: +33 (0)2 43 01 40 76. **RV** parks Les Charrières: +33 (0)2 43 01 40 10.

T Eating Out

La Cabane, light meals (in summer): +33 (0)6 11 32 58 01. Café des Tours, light meals: +33 (0)2 43 66 10. Hôtel-restaurant Beauséjour: +33 (0)2 43 01 40 31). Péché de Gourmandise, Le Bistrot: +33 (0)6 83 75 10 76.

Local Specialties

Food and Drink Local beers and lemonade • Honey. Art and Crafts Antiques • Medieval crafts • Calligrapherilluminator • Painting, sculpture, and jewelry • Local soaps.

★ Events

Market: Saturday mornings, Place Ambroise-de-Loré. May–September: Local flea market (ast Sunday of the month). July: Journée des Peintres et de la Photo, art and photography festival (3rd weekend), medieval activities. August: "Nuits de la Mayenne," theater festival.

September: Fête des Vieux Papiers et des Métiers de Tradition, rummage sale and fair celebrating traditional skills and antique paper products. December: Christmas market.

W Outdoor Activities

Recreation area (La Croix Couverte) • Horse-riding trails • Walking and mountain-biking (maps from tourist information center).

🕊 Further Afield

• La Promenade des Moulins, history trail; La Rivière, hamlet (½ mile/1 km).

- Tertre Ganne: view across to the village (1 mile/1.5 km).
- Pays d'Art et d'Histoire Coëvrons-Mayenne, regional cultural heritage: Évron, Saulges, Jublains, Mayenne (3–22 miles/5–35 km).
- Laval (22 miles/35 km).
- Le Mans (34 miles/55 km).

I Did you know?

The Musee de l'Auditoire in Sainte-Suzanne has on display the oldest armor in France (1410–30).

Saint-Suliac

Between land and sea

Ille-et-Vilaine (35) • Population: 930 • Altitude: 69 ft. (21 m)

With a stunning view over the Rance estuary, Saint-Suliac sits in a beautifully unspoilt landscape.

The impressive steeple of the Église de Saint-Suliac rises loftily above an old cemetery that represents a unique kind of churchyard in Haute Bretagne. The church is set in the center of a maze of narrow alleyways lined with fishermen's houses and low granite garden walls. Paths from the village lead to a variety of delightful attractions: the tide mill; the old salt marshes at Guettes, created in 1736; the standing stone of Chablé, dubbed the "Dent de Gargantua" (Gargantua's Tooth), and the intriguing remains of a Viking camp. The port, busy with both fishing and pleasure boats, evokes Saint-Suliac's rich maritime history. This was a population of sailors, and the Vierge de Grainfollet (patron saint of Newfoundland), sitting above the village, reveals the heavy price that these coastal folk paid the sea in order to support their families.

By road: Expressway A84, exit 34–Saint-Malo (32 miles/51 km); N175 then N176, exit Châteauneuf-d'Ille-et-Vilaine (2 ½ miles/4 km). By train: Saint-Malo station (8 miles/13 km); Dinan station (16 miles/26 km). By air: Dinard-Pleurtuit airport (16 miles/26 km); Rennes-Saint-Jacques airport (43 miles/69 km).

Tourist information: +33 (0)2 99 58 39 15 www.saint-suliac-tourisme.com

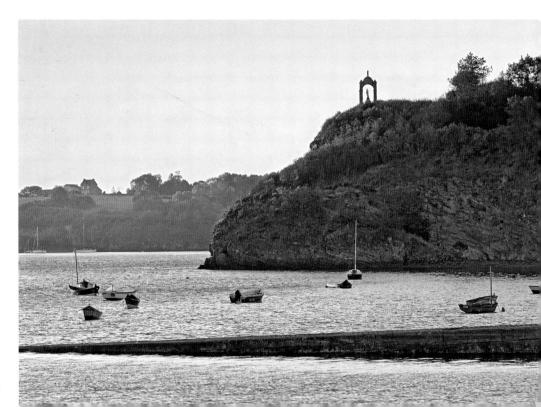

Highlights

• Church (13th century): Stained-glass windows, wood carving, sailors' shrine. • Village: Guided tour by appointment only; Guillemette Tremaudan: +33 (0)2 23 15 03 85.

✓[★] Accommodation Guesthouses

L'Acadie****: +33 (0)2 23 15 04 94. La Chabossière: +33 (0)2 99 58 32 87. Entre Terre et Mer: +33 (0)2 99 58 30 41. Les Mouettes: +33 (0)2 99 58 30 41. Les Salines de la Rance: +33 (0)2 99 58 21 37. La Vie en Rose: +33 (0)2 23 15 07 97. **Gîtes**

L'Escale****: +33 (0)2 99 82 38 61. Brigitte Lefrançois***: +33 (0)5 62 95 08 61. La Métairie du Clos de Broons***: +33 (0)2 99 89 12 30.

Other gîtes and vacation rentals Further information: +33 (0)2 99 58 39 15 www.saint-suliac-tourisme.com

Campsites Les Cours**: +33 (0)6 07 80 48 51. Mobile homes Le Bigorneau: +33 (0)6 59 87 71 72.

T Eating Out

La Ferme du Boucanier: +33 (0)2 23 15 06 35. Le Galichon: +33 (0)2 99 58 49 49. La Guinguette: +33 (0)2 99 58 32 21.

I Did you know?

The history of Newfoundland inspired the French TV miniseries *Entre Terre et Mer* (Between Land and Sea), which was filmed at Saint-Suliac in 1995.

Local Specialties

Food and Drink Cider • Buckwheat galettes (pancakes) • Fish and shellfish. Art and Crafts Flowercraft • Painter.

★ Events

Market: Summer market, June 20– August 31.

June: "Feu de la Saint-Jean," Saint John's Eve bonfire (2nd fortnight); triathlon (last weekend).

August: "Saint-Suliac Autrefois," historical event (1st weekend); Pardon de la Mer ceremony at Notre-Dame-de-Grainfollet (15th). September: "Copeaux d'Abord," sea festival (last weekend). December: Christmas market and living Nativity (1st and 2nd weekends).

W Outdoor Activities

Swimming • Fishing • Sailing • Horseriding • Walking: 3 marked trails, Route GR34 and GR route in the Pays Malouin • Mountain-biking.

🖗 Further Afield

- Saint-Malo (6 miles/9.5 km).
- Cancale (11 miles/18 km).
- Mont-Dol (12 miles/19 km).
- Dinan (14 miles/23 km).
- Mont-Saint-Michel (19 miles/31 km).

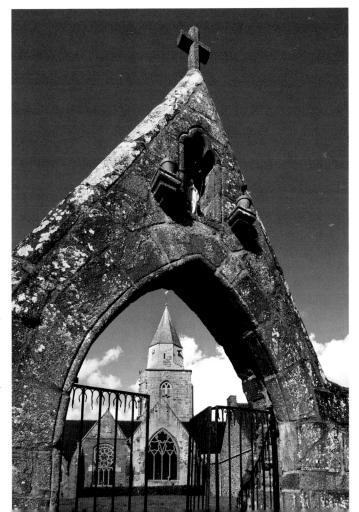

Vouvant Village of painters and legends

Vendée (85) • Population: 919 • Altitude: 361 ft. (110 m)

Deep in the forest of Vouvant-Mervent, the Mère river winds through a landscape that has inspired both art and mystery.

William V, Duke of Aquitaine (969–1030) discovered the site of Vouvant while hunting. Struck by its strategic position, he built a castle, a church, and a monastery here in the 11th century. In the church, the 12th-century portal, the 12th-century apse, and the 11thcentury crypt are all well worth seeing. The castle has retained only its keep, the Mélusine Tower, sections of the ramparts, and a 13thcentury postern gate, which was used by Saint Louis (King Louis IX). A Romanesque bridge straddles the river Mère, linking the two riverbanks. Everyday life in the village is enhanced by numerous artists who form the "Vouvant, Village de Peintres" art association, which organizes a wide range of cultural events.

Highlights

• Église Notre-Dame (11th and 13th century). • Nef Théodelin (11th century): Exhibition center.

• Mélusine Tower (13th century): 115 ft. (35 m) high; views over the village and the Vendée landscape, musical exhibition about the legend of Mélusine in 19thcentury house: +33 (0)2 51 00 86 80.

Accommodation Guesthouses

↓ La Grange aux Peintres****:
+33 (0)6 98 24 12 00.
↓ La Porte aux Moines***:
+33 (0)2 53 72 01 37.
Auberge de Maître Pannetier**:
+33 (0)2 51 00 80 12.
M. and Mme Berland: +33 (0)2 51 00 83 56
+33 (0)6 17 27 87 35.
Les Pousses Vieilles, Pierre Blanche:
+33 (0)2 51 00 36 48.
M. and Mme Roy: +33 (0)2 51 52 65 67.
Gîtes
Bruno and Isabelle de la Pintière***:
+33 (0)2 51 99 66 94.
Louis and Anne Mario Behia*t*:

Louis and Anne-Marie Robin***: +33 (0)2 51 69 64 38.

Family vacation centers Relais Mélusine: +33 (o)2 51 00 80 14. Vacation villages La Girouette: +33 (o)2 51 50 10 50.

I Eating Out

Auberge de Maître Pannetier: +33 (0)2 51 00 80 12. Le Pic Vert: +33 (0)2 51 00 88 49. V., café and tea room: +33 (0)2 51 00 85 69.

Local Specialties

Food and Drink Brioches and cakes • Pâtés, foie gras,

and duck confit • Honey. Art and Crafts

Artists' studios • Art galleries • Icon painter.

★ Events

July-August: "Vouvant, Village de Peintres," exhibitions and activities. August: Village fête (2nd Sunday), "Festival des Nuits Musicales en Vendée Romane," music festival.

W Outdoor Activities

Horse-riding • Fishing • Tennis • Walking and mountain-biking: 3 marked trails.

🕊 Further Afield

• Forêt de Vouvant-Mervent, forest; Mervent (4 ½ miles/7 km).

- Fontenay-le-Comte (10 miles/16 km).
- Marais Poitevin, region (19 miles/31 km).
- Puy-du-Fou, theme park (28 miles/ 45 km).

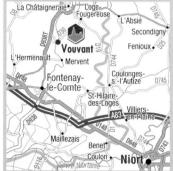

By road: Expressway A83, exit 8– Fontenay-Ouest (11 miles/18 km). By train: Fontenay-le-Comte station (10 miles/16 km); Niort TGV station (35 miles/56 km). By air: La Rochelle-Laleu airport (40 miles/64 km).

(1) Tourist information: +33 (0)2 51 00 86 80 www.tourisme-sudvendee.com

I Did you know?

Mélusine—half-woman, half-serpent or fish—often appears in legends told in the north and west of France, the Low Countries, and Cyprus. The fairy Mélusine has been referenced numerous times in literature, sculpture, and musical compositions from the 14th century to the present day, by writers such as Jean d'Arras and Sir Walter Scott, and by the composer Felix Mendelssohn in his Opus 32, "The Fair Melusina." Mélusine is said to have built the castle in one night "with three aprons-full of stones and one mouthful of water."

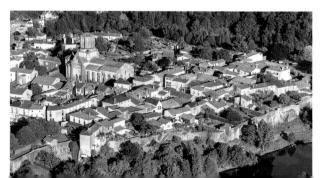

Yèvre-le-Châtel (commune of Yèvre-la-Ville) A medieval inspiration for modern artists

Loiret (45) • Population: 231 • Altitude: 361 ft. (110 m)

On the boundary between the regions of Beauce and Gâtinais, Yèvre-le-Châtel is a happy blend of medieval heritage and contemporary art.

Yèvre Castle, built in the 13th century under King Philip Augustus and recently restored, commands the Rimade valley and a wide horizon. Its high ramparts and four round towers dominate the Romanesque church of Saint-Gault and the unfinished nave of Saint-Lubin. There is a circular walk around the curtain wall and, from the top of the towers, there are stunning views over the surrounding landscape, as far as the forest of Orléans. All along the flower-bedecked streets from the Place du Bourg, near the old well, to the Pont de Souville straddling the Rimarde, old houses and gardens hide behind limestone walls. The village seduced many 20th-century painters, including Maria Vieira da Silva (1908–1992), Árpád Szenes (1897–1985), and Eduardo Luiz (1932–1988), and continues to attract artists and galleries.

Highlights

- Castle (13th century): +33 (0)2 38 34 25 91. • Église Saint-Gault (12th century). • Remains of Église Saint-Lubin (13th century).
- Village: Guided tour by appointment: +33 (0)2 38 34 25 91.

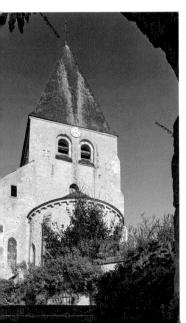

Accommodation

Gîtes M. and Mme Liger****: +33 (0)2 38 62 04 88. M. and Mme Blanvillain***: +33 (0)2 38 34 25 22.

T Eating Out

Le Courtil, tea room: +33 (0)2 18 13 21 52. La Rolanciène: +33 (0)2 38 34 28 47.

Local Specialties

Art and Crafts Art galleries. Food and Drink Farm produce: e.g. oil, honey, saffron, cider, wine, jam.

★ Events

Market: Sunday mornings, Place du Bourg. May–September: Art and sculpture exhibitions indoors and outside. July–August: Concerts in Église Saint-Gault, evening village strolls. August: Medieval games and activities.

W Outdoor Activities

Walking: Route GR 655 and Rimarde valley.

By road: Expressway A6, exit 14– Malesherbes (27 miles/43 km), N152 (5 ½ miles/9 km); N20 (21 miles/34 km); expressway A19, exit 7–Pithiviers (8 ½ miles/13.5 km). By air: Paris-Orly airport (59 miles/95 km).

(i) Tourist information: +33 (0)2 38 34 25 91

www.yevre-la-ville.fr

🕊 Further Afield

- Boynes: Musée du Safran, saffron museum (3 ½ miles/5.5 km).
- Pithiviers (3 1/2 miles/5.5 km).
- Pithiviers-le-Vieil: Gallo-Roman site (5 miles/8 km).
- Vrigny: Maison du Père Mousset,
- rural history museum (7 ½ miles/12 km).
- Château de Chamerolles
- (12 miles/19 km).
- Malesherbes (16 miles/26 km).
- Montargis (26 miles/42 km).
- Orléans (28 miles/45 km).

1 Did you know?

Yèvre and its castle charmed Victor Hugo, who, in a letter to his wife dated August 22, 1834, said, "I had an admirable journey to Pithiviers and its surrounding area. Yèvrele-Châtel, which is two leagues away and where I went on foot with holes in my shoes, keeps all to itself a convent and a castle, ruined but complete. It is magnificent. I am drawing everything I see." Indeed, two of these drawings are kept at the Maison de Victor Hugo, Paris.

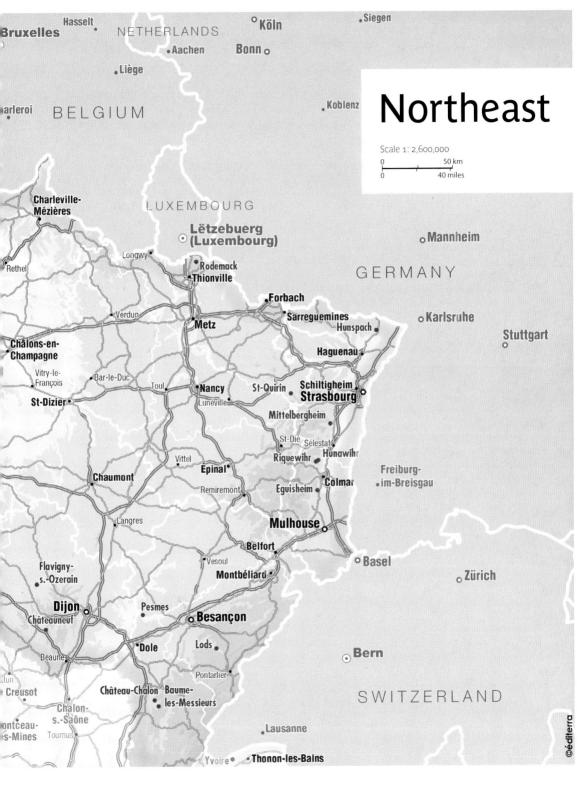

Apremont-sur-Allier

Cher (18) • Population: 77 • Altitude: 581 ft. (177 m)

Overlooked by a castle surrounded by landscaped gardens, the village—which was entirely restored in the last century—is reflected in the Allier river.

To the east of the Cher river, Apremont is part of the Berry region. which is evident not only from the wooded countryside around and the high, leafy hedges within, but also from the very ground on which it is built: for a long time, this humble village of quarrymen and bargemen dispatched, via the Allier and then the Loire, cut stones that still dress Orleans Cathedral and the Abbave de Saint-Benoît-sur-Loire. The Maison des Mariniers, at the end of the village, preserves this aspect of the village's history. However, it was in Burgundy that its fate was twice decided. In the Middle Ages, the Château d'Apremont, the westernmost possession of the duchy of Burgundy, was a powerful fortress. Four centuries later, in 1894, Eugène II Schneider, third in the dynasty of powerful industrialists based around Le Creusot, married Antoinette de Saint-Sauveur, a direct descendant on the female line of the family that had owned the castle since 1722. Until his death in 1942. Schneider worked tirelessly, with the aid of his architect and decorator, M. de Galéa, to restore this château and every house in Apremont in the Berry style. His grandson Gilles de Brissac continued his work, and in 1970 created a floral garden at the foot of the castle. inspired by Vita Sackville-West's garden at Sissinghurst in England. Among ponds, waterfalls, and the scents and colors of more than a thousand tree and flower species, a Chinese covered bridge, a Turkish pavilion, and a gazebo decorated with Nevers faïence, designed in the style of the 18th-century "manufactories," add a nice, exotic touch.

Highlights

 Floral gardens (classed as "remarkable" by the Ministry of Culture): Musée des Calèches, permanent and temporary exhibitions, and a walk around the castle ramparts: +33 (o)2 48 77 55 o6.
 Village: Guided tour by appointment only: +33 (o)2 48 74 25 6o.

T Eating Out

La Brasserie du Lavoir: +33 (o)2 48 80 25 76. La Carpe Frite: +33 (o)2 48 77 64 72.

🖈 Events

May: Fête des Plantes de Printemps (3rd weekend); classical music festival. June: Brocante de Charme, flea market (4th weekend). October: Fête du Vin et de la Gastronomie, wine and food festival (3rd weekend).

W Outdoor Activities

Fishing • Walking on the Chemin de Saint-Jacques-de-Compostelle (Saint James's Way) via Route GR 654; strolling along the banks of the Allier • Cycling: "Loire à Vélo" trail.

By road: Expressway A77, exit 37– Bourges (8 ½ miles/13.5 km); N7, exit 76–Bourges (20 miles/32 km). By train: Nevers station (10 miles/ 16 km).

By air: Clermont-Ferrand-Auvergne airport (98 miles/158 km).

(i) Tourist information— Val d'Aubois: +33 (0)2 48 74 25 60 www.mairie-apremontsurallier.info

🕊 Further Afield

- Bec d'Allier and Pont-canal (aqueduct) du Guétin (3 miles/5 km).
- Espace Métal/Halle de Grossouvre—
- museum of industry (6 miles/9.5 km).
- Nevers (9 ½ miles/15.5 km).
- Abbaye de Fontmorigny (12 miles/19 km).
- Château de Sagonne (16 miles/26 km).

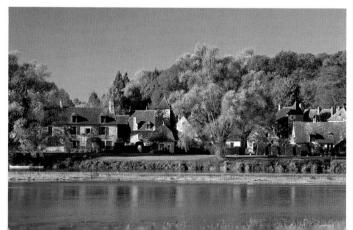

Baumeles-Messieurs

An imperial abbey in the Jura

Jura (39) • Population: 196 • Altitude: 1,083 ft. (330 m)

Baume-les-Messieurs combines the simplicity of a village with the spirituality of the abbey that inspired the founding of the Order of Cluny, which spread throughout the West during the Middle Ages.

Nestled in a remote valley typical of the Jura landscape formed by the Seille river, the Baume Abbey experienced remarkable growth throughout the Middle Ages. Developed from the 9th century at the instigation of Abbot Berno, later the founder of Cluny, it enjoyed such widespread influence that Frederick Barbarossa made it an imperial abbey. Of great architectural wealth (Romanesque with alterations in the 16th century), the abbey contains several convent buildings, a 16th-century Flemish altarpiece, a tomb-chapel, and Burgundian statuary. During the French Revolution, the abbey was divided up into private dwellings. Lulled by the gentle sound of the cloister fountain or by the louder noise of the Seille, which cascades in waterfalls not far off, the pale-fronted, brown-roofed houses live in harmony with this green, wild valley, whose rich soil produces some fine wines.

By road: Expressway A39, exit 8– Lons-le-Saunier (17 miles/27 km). By train: Lons-le-Saunier station (8 ½ miles/13.5 km). By air: Dijon-Bourgogne airport (61 miles/98 km); Geneva airport (68 miles/109 km).

(i) Tourist information—Coteaux du Jura: +33 (0)3 84 44 62 47 www.tourisme-coteaux-jura.com

Gîtes, vacation rentals, and campsites

Further information: +33 (0)3 84 44 99 28 or +33 (0)3 84 44 61 41 www.tourisme-coteaux-jura.com

TEating Out

L'Abbaye: +33 (0)3 84 44 63 44. Des Grottes et Des Roches: +33 (0)3 84 48 23 15. Le Grand Jardin: +33 (0)3 84 44 68 37.

Local Specialties

Food and Drink AOC Jura and Côtes du Jura wines • Honey • Abbey produce. Art and Crafts Puppets and figurines made from plants • Potter.

★ Events

Pentecost: Open-air rummage sales. December: Christmas market (1st weekend); Les Fayes, celebration of the winter solstice (25th).

W Outdoor Activities

Walking, riding, and mountain-biking: Route GR 59 and 5 themed trails.

🕊 Further Afield

- Voiteur (3 miles/5 km).
- *Château-Chalon (7 ½ miles/12 km), see p. 60.
- Châteaux of Le Pin and Arlay (10 miles/16 km).
- Lons-le-Saunier (11 miles/18 km).
- Lac de Chalain (16 miles/26 km).
- Cascades du Hérisson, waterfalls
 (19 miles/31 km).

• Imperial abbey: Abbey church, 16th-century Flemish altarpiece, 15th-century Burgundian statuary, tomb-chapel. Option of guided tour. Further information and bookings:

- +33 (0)3 84 44 99 28 or
- +33 (0)3 84 44 61 41); audioguides in French, English, and German.

• Baume caves: Considered to be among the most spectacular in Europe, with ½ mile (1 km) of accessible galleries and new lighting effects. Further information and bookings: +33 (0)3 84 48 23 02 or +33 (0)3 84 44 61 41.

· Cascade des Tufs: waterfalls.

Accommodation Guesthouses

Ghislain Broulard**: +33 (0)3 84 44 64 47. Rex Andrews*: +33 (0)3 84 44 65 72. Bernard Lechat: +33 (0)3 84 85 26 49. Chez Josette: +33 (0)6 42 69 34 47. Daniel Coudorc: +33 (0)3 84 44 61 84. Félicette Debonis: +33 (0)3 84 85 29 28. Didier Favre: +33 (0)3 84 44 68 37. Le Dortoir des Moines: +33 (0)3 84 44 97 31. La Grange à Nicolas: +33 (0)3 84 85 20 39. Yvan Remeuf: +33 (0)6 74 99 83 60.

Château-Chalon

Flagship of the Jura vineyards

Jura (39) • Population: 162 • Altitude: 1,529 ft. (466 m)

Overlooking the valley of the Seille and the Bresse plain, Château-Chalon watches over its vineyards, the birthplace of vinjaune, the white wine that resembles a dry sherry.

Between the grasslands and forests of the Jura plateau and the vinevards huddled beneath the cliff, the village emerged around a Benedictine abbey, as is evidenced by the Romanesque Église Saint-Pierre, covered with limestone laves (flagstones), and a castle, now reduced to a ruined keep. Lined with sturdy winemakers' houses, which are often flanked by a flight of steps and pierced with large arched openings, nearly every street in Château-Chalon leads to one of the four viewpoints overlooking the vineyards, where Savagnin reigns supreme. In the secrecy of their cellars, winemakers use this distinctive grape variety to make vinjaune, ageing the nectar in oak casks for at least six years and three months. At the heart of the village, the old cheese factory has been revived to reveal the secrets of the manufacture and ageing of Comté. The school, which has been reconstructed as it was in 1928, relives yesteryear, while the Maison de la Haute-Seille houses the tourist information center, as well as an interactive museum on the terroir of the Jura.

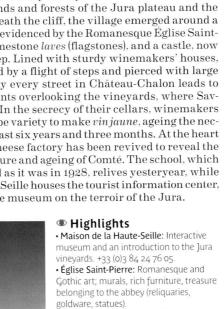

- École d'Autrefois: School furniture and teaching materials from 1880 to 1930; activities from April to October: +33 (0)3 84 44 62 47.
- · Old cheese factory: Guided tours: +33 (0)3 84 44 92 25.

• Vigne conservatoire: Collection of 53 old Jura grape varieties from the 19th century: +33 (0)3 84 44 62 47

• Landscape: Listed as "outstanding."

Accommodation Guesthouses

La Tour Charlemagne****: +33 (0)3 84 47 21 98. La Maison d'Eusébia: +33 (0)3 84 44 66 58 Le Relais des Abbesses: +33 (0)3 84 44 98 56. T'Nature: +33 (0)3 84 85 29 83 Gîtes

La Maison d'Anna: +33 (0)3 84 52 50 87. La Maison Vincent: +33 (0)3 84 44 60 48.

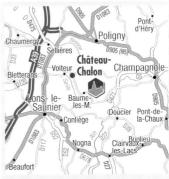

By road: Expressway A39, exit 7-Poligny (7 1/2 miles/11.5 km). By train: Lons-le-Saunier station (9 ½ miles/15.5 km). By air: Dole-Jura airport (30 miles/48 km).

 Tourist information—Coteaux du Jura: +33 (0)3 84 24 65 01 www.tourisme-coteaux-jura.com

T Eating Out

Le P'tit Castel: +33 (0)3 84 44 20 50. Les Seize Quartiers: +33 (0)3 84 44 68 23. La Taverne du Roc: +33 (0)3 84 85 24 17.

Local Specialties

Food and Drink

Cheeses • AOC Château-Chalon, Côtes du Jura, Crémant, Macvin, and Vin de Paille wines.

* Events

April: Fête de la Saint-Vernier festival (3rd Sunday). June-September: Entertainment, tasting evenings, gourmet walks: +33 (0)3 84 44 62 47. July: Sound and light show. December: Les Fayes, winter solstice festival (25t

W Outdoor Activities

Walking: Route GR 59 and 5 marked trails for discovering the vineyards • Mountain-biking: 2 circuits • Exploring the area by electric bike.

🕊 Further Afield

- Château de Frontenay (3 ½ miles/5.5 km).
- *Baume-les-Messieurs (7 1/2 miles/12 km), see p. 59.
- Château d'Arlay (7 1/2 miles/12 km).
- Poligny; Arbois (7 1/2-9 miles/12-14.5 km).
- Lons-le-Saunier (9 1/2 miles/15.5 km).

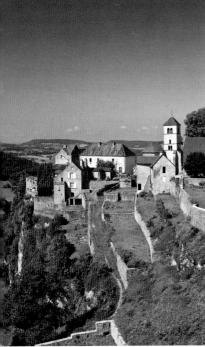

Châteauneuf

Côte-d'Or (21) • Population: 87 • Altitude: 1,558 ft. (475 m)

The castle is situated to the fore of this village, the waters of the Burgundy Canal reflecting its medieval military architecture.

The fortress was built in the late 12th century by Jean de Chaudenay to control the old road from Dijon to Autun. It owes its austere bearing to its polygonal curtain wall flanked by massive towers and wide moats, which are crossed via one of the old drawbridges transformed into a fixed bridge. In the inner courtyard, the original keep is surrounded by two 15th-century *corps de logis* (central buildings). Below the castle, the church contains a Renaissance-style pulpit and a 14th-century Virgin and Child. Opposite the building is the Maison Blondeau, one of many old merchant houses of the 14th, 15th, and 16th centuries. Distinguished by their turrets, ornamented cartouches, mullioned windows, and ogee lintels, these houses are a recurrent feature of the fortified village, which stretches from the north gate to the spectacular mission cross view point on the hilltop. From there, the view takes in the wooded hillsides of Auxois, with, in the background, the mountains of Morvan and Autun.

Highlights

• Castle: 12th-century keep, 15th-century grand *logis* (Flemish tapestries, medieval furniture), residence of Philippe Pot (15th century), chapel (15th-century "distemper" paintings, copy of the recumbent statue of Philippe Pot retained at the Louvre), 14thcentury south tower; multimedia visitor interpretive center; medieval garden; medieval-themed activities for children: +33 (0)3 80 49 21 80.

 Église Saint-Jacques-et-Saint-Philippe (16th century): Statues, 14th-century Virgin and Child: +33 (0)3 80 49 21 59.
 Village: Guided tour by appointment only: +33 (0)3 80 49 21 59.

Accommodation

Hotels Hostellerie du Château**: +33 (0)3 80 49 22 00. Guesthouses Au Bois Dormant***: +33 (0)6 79 49 25 62. Mme Bagatelle***: +33 (0)3 80 49 21 00. Gîtes and vacation rentals Further information: 03 80 90 74 24/ www.pouilly-auxois.com

T Eating Out

Au Marronnier: +33 (0)3 80 49 21 91. Le Grill du Castel: +33 (0)3 80 49 26 82. Hostellerie du Château: +33 (0)3 80 49 22 00. L'Orée du Bois: +33 (0)3 80 49 25 32.

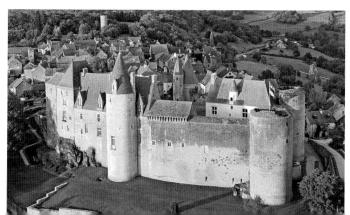

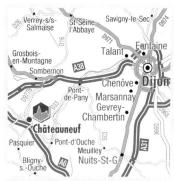

By road: Expressway A6, exit Pouilly-en-Auxois (5 ½ miles/9 km); expressway A38, exit 24–Autun (5 ½ miles/9 km). By train: Dijon station (27 miles/43 km). By air: Dijon-Bourgogne airport (35 miles/56 km).

() Tourist information—Pouillyen-Auxois: +33 (0)3 80 90 74 24 www.pouilly-auxois.com

Local Specialties

Art and Crafts Antique dealers • Ceramicists • Sculptors • Artists • Wood carvers.

★ Events

July (in even years): Medieval market (last weekend).

October: Mass of Saint Hubert and gourmet and local produce market (1st Sunday). December: Christmas Mass with living Nativity scene, after a 15-century painting by the Master of Flémalle (24th). All year round: Art and crafts exhibitions, concerts, theater (castle, church, covered market, Maison des Amis).

W Outdoor Activities

Riding • Fishing • Mountain-biking • Walking around the Auxois lakes, Romanesque chapels trail.

🕊 Further Afield

• Castles in Auxois: Chailly-sur-Armançon, Commarin, Mont-Saint-Jean (5–19 miles/8–31 km).

- Burgundy Canal: boat trip; Pouillyen-Auxois (6 miles/9.5 km).
- Abbaye de la Bussière; Ouche valley (7 ½ miles/12 km).
- Beaune; Burgundy vineyards
- (22 miles/35 km).
 - Dijon (27 miles/43 km).

Eguisheim

Haut-Rhin (68) • Population: 1,802 • Altitude: 689 ft. (210 m)

Just a short distance from Colmar, Eguisheim—the birthplace of winegrowing in Alsace—winds in concentric circles around its castle.

Whether around the castle at the center of the village, which witnessed the birth of the future Pope Leo IX (1002–1054), or along the ramparts that encircle it, Eguisheim encourages visitors to go round in circles. With every step, from courtyard to fountain, lane to square, the ever-present curve changes one's perspective of the colorful houses arrayed with flowers, half-timbering, and oriel windows. Rebuilt in the Gothic style, the Église Saint-Pierre-et-Saint-Paul is distinguished by its high square tower of yellow sandstone, and a magnificent tympanum depicting Christ in Majesty flanked by two saints, as well as the Parable of the Wise and Foolish Virgins.

The winegrowers' and coopers' houses, with their large courtyards, are a reminder that—as well as being a feast for the eyes— Eguisheim also delights the palate with its *grand cru* wines, which are celebrated with festivals throughout the year.

Highlights

• Chapel of the Château Saint-Léon (19th century, neo-Romanesque style): Relics of Pope Leo IX.

• Église Saint-Pierre-et-Saint-Paul (11th– 14th centuries): Polychromed wooden statue known as "the Opening Virgin" (13th century), porch of the old church. • Parc des Cigognes (stork garden): Free entry to the enclosure, information board on the life of Alsace's legendary bird.

• Vineyards: Guided tour of the wine route followed by a guided tasting session

of the wines of Alsace. By arrangement with the winegrowers, and on Saturdays from mid-June to mid-September and on Saturdays and Tuesdays in August: +33 (o)3 89 23 40 33. • Village: Guided tour all year round for groups and by arrangement, and Thursdays from mid-June to mid-September: +33 (o)3 89 23 40 23; guided tour on a tourist train and tour of the area on the Train Gourmand du Vignoble Tuesdays and Thursdays: +33 (o)3 89 73 74 24, discovery tour of the old village (information boards).

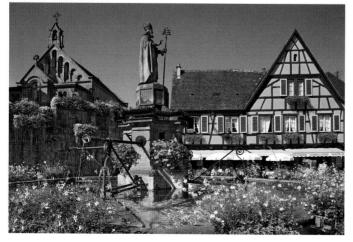

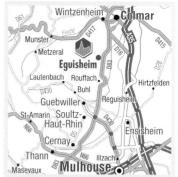

By road: Expressway A35, exit 27-Sainte-Croix-en-Plaine (4 ½ miles/7 km). By train: Colmar station (4 ½ miles/7 km). By air: Bâle-Mulhouse station (35 miles/56 km); Strasbourg-Inter airport (45 miles/72 km).

() Tourist information: +33 (0)3 89 23 40 33 www.ot-eguisheim.fr

Accommodation

Auberge Alsacienne***: +33 (0)3 89 41 50 20. Ferme du Pape***: +33 (0)3 89 41 41 21. ♥ Hostellerie du Château*** +33 (0)3 89 23 72 00. Hôtel Saint-Hubert***: +33 (0)3 89 41 40 50. À la Ville de Nancy**: +33 (0)3 89 41 78 75. Auberge des Trois Châteaux**: +33 (0)3 89 23 70 61. Hostellerie des Comtes**: +33 (0)3 89 41 16 99. Auberge du Rempart: +33 (0)3 89 41 16 87. Aparthotel Résidence*** Pierre et Vacances: +33 (0)3 89 30 41 20. Guesthouses M. et Mme Bombenger +33 (0)3 89 23 71 19. Other guesthouses, gîtes, and vacation rentals Further information: 03 89 23 40 33 www.ot-eguisheim.fr Campsites Les Trois Châteaux***: +33 (0)3 89 23 19 39.

T Eating Out

À la Ville de Nancy: +33 (0)3 89 41 78 75. Auberge Alsacienne: +33 (0)3 89 41 50 20. Auberge du Rempart: +33 (0)3 89 41 16 87.

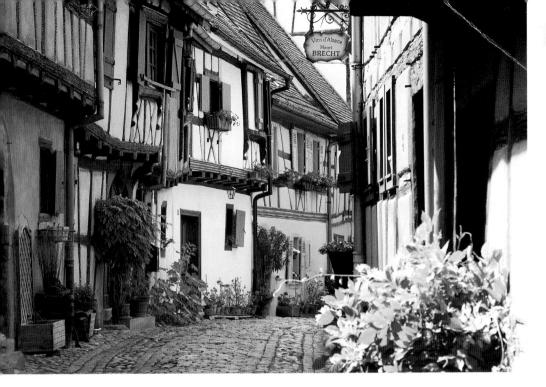

Auberge des Trois Châteaux: +33 (0)3 89 23 70 61.

+33 (0)3 89 41 87 66.

Au Vieux Porche: +33 (0)3 89 24 01 90. Caveau des Douceurs: +33 (0)3 89 23 10 01. Caveau Heuhaus: +33 (0)3 89 41 85 72. Le Dagsbourg: +33 (0)3 89 41 51 90. Ferme du Pape: +33 (0)3 89 41 41 21. La Grangelière: +33 (0)3 89 23 00 30. Hostellerie des Comtes: +33 (0)3 89 41 16 99. Le Pavillon Gourmand: +33 (0)3 89 24 36 88. Wistub-Bierstub Kas Fratz:

Local Specialties Food and Drink

Pretzels • *Pain d'épice* (spice cake) • Mushrooms • Alsatian charcuterie • AOC Alsace wines and Eichberg and Pfersigberg *grands crus*.

Art and Crafts Artists' studios • Art gallery • Painting • Upholstery and decoration.

★ Events

July: Eguisheim wines week and "Nuit des Grands Crus" wine festival (2nd fortnight). August: Discovery Day, Parc à Cigognes (1st Sunday), guided wine tasting

(1st week), Fête des Vignerons, winegrowers' festival (last weekend).
September: Fête du Vin Nouveau, new wine festival (last weekend).
October: Fête du Vin Nouveau (1st weekend), Fête du Champignon, mushroom festival (last weekend).
November and December: Christmas market (daily for the four weeks of Advent).

W Outdoor Activities

Discovery of the village by microlight • Standard and electric bike rental • Walking: 12 marked trails • Segway rides.

🕊 Further Afield

• Hautes Vosges, region: Munster valley; Col de la Schlucht (3–19 miles/ 5–31 km).

- Colmar (3 ½ miles/5.5 km).
- Alsace wine route: Turckheim (5 miles/ 8 km); Rouffach (7 miles/11.5 km);
- Kaysersberg (8 miles/13 km);

*Riquewihr (11 miles/18 km), see pp. 76–77; *Hunawihr (12 miles/19 km), see pp. 66–67; Guebwiller (13 miles/ 21 km).

- Château du Hohlandsbourg and
- Five Castles route (5 miles/8 km).
- Neuf-Brisach (13 miles/21 km).

I Did you know?

Here, if stones could speak, they would tell the story of the illustrious family of the counts of Eguisheim, into which was born a certain Bruno, son of Hugh IV. A highranking nobleman, he was called to papal office. Bruno went to Rome on foot, stick in hand, cape on his shoulders, just as he is depicted in his statue on the Place du Château. On his arrival, he was acclaimed by the people of Rome and enthroned as Pope Leo IX.

Flavigny-sur-Ozerain

Côte-d'Or (21) • Population: 338 • Altitude: 1,398 ft. (426 m)

The site of an abbey, Flavigny also produces an aniseed candy that is enjoyed throughout the world; its sweet fragrance perfumes the air here.

The Romans chose this location during the siege of Alesia in 52 BCE; the town grew with the founding of the Benedictine abbey of Saint-Pierre, which is where the famous candies are now produced. The parish church of Saint-Genest, whose nave and aisles are partially surmounted by a 13th-century gallery, contains stalls made by the brotherhood in the 14th century and fine Burgundian statuary from the 14th and 15th centuries. At Flavigny's heart, the village's artisanal and commercial prosperity is visible today in the bay windows of single-storey houses such as the Maison au Donataire, which contains the "Point I" visitor center. The medieval fortifications of the Portes du Val and du Bourg still stand, as do Flavigny's ramparts, from where the view stretches out over the green hills of Auxois.

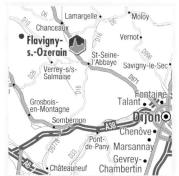

By road: Expressway A6, exit 23–Bierrelès-Semur (14 miles/23 km). By train: Venareyles-Laumes station (5 miles/8 km); Montbard TGV station (15 miles/24 km). By air: Dijon-Bourgogne airport (45 miles/72 km).

(i) Tourist information—"Point I" visitor center: +33 (0)3 80 96 25 34 www.flavigny-sur-ozerain.fr Tourist information—Pays d'Alésia et de la Seine: +33 (0)3 80 96 89 13

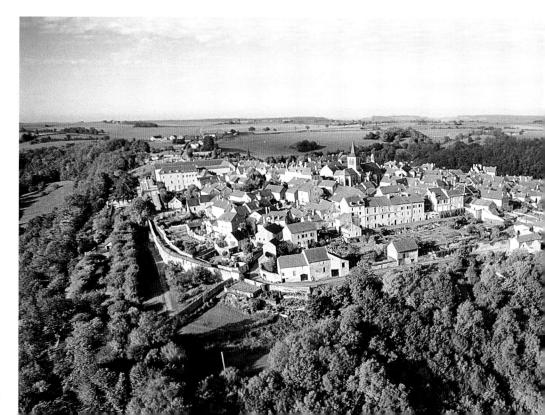

Flavigny-sur-Ozerain Côte-d'Or

Highlights

• Crypt of the Abbaye Saint-Pierre (8th century).

• Église Saint-Genest (13th– 16th centuries): Gothic style with 15th-century stalls and relics of Saint Reine: +33 (0)3 80 96 25 34 or +33 (0)3 80 96 21 73.

 Aniseed factory: In the former Abbaye Saint-Pierre; free entry and tasting: +33 (0)3 80 96 20 88.
 Maison des Arts Textiles

et du Design: Algranate museum collection, exhibitions, traditional Auxois weaving workshop: +33 (0)3 80 96 20 40.

Village: Guided tour for groups by appointment only: +33 (0)3 80 96 25 34.
Flavigny-Alésia vineyards: Self-guided visit of the winery and free tasting: +33 (0)3 80 96 25 63.

L'Ange Souriant***: +33 (0)3 80 96 24 93. Les Adages: +33 (0)6 64 52 18 60. Chez Elle: +33 (0)3 80 96 28 23.

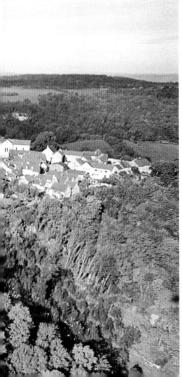

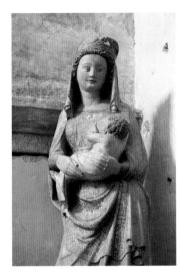

Couvent des Castafours: +33 (0)3 80 96 24 92. Le Logis Abbatial: +33 (0)6 87 25 60 08. Le Logis de l'Ozerain: +33 (0)6 84 83 18 99. La Maison du Tisserand: +33 (0)3 80 96 20 40. Mme Troubat: +33 (0)3 80 96 24 00. **Gîtes, bunkhouses** Further information: +33 (0)3 80 96 25 34/ www.flavigny-sur-ozerain.fr

T Eating Out

Le Garum: +33 (0)3 80 89 07 78. La Grange des Quatre Heures Soupatoires, farmhouse inn: +33 (0)3 80 96 20 62. Le Relais de Flavigny: +33 (0)3 80 96 27 77.

Local Specialties Food and Drink

Abbaye de Flavigny aniseed, specialty confectionery • Charcuterie • Cheese (Époisses) • Burgundy wines; vins de pays des Coteaux de l'Auxois.

Art and Crafts

Wrought ironworker • Art galleries • Lithographer • Organic wool and vegetable dyes.

I Did you know?

According to the writer Saint-Simon, Louis XIV loved aniseed candies, which he liked to keep with him in special box in his pocket. Madame de Sévigné,

★ Events

Ascension weekend: Walks open to all. June: Pimpinella music festival. July: Village meal (14th). August: PontiCelli cello workshops (early August). October: Marché de la Saint-Simon, market (penultimate Sunday). December and January: Nativity scenes exhibited in the streets, and at the old *lavoir* (washhouse) on January 1.

Winter: "Hors Saison Musicale" concerts.

W Outdoor Activities

Hunting • Fishing • Mountain-biking • Walking and riding from Bibracte to Alésia and 5 marked trails.

🕊 Further Afield

Alésia: archeological site; Château de Bussy-Rabutin (3–6 miles/5–9.5 km).
Venarey-les-Laumes: Burgundy Canal (5 miles/8 km).

- Semur-en-Auxois (11 miles/18 km).
- Montbard; Buffon: foundry; Abbaye de Fontenay (12–16 miles/19–26 km).

Madame de Pompadour, and the comtesse de Ségur also enjoyed the aniseed treats, which they used to offer to their friends.

Hunawihr The colors of the vines

Haut-Rhin (68) • Population: 603 • Altitude: 525 ft. (160 m)

Situated on the Alsace wine route amid the vineyards, Hunawihr is a typical Alsatian village, bedecked with flowers.

Hunawihr owes its name to a laundry woman. Saint Huna: according to legend, she lived here in the 7th century with her husband, the Frankish lord, Hunon. The 15th–16th–century church contains 15th–century frescoes that recount the life of Saint Nicholas. Surrounded by a cemetery fortified by six bastions, it is built on the hill overlooking the village, whose attractions include the Saint June Fountain with its washhouse, the town hall (formerly the corn exchange), the Renaissance-style Maison Schickhart, halftimbered houses, and bourgeois residences from the 16th and 19th centuries. Nature-lovers can visit the center for reintroducing storks and otters, and the butterfly garden—both magical places.

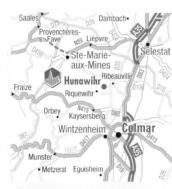

By road: Expressway A35, exit 23– Ribeauvillé then N83 (5 ½ miles/9 km). By rail: Colmar station (11 miles/18 km). By air: Bâle-Mulhouse airport (47 miles/ 76 km).

(i) Tourist information: +33 (0)3 89 73 23 23 www.ribeauville-riguewihr.com

Highlights

• Church (15th and 16th centuries) and its fortified cemetery: Saint Nicholas frescoes (15th century).

• Centre de Réintroduction des Cigognes et des Loutres: 12-acre (5-ha.) wildlife park dedicated to reintroducing and preserving storks, otters, and other local species: +33 (0)3 89 73 72 62.

• Jardin des Papillons: Several hundred exotic butterflies from Africa, Asia, and the Americas, living in a lush garden: +33 (0)3 89 73 33 33.

• Village: Guided tour of the fortified church and the village every Wednesday and Friday in July and August: +33 (0)3 89 73 23 23.

• Grands crus wine trail: Permanent discovery trail; guided tour by a winemaker and free tasting sessions in summer. Further information: +33 (0)3 89 73 23 23.

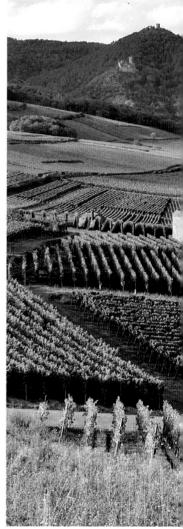

• Vineyards: Guided tour followed by a guided tasting session every Thursday at 3.30 p.m. in July and August. Further information: +33 (0)3 89 73 61 67.

✓ Accommodation Guesthouses

M. Richter Gilbert: +33 (0)3 89 73 71 61. Mme Schwach: +33 (0)3 89 73 62 15. **Gîtes and vacation rentals** Further information: +33 (0)3 89 73 23 23/ www.ribeauville-riguewihr.com

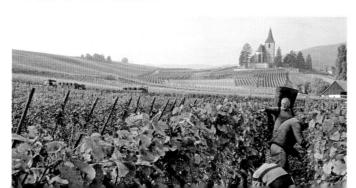

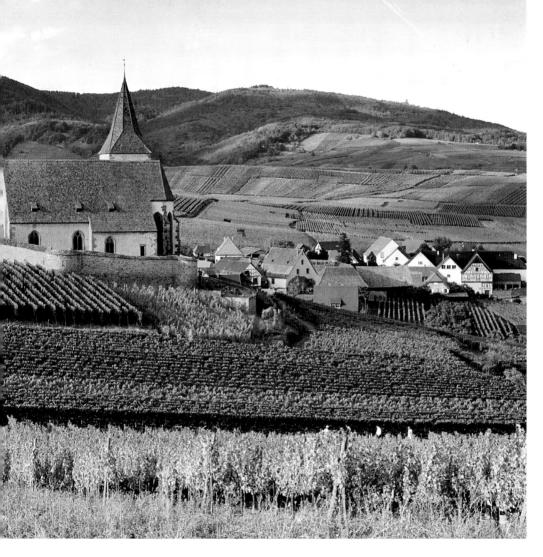

T Eating Out

Caveau du Vigneron: +33 (0)3 89 73 70 15. O'Goutchi: +33 (0)3 89 58 88 23. Wistub Suzel: +33 (0)3 89 73 30 85.

Local Specialties

Food and Drink

Distilled spirits • AOC Alsace wines and grand cru Rosacker (Gewürztraminer, Riesling, Pinot Gris).

★ Events

August: Hunafascht, Alsatian open-air evenings under paper lanterns (1st Friday and Saturday).

W Outdoor Activities

Cycle touring • Walking • Mountain-biking, 1 marked trail.

🕊 Further Afield

• Alsace wine route: *Riquewihr (1 mile/1.5 km), see pp. 76–77; Ribeauvillé; Bergheim; Kintzheim; *Eguisheim (12 miles/19 km), see pp. 62–63.

- Haut-Koenigsbourg (8 ½ miles/13.5 km).
- Colmar; Sélestat (9 ½ miles/15.5 km).
- *Mittelbergheim (23 miles/37 km),
- see pp. 71–72.

I Did you know?

The village joined the Reformation in 1537, but after Alsace was annexed to France in 1648 Catholicism was reintroduced. "Simultaneum"—whereby Protestants and Catholics share a church but worship at different times—was instigated in 1687 and is ongoing.

Hunspach Alsace "beyond the forest"

Bas-Rhin (67) • Population: 700 • Altitude: 525 ft. (160 m)

Situated in the heart of the Parc Naturel Régional des Vosges du Nord (nature park), Hunspach features houses with white cob walls and half-timbering that are typical of the Wissembourg region, showing that, in this village, the carpenter is king.

At the end of the Thirty Years War, Hunspach was almost on its knees: it owes its salvation to French refugees and, in particular, to the Swiss immigrants who were granted farmland here. With wood and clay to hand, they built black-and-white half-timbered houses, just like those back home: the village owes its charm and attractiveness to these buildings. With their hipped gables and tiled canopies, they make a lovely sight lined up along the main road and around the pink sandstone bell tower of the Protestant church. Everywhere geraniums bloom at windows or on walls but, in this village where everything is neat and tidy, there still remains some mystery. The balloon-shaped windowpanes of Hunspach work like distorting mirrors, giving passers-by a false reflection and preventing them peering inside. Behind their windows, the residents can see out without being seen.

By road: Expressway A35, exit 57–Seltz (12 miles/19 km); expressway A4, exit 47– Haguenau (24 miles/39 km). By train: Hunspach station (1 mile/1.5 km); Wissembourg station (6 miles/9.5 km). By air: Strasbourg-Inter airport (48 miles/ 77 km).

(i) Tourist information: +33 (0)3 88 80 59 39 / www.hunspach.com

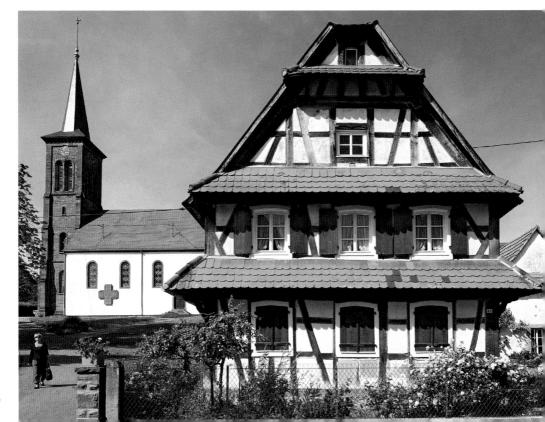

★ Events

June: Fête du Folklore (last weekend in spring).

July-August: Folklore activities and evenings: +33 (0)3 88 80 59 39. December: Christmas country market (2nd Sunday of Advent).

W Outdoor Activities

Pedestrian trail around village.

🕊 Further Afield

- Route around picturesque villages: Hoffen, Seebach, Steinselz, Cleebourg (2–6 miles/3–9.5 km).
- Alsace wine route: Steinselz, Oberhoffen, Rott-Cleebourg (4 ½ miles/7 km).
- Pottery-making villages: Betschdorf, Soufflenheim (5-11 miles/8-18 km).
- Wissembourg (6 miles/9.5 km).
- Germany: Palatinate region, vineyards, the Black Forest (6–25 miles/9.5–40 km)
- Haguenau (14 miles/23 km)
- Niederbronn-les-Bains (17 miles/27 km).
- Strasbourg (34 miles/55 km).

I Did you know?

Fort Schoenenbourg, designed to accommodate 600 men and be selfsufficient for three months, was heavily bombarded as German forces streamed over the Belgian border into France in June 1940; the fortress crews nevertheless held firm. But the French General Staff ordered its surrender to German troops on July 1, 1940.

Highlights

 • ♥ Fort Schoenenbourg (Maginot Line): World War II fortress built 1930–40; the most important Maginot Line construction in Alsace open to visitors. Visit the military blocks, command post, gallery, infantry casemates, kitchen. Accessible for wheelchair users: +33 (0)3 88 80 96 19.

• Village: Guided visit for groups of 15+ by reservation: +33 (0)3 88 80 59 39; self-guided trail around the historic site (map available from tourist information center).

Accommodation Guesthouses

Mme Billmann***: +33 (0)3 88 54 76 93. Maison Ungerer***: +33 (0)3 88 80 59 39.

Gîtes

Mme Billmann***: +33 (0)3 88 54 76 93. Maison Ungerer*** and **: +33 (0)3 88 80 59 39. Mme Lehmann**: +33 (0)3 88 80 42 25. **Vacation rentals** Mme Derrendinger: +33 (0)3 88 80 43 95.

T Eating Out

Au Cerf : +33 (0)3 88 80 41 59. Chez Massimo: +33 (0)3 88 80 42 32.

Local Specialties Food and Drink

Wine • Dickuechen (brioche loaf) • Fleischnacka (meat and pasta roulade). Art and Crafts Painter • Alsace artifacts • kelsch household linen.

LODS Born from the river

Doubs (25) • Population: 231 • Altitude: 1,214 ft. (370 m)

Exploiting the energy of the Loue river as it tumbled through the valley, the inhabitants of this little village built thriving iron forges and produced wine in the relatively mild climate.

The smithies may be idle now, and Lods may no longer produce grapes, but the village still has its 16th- and 17th-century winegrowers' houses with their spacious vaulted cellars, clustered higgledy-piggledy around the 18th-century church and its tufa-stone bell tower. The Musée de la Vigne et du Vin (vine and wine museum), which is housed in a beautiful 16th-century building, the old smithy on the other side of the river, and a historical trail through the village all tell the stories of the blacksmiths and winegrowers who used to live here.

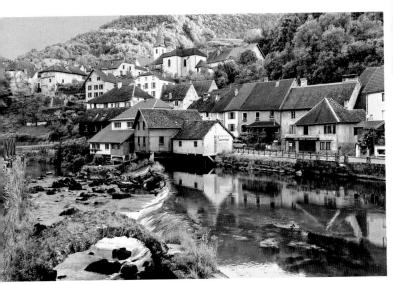

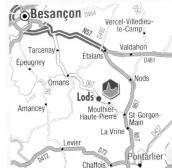

By road: Expressway A36, exit 3–Pontarlier (41 miles/66 km); N57 (7 miles/11.5 km). By rail: Pontarlier station (15 miles/24 km); Besançon-Viotte station (23 miles/37 km). By air: Geneva airport (87 miles/ 140 km); Dijon-Bourgogne airport (92 miles/148 km).

(i) Tourist information—Ornans-Vallées de la Loue et du Lison:

+33 (0)3 81 62 21 50 www.ornans-lou-lison.com www.lods-village.fr

Trout • Mountain ham • Comté cheese • Cancoillotte cheese. Art and Crafts Painters.

W Outdoor Activities

Canoeing • Fishing • Walking • Mountain-biking.

🕊 Further Afield

- Source of the Loue river; Pontarlier; Joux Fort; Lac de Saint-Point, lake (6–31 miles/9.5–50 km).
- Loue valley; Ornans; Besançon (7 1/2-23 miles/12-37 km).
- Ornans: Musée Courbet and Musée
- du Costume (7 ½ miles/12 km).
- Dino-zoo (12 miles/19 km).

I Did you know?

The heyday of Lods' wine production was in the 17th and 18th centuries, when wine from Lods was exported to Switzerland and Alsace. The development of railway routes brought cheaper wines from Algeria and the South, drastically reducing local production; by the end of the 19th century, phylloxera had also wreaked havoc in the vineyards, marking the end of a hitherto thriving local industry.

Highlights

Église Saint-Théodule.
Musée de la Vigne et du Vin: +33 (0)3 81 60 90 11.

Accommodation

La Truite d'Or**: +33 (0)3 81 60 95 48. Hôtel de France: +33 (0)3 81 60 95 29. **Guesthouses** Au Fil de Lods***, licensed fishing lodges: +33 (0)3 81 60 97 51. Gîtes and vacation rentals Further information: +33 (0)3 81 62 21 50 . Campsites Champaloux**: +33 (0)3 81 60 90 11.

T Eating Out

Hôtel de France: +33 (0)3 81 60 95 29. La Truite d'Or: +33 (0)3 81 60 95 48.

Local Specialties Food and Drink

"Jésus de Morteau" smoked sausage •

Mittelbergheim Rainbow colors and fine wines

Bas-Rhin (67) • Population: 682 • Altitude: 722 ft. (220 m)

On the wine route in Alsace, at the foot of Mont Sainte-Odile. Mittelbergheim sings with color and produces excellent wines.

Mittelbergheim was founded by the Franks near Mont Sainte-Odile, and was dedicated to Alsace's patron saint: for many years it belonged to nearby Andlau Abbey, erected in the 9th century by the wife of Emperor Charles le Gros. The village is devoted to wine production. Glowing with vibrant colors in fall and wild tulips in springtime, it is surrounded by vinevards it from its base (where the Rhine Plain begins) to the Zotzenberg vinevard on the hilltop. Here the Sylvaner grape is grown, among other varieties, making some of the very best grand cru wines. Vines are ubiquitous in the landscape—and also in Mittelbergheim's architecture. The facades of the houses lining the streets have a remarkable unity of style. Dating from the 16th and 17th centuries, they are superbly preserved, adorning the streets with their eve-catching pink sandstone frontages. Their massive wooden gates open wide in the morning to reveal huge interior courtvards at the center of buildings dedicated to wine production. Once closed, they guard the secret of the cellars, where Zotzenberg Sylvaners-the only Sylvaners in Alsace classified as grands crus—are aged, alongside Rieslings, Pinot Gris, and Gewürtztraminers.

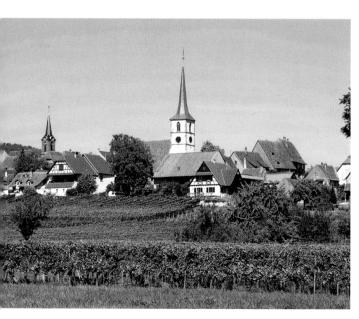

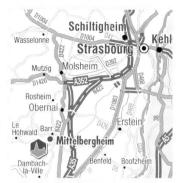

By road: Expressway A35, exit 13– Mittelbergheim (2 miles/3 km). By train: Barr station (1 mile/1.5 km); Strasbourg TGV station (23 miles/37 km). By air: Strasbourg Inter airport (19 miles/31 km); Bâle-Mulhouse airport (63 miles/101 km).

() Tourist information— Pays de Barr et du Bernstein: +33 (0)3 88 08 66 65 www.pays-de-barr.com www.mittelbergheim.fr

Highlights

 Former oil mill (18th century).
 Museum "Mémoire de Vignerons": Conserving wine-producing heritage with a large collection of relevant artifacts; open every Sunday July–October, and by appointment: +33 (0)3 88 08 00 96.
 Wine path: Open all year.

• Village: Guided tour by appointment only; self-guided visit with a dozen information boards; map available: +33 (0)3 88 08 92 29.

Accommodation Hotels

Winstub Gilg**: +33 (0)3 88 08 91 37. Guesthouses

Robert Boeckel: +33 (0)3 88 08 42 40. Henri Dietrich: +33 (0)3 88 08 93 54. Christian Dolder: +33 (0)3 88 08 96 08. Jacqueline Dolder: +33 (0)3 88 08 15 23. Marie-Paule Dolder: +33 (0)3 88 08 17 49. Bernard Haegi: +33 (0)3 88 08 95 80. Paul Hirtz: +33 (0)3 88 08 54 86. Le Petit Nid: +33 (0)6 87 36 11 17. Charles Schmitz: +33 (0)3 88 08 93 9. André Wittmann: +33 (0)3 88 08 95 79. **Gîtes and vacation rentals**

Further information: 03 88 08 66 65 www.pays-de-barr.com

T Eating Out

Am Lindeplatzel: +33 (0)3 88 08 10 69. Au Raisin d'Or: +33 (0)3 88 08 93 54. Winstub Gilg: +33 (0)3 88 08 91 37.

Local Specialties Food and Drink

Preserves • Honey • AOC Alsace and grand cru Zotzenberg wines. Art and Crafts Cabinetmaker.

★ Events

January–June: Exhibitions. March–April: "Henterem Kallerladel," open house at wine cellars (end March– beginning April). July: Fête du Vin, wine festival (last weekend). July–August: "Sommermarik," country market (Wednesday evenings). October: Fête du Vin Nouveau, new wine festival (2nd weekend). December: "Bredelmarik," market for Alsatian Christmas cakes (1st Sunday).

W Outdoor Activities

Walking: Routes GR 5 and GR 10; marked trails, including wine path and "Randocroquis" (walk and draw trail) • Horse-riding • "Sentier des Espiègles" (family fun trail) • Mountain-biking.

🕊 Further Afield

- Barr (1 mile/1.5 km).
- Andlau; Le Hohwald; Champ-du-Feu
- (1–12 miles/1.5–19 km).
- Obernai (6 miles/9.5 km).
- Mont Saint-Odile (9 ½ miles/15.5 km).
- Sélestat (12 miles/19 km).
- Haut-Koenigsbourg (17 miles/27 km).
- Strasbourg (22 miles/35 km).
- *Hunawihr (23 miles/37 km), see pp. 66–67.
- *Riquewihr (24 miles/39 km), see pp. 76–77.
- Colmar (26 miles/42 km).

I Did you know?

At "Mittel," as the locals call it, there is a long history of wine-growing. Behind its elegant Renaissance facade on the main street, the town hall holds the *Weinschlag*, a precious document that contains many records of vineyards and wines, dating from 1510.

Noyers Medieval Burgundy

Yonne (89) • Population: 690 • Altitude: 620 ft. (189 m)

Curved around a meander on the Serein river, Noyers is a typical medieval fortified town.

The village is still protected by ramparts studded with sixteen towers and three fortified gateways: the Tonnerre, topped with lava tiles: the Venoise, on the old castle site: and the painted gateway, with culverin points on the machicolated gatehouse. Renaissance houses rub shoulders with half-timbered and corbeled ones on the Place de la Petite-Étape-aux-Vins, the Place du Marché-au-Blé, and the Place du Grenier-à-Sel. At the base of the village, stone steps outside winegrowers' houses fall smartly into line. In the center of the village, the church of Notre-Dame is in the Flamboyant Gothic style. While decidedly medieval within its ramparts. Novers moves with the times: it organizes vibrant cultural activities that combine music and craftsmanship with a stunning collection of naive art.

Highlights

Musée des Arts Naïfs et Populaires

de Noyers (in the 17th-century college): Naive art collection; collection of folk art from Southern Europe, Asia, and Latin America; "Le Monde Villageois Naïf et Rêvé" exhibition (miniatures): +33 (0)3 86 82 66 06.

• Site of the former castle: Self-guided visit: +33 (0)3 86 82 66 06.

• Tour of the ramparts.

• Village: Guided tours at 3 p.m., mid-June–mid-September, for individuals (contact tourist information center first), and throughout the year for groups by appointment only: +33 (o)3 86 82 66 o6.

Accommodation Guesthouses

Le Moulin de la Roche***: +33 (0)3 86 82 68 13. La Loge: +33 (0)3 86 75 04 52. La Porte Peinte: +33 (0)3 86 75 05 11. Le Tabellion: +33 (0)3 86 82 62 26. La Vieille Tour: +33 (0)3 86 82 87 69.

Gîtes and vacation rentals

Further information: +33 (0)3 86 82 66 06 www.noyers-et-tourisme.com

Nature zone

Further information: +33 (0)3 86 82 83 72.

T Eating Out

Les Granges: +33 (0)3 86 55 45 91. Le Marquis Perché: +33 (0)3 86 75 16 70. Les Millésimes: +33 (0)3 86 82 82 16. Restaurant de la Vieille Tour: +33 (0)3 86 82 87 36.

Local Specialties

Food and Drink AOC Chablis wines. Art and Crafts Antiques • Contemporary art • Ceramic artist • Medieval illuminator • Maker of

feathered masks • Wrought ironwork • Gallery • Jewelers • Tapestry artist • Leather craftsman • Potters.

★ Events

Market: Wednesday mornings. July: Flea market (3rd Sunday). July-August: Flea markets (Saturday mornings).

July–August: Musical events, part of the Festival des Grands Crus de Bourgogne. August: Festival Vallée et Veillée (1st weekend); "Gargouillosium," sculpting gargoyles (mid-August).

By road: Expressway A6, exit 21– Nitry (7 miles/11.5 km). By train: Tonnerre station (14 miles/23 km); Montbard TGV station (20 miles/32 km). By air: Dijon-Bourgogne airport (84 miles/135 km).

(i) Tourist information—Noyers-

Montréal: +33 (0)3 86 82 66 06 www.noyers-et-tourisme.com

September: Illuminations as part of the Heritage Weekend (3rd weekend). November: Truffle market (1st and last Sunday).

W Outdoor Activities

Swimming (no lifeguard) • *Boules* area • Fishing • Walking: 3 marked trails.

🕊 Further Afield

• Vausse Priory; Buffon: foundry; Fontenay Abbey (9 ½– 25 miles/15.5–40 km).

- Castles at Ancy-le-Franc, Tanlay, and Tonnerre Hôtel Dieu (12–19 miles/ 19–31 km).
- *Vézelay (25 miles/40 km), see pp. 81–83.

Parfondeval In the vanguard of the Reformation

Aisne (o2) • Population: 500 • Altitude: 725 ft. (221 m)

A compact village of red bricks and silver-gray slate roofs, Parfondeval is typical of this region and remains characterized by farming life.

During the reigns of Louis XIII and Louis XIV, to defend themselves against hordes of brigands, the villagers of Parfondeval constructed a fortified church dedicated to Saint Médard, around which they built squat houses that served as ramparts. To get to the church, you have to go through a porch that is set into a house, then pass between two round towers that flank a spire. The road leads to a square that is partially occupied by a pond. In the early 19th century, the village had six others, which provided drinking water for animals. Walking through the village, the visitor sees houses decorated with glazed bricks in diamond shapes, half-timbered facades, and, surprisingly, at the end of the Rue du Chêne, a Protestant church. The latter reflects the peculiarity of Parfondeval's religious history. During the 16th century, villagers and others from the Thiérache region, returning from the annual harvest in the Pays de Meaux, brought back to Parfondeval copies of the Bible translated into French and communicated the new ideas of the Reformation. The present church bears witness to the continuing presence of this community. Apple orchards, pastures, and cornfields separated by copses make up the landscape of Parfondeval, which is almost entirely devoted to farming.

Highlights

• Village: Self-guided tour with audioguides on the signposted walk. Further information: +33 (0)3 23 91 30 10. • Église Saint-Médard (16th century): Daily 9 a.m.–6 p.m. June–September. • Protestant church (1858).

• La Maison des Outils d'Antan: Collection of 2,000 farming tools and everyday items from the 1900s: +33 (0)3 23 97 61 59.

Accommodation Guesthouses

Françoise and Lucien Chrétien**: +33 (0)3 23 97 61 59.

Gîtes

Le Village***: +33 (0)3 23 97 62 54 or +33 (0)6 48 73 29 77.

T Eating Out

Françoise and Lucien Chrétien, farmhouse, afternoon tea: +33 (0)3 23 97 61 59. Le Moulin, weekends May-October: +33 (0)6 31 08 73 01. ♥ Le Relais de la Chouette: +33 (0)3 75 10 00 15.

Local Specialties Food and Drink

Cider and apple juice.

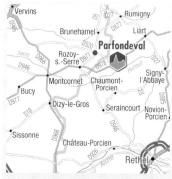

By road: Expressway A34, exit 26– Cormontreuil then N51 (22 miles/ 35 km); Expressway A26, exit 13– Laon then N2 (24 miles/39 km). By train: Vervins station (21 miles/34 km); Laon station (30 miles/48 km). By air: Reims-Champagne airport (39 miles/63 km).

Tourist information—Thiérache: +33 (0)3 23 91 30 10 www.tourisme-thierache.fr

★ Events

June: Village fête. August: Flea market (Sunday after the 15th). October: "Potironnade," squash tastings and guided walk (4th Saturday).

W Outdoor Activities

Walking, horse-riding, and mountain-biking ("Par le Fond du Val" trail).

🖗 Further Afield

- Aubenton (8 miles/13 km).
- Saint-Michel: abbey (17 miles/27 km).
- Liesse-Notre-Dame: basilica (21 miles/34 km).
- Marle: Musée des Temps Barbares, museum
- of the Middle Ages (21 miles/34 km). • Rocroi, star-shaped fortified town (31 miles/50 km).

I Did you know?

Parfondeval is the only village in Thiérache to have both a Catholic and a Protestant church as well as a Catholic and a Protestant cemetery. In the past, Catholics used to live at the top of the village, where the Catholic church is located, while Protestants lived further down, near their place of worship.

Pesmes

A village with a prosperous past

Haute-Saône (70) • Population: 1,181 • Altitude: 689 ft. (210 m)

On the bank of the Ognon river, Pesmes bears witness to the work of winemakers, the glory days of the old lords of the town, and the hevday of Franche-Comté's metalworking industry.

Perched high up on a rocky plateau beside a delightful river, Pesmes was founded in the Middle Ages around a church and a castle, whose location enabled it to control the route from Gray to Dole. Pesmes was much coveted for its strategically important position. and was by turns Frankish, Germanic, Burgundian, and Spanish, before becoming French during the reign of Louis XIV (1643-1715). At that time, it was a major trading post that brought together merchants and burghers. The village has inherited many buildings from this period: the Église Saint-Hilaire, built and rebuilt between the 13th and 17th centuries, with its imperial bell tower; the castle ruins; part of the old ramparts; and two gateways. Along the streets and alley ways, beautiful old houses and mansions mix with charming winegrowers' homes. Founded in 1660 by Charles de La Baume, marquis of Pesmes, and built on the site of an old mill, the old forge, which was operational until 1993, has now heen converted into a museum.

Highlights

• Château de Pesmes (17th–18th centuries).

• Église Saint-Hilaire (13th–17th centuries): Interior decoration, altarpiece, 16th-century statues, pipe organ.

Hôtel Châteaurouillaud (14th century).

• Musée des Forges: Collection of machines and tools in the former

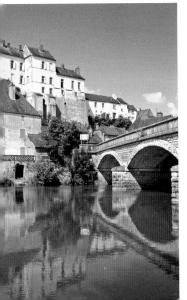

workshops, forge-owner's house: +33 (0)6 87 73 13 05 or

- +33 (0)3 84 31 23 37.
- Village: Guided tour: +33 (0)6 87 73 13 05.

Accommodation

Hotels

Hôtel de France**: +33 (0)3 84 31 20 05. Guesthouses

La Maison Royale: +33 (0)3 84 31 23 23. Gîtes

Further information: +33 (0)3 84 31 22 77 or +33 (0)3 84 31 20 15. Campsites

La Colombière**: +33 (0)3 84 31 20 15.

T Eating Out

Hôtel de France: +33 (0)3 84 31 20 05. Les Jardins Gourmands: +33 (0)3 84 31 20 20. O'Ma Pizza, pizzeria: +33 (0)3 84 31 29 68.

Local Specialties Food and Drink

Oil • *Poulet d'horloger* (local recipe with potatoes and Cancoillotte cheese) • Pesmes pie and tart.

Art and Crafts Cutler • Leatherworker • Wrought ironworker • Lithographer • Artist • Potter • Sculptor.

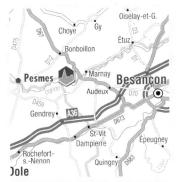

By road: Expressway A39, exit 5–Saint-Jean-de-Losne (16 miles/26 km); expressway A36, exit 2–Dole (12 miles/ 19 km). By train: Dole station (15 miles/ 24 km); Besançon-Viotte station (32 miles/ 52 km); Dijon TGV station (32 miles/51 km). By air: Dole-Jura airport (21 miles/34 km).

(i) Tourist information:

+33 (0)9 50 17 09 00 or +33 (0)6 87 73 13 05 www.pesmes.fr

★ Events

Market: Wednesday morning, Place des Promenades.

May: Handicrafts fair (Saturday and Sunday). July: Fête de l'Île festival (2nd fortnight). July and August: Art exhibition at the Voûtes.

August: Flea market, open-air rummage sale (1st Saturday); Fête de la Saint-Hilaire (festival).

All year round: Cinema, theater, and entertainment at the Forges de Pesmes.

W Outdoor Activities

Watersports • Canoeing • L'Île des Forges • Fishing • Hiking and Nordic walking: 4 marked trails • Rock climbing • Mountain-biking.

🕊 Further Afield

• Ognon valley: Malans ("Île Art" sculpture park), Acey (Cistercian abbey), Marnay (fortified town) (3–12 miles/ 5–19 km).

• Moissey; Forêt de la Serre, forest; Dole (6–12 miles/9.5–19 km).

- Gray; Musée Baron Martin (16 miles/26 km).
- Grotte d'Osselle, cave (19 miles/31 km).

 Arc-et-Senans: Saline Royale, royal saltworks (28 miles/45 km).

Riquewihr The pearl of Alsatian vineyards

Haut-Rhin (68) • Population: 1,308 • Altitude: 728 ft. (222 m)

Producing wines that, for centuries, have matched the quality of its architecture, Riquewihr remains a center of Alsatian heritage and lifestyle.

Behind its ramparts, today besieged only by the vines, the village was for a long time linked to the duchy of Wurtemberg. Now it is associated with excellence: that of the architecture of its houses, with their splendid inner courtyards, and of its powerfully aromatic wines, produced on the Sporen and Schoenenbourg hillsides. Walking along the narrow streets, one never tires of admiring the large houses, which—from the richer bourgeois residences of the 16th century to more modest dwellings—are masterpieces of colorful half-timbered façades, carved wooden window-frames, flowerdecked balconies, decorated windowpanes, and "beaver-tail"-tiled roofs, which often hide magnificent painted ceilings. Some of the old store signages are the work of Jean-Jacques Waltz (1873-1951), known as "Hansi," an Alsatian illustrator and caricaturist to whom the village has dedicated a museum. From the Dolder, the tall halftimbered bell tower, there is a stunning view over the village and neighboring vineyards.

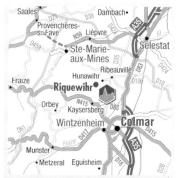

By road: Expressway A35-N83, exit-Riquewihr (5 miles/8 km); N415, exit-Colmar (19 miles/31 km). By train: Colmar station (9 ½ miles/15,5 km); Strasbourg TGV station (43 miles/69 km). By air: Strasbourg-Inter airport (40 miles/64 km); Bâle-Mulhouse airport (45 miles/72 km).

(i) Tourist information— Pays de Ribeauvillé et Riquewihr: +33 (0)3 89 73 23 23 www.ribeauville-riquewihr.com www.riquewihr.fr

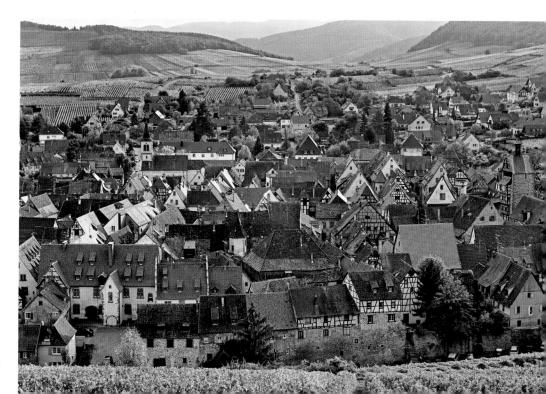

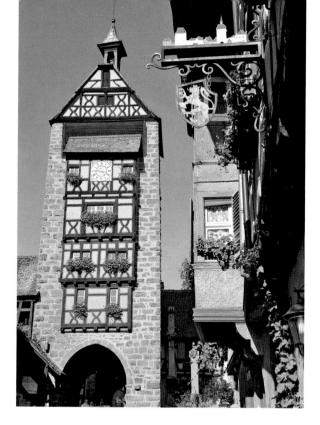

Highlights

Musée de l'Oncle Hansi: Watercolors, lithographs, etchings, decorative tableware, posters, video projections, play area, and store: +33 (0)3 89 47 97 00.
Musée du Dolder (local history): The history of Riquewihr from the 12th to the 12th centuries: +33 (0)3 89 73 23 23.
Musée de la Communication en Alsace, in the Château des Wurtemberg-Montbéliard: 2,000 years of history of the postal and telecommunications service recounted via a collection of stagecoaches and mail coaches unique in France: +33 (0)3 89 47 93 80.

• Tour des Voleurs et Maison de Vigneron: A former Riquewihr prison and its instruments of torture; the interior of a winegrower's house from the 16th century: +33 (o)3 89 73 23 23.

• Grands crus wine trail: Self-guided visits all year round; guided tour led by a winemaker followed by a visit to the wine cellar, with tastings in summer: +33 (0)3 89 73 23 23. Village: Guided tour led by tourist information center guides: +33 (0)3 89 73 23 23); tour of the village and vineyard by tourist train: +33 (0)3 89 73 74 24.
Signposted nature trail in Riquewihr Forest: +33 (0)3 89 73 23 23.

Accommodation

À l'Oriel***: +33 (0)3 89 49 03 13. Le Riquewihr***: +33 (0)3 89 86 03 00. Le Schoenenbourg***: +33 (0)3 89 49 01 11. La Couronne**: +33 (0)3 89 49 03 03. Saint-Nicolas**: +33 (0)3 89 46 01 51. Le Sarment d'Or**: +33 (0)3 89 86 02 86. Guesthouses

Bernard Bronner**: +33 (o)3 89 47 83 50. Jean-Luc Brendel: +33 (o)3 89 47 89 54 54. Christophe Kiefer: +33 (o)3 89 47 89 81. Brigitte Melich-Greiner: +33 (o)3 89 47 83 16. Martine Rentz: +33 (o)3 89 49 03 97. Mireille Schwach: +33 (o)3 89 47 92 34. **Gîtes and vacation rentals** Further information: +33 (o)3 89 73 23 23 www.ribeauville-riguewihr.com

Campsites

Camping de Riquewihr: +33 (0)3 89 47 90 08.

I Eating Out

À la Couronne: +33 (0)3 89 49 02 12. Asian Tapas, sushi bar: +33 (0)3 89 47 96 47. Au Dolder: +33 (0)3 89 47 92 56. Au Tire-bouchon: +33 (0)3 89 47 95 161. Au Trotthus: +33 (0)3 89 47 96 47. L'Écurie: +33 (0)3 89 47 92 48. La Grappe d'Or: +33 (0)3 89 47 89 52. Le Grognard, brasserie: +33 (0)3 89 22 32 75. Le Manala, *winstub* (traditional Alsatian brasserie): +33 (0)3 89 49 01 51. Relais des Moines: +33 (0)3 89 86 04 74. Le Sarment d'Or: +33 (0)3 89 86 02 86.

*** Local Specialties** Food and Drink

AOC Alsace and *grands crus* Schoenenbourg and Sporen wines • Beer and distilled spirits • Alsatian cookies • Honey. Art and Crafts Handicrafts • Gifts • Art galleries.

★ Events

Market: Friday morning, Place Fernand Zeyer. June: International male choir festival. December: Christmas market and activities, daily 10 a.m.-7 p.m.

W Outdoor Activities

Fishing • Walking: Route GR 5 and marked trails (including the Saint James's Way and the *Grands crus* wine trail) • Mountain-biking.

🖗 Further Afield

• Alsace wine route: *Hunawihr (2 miles/ 3 km), see pp. 66–67. Ribeauvillé (4 ½ miles/ 7 km), *Eguisheim (10 miles/16 km), see pp. 62–63.

- Kaysersberg (6 miles/9.5 km).
- Colmar (7 ½ miles/12 km).
- Haut-Koenigsbourg (16 miles/26 km).
- *Mittelbergheim (24 miles/39 km),
- see pp. 71–72.

• Écomusée de Haute-Alsace, local heritage museum (28 miles/45 km).

I Did you know?

When, in the 18th century, one of the lords of Riquewihr found himself saddled with debt, he borrowed 500 livres from the writer Voltaire by mortgaging the vineyards of his estate. The sum was eventually repaid, so Voltaire never became owner of Riquewihr.

Rodemack The little Carcassonne of Lorraine

Moselle (57) • Population: 1,110 • Altitude: 722 ft. (220 m)

Rodemack, near Luxembourg, owes its nickname—"the little Carcassonne of Lorraine"—to its impressive medieval heritage.

In 907, Rodemack was exchanged by the monks of Fulda, passing into the hands of the abbots of Saint-Willibrord and thus influenced by Germano-Luxemburgian culture. A fief of the house of Luxembourg, Rodemack lived in relative peace and experienced five centuries of prosperity. The fortress, built in the 12th century, then gave way to a castle, which was later extended and rebuilt. The village grew up around the church, built in the 10th century, and the ramparts were erected in the 13th and 15th centuries. Fought over by France and Germany, Rodemack was attacked, occupied, and retaken many times. In 1815, during Napoléon's Hundred Days, it was defended by General Hugo, father of the poet Victor Hugo. Walk along the Ruelle de la Forge, Rue du Four, and the Place de Gargants to discover its defensive walls and towers: the Boucour, Barbacane, and twin towers. The village itself is surrounded by a second wall with demi-lune (half-moon) towers and gateways flanked by round towers. The 14th-century Sierck Gate was built by the villagers themselves. Inside the city wall, narrow streets lead to the old post office, the lavoir (washhouse), and the former Officers' Pavilion.

Highlights

• Village: Guided tour for groups all year round, booking essential. Further information: +33 (0)3 82 56 00 02.

• Citadelle de Rodemack: Park opening mid-June 2016.

• Jardin Médiéval (medieval garden): All year round.

Accommodation

Mme Bertrand: +33 (0)6 29 33 31 09. Gîte Morisseau: +33 (0)3 54 54 15 89. Mme Herfeld: +33 (0)3 82 50 01 49. M. and Mme Kremer: +33 (0)3 82 51 23 07. Mme Schuster: +33 (0)6 23 40 18 98. M. Werner: +33 (0)3 82 51 24 07. Communal gîtes +33 (0)3 82 83 05 50.

I Eating Out

La Grange à Georges (Café Terroir de Moselle), concerts (Wednesday and Friday evenings and weekends: +33 (0)3 83 50 35 24. La Petite Carcassonne: +33 (0)3 82 82 08 78.

Local Specialties

Art and Crafts Designers • Artists • Photographers • Jewelry • Ceramics • Leatherwork.

★ Events

April: Most Beautiful Villages of France wine festival (mid-April). May: Flower market (1st weekend). June: Rodemack Solex (bike) Tour (mid-June); "Rodemack, Cité Médiévale en Fête," festival (late June). July and August: Summer activities. August: Fête de la Grillade barbecue

(mid-August). September: Antiques and collectors' fair.

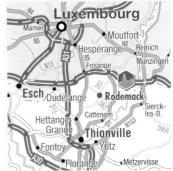

By road: Expressway A13, exit 10–Frisange (3 ½ miles/5.5 km); expressway A31, exit 38–Thionville centre (11 miles/18 km). By train: Thionville TGV station (10 miles/ 16 km). By air: Luxembourg-Findel airport (20 miles/32 km); Metz-Nancy Lorraine airport (43 miles/69 km).

 Tourist information—Communauté de Communes de Cattenom et Environs: +33 (0)3 82 56 00 02 / www.tourisme-ccce.fr www.mairie-rodemack.fr

W Outdoor Activities

Walking • Mountain-biking.

🕊 Further Afield

- Mondorf-les-Bains (3 ½ miles/5.5 km).
- Sierck-les-Bains; Manderen: Château de
- Malbrouk (7 ½-12 miles/12-19 km).
- Schengen: Musée de l'Europe (10 miles/16 km)
- Thionville (10 miles/16 km).
- Luxembourg (16 miles/26 km).
- Veckring: Ouvrage Hackenberg, Maginot Line fortification (19 miles/31 km).
- Neufchef: Ecomusée des mines de fer de Lorraine, local iron mining museum (22 miles/35 km).
- Metz: (31 miles/50 km)

Saint-Quirin A place of pilgrimage

Moselle (57) • Population: 821 • Altitude: 1,050 ft. (320 m)

At the foot of an amphitheater of hills, the village is surrounded by the vast and game-filled Vosges forest, where beech and oak grow alongside spruce and larch.

Higher up, the archeological site of La Croix-Guillaume contains important Gallo-Roman remains of the 1st, 2nd, and 3rd centuries, which bear witness to the ancient culture of the peaks. Saint-Quirin is named after Quirinus, the military tribune of Rome who was martyred in 132 CE under the Emperor Hadrian, and whose relics lie in the priory church. Many buildings testify to the village's glorious past: the priory and the Baroque priory church (1722), with its Jean-André Silbermann organ (1746), which is a listed historic monument: the Église des Verriers, a beautiful Rococo-style edifice built in 1756 at Lettenbach: and the Romanesque-style high chapel dating from the 1180s. Below the church, the water from the miraculous spring is said to have healed skin diseases through the intercession of Saint Quirin. The village thus became a place of pilgrimage and of devotion to its healing saint.

By road: Expressway A4, exit 44–Lunéville (20 miles/32 km), then N4 (16 miles/ 26 km). By train: Sarrebourg station (11 miles/18 km). By air: Strasbourg airport (65 miles/105 km); Metz-Nancy Lorraine airport (78 miles/126 km).

(i) Tourist information: +33 (0)3 87 08 08 56 www.saintquirin.fr

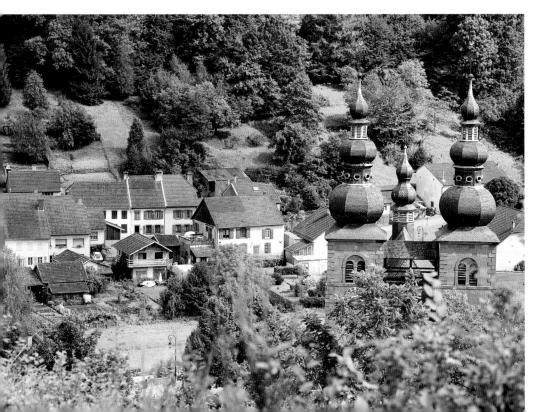

Highlights

• Priory church (18th century): Silbermann organ, relics of Saint Quirin, large crystal chandelier. • High chapel (12th century): Stained-glass

windows by V. Honer de Nancy.

Chapelle Notre-Dame-de-l'Hor at Métairies-Saint-Quirin (15th and 18th centuries): Statue of the Immaculate Conception, paintings.

· Gallo-Roman archeological site of La Croix-Guillaume:

+33 (0)3 87 08 08 56.

Accommodation Hotels

Le Prieuré**: +33 (0)3 87 08 65 20.

Guesthouses

Le Temps des Cerises: +33 (0)6 78 15 76 02. Gîtes

Further information: +33 (0)3 87 08 08 56/ www.saintguirin.fr

Campsites

Camping municipal**. Further information: +33 (0)3 87 08 60 34.

T Eating Out

Auberge de la Forêt: +33 (0)3 87 03 71 78. Hostellerie du Prieuré: +33 (0)3 87 08 66 52.

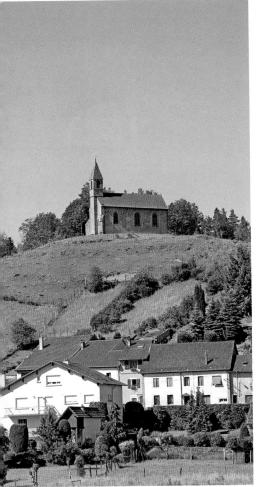

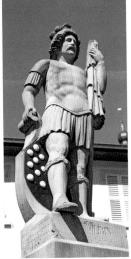

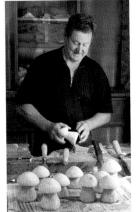

Local Specialties

Food and Drink Honey • Salted meats and fish. Art and Crafts

Painting and sculpture workshop • Furniture and paintings gallery • Artist • Sculpture in stone and wood • Glassblower.

* Events

March: "La Ronde des Chevandiers" car rally.

Pentecost: Festival International de Randonnée (international hiking festival). May: Saint-Quirin-Marmoutier evening market (2nd Saturday).

Ascension: Procession and fair. June: Organ recitals.

August: "Barakozart" music festival. September: Plant sale (4th Sunday). November: Mass of Saint Hubert. December: Christmas market, giant Advent calender (1st weekend).

W Outdoor Activities

Fishing • Walking: Route GR 5 and 5 "Moselle Pleine Nature" marked trails.

🕊 Further Afield

- Abreschviller (3 miles/5 km).
- Sarrebourg (11 miles/18 km).
- Rhodes; Parc Animalier de Sainte-Croix:
- wildlife park (12 miles/19 km).
- Massif du Donon, mountain; Col du Donon (14 miles/23 km).
- Saint-Louis-Arzviller, inclined plane (16 miles/26 km).
- Phalsbourg (19 miles/31 km).
- Baccarat (25 miles/40 km).
- Saverne (25 miles/40 km).
- Lunéville (31 miles/50 km).

Did you know?

In 1049, Geppa, sister of Alsace-born Pope Leo IX, returned the relics of the tribune Quirinus, who had been tortured in 132 CE under Emperor Hadrian, to Rome. The convoy passed the night on a hill overlooking the village of Godelsadis. The following day, it proved impossible to move the reliquary containing the precious relics. Godelsadis thus became Saint-Quirin, and a chapel was built on the hill to house Quirinus's remains.

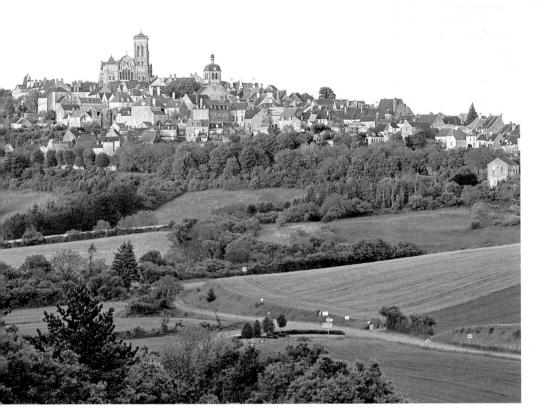

Vézelay The hill where the spirit soars

Yonne (89) • Population: 450 • Altitude: 991 ft. (302 m)

Gazing at the Monts du Morvan, Vézelay sits on a steep hill surmounted by the basilica of Sainte-Madeleine.

Built in the 12th century in honor of Mary Magdalen, whose relics are believed to lie there, the abbey was both a pilgrimage destination and a departure point for Compostela before the arrival in 1146 of the abbot and reformer Bernard de Clairvaux made it an important Christian center. Beautiful Romanesque and Renaissance residences survive from this thriving era, rubbing shoulders with charming winegrowers' houses in a symphony of stone façades and rooftops, all covered with the flat, brown tiles typical of Burgundy. The basilica was restored in the 19th century by the architect Viollet-le-Duc, and both it and Vézelay hill were listed as UNESCO World Heritage Sites in 1979. The basilica is renowned for its Romanesque art and continues to attract visitors from all over the globe.

By road: Expressway A6, exit 22–Avallon (14 miles/23 km); expressway A6, exit 21– Nitry (18 miles/29 km). By train: Sermizelles station (6 miles/9,5 km). By air: Dijon-Bourgogne airport (81 miles/130 km).

() Tourist information: +33 (0)3 86 33 23 69 www.vezelaytourisme.com

Highlights

• Basilique Sainte-Madeleine (12th– 19th centuries): Carved tympana, Romanesque-style arches, Gothic choir, relics of Mary Magdalen. Guided visits for individuals or groups by the Fraternités de Jérusalem: +33 (0)3 86 33 39 50. • Maison du Visiteur: Multimedia exhibition on the world of the 12thcentury builder, as preparation for a visit to the basilica and to help interpret it. Slide-show, guided view of models, architecture, light show at solstices; reproductions of carved capitals to help decode the symbols: +33 (0)3 86 32 35 65.

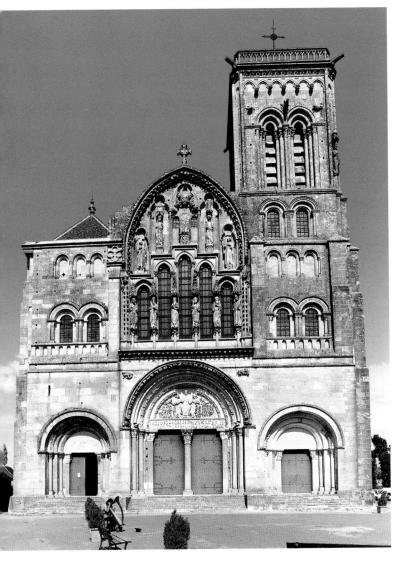

Musée de l'Œuvre-Viollet-le-Duc:

Romanesque capitals and fragments deposited by Viollet-le-Duc during his restoration work at the basilica: +33 (0)3 86 33 24 62.

• Maison Jules-Roy (house and gardens): House of the writer, reconstructed study; literary exhibitions and receptions: +33 (0)3 86 33 35 01.

• Musée Zervos (modern art 1925–65), in Maison Romain-Rolland: Collection bequeathed to the village by art critic and publisher Christian Zervos. Founder of *Cahiers d'art*, a journal published 1926–60, which courted the major artists of the time: Picasso, Chagall, Laurens, Léger, Calder, Kandinsky, Giacometti, Hélion, Miró, Poliakoff: Works by them are exhibited in the museum. Temporary exhibition each year: +33 (0)3 86 32 39 26.

• Village: Guided tour for individuals in summer: +33 (0)3 86 33 23 69; for groups all year round by appointment with Guides de Pays des Collines: +33 (0)3 86 33 23 69, or Guides de l'Yonne: +33 (0)3 86 41 50 30.

• Village and basilica: Guided tour (art, history, symbolism, tradition) by Lorant Hecquet, professional tour guide, by appointment: +33 (0)3 86 33 30 o6; or with Guides de l'Yonne: +33 (0)3 86 41 50 30.

Accommodation

La Poste et Lion d'Or***: +33 (0)3 86 33 21 23. Le Compostelle**: +33 (0)3 86 33 28 63. Le Cheval Blanc: +33 (0)3 86 33 22 12. Le Relais du Morvan: +33 (0)3 86 33 25 33. SY La Terrasse: +33 (0)3 86 33 25 50.

Guesthouses

Au Poirier de la Perdrix***: +33 (0)3 86 33 20 17. À l'Atelier**: +33 (0)3 86 32 38 59. Cabalus: +33 (0)3 86 33 20 66. Le Pontot: +33 (0)3 86 32 42 01.

Gîtes and vacation rentals

Further information: +33 (0)3 86 33 23 69/ vezelaytourisme.com

Group accommodation

Auberge de Jeunesse: +33 (0)3 86 33 24 18. Centre Sainte-Madeleine, Maisons Saint-Bernard et Béthanie: +33 (0)3 86 33 22 14. Campsites

L'Ermitage*: +33 (0)3 86 33 24 18.

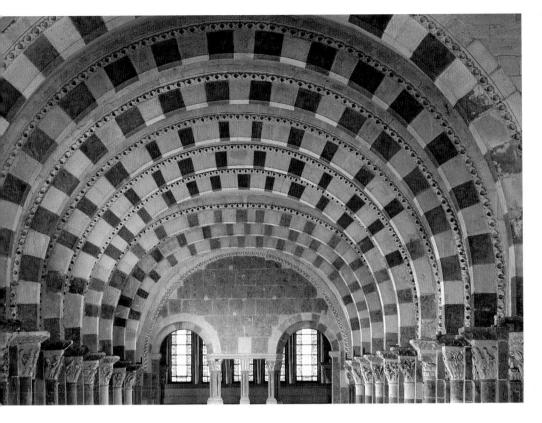

T Eating Out

Auberge de la Coquille: +33 (0)3 86 33 35 57. Le Bougainville: +33 (0)3 86 33 27 57. Le Cheval Blanc: +33 (0)3 86 33 22 12. La Dent Creuse: +33 (0)3 86 33 36 33. La Poste et le Lion d'Or: +33 (0)3 86 33 21 23. Le Relais du Morvan: +33 (0)3 86 33 25 33. SY La Terrasse: +33 (0)3 86 33 25 50. Vézelay, tea room: +33 (0)3 86 33 23 01. Le Vézelien, brasserie: +33 (0)3 86 33 25 09.

Local Specialties Food and Drink

Honey • Heritage bread • AOC de Bourgogne Vézelay wine · Chablis wine. Art and Crafts

Antiques • Illuminator • Earthenware potter • Icons • Books • Metal, stone, and fabric crafts • Painter-sculptors, galleries • Monastic crafts • Sculptor • Weaver.

* Events

Market: Wednesday mornings, May-October. April-October: Art exhibition (Salle Gothique). Mav-October: Concerts in the basilica. July: Pilgrimage Sainte-Madeleine (22nd). Late July-early August: Multimedia show (4 evenings). August: Festival d'Art Vocal (2nd fortnight). September: Organic produce market. November: Truffle market. December: Christmas celebrations. All year round: discussion groups, pilgrimages, and workshops.

W Outdoor Activities

Canoeing, rafting • Horse-riding • Fishing • Walking: Routes GR 13 and 654, Chemin de Compostelle (Saint James's Way), 4 circular trails • Mountain-biking: 5 circular trails.

W Further Afield

Église d'Asquins (1 mile/2 km).

· Fontaines-Salées: archeological site; Saint-Pèresous-Vézelay: museum-church (1 mile/2 km).

Chamoux: Cardo Land, fantasy

- prehistoric park (4 1/2 miles/7 km).
- Château de Bazoches-du-Morvan (6 miles/9.5 km).
- Avallon (9 1/2 miles/15.5 km).
- Château de Chastellux (11 miles/18 km).
- Grottes d'Arcy-sur-Cure, caves (12 miles/19 km).
 - *Novers (25 miles/40 km), see p. 73.

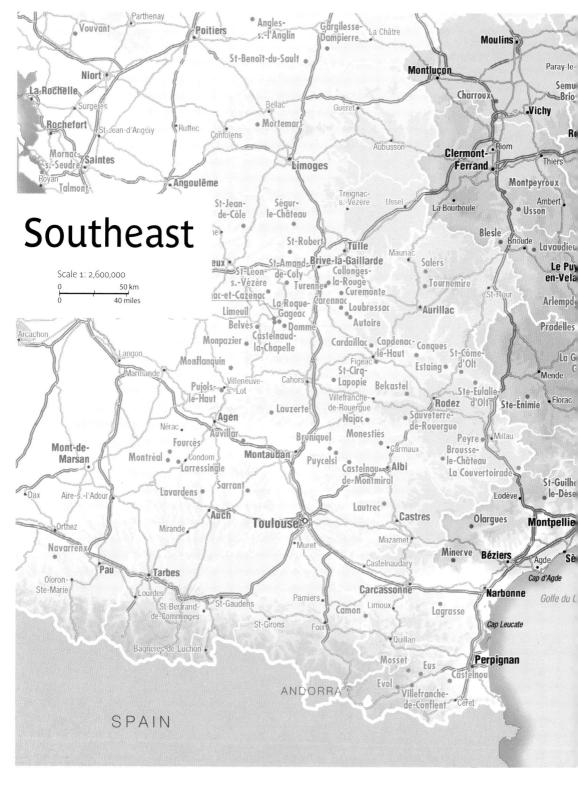

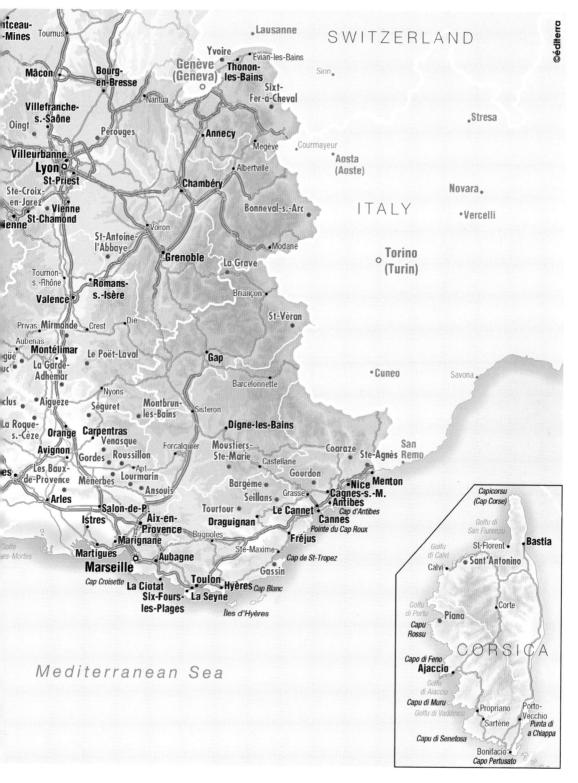

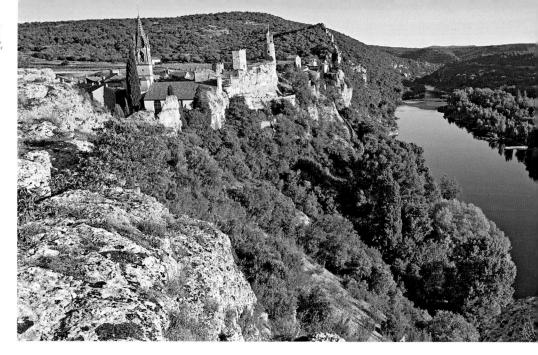

Aiguèze A phoenix from the ashes

Gard (30) • Population: 220 • Altitude: 292 ft. (89 m)

A fortress perched on a cliff overlooking the Gorges of the Ardèche, Aiguèze protects its medieval heritage, cultivates vines, and ensures its inhabitants are always friendly and welcoming.

Like any strategic defense site, Aiguèze has had a turbulent past. From 725 to 737 CE, the region was occupied by the Saracens, who gave their name to one of the village's towers. The fortification of the site dates back to the 11th century: it was the work of the count of Toulouse, who wanted to make Aiguèze the outpost for his operations against the region of Vivarais. In 1360, uprisings caused Aiguèze its last great period of turmoil: local peasants, oppressed by hefty taxes, became restless, and the village endured more destruction and looting. Often attacked but always liberated afterwards, Aiguèze survived, and managed to preserve traces of its history. The village owes much of its present-day appeal to Frédéric Fuzet, archbishop of Rouen and a local man, who, in the early 20th century, devoted his time and means to its conservation and modernization, notably the main square shaded by plane trees and the 11th-century church. In the narrow cobbled and vaulted streets arch-covered balconies, mullioned windows, and arched doorways are on display. They lead to the *castelas*, the old ramparts of the castle, from where there is a splendid view of the Ardèche, garrique (scrubland), and Côtes du Rhône vinevards.

By road: Expressway A7, exit 19– Bollène (14 miles/22 km), N86 (8 ½ miles/ 13.5 km). By train: Montélimar TGV station (27 miles/43 km). By air: Avignon-Caumont airport (42 miles/ 68 km).

(i) Tourist information—Gard Rhodanien: +33 (0)4 66 39 16 89 or +33 (0)4 66 82 30 02 www.tourisme-gard-rhodanien.com

Highlights

• Church (11th century): Open daily. • Village: Guided tours in summer, and by appointment off-season: +33 (0)04 66 39 26 89.

Accommodation

Le Castelas^{**}: +33 (0)4 66 82 18 76. Le Rustic Hôlet^{*}: +33 (0)4 66 82 11 26.

Guesthouses

Les Jardins du Barry***: +33 (0)4 66 82 15 75. Les Mazets d'Aiguèze: +33 (0)4 66 82 34 28. **Gîtes, vacation rentals, and campsites** Further information: +33 (0)4 66 82 14 77 or +33 (0)4 66 39 26 89.

T Eating Out

Le Belvédère, pizzeria: +33 (0)4 66 50 66 69. Bistrot La Charriotte: +33 (0)4 66 82 11 26. Le Bouchon, café and wine bar: +33 (0)4 66 39 47 70. Café Chabot, steak house: +33 (0)4 66 33 80 51. Le Chaudron: +33 (0)4 66 59 43 48. Chez David: +33 (0)4 66 50 39 91.

Local Specialties Food and Drink

AOC Côtes du Rhône wines • Honey • Goat cheese (*þélardons*). Art and Crafts Art gallery • Pottery • Craft studios.

★ Events

Market: Thursday mornings, mid-June to mid-September. April: Flower market (2nd weekend). Pentecost: Flea market (weekend). Mid-July and mid-August: Welcome days for vacationers, activities. December: Christmas market (2nd Sunday).

W Outdoor Activities

Swimming in the Ardèche river • Canoeing and boating trips down the Ardèche river • Walking: Trail from Castelvieil *oppidum* (main settlement), walk through the vineyards.

🕊 Further Afield

• Chartreuse de Valbonne, monastery (4 ½ miles/7 km).

• Gorges of the Ardèche; Vallon-Pont-d'Arc; Grotte Chauvet, cave; Aven d'Orgnac, sinkhole; Grotte de la Madeleine, cave; Grotte de Saint-Marcel-d'Ardèche, cave; Aven-Grotte de la Forestière, cave (4 ½– 22 miles/7–35 km).

- Pont-Saint-Esprit (6 miles/9.5 km).
- *Montclus (9 miles/14.5 km), see p. 117.
- *La Roque-sur-Cèze (11 miles/18 km), see pp. 126–27.
- Cornillon; Goudargues (12 miles/19 km).
- Castles at Suze-la-Rousse (17 miles/27 km) and Grignan (27 miles/43 km).
- Orange: Roman theater (21 miles/34 km).

Aiguèze Gard

I Did you know?

The Aiguézois (as the villagers are known), who enjoy a joke, have concealed a few hoaxes around the village's narrow streets. Was it really Honoré Agrefoul who invented absinthe? Is Andris Nali really a professor of "expansiologie"? Find out for yourself during your tour of the village.

Ansouis A fan-shaped refuge in southeast France

Vaucluse (84) • Population: 1,140 • Altitude: 968 ft. (295 m)

Standing at the heart of the Pays d'Aigues, with the Grand Luberon mountain range and the Durance river on the horizon, the hilltop village of Ansouis is crowned by an old château.

Spread out in a fan shape, open to the sun, the village is crisscrossed by a maze of streets and alleys that remain shady and cool. From the Place Saint-Elzéar, the Rue du Petit-Portail climbs up to a peaceful little square: bordered by the 12th-century perimeter wall, which serves as the façade of the Église Saint-Martin, and by the elegant 13th-century presbytery, it offers a vast panorama of a landscape of vines overlooked by the Grand Luberon. At the top of the village, the castle, owned for generations by the Sabran family, condenses a thousand years of castle architecture. The austerity of the medieval fortress on the north side contrasts with the classical southern façade of the 17th-century residence, which overlooks the terraced gardens with their box topiary.

Le Coustellet	
Pohion	La Bégude
Ménerbes •Bonnieux	
Se Se Lourmarin	<
0913 Lauris	Ansouis /
Mallemort Cadenet	056
D561 •La Roque- D9	Pertuis
Salon- Lambesc d'Anthéron	100
de-P. Dis Rognes D. Pélissanne St-Cannat	67.
- D570	D96
011	
La Fare- les-Oliviers Aix-en-Pro	vence
•Velaux	

By road: Expressway A7, exit 26–Sénas (22 miles/35 km); expressway A51, exit 15–Pertuis (7 ½ miles/12 km). By train: Aix-en-Provence TGV station (30 miles/ 48 km). By air: Marseille-Provence airport (37 miles/60 km).

() Tourist information: +33 (0)4 90 09 86 98 www.luberoncotesud.com

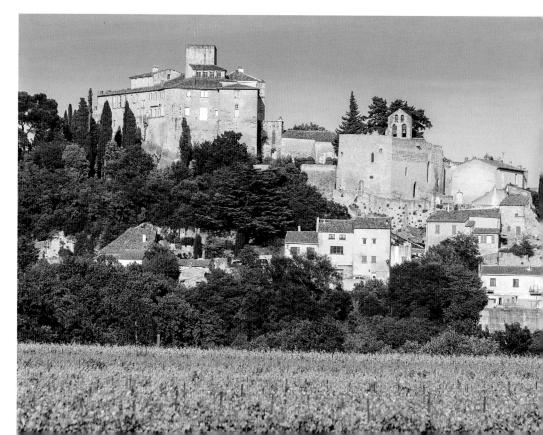

Highlights

• Castle: Erected in the 12th and 13th centuries and rebuilt in the 17th century, this imposing fortress has been completely restored and is open to the public from April to October: +33 (0)4 90 77 23 36. • Église Saint-Martin: Fortified 12thcentury building and formerly the castle's law court; 18th-century statues and

altarpieces. • Musée Extraordinaire: This Provençal building presents artistic creations as well as a collection of fossils, shells, and furniture belonging to its owner, a painter and diver: +33 (0)4 90 09 82 64.

• Musée des Arts et des Métiers du Vin: More than three thousand objects used by the winemakers and grape-pickers of the Château Turcan: +33 (0)4 90 09 83 33.

Accommodation Guesthouses

Le Jardin d'Antan***: +33 (0)4 90 09 89 41. Le Jardin d'Antan***: +33 (0)4 90 09 89 41. Le Mas du Grand Luberon***: +33 (0)4 90 09 97 92. Un Patio en Luberon***: +33 (0)4 90 09 94 25. La Maison de Clémentine**: +33 (0)4 90 09 97 68. L'Atrium: +33 (0)6 62 70 17 27. Le Mas de la Farigoule: +33 (0)6 51 04 07 45. Le Mas de la Huppe: +33 (0)4 90 09 08 41.

Gîtes and vacation rentals

Further information: +33 (0)4 90 09 86 98/ www.luberoncotesud.com

T Eating Out

Bar des Sports: +33 (0)4 90 08 44 33. La Closerie: +33 (0)4 90 09 90 54. Les Moissines, restaurant and tea room: +33 (0)4 90 09 85 90. Pâtisserie d'Antan, tea room: +33 (0)6 28 41 45 73. Le Puy des Arts, wine and tapas bar: +33 (0)4 90 09 81 76.

Local Specialties Food and Drink

Homemade ice cream • AOC Côtes du Luberon wines. Art and Crafts

Santon (crib figure) maker • Bronze sculptures and jewelry • Artist.

★ Events

Market: Sunday morning, Place de la Vieille-Fontaine. May: Les Botanilles, festival and flower market (last two weeks). June: Ansouis en Musique (music festival). July and August: Various activities. September: Fête de la Saint-Elzéar (mid-month).

W Outdoor Activities

Walking: 3 marked trails.

I Did you know?

Elzéar, count of Sabran, was born in 1285 at the Château d'Ansouis and was married very young to Delphine de Signe. The two took a vow of chastity and lived a life of prayer, penance, and devotion to the poor. Elzéar was canonized by Pope Urban V and the cult of Delphine was approved by Pope Innocent VII. This popular cult has survived the centuries and, every year in September, the villagers of Ansouis gather in the village church for a Mass in honor of their saints.

🕊 Further Afield

- La Tour-d'Aigues (5 miles/8 km).
 Villages on the Durance river: Cadenet.
- Pertuis, Mirabeau (6–12 miles/9.5–19 km).
- *Lourmarin (7 miles/11.5 km), see pp. 111-12.
- Aix-en-Provence (19 miles/31 km).
- *Ménerbes (21 miles/34 km), see pp. 113–14.
- *Roussillon (21 miles/34 km), see pp. 128–29.
- *Gordes (24 miles/39 km), see pp. 104–5

Arlempdes The first château of the Loire

Haute-Loire (43) • Population: 131 • Altitude: 2,756 ft. (840 m)

Arlempdes (pronounced "ar-lond") sits at the top of a volcanic peak in the Velay, close to the source of the Loire river. The remains of the castle built by the Montlaur family in the 12th-14th centuries are at the top of a basalt dike, into which the Loire has cut deep, wild gorges. Crenellated ramparts and curtain walls enclose the ancient courtvard, dominated by the round tower of the keep and the Chapelle Saint-Jacques-le-Majeur. probably built in the 11th-12th centuries on the site of a Celtic sanctuary, standing some 330 ft. (100 m) above the river. At the foot of this imposing castle, behind a 13th-century gateway, the village spreads out around a peaceful square. This serves as the forecourt of the Romanesque Église Saint-Pierre, noteworthy for its polylobed door and its four-arched bell gable. From this square, a path leads to the castle, whose entrance is via a Renaissance porch. On the plateau through which the Loire has carved its course, agricultural production has been given a new lease of life by the Puy green lentil, which, benefiting from the area's volcanic soil and microclimate, was the first dried legume to be awarded an AOC, in 1996, and it obtained an AOP in 2008.

Highlights

• Castle: Remains; visits possible: +33 (o)4 71 00 82 65 or +33 (o)4 71 57 17 14); guided tours every afternoon in July and August.

- Écomusée de la Ruralité (museum of rural life): Tools and ways of life of a bygone age.
- Église Saint-Pierre.

Accommodation

Hotels Le Manoir: +33 (0)4 71 57 17 14. Guesthouses La Freycenette***: +33 (0)4 71 49 43 43.

Gîtes and vacation rentals Le Clos des Fontaines***:

Les fous des 1 des des

I Eating Out

• Le Manoir: +33 (0)4 71 57 17 14.

Local Specialties

Food and Drink Cheeses • AOP Puy green lentils.

★ Events

July: Open-air rummage sale (around the 15th). August: Fête du Pain, bread festival (1st fortnight). November: Hot-air balloon flights (1st fortnight).

W Outdoor Activities

Swimming (no lifeguard) • Fishing • Walking: Route GR 340 and several marked trails • Mountain-biking.

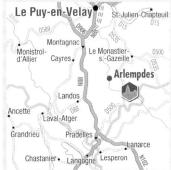

By road: Expressway A75, exit 20–Le Puyen-Velay (56 miles/90 km), N102-N88 (5 ½ miles/9 km). By train: Puy-en-Velay station (17 miles/28 km). By air: Clermont-Ferrand-Auvergne airport (91 miles/146 km).

(1) Tourist information—

Pays de Pradelles: +33 (0)4 71 00 82 65 www.gorges-allier.com

🕊 Further Afield

- *Pradelles (11 miles/18 km), see p. 125.
- Lac du Bouchet, lake (11 miles/18 km).
- Le Monastier-sur-Gazeille (14 miles/ 23 km).
- Lac d'Issarlès, lake (16 miles/26 km).
- Le Puy-en-Velay (17 miles/27 km).
- Mont Gerbier-de-Jonc (28 miles/45 km).

I Did you know?

The marquis d'Arlandes, whose family was from Arlempdes, made the first manned hot-air-balloon flight on November 21, 1783, accompanied by the science teacher and aviation pioneer Jean-François Pilâtre de Rozier.

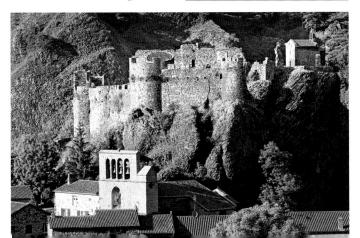

Balazuc The sentry of the Ardèche

Ardèche (07) • Population: 352 • Altitude: 600 ft. (183 m)

Facing the sunset, Balazuc clings to a steep limestone cliff overlooking the Ardèche river. From the early Middle Ages until the Wars of Religion, the lords of Balazuc—simple knights, crusaders, and troubadours—made this village into an important stronghold. Its historic stature is evident in the 13th-century castle, rebuilt in the 17th and 18th centuries (now privately owned); the 13th-century square tower, whose façade still retains an iron rod on which the public scale for weighing silkworm cocoons used to hang; the fortified Romanesque church, crowned with a Provençal bell gable; and its gates, the Portail d'Été and the Porte de la Sablière. Balazuc has also kept its distinctive layout from the medieval period: a veritable maze of narrow, winding streets, vaulted passageways, and steps carved into the rock. Outside the village, the Chemin Royal leads slowly toward the Ardèche river and, beyond the bridge, to the reemerging hamlet of Le Viel Audon.

Highlights

• Romanesque church (11th century): Restored in 2007 and decorated with stained-glass windows by Jacques Yankel, it has two adjoining naves, one barrelvaulted with four transverse ribs, the other with a cul-de-four-vaulted chancel. Exhibitions March-September. Further information: +33 (0)4 75 37 75 60 or +33 (0)4 75 37 75 08.

• Le Viel Audon: This hamlet, restored in the 1970s, includes an environment and sustainable development training center. • Village: Guided tour, Wednesday mornings in July and August. Further information: +33 (o)4 75 37 75 60 or +33 (o)4 75 37 75 08.

Accommodation Guesthouses

Château de Balazuc: +33 (o)4 75 88 23 27. La Cloche Qui Rit: +33 (o)6 07 48 94 71. Les Dolines: +33 (o)4 75 89 17 70. Gîtes, walkers' lodges, and vacation rentals

Further information: +33 (o)4 75 37 75 08 www.ot-pays-ruomsois.com

Campsites

La Falaise***: +33 (0)4 75 37 74 27. Beaume-Giraud**: +33 (0)4 75 89 09 36. Le Retourtier**: +33 (0)4 75 37 77 67. Barbine, farm campsite: +33 (0)4 75 37 70 16. La Croix du Bois, natural area: +33 (0)4 75 37 70 20.

Eating Out

Le Buron (summer only): +33 (0)4 75 37 70 21. Le Celtis (summer only): +33 (0)4 75 87 13 61 Chez Paulette: +33 (0)4 75 87 17 40. Le Cigalou (summer only): +33 (0)4 75 37 02 15. Le Fazao, snack bar (summer only): +33 (0)4 75 37 04 44. La Fenière, crêperie/pizzeria: +33 (0)4 75 37 01 08 or +33 (0)4 75 88 85 50 La Granja Delh Gourmandás (summer only): +33 (0)6 30 11 67 08 or +33 (0)6 98 22 05 77 Le Viel Audon, local dishes (summer only): +33 (0)4 75 37 73 80.

Local Specialties

Food and Drink Goat cheeses • Herbal produce (syrups, etc.) • AOC Côtes du Vivarais wines and Coteaux de l'Ardèche vins de pays. Art and Crafts Pottery • Jeweler • Sculptor.

Events

Market: Tuesdays, 6.30 p.m., Place de la Croisette (July and August). July: Village festival. July and August: Concerts and art exhibitions in the Romanesque church. August: Folk dance.

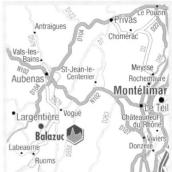

By road: Expressway A7, exit 17– Montélimar-Nord (32 miles/51 km), N102 (7 ½ miles/12 km). By train: Montélimar TGV station (25 miles/40 km). By air: Avignon-Caumont airport (80 miles/129 km).

(1) Tourist information—Pays

Ruomsois: +33 (0)4 75 93 91 90 or +33 (0)4 75 37 75 60 (in summer). www.ot-pays-ruomsois.com

Outdoor Activities

Swimming in the Ardèche river (no lifeguard) • Canoeing (rental) • Rock climbing • Fishing (Ardèche river) • Walking: marked trails • Mountain-biking.

Further Afield

- *Vogüé (4 ½ miles/7 km), see p. 153.
- Ruoms; Largentière (6 miles/9.5 km).
- Labeaume: village and gorges (9 ½ miles/ 15.5 km).
- Vallon-Pont-d'Arc; Caverne du Pont d'Arc,
- cave (11 miles/18 km).
- Aubenas (12 miles/19 km).
- Gorges of the Ardèche (12–35 miles/19–56 km).
- Aven d'Orgnac, sinkhole (24 miles/39 km).

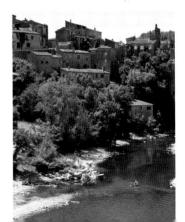

Bargème A mountain in Provence

Var (83) • Population: 140 • Altitude: 3,599 ft. (1,097 m)

Facing the Canjuers and Var mountains, Bargème is, at 3,599 ft. (1.097 m), the highest village in the Var-still Provencal, yet almost alpine. Sheltered by the ruins of the Château Sabran-de-Pontevès, the silhouette of the feudal village stands out on the steep slopes of the Brouis mountain. In 1393, the lordship of the village passed to Foulques d'Agoult de Pontevès, and it remained in the hands of the Ponteves family for the following two centuries. The region was by then suffering great religious upheaval; the people of Bargème avenged the neighboring village of Callas, which had been betrayed by Jean-Baptiste de Pontevès, by bringing the line of châtelains to an end. After murdering his grandfather, father, and uncles, inhabitants of Bargème slit Antoine de Pontevès's throat in the middle of Mass in 1595. The parliament of Aix-en-Provence issued a judgment requiring the inhabitants to build an expiatory chapel, Notre-Dames-des-Sept-Douleurs, which is located at the end of the esplanade leading to the castle. The village retains its defensive perimeter wall-the two fortified gates, the Levant and the Garde, were added in the 14th centuryas well as the white-stone Romanesque church. Under the patronage of Saint Nicholas, this 12th-century church has an apse that ends in a semidomed vault. It has three altarpieces, one of which, dedicated to Saint Sebastian, is a triptych carved in half relief.

Highlights

• Château Sabran-de-Pontevès (July and August): First mentioned in 1225, it was partially destroyed during the Wars of Religion but has retained its outer defensive elements: +33 (0)4 94 50 21 94. • Église Saint-Nicolas (July and August): This 12th-century Romanesque church was restored, along with its altarpieces, from 1990 to 2000.

• Village: Self-guided visit.

Accommodation

Vacation rentals Pierre Chassigneux***: +33 (0)6 72 95 39 21. Thiébaut Renger*: +33 (0)4 94 68 16 33 or +33 (0)6 50 77 66 26. Gîtes, teepees, wooden trailer La Ferme Saint-Pierre: +33 (0)4 94 84 21 55.

T Eating Out

Le Bart J'Aime, crêperie: +33 (0)6 66 54 75 69 or +33 (0)4 94 85 09 47. Les Jardins de Bargème: +33 (0)06 86 85 26 69.

Local Specialties

Food and Drink Cheeses • Beef and lamb • Vegetables Art and Crafts

Art gallery • Painter-sculptor • Sculptor.

★ Events

July and August: Été Musical (early music concerts), exhibition of santons (crib figures). August: Saint-Laurent festival

(2nd weekend).

W Outdoor Activities

Walking and riding: Route GR 49 and 2 marked trails • Hang gliding • Mountain-biking.

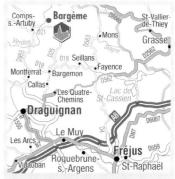

By road: Expressway A8, exit 36– Draguignan (33 miles/53 km); N85, exit Nice (50 miles/80 km). By train: Draguignan station (25 miles/40 km). By air: Nice-Côte-d'Azur airport (57 miles/92 km).

(i) Town hall: +33 (0)4 94 50 21 94 www.mairie-bargeme.fr

I Did you know?

Just over a mile (2 km) south of the village, on the roadside, stands a chapel dedicated to Saint Petronilla. Shepherds used to visit this chapel for their sheep to be blessed before they led them up to their summer pastures. Every year, on May 31, a Mass is still celebrated to bless bread and salt, which once formed the shepherds' main diet.

🕊 Further Afield

• Route Napoléon (6 miles/9.5 km) and views on the way to Castellane (18 miles/29 km) or Grasse (27 miles/43 km).

• La Bastide: summit of Montagne de Lachens (7 ½ miles/12 km).

- Le Grand Canyon du Verdon (16 miles/26 km).
- *Seillans (21 miles/34 km), see pp. 142–43.
- *Tourtour (29 miles/47 km), see pp. 148–49.

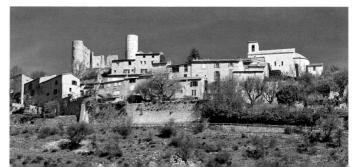

Les Bauxde-Provence Geological grandeur

deological granueur

Bouches-du-Rhône (13) • Population: 465 • Altitude: 715 ft. (218 m)

Perched on a rocky outcrop of the Alpilles hills in Provence, the village of Baux stands high above the Crau and the Camargue like a beacon.

Rock reigns supreme in the strange landscape of the Val d'Enfer. Outlined against the sky, the *baux* (from the Provencal word *baù*, meaning rocky escarpment) is a majestic outcrop 3,000 ft. (900 m) by 700 ft. (200 m) that dominates the Baux valley, in a landscape that opens into the Camargue and Mont Sainte-Victoire. Since the dawn of time, humans have sought refuge in this rocky mass; but the story of Baux really begins in the 10th century, when its lords built a fortress right at the top of this eagle's nest. They reigned here for five centuries, during which time they waged countless battles against the other lords of the region. The ruins of the medieval citadel still bear witness to the lords' power: they dominate both the Entreconque valley's olive groves and vineyards, and the La Fontaine valley, where the Mistral wind rushes into the gaping mouths of ancient quarries. The Renaissance, too, has left its mark on the center of the villagein the form of the Maison du Roy (the tourist information center). which bears the Calvinist inscription "Post Tenebras Lux" (Light After Darkness) on its window; and in many town houses, such as the Hôtel de Manville (the present town hall), Hôtel de Porcelet (Musée Yves Brayer), Hôtel Jean de Brion (Fondation Louis Jou), and even the former guardroom (Musée des Santons). Given a new lease of life by its hoteliers, restaurateurs, oil and wine producers, and artists, this beautiful village today recalls a lost way of life.

Highlights

• Carrières de Lumières: Multimedia show projected onto giant natural backdrops throughout the year: +33 (0)4 90 54 47 37. • Château des Baux: Medieval castle with keep, Sarrasine and Paravelle towers, lords' dovecote, castle chapel, Chapelle de Saint-Blaise (showing the movie "A bird's-eye view of Provence"), former Quiqueran hostel, exhibition of medieval siege engines, guided tours; treasure hunt (children age 7–12), medieval activities April–September; audioguide in 10 languages: +33 (0)4 90 54 55 56.

 Fondation Louis Jou: Exhibition of the works of Louis Jou (master typographer, engraver, printer, publisher) discovered in his workshop, and of his personal collection of incunabula, antiquarian books, engravings by Dürer and Goya, paintings, sculptures, and ceramics; by appointment only: +33 (0)4 90 54 34 17. • Musée Yves Brayer: Oil paintings, watercolors, sketches, engravings, and lithographs. Temporary exhibitions April– September: +33 (0)4 90 54 36 99.

• Musée des Santons: Varied collections of china figurines, including 17th-century Neapolitan figurines, 19th-century church figurines, works by local santon (crib figures) makers Carbonnel, Fouque, Jouve, Peyron Campagna, Toussaint, Thérèse Neveu, Louise Berger, Simone Jouglas; Christmas Nativity scenes: +33 (0)4 90 54 34 39.

 Village: Take the unique "history and architecture" walking trail for individuals, and for groups on request; visit the Trémaïe and take the perfumed trail; enjoy the natural and man-made heritage

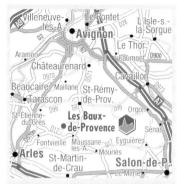

By road: Expressway A7, exit 24–Avignon Sud (18 miles/29 km); expressway A9-A54, exit 7–Arles (12 miles/19 km); expressway A54-N113, exit 7–Avignon (12 miles/19 km); By train: Arles station (11 miles/18 km); Avignon TGV station (22 miles/35 km). By air: Nîmes-Arles-Camargue (22 miles/ 35 km), Avignon-Caumont (25 miles/ 40 km), and Marseille-Provence (37 miles/ 60 km) airports.

(i) Tourist information: +33 (0)4 90 54 34 39 www.lesbauxdeprovence.com

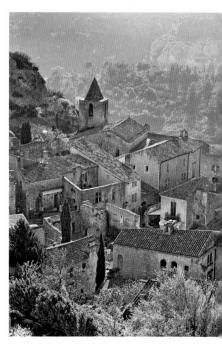

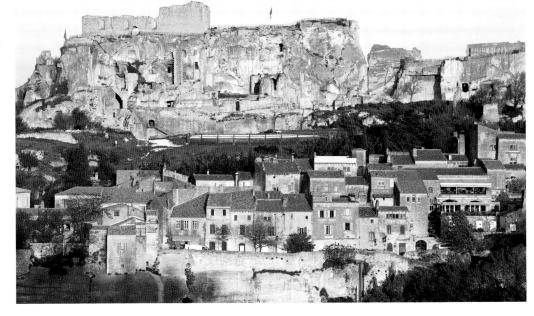

at the foot of the village; guided visit on request for groups only; accessible visit for the visually impaired: audioguide and touch tours, large print and Braille guides; free E-visit app: town visit accessible for all (general public, visual and hearing impaired): +33 (0)4 90 54 34 39.

Accommodation

Baumanière Les Baux de Provence*****: +33 (0)4 90 54 33 07. Domaine de Manville****: +33 (0)4 90 54 40 20. La Benvengudo****: +33 (0)4 90 54 32 54. ♥ Le Mas de l'Oulivié****: +33 (0)4 90 54 35 78. Le Fabian des Baux***: +33 (0)4 90 54 37 87. Le Mas d'Aigret ***: +33 (0)4 90 54 20 00. Hostellerie de la Reine Jeanne**: +33 (0)4 90 54 32 06. Guesthouses

Le Mas de l'Esparou: +33 (0)4 90 54 39 57. Mas Derrière Château:

+33 (0)4 90 54 50 62. Le Prince Noir: +33 (0)4 90 54 39 57. Taven Résidences: +33 (0)4 90 54 34 23.

Vacation rentals

Further information: +33 (0)4 90 54 34 39 www.lesbauxdeprovence.com

T Eating Out

Auberge du Château: +33 (0)4 90 54 50 48. Au Porte Mages, restaurant/crêperie: +33 (0)4 90 54 40 48. Au Relais de la Porte Evguières, salad bar: +33 (0)4 90 54 48 86. Le Bautezar: +33 (0)4 90 54 32 09. La Benvengudo: +33 (0)4 90 54 32 54. Le Bouchori Rouge: +33 (0)4 90 18 26 07. La Cabro d'Or: +33 (0)4 90 54 33 21. Café des Baux: +33 (0)4 90 54 52 69. Le Café du Musée: +33 (0)4 90 54 21 47. Le Fabian des Baux: +33 (0)4 90 54 37 87. Hostellerie de la Reine Jeanne: +33 (0)4 90 54 32 06. Le Mas d'Aigret: +33 (0)4 90 54 20 00. Oustau de Baumanière: +33 (0)4 90 54 33 07. La Table and Bistro at Domaine de Manville: +33 (0)4 90 54 40 20. Les Variétés: +33 (0)4 90 54 55 88.

Local Specialties Food and Drink

AOP Vallée des Baux-de-Provence olive oil • AOC Baux-de-Provence wines • Local wines of the Alpilles.

Art and Crafts

Studios and art galleries • Silver/goldsmith and jewelry studio • Household linen, Provençal specialties • Natural and organic aromatic products • *Santon* (crib figure) workshop • Soaps and beauty products • Weaver • Hatter.

★ Events

May: Fête des Vignerons de Baux (winegrowers' fair), Festival Européen de la Photo de Nu (European nude photography). June: "Fête de la Saint-Jean," Saint John's feast day. June-August: Festival des Alpilles (concerts).

July and August: Festival "A-part" (contemporary art).

September: Festival of Ceramics and Glass; Fête de la Pierre et du Patrimoine (stone and heritage fair). October: Exhibition of designers and santon (crib figure) makers. December: "Noël aux Baux-de-Provence" exhibition and Christmas

activities, dawn ceremony, Midnight Mass, and living Nativity. **All year round:** After-dark projections

onto façades, monuments, and rocks in the village.

W Outdoor Activities

Golf: 18 holes (Domaine de Manville) • Walking: Route GR 6, 1 marked trail and 1 wine-lovers' trail at Saint Berthe, the Trémaïe Path (botanical trail, restricted access to forested massifs June–September). Further information: +33 (0)8 11 20 13 13.

🕊 Further Afield

• Landscape and villages of the Alpille hills: Eygalières, Fontvieille, Maussane, Saint-Rémy-de-Provence (3–22 miles/5–35 km).

- Arles (11 miles/18 km).
- Avignon (19 miles/31 km).
- Les Saintes-Maries-de-la-Mer (36 miles/ 58 km).

Bonneval-sur-Arc

A village of open spaces

Savoie (73) • Population: 244 • Altitude: 5,906 ft. (1,800 m)

Lving between the Vanoise national park and the Grand Paradis national park in Italy. Bonneval's backdrop is nature writ large.

Ringed by dark mountains at the end of the Haute-Marienne valley, for centuries Bonneval was cut off from the rest of the world. But now each winter, when the road to the Col de l'Iseran closes. the inhabitants of Bonneval turn their isolation to their advantage by developing their own breed of tourism that respects both this remarkable environment and the ancient traditions of shepherds and artisans. Just down the road from Tralenta, whose buildings lining the Arc river lead straight to ski slopes, the huge stone houses topped with *lauzes* (schist tiles) and bristling with chimneys still nestle around the cheese dairy, the manor house, and the old village church. A few miles from the village, the hamlet of Écot, which built up around a listed 12th-century chapel, is a perfect example of Bonneval's traditional architecture. Above the rooftops, the Albaron, Levanna, and Ciamarella mountains, rising to nearly 13,000 ft. (4,000 m), tower over an exquisite amphitheater of glaciers: 42 square miles (11,000 hectares) twinkle in the winter silence. or gurgle to the music of summer streams and waterfalls. Bonneval really gets up close and personal with the mountains.

By road: Expressway A43, exit 30-Modane (17 miles/27 km). By train: Modane station (27 miles/43 km). By air: Chambéry-Aix airport (96 miles/154 km); Lyon-Saint-Exupéry airport (144 miles/232 km).

(i) Tourist information: +33 (0)4 79 05 95 95

www.bonneval-sur-arc.com

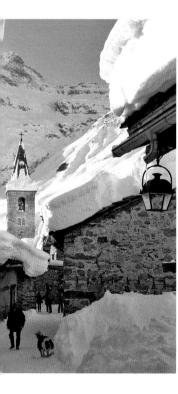

Highlights

 Musée "Espace Neige et Montagne" (snow and mountain museum): Daily life and local crafts, winter sports and historic mountaineering at Bonneval: +33 (0)4 79 05 95 95

• Village: Guided tours for groups and individuals: +33 (0)4 79 05 95 95.

~ Accommodation Hotels

Le Glacier des Évettes**: +33 (0)4 79 05 94 06. La Pastourelle**: +33 (0)4 79 05 81 56. Guesthouses Les Abeillos***: +33 (0)4 79 05 96 08. La Rosa***: +33 (0)4 79 05 95 66. L'Auberge d'Oul: +33 (0)4 79 05 87 99. La Greppa: +33 (0)4 79 05 32 79. Gîtes, walkers' lodges, and vacation rentals Further information: +33 (0)4 79 05 95 95 Central booking service:

www.bonneval-sur-arc.com Mountain refuges Bonneval Village, alt. 5,938 ft. (1,810 m): +33 (0)6 86 66 90 12.

Le Carro, alt. 9,055 ft. (2,760 m): +33 (0)4 79 05 95 79. Les Évettes, alt. 8,497 ft. (2,590 m): +33 (0)4 79 05 96 64.

TEating Out

Auberge d'Oul: +33 (0)4 79 05 87 99. La Benna, pizzeria: +33 (0)4 79 05 83 78. La Cabane: +33 (0)4 79 05 34 60. Chez Mumu, at l'Écot: +33 (0)6 87 83 90 52. Le Criou, mountain-top restaurant (winter only): +33 (0)4 79 05 97 11. Les Évettes: +33 (0)4 79 05 94 06. L'Isba: +33 (0)4 79 64 03 99 La Pastourelle, crêperie and snack bar: +33 (0)4 79 05 81 56. La Taverne des Éterlous: +33 (0)4 79 05 80 66. Le Vieux Pont: +33 (0)4 79 05 94 07.

Local Specialties

Food and Drink Charcuterie, salted meats, and fish • Cheeses (Beaufort and Bleu de Bonneval). Art and Crafts Local crafts.

Bonneval-sur-Arc Savoie

★ Events

Market: Every Sunday in winter and summer seasons. January: La Grande Odyssée (international dog-sled race); ice-climbing rally. July: L'Iserane bicycle touring rally; Fête du Rocher. December: Christmas festivals (Christmas Eve and Saint Sylvester's Eve).

W Outdoor Activities Summer

Mountain sports (mountaineering, canyoning, climbing, glacier walks, Via Ferrata) • Paragliding • Fishing in the lake and mountain streams • Lake (bathing and fishing) at Bessans (3 ½ miles/5.5 km) • Mountain hiking (16 paths, 6 trails) • Summer skiing on the Pisaillas glacier at the Col de l'Iseran.

Winter

Winter sports (Alpine skiing from Christmas through end of April, 5,900–10,000 ft. /1,800–3,050 m, 8 ski lifts, 3 chair lifts; ski touring and walking; snowshoe treks; ice-climbing) • Natural ice-skating.

🕊 Further Afield

• Vanoise national park.

- L'Écot (2 ½ miles/4 km).
- Haute-Marienne valley: Bessans and surrounding hamlets, Lanslevillard, Termignon (4–19 miles/6.1–31 km).
- Col de l'Iseran (8 ½ miles/13.5 km).
- Haute-Tarentaise valley and resorts:
- Val-d'Isère, Tignes (19–27 miles/31–43 km).
- Col du Mont Cenis: lake (22 miles/35 km).

I Did you know?

In 1957, after the Arc river burst its banks and a torrential flood destroyed half the village, the inhabitants decided to rebuild and to diversify their activities while still protecting their environment. The shepherds and farmers became businessmen, creating a cooperative and building a modern cheese dairy in a traditional chalet-style; their milk production increased tenfold in 15 years. They even took out loans to build dressedstone chalets as vacation gites for tourists. In 1968, the village itself borrowed money to develop a proper ski resort, with all the necessary infrastructure, around the hamlet of Tralenta.

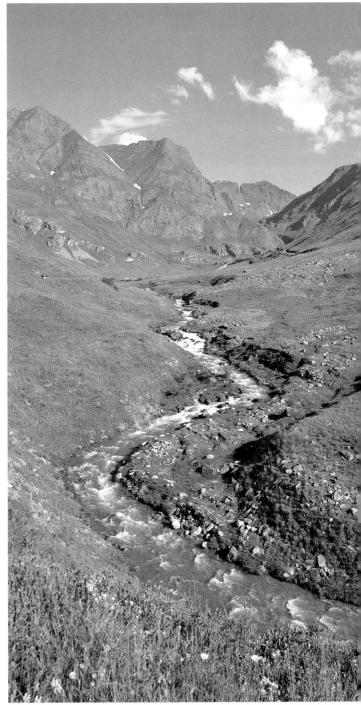

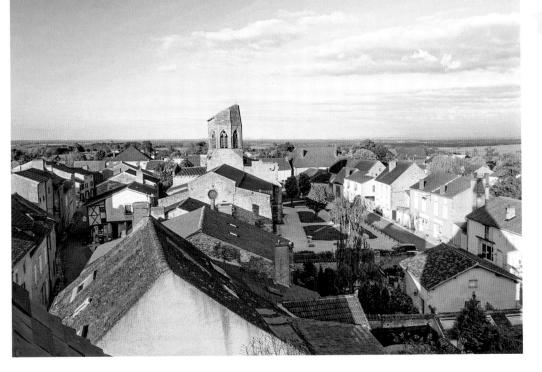

Charroux A trading town in Bourbonnais

Allier (03) • Population: 387 • Altitude: 1,355 ft. (413 m)

At the crossroads of Roman roads, Charroux became a tax-free stronghold at the time of the dukes of Bourbon.

The rise of Charroux was linked to the charter of franchise that it obtained in 1245. The fortified city flourished in the Renaissance owing to its tannery and winemaking, as well as the fairs and markets that it held regularly, and thus attracted merchants, notaries, doctors, and clergymen. Evidence of this intense economic activity can be seen throughout the streets, some of which are named after the professions or trades that were carried out there at that time. The Halle (covered market), built in the early 19th century, has retained its old wooden pillars, which are protected from horse-andcart collisions by large stone blocks. Despite the church being burned twice during the Wars of Religion, Charroux has retained its Église Saint-Jean-Baptiste, whose truncated bell tower remains a mystery. Adopting the arrangement of a *bastide*, the village is organized around its square. From the Cour des Dames, a magical place in the village center, the narrow streets pass by the house of the Prince of Condé and finish at the gates of the ramparts, one of which, the Porte d'Occident, received the village clock in the 16th century. During recent years, Charroux has reclaimed its identity as a place of trade, and now attracts many local producers and craftsmen.

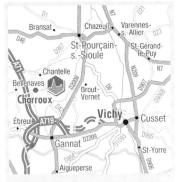

By road: Expressway A71, exit 12–Vichy, then exit 14–Gannat (7 ½ miles/12 km). By train: Vichy station (21 miles/34 km). By air: Clermont-Ferrand-Auvergne airport (37 miles/60 km).

(i) Tourist information— Pays Saint-Pourcinois: +33 (0)4 70 56 87 71 www.charroux03.fr

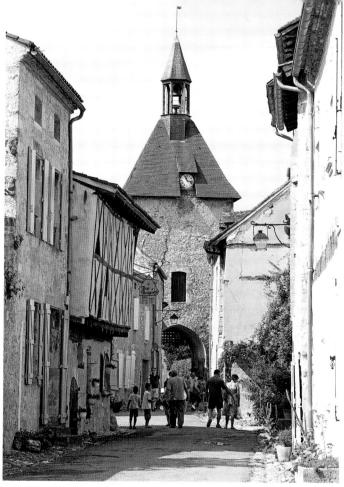

Highlights

 Musée de Charroux (popular arts and traditions): Discover the town of Charroux, which became a village in the 2oth century: +33 (0)4 70 56 87 71.
 Maison des Horloges: Antique clock mechanisms: +33 (0)4 70 56 87 39.
 Les Pots de Marie: Exhibition of more

than 500 spice pots: +33 (0)4 70 56 88 80.

 Église Saint-Jean-Baptiste (12th century).
 Village: Guided tour, by appointment only, all year round for groups; for individuals, Wednesday at 11 a.m. in July and August. +33 (0)4 70 56 87 71.

Accommodation

♥ La Maison du Prince de Condé****:
 +33 (0)4 70 56 81 36.
 Les Templiers****: +33 (0)4 70 90 84 62.

Le Petit Café Bleu: +33 (o)4 70 56 88 16. Le Relais de l'Orient: +33 (o)4 70 56 89 93. Gîtes

Gîte du Vieux Four****: +33 (o)4 70 56 88 37. Gîte du Peyrou**: +33 (o)9 88 99 67 78.

T Eating Out

À l'Envi, crêperie: +33 (0)4 70 90 38 21. L'Auberge du Beffroi: +33 (0)4 70 56 86 82. La Ferme Saint-Sébastien: +33 (0)4 70 56 88 83.

I Did you know?

Mustard is a specialty of Charroux. Since the early 19th century, Messieurs Favier, Portier, and Poulain have distinguished themselves here as master mustardLe Petit Café Bleu: +33 (0)4 70 56 88 16. Rose-Thé: +33 (0)4 70 56 83 26. La Table d'Océane: +33 (0)6 80 12 46 75. ♥ La Table du Prince: +33 (0)4 70 56 81 36.

Local Specialties Food and Drink

Charroux jams • Charroux mustard • Walnut and hazelnut oil • Charroux saffron • Handmade candies and organic sugar • Cheeses and salted meats and fish • AOC St-Pourçain-sur-Sioule wines Teas and coffees • Fruit juices.

Art and Crafts

Mother-of-pearl objects • Jewelry • Candles • Embroidery, gifts, and antique linens • Stone objects • Decorative objects • Earthenware potter, sculptor • Dried flowers • Bead and wirework artist • Potter • Soap-makers • Stained-glass artist • Silk crafts • Painter on wood • Textile accessories • Upholsterer/decorator • Art gallery.

★ Events

April: Antiques fair (last Sunday). May: Printemps des Saveurs, wine and local produce fair (1st weekend). August: Fête des Artistes et Artisans, art and craft fair (1st Sunday). November: Fête de la Soupe (1st Saturday, unless November 1). December: Christmas market (3rd weekend).

W Outdoor Activities

Walking: 3 marked trails.

🕊 Further Afield

• Bellenaves: Musée de l'Automobile, car museum; Chantelle: abbey; Jenzat (Maison du Luthier) (3-4 ½ miles/5-7 km).

• Gannat: Paléopolis, theme park (8 miles/13 km).

- Gorges of the Sioule (8 miles/13 km).
- Saint-Pourçain-sur-Sioule: Musée du Vin,
- wine museum; vineyards (12 miles/19 km). • Vichy (19 miles/31 km).

makers, with two oil presses nearby. Traditionally prepared with Saint-Pourçain wine, Charroux mustard becomes purple when made from grape must instead of white wine.

Coaraze

Alpes-Maritimes (o6) • Population: 783 • Altitude: 2,083 ft. (635 m)

A short distance from the Parc National du Mercantour, Coaraze is a medieval village bathed in sunlight.

In the middle of olive trees, the cobblestone lanes of Coaraze lead to the 14th-century church, the multicolored interior of which was embellished in the Baroque style of Nice in the 18th century with 118 cherubs. The Blue Chapel—decorated with frescoes in different stadesof blue by Angel Ponce de Léon in 1962—is an oratory dedicated to the Virgin Mary. The Chapelle Saint-Sébastien, which is decorated with 16th-century frescoes, stands alongside the old mule track that linked the village to Nice. With its steep, narrow streets, its houses with pink-tiled roofs, roughcast walls, and pastel shutters, and its fountains and squares, Coaraze is evocative of nearby Italy. Many artists have contributed their designs to Coaraze's sundials, including Jean Cocteau, Henri Goetz, and Mona Christie.

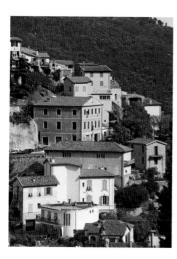

Highlights

• Chapelle Bleue: Old oratory dedicated to the Virgin Mary; frescoes by Angel Ponce de Léon.

• Chapelle Saint-Sébastien: 16th-century frescoes.

- Église Saint-Jean-Baptiste: Built in the 14th century, rich furnishings.
- Village: Guided tour by arrangement: +33 (0)4 93 79 37 47.

• Musée Figas (in L'Engarvin): Museum dedicated to the fantastical futurist

paintings of artist Marcel Figas from Nice, by appointment only: +33 (0)6 67 15 66 85. • **Tour of the olive groves:** Organized by the Comité Régional de Tourisme de Nice (tourist board).

Accommodation Guesthouses

La Feuilleraie: +33 (o)6 38 83 02 16. La Pitcholine: +33 (o)6 25 78 62 27. Communal gîtes Gîtes du domaine de l'Euzière***: +33 (o)6 77 55 15 78.

Communal walkers' lodges,

other rural gîtes Further information: 04 93 79 34 79 www.coaraze.eu Yurts

Les Yourtes du Soleil: +33 (0)6 98 22 78 78.

T Eating Out

Au Fil des Saisons: +33 (o)4 93 79 oo 62. Bar Les Arts, snacks: +33 (o)4 93 79 34 90. Lo Castel, May–September: +33 (o)6 75 24 43 24.

Local Specialties

Food and Drink Organic olive oil • Honey, jams. Art and Crafts Local crafts on sale at the Maison du Tourisme (jewelry, pottery, turned wood).

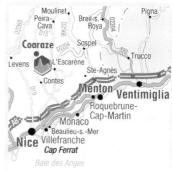

By road: Expressway A8, exit 55– Nice-Est (13 miles/21 km). By bus: Nos. 300 and 303 from Nice bus station (16 miles/26 km). By train: Nice-Ville TGV station (16 miles/26 km). By air: Nice-Côte-d'Azur airport (23 miles/37 km).

(1) Tourist information:

+33 (0)4 93 79 37 47 www.coaraze.eu

★ Events

March: Le Printemps des Poètes (poetry). May: Journée de la Brocante (flea market, May 1).

June: Voix du Basilic (literary events); La Jòia de la Saint-Jean (cart racing); Coaraze S'Expose (photos).

July and August: Pilo (traditional sport from Nice) world championship; summer concerts; De l'Olivier (choral events); olive tree festival; Coartjazz (music).

October: Nuit de l'Écrit (writing night). December: Marché de Noël d'Ici et d'Ailleurs (Christmas market).

W Outdoor Activities

Walking: 30 marked trails.

🕊 Further Afield

• Old village of Rocca Sparviera (3 ½ miles/ 5.5 km).

• Hilltop villages of Lucéram, Contes, Berreles-Alpes, Peillon (5 ½–12 miles/9–19 km).

- Châteauneuf-Villevieille: ruins
 (11 miles/18 km)
- Nice; Côte d'Azur (16 miles/26 km).
- Peira-Cava; Forêt de Turini, forest;
- Col de Turini (17 miles/27 km).
- *Sainte-Agnès (24 miles/39 km), see p. 132.

La Garde-Adhémar

Drôme (26) • Population: 1,177 • Altitude: 558 ft. (170 m)

Set on a limestone spur, La Garde-Adhémar looks out over the Rhone valley and the Tricastin plain.

La Garde-Adhémar has retained its medieval structure—fortifications with gates and curtain wall, elements of the castle and fortified town, narrow streets, and old houses—and is today mostly restored. At the end of the village are the remains of the Renaissance castle built by Antoine Escalin. The Romanesque Église Saint-Michel, a testimony to Provençal architecture of the 12th century, has three naves and a western apse. Nearby, the old Chapelle des Pénitents-Blancs houses an exhibition devoted to the heritage of the Tricastin region. About a mile (1.5 km) away, the Val des Nymphes was a Gallo-Roman, and later a Christian, worship site. Only the 12th-century Chapelle Notre-Dame now remains. During that century, the inhabitants deserted this fertile valley to seek refuge in the fortified town of Adhémar.

Highlights

• Église Saint-Michel (12th century). • Jardin des Herbes: A remarkable medicinal garden with 200 species, plus a ¾-acre (3,000-sq. m) botanical garden.

Val des Nymphes and its chapel.

• Village: Guided tour by arrangement: +33 (0)4 75 04 40 10.

Accommodation

Le Logis de l'Escalin***: +33 (0)4 75 04 41 32. **Guesthouses** Mas Bella Cortis****: +33 (0)6 22 00 20 36. Gîte du Val des Nymphes***: +33 (0)4 75 04 44 54. Les Esplanes: +33 (0)4 75 49 04 16. La Ferme des Rosières: +33 (0)4 75 04 72 81. Le Mas de la Croix: +33 (0)4 75 04 40 51.

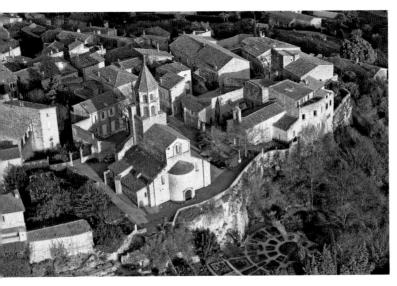

By road: Expressway A7, exit 18– Montélimar Sud (8 miles/13 km), then N7 (3 ½ miles/5,5 km). By train: Pierrelatte station (3 ½ miles/5,5 km); Avignon TGV station (42 miles/68 km). By air: Avignon-Caumont airport (43 miles/69 km).

(i) Tourist information: +33 (0)4 75 04 40 10 www.la-garde-adhemar-ot.org

Gîtes

Further information: +33 (0)4 75 04 40 10 www.la-garde-adhemar-ot.org

T Eating Out

L'Absinthe, local bistro: +33 (0)4 75 04 44 38. Côté Pizza: +33 (0)4 75 46 40 89. Le Logis de l'Escalin: +33 (0)4 75 04 41 32. Le Prédaïou: +33 (0)4 75 04 40 08. Le Tisonnier: +33 (0)4 75 04 44 03.

Local Specialties

Food and Drink Goat cheeses • Fruits • Herbs • Honey • Wines. Art and Crafts Contemporary art publisher • Ceramicistenameler.

W Outdoor Activities

Walking: 2 marked trails and Sentier des Arts • Mountain-biking (marked trails) • Horse-riding trail.

🕊 Further Afield

- Pierrelatte: crocodile farm (4 ½ miles/7 km).
- Tricastin villages: Clansayes, Saint-Paul-Trois-Châteaux, Saint-Restitut (4 ½–9 ½ miles/ 7–15.5 km).
- Châteaux de Grignan and de Suze-la-Rousse Valréas (11–17 miles/18–27 km).
- *Séguret (25 miles/40 km), see p. 141.

La Garde-Guérin (commune of Prévenchères) In the knights' shadow

Lozère (48) • Population: 281 • Altitude: 2,815 ft. (858 m)

The archetype of the fortified village, La Garde-Guérin has retained its 12th-century structure.

The fortified village can be seen from afar, built as it is at nearly 3,000 ft. (900 m), and remarkably situated 1,300 ft. (400 m) above the nearby Chassezac Gorge. The site is crossed by the Régordane Way, a natural communication route linking the Mediterranean to the Auvergne through Nimes and Le Puy. In the Middle Ages, a community of knights, known as the *chevaliers pariers* (knights with equal rights), settled in the village to provide protection to travelers using this route and safeguard their animals and goods. Inside the ramparts stand the tall watchtower and the Chapelle Saint-Michel, which date from the 12th century, and the walls of the castle that the Molette de Morangiès family built in the 16th century. Today, the site's history and its rugged natural landscape lend a wild and mysterious beauty to La Garde-Guérin.

By road: N88 (22 miles/35 km). By train: Villefort station (5 miles/8 km); La Bastide-Puylaurent station (11 miles/18 km). By air: Nîmes airport (72 miles/116 km); Montpellier-Méditerranée airport (97 miles/156 km).

(i) Tourist information:

+33 (0)4 66 46 87 12 Tourist information—Villefort en Cévennes: +33 (0)4 66 46 87 30 www.lagardeguerin.fr

Highlights

- Village: Guided tour for groups:
- +33 (0)4 66 46 87 12 or
- +33 (0)6 74 97 22 32.

• Église Saint-Michel (12th century): Old Romanesque chapel of the fortified village; carved and gilded wooden statue of Saint Michael (18th century), painting of the Crucifixion.

Accommodation

Hotel Auberge Régordane**: +33 (0)4 66 46 82 88. Guesthouses La Butinerie, Albespeyres: +33 (0)4 66 46 06 47 or +33 (0)6 81 98 90 56. Chez Chiff's, Prévenchères: +33 (0)4 66 46 01 53. Municipal campsite Les Pervenche, Prévenchères: +33 (0)6 84 12 11 18.

T Eating Out Auberge Régordane: +33 (0)4 66 46 82 88.

Local Specialties

Food and Drink Farm produce. Art and Crafts Craftspeople's collective • Worker in brass.

★ Events

June: Transhumance, movement of livestock to fresh pasture (1st Sunday after the 15th). August: Prévenchères festival (1st weekend).

W Outdoor Activities

Canyoning • Rock climbing and Via Corda • Walking: Routes GR 700 (Chemin de Régordane) and GR 70 (Chemin de Stevenson); numerous marked trails • Golf nine holes • Trout fishing (Chassezac) • Mountain-biking.

🕊 Further Afield

Lac de Villefort and Lac de Rachas, lakes (3 miles/5 km).
Prévenchères: 12th-century church and its *tilleul de Sully*, a historic lime tree (3 ½ miles/5.5 km).
Mas de La Barque and Mont Lozère (16 miles/26 km).
Langogne (23 miles/37 km).

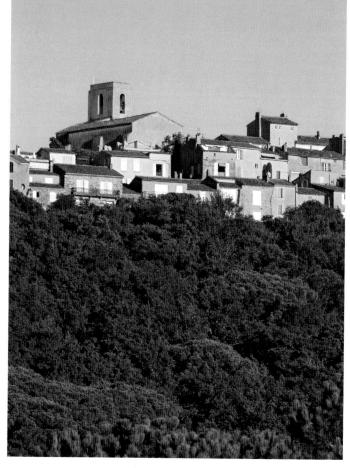

Gassin A haven on the Côte d'Azur

Var (83) • Population: 2,887 (500 in the village itself) • Altitude: 656 ft. (200 m)

From its ridge surrounded by vineyards and forests, Gassin has a unique view of the peninsula and Gulf of Saint-Tropez.

A longside the protection of the surrounding landscape, the development of the new village next door has also been sensitively handled, a feat recognized by several international awards. In addition to the delight of exploring the new village is the pleasure to be had from strolling, accompanied by the fragrance of oleanders and bougainvillea, along the maze of winding lanes in the old village, with its façades weathered by time. From the Deï Barri terrace, the view stretches from the Îles d'Hyères to the Massif des Maures and, when the Mistral has blown the clouds away, to the snow-capped summits of the Alps.

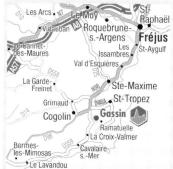

By road: Expressway A57, exit 13–Le Luc (23 miles/37 km); expressway A8, exit 36– Draguignan (22 miles/35 km), N98 (3 ½ miles/5.5 km). By train: Fréjus-Saint-Raphaël TGV station (22 miles/35 km). By air: Toulon-Hyères airport (30 miles/ 48 km); Nice Côte-d'Azur airport (58 miles/93 km).

(1) Tourist information:

+33 (0)4 94 55 22 00 www.golfe-saint-tropezinformation.com

Highlights

• Village: Free guided tour Wednesday at 4 p.m. from Easter to end October, 6 p.m. in July and August, departing from the viewpoint indicator: +33 (0)4 94 55 22 00.

- Church (16th century): Listed font,
- 18th-century bust of Saint Lawrence.

Accommodation

Le Kube*****: +33 (0)4 94 97 20 00. Le Mas de Chastelas*****: +33 (0)4 94 56 71 71. Villa Belrose****: +33 (0)4 94 55 97 97. La Bastide d'Antoine****: +33 (0)4 94 97 70 08. Le Domaine de l'Astragale****: +33 (0)4 94 97 78 98. Le Brin d'Azur***: +33 (0)4 94 97 70 05. Dune***: +33 (0)4 94 97 00 83. Bello Visto**: +33 (0)4 94 50 17 30. La Villa**: +33 (0)4 94 97 70 14. Les Lavandes: +33 (0)4 94 56 20 10. Aparthotels

Caesar Domus: +33 (0)4 94 55 86 55. Le Mas de Chastelas: +33 (0)4 94 56 71 71. Odalys: Le Clos Bonaventure et Les Jardins d'Artémis: +33 (0)4 94 97 73 34.

Parc Résidentiel Oasis: +33 (0)4 94 96 90 56. Villa Maya: +33 (0)4 94 97 81 42. **Guesthouses, gîtes, and vacation rentals** Further information: +33 (0)4 94 55 22 00 www.golfe-saint-tropezinformation.com **Campsites**

Farm campsite: +33 (0)4 94 56 27 78. Moulin de la Verdagne: +33 (0)4 94 79 78 21. Parc Saint-James Montana: +33 (0)4 94 55 20 20. Roche Club: +33 (0)4 94 56 12 29.

T Eating Out

Au Vieux Gassin: +33 (0)4 94 56 14 26. Bello Visto: +33 (0)4 94 56 17 30. Le Carpaccio: +33 (0)4 94 56 17 30. La Ciboulette: +33 (0)4 94 56 25 52. Golf Country Club restaurant: +33 (0)4 94 17 42 41. Le Mas de Chastelas: +33 (0)4 94 56 71 71. Le Micocoulier: +33 (0)4 94 56 14 01. Le Pescadou: +33 (0)4 94 56 12 43. Le P'tit Chef: +33 (0)4 94 43 06 71. Les Sarments: +33 (0)4 94 56 38 20. La Table du Polo: +33 (0)4 94 55 22 14. La Verdoyante: +33 (0)4 94 56 16 23. Villa Belrose: +33 (0)4 94 55 97 97.

Local Specialties

Food and Drink Jams • Organic olive oil • AOC Côtes de Provence wines. Art and Crafts Art galleries and studios • Gifts • Potteries.

\star Events

March: La Gassinoise cross-country run. April: Internationale Granfondo cycle race; opening of the art-exhibition season. June: "Fête de la Saint-Jean," Saint John's feast day; Brazilian festival. July: Polo Masters at the Haras de Gassin (international tournament). August: Fête Patronale de la Saint-Laurent; August 15th Ball. September: Horse festival. December: Noël des Enfants (children's Christmas). All year round: Exhibitions, concerts, activities for children, mountain-biking competitions, polo tournaments.

W Outdoor Activities

Swimming (no lifeguard) • Walking • Mountain-biking • Golf • Sailing.

🕊 Further Afield

- La Croix-Valmer; Cavalaire (2 ½– 5 ½ miles/4–9 km).
- Saint-Tropez (3 1/2-6 miles/5.5-9.5 km).
- Ramatuelle; Sainte-Maxime (3 ½–
- 8 ½ miles/5.5–13.5 km).
- Massif des Maures, uplands; La Garde-Freinet; Grimaud (8–14 miles/13–23 km).
- Corniche des Maures, coastal drive (21 miles/34 km).
- Fréjus; Saint-Raphaël (25 miles/40 km).
- Le Lavandou (25 miles/40 km).

I Did you know?

Legend has it that, after the plague hit Gassin, the only survivor in the village carried embers in his bare hands, using them to rekindle fires in the hearths of the empty houses to pretend that the village was still inhabited.

Gordes Jewel of the Luberon

Vaucluse (84) • Population: 2,100 • Altitude: 1,171 ft. (357 m)

Like an eagle's nest perched on the foothills of the Monts de Vaucluse, facing the famous Luberon mountain, Gordes is the archetypal Provençal village.

Surrounded by a mosaic of holm oaks, wheat fields, and vines, the village's dry-stone houses—solidly attached to the rock—seem to tumble down in cascades. Its history, its rich architecture and heritage, its marvelous views, its cobbled winding lanes, and its fountain shaded by a plane tree on the Place du Château have appealed to numerous artists, from André Lhote (1885–1962) and Pol Mara (1920–1998) to Victor Vasarely (1906–1997). A short distance from the village, at the end of a lavender field, which in springtime enhances the pale stone of its façade, the Abbaye de Sénanque is a perfect example of Cistercian architecture and is still inhabited by monks.

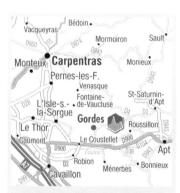

By road: Expressway A7, exit 24– Avignon Sud (17 miles/27 km). By train: Cavaillon station (11 miles/18 km); Avignon TGV station (25 miles/40 km). By air: Avignon-Caumont airport (19 miles/31 km); Marseille-Provence airport (48 miles/77 km).

Tourist information—Luberon Monts de Vaucluse: +33 (0)4 90 72 02 75 www.luberonmesvacances.com

Highlights

• Abbaye de Sénanque (12th century): The church, dormitory, cloister, and chapter house are accessible to visitors on guided tours. Further information: +33 (0)4 90 72 02 75.

• Cellars of the Palais Saint-Firmin: Situated beneath a large house, the cellars feature caves, cisterns, and an old seigneurial oil press; documentary, museum, MP3 audioguide. Further information: +33 (o)4 90 72 02 75.

• Moulin des Bouillons and Musée du Vitrail: One of the oldest preserved oil mills with all its workings, presses from the 1st to the 14th centuries, collections of oil lamps, amphorae; at the same site, the Musée du Vitrail recounts the history of glass and stained-glass windows via a large collection (6,500 sq. ft. / 600 sq. m): +33 (0)4 90 72 22 11.

• Castle (16th century): Of medieval origin, rebuilt during the Renaissance. Exhibitions of works by artists who have lived in Gordes or that relate to the history of the village, also temporary exhibitions: +33 (0)4 90 72 02 75.

• Village des Bories: Museum of rural dry-stone dwellings (*bories*) that served as housing until the middle of the 19th century: +33 (o)4 90 72 03 48.

• Village: Guided tour by arrangement: +33 (0)4 90 72 02 75.

Accommodation

La Bastide*****: +33 (0)4 90 72 12 12. Les Bories****: +33 (0)4 90 72 00 51.

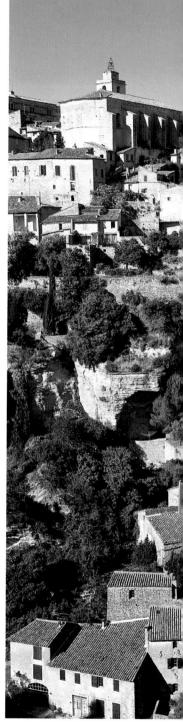

La Ferme de la Huppe****: +33 (0)4 90 72 12 25. Auberge de Carcarille***: +33 (0)4 90 72 02 63. ♥ Le Mas de Gordes***: +33 (0)4 90 72 00 75. ♥ Le Mas des Romarins***: +33 (0)4 90 72 12 13. Le Mas de la Sénancole***: +33 (0)4 90 76 76 55. **Guesthouses, gîtes, and vacation rentals** Further information: +33 (0)4 90 72 02 75

Aparthotels La Bastide des Chênes: +33 (0)4 90 72 73 74.

Campsites Les Sources***: +33 (0)4 90 72 12 48.

TEating Out

Restaurants L'Artégal: +33 (0)4 90 72 02 54. Auberge de Carcarille: +33 (0)4 90 72 02 63. La Bastide: +33 (0)4 90 72 12 12. Le Bistro de la Huppe: +33 (0)4 90 72 12 25. Les Bories: +33 (0)4 90 72 00 51. Casa Rosario: +33 (0)4 90 72 06 98. ♥ Le Clar'Ôme: +33 (0)4 90 72 12 13. Les Cuisines du Château: +33 (0)4 90 72 01 31. L'Estaminet: +33 (0)4 90 72 14 45. L'Estellan: +33 (0)4 90 72 04 90. La Farigoule: +33 (0)4 90 76 92 76. Le]ardin: +33 (0)4 90 72 12 34. Le Loup Blanc: +33 (0)4 90 72 12 43. Le Mas Tourteron: +33 (0)4 90 72 00 16. Le Renaissance: +33 (0)4 90 72 02 02. Les Sources: +33 (0)4 90 72 12 48. Tartares Club: +33 (0)4 32 50 22 50. Le Teston: +33 (0)4 32 50 21 74. Light meals

Aurore & Michel: +33 (0)6 21 75 65 35. La Créperie de Fanny: +33 (0)4 32 50 13 01. L'Encas: +33 (0)4 90 72 29 82. Le Gordes Manger: +33 (0)4 90 72 08 01. La Trinquette, wine bar/tapas: +33 (0)4 90 72 11 62.

Local Specialties

Food and Drink Honey • AOC Côtes du Ventoux wine • Olive oil. Art and Crafts Iewelry • Art galleries • Potters •

★ Events

Sculptor • Weaver.

Market: Tuesday mornings, Place du Château. lanuary: Fête de la Saint-Vincent (2nd fortnight). Easter: Weavers' market. April-October: Painting and sculpture exhibitions in the municipal halls. July and August: Numerous concerts at the Théâtre des Terrasses. August: "Les Soirées d'Été," festival (1st fortnight); Fête du Vin des Côtes du Ventoux, wine festival (1st Sunday). December: "Veillée Calendale", Christmas songs and tasting of the thirteen desserts, representative of Jesus and his apostles (1st fortnight).

W Outdoor Activities

Walking: Route GR 6 and 2 marked trails • Mountain-biking/Electric mountain-bike rentals.

🕊 Further Afield

- Véroncles: water mills (1 mile/1.5 km).
- Murs (5 ½ miles/9 km).
- *Roussillon (5 ½ miles/9 km), see pp. 128–29.
- *Ménerbes (7 miles/11.5 km), see pp. 113–14.
- Fontaine-de-Vaucluse (7 ½ miles/12 km).
- *Venasque (9 ½ miles/15.5 km),
- see pp. 151–52.
- *Lourmarin (18 miles/29 km),
- see pp. 111–12.
- Avignon (24 miles/39 km).
- •*Ansouis (24 miles/39 km), see pp. 88–89.

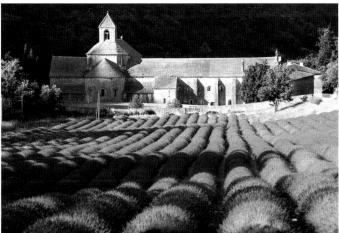

105

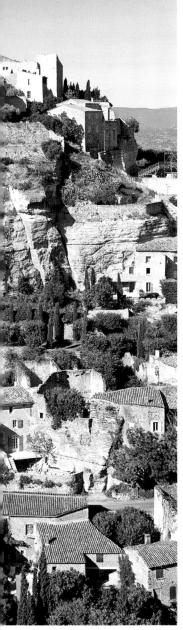

Gourdon Between sea and sky

Alpes-Maritimes (o6) • Population: 396 • Altitude: 2,493 ft. (760 m)

Built on an isolated rock above the Loup valley, Gourdon looks out over the Gorges of the Loup toward the blue waters of the Mediterranean. Designed to repel Saracen invasions in the 8th-10th centuries. Gourdon has often served as a stronghold. Protected by the gorges to the south, the village built fortifications on the side facing the mountain. A first fortress was constructed in the 9th century. In the 12th century, the castle was built, overlooking the whole valley. Sheltered by the imposing fortress, and crisscrossed by infinitely narrow streets, the village showcases its restored houses, the Romanesque Église Saint-Vincent, and numerous artists' stalls; at the end stands its showpiece, the Place Victoria. Immortalized by Queen Victoria's visit in 1891, this panoramic viewpoint offers a breathtaking vista, from Nice and Cap Ferrat in the east as far as the cape of Saint-Tropez and the Massif des Maures in the west, via Antibes, Cannes, the Îles de Lérins, and the Massif de l'Esterel. In the late 19th century, the village spread to the hamlet of Pont-du-Loup, at the foot of the rock, in the Loup valley, where the climate was more conducive to growing herbs.

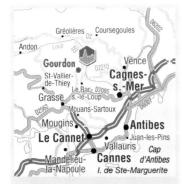

By road: Expressway A8, exit 47– Villeneuve-Loubet (16 miles/26 km). By rail: Grasse station (9 ½ miles/15.5 km); Nice TGV station (24 miles/38 km). By air: Nice-Côte d'Azur airport (20 miles/32 km).

(i) Tourist information: +33 (0)8 11 81 10 67 www.gourdono6.fr

Highlights

• Place Victoria: Panoramic viewpoint of the Côte d'Azur.

• Église Saint-Vincent (12th century).

• Galerie de La Mairie: Exhibitions: +33 (0)8 11 81 10 67.

• Castle gardens designed by André Le Nôtre (1613–1700). Further information: +33 (0)4 93 09 68 02.

• Saut du Loup waterfalls (Gorges du Loup): Guided tours of the waterfalls and viewpoint over the valley, from May to October: +33 (0)4 93 09 68 88.

• Lavanderaies de la Source Parfumée: Fields of flowers and herbs; guided tours for groups by a master gardener: +33 (0)4 93 09 68 23.

Accommodation

Gîtes and vacation rentals Further information: www.gourdono6.fr

T Eating Out

Auberge de Gourdon: +33 (0)4 93 09 69 69. Les Grands Hommes: +33 (0)4 93 77 66 21. La Taverne Provençale: +33 (0)4 93 09 68 22. Au Vieux Four: +33 (0)4 93 09 68 60.

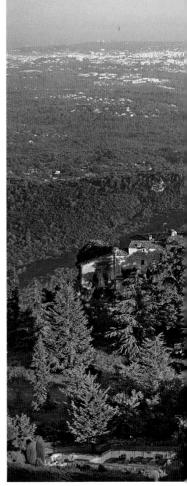

Local Specialties

Food and Drink Nougat and *calissons* (candy) • *Pain d'épice* (spice cake). Art and Crafts Perfumery • Soap factory • Glassworks.

★ Events

August: Open-air theater festival. November–March: Theater festival (last Fridays), Pont-du-Loup.

W Outdoor Activities

Paragliding • Walking: Chemin du Paradis and numerous marked trails.

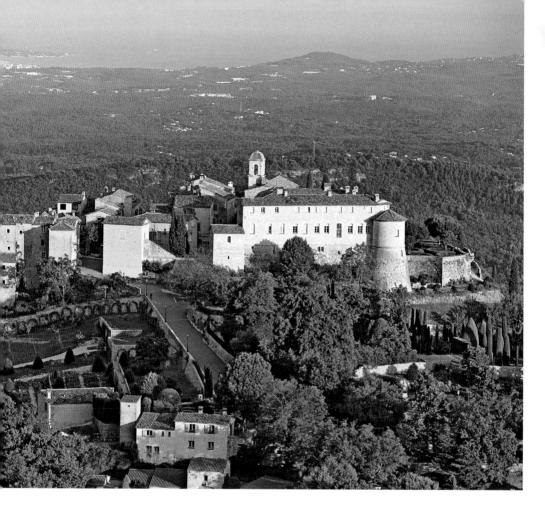

🕊 Further Afield

- Gorges of the Loup (5 miles/8 km).
- Grasse (8 ½ miles/13.5 km).
- Valbonne; Biot; Tourrettes-sur-Loup; Saint-Paul-de-Vence (9 ½–19 miles/ 15.5–31 km).
- Côte d'Azur: Cannes, Antibes, Nice (17–22 miles/27–35 km).
- Corniche de l'Esterel, coastal drive (22–43 miles/35–69 km).

I Did you know?

In the early 20th century, there was no road to link Gourdon to Pont-du-Loup. Locals traveled from one village to the other by mule, on the Chemin du Paradis. Until 1900, caravans of mules could still be seen passing each other on this rocky Provençal road.

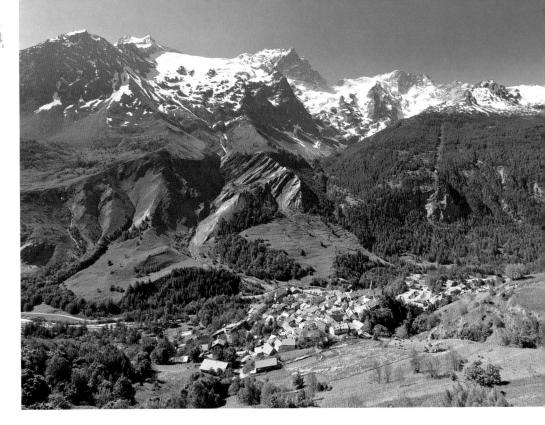

La Grave

Hautes-Alpes (05) • Population: 500 • Altitude: 4,757 ft. (1,450 m)

With its larch trees, rich pastures, and abundant snow, La Grave invites visitors to explore a spectacular mountain.

Tectering on a rocky outcrop, La Grave packs its robust stone houses tightly along narrow streets called *trabucs*, which climb to the top of the village. The Romanesque–Lombard-style Église Notre-Dame-de-l'Assomption, which adjoins the Chapelle des Pénitents-Blancs, offers a breathtaking view of the Massif des Écrins, and in particular La Meije mountain. This legendary summit, which reaches 13,070 ft. (3.983 m), has made La Grave a mecca for mountaineers: laid to rest in the cemetery next to the church, beneath simple wooden crosses, are climbers that the mountain has claimed. Since the 1970s, La Grave has also gained an international reputation for its unique off-piste ski area. In summer, the Meije glaciers' cable cars enable visitors to reach the Col des Ruillans and the Glacier de la Girose. La Grave and Les Traverses—the hamlets scattered on its southern slope—provide ideal starting points for numerous walks.

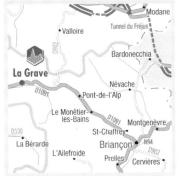

By road: Expressway A480, exit 8–Vizille (43 miles/69 km). By rail: Briançon station (24 miles/39 km). By air: Grenoble-Isère airport (73 miles/117 km); Chambéry-Aix airport (90 miles/145 km); Lyon-Saint-Exupéry airport (103 miles/166 km).

(i) Tourist information: +33 (0)4 76 79 90 05 www.lagrave-lameije.com

Highlights

Église Notre-Dame (11th century): 18thand apth-century furnishings; cemetery.
Further information: +33 (0)4 76 79 90 05.
Hamlet of Le Chazelet: Traditional houses, church, communal oven.
Meije glaciers (alt. 10,500 ft./3,200 m) by cable car: Daily mid-June-mid-September.
Further information: +33 (0)4 76 79 94 65.
Le Chazelet oratory: Splendid view of La Meije.

Accommodation

Les Chalets de la Meije***, aparthotel: +33 (0)4 76 79 97 97. L'Édelweiss***: +33 (0)4 76 79 90 93. Le Castillan**: +33 (0)4 76 79 90 94. La Meijette**: +33 (0)4 76 79 90 34. Le Sérac**: +33 (0)4 76 79 91 53. Hôtel des Alpes (in winter): +33 (0)4 76 11 03 18.

Aparthotels

Apart'Hôtel les Chalets de la Meije ****: +33 (0)4 76 79 97 97.

Gîtes, walkers' lodges, vacation rentals, family vacation centers, and campsites Further information: +33 (0)4 76 79 90 05 www.lagrave-lameije.com

Mountain huts

Évariste Chancel, alt. 8,200 ft. (2,500 m): +33 (0)4 76 79 92 32 0r +33 (0)4 76 79 97 05. Refuge Goléon, alt. 8,000 ft. (2,440 m): +33 (0)6 87 26 46 54.

T Eating Out

Alp'Bar, crêperie: +33 (0)4 76 79 96 67. Auberge Chez Baptiste: +33 (0)4 76 79 92 09. Au Vieux Guide: +33 (0)4 76 79 90 75. Le Castillan: +33 (0)4 76 79 90 04. Le Chalet des Plagnes, crêperie/pizzeria: +33 (0)4 76 79 95 23. L'Édelweiss: +33 (0)4 76 79 90 03. Les Glaciers: +33 (0)4 76 79 90 04. La Meijette: +33 (0)4 76 79 90 04. La Pierre Farabo: +33 (0)4 76 79 90 34. La Pierre Farabo: +33 (0)4 76 79 95 25. Pizza et Pasta: +33 (0)6 82 13 56 76. Lou Ratel: +33 (0)4 76 79 91 53.

Local Specialties Food and Drink

Goat cheeses • Honey. Art and Crafts Fabric designers • Creator of decorative objects (mobiles, pictures) and jewelry.

🖈 Events

Market: Thursday morning, Place du Téléphérique (off-season) or Place de la Salle-des-Fêtes (summer). January: Rendez-Vous Nordique au Pays de la Meije (end January), "Reines de la Meije," girls' weekend (ard weekend).

February: Ultimate Test Tour, freeride and security equipment fair (mid-February).

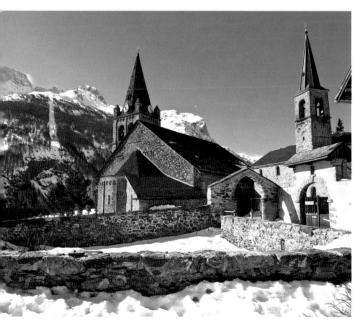

April: Derby de la Meije, ski race (1st weekend).

June: La Grave'y Cîmes mountaineering (2nd weekend), Rencontres de la Haute Romanche arts festival, country trails. July: Messiaen au Pays de la Meije, music festival (last ten days).

August: Fête du Pain du Chazelet, bread festival (2nd weekend); Fête des Guides de La Grave, celebration of mountain guides (August 15); Tour du Plateau d'Emparis, foot and mountain-bike race (3rd Sunday). September: Ultra Raid de la Meije, mountain-bike race (3rd weekend).

W Outdoor Activities

Guided walk on the glacier, Via Ferrata, Via Cordata • Mountaineering • Rock climbing, climbing wall • Paragliding • Walking, walking with donkeys with packsaddles • Mountain-biking • Cycle touring • Astronomy • Fishing • Rafting. In winter

Ski area (alt. 4,920–11,650 ft./1,500– 3,550 m) of the Meije glaciers (off piste) and Le Chazelet (3 ski lifts, 1 chairlift): Downhill skiing, ski touring, off-piste and hiking trails, monoski, kiteboarding, snowshoeing, surfing, telemarking, snowshoeing, mountaineering, iceclimbing, and dry tooling, snow and ice school • Sled dogs.

🕊 Further Afield

• Villar-d'Arène: Historic bread oven and water mill (2 miles/3 km).

- Jardin Botanique Alpin du Lautaret, botanic garden (open during summer) (6 miles/9.5 km).
- Col du Lautaret: Maison du Parc National des Écrins, national park visitor center (6 miles/9.5 km).
- Col du Galibier (11 miles/18 km).
- Bourg-d'Oisans: Musée de la Faune et des Minéraux, museum of geology and wildlife (17 miles/27 km).

• Saint-Christophe-en-Oisans: Musée de l'Alpinisme, mountaineering museum (25 miles/40 km).

I Did you know?

In La Grave, locals continue to make black (rye) bread, as they did in the past. This custom is celebrated every year on All Saints' Day.

Lavaudieu

In God's valley

Haute-Loire (43) • Population: 228 • Altitude: 1,411 ft. (430 m)

In the Middle Ages, Benedictine monks built a monastery in the Senouire valley, turning it into la vallée de Dieu (God's valley), which gave the village its name. Robert de Turlande, first abbot of La Chaise-Dieu abbey and later Saint Robert, founded the abbey at Lavaudieu in 1057. Nuns lived here until the French Revolution. It is the only monastery in the Auvergne with a Romanesque cloister. Running along the wall of the refectory, with its line of columns featuring carved capitals, is a 12th-century Byzantine-inspired mural. The abbey sheltered Cardinal de Rohan, when he fled La Chaise-Dieu after the Affair of the Diamond Necklace (an intrigue involving Marie Antoinette, Rohan, and the costly necklace). The 11th-12th-century church adjoining the monastery lost its steeple during the French Revolution. Inside, a 15th-century Pietà in polychrome stone sits alongside 14th-century Italian-influenced murals of an allegory of the Black Death. In the center of the village, the Musée des Arts et Traditions Populaires de Haute-Loire displays a typical Auvergne interior.

Highlights

• Abbey: Cloisters, refectory (12th-century mural); Église Saint-André (Pietà, murals); further information: +33 (0)4 71 76 08 90 or +33 (0)4 71 76 46 00.

• Musée des Arts et Traditions Populaires: Reconstruction of a traditional Auvergne interior (joint tickets with abbey).

Accommodation Guesthouses

La Buissonnière***: +33 (0)4 71 76 49 02. Le Colombier***: +33 (0)4 71 76 09 86 or +33 (0)6 86 17 96 81. La Maison d'à Côté***: +33 (0)4 71 76 45 04 or +33 (0)4 71 50 24 85.

Gîtes

M. and Mme Perrey***: +33 (0)4 71 76 82 39. M. and Mme Watel***: +33 (0)4 71 76 45 79.

T Eating Out

Auberge de l'Abbaye: +33 (0)4 71 76 44 44. Café La Fontaine, bar/brasserie: +33 (0)4 71 76 08 03 or +33 (0)6 48 32 60 50. Court la Vigne: +33 (0)4 71 76 45 79.

Local Specialties

Food and Drink Honey. Art and Crafts Essential-oil distillery.

★ Events

July: Fête de la Barrique, barrel festival, and outdoor rummage sale (weekend after 14th).

July-August: Choir festivals; music concerts at the abbey; further information: +33 (0)4 71 76 46 00); exhibitions. September: Deschamps festival, jazz, rock, folk (2nd Saturday).

W Outdoor Activities

Climbing • Swimming pool (at Brioude) • Walking: 3 marked trails.

🕊 Further Afield

• Brioude (5 miles/8 km).

- •*Blesle (19 miles/31 km), see p. 174.
- La Chaise-Dieu (24 miles/39 km).
- Allier valley: gorges (31 miles/50 km).

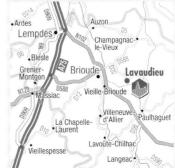

By road: Expressway A75, exit 20–Brioude (13 miles/21 km); N102 (5 miles/8 km). By train: Brioude station (6 miles/9.5 km). By air: Clermont-Ferrand-Auvergne airport (48 miles/77 km).

Tourist information—Brioude et sa Région: +33 (0)4 71 74 97 49 0r +33 (0)4 71 76 46 00 / www.ot-brioude.fr www.abbayedelavaudieu.fr

I Did you know?

The Fête de la Barrique, held each year on the Sunday after July 14, has its origins in the events of the French Revolution, when the inhabitants of Lavaudieu surrounded the abbey in order to seize the clergy's possessions—in particular the barrels of wine destined for the monks of La Chaise-Dieu. During the fête, this historic wine village traditionally places a barrel of wine on the village square for everyone to share.

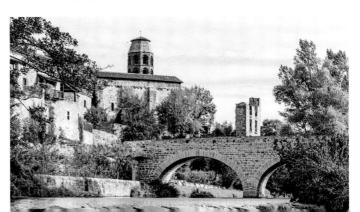

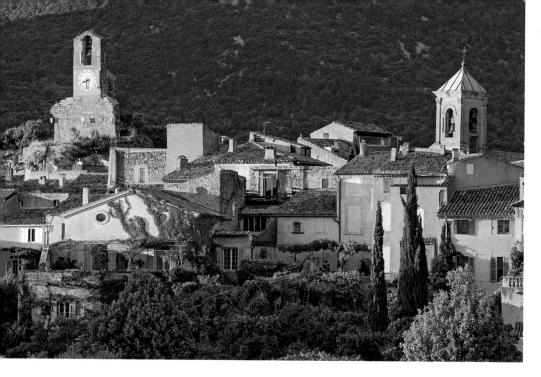

Lourmarin The Provence of Camus and Bosco

Vaucluse (84) • Population: 1,088 • Altitude: 722 ft. (220 m)

Standing at the mouth of a gorge in the Luberon clawed out by a dragon, Loumarin attracted the writers Albert Camus and Henri Bosco, who slumber in the shade of the cemetery's cypress trees.

The rough gash created by the Aiguebrun river is the only route and an ancient one-through the Luberon mountains, and the water tumbles under an old shell bridge. It is the reason why Lourmarin sprang up around a modest Benedictine monastery and a simple castle, the Castellas, belonging to the lords of Baux-de-Provence. Surrounded by a plain dotted with fortified Provençal mas houses, where fruit and olive orchards mingle with vines, the village today winds along streets lined with fountains, and sun-kissed rooftops that cascade around the Castellas (now a belfry and clock tower) and the Romanesque church of Saint-Trophime-et-Saint-André. A stone's throw away is the Protestant church, which recalls the tragic massacre of the Vaud people in the 16th century, survivors of which converted to Protestantism. Just beyond it, the castle of La Colette, built in the 15th and 16th centuries, looks down over fields and terraced gardens. The castle was rescued in the early 20th century by the benefactor Laurent Vibert; he created a stunning collection of furniture and objets d'art, and each year welcomes painters, sculptors, musicians, and writers to the castle.

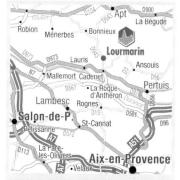

By road: Expressway A7, exit 26–Sénas (17 miles/27 km); expressway A51, exit 15–Pertuis (13 miles/21 km). By train: Pertuis station (12 miles/19 km); Cavaillon station (25 miles/40 km); Avignon TGV station (40 miles/64 km). By air: Avignon-Caumont airport (34 miles/55 km); Marseille-Provence airport (41 miles/66 km).

() Tourist information: +33 (0)4 90 68 10 77 www.lourmarin.com

Highlights

• Castle (15th and 16th centuries): First Renaissance castle in Provence, furnished throughout; collection of engravings and objets d'art: +33 (0)4 90 68 15 23. • Literary walks (Camus and Bosco):

"Sur les Pas d'Albert Camus" and "Sur les Traces d'Henri Bosco," by appointment only, 3+ people: +33 (o)4 90 68 10 77. • Village tours: For 3+ people, by appointment only: +33 (o)4 90 68 10 77.

• Protestant church (19th century), included in village tour: Huge organ attributed to the Lyon manufacturer Augustin Zieger.

• Romanesque church (11th century), included in village tour.

• La Ferme de Gerbaud: Plants and herb farm. Tastings available Thursdays, booking essential: +33 (0)4 90 68 11 83.

Accommodation

Hôtel Bastide***: +33 (0)4 90 07 00 70. Le Mas de Guilles***: +33 (0)4 90 68 30 55. Auberge du Père Panse: +33 (0)4 90 68 02 89. Le Moulin: +33 (0)4 90 68 06 69. Le Paradou: +33 (0)4 90 68 04 05. **Guesthouses** La Cordière***: +33 (0)4 90 68 03 32. La Villa Saint-Louis***: +33 (0)4 90 68 39 18. La Luberonne**: +33 (0)4 90 08 58 63. Ancienne Maison des Gardes: +33 (0)4 90 07 53 16.

La Bastide aux Oiseaux: + 33 (0)4 90 08 51 67. La Bohème: +33 (0)4 90 68 31 15. La Chambre d'Hôte: +33 (0)6 07 19 97 92. Côté Lourmarin: +33 (0)6 09 16 91 80. Le Galinier de Lourmarin:

+ 33 (0)4 90 08 92 46. Maison Collongue: +33 (0)4 90 77 44 69. Media Luz: +33 (0)7 89 49 77 12. Les Oliviers: +33 (0)4 90 68 37 30.

Gîtes, walkers' lodges, and vacation rentals

Further information: +33 (0)4 90 68 10 77 www.lourmarin.com

Campsites

Les Hautes Prairies***: +33 (0)4 90 68 02 89.

T Eating Out

Restaurants

L'Antiquaire: +33 (0)4 90 68 17 29. L'Auberge du Père Panse: +33 (0)4 90 68 27 97. Le Bamboo Thaï : +33 (0)4 90 68 04 05.

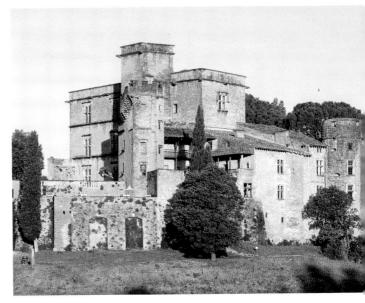

Le Bistrot: +33 (0)4 90 68 29 74. Le Café Gaby: +33 (0)4 90 68 38 42. Le Café de l'Ormeau: +33 (0)4 90 68 02 11. Le Café Phuket, Thai cuisine: +33 (0)4 90 09 02 26. Le Club: +33 (0)4 90 77 89 88. Le Comptoir 2 Michel Ange, wine bar: +33 (0)4 90 08 49 13. L'Insolite: +33 (0)4 90 68 02 03. Le Jardin de Lourmarin: +33 (0)9 82 27 14 07. La Louche à Beurre, crêperie: +33 (0)4 90 68 00 33. Le Mas de Guilles: +33 (0)4 90 68 30 55. Le Moulin: +33 (0)4 90 68 06 69. Le Numéro Neuf: +33 (0)4 90 79 00 46. L'Oustalet: +33 (0)4 90 68 07 33. Pizzeria Nonni: +33 (0)4 90 68 23 33. La Récréation: +33 (0)4 90 68 23 73. La Réserve: +33 (0)4 90 77 83 54. Tea rooms

La Calade: +33 (0)4 90 68 84 43. La Luce d'Angeuse: +33 (0)4 90 68 89 45. La Maison Café: +33 (0)4 90 09 54 01.

Local Specialties Food and Drink

Herbs • Olive oil and regional produce • AOC Côtes du Luberon wines.

Art and Crafts

Jewelry maker • Fashion designers • Smith • Art galleries • Household linen • Potters • Sculpture • Textile painter.

\star Events

Markets: Fridays 8 a.m.-1 p.m., Place Henri-Barthélemy and Avenue Philippe-de-Girard; Tuesdays 5:30-8:30 p.m., May-October, farmers' market, fruit cooperative. May-September: music festival at the castle, lectures, shows. June: Festival Yeah (pop/rock). July-August: "Rencontres Méditerranéennes Albert Camus," literary festival; craft fairs; artists' markets. August: "Salon du Livre Ancien," antiquarian book fair.

W Outdoor Activities

Mini-golf • Swimming pool, summer only • Walks around Lourmarin.

- •*Ansouis (6 miles/9.5 km), see pp. 88–89.
- Fort de Buoux (6 miles/9.5 km).
- Durance valley; Cavaillon (6–21 miles/ 9.5–34 km).
- Lourmarin valley; Forêt de Cèdres, forest; Apt (7–11 miles/11.5–18 km).
- *Ménerbes (14 miles/23 km), see pp. 113–14.
- *Roussillon (14 miles/23 km),
- see pp. 128–29.
- *Gordes (18 miles/29 km), see pp. 104–5.
- Aix-en-Provence (21 miles/34 km).
 *Venasque (28 miles/45 km),
- see pp. 151–52.

Ménerbes

Tranquillity and beauty in the Luberon

Vaucluse (84) • Population: 1,144 • Altitude: 735 ft. (224 m)

Perched on a ridge clinging to the side of the Luberon mountains. Ménerbes looks down over fields of vines and cherry trees.

Ménerbes has been inhabited since prehistoric times, as is shown by the La Pichouno dolmen (funerary monument), unique in Vaucluse. But it was during the Middle Ages and the Renaissance that the village acquired its heritage buildings, for example the abbey of Saint-Hilaire, the priory where Saint Louis (1214-1270) stopped on his return from the Crusades. The 16th-century church boasts rich decoration, and the neighboring old cemetery affords superb panoramic views. Once the Protestant capital during the Wars of Religion, Ménerbes retains some very fine 16th- and 17th-century residences that survived this turbulent period. In a symphony of luminous, golden stone, these houses are dotted along the fortified rocky spine, facing the Vaucluse mountains, or can be found at the end of arched passageways. The citadel, reinforced after a siege to protect the town's inhabitants, strikes an imposing silhouette at one end of the village. Also noteworthy are Le Castellet, home of painter Nicolas de Staël (1914–1955) and still owned by his descendants; La Carmejane, a fortified residence dating back to the 11th century, with its stunning gardens; an 18th-century townhouse, owned by Picasso and bequeathed to his sometime partner, the artist and poet Dora Maar (1907-1997); and the Hôtel d'Astier de Montfaucon, a historic hospice that today houses the Maison de la Truffe et du Vin du Luberon.

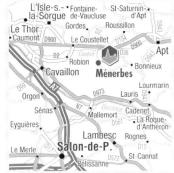

By road: Expressway A7, exit 24– Avignon Sud (17 miles/27 km). By train: Cavaillon station (9 ½ miles/15,5 km); Avignon TGV station (25 miles/40 km). By air: Avignon-Caumont airport (19 miles/31 km); Marseille-Provence airport (43 miles/69 km).

() Tourist information—Provence en Luberon: +33 (0)4 90 72 21 80 www.tourisme-en-luberon.com www.menerbes.fr

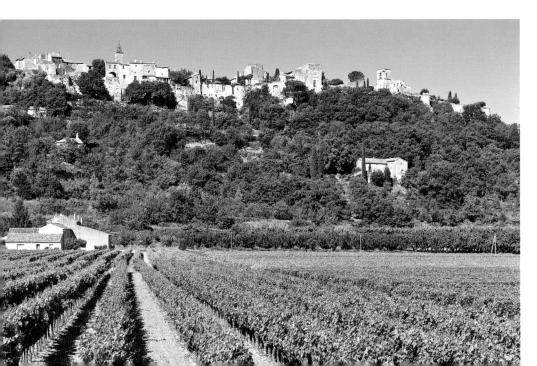

Highlights

Abbaye Saint-Hilaire (13th century): Former Carmelite convent; chapel, cloisters, chapter house, refectory.
Maison de la Truffe et du Vin (mansion of Astier de Montfaucon, 17th–18th centuries): Showcase for truffles and wines of the Luberon; wine collection, exhibitions, shop: +33 (0)4 90 72 38 37.

• Maison Jane Eakin: House/museum of the American painter (1919–2002): +33 (0)4 90 72 21 80.

• Musée du Tire-bouchon at La Citadelle: Collection of more than 1,200 corkscrews from the 17th century onward:

+33 (0)4 90 72 41 58.

Chapelle Saint-Blaise (18th century).

• Église Saint-Luc (16th century,

recently restored).

• La Pitchouno dolmen (funerary site).

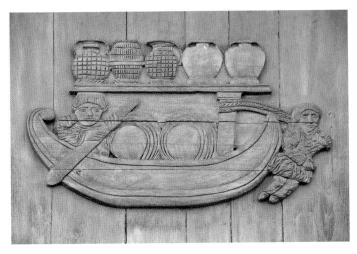

Accommodation

La Bastide de Marie: +33 (0)4 90 72 30 20. Guesthouses

La Bastide de Soubeyras:

+33 (0)4 90 72 94 14.

Les Douze Oliviers: +33 (o)6 81 07 01 53. Le Jardin des Cigales: +33 (o)4 90 04 87 18. Mas du Magnolia: +33 (o)4 90 72 48 00. Nulle Part Ailleurs: +33 (o)6 72 22 81 03. Les Peirelles: +33 (o)4 90 72 23 42.

Gîtes and holiday rentals

Further information: +33 (0)4 90 72 21 80/ www.tourisme-en-luberon.com

T Eating Out

La Bastide de Marie: +33 (0)4 90 72 30 20. Le Café du Progrès, country fare: +33 (0)4 90 72 22 09. Café Véranda: +33 (0)4 90 72 33 33. Le 5 [cinq]: +33 (0)4 90 72 31 84. Croc'In, salad bar: +33 (0)4 90 72 16 47. Le Galoubet: +33 (0)4 90 72 36 08. Maison de la Truffe et du Vin, wine bar and truffle restaurant: +33 (0)4 90 72 38 37. Le Roy Soleil: +33 (0)4 90 72 25 61. Les Saveurs Gourmandes: +33 (0)4 32 50 20 53. La Table de Régis, communal dining: +33 (0)4 90 72 43 20.

Local Specialties Food and Drink

Fruit and vegetables • Luberon truffles • AOC Côtes du Luberon wines. Art and Crafts Gifts • Fashion • Painters • Potter • Art photographer.

🖈 Events

Market: April–October, small village market.

July: Fête des Vignerons (winegrowers' festival), and "OEno-vidéo" (movies and wine).

July-August: Les Musicales du Luberon; La Strada (open-air cinema). August: Fête de Saint-Louis (3rd weekend). October: Outdoor rummage sale (1st Sunday).

December: Christmas market; truffle market (last weekend).

W Outdoor Activities

Walking: 10 marked trails • Cycling: "Autour du Luberon à Vélo," Luberon by bike (Luberon regional nature park) • Mountain-biking.

🕊 Further Afield

• *Gordes (7 miles/11.5 km), see pp. 104–5.

- Cavaillon; Apt; Avignon (10–25 miles/ 16–40 km).
- Fontaine-de-Vaucluse (10 miles/16 km).
- *Roussillon (10 miles/16 km),
- see pp. 128–29.
- *Lourmarin (15 miles/24 km),
- see pp. 111-12.
- *Venasque (15 miles/24 km),
- see pp. 151–52.
- *Ansouis (21 miles/34 km), see pp. 88–89.

Mirmande Hilltop orchard in the Drôme valley

Drôme (26) • Population: 504 • Altitude: 640 ft. (195 m)

Mirmande clambers up the hill to the Église Sainte-Foy, from where there are far-reaching views of the Rhône valley and the Vivarais mountains. The high facades of Mirmande scale the north face of the Marsanne massif, emerging from the ancient ramparts and overlapping each other to seek protection from the Mistral. Dominating the Tessonne valley, where thousands of fruit trees bloom in spring, this jewel in the Drôme valley is a maze of lanes, cobblestones, and steps, all ablaze with flowers. At the top is the delightful 13th-century Église Sainte-Foy. Mirmande stopped breeding silkworms at the end of the 19th century, but several silk worm nurseries keep the memory of this industry alive. The town was given a new lease of life by growing fruit. and thanks to the input of two individuals: the cubist painter and writer André Lhote (1885-1962), who created his summer school here, and the geologist Haroun Tazieff (mayor 1979-89). The old houses have been beautifully restored: many have been brought back to life by the talent and imaginative spark of local artists and craftsmen.

Highlights

Église Sainte-Foy (12th century): Exhibitions and concerts.
Chareyron orchard: Open all year, self-guided visit: +33 (0)4 75 63 10 88.
Village: Guided tours throughout the year for groups, booking essential; weekly tours in July–August for individuals.
Further information: +33 (0)4 75 63 10 88.

Accommodation

La Capitelle***: +33 (0)4 75 63 02 72. L'Hôtel de Mirmande: +33 (0)4 75 63 13 18. **Guesthouses**

Le Bruchet***: +33 (0)4 75 63 22 52. Domaine Les Fougères***: +33 (0)4 75 63 01 66. Le Petit Logis***: +33 (0)4 75 63 02 92. Les Vergers de la Bouliguaire***: +33 (0)4 75 63 22 07. Margot: +33 (0)4 75 63 08 05. La Petite Véronne: +33 (0)4 75 63 15 53. **Gîtes and vacation rentals**

Further information: +33 (o)4 75 63 10 88 valdedrome-tourisme.com Campsites La Poche**: +33 (o)4 75 63 02 88.

T Eating Out

Café Bert, local bistro: +33 (0)4 75 56 18 51. Café Patine: +33 (0)4 75 41 21 82. La Capitelle: +33 (0)4 75 63 02 72. Chez Margot: +33 (0)4 75 63 08 05.

Local Specialties

Food and Drink Seasonal fruit juice, fruit, and vegetables • Drôme vins de pays. Art and Crafts Jewelry designer • Painters • Photographer • Potters • Silkscreen printer • Sculptors • Glassmaker • Gifts • Antiques • Dressmaker.

\star Events

March: Nature trail (last weekend). May-September: Concerts and exhibitions at the Église Sainte-Foy and in the village. October: Garden plants and rare plants fair (2nd Sunday). December: Festival of lights (start of December).

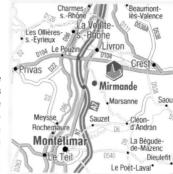

By road: Expressway A7, exit 16–Loriol (5 miles/8 km). By train: Loriol-sur-Drôme station (5 ½ miles/9 km); Livronsur-Drôme station (8 miles/13 km); Montélimar TGV station (12 miles/19 km); Valence TGV station (32 miles/51 km). By air: Lyon-Saint-Exupéry airport (96 miles/154 km).

 Tourist information—Val de Drôme: +33 (0)4 75 63 10 88 valdedrome-tourisme.com Town hall: +33 (0)4 75 63 03 90

W Outdoor Activities

Husky dogs (summer) and "Cani-rando," walking with dogs • Walking • Horse-riding • Mountain-biking.

- Cliousclat, pottery village (1 mile/2 km).
- Crest (11 miles/18 km).
- Montélimar (11 miles/18 km).
- Dieulefit (19 miles/31 km).
- *Le Poët-Laval (21 miles/34 km), see p. 124.
- Grignan (25 miles/40 km).
- *La Garde-Adhémar (26 miles/42 km), see p. 100.

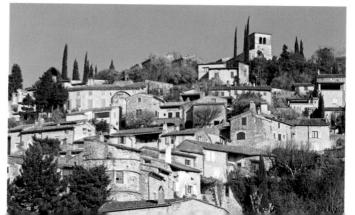

Montbrun-les-Bains

Thermal treatments at the gateway to Provence

Drôme (26) • Population: 430 • Altitude: 1,969 ft. (600 m)

At Montbrun, sandwiched between the Lure and Ventoux mountains. the region of Drôme takes on Provencal features: it is adorned with lavender, garrique scrubland, and vines. Tiered on the steep sides of a hill, the high facades of Montbrun are pierced with windows like arrow slits. They stand as the last line of defense protecting the imposing remains of an historic medieval castle. Rebuilt during the Renaissance, the castle was looted during the French Revolution. From the Place de l'Horloge and its belfry as far as the Sainte-Marie gate, narrow cobblestone alleyways lead from fountain to fountain. right to the 12th-century church. This houses a splendid Baroque altar and several paintings, including Coronation of the Birgin by Pierre Parrocel. At the foot of the village, thermal baths in a modern building benefit from a spring that the Romans used; the waters help respiratory and rheumatic ailments, and improve fitness.

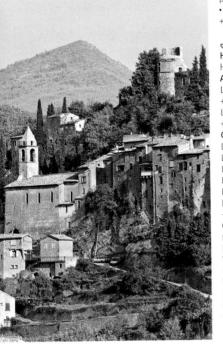

Highlights

 Church (12th century): Baroque building, painting by Pierre Parrocel (key at town hall). • Village: Further information: +33 (0)4 75 28 82 49.

Accommodation

Hotels Hôtel des Voyageurs*: +33 (0)4 75 28 81 10. Aparthotels Le Château des Gipières***:

+33 (0)4 75 28 87 33 Le Hameau des Sources: +33 (0)4 75 26 96 88.

Guesthouses

L'Abbaye**: +33 (0)4 75 28 83 12. L'Amelie: +33 (0)4 75 26 86 33. Le Bellevue: +33 (0)4 75 28 84 92. Le Deffend de Redon: +33 (0)4 75 28 68 19. La Ferme du Vallon: +33 (0)4 75 27 43 29. La Maison de Marguerite: +33 (0)4 75 28 41 23 Gîtes, walkers' lodges, and vacation

rentals Further information: +33 (0)4 75 28 82 49.

Vacation villages Léo Lagrange: +33 (0)4 75 28 89 00.

VVF: +33 (0)4 75 28 82 35. Campsites

La Boucoule, farm campsite: +33 (0)4 75 28 86 49. Le Pré des Arbres: +33 (0)4 75 28 85 41.

T Eating Out

L'Ô Berge de l'Anary: +33 (0)4 75 28 88 14. L'Ô des Sources: +33 (0)4 75 27 11 09.

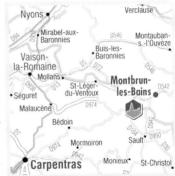

By road: Expressway A7. exit 19-Bollène (46 miles/74 km); expressway A51, exit 22-Vallée du Jabron (32 miles/52 km). By train: Carpentras station (33 miles/ 53 km); Orange TGV station (44 miles/ 71 km). By air: Avignon-Caumont airport (52 miles/84 km).

(1) Tourist information:

+33 (0)4 75 28 82 49 www.montbrunlesbainsofficedutourisme.fr

La Tentation, pizzeria: +33 (0)4 75 28 87 26. Les Voyageurs: +33 (0)4 75 28 81 10.

Local Specialties Food and Drink

Goat cheese • Honey, herbs, and spices • Einkorn wheat • Organic produce. Art and Crafts Potter • Perfumes and herbs.

* Events

Market: Saturday mornings. Place de la Mairie. April: Cheese and craft market (1st Sunday). September: Journée Bien-être au Naturel (plant and wellbeing fair); local saint's day and fireworks, Saturday evening (2nd weekend).

W Outdoor Activities

Canyoning and climbing • Via Ferrata • Horse-riding • Walking: Route GR 9 and 10 marked trails • Thermal baths and convalescence (mid-March-mid-November).

- Sault (7 1/2 miles/12 km).
- Buis-les-Baronnies (16 miles/26 km).
- Nyons (19 miles/31 km).
- Toulourenc valley; Vaison-la-Romaine (20 miles/32 km).
 - Mont Ventoux (24 miles/39 km).

Montclus Clothed in vineyards and lavender

Gard (30) • Population: 159 • Altitude: 295 ft. (90 m)

Sitting at a bend in the Cèze river, Monclus exudes all the charm of a Languedoc village.

Inhabited since prehistoric times, the site attracted fishing tribes to settle before it became Castrum Montecluso in the Middle Ages, earning its name from its hilltop position at the foot of a mountain. In the 13th century both the abbey of Mons Serratus and an imposing fortified castle were built here. A few ruins of the old troglodyte Benedictine monastery remain, used as a chapel by the Knights Templar, as well as a vast room hewn out of the rock, while the massive square tower of the castle still casts its long shadow over the pink-tiled roofs. From the Place de l'Église, narrow alleys, steps, and covered passageways punctuate the village. As you wander, you catch occasional glimpses, beyond the bright stone façades of lovingly restored residences, of lush green gardens tumbling down to the Cèze.

Highlights

• Church (Tuesday mornings in July and August).

• Castle (Tuesday mornings in July and August): Main hall, spiral staircase. Guided tours by appointment only. Further information: Association des Amis du Château: +33 (0)6 14 49 48 20. • Village: Guided tours in summer. Further information: +33 (0)4 66 82 30 02.

Accommodation

La Magnanerie de Bernas***: +33 (0)4 66 82 37 36.

Guesthouses

La Micocoule: +33 (0)4 66 82 76 09. Le Moulin: +33 (0)4 66 82 32 52. Nid d'Abeilles: +33 (0)6 82 86 83 00 or +33 (0)6 33 09 03 84. Aparthotels L'Entremont: +33 (0)4 66 82 23 67. Campsites, farm campsites, gîtes, and vacation rentals Further information: +33 (0)4 66 82 30 02.

T Eating Out Le Mûrier: +33 (0)4 66 82 59 98.

Local Specialties

Food and Drink

Honey • Olive oil • Lavender essence. Art and Crafts Painter • Joiner • Ironworker.

★ Events

Market: Provençal market Tuesday mornings (July–August). July–August: Cultural activities and shows. August: Local saint's day (1st weekend).

W Outdoor Activities

Swimming • Canoeing • Walking • Horse-riding • Mountain-biking.

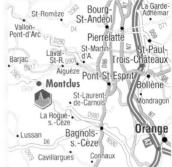

By road: Expressway A7, exit 19–Bollène (21 miles/34 km); expressway A9, exit 23–Remoulins (32 miles/51 km); N86 (14 miles/23 km). By train: Bollène-La Croisière station (18 miles/29 km); Avignon TGV station (37 miles/60 km). By air: Avignon-Caumont airport (40 miles/64 km); Nimes-Arles-Camargues airport (55 miles/89 km).

() Tourist information—Gard Rhodanien: +33 (0)4 66 82 30 02

www.village-montclus.fr

- Aven d'Orgnac, sinkhole (5 ½ miles/9 km).
- Cornillon; Goudargues (6 miles/9.5 km).
- *Aiguèze (9 ½ miles/15.5 km), see pp. 86-87.
- *La Roque-sur-Cèze (9 ½ miles/15.5 km), see pp. 126–27.
- Valbonne: monastery (11 miles/18 km).
- Bagnols-sur-Cèze: market (15 miles/24 km).
- Pont-Saint-Esprit (15 miles/24 km).
- Gorges of the Ardèche (21 miles/34 km).

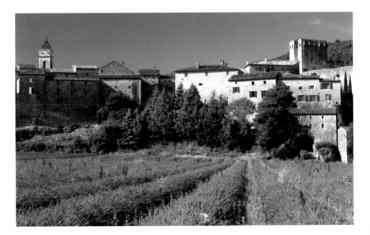

Montpeyroux A labyrinth of sandstone

Puy-de-Dôme (63) • Population: 355 • Altitude: 1,499 ft. (457 m)

Perched on a mound to the south of Clermont-Ferrand and winding around its castle keep, the medieval village offers a panoramic view of the Auvergne volcanos.

Sitting on the ancient Régordane Way linking the Auvergne with Languedoc, Montpeyroux brings a flavor of southern France. Over the centuries, its inhabitants have lived off the proceeds of its vineyards and its arkose quarry. Arkose is a sandstone rich in crystalline feldspar; the stone lights up Montpeyroux's houses with golden glints, and was used to build the major Romanesque churches in the Auvergne—Saint-Austremoine at Issoire and Notre-Dame-du-Port at Clermond. The vineyards of Montpeyroux disappeared at the end of the 19th century during the outbreak of phylloxera, and the quarry closed in 1935, heralding the village's decline. However, restoration began in the 1960s, and Montpeyroux has recovered its vigor through growing vines again and encouraging artists and craftspeople to come. With its massive, gold-flecked winegrowers' houses and its roofs of round tiles, Montpeyroux is one of the jewels of the Allier valley.

Highlights

• Ferme Pédagogique de la Moulerette: Discover farm animals: +33 (0)4 73 96 62 68.

• Montpeyroux tower (13th century): Exhibition and audiovisual presentation: +33 (0)4 73 96 62 68.

• Village: Guided tours for groups by appointment only: +33 (0)4 73 89 15 90. Special tours for the visually impaired (tactile models of the tower, the 12th-century gate, and the village) by appointment: +33 (0)4 73 96 62 68.

✓ Accommodation Guesthouses

Les Pradets****: +33 (0)4 73 96 63 40. Le Cantou***: +33 (0)4 73 96 92 26. L'Écharpes d'Iris***: +33 (0)6 77 19 19 77. Le Petit Volcan***: +33 (0)6 77 89 11 41 or +33 (0)6 78 84 86 64. La Vigneronne***: +33 (0)4 73 96 66 71.

T Eating Out

Déco Thé, tea room: +33 (0)4 73 96 69 67. Le Donjon, bar/crêperie: +33 (0)4 73 96 69 25. Mon Bistrot Zen—CZ: +33 (0)4 73 96 63 46.

Local Specialties

Local produce AOC Côtes d'Auvergne wines. Art and Crafts Jewelry • Ceramic artists • Art galleries • Painters • Visual artists.

★ Events

May: Potters' sale (8th). September: "Dédal'Art" (weekend of Journées du Patrimoine, heritage festival).

W Outdoor Activities

Fishing • Walking: 1 marked trail, "L'Arkose" (5 ½ or 7 ½ miles/9 or 12 km) • Mountain-biking.

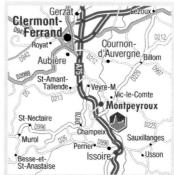

By road: Expressway A75, exit 7– Montpeyroux (1 mile/1.5 km). By train: Clermont-Ferrand station (19 miles/31 km). By air: Clermont-Ferrand Auvergne airport (15 miles/24 km).

(i) Tourist information—Pays d'Issoire: +33 (0)4 73 89 15 90 www.sejours-issoire.com www.montpeyroux63.com

🕊 Further Afield

- Issoire (9 ½ miles/15.5 km).
- Clermont-Ferrand (12 miles/19 km).
- Saint-Nectaire; Besse-en-Chandesse;
- Massif de Sancy (12–25 miles/19–40 km).
- *Usson (15 miles/24 km), see p. 150.

• La Chaîne des Puys, series of volcanic domes Vulcania, theme park (31 miles/50 km).

I Did you know?

As an 80th birthday present for her husband, Pablo, Jacqueline Picasso bought a house in Montpeyroux. Restored, then later sold, this house still stands in the village.

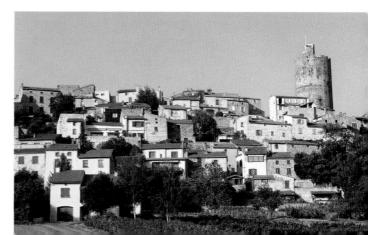

Moustiers-Sainte-Marie

The star of Verdon

Alpes-de-Haute-Provence (04) • Population: 740 • Altitude: 2,100 ft. (640 m)

Moustiers sits at the entrance to the Grand Canyon du Verdon, protected by a golden star suspended on a chain high above the village between two rocky cliffs.

Moustiers owes its existence to a body of water, and its fame to an Italian monk. The water is the Adou river: it made medieval Moustiers a village of stationers, potters, and drapers. In the 17th century, a monk from Faenza brought the secret of enameling (tin-glazed earthenware) here, and Moustiers became the capital of "the most beautiful and the finest faience in the kingdom." Although the faience industry disappeared in the 19th century. it has been revitalized in recent years, and now over a dozen studios marry tradition with innovation. The Adou river tumbles through the village and is spanned by little stone bridges. On both sides, the golden houses topped with Romanesque tiles huddle round small courtvards and line alleys linked by steps and vaulted passageways. At the heart of the village, the church has been altered several times and contains a pre-Roman vault, a nave dating to the 14th and 16th centuries, and a square Lombard tower. A flight of 262 steps links the village with the chapel of Notre-Dame-de-Beauvoir, which blends charming Gothic and Romanesque architecture.

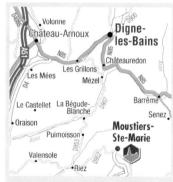

By road: Expressway A51, exit 18– Manosque (34 miles/55 km); expressway A8, exit 36–Draguignan (47 miles/76 km). By coach: LER No. 27 from Aix-en-Provence bus station (58 miles/93 km; Monday and Saturday April 1–June 30, and daily July–August). By train: Digneles-Bains station (34 miles/55 km); Manosque station (35 miles/56 km). By air: Marseille-Provence airport (71 miles/114 km).

(i) Tourist information: +33 (0)4 92 74 67 84 www.moustiers.eu

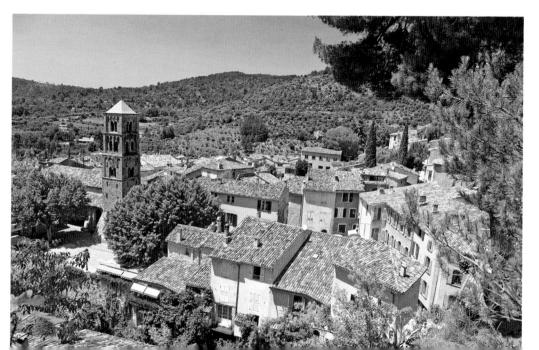

Highlights

ChapeIle Notre-Dame-de-Beauvoir (12th and 16th centuries).
Parish church (12th and 14th centuries).
Musée de la Faïence: History of faience ceramics, 17th century to today, a collection of over 400 pieces; temporary exhibitions: +33 (0)4 92 74 61 64.
Village: Guided tours for individuals, Tuesdays 10 a.m. and Thursdays 5 p.m. July-August; groups all year by appointment: +33 (0)4 92 74 67 84.

Accommodation

La Bastide de Moustiers****: +33 (0)4 92 70 47 47. La Bastide du Paradou***: +33 (0)4 88 04 72 01. Le Colombier***: +33 (0)4 92 74 66 02. La Ferme Rose***: +33 (0)4 92 75 75 75. Les Restanques***: +33 (0)4 92 74 93 93. Le Belvédère**: +33 (0)4 92 74 66 04. La Bonne Auberge**: +33 (0)4 92 74 66 18. Le Clos des Iris**: +33 (0)4 92 74 63 46. Le Relais**: +33 (0)4 92 74 66 10.

Guesthouses

Bélière***: +33 (o)4 92 72 95 69. La Bergerie Angouire***: +33 (o)6 08 48 71 87. Ferme du Petit Segries***: +33 (o)4 92 74 68 83. Maison de Melen***: +33 (o)4 92 74 44 93. Le Mas du Loup***: +33 (o)4 92 74 65 61. Other guesthouses, gîtes, walkers' lodges, vacation rentals, vacation villages, and campsites Further information: +33 (o)4 92 74 67 84.

www.moustiers.eu

T Eating Out

La Bastide de Moustiers: +33 (0)4 92 70 47 47. Le Belvédère: +33 (0)4 92 74 66 04. La Bonne Auberge: +33 (0)4 92 74 60 40. La Bouscatière: +33 (0)4 92 74 67 67. La Cantine: +33 (0)4 92 77 46 64. La Cascade: +33 (0)4 92 74 66 06. Clérissy, crêperie/pizzeria: +33 (0)4 92 77 29 30. Les Comte: +33 (0)4 92 74 63 88. Côté]ardin: +33 (0)4 92 74 68 91. Le Da Vinci: +33 (0)4 92 77 24 69. L'Étoile de Mer: +33 (0)4 92 74 62 24. Ferme Sainte-Cécile: +33 (0)4 92 74 64 18. La Grignotière: +33 (0)4 92 74 69 12.]adis, pizzeria: +33 (0)4 92 74 63 01. Les Magnans, brasserie: +33 (0)4 92 74 61 20. Le Relais: +33 (0)4 92 74 66 10. Les Santons: +33 (0)4 92 74 66 48. La Treille Muscate: +33 (0)4 92 74 64 31.

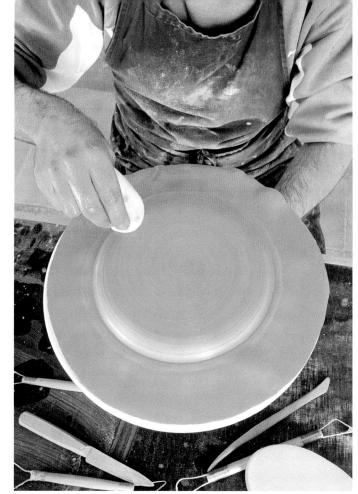

Local Specialties Food and Drink

Cookies • Artisan preserves, salted produce • Olive oil • Lavender honey. Art and Crafts Faience workshops • Painters.

\star Events

Markets: Fridays 8 a.m.–1 p.m, Place de l'École; Wednesdays 6–11 p.m. July–August, Place de la Mairie. August–September: "Fête de la Diane," festival (August 31–September 8).

W Outdoor Activities

Walking: Route GR 4 and 12 marked trails • White-water sports: canyoning, kayaking, pedalo • Climbing, paragliding • Mountainbiking.

🖗 Further Afield

Lac de Sainte-Croix, lake (3 miles/5 km).Le Grand Canyon du Verdon;

Castellane (6-28 miles/9.5-45 km).

Riez; Valensole; Gréoux-les-Bains: spa;

Manosque (9 ½–31 miles/15.5–50 km).

I Did you know?

According to the account by Frédéric Mistral (1830–1914), the star was hung between the two cliffs over Moustiers as an expression of thanks to the Virgin Mary. It was put there on the wishes of Blacas, a crusader knight imprisoned by the Saracens; he had promised that if he returned safely to his village, he would hang a star and his chain in that spot.

Oingt A golden nugget at the heart of vineyards

Rhône (69) • Population: 614 • Altitude: 1,804 ft. (550 m)

Overlooking the Beaujolais vineyards, Oingt is a jewel amid the *pierres dorées* (golden stones), rich in iron oxide, found in this region.

Built on a ridge overlooking the Roman roads between Saône and Loire, this former Roman *castrum* saw its heyday in the Middle Ages. It was around the year 1000 CE that the Guichard d'Oingt lords, powerful *viguiers* (judges) for the count of Le Forez, built a motte-and-bailey castle and its chapel here, and in the 12th century a keep was added. Today, the fortified Nizy Gate at the entrance to the village provides the first sign of its medieval past. Houses with yellow-ocher walls, where the play of light and shadow constantly changes, line the road leading to the old chapel, which became a parish church in 1660. Next to it are the remains of the castle's residential buildings and keep, which have now been made into a museum. From the terrace, there is an exceptional view of the Beaujolais vineyards, the Azergues valley, and the Lyonnais mountains.

Highlights

• Musée de la Tour (12th century): Museum of the village's history, panoramic terrace with viewpoint indicator: +33 (0)4 74 71 21 24.

• Église Saint-Matthieu (10th century): 12th-century polychrome sculptures, Stations of the Cross, Pietà, pulpit; liturgical museum.

• Musée de la Musique mécanique et de l'Orgue de Barbarie: Display of old objects (collection of 60 European instruments) plus music demonstrations.

• Musée Automobile, Viticole, et Agricole: Vintage cars from 1927 to 1967: +33 (0)4 74 71 20 52 0r

+33 (0)6 07 45 75 75.

• Maison Commune (16th century): Exhibition of the works of regional artists (painters, sculptors, ceramicists), April–October: +33 (0)4 74 71 21 24. Village: Guided tour, booking essential: +33 (0)4 74 71 21 24.

Accommodation Guesthouses

M. and Mme Bourbon***: +33 (0)4 74 71 24 41 0r +33 (0)6 80 50 27 93. **Gîtes**

Mme Marie-Pierre Guillard***: +33 (0)4 74 71 20 52. M. and Mme Lucien Guillard*: +33 (0)4 74 71 20 49 0r +33 (0)6 87 25 62 39. M. and Mme Margand: +33 (0)4 74 71 26 92 or +33 (0)6 64 38 44 34.

T Eating Out

Chez Marguerite: +33 (0)4 74 71 20 13. Chez Marlies: +33 (0)4 74 71 66 18. Crêperie des Pierres Dorées: +33 (0)4 74 71 29 91. La Table du Donjon: +33 (0)4 74 21 20 24. La Vieille Auberge: +33 (0)4 74 71 21 14.

Local Specialties Food and Drink

Chocolates • AOC Beaujolais wines. Art and Crafts Calligrapher • Ceramicist • Textile

designer • Interior designer • Mosaic artist • Potter • Sculptor • Stained-glass artist.

* Events

Market: Thursday, Place de Presberg, 10 a.m.-7 p.m.

February: "Fête de l'Amour," Oingt craftsmen celebrate Valentine's Day. July: "Rosé Nuit d'Eté," aperitif and concert (first week).

September: Festival International d'Orgue de Barbarie et de Musique Mécanique, organ festival (1st weekend). November: Beaujolais Nouveau festival

(3rd Thursday).

December–January: Oingt en Crèches, Oingt nativity scenes (last 3 weeks of December and 1st week of January).

By road: Expressway A6, exit 31.2– Roanne (10 miles/16 km); N7 (8 ½ miles/ 13.5 km). By train: Villefranche-sur-Saône station (9 ½ miles/15.5 km); Lyon-Part-Dieu TGV station (24 miles/39 km). By air: Lyon-Saint-Exupéry airport (41 miles/66 km).

() Tourist information—Pays des Pierres Dorées: +33 (0)4 74 60 26 16 www.tourismepierresdorees.com www.oingt.com

W Outdoor Activities

Walking • Mountain-biking (marked trails).

- Pays des Pierres Dorées, region: golden
- stone villages (2 ½–12 miles/4–19 km).
- Villefranche-sur-Saône (8 ½ miles/13.5 km).
- Lyon (23 miles/37 km).

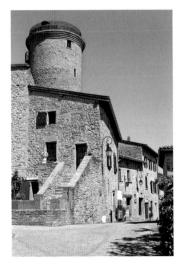

Pérouges The cobblestones of Ain

Ain (01) • Population: 1,250 • Altitude: 919 ft. (280 m)

At the top of a hill, the medieval village of Pérouges forms a circle around its square, which is shaded by a 200-year-old lime tree.

Long coveted for its prosperity, created by its weaving industry, and for its strategic position overlooking the plain of the Ain river, the town was ruled by the province of Dauphiné, and then the region of Savoy, before becoming French at the dawn of the 17th century. Despite being besieged several times, Pérouges was saved from ruin in the early 19th century and has retained an exceptional heritage inside its ramparts, with no fewer than 83 listed buildings. The fortified church, with its ramparts, arrow-slits, and keystones bearing the Savoyard coat of arms, is one of its principal treasures. Surrounded by corbeled and half-timbered mansions built in the 13th century, the Place du Tilleul, shaded by its "tree of freedom," planted in 1792, reflects several centuries of history in the narrow cobblestone streets that lead off the square, with their central gutter to channel away dirty water.

Highlights

• Fortified church (15th century): Altarpiece, wooden statues.

• Maisons des Princes: Musée d'Art et d'Histoire du Vieux Pérouges et Hortulus, watchtower, medieval garden.

• Village: Guided tours for individuals and groups; dramatized evening tours in July and August; accessible tours for the visually impaired (sensory tour, large print and Braille guidebooks, audioguides). Further information: +33 (0)4 74 46 70 84.

✓[★] Accommodation Hotels

Hostellerie du Vieux Pérouges*** and ****: +33 (0)4 74 61 00 88.

La Bérangère**: +33 (0)4 74 34 77 77. Guesthouses

Casa la Signora di Perugia***: +33 (0)4 74 61 47 03. Chez Françoise: +33 (0)6 99 31 98 69. Com' à la Maison: +33 (0)7 77 76 89 11. La Ferme de Rapan: +33 (0)7 77 76 89 11. Le Grenier à Sel: +33 (0)6 98 87 62 16. The Resid for Calixte: +33 (0)6 72 14 95 18.

T Eating Out

L'Auberge du Coq: +33 (0)4 74 61 05 47. Hostellerie du Vieux Pérouges: +33 (0)4 74 61 00 88. Le Ménestrel: +33 (0)4 74 61 11 43. Le Relais de la Tour: +33 (0)4 74 61 01 03. Les Terrasses de Pérouges: +33 (0)4 74 61 38 68. Le Veneur Noir: +33 (0)4 74 61 07 06.

Local Specialties Food and Drink

Chocolates • Galettes de Pérouges • Bugey wine. Art and Crafts Antique dealers • Ceramicist •

Costumer • Papermaker.

🖈 Events

April–November: Exhibitions and creative workshops. May 1: Crafts market. May–June: Printemps Musical de Pérouges, spring music festival; plants fair. June: Medieval festival (1st fortnight). July: Crafts market; "Festival des Temps Chaude : unsmore factival "Festival des Temps

Chauds," summer festival; "Festival des Cuivres en Dombes," brass concerts at local heritage sites; "Pérouges de Cape et d'Épée," "cape and sword" historical weekend.

October: Automnales Oenologiques (autumn wine fair). December: Christmas market.

W Outdoor Activities

Étang de l'Aubépin (lake) • Étangs des Dombes (lakes) • Walking: 4 marked trails.

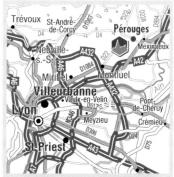

By road: Expressway A42, exit 7–Pérouges (3 ½ miles/5,5 km). By train: Villars-les-Dombes station (13 miles/21 km); Lyon-Saint-Exupéry TGV station (21 miles/ 34 km). By air: Lyon-Saint-Exupéry airport (20 miles/32 km).

(i) Tourist information: +33 (0)4 74 46 70 84 www.perouges.org

- Villars-les-Dombes: bird sanctuary (11 miles/18 km).
- Ambérieu-en-Bugey: Château des Allymes (11 miles/18 km).
- Ambronay: abbey (13 miles/21 km).
- Lyon (22 miles/35 km).

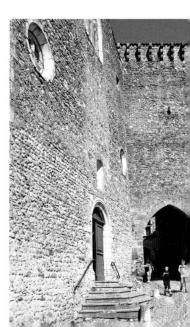

Piana On Corsica-the Isle of Beauty

Corse-du-Sud (2A) • Population: 439 • Altitude: 1,437 ft. (438 m)

At the entrance to the magnificent Calanques de Piana ("Calanche" in Corsican), which are listed as a UNESCO World Heritage Site, stands Piana, looking down over the Gulf of Porto.

The site was inhabited intermittently from the late Middle Ages until the early 16th century, but the founding of the current village dates back to the 1690s. Twenty years later, the village had 32 households, and the Chapelle Saint-Pierre-et-Saint-Paul was built on the ruins of a medieval oratory. It was decided that another, larger church should be built. Completed in 1792, it was dedicated to Sainte-Marie. Its bell tower, which was finished in the early 19th century, is a replica of the one at Portofino, on the Ligurian coast. It was on the sandy beach at Arone, near Piana, on February 6, 1943, that the first landing of arms and munitions for the Corsican Maquis (Resistance fighters) took place, delivered by the submarine *Casabianca* from Algeria.

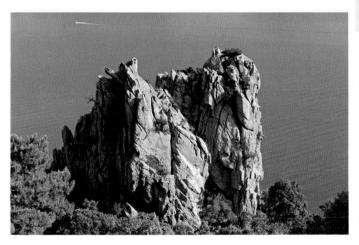

Highlights

• Church (Baroque style): Polychrome wooden door, frescoes, miniature portraits by Paul-Mathieu Novellini: +33 (0)9 66 92 84 42.

• Chapelle Sainte-Lucie (hamlet of Vistale): Byzantine-style frescoes, view of the Gulf of Porto. Open July and August.

• E Calanche di Piana: UNESCO World Heritage Site: +33 (0)9 66 92 84 42.

Accommodation

Capo Rosso****: +33 (0)4 95 27 82 40. Mare e Monti***: +33 (0)4 95 28 82 14. Les Roches Rouges***:

+33 (0)4 95 27 81 81. Le Scandola***: +33 (0)4 95 27 80 07. Les Calanches: +33 (0)4 95 27 80 83. **Guesthouses**

Giargalo: +33 (0)4 95 27 82 05. San Pedru: +33 (0)9 53 75 72 94.

Gîtes and vacation rentals

Marina d'Arone: +33 (0)4 95 23 01 46. Résidence U Casinu: +33 (0)4 95 10 78 66. Campsites

Plage d'Arone***: +33 (0)4 95 20 64 54.

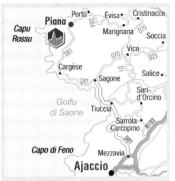

By road: D81 and D84.

By train: Ajaccio station (42 miles/68 km). By sea: Ajaccio harbor (42 miles/68 km). By air: Ajaccio-Campo Dell'Oro airport (44 miles/70 km); Calvi-Sainte-Catherine airport (49 miles/79 km).

(i) Tourist information:

+33 (0)9 66 92 84 42 www.otpiana.com

I Eating Out

Auberge U^{*}Spuntinu: +33 (o)4 95 27 80 o2. Campanile: +33 (o)4 95 27 81 71. Capo Rosso: +33 (o)4 95 27 82 40. Casabianca, Arone: +33 (o)4 95 20 70 40. Casa Corsa: +33 (o)4 95 24 57 93. Le Casanova, pizzeria: +33 (o)4 95 27 81 73. L'Onda, Arone: +33 (o)4 95 27 81 73. L'Onda, Arone: +33 (o)4 95 27 88 86. La Plage, Arone: +33 (o)4 95 20 17 27. Les Roches Rouges: +33 (o)4 95 27 81 81. La Voûte: +33 (o)4 95 27 80 46.

★ Events

Good Friday: La Granitola procession. July: Rencontres Interconfréries, Mass and procession (last Sunday). July and August: Exhibitions. August 15: Festival and procession. All year round: Exhibition of photographs by André Kertész (town hall).

W Outdoor Activities

Swimming • Walking • Mountain-biking.

- Calanche (2 miles/3 km).
- Scandola: nature reserve (6 miles/9.5 km,
- access by sea from Porto).
- Porto (7 ½ miles/12 km).
- Cargèse (12 miles/19 km).
- Gorges de la Spelunca: rocky trail
- (12 miles/19 km).
- Forêt d'Aïtone, forest (19 miles/31 km).

Le Poët-Laval

On the roads to Jerusalem

Drôme (26) • Population: 946 • Altitude: 1,007 ft. (307 m)

Surrounded by lavender and aromatic plants, this village was once a commandery.

Le Poët-Laval, bathed in Mediterranean light, emerged from a fortified commandery of the order of the Knights Hospitaller, soldier-monks watching over the roads to Jerusalem. At the summit of the village, on a steep slope of the Jabron valley, stands the massive keep of the castle, built in the 12th century. Rebuilt twice, in the 13th and 15th centuries, and topped with a dovecote, it has now been restored and hosts permanent and temporary exhibitions. Of the Romanesque Saint-Jean-des-Commandeurs chapel, situated below the castle, there remains part of the nave and the chancel, topped by a bell gable, against which the fortifications surrounding the village were built. At the southwestern corner of the ramparts, the Renaissance façade of the Salon des Commandeurs harks back to the order's heyday in the 15th century, before the village rallied to Protestantism, as witnessed by the former Protestant church, now a museum, near the Grand Portail.

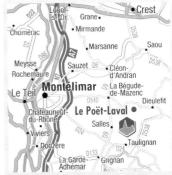

By road: Expressway A7, exit 17– Montélimar (22 miles/35 km). By train: Montélimar station (16 miles/ 26 km). By air: Valence-Chabeuil airport (45 miles/72 km); Marseille-Provence airport (106 miles/171 km).

Tourist information—Pays de Dieulefit-Bourdeaux: +33 (0)4 75 46 42 49 www.paysdedieulefit.eu www.lepoetlaval.org

Local Specialties

Art and Crafts Jewelry and clothing • Artists/galleries • Potters

★ Events

July: "Jazz à Poët" festival; three-day local sair festival (last weekend). August: Les Musicales de Poët-Laval, chamber music (early August).

W Outdoor Activities

Walking: Route GRP "Tour du Pays de Dieulefill route GR 965: departure point of the Sentier International des Huguenots and 2 short mark trails • Horse-riding • Mountain-biking.

🕊 Further Afield

 Dieulefit: Maison de la Céramique (2 ½ miles, 4 km).

• La Bégude-de-Mazenc: (4 ½ miles/7 km).

• Comps: 12th-century church; "Ruches du Monde" (beehives of the world) exhibition (6 miles/9.5 km).

- Rochefort-en-Valdaine: 10th-century castle;
- 14th-century chapel (9 ½ miles/15.5 km).
- Marsanne (13 miles/21 km).
- Grignan; Nyons (17–22 miles/27–35 km).
 - *Mirmande (21 miles/34 km), see pp. 115–16
 - Crest (23 miles/37 km).
 - *La Garde-Adhémar (24 miles/39 km), see p. 1

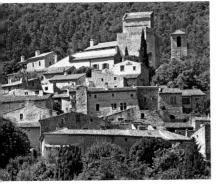

Highlights

• Castle (12th, 13th, and 15th centuries): Permanent exhibition on the reconstruction of the village and temporary exhibitions in summer: +33 (0)4 75 46 44 12.

 Centre d'Art Yvon Morin: Exhibitions, concerts: +33 (0)4 75 46 49 38.
 Musée du Protestantisme Dauphinois:

Old 15th-century residence that became a church in the 17th century; history of Protestantism in Dauphiné, from the Reformation to the present day; collections of contemporary mosaics: +33 (0)4 75 46 46 33.

• Village: Free guided tour Wednesday mornings in July and August: +33 (0)4 75 46 42 49.

Accommodation

Les Hospitaliers***: +33 (0)4 75 46 22 32. **Guesthouses** Le Mas des Alibeaux***: +33 (0)4 75 46 35 59. Ferme Saint-Hubert: +33 (0)4 75 46 48 71. Le Mas des Vignaux: +33 (0)4 75 46 55 47. Les Terrasses du Château: +33 (0)4 75 50 20 30.

Gîtes, walkers' lodges, and vacation rentals Further information: +33 (0)4 75 46 42 49

www.paysdedieulefit.eu

Campsites

Lorette**, May–September: +33 (0)4 75 91 00 62.

T Eating Out

Les Hospitaliers: +33 (0)4 75 46 22 32. La Rose des Vents, tea room, April-October: +33 (0)4 75 00 43 28. Tous les Matins du Monde: +33 (0)4 75 46 46 00.

Pradelles

Taking the Stevenson Trail

Haute-Loire (43) • Population: 651 • Altitude: 3,796 ft. (1157 m)

Protecting pilgrims and mule-drivers on the Régordane Way, Pradelles was—in the 11th century—the "stronghold of the high pastures."

Overlooking the Haut Allier valley, with the Margeride mountains to the west, Mont Lozère to the south, and the Tanargue range to the east, Pradelles was for a long time a stronghold surrounded by ramparts. A stopping place on the Régordane Way linking the Auvergne to the Languedoc, the village was also a crossroads for pilgrims traveling to Le Puy-en-Velay or Saint-Gilles-du-Gard: for merchants bringing in salt, oil, and wines from the south by mule: and for armies and free companies (of mercenaries) transporting weapons and ammunition. Throughout the ages, Pradelles' high façades have thus seen generations of travelers as diverse as Saint Jean-François Régis who, in the 17th century, preached the Catholic faith in lands bordering the Cévennes, which had been won over by Protestantism; the 18th-century highwayman and popular hero Louis Mandrin: and, more recently, Robert Louis Stevenson, who, with his donkey, traveled the route that now bears his name.

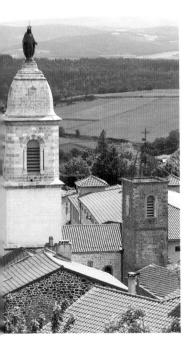

Highlights

• Musée du Cheval de Trait (draft-horse museum; in summer): Miniature village, 19th-century horse-drawn carts and carriages, multimedia show recounting the travels of Robert Louis Stevenson, stables: +33 (0)4 71 00 87 87. Village: Guided tour by appointment only: +33 (0)4 71 00 82 65.

Accommodation

L'Arche**: +33 (0)4 71 00 85 20. **Gîtes, communal gîtes, walkers' lodges, and vacation rentals** Further information: +33 (0)4 71 00 82 65 or +33 (0)4 71 00 85 74. **Campsites** Le Rocher du Grelet*: +33 (0)4 71 00 85 74. **Holiday villages** La Valette: +33 (0)4 71 00 85 74.

I Eating Out

L'Arche: +33 (0)4 71 00 82 98. L'Auvergnat Gourmand: +33 (0)4 71 07 60 62. Aux Légendes: +33 (0)4 71 00 88 00. Brasserie du Musée: +33 (0)4 71 00 87 88. La Ferme de Livarat: +33 (0)4 71 02 91 69. Le Renaissance: +33 (0)4 71 02 47 03.

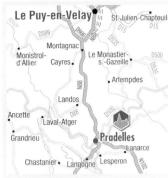

By road: Expressway A75, exit 20– Le Puy-en-Velay (60 miles/97 km), then N102-N88. **By train:** Langogne station (4 ½ miles/7 km); Puy-en-Velay station (21 miles/34 km). **By air:** Clermont-Ferrand-Auvergne airport (95 miles/153 km).

(i) Tourist information:

+33 (0)4 71 00 82 65 / www.gorges-allier.com www.pradelles-43.com

Local Specialties

Food and Drink Salted meats and fish.

★ Events

Market: Thursday mornings. July: Renaissance festival. August: Lamb fair (1st fortnight); procession of floral floats to celebrate local saint's day (15th).

W Outdoor Activities

Hunting • Fishing • Swimming pool • Horseriding • Donkey hire • Walking: Routes GR 70 (Stevenson Trail), GR 470 (Sources et Gorges de l'Allier), and GR 700 (Régordane Way); marked trails • Vélorail (pedal-powered railcars) • Mountain-biking.

🖗 Further Afield

• Langogne: Lac de Naussac, watersports base (4 ½ miles/7 km).

- Lanarce: L'Auberge Rouge, (Red Inn) (5 miles/8 km).
- *Arlempdes (11 miles/18 km), see p. 90.
- Lac du Bouchet, lake; Devès, volcanic
- field (12-22 miles/19-35 km).
- Lac d'Issarlès, lake; Mont Gerbier-de-Jonc; Mont Mézenc, (16–28 miles/26–45 km).
- Cascade de la Beaume, waterfall
- (16 miles/26 km).
- Le Puy-en-Velay (22 miles/35 km).

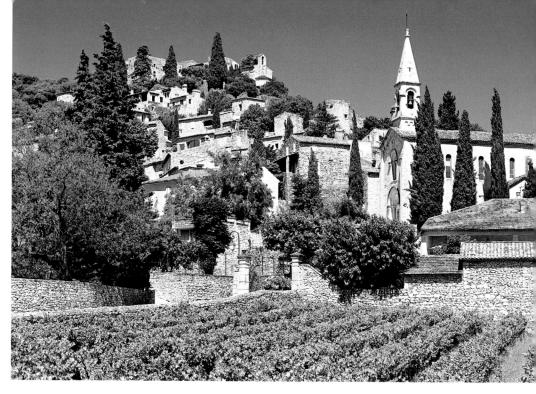

La Roque-sur-Cèze

Stone, vines, and water

Gard (30) • Population: 178 • Altitude: 295 ft. (90 m)

Surrounded by *garrigue* scrubland, La Roque-sur-Cèze has established itself on a rocky slope overlooking the Cèze river and surrounding vinyards.

Past the Pont Charles-Martel with its twelve arches, along steep, winding, cobbled streets, lies an endless jumble of buildings, rooftops, and covered terraces, whose sun-weathered stone walls and Genoese tiles give them a Tuscan feel. When you reach the top of the village, after a certain amount of physical exertion, the ruins of the 12th-century castle and its Romanesque chapel are reminders of the strategic position that the site enjoyed in the Middle Ages on the Roman road leading from Nîmes to Alba. Presenting a sharp contrast with the serenity and aridity of the village are the dramatic waterfalls, rapids, and crevices of the Cascades du Sautadet, including the magnificent "giants' cauldrons"—cylindrical cavities, some of them huge, cut into the Cèze: they require great caution but offer a refreshing place to relax in the wilderness.

By road: Expressway A7, exit 19– Bollène (17 miles/28 km); expressway A9, exit 22–Roquemaure (19 miles/31 km); N86 (6 miles/9,5 km). By train: Bollène-La Croisière station (15 miles/24 km); Avignon TGV station (29 miles/47 km). By air: Avignon-Caumont airport (32 miles/ 51 km); Nîmes-Alès-Camargue-Cévennes airport (50 miles/80 km).

Gard Rhodanien: +33 (0)4 66 82 30 02 www.tourisme-gard-rhodanien.com www.laroquesurceze.fr

TEating Out

L'Auberge des Cascades: +33 (o)4 66 50 80 98. La Créperie: +33 (o)4 66 82 08 42. La Hulotte: +33 (o)4 66 82 78 60. Le Mas du Bélier: +33 (o)4 66 82 21 39. Chez Piou, open-air café/restaurant (summer only): +33 (o)4 66 82 77 72.

Local Specialties

Food and Drink AOC Côtes du Rhône wines.

\star Events

Mid-August: Jam fair. Throughout the summer: Concerts and entertainment as part of "Les Arts de la Voix" festival.

W Outdoor Activities

Walking and mountain-biking • Swimming • Canoeing • Fishing.

🕊 Further Afield

- Chartreuse de Valbonne, monastery (3 ½ miles/5.5 km).
- Cornillon; Goudargues (5 miles/8 km).
- Pont-Saint-Esprit (6 miles/9.5 km).
- Bagnols-sur-Cèze: market (7 ½ miles/ 12 km).
- Gorges of the Cèze (9 ½ miles/15.5 km).
- *Montclus (9 ½ miles/15.5 km), see p. 117.
- *Aiguèze (11 miles/18 km), see pp. 86–87.
- Méjannes-le-Clap: Grotte de la
- Salamandre (14 miles/23 km). • Barjac: market (15 miles/24 km).
- Gorges of the Ardèche; Aven d'Orgnac, sinkhole; Vallon-Pont-d'Arc (19–25 miles/ 31–20 km).
- Uzès (19 miles/31 km).
- Orange (22 miles/35 km).
- Pont du Gard, Roman aqueduct (25 miles/40 km).
- Avignon (27 miles/43 km).

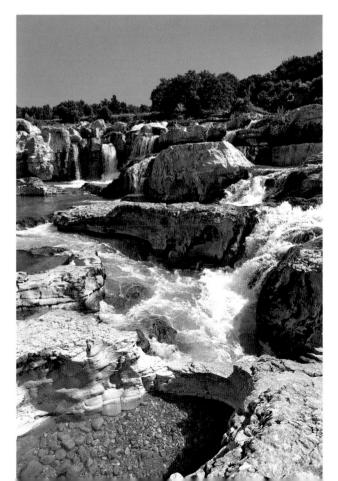

Highlights

• Village: Guided tour by arrangement: +33 (0)4 66 82 30 02.

 Church (10th century): restored in 2013, contemporary stained-glass windows.
 Chapelle du Presbytères: exhibitions.

· Chapelle du Fresbyteres. exhibitio

Accommodation

Guesthouses Le Moulin de Cors***: +33 (0)4 66 82 76 40. M. and Mme Rigaud***: +33 (0)4 66 82 79 37. Mme Welland**: +33 (0)4 66 79 27 76. Gîtes and vacation rentals Further information: +33 (0)4 66 82 30 02 www.tourisme-gard-rhodanien.com Campsites

Les Cascades****: +33 (0)4 66 82 72 97. La Vallée Verte****: +33 (0)4 66 79 08 89.

I Did you know?

Hannibal is said to have crossed the Cèze at Sautadet. Sautadet's name comes from "saut d'Hadès" (Hades's jump), Hades being the Greek god of the underworld.

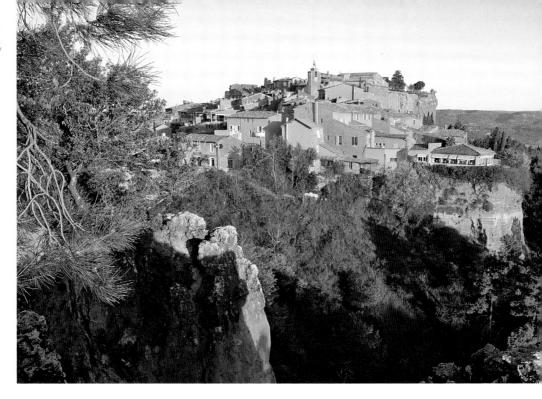

Roussillon

The flame of the Luberon

Vaucluse (84) • Population: 1348 • Altitude: 1,066 ft. (325 m)

Sparkling with colors in its verdant setting, Roussillon, north of Marseille, is a jewel in its ocher surroundings.

In Roman times, the ocher of Mont Rouge was transported to the port of Marseille, and from there it was shipped to the East. Taking over from silk farming, which was responsible for the village's rise in fortunes from the 14th century, the ocher industry developed in the late 18th century thanks to a local man, Jean-Étienne Astier, who devised the idea of extracting the pigment from the sands. Since then, Roussillon has built its reputation on this brightly colored mineral. Today, ocher presents visitors with an almost infinite palette in every narrow street and on house fronts, and can be seen, too, in its natural setting, on the ocher trail, with its spectacular sites sculpted by water, wind, and humankind. On the Place de la Mairie, a lively meeting place for both locals and visitors, the Hôtel de Ville and the houses facing it date from the 17th century.

By road: Expressway A7, exit 24–Avignon sud (23 miles/37 km); expressway A51, exit 18–Valensole (34 miles/55 km), D900 (16 miles/26 km). By train: Cavaillon station (19 miles/31 km); Avignon TGV station (32 miles/51 km). By air: Avignon-Caumont airport (25 miles/40 km); Marseille-Provence airport (54 miles/87 km).

() Tourist information: +33 (0)4 90 05 60 25 www.luberon-apt.fr www.roussillon-provence.fr

Highlights

 Conservatoire des Ocres: Guided tour on the manufacture, geology, and heritage of ocher; workshops and courses. +33 (0)4 90 05 66 69. • Sentier des Ocres (ocher trail): July and August, 9 a.m.–7.30 p.m.; off-season: +33 (0)4 90 05 60 16.

Accommodation

La Clé des Champs***: +33 (0)4 90 05 63 22. Le Clos de la Glycine***: +33 (0)4 90 05 60 13. Les Sables d'Ocre***: +33 (0)4 90 05 55 55. La Petite Auberge**: +33 (0)4 90 05 65 56. Rêves d'Ocres**: +33 (0)4 90 05 60 50.

Guesthouses

La Bastide des Ocres: +33 (o)4 90 05 64 50. Le Clos des Cigales: +33 (o)4 90 05 73 72. La Lavandine: +33 (o)4 90 05 63 24. Mas d'Estonge: +33 (o)4 90 05 63 13. Les Passiflores: +33 (o)4 90 71 43 08. Poterie de Pierroux: +33 (o)4 90 05 68 81. Li Roule: +33 (o)4 90 05 64 93. Le Trèfle à 5 [cinq] Feuilles: +33 (o)4 90 05 63 90.

Gîtes and vacation rentals

Further information: +33 (0)4 90 05 60 25 www.luberon-apt.fr Campsites

Arc-en-Ciel***: +33 (0)4 90 05 73 96.

T Eating Out

Le Bistrot: +33 (0)4 90 05 74 45. Le Café des Couleurs: +33 (0)4 90 05 62 11. Le Castrum: +33 (0)4 90 05 62 23. Chez Nino: +33 (0)4 90 74 29 17. Le Comptoir des Arts: +33 (0)4 90 74 11 92. David: +33 (0)4 90 05 60 13. La Grappe de Raisin: +33 (0)4 90 71 38 06. L'Ocrier: +33 (0)4 90 05 79 53. Le Piquebaure: +33 (o)4 90 05 79 65. Le P'tit Gourmand: +33 (o)4 90 71 82 58. La Sirmonde: +33 (o)4 90 75 70 41. La Treille: +33 (o)4 90 05 64 47.

*** Local Specialties** Food and Drink

Olive oil • Fruit juices • AOC Côtes du Luberon and Côtes du Ventoux wines. Art and Crafts

Candles - Ceramicists - Ocher-based crafts - Interior designers - Fossils and minerals - Art galleries - Artists - Sculptors.

★ Events

Market: Thursday mornings, Place du Pasquier.

June: Saint-Jean des Couleurs, Les Vieux Tracteurs (old tractors; exhibition and country fair). July: Beckett festival (late July), early music and song festival. August: String quartet festival. July and August: Outdoor film festival. September: Le Livre en Fête, book fair. November: Salon du Livre et de l'Illustration Jeunesse (books and illustrations for children fair, late November).

W Outdoor Activities

Walking: Routes GR 6 and 97, and 4 marked trails • Hot-air balloon flights.

🕊 Further Afield

- Apt (6 miles/9.5 km)
- Luberon, region (6–12 miles/9.5–19 km).
- *Gordes (6 miles/9.5 km), see pp. 104-5.
- *Ménerbes (11 miles/18 km), see pp. 113–14.
- *Lourmarin (14 miles/23 km), see pp. 111–12.
- *Venasque (15 miles/24 km), see pp. 151-52.
- L'Isle-sur-la-Sorgue (17 miles/27 km).
- Cavaillon (19 miles/31 km).
- •*Ansouis (21 miles/34 km), see pp. 88–89.

I Did you know?

Raymond d'Avignon, lord of Roussillon, having neglected his wife, Sermonde, to go off hunting, discovered she was enjoying the company of the troubadour Guillaume de Cabestan. In a jealous rage, Raymond killed his wife's lover, tore out his heart, and fed it to Sermonde, before revealing to her the nature of the dish. In despair, the lady threw herself from the cliff top. And this is why, it is said, the cliffs of Roussillon have been blood red ever since.

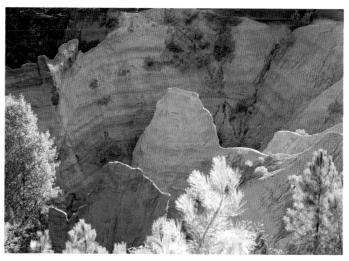

Saint-Antoinel'Abbaye Miracles in medieval Dauphiné

Isère (38) • Population: 1,039 • Altitude: 1,247 ft. (380 m)

Deep in a verdant valley surrounded by the Vercors massif, the Abbaye Saint-Antoine watches over the village that bears its name.

The history of Saint-Antoine-l'Abbaye began in the 11th century, when Geilin, a local lord, brought back from his pilgrimage to the Holv Land the relics of Saint Anthony of Egypt, who was believed to have performed many miracles. In around 1280, building started on the abbey that was to house these famous relics, which were said to have the power to cure "Saint Anthony's Fire," a poisoning of the blood that was treated by the Hospitallers (who had settled in the village after chasing out the Benedictines) in their institutions. The Wars of Religion brought this prosperous period of pilgrimages to an end. Reconstruction work undertaken in the 17th century has enabled visitors to admire the abbey-considered to be one of the most remarkable Gothic buildings in the Dauphiné region—and its rich interior. At the foot of this mighty building, the village bears living witness to the medieval and Renaissance eras: noblemen's houses built in the 15th-18th centuries from molasse stone and featuring mullioned windows link-via *aoulets* (half-covered narrow streets)-with old shops with half-timbered façades and the medieval covered market.

By road: Expressway A49, exit 9–Saint-Marcellin (8 miles/13 km); expressway A48, exit 9–La Côte-Saint-André (26 miles/24 km). By train: Saint-Marcellin station (8 miles/ 13 km); Romans station (15 miles/24 km). By air: Grenoble-Saint-Geoirs airport (19 miles/31 km); Lyon-Saint-Exupéry airport (63 miles/101 km).

(i) Tourist information: +33 (0)4 76 38 53 85

+33 (0)4 76 38 53 85 www.tourisme.pays-saint-marcellin.fr www.saint-antoine-labbaye.fr

Highlights

• Abbey church (12th–15th centuries): Murals, Aubusson tapestries, wood paneling, 17th-century organ: +33 (0)4 76 38 53 85.

• Abbey treasury: Liturgical vestments, surgical instruments, antiphonaries, 17th-century ivory Christ, one of the largest reliquaries in France: +33 (0)4 76 38 53 85.

• Musée de Saint-Antoine-l'Abbaye (museum of the Isère *département*): Housed in 17th- and 18th-century convent buildings; exhibitions on the Hospitallers of Saint-Antoine, therapeutic perfumes, and the history of the gardens; temporary exhibitions: +33 (0)4 76 36 40 68. www.musee-saint-antoine.fr

• Jardin Médiéval de l'Abbaye (medieval garden): In the Cour des Grandes Écuries, four symmetrical gardens filled with luxuriant plants, herbs, flowers, and fruit trees, together with a fountain and pools: +33 (0)4 76 36 40 68.

www.musee-saint-antoine.fr • Stonemason's workshop: Housed in the abbey's old infirmary; a presentation

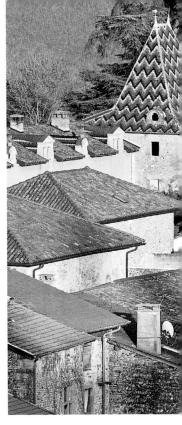

of building construction techniques in the Middle Ages, with demonstrations: +33 (0)4 76 36 44 12.

• Village: Self-guided discovery trail, "Le Sentier du Flâneur" (leaflet available from tourist information center); guided tours all year round for groups and April-October for individuals: +33 (o)4 76 38 53 85.

Accommodation

Hotels

Chez Camille: +33 (0)4 76 36 86 98. Guesthouses

L'Antonin***: +33 (0)4 76 36 41 53. Mme Philibert***: +33 (0)4 76 36 41 65. La Grange du Haut: +33 (0)4 76 64 30 74. Treehouses

Ireehouses

Les Cabanes de Fontfroide: +33 (0)4 76 36 46 84.

Gîtes and vacation rentals

Les Genets*** and **: +33 (0)4 76 36 43 81. Mme Nivon**: +33 (0)4 76 40 79 40. La Grange du Haut: +33 (0)4 76 64 30 74.

Community accommodation

Communauté de l'Arche: +33 (0)4 76 36 45 97.

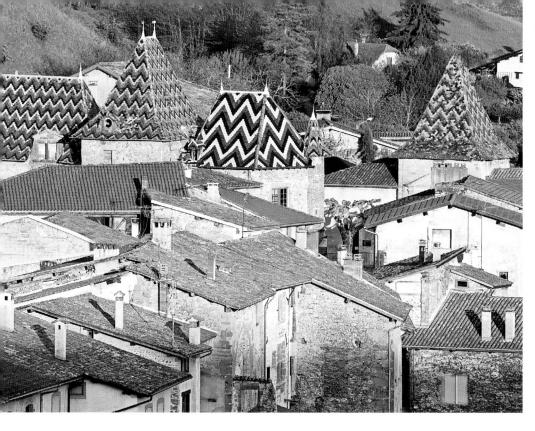

T Eating Out

L'Auberge de l'Abbaye: +33 (0)4 76 36 42 83. L'Auberge du Chapeau Rouge: +33 (0)4 76 36 45 29. Chez Camille: +33 (0)4 76 36 86 98. Hostellerie du Vieux Saint-Antoine: +33 (0)4 76 36 40 51. Mon Manège à Moi, pizzeria: +33 (0)4 76 36 40 53. Les Tentations d'Antoine: +33 (0)4 76 36 71 77.

Local Specialties

Food and Drink Honey, mead, hippocras, *pain d'épice* (spice cake) • Fruit wines.

Art and Crafts

Jewelry designer • Ready-to-wear clothing designer • Cabinetmaker • Potter • Bookbinder • Stonemason and sculptor in stone • Milliner • Painter and mixedmedia artist • Antique-furniture restorer • Local artists' galleries and studios.

★ Events

Market: Local produce and crafts market, May–October, Friday 4–7 p.m., Place de la Halle.

January: Fête de la Truffe and Marché des Tentations, truffle festival (Sunday after 17th).

May: Rare flower and plant fair (3rd Sunday).

Late June-late September: Sacred music festival (organ recitals Sundays at 5 p.m. in the abbey church).

July: "Textes en l'Air" festival, contemporary theater (penultimate week). August: Saint-Antoine en Moyen Âge (medieval festival, early August); antiques, secondhand goods, and collectors' fair (3rd Sunday).

October: Foire à l'Ancienne et aux Potirons, local produce and pumpkin fair (4th Sunday).

December: "Noël des Tentations": Christmas fair with local produce and crafts (2nd weekend).

W Outdoor Activities

Miripili, l'Île aux Pirates theme park, Étang de Chapaize • Walking and mountain-biking.

🕊 Further Afield

• La Sône: Jardin des Fontaines Pétrifiantes (exotic plants, rocks, and water; closed from mid-October to May 1); Royans-Vercors paddle steamer (7 ½ miles/12 km).

Saint-Marcellin (8 miles/13 km).

• Pont-en-Royans: Musée de l'Eau, water museum; "suspended" houses (14 miles/23 km).

- Romans: Musée de la Chaussure, shoe museum; collegiate church of Saint-Barnard (14 miles/23 km).
- Parc Naturel Régional du Vercors, nature park (14 miles/23 km).
- Grotte de Choranche, cave (16 miles/ 26 km).
- Hauterives: Postman Cheval's Palais Idéal, naive architecture (19 miles/ 31 km).

Sainte-Agnès A balcony over the Mediterranean

Alpes-Maritimes (06) • Population: 1,191 • Altitude: 2,559 ft. (780 m)

Perched nearly 2,600 ft. (800 m) in the air, the highest coastal village in Europe has an amazing panorama over the Mediterranean from Cap-Martin to the Italian Riviera.

Sainte-Agnès is a strategic site that has been fought over for centuries. It was initially a fortified Roman camp, then the site of a defensive castle built in the 12th century by the House of Savoie, and in 1932–38 its fort was dug out of the rock to become the most southerly post on the Maginot Line, built to defend the Franco-Italian border. Today the village is valued for its unique location away from the crowds and concrete of the coast. The village has an authentic feel, with its crisscrossing alleyways (some of which recall the tales of Saracen inhabitants), old cobblestones, secret vaults, and higgledy-piggledy houses. The lofty ruins of the fortified castle now contain a medieval garden designed on the theme of courtly love. From its highest point, a 360-degree panorama gives the viewer a superb contrast between the blue Mediterranean and, in winter, the snowy peaks of the Mercantour National Park.

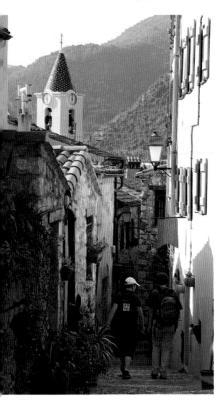

Highlights

• Espace Culture et Traditions: Local heritage museum, archeology, painting, and sculpture: +33 (0)4 93 28 35 31. • Maginot Line fort: 6.500 sq. ft. (2,000 sq. m) of galleries and rooms, multimedia exhibition: +33 (0)6 88 75 70 89.

• Église Notre-Dame-des-Neiges (16th century): Gilded wooden altar, 16th-century) stone font, 17th-century statue of Saint Agnes, 16th- and 18th-century paintings, chandeliers from Monaco Cathedral.

• Castle site: Tour of the ruins and medieval garden.

• Village: Guided tour by Menton tourist information center, Tuesday afternoons; audioguides.

Le Saint-Yves: +33 (0)4 93 35 91 45. Gîtes

Further information: +33 (0)4 92 15 21 30, or +33 (0)4 93 16 20 98 / www.sainteagnes.fr

T Eating Out

Le Logis Sarrasin: +33 (0)4 93 35 86 89. Le Righi: +33 (0)4 92 10 90 88. Le Saint-Yves: +33 (0)4 93 35 91 45.

*** Local Specialties** Art and Crafts

Leather and cloth crafts • Painter • Master glassblower.

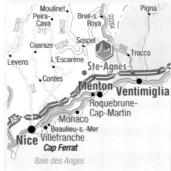

By road: Expressway A8, exit 59-Menton (6 miles/9.5 km). By train: Menton station (6 miles/9.5 km). By air: Nice-Côte-d'Azur airport (26 miles/42 km).

(i) Town hall: +33 (0)4 93 35 84 58 www.sainteagnes.fr

★ Events

January 21: Mass and procession for Saint Agnes's day.

May 1: Walking rally.

July: Fête de la Lavande et du Temps Passé, lavender and history festival (2nd fortnight). October: Fête des Champignons et de l'Automne, mushroom and autumn produce festival (mid-October); "Cinéma sous les Étoiles" festival, outdoor cinema.

W Outdoor Activities

Treasure hunt • Mountain-biking • Horseriding • Walking.

🕊 Further Afield

• Hilltop villages of Castellar, Gorbio, Peille (3–12 miles/5–19 km).

- Menton (7 miles/11.5 km).
- Monaco (12 miles/19 km).
- *Coaraze (24 miles/39 km), see p. 99.
- Nice (27 miles/43 km).

I Did you know?

A princess named Agnès was once caught in a torrential storm. She prayed to her namesake, Saint Agnes, who showed her a grotto in which to shelter. In gratitude, she decided to build a sanctuary dedicated to the saint near this grotto, around which the present village grew up. There is now a military outwork on the site of this chapel, and an oratory next to the fort. Saint Agnes's day is celebrated on January 21.

Sainte-Croixen-Jarez A charterhouse reborn as a village

Loire (42) • Population: 450 • Altitude: 1.378 ft. (420 m)

Sainte-Croix-en-Jarez has taken root in a former Carthusian monastery, with the Pilat massif as a backdrop.

Almost entirely contained within the monastery buildings, the village forms a rectangle of more than 5 acres (2 hectares) in the Pilat regional nature park. A school, town hall, and dwellings occupy the former monks' cells, which were abandoned during the French Revolution. The monastic church, with decorative paneling and Gothic stalls, contains a reproduction of Andrea Mantegna's famous *Martyrdom of Saint Sebastian* and polychrome wood statues. In the 13th-century church choir there are early 14th-century wall paintings. The charterhouse kitchen still has its enormous fireplace. A restored and furnished cell, the iron grille forged in 1692; the clock tower, its fortified façade altered in the 17th century; the cloisters; and the grand staircase all remain intact from the old monastery. The village also boasts a 12th-century chapel and the megalithic site of Roches de Marlin.

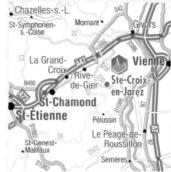

By road: Expressway A47, exit 11– Rive-de-Gier (7 ½ miles/12 km). By train: Rive-de-Gier station (5 miles/8 km); Saint-Etienne station (19 miles/31 km). By air: Saint-Étienne-Bouthéon airport (29 miles/47 km); Lyon-Saint-Exupéry airport (39 miles/63 km).

(1) Tourist Information: +33 (0)4 77 20 20 81 www.chartreuse-saintecroixenjarez.com

Highlights

• ♥ Former charterhouse (13th century): Bakery, Brothers' court, cloisters, medieval church with 14th-century wall paintings, parish church, Fathers' court, kitchen, cells. Standard and themed guided visits for groups and individuals. Further information: +33 (0)4 77 20 20 81

Accommodation

Le Prieuré: +33 (0)4 77 20 20 09. **Guesthouses** Le Clos de Jeanne***: +33 (0)4 77 54 82 28. La Rose des Vents: +33 (0)4 77 20 29 72 or +33 (0)4 77 20 22 58. **Gîtes** Le Chant du Ruisseau***: +33 (0)4 77 20 20 86. L'Elixir***: +33 (0)4 77 20 20 81.

Eating Out Le Cartusien: +33 (0)4 77 20 29 72. Le Prieuré: +33 (0)4 77 20 20 09.

Local Specialties Food and Drink Charcuterie • Cheese • Honey. Art and Crafts Basketry • Local crafts (shop and information point).

★ Events

March-April: Craft market. March-November: Art exhibitions. Pentecost: Traditional fair. July-September: Medieval supper and tour by lamplight. September: "Les Musicales," classical music festival. September-March: Family activities (giant Cluedo, games festival, treasure hunts, tours in costume).

December: Provençal crib and Christmas activities.

W Outdoor Activities

Fishing • Walking: 3 marked trails • Mountain-biking.

- Monts du Pilat (14 miles/23 km).
- Saint-Étienne (19 miles/31 km).
- Lyon (29 miles/47 km).

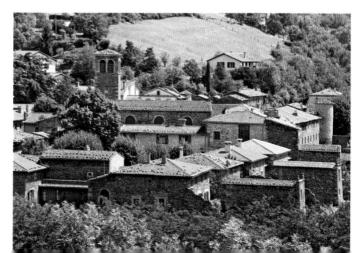

Sainte-Énimie Amid the wonders of the Tarn Gorges

Lozère (48) • Population: 548 • Altitude: 1,591 ft. (485 m)

The Merovingian princess Énimie gave her name to the village: legend has it that she was cured of leprosy in spring waters here. The village is encircled by the cliffs of the limestone plateaus of Sauveterre and Méjean, through which the Tarn has gouged its gorges. Sainte-Énimie retains its distinctive steep alleyways, massive limestone residences that evoke its prosperous past, and half-timbered workshops and houses. The Romanesque church of Notre-Dame-du-Gourg contains some splendid statues from the 12th and 15th centuries. At the top of the village, the chapel of Sainte-Madeleine and a chapter house are all that remain of a Benedictine monastery. At its feet flows the Burle river, which is supposed to have healing properties, and several paths lead to the cell to which Saint Énimie retreated. From here, there is a superb view of the village and the spectacular scenery of the Tarn, Jonte, and Causses gorges, all listed as UNESCO World Heritage Sites.

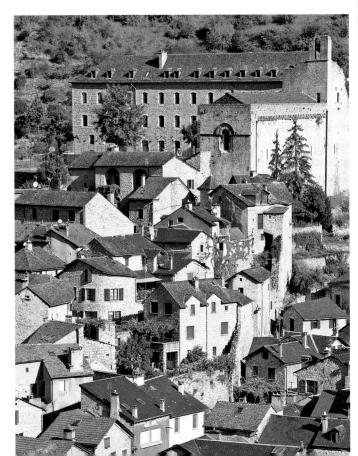

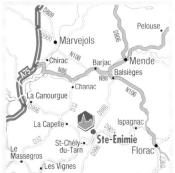

By road: Expressway A75, exit 40– La Canourgue (17 miles/28 km); N88 (12 miles/19 km); N106 (2 ½ miles/4 km). By train: Mende station (17 miles/27 km). By air: Rodez-Marcillac airport (65 miles/ 105 km); Nîmes-Arles-Camargue airport (94 miles/151 km).

() Tourist information—Cévennes-Gorges du Tarn: +33 (0)4 66 45 01 14 www.gorgesdutarn.net

Highlights

• Église Notre-Dame-du-Gourg (13th-

14th centuries): Statues, notable artifacts.

- Refectory known as the "salle
- capitulaire" (12th century).

• Chapelle Sainte-Madeleine (13th century).

• Hermit's hut: Semi-troglodyte hut over the natural grotto (45 minutes' walk from the village); viewpoint. • Village: Self-guided tour, heritage discovery trail available from tourist information center; guided evening tour at 9:30 p.m., Mondays and Wednesdays in July–August; tour with forge demonstration Thursdays in July– August: +33 (0)4 66 45 01 14.

Accommodation

Auberge du Moulin***: +33 (0)4 66 48 53 08. Auberge de la Cascade**: +33 (0)4 66 48 52 82. Le Chante-Perdrix**: +33 (0)4 66 48 55 00. Bleu Nuit: +33 (0)4 66 48 52 30. Guesthouses, gîtes, walkers' lodges, and vacation rentals Further information: +33 (0)4 66 45 01 14 www.gorgesdutarn.net

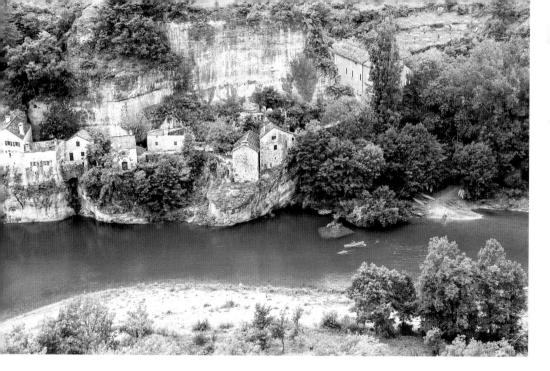

Campsites

Couderc***: +33 (0)4 66 48 50 53. Les Fayards***: +33 (0)4 66 48 57 36. Les Gorges du Tarn*: +33 (0)4 66 48 59 38. Le Site: +33 (0)4 66 48 58 08.

T Eating Out

Auberge de la Cascade: +33 (0)4 66 48 52 82. Auberge du Moulin: +33 (0)4 66 48 53 08. Au Vieux Moulin, pizzeria: +33 (0)4 66 48 58 04. Le Bel Été: +33 (0)4 66 48 18 24. La Calabrèse, pizzeria: +33 (0)4 66 31 67 90. La Cardabelle: +33 (0)4 66 48 50 49. Les Deux Sources, pizzeria: +33 (0)4 66 48 53 87. L'Eden: +33 (0)4 66 45 66 71. Les Gorges du Tarn: +33 (0)4 66 48 50 10. La Halle au Blé: +33 (0)4 66 48 59 34. Le Pêcheur de Lune, crêperie: +33 (0)4 66 48 58 12. Restaurant du Nord: +33 (0)4 66 48 53 46. La Tendelle: +33 (0)4 66 47 48 87.

Local Specialties

Food and Drink Lozère and local wines • Cheese • Charcuterie. Art and Crafts Jeweler • Potter.

★ Events

June: cartoon and book festival; music festival.

July: Pottery market; fireworks (14th). July–August: Concerts, theater, exhibitions; evening market (Thursdays); medieval shows (Tuesdays). October: Village fête and pilgrimage (1st Sunday).

W Outdoor Activities

Canoeing, canyoning • Caving • Fishing • Swimming • Climbing • Adventure park • Via Ferrata and Via Cordata • Horseriding • Walking • Mountain-biking.

🕊 Further Afield

- Causse de Sauveterre, plateau: Utopix; Boissets farm (5 miles/8 km).
- Causse Méjean: Dargilan caves and Aven
- Armand cave (4 ¹/₂-11 miles/7-18 km). • Parc National des Cévennes, national
- park (6 miles/9.5 km).

Did you know?

Énimie was the daughter of Chlothar II (584– 629) and the sister of Dagobert I (603–639), both Frankish Kings. She was the founder of the monastery whose remains can still be seen at the top of the village.

Saint-Guilhemle-Désert

Romanesque architecture and wilderness

Hérault (34) • Population: 250 • Altitude: 292 ft. (89 m)

At the bottom of a wild gorge, Saint-Guilhem surrounds its abbey, one of the finest examples of Romanesque architecture in the Languedoc.

A stopping place on the Saint James's Way, Saint-Guilhem was, in the Middles Ages, a center of Christianity, where believers, Crusaders, and pilgrims came to pray and to venerate a piece of the True Cross. Although little remains of the original abbey, founded by Saint Guilhem in the 9th century, the present church is a gem of Romanesque architecture, listed as a UNESCO World Heritage Site. The heart of the village is the delightful Place de la Liberté. There is an impressive plane tree, more than 150 years old: fountains dating from 1907; and an old 18th-century covered market with arches, making the square a magical place where people like to gather to enjoy the cool evenings on café terraces. Huddled together along the main streets, sturdy houses, with their sunweathered façades and traditional pink barrel-tiled roofs, are adorned with double Romanesque windows, Gothic lintels, and Renaissance mullions.

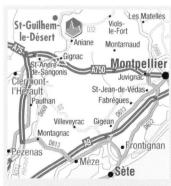

By road: Expressway A75, exit 58– Gignac-Font d'Encauvi (8 miles/13 km). By train: Montélimar TGV station (27 miles/43 km). By air: Montpellier-Méditerranée airport (37 miles/66 km).

(i) Tourist information:

+33 (0)4 67 56 41 97 or +33 (0)4 67 57 58 83 www.saintguilhem-valleeherault.fr www.saint-guilhem-le-desert.com

Highlights

• Abbaye de Gellone: Abbey church of the 11th, 12th, and 15th centuries; treasury: +33 (0)4 67 57 58 83.

• Musée Lapidaire de l'Abbaye: Collection of Romanesque and Gothic sculpture, remains of the cloister (restored); film reconstructing the history of the abbey and its rebuilding: +33 (0)4 67 57 70 17. • Musée d'Antan: History of the village and its traditional trades: +33 (0)4 67 57 77 07. • Village: Daily tours for groups and by appointment: +33 (0)4 67 57 00 03.

Accommodation

Le Guilhaume d'Orange: +33 (0)4 67 57 24 53. La Taverne de l'Escuelle: +33 (0)4 67 57 72 05. Guesthouses La Maison des Légendes:

+33 (0)6 85 39 73 70.

Gîtes and vacation rentals

Alain Duverge**: +33 (0)4 67 57 40 22. Lou Cap del Mund: +33 (0)4 67 71 76 67. Lucette Diez: +33 (0)4 67 22 42 70. Walkers' lodges, accommodation for groups

Further information: +33 (o)4 67 57 58 83 www.saintguilhem-valleeherault.fr

T Eating Out

La Belliloise, crêperie: +33 (0)4 67 58 89 20. Le Bon Moment: +33 (0)4 67 86 61 64. Isa and Luc, tea room: +33 (0)4 67 58 83 31. Le Logis des Pénitents, crêperie: +33 (0)4 67 57 48 63. Le Musée d'Antan, tea room: +33 (0)4 67 57 77 07. L'Oustal Fonzes: +33 (0)4 67 57 39 85. Le Petit Jardin: +33 (0)4 67 57 35 18. La Source: +33 (0)6 59 29 56 34. Sur le Chemin: +33 (0)4 99 63 93 71. La Table d'Aurore: +33 (0)4 67 57 24 53. La Taverne de l'Escuelle: +33 (0)4 67 57 72 05. Le Val de Gellone, pizzeria: +33 (0)4 67 57 33 99. Vent de Soleil, light meals: +33 (o)4 67 57 78 85. La Voûte Gourmande, light meals: +33 (0)4 67 57 33 65.

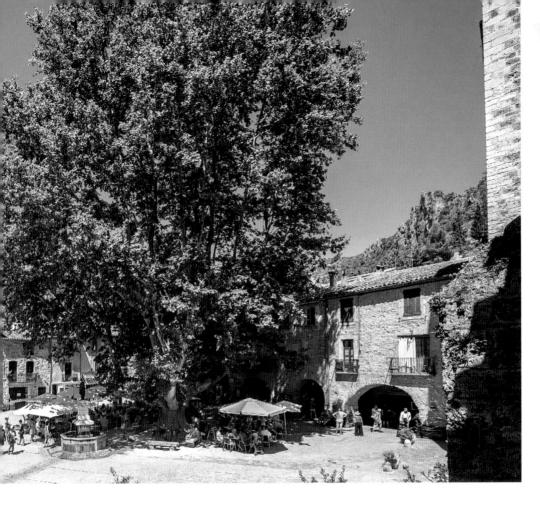

Local Specialties

Food and Drink Olive oil and grapes • Trout and crawfish • Wine and truffles. Art and Crafts

Craftsmen • Painters • Potters • Sculptors.

★ Events

July–September: Musical season and *heures d'orgues* (organ recitals), theater, exhibitions.

December: Christmas concert (abbey church), Christmas market.

I Did you know?

Legend tells that a bloodthirsty giant used to live in the castle overlooking the Gellone valley. His only companion was a mischievous magpie that liked to play tricks on him. When the magpie warned

W Outdoor Activities

Swimming • Fishing • Canoeing • Walks for all levels • Caving.

🕊 Further Afield

• Pont du Diable, bridge; Grotte de Clamouse, cave (2 miles/3 km).

- Saint-Jean-de-Fos: Argileum, pottery workshop (2 ½ miles/4 km).
- Aniane: Maison du Grand Site de France (5 miles/8 km).
- Gignac (9 ½ miles/15.5 km).
- Clermont-l'Hérault; Lac de Salagou, lake (16 miles/26 km).

him that Guilhem was coming to challenge him, the giant thought the magpie was deceiving him again; he was taken off guard by Guilhem, who threw him from the top of the castle. Since then, magpies have not dared venture near the village.

Saint-Véran

"Where hens peck at the stars"

Hautes-Alpes (05) • Population: 235 • Altitude: 6,699 ft. (2,042 m)

The highest inhabited village in Europe—hence its motto. "where hens peck at the stars"—Saint-Véran lies at the heart of the Queyras regional nature park.

As Saint-Véran has been accessible by road for little more than a century, the inhabitants had plenty of time to learn to pull together in this extreme environment (altitude of 6,699 ft./2,042 m). They battled floods, avalanches, and fires; and worked shale and larch in the Queyras to build the *fustes* and *casets* (traditional dwellings that shelter animal fodder and livestock under protruding roofs). They also smelted copper, carved wood, tapped the water from the hill-sides for their fountains, and harnessed the sun's rays for their brightly colored sundials. Moreover, they devised both winter and summer tourism, which capitalizes on the great outdoors while respecting their traditions. The mission crosses, erected in tribute to missionaries who came to convert this Queyras backwater, symbolize the area's fervent religious belief and practice, and form part of its heritage.

Highlights

Church (17th century): Stone lions, font.
 Old copper mine exhibition: In the communal oven at Les Forannes.

• Maison Traditionnelle: Traditional house, inhabited and shared with animals until 1976; preserved (furniture, everyday objects, clothes): +33 (o)4 92 45 82 39.

• Musée Le Soum: The oldest house in the village (1641); discover village life and traditions in bygone days: +33 (0)4 92 45 86 42.

• Observatory (alt. 9,633 ft./2,936 m): Tour of the dome and its equipment; further information, Saint-Véran Culture Développement: +33 (0)6 60 31 23 33. • Maison du Soleii: Complex dedicated

to solar observation, interactive experience; further information, Saint-Véran Culture Développement: +33 (0)6 60 31 23 33.

• Village: Guided tour for groups only, by reservation. Further information: +33 (0)4 92 45 82 21.

Accommodation

L'Alta Peyra****: +33 (0)4 92 22 24 00. Les Chalets du Villard***: +33 (0)4 92 45 82 08. Le Grand Tétras**: +33 (0)4 92 45 82 42. Auberge Coste Belle: +33 (0)4 92 45 82 17. Auberge L'Estoilies: +33(0)4 92 45 82 65. La Baïta du Loup, gîte-hotel: +33 (0)4 92 54 00 12. **Guesthouses** Cascavelier: +33 (0)4 92 45 88 31. La Chevrette: +33 (0)4 92 45 88 42.

La Chevrette: +33 (0)4 92 45 81 42. Jacqueline and Eric Turina: +33 (0)4 92 45 81 77.

Gîtes and vacation rentals

Further information: +33 (0)4 92 45 82 21 or +33 (0)4 92 51 04 23/ www.saintveran.com

Family vacation centers, accommodation for groups Les Perce-Neige: +33 (0)4 92 45 82 23.

Vacation villages

Centre de montagne OVL Saint-Ouen: +33 (0)4 92 45 82 28.

Walkers' lodges

Le Chalet des Routiers: +33 (0)4 75 02 01 12. Le Chant de l'Alpe: +33 (0)4 92 54 22 41. Les Gabelous: +33 (0)4 92 45 81 39. Les Perce-Neige: +33 (0)4 92 45 82 23. Mountain refuges

Refuge de la Blanche (alt. 8,202 ft./ 2,500 m): +33 (0)4 92 45 80 24. RV parks (June–September): +33 (0)4 92 45 83 91

T Eating Out

Auberge L'Estoilies: +33 (0)4 92 45 82 65. La Baïta du Loup: +33 (0)4 92 54 00 12.

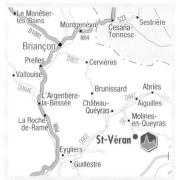

By road: Expressway A32, exit 12–Oulx Circonvalazzione (50 miles/80 km); N94 (35 miles/56 km). By train: Montdauphin-Guillestre station (24 miles/39 km); Briançon station (30 miles/48 km). By air: Marseille-Provence airport (162 miles/261 km).

(i) Tourist information—Queyras: +33 (0)4 92 45 82 21 www.saint-veran-queyras.com Les Amis de Saint-Véran www.saintveran.com

Coste Belle: +33 (0)4 92 45 82 17. Le Bouticari: +33 (0)4 92 45 89 20. Les Chalets du Villard—La Gratinée: +33 (0)4 92 45 82 08. Le Dardaya : +33 (0)4 92 22 24 00. La Fougagno: +33 (0)4 92 45 86 39. Le Grand Tétras: +33 (0)4 92 45 82 42. La Maison d'Élisa: +33 (0)4 92 45 82 48. La Marmotte: +33 (0)4 92 45 84 77. Refuge de la Blanche: +33 (0)4 92 45 80 24. Le Roc Alto: +33 (0)4 92 22 24 00.

Local Specialties

Food and Drink Queyras honey. Art and Crafts Craft courses (plant collecting, lacemaking, weaving, knitting) • Cutlerblacksmith • Wood carvers.

★ Events

January: Cross-country skiing in the Queyras (last Sunday). February-early March: Shows, taster workshops, snowshoeing outings, torchlit descents.

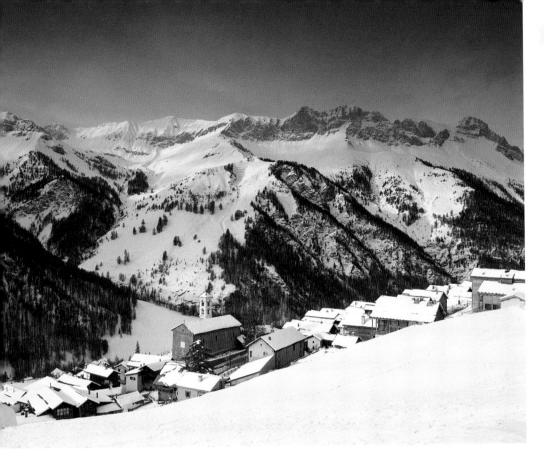

July: Franco-Italian pilgrimage to Clausis chapel (16th); Saint Anne's day at Raux (Sunday nearest 26th).

July-August: Sale of bread baked at the communal oven; "Astro-Raquette" (snowshoeing and star-gazing); guided tours in the steps of the miners. August: "Fête des Traditions" festival.

W Outdoor Activities

Climbing • Forest adventure course • Fishing • Walking • Pack-donkey or packhorse rides • Skiing: Alpine, crosscountry, ski touring, snowshoeing • Mountain-biking.

🕊 Further Afield

- Château-Queyras (8 ½ miles/13.5 km).
- Aiguilles; Abriès (10–13miles/16–21 km).
 Col d'Agnel and the Italian border
- (12 miles/19 km).

- Guillestre; Mont-Dauphin (24 miles/ 39 km).
- Col de l'Izoard (30 miles/48 km).
- Briançon (30 miles/48 km).

I Did you know?

In the old days, using wood as a fuel for heating caused many fires. To prevent blazes from ripping through the village, the inhabitants carved up their settlement into five distinct areas, each separated from the others by open spaces in which building was prohibited. This created small neighborhoods that still exist today. Each neighborhood had its own bread oven and fountain—made up of a circular part, used as an animal drinking trough, and a rectangular part acting as a laundry area. Each neighborhood also worshiped separately in its own chapel and with its own mission cross.

Sant'Antonino

In the skies over the Balagne

Haute-Corse (2B) • Population: 113 • Altitude: 1,624 ft. (495 m)

From its eagle's nest high above the Balagne, Sant'Antonino surveys the Mediterranean and Corsica's mountains.

Although the Chapelle de La Trinité outside the village was built in the 12th century, families began to settle here only in the 15th century. They fused their homes together in the rock so that they became a protective wall to withstand invaders. The houses are so tightly packed that there was not enough space to build churches. Only the Chapelle Sainte-Anne is in the village itself; all the others, including the Chapelle de la Trinité and the parish church of L'Annonciade, were built in a meadow outside the village. Sant'Antonino is one of Corsica's oldest villages, with origins reputedly dating back to the 9th century. Stone reigns supreme here: in the tall facades of houses gripping the granite; in cobblestones mingling with rock in narrow, winding alleyways; in vaulted passageways leading to the old castle ruins. From here you can see right across the plain and the olive-planted hills of the Balagne, all the way to the shining sea. In a secluded spot on the former threshing ground at the foot of the village, the Baroque church of L'Annonciade houses an organ by the Italian artist Giovanni Battista Pomposi, dating from 1744.

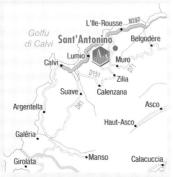

By road: N197 (6 miles/9.5 km). By boat: L'Île Rousse port (7 ½ miles/ 12 km); Calvi port (13 miles/21 km). By air: Calvi-Sainte-Catherine airport (12 miles/19 km).

(i) Town hall: +33 (0)4 95 61 78 38 www.santantonino.fr

Wines, muscats • Olive oil • Corsican charcuterie and cheeses.

★ Events

June: Corsican shepherd songs; religious festival at Notre-Dame-des-Grâces.

W Outdoor Activities

Donkey rides • Walking: 3 marked trails • Mountain-biking.

🕊 Further Afield

Aregno; Corbara; L'Île-Rousse (10 miles/ 16 km).
Calvi (11 miles/18 km).

I Did you know?

Sant'Antonino was founded in the early 9th century by Guido Savelli, the lieutenant of Ugo Colonna (a significant figure in Corsica after conquering the Moors to take the island). The Savellis were a warrior family who won fame for their independent spirit through the centuries: during the Genoese occupation they invited the occupiers to a banquet just so that they could massacre them. Similarly, during the siege of Calvi, Savelli refused to surrender the village, even after seeing his son killed before his own eyes.

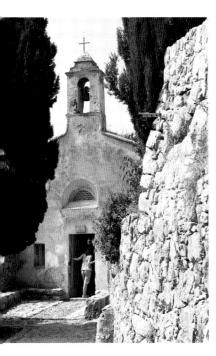

Highlights

 Église de l'Annonciade (17th century): 18th-century organ, historic paintings.
 Chapelle de la Trinité (12th century).

Accommodation Gîtes and vacation rentals

Further information: +33 (0)4 95 61 78 38 www.santantonino.fr

T Eating Out

A Casa Corsa: +33 (0)4 95 47 34 20. A Merendella: +33 (0)4 95 61 74 27 or +33 (0)6 25 86 25 96. A Stalla: +33 (0)4 95 61 33 74. Le Bellevue: +33 (0)4 95 61 73 91. U Lazzu, light meals: +33 (0)6 43 11 72 08. Sant'Antonino Café. I Scalini: +33 (0)4 95 47 12 92. U Spuntinu, light meals: +33 (0)6 12 96 94 43. La Taverne Corse: +33 (0)4 95 61 70 15. La Voûte, pizzeria: +33 (0)4 95 61 74 71.

Local Specialties Food and Drink Almonds • Citrus fruits • Jams •

Séguret The vineyards of Montmirail

Vaucluse (84) • Population: 945 • Altitude: 886 ft. (270 m)

With a front-row seat, Séguret overlooks the Rhône valley from the foot of the Dentelles de Montmirail mountain chain.

On a hillside dominated by its medieval castle tower. Séguret rises above a landscape of vineyards. Inhabited since prehistoric times and improved in the Gallo-Roman era, the village proper was built in the 10th-12th centuries. Until the French Revolution it was a papal state, then rejoined France in 1792. Its heritage is considerable: winding streets. cobblestones, the Reynier Gate, the 15thcentury belfry, the Romanesque Saint-Denis church (12th-13th centuries), the chapel of Notre-Dame-des-Grâces (17th century), and the Mascarons fountain (17th century). The Place des Arceaux and the Place de l'Église command marvelous views over the Comtat plain, as far as the Rhône and the Cévennes rivers. The village has great respect for its traditions, and every Christmas celebrates the Bergié, a mystery play that has been handed down orally from generation to generation since the Middle Ages.

Highlights

• Chapelle Notre-Dame-des-Grâces (17th century): By appointment only: +33 (0)4 90 46 91 08.

• Chapelle Sainte-Thècle (18th century): Exhibition of paintings and santons (crib figures). Further information: +33 (0)4 90 36 02 11.

 Église Saint-Denis (12th-13th century): By appointment only: +33 (0)4 90 46 91 08.
 Village: Signposted walk.

Accommodation

♥ Domaine de Cabasse***:
 +33 (0)4 90 46 91 12.
 La Bastide Bleue: +33 (0)4 90 46 83 43.
 Guesthouses
 Patios des Vignes: +33 (0)4 90 65 47 96.
 Gites and vacation rentals
 Le Balcon de Séguret***:
 +33 (0)6 09 18 18 98.
 Daniel Vollkindt***: +33 (0)4 90 46 86 15.
 Marie-José Gras**: +33 (0)4 90 46 95 21.
 Clairette Bayle**: +33 (0)4 90 46 97 86.
 M. and Mme Corbit*: +33 (0)4 90 46 95 46.

T Eating Out

La Bastide Bleue: +33 (0)4 90 46 83 43. Côté Terrasse: +33 (0)4 90 28 03 48. L'Églantine, tea room: +33 (0)4 90 46 81 41. La Table de Cabasse: +33 (0)4 90 46 91 12. Le Mesclun: +33 (0)4 90 46 93 43.

Local Specialties

Food and Drink AOC Côtes du Rhône and local wines Art and Crafts Postcard publisher • Pottery • Santons (crib figures) • Art gallery.

★ Events

July: Local saint's day (3rd Sunday). July–August: "Musiques dans les Vignes," music festival (end July–early August); book fair (August 15); "Fête d'Hue Vin," wine-tasting and traditional activities (4th Sunday); harvest festival (end August). December: "Bergié de Séguret," mystery play (24th); Journée des Traditions, heritage fair (3rd Sunday).

December–January: *Santons* (crib figures) exhibition.

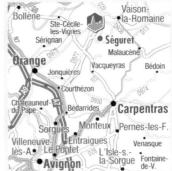

By road: Expressway A7, exit 22–Orange Sud (14 miles/23 km). By train: Orange TGV station (12 miles/19 km); Avignon TGV station (29 miles/47 km). By air: Avignon-Caumont airport (33 miles/53 km); Marseille-Provence airport (71 miles/114 km).

① Tourist information—Pays de Vaison Ventoux en Provence:

+33 (0)4 90 36 02 11 www.vaison-ventoux-tourisme.com www.seguret.fr

W Outdoor Activities

Hunting • Fishing • Cycle routes • Climbing in the Dentelles de Montmirail • Walking: Route GR 4.

- Dentelles de Montmirail, chain of mountains (3 miles/5 km).
- Vaison-la-Romaine (5 miles/8 km).
- Orange (14 miles/23 km).
- Carpentras (14 miles/23 km).
- *Venasque (21 miles/34 km), see pp. 151–52.
- Avignon (25 miles/40 km).
- Mont Ventoux (25 miles/40 km).
- *La Garde-Adhémar (25 miles/40 km), see p. 100.

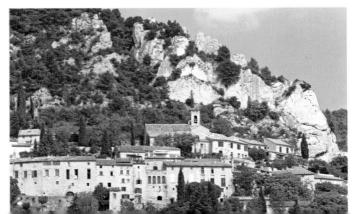

Seillans Tradition and innovation in a Provençal village

Var (83) • Population: 2,555 • Altitude: 1,201 ft. (366 m)

From below, Seillans looks like a huge staircase, its tall façades scaling the slope in steps.

Gathered at the top, as if on a throne, are the Sarrasine Gate, a medieval castle, a former priory of monks from Saint-Victor Abbey in Marseille, and the 11th-century church of Saint-Léger. Inside its three consecutive walls. Seillans is a patchwork of light and shade. an enticing maze of paved streets still echoing to the sound of horse hooves, steeply sloping cobbled alleys, vaulted passageways, and shady corners in which fountains tinkle musically. On the square at the entrance to the village stands the statue "Génie de la Bastille" by Max Ernst (1891-1976), a permanent reminder that he fell so in love with Seillans that he moved here with his wife. Dorothea Tanning, and used to enjoy playing pétanque with the locals on this very spot. In the valley below, where pines. olive trees. and vinevards jostle for space, the chapel of Notre-Dame-de-l'Ormeau protects an altarpiece unique in Provence. The village welcomes artists and craftspeople to its silk farm and old cork factory, emblems of its past economic life, and also spotlights events that celebrate artistic expertise and innovation.

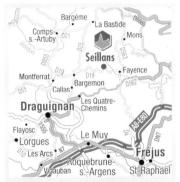

By road: Expressway A8, exit 39– Les Adrets-de-l'Estérel (13 miles/21 km). By train: Arcs-Draguignan TGV station (19 miles/31 km); Saint-Raphaël-Valescure TGV station (22 miles/35 km). By bus: Nos. 3601 from Saint-Raphaël bus station (25 miles/40 km) and 3001 from Grasse bus station (20 miles/32 km). By air: Nice-Côte-d'Azur airport (40 miles/64 km).

() Tourist information: +33 (0)4 94 76 85 91 www.paysdefavence.com / www.seillans.fr

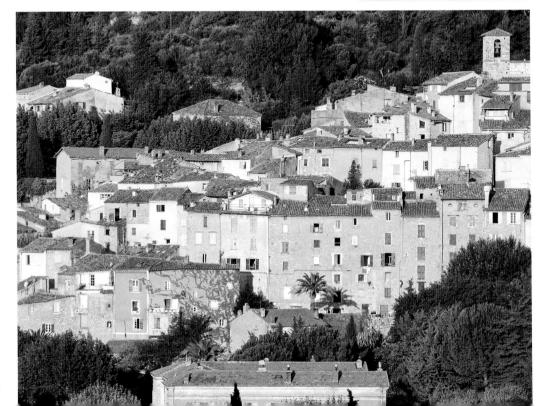

Highlights

• ChapeIle Notre-Dame-de-l'Ormeau (12th century): Provençal Cistercian building; 16th-century polychrome woodcarved altarpiece, unique in Provence. Tours all year round by appointment for groups 5+, Thursdays 11.15 a.m.: +33 (0)4 94 76 85 91.

• Max Ernst, Dorothea Tanning, and Stan Appenzeller Collections: In the Maison Waldberg (mid-13th-century mansion), a collection of lithographs by surrealist artists Max Ernst and Dorothea Tanning, made while the couple lived in Seillans; a collection of works by artist Stan Appenzeller (1901–1980). Guided tours all year round for groups of 5+ by appointment: +33 (0)4 94 76 85 91. • Village: Guided tours, Thursdays,

10 a.m. all year round, for groups of 5+, by reservation: +33 (0)4 94 76 85 91.

Accommodation

Les Deux Rocs***: +33 (0)4 94 76 87 32. Guesthouses

La Cabane d'Esteban: +33 (0)6 27 27 58 35. Chez.Niko et Julie: +33 (0)6 64 83 76 99. La Magnanerie de Seillans: +33 (0)4 94 50 83 56 or +33 (0)6 20 13 73 67. Le Mas de Canbelongues: +33 (0)4 94 47 65 27 or +33 (0)6 24 77 20 23. Les Mûriers: +33 (0)4 94 85 51 46 or +33 (0)6 11 60 33 90. Gîtes, vacation rentals, and vacation centers

Further information: +33 (0)4 94 76 85 91www.paysdefayence.com

Rural campsite

Le Rouquier: +33 (0)4 94 76 86 71 or +33 (0)6 88 18 00 05.

T Eating Out

Bar Charlot, light meals: +33 (o)4 94 76 40 82. Chez Hugo: +33 (o)4 94 85 54 70. Les Deux Rocs: +33 (o)4 94 76 87 32. La Gloire de Mon Père: +33 (o)4 94 76 98 68. Pepperoni and Co, pizzeria: +33 (o)4 94 68 15 85. Tilleul Citron, tea room: +33 (o)4 94 50 47 64.

Local Specialties Food and Drink

Honey • AOC Côtes de Provence wine • Olive oil • Farm produce • Goat cheese • Institut Gastronomique (cookery courses). Art and Crafts

Art galleries and studios • Ceramicist •

Cabinet designer and -maker • Wrought ironwork • Figurine maker and history painter • Engraver • Model-maker • Leather craftsman • Painters • Beadmaker • Soap-maker • Silk screening • Sculptor • Photographer.

★ Events

Market: Wednesday mornings, 8 a.m.-12.30 p.m., Place de la République. February: Cycle tour, Haut Var (last weekend). March: Marché Gourmand, gourmet market (1st Sunday). April: "Des Roses et des]asmins," cycling competition. May: "Salon de Mai," art exhibition; art and crafts market. May-June: "Les Rencontres de la Photo," photography exhibition. July: Notre-Dame-des-Selves Provençal fair (1st weekend); feast day of Saint Cyr and Saint Léger (last weekend). July-August: Contemporary and/or surrealist art exhibition. August: "Musique Cordiale," music festival (1st fortnight); pottery market (15th); art and crafts market. September: Art and crafts market. September-November: Provencal

heritage and history exhibition

(September 15–November 6). October: "Musique en Pays de Fayence," music festival (last week).

November: Fête de l'Olive, olive festival (last weekend); Christmas market (last Sunday).

December: Christmas exhibition, craft fair, and "13 Desserts" (Provençal dessert tasting).

W Outdoor Activities

Sports park with multisports area • *Pétanque* • Horse-riding • Swimming pool (July–August) • Walking: 15 marked trails.

🕊 Further Afield

- Pays de Fayence, region: hilltop villages (3–12 miles/5–19 km).
- Gorges of the Siagnole (9 ½–12 miles/ 15.5–19 km).
- Lac de Saint-Cassien, lake (12 miles/19 km).
- Grottes de Saint-Cézaire, caves (19 miles/ 31 km).
- *Bargème (21 miles/34 km), see p. 92.
- Draguignan (22 miles/35 km).
- Grasse (22 miles/35 km).
- La Corniche d'Or, coastal drive; Saint-
- Raphaël; Fréjus (24 miles/39 km).
- *Tourtour (27 miles/43 km), see pp. 148–49.

Semur-en-Brionnais ^{Cluny history in Burgundy}

Saône-et-Loire (71) • Population: 649 • Altitude: 1,299 ft. (396 m)

Birthplace of Saint Hugh, one of the great abbots at the powerful monastery of Cluny, Semur is the historic capital of the Brionnais region, in the depths of Burgundy.

Founded on a rocky spur, in the 10th century Semur-en-Brionnais became a defensive site ruled by the counts of Chalon. The Château Saint-Hugues is considered one of the oldest fortresses in Burgundy, and its keep is intact. Inside, a collection of posters evokes the French Revolution, during which time the guards' rooms functioned as a prison. The Romanesque church dedicated to Saint Hilaire was erected by Geoffroy V in the 12th and 13th centuries. Its gate shows the saint defending the Catholic orthodoxy against Arians at the Council of Seleucia. Inside, the triple elevation of the nave and the corbeled gallery are directly inspired by Cluny. The chapter house, founded in 1274 by Jean de Châteauvillain, provides information about the Romanesque style in the Brionnais. The main square contains the 18th-century law courts (now the town hall), 16th-century men-at-arms' houses, and the salt store, whose ceiling is decorated with allegorical paintings. The rampart walk still exists, as does the postern gate. Nestled in the valley, the 11th-century church of Saint-Martin-la-Vallée is decorated with 14th-century wall paintings.

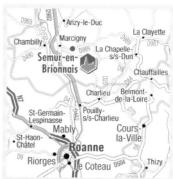

By road: Expressway A6, exit 33–Balbigny (36 miles/58 km); N79 (12 miles/19 km); expressway A89, exit 5.1–Balbigny (40 miles/64 km), then N82-N7 (18 miles/ 29 km). By train: Paray-le-Monial station (17 miles/27 km); Le Creusot-Montceau TGV station (49 miles/79 km). By air: Lyon-Saint-Exupéry airport (79 miles/ 127 km).

() Tourist information: +33 (0)3 85 25 13 57 www.semur-en-brionnais.fr

Highlights

• **Château Saint-Hugues** (10th century): Keep, towers, medieval warfare room; French Revolution poster collection; family tree of Hugh of Semur, abbot of Cluny: +33 (0)3 85 25 13 57.

• Collegiate church of Saint-Hilaire (12th–13th centuries): Pre-eminent Romanesque church in the region; polychrome wood statues.

• Église Saint-Martin-la-Vallée (11– 12th centuries): 15–16th-century wall paintings.

• Maison du Chapitre: Hall with ceiling and fireplace painted late 16th century; exhibition about Romanesque art in the region.

• Salt store: Building where salt tax was paid; ceiling decorated with allegorical paintings from end of 16th century.

 Former law courts (now the town hall) (18th century): Louis XVI-style building.
 Saint-Hugues priory: Chapel, reception hall (exhibition).

• Village: Various guided tours for groups, May–November. Further information: "Les Vieilles Pierres" association: +33 (0)3 85 25 13 57.

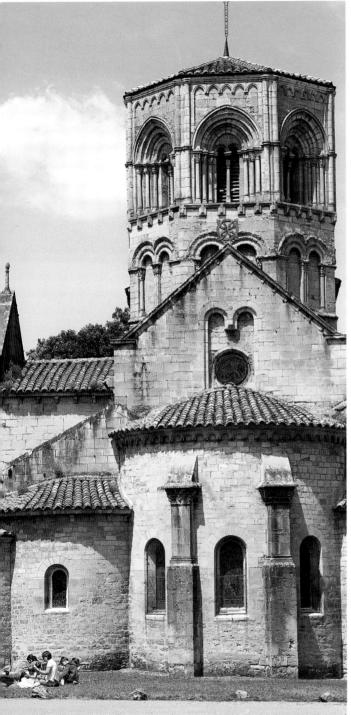

✓ Accommodation Guesthouses Maison Guillon Kopf: +33 (0)3 85 81 55 59.

Malson Guillon Rop: +33 (0)3 85 81 55 5 Gîtes Belle Vue***, farm accommodation: +33 (0)6 42 70 03 89. M. Lorton: +33 (0)3 85 25 36 63.

T Eating Out

L'Entrecôte Brionnaise: +33 (0)3 85 25 10 21.

Local Specialties

Food and Drink Brionnais wines. Art and Crafts Monastic crafts.

★ Events

May-October: Exhibitions in the salt store. July: La Madeleine, patron saint's day (1st weekend after 14th). August: Art market (1st Sunday); medieval supper (1st Tuesday evening).

W Outdoor Activities

Walking • Mountain-biking.

🕊 Further Afield

- Marcigny: museums and exhibitions (3 miles/5 km).
- Voie Verte, picturesque greenway (3 miles/5 km).
- Saint-Christophe-en-Brionnais:
- cattle market (5 miles/8 km).
- Romanesque churches in Brionnais region: Anzy-le-Duc, Iguerande, Montceaux-l'Étoile, Saint-Julien-de-Jonzy (6–9 ½ miles/9.5–15.5 km).
- Charlieu: abbey (12 miles/19 km).
- Paray-le-Monial (16 miles/26 km).
- Château de Drée (16 miles/26 km).
- Roanne (20 miles/32 km).

I Did you know?

In 1024 Hugh was born at Semur castle; he later became the sixth chief abbot of the Cluniac order. For 60 years, until his death, he led the order of more than 10,000 monks across the Christian world. He also built the great abbey church, sadly destroyed after the French Revolution, which was the largest church in all Christendom before the construction of Saint Peter's in Rome.

Sixt-Fer-à-Cheval

Nature writ large

Haute-Savoie (74) • Population: 800 • Altitude: 2,493 ft. (760 m)

At the foot of the mountains of Savoie, Sixt-Fer-à-Cheval has a rich natural, religious, and architectural heritage.

The first historical references to Sixt relate to the foundation of the abbey in 1134 by Ponce de Faucigny, from a powerful family of local lords. With his monks, Faucigny directed activities in this sparsely populated region and gave the village a strong religious identity. Nestled in a glacial valley surrounded by two important cirques, Sixt is above all a village that knows how to preserve its traditions and natural heritage. The Fer-à-Cheval cirque, the Cascade du Rouget waterfall, and the Gorges des Tines are the local area's main listed natural heritage sites, and among the most famous in the whole region. They are easy to reach and therefore allow everybody to see the highlights of this magnificent scenery as well as the largest nature reserve in Haute-Savoie. In winter, Sixt is a ski resort linked to the Grand Massif by the excellent Piste des Cascades.

By road: Expressway A40, exit 18–Scionzier (17 miles/27 km). By train: Cluses station (15 miles/24 km). By air: Geneva airport (39 miles/63 km); Annecy-Meythet airport (43 miles/69 km).

() Tourist information: +33 (0)4 50 34 49 36 www.sixtferacheval.com

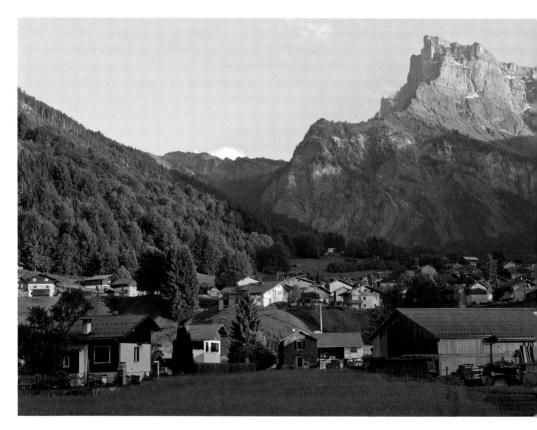

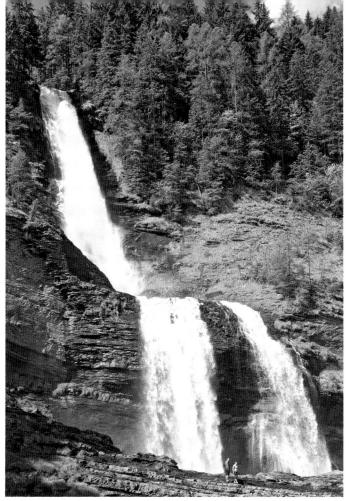

Highlights

• Abbey (12th century) and village: Guided tour of the village and abbey, Mondays in school vacations: +33 (0)4 50 34 49 36.

• Protected natural sites: Fer-à-Cheval cirque, walk to the valley bottom in summer; cirque visitor center with exhibition "Dans Mon Ciel, un Gypaète Barbu," about bearded vultures; Gorges des Tines, Cascade du Rouget, Cascades de la Pleureuse, and Cascades de la Sauffaz waterfalls: numerous walking trails: +33 (0)4 50 34 49 36.

• Maison de la Réserve naturelle: Permanent exhibition, model of the valley, stuffed animals, and temporary exhibitions: +33 (0)4 50 34 49 36.

Accommodation

Le Choucas**: +33 (0)4 50 34 47 60. Guesthouses

L'Alpée: +33 (0)4 50 89 06 18. Chalet Vaia: +33 (0)4 50 89 70 44. Chambre d'Hôtes du Mont:

+33 (0)4 50 34 95 10.

Gîtes, walkers' lodges, and vacation rentals

Further information: + 33 (0)4 50 34 49 36 www.sixtferacheval.com

Family vacation centers Le Choucas: +33 (0)4 50 34 47 60. Le Salvagny: +33 (0)4 50 34 42 09. Campsites

Le Pelly**: +33 (0)4 50 34 12 17. Point Accueil Jeunes du Pont de Sales: +33 (0)4 50 34 44 25.

Mountain refuges

Anterne Alfred Wills (alt. 5,928 ft./1,807 m): +33 (0)6 70 63 12 45. Les Fonts (alt. 4,528 ft./1,380 m): +33 (0)4 50 34 12 41. Le Grenairon (alt. 6,398 ft./1,950 m): +33 (0)4 50 34 47 31. Sales (alt. 6,188 ft./1,886 m): +33 (0)4 50 34 47 01. La Vogealle (alt. 6,240 ft./1,902 m): +33 (0)6 20 60 91 40.

T Eating Out

Auberge de la Cascade du Rouget, in summer: +33 (0)4 50 34 19 94. Chalet-restaurant du Fer-à-Cheval: +33 (0)4 50 89 13 88. La Chaoune, pizzeria: +33 (0)4 50 91 21 52. La Feuille d'Érable: +33 (0)4 50 34 44 47.

Local Specialties

Food and Drink Cheese (Tomme de montagne, Chevrotin ewe-milk cheese) and yogurt. Art and Crafts Cabinetmaker • Fashion and softfurnishings designer.

★ Events

February: "Grande Odyssée Savoie Mont Blanc," international dog-sled race; "Les Hivernales du Haut Giffre," Nordic sports day. August: Festival of stories from around the world.

Woutdoor Activities

Winter

Alpine skiing • Cross-country skiing • Snowshoeing • Tobogganing • Ice cascade • Dog sledding • Walking in the nature reserve. Summer

Climbing • Via Ferrata • Walking, horse-riding, and rides on pack mules • White-water sports • Mountain-biking.

🖗 Further Afield

- Samoëns (4 ½ miles/7 km).
- Morillon: leisure center; lake for swimming (7 ½ miles/12 km).

• Mieussy: Fruitière, cheese-maker (16 miles/ 26 km).

I Did you know?

Sixt's division into hamlets contributes to both the charm and the distinctiveness of the village. Spread over 30,000 acres (12,000 ha), it consists of 24 hamlets, containing 9 chapels and 53 shrines. These show a strong village connection between farming and faith.

Tourtour In the skies above Provence

Var (83) • Population: 593 • Altitude: 2,133 ft. (650 m)

Perched on a plateau soaring above Provence, with vineyards to the south and lavender to the north, Tourtour exudes the perfume of thyme and olive trees.

Tourtour was fortified in the early Middle Ages to protect itself from frequent Saracen attacks. From this long-distant and precarious past, it still has some fortifications and its street plan, in which streets encircle the old castle. The narrow alleyways of the medieval village boast buildings of old stone and curved tiles, and they accommodate a traditional oil mill and a fascinating fossil museum. Alleyways, steps, and vaulted passageways are dotted with fountains, refreshing passersby exhausted by the sun. Intertwined streets surround the two castles—a medieval one with two towers, and a 17th-century one with four towers. The church stands high above both village and landscape; built in the 11th century and restored in the 19th, it provides an exceptional view of inland Provence, from Sainte-Baume and Mont Sainte-Victoire as far as the Maures massif and the Mediterranean.

Highlights

• Église Saint-Denis (11th century): Summer concerts.

• Traditional olive mill: In operation November–February; art exhibitions mid-May–mid-September.

• Musée des Fossiles: Collection of ammonites and local fossils (especially dinosaur eggs).

• Town hall: Sculptures by Bernard Buffet (1928–1999) of giant insects and permanent exhibition of drawings by Ronald Searle (1920–2011) at the town gallery.

• Village: Guided tours of the village, mill, and museum for groups all year round by appointment: +33 (0)4 94 70 59 47.

✓[★] Accommodation Hotels

La Bastide de Tourtour****: +33 (0)4 98 10 54 20. Auberge St-Pierre***: +33 (0)4 94 50 00 50. Le Mas des Collines: +33 (0)4 94 70 59 30. La Petite Auberge: +33 (0)4 98 10 26 16. **Guesthouses** Chanteciel: +33 (0)6 95 92 59 69. Le Colombier: +33 (0)4 94 70 53 93.

Chanteciel: +33 (0)6 95 92 59 69. Le Colombier: +33 (0)4 94 70 53 93. Domaine de la Baume: +33 (0)4 57 74 74 74. Maison de la Treille: +33 (0)6 15 17 37 64. Le Mas de la Tour, naturist establishment: +33 (0)6 18 07 90 28. Villa Pharima: +33 (0)6 23 74 41 67.

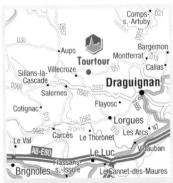

By road: Expressway A8, exit 36– Draguignan (20 miles/32 km), N555 (11 miles/18 km); expressway A51, exit 18– Valensole (41 miles/66 km). By train: Draguignan station (13 miles/21 km). By air: Toulon-Hyères airport (58 miles/ 93 km); Nice-Côte d'Azur airport (66 miles/ 106 km).

(i) Tourist information:

+33 (0)4 94 70 59 47 www.tourtour.org

Gîtes

Further information: +33 (0)4 94 70 59 47 www.tourtour.org

I Eating Out

L'Aléchou, crêperie: +33 (0)4 94 70 54 76. Auberge St-Pierre: +33 (0)4 94 50 00 50. La Bastide de Tourtour: +33 (0)4 98 10 54 20. La Farigoulette: +33 (0)4 94 70 57 37. Le Mas des Collines: +33 (0)4 94 70 57 30. La Mimounia, Moroccan cuisine: +33 (0)4 94 47 67 89. Les Ormeaux, bar: +33 (0)4 94 70 57 07. La Petite Auberge: +33 (0)4 94 70 57 07. Le Relais de Saint-Denis: +33 (0)4 94 70 55 406. La Table, gourmet restaurant: +33 (0)4 94 70 55 95.

Local Specialties

Food and Drink

Goat cheese • Organic produce (fruit, vegetables, fruit juice) • Olive oil. Art and Crafts

Gifts • Art galleries and artists' studios • Fashion.

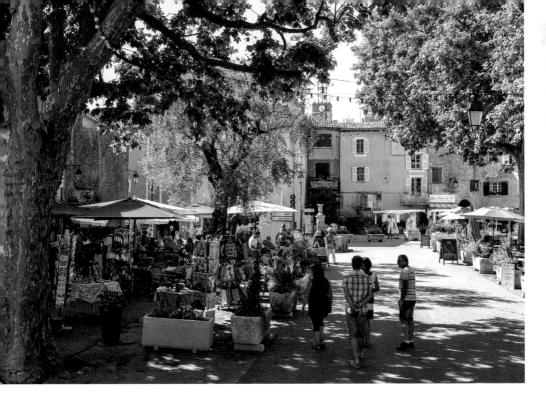

★ Events

Market: Small Provençal market, Wednesday and Saturday mornings. February: "Roustide," new olive oil festival. Easter: "Fête de l'Œuf," Easter festival (Sunday and Monday). June-September: Exhibitions at the oil mill. July: "Courts, Courts," short-film festival (last weekend). August: Village fair, ball with Provençal dancing (1st Sunday); "Piano dans le Ciel," music festival (early August). October: Saint Denis's feast day. December: Christmas market. December-January: "La Pastorale," Nativity play.

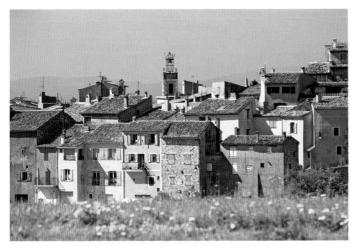

W Outdoor Activities

Boules area • Walking and mountainbiking • Pack-donkey rides • Horse-riding.

🕊 Further Afield

- Villecroze: park, caves, and waterfalls (4 ½ miles/7 km).
- Salernes; Sillans-la-Cascade; Cotignac;
 Bargemon; Draguignan; Châteaudouble:
 gorges (7–18 miles/11.5–29 km).
 Lac de Sainte-Croix, lake (18 miles/
- Lac de Sainte-Croix, lake (18 miles/ 29 km).
- Le Thoronet Abbey, Sainte-Roseline chapel (19 miles/31 km).
- *Seillans (27 miles/43 km), see pp. 142–43.
- *Bargème (29 miles/47 km), see p. 92.
- Le Grand Canyon du Verdon (31 miles/ 51 km).

USSON A gilded cage for Queen Margot

Puy-de-Dôme (63) • Population: 263 • Altitude: 1,772 ft. (540 m)

On the fringes of the regional nature park of Livradois-Forez. Usson perches on a volcanic mound and surveys the vast panorama of the mountains of Puv de Dôme, Mont Dore, and Cézallier. The village, overshadowed by a statue of the Virgin, used to be overlooked by an impressive castle. After improvements by Jean de Berry and restoration work by Louis XI in the late 15th century, the castle of Usson housed the exiled Queen Margaret (1553-1615), known as Margotsister of Charles IX and foolish young wife of the future Henri IV. She eloped with her lover, the equerry Jean d'Aubiac, but they were discovered at Ybois; her lover was executed and Margaret was held at Usson. She remained there for nineteen years, leading both a courtly and religious life. In July 1605, aged 52, she returned to Paris, having managed to get Usson exempted from taxation and offering a grant in perpetuity for the local poor. Behind the village's basalt façades remain parts of its triple surrounding walls flanked by towers, which were destroyed under Cardinal Richelieu (1585-1642). The Église Saint-Maurice, Romanesque in origin, was extended in the 16th century with the addition of the Queen's Chapel, under whose starry vault Margaret praved. The tabernacle shutters, made in 1622, show her in old age personified as Saint Radegonde and wearing a gown and crown decorated with fleurs-de-lys, beside her husband, Henri IV. South of this building, a path leads to the village's impressive basalt columns and to a summit that towers above the village.

Highlights

Église Saint-Maurice (12th–16th centuries): 17th-century tabernacle, statues, paintings: +33 (0)4 73 71 05 90.
Old forge: Restored with all its tools (e.g. hearth, bellows, anvil).
Village: Guided tour of the village and church for groups by reservation: +33 (0)4 73 89 15 90.
Exhibition on the history and culture

of Usson (at the Usson tourist office): +33 (0)4 73 71 05 90

Accommodation

Hotels Auberge de Margot: +33 (0)4 73 71 97 92. Gîtes Gérard Serre: +33 (0)4 73 96 84 88. Jean-Claude Roux: +33 (0)4 73 96 80 69.

T Eating Out

Auberge de Margot: +33 (0)4 73 71 97 92.

Local Specialties

Art and Crafts Workers in with glass, wood, stone, and steel (gifts and furniture).

★ Events

May: Pilgrimage to Notre-Damed'Usson (Ascension). July: Flea market (last Sunday).

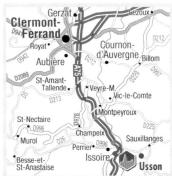

By road: Expressway A75, exit 13– Sauxillanges (6 miles/9,5 km). By train: Issoire station (7 ½ miles/12 km); Clermont-Ferrand station (32 miles/ 51 km). By air: Clermont-Ferrand-Auvergne airport (29 miles/47 km).

 Tourist information—Pays d'Issoire: +33 (0)4 73 89 15 90 www.sejours-issoire.com

W Outdoor Activities

Fishing • Walking: 2 marked trails.

🕊 Further Afield

- Château de Parentignat (5 miles/8 km).
- Issoire (7 miles/11.5 km).
- Hilltop villages: Nonette, Auzon
- (9 ½–16 miles/15.5–26 km).
- *Montpeyroux (15 miles/24 km), see p. 118.
- Billom (20 miles/32 km).
- Clermont-Ferrand (28 miles/45 km).
- Massif du Livardois; Ambert (32 miles/ 51 km).

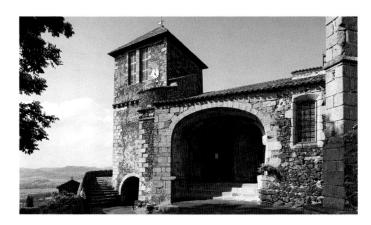

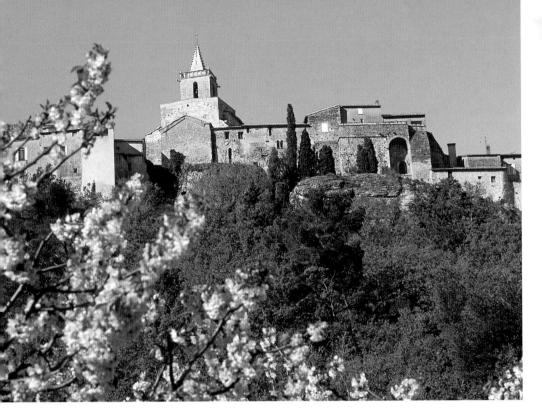

Venasque

Vaucluse (84) • Population: 1,180 • Altitude: 1,050 ft. (320 m)

Giving its name to the Comtat Venaissin region, Venasque is a crow's nest towering above a sea of *garrigue* scrubland, vineyards, and cherry orchards.

At the foot of Mont Ventoux, Venasque has molded itself to the shape of a rocky spur at the northwestern tip of the Vaucluse plateau, high above the Carpentras plain, where the Gorges of the Nesque open out. Occupied in Neolithic times, then during the Roman era, this naturally defensive site is reinforced by a rampart and three towers. The Église Notre-Dame was rebuilt in the 13th century, on the site of a 6th-century church probably built by Saint Siffredus, and contains a Crucifixion from 1498 attributed to a primitive painter of the Avignon school. Below, a stunning baptistery in the form of a Greek cross contains marble columns from Roman buildings. Dotted along the steep alleyways are houses with golden façades, built in the 14th-17th centuries, which echo the old hospice in Rue de l'Hôpital, very close to a delightful 18th-century Provency cal fountain. The village is proud of its local heritage, and is the capital of cherry growing, a fruit celebrated each June.

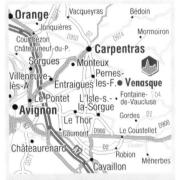

By road: Expressway A7, exit 22–Orange-Sud (21 miles/34 km). By train: Avignon station (20 miles/32 km); Orange station (23 miles/37 km); Avignon TGV station (27 miles/43 km). By air: Avignon-Caumont airport (28 miles/45 km).

(i) Tourist information: +33 (0)4 90 66 11 66 www.tourisme-venasque.com

Highlights

• Baptistery (6th century, much altered): Decorated blind arches and various decorated capitals. Further information: +33 (0)4 90 66 62 01.

• Église Notre-Dame (13th century): Avignon school Crucifixion, and 1498 processional cross.

• Village: Information boards; guided tours Thursday, 5 p.m. in summer, book at tourist information center; accessible tours for the visually impaired; "Visites en Scènes," musical and theatrical history show, presented by TRAC in July–August: +33 (0)4 90 66 11 66.

Accommodation

La Garrigue**: +33 (0)4 90 66 03 40. Les Remparts: +33 (0)4 90 66 02 79. Guesthouses

Mme Lubiato***: +33 (0)4 90 66 60 71. Mme Maret***: +33 (0)4 90 66 03 04. M. and Mme Ruel***: +33 (0)4 90 66 03 04. M. Velay***: +33 (0)4 90 66 63 98. Mme Charles**: +33 (0)4 90 66 14 20. Mme C. Ruel**: +33 (0)4 90 66 04 20. Mme Dulière: +33 (0)4 90 66 04 69. Mme Laroche: +33 (0)4 90 34 84 11. Mme Leroy: +33 (0)4 90 66 45. Le Mas du Kairos: +33 (0)4 90 30 99 18. Mme Tourrette: +33 (0)4 90 66 03 71. **Gites, vacation rentals, and houses**

Further information: +33 (0)4 90 66 11 66 www.tourisme-venasque.com

T Eating Out

Côté Fontaine: +33 (0)4 90 66 64 85. Les Remparts: +33 (0)4 90 66 02 79.

Local Specialties

Food and Drink Cherries and dessert grapes. Art and Crafts Ceramicists • Weaver • Painters • Potters • Sculptor.

★ Events

Market: Fridays, 5–8 p.m., mid-Junemid-September. April: Venasque rally-driving. June: Festival de la Cerise, cherry festival. July: July 14 festival.

July–August: Art exhibitions at Salle Romane. August: Local saint's day (around 15th).

December: Christmas market.

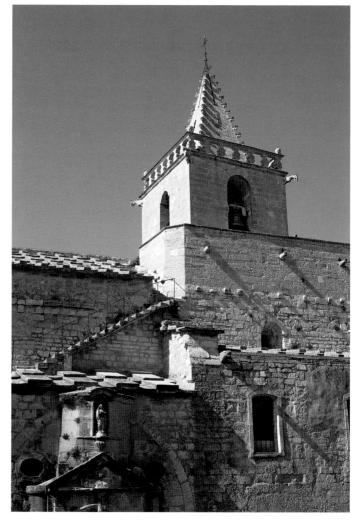

W Outdoor Activities

Climbing • Horse-riding • Walking • Golf • Cycle touring.

🖗 Further Afield

• Hilltop villages: Beaucet, La Roquesur-Pernes (3–6 miles/5–9.5 km).

- Pernes-les-Fontaines (4 ½ miles/7 km).
- Carpentras (7 miles/11.5 km).
- Gorges of the Nesque (9 ½ miles/15.5 km).
- *Gordes (9 ½ miles/15.5 km), see pp. 104–5. • *Ménerbes (15 miles/24 km), see pp. 113–14.
- *Roussillon (15 miles/24 km), see pp. 128–29.

- Avignon (19 miles/31 km).
- *Séguret (21 miles/34 km), see p. 141.
- Mont Ventoux (22 miles/35 km).
- Vaison-la-Romaine (24 miles/39 km).
- Pays de la Lavande, region; Sault (25 miles/40 km).

I Did you know?

Venasque is famous for its cherries. In 1978, the fruit prompted the foundation of the Confrérie de la Cerise des Monts de Venasques (a cherry federation), and for several years now a festival has been celebrated in their honor every June.

Vogüé A castle in the south of France

Ardèche (07) • Population: 973 • Altitude: 486 ft. (148 m)

Nestled in an amphitheatre at the foot of a cliff, Vogüé dips its toes in the almost Mediterranean-like waters of the Ardèche river.

The riverside roads dotted with arched passageways lead to the castle that dwarfs the village. This ancestral home of the Vogüés, one of the most illustrious families in the region, was rebuilt in the 16th and 17th centuries. It has a tower at each corner, and façades decorated with mullioned windows. It is now managed by Vivante Ardèche and houses an exhibition on the region's history and architecture, the works of Ardèche engraver Jean Chièze (1898–1975), and contemporary art. In the old village streets, medieval houses roofed with curved tiles are interspersed with arcades. Their stepped terraces overflow with flowers, and in the Midi sunshine everything radiates a Mediterranean air.

Highlights

• Castle (16th and 17th centuries): 12thcentury state room, keep, and kitchen, Jean Chièze room, Vogüé room, chapel, hanging garden; temporary art and craft exhibitions: +33 (0)4 75 37 01 95.

• Wine cellar: +33 (0)4 75 37 71 14. • Village: Guided tours by reservation in summer: +33 (0)4 75 37 01 17.

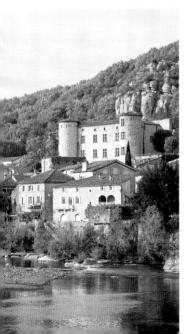

Accommodation

Hotels

Les Falaises: +33 (0)4 75 37 72 59. Les Voyageurs: +33 (0)4 75 37 71 13. **Guesthouses** Le Mas des Molines****: +33 (0)6 61 72 83 78. Les Carriers: +33 (0)6 84 43 35 73. Pierre et Eau: +33 (0)6 51 04 68 62. **Gîtes** Further information: +33 (0)4 75 37 01 17

www.vogue-tourisme.com

Aparthotels

Domaine Lou Capitelle: +33 (0)4 75 37 71 32. Campsites L'Oasis des Garrigues***: +33 (0)4 75 37 03 27. Les Chênes Verts**: +33 (0)4 75 37 71 54.

Les Roches*: +33 (0)4 75 37 70 45. Residential leisure parks Les Roulottes de Saint-Cerice: +33 (0)6 11 49 75 33.

T Eating Out

Au Cabanon: +33 (0)6 61 19 67 81. Chez Papytof: +33 (0)4 75 37 01 62. L'Esparat: +33 (0)4 75 38 86 21. La Falaise: +33 (0)4 75 37 72 59. Le Horse Pub, pizzeria: +33 (0)4 75 37 75 44. Khon Ngam Thaï, world cuisine: +33 (0)4 75 37 03 71. L'Oasis, pizzeria: +33 (0)4 75 37 78 29. Le Paséo, pizzeria: +33 (0)4 75 38 86 76. La Rôtisserie: +33 (0)4 75 37 78 29. Le Temps'Danse: +33 (0)4 75 37 70 23. Le Voyageurs: +33 (0)4 75 37 00 23. La Voguette, créperie: +33 (0)4 75 37 01 61.

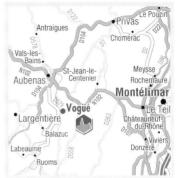

By road: Expressway A7, exit 17– Montélimar (30 miles/48 km); N102 (4 ½ miles/7 km). By train: Aubenas station (7 miles/11.5 km). By air: Valence-Chabeuil airport (52 miles/84 km).

(i) Tourist information:

+33 (0)4 75 37 01 17 www.vogue-tourisme.com

Local Specialties

Food and Drink Honey • Coteaux de l'Ardèche wines.

★ Events

Market: Monday mornings, July–August. July–August: Musical theater shows. August: Flea market (1st Sunday). Easter–All Saints' Day: Contemporary art exhibitions at the castle.

W Outdoor Activities

Canoeing • Climbing • Walking: *Topoguide*, book of walks, available at tourist information center • Mountain-biking.

🕊 Further Afield

• Sauveplantade: church; Rochecolombe (1–2 ½ miles/1.5–4 km).

• *Balazuc (4 ½ miles/7 km), see p. 91. • Aubenas (6 miles/9.5 km). • Le Pradel: estate of Olivier de Serre;

Coiron plateau (8–12 miles/13–19 km). • Ruoms: winegrowers' boutique (9 ½ miles/15.5 km).

• Gorges of the Ardèche; Vallon-Pontd'Arc; Grotte du Pont-d'Arc, cave (12 miles/19 km).

Yvoire Medieval reflections in the waters of Lake Geneva

Haute-Savoie (74) • Population: 911 • Altitude: 1,181 ft. (360 m)

Yvoire combines the pleasures of a lakeside village with the strength of its medieval heritage as a sentry overlooking an important waterway. Its strategic position between the Petit Lac and the Grand Lac inspired the count of Savoy, Amadeus V the Great, to begin important fortification works here in 1306, at the height of the Delphino-Savoyard war. He built the castle on the site of a former stronghold and surrounded it with a fortified village. Castle, ramparts, gates, ditches, and medieval houses have miraculously survived an extremely stormy past. The whole village is overflowing with flowers in all colors of the rainbow, which makes for a wonderful sight against the stone squares and façades. The flower display changes with the seasons, so that there is always something new to discover. The dazzling setting—with its dramatic backdrop of mountains and lake, and the bustle of fishing boats, yachts, and steamers on the water—make it easy to see why Vvoire is known as the "pearl of Lake Geneva."

Highlights

• V Le Jardin des Cinq Sens (classified as "remarkable" by the Ministry of Culture): Plant maze on the theme of the five senses in the castle's old vegetable garden, recreating the style and symbolism of medieval gardens: +33 (o)4 50 72 88 80. • La Maison de l'Histoire: Permanent exhibition, "Un Patrimoine Écrit Exceptionnel": documents from Yvoire's heritage: +33 (0)4 50 72 80 21. • Le Domaine de Rovorée-La Châtaignière: Nature reserve of 59 acres (24 ha); walking trails: +33 (0)4 50 72 80 21.

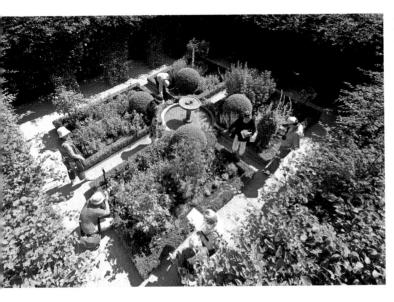

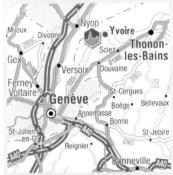

By road: Expressway A40, exit 14– Annemasse (18 miles/29 km); expressway A41-A40, exit 15–Vallée Verte (18 miles/ 29 km). By train: Thonon-les-Bains station (10 miles/16 km); Geneva station (16 miles/26 km). By air: Geneva airport (19 miles/31 km).

() Tourist information: +33 (0)4 50 72 80 21 www.yvoiretourism.com

• La Châtaignière (mansion, 20th-century architecture typical of the lakeside): "Domaine Départemental d'Art et de Culture" (exhibitions), June–September: +33 (0)4 50 72 26 67.

• La Grange à la Marie: Restored small 19th-century farm: +33 (0)4 50 72 80 21.

• Village: Guided tours with tour guides from "Patrimoine des Pays de Savoie"; for individuals June-September, for groups all year round by appointment: +33 (0)4 50 72 80 21.

Accommodation

Le Jules Verne***: +33 (0)4 50 72 80 08. Le Port***: +33 (0)4 50 72 80 17. Villa Cécile***: +33 (0)4 50 72 27 40. Le Pré de la Cure***: +33 (0)4 50 72 83 58. Le Vieux Logis: +33 (0)4 50 72 80 24.

Gîtes

La Falescale**: +33 (0)4 50 72 92 95. La Pointe d'Yvoire: +33 (0)6 09 17 85 26. Campsites

Léman I**: +33 (0)4 50 72 84 31. Léman II**: +33 (0)4 50 72 84 96.

T Eating Out

Le Bacouni: +33 (0)4 50 72 85 67. Le Bar des Pêcheurs: +33 (0)4 50 72 80 26. Le Bateau Ivre: +33 (0)4 50 72 81 84.

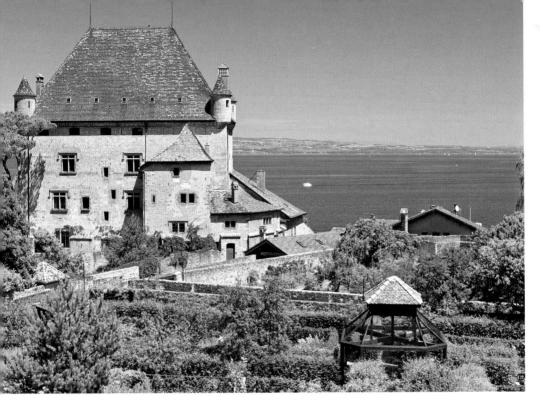

Le Café de la Marine, brasserie: +33 (0)4 50 72 85 67. Le Chardon, brasserie: +33 (0)4 50 72 81 71. Chez Jaja, pizzeria: +33 (0)4 50 72 88 55. La Crêperie d'Yvoire: +33 (0)4 50 72 80 78. Les Cygnes, brasserie: +33 (0)4 50 72 82 88. La Dîme, pizzeria: +33 (0)4 50 72 89 87. Les Galets, crêperie: +33 (0)4 50 72 69 73. Les lardins du Léman: +33 (0)4 50 72 80 32. Le Jules Verne: +33 (0)4 50 72 80 08. La Perche: +33 (0)4 50 72 89 30. Le Pirate: +33 (0)4 50 72 83 61. Le Port: +33 (0)4 50 72 80 17. Le Pré de la Cure: +33 (0)4 50 72 83 58. La Traboule: +33 (0)4 50 72 83 73. La Vieille Porte: +33 (0)4 50 72 80 14. Le Vieux Logis: +33 (0)4 50 72 80 24. Villa Cécile: +33 (0)4 50 72 27 40.

*** Local Specialties** Food and Drink

Lake Geneva perch • Artisan ice creams • Macarons • Gingerbread • Artisan cookies • Savoy produce.

Art and Crafts

Wood crafts • Crystal artist • Lacemaker • Leather-covered goods and upholstery • Art galleries • Potter • Rocks and minerals specialist • Basketmaker • Glassblowers • Contemporary artists.

★ Events

Seasonal market: "Rencontres Gourmandes" (local produce): monthly events in June, July, and August April: "Fête de la Cuisine," food fair. May: Parade Vénitienne, Venetian parade. July–August: "Fête du Sauvetage," festival organized by the Yvoire Lifesavers association; local fairs, concerts, other activities August: "Course Pédestre," running race. September: Journée des Peintres, art fair. October: Fête des Ånes, donkey fair; Marché Bio, organic market; Fête de la Cuisine d'Automne, autumn food fair; discount market.

🕷 Outdoor Activities

Boat trips on Lake Geneva • Walking.

🖗 Further Afield

- Nernier (1 mile/1.5 km).
- Château d'Allinges (9 ½ miles/15.5 km).
- Thonon-les-Bains; Ripaille: castle;
- Évian-les-Bains (10–16 miles/16–26 km).
- Geneva (17 miles/27 km).
- Nyon (20 minutes by boat).

I Did you know?

At dusk on September 29, 1844, the traveler and writer Alfred de Bougy arrived at Yvoire. In a chapter titled "Chez les sauvages du Léman" ("Among the savages of Lake Geneva"), he wrote this damning description of Yvoire as, "A jumble of ugly huts, hovels that resemble pig-sties." He added that he "would never have imagined such a sordid collection of uncivilized men at the heart of Europe." He spoke of "the most detestable village," and finished by saying that "when the magnificent steam boats tour the lake, they pass in sight of Yvoire, they round its protruding headland, but they take care not to put into port there." It's fair to say that Yvoire has had its revenge on both fate and history.

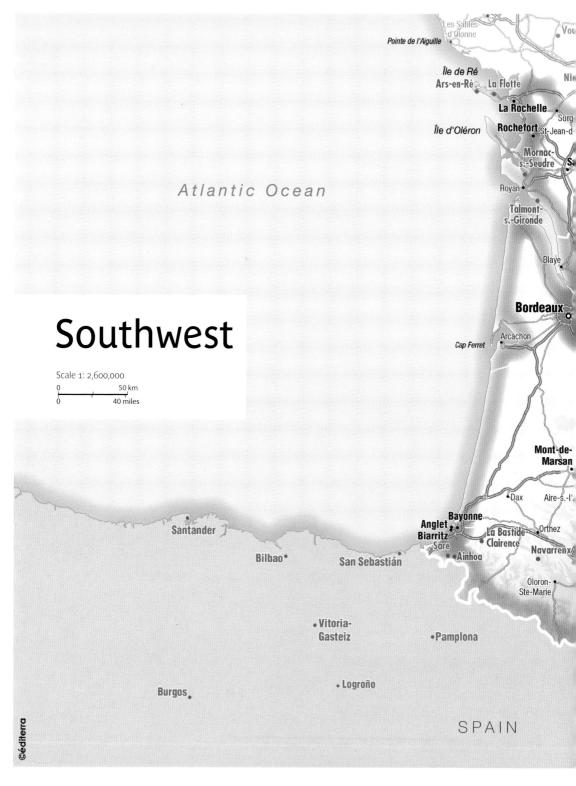

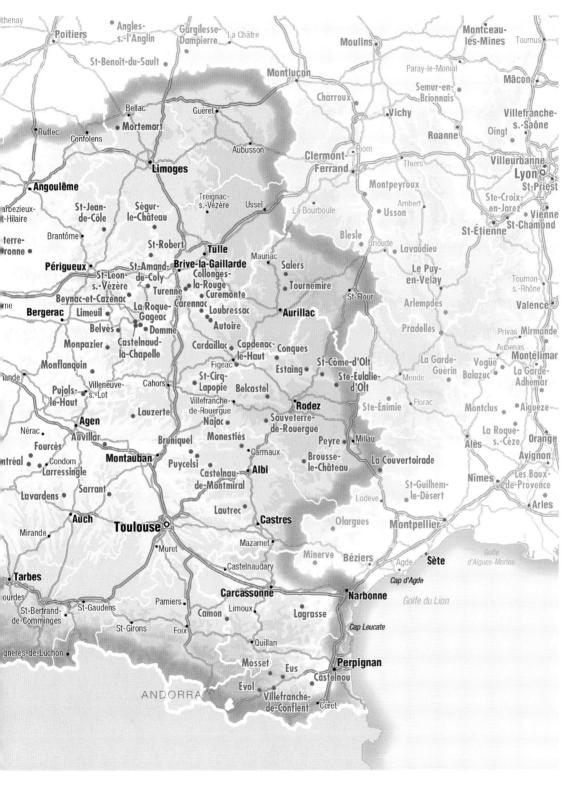

Ainhoa All the colors of the Basque country

Pyrénées-Atlantiques (64) • Population: 680 • Altitude: 394 ft. (120 m)

Marrying its green hillsides with the red-and-white facades of its Labourdin and Navarrese houses. Ainhoa displays the colors of the Basque country along its single street. In the 13th century, the Roman Catholic religious order known as the Premonstratensians set up a vicariate at Ainhoa to provide assistance to pilgrims traveling to Santiago, and a *bastide* (fortified town) emerged from the plain to provide for their welcome. Rebuilt in the 17th century, its finest façades face east. The rings for tying up mules on the lorios (doors) of some houses bear witness to their former role as merchant inns on the road to Pamplona. Further back, gardens extend at the rear of the houses. The immaculate house fronts, some of which have balconies. are full of character, with typically Basque red and green shutters and timbering. Next to the *fronton* (Basque pelota court), which still hosts a few games in summer, the 13th-century church has been rebuilt. but the cut stones of its lower parts date back to the founding of the bastide. Higher up, the Notre-Dame-d'Arantzazu chapel (arantza means "hawthorn" in Basque: it is also known as Notre-Dame-del'Aubépine in French) stands on the Atsulai mountainside.

Highlights

Église Notre-Dame-de-l'Assomption: Spanish-style gilded wooden altarpiece.
Maison du Patrimoine: Exhibition, film on the history of the village and the border area: +33 (0)5 59 29 93 99.

• Village: Bastide, fronton, church, and open-air washhouse. Guided tour from June to September; groups of 7+ all year by appointment: +33 (0)5 59 29 93 99.

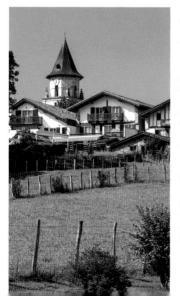

Accommodation

Argi-Eder****: +33 (0)5 59 93 72 00. Ithurria****: +33 (0)5 59 29 92 11. Oppoca***: +33 (0)5 59 29 90 72. Ur-Hegian**: +33 (0)5 59 29 91 16. Etchartenea*: +33 (0)5 59 29 90 26. Guesthouses

Ohantzea***: +33 (0)5 59 29 57 17. Les Hortensias: +33 (0)6 89 20 20 39. Maison Goxoki: +33 (0)6 21 20 92 34. Maison Xaharenea: +33 (0)6 21 37 40 71. **Gîtes, vacation rentals, and campsites** For information: +33 (0)5 59 29 93 99 www.ainhoa-tourisme.com

T Eating Out

Argi-Eder: +33 (0)5 59 93 72 00. Auberge Alzate: +33 (0)5 59 29 77 15. Ithurria: +33 (0)5 59 29 92 11. Ohantzea, tea room: +33 (0)5 59 29 90 50. Oppoca: +33 (0)5 59 29 90 72. Pain d'Épice d'Ainhoa, tea room: +33 (0)5 59 29 34 17. Ur-Hegian: +33 (0)5 59 29 91 16.

Local Specialties Food and Drink

Pain d'épice (spice cake) • Salted meats and fish • Basque specialties. Art and Crafts Artisan perfumer • Jeweler, artist-creator.

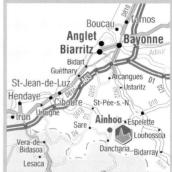

By road: Expressway A63, exit 5–Bayonne Sud (16 miles/26 km). By train: Camboles-Bains station (8 miles/13 km); Biarritz station (15 miles/24 km). By air: Biarritz-Bayonne-Anglet airport (16 miles/26 km).

(i) Tourist information: +33 (0)5 59 29 93 99 www.ainhoa-tourisme.com

★ Events

April: Mountain-biking tour. Pentecost: Pilgrimage to Notre-Damede-l'Aubépine (Monday). May: Journée de la Nature et du Terroir, demonstrations and workshops relating

to farm animals and breaders.

June-September: Basque pelota games, Basque songs in the church. July: "Xareta Oinez" hiking trail (3rd Sunday). August: Romeria (open-air meal) and xahakoa (wineskin) drinking championship;

festivals (15th). October: Fête de la Palombe, pigeon

October: Fête de la Palombe, pigeon festival, including cooking demonstrations, Basque songs, local produce and craft fair.

W Outdoor Activities

Basque pelota • Walking: Routes GR 8 and 10, and 5 marked trails • Mountain-biking: 1 marked trail.

🖗 Further Afield

- Urdax and Zugarramurdi caves (3–5 miles/5–8 km).
- Espelette (4 miles/6.5 km).
- *Sare (5 miles/8 km), see pp. 250-51.
- Cambo-les-Bains (7 miles/11.5 km).
- Saint-Pée-sur-Nivelle (7 ½ miles/12 km).
- Saint-Jean-de-Luz; Bayonne; Biarritz (14–17 miles/23–27 km).

• *La Bastide-Clairence (19 miles/31 km), see pp. 166–67.

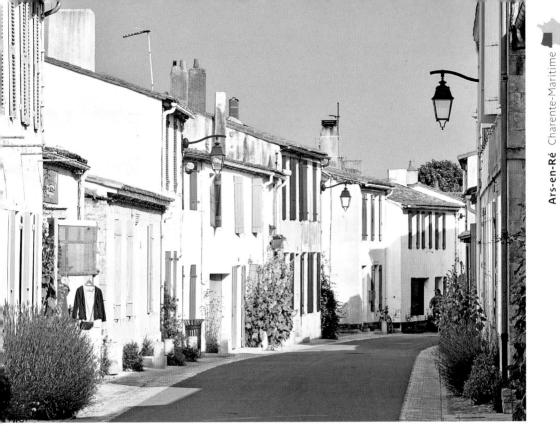

Ars-en-Ré

Between port and marshes

Charente-Maritime (17) • Population: 1,315 • Altitude: 10 ft. (3 m)

At the far west of the island, the village's bell tower keeps vigil over the ocean and the Fiers d'Ars marshes. Born from the salt marshes created in the 11th century and still exploited by more than sixty salt merchants, Ars is one of the Île de Ré's oldest parishes. The church retains its 12thcentury door and its 15th-century bell tower, whose 130 ft. (40 m) black-and-white spire used to serve as a day-mark for seafarers. In the Rue des Tourettes, the two corner towers of the Maison du Sénéchal, built in the 16th century, are a reminder

-Mei Île de Ré St-Clément-Villedoux des-Baleines St-Xandre Ars-en-Ré 0795 de-Ré a Flotte Lagor Le Bois-Plage-en-Ré Ste-Marie-de-Ré Aigrefeuill La Rochelle d'Aunis By road: Expressway A10, exit 33-La Rochelle (58 miles/93 km), N11-N237 (17 miles/27 km). By train: La Rochelle station (22 miles/35 km). By air: La Rochelle-Laleu airport (19 miles/31 km). (i) Tourist information: +33 (0)5 46 29 46 09 www.iledere-arsenre.com

that the village was once under the jurisdiction of a seneschal. Abandoned by ships coming from Northern Europe to load salt, the port now provides shelter for pleasure craft. Pleasant to explore on foot or bike, the narrow streets, dotted with hollyhocks, are lined with white houses with green or light blue shutters, typical of the traditional architecture of this region.

Highlights

• Église Saint-Étienne (12th, 15th, and 17th centuries): Romanesque style; arched door, rich furnishings.

• Tours of the bell tower and salt marshes: April to September.

• Huîtrière de Ré, oyster farm:

Guided tours April to September, Wednesday evening with tasting and Thursday evening: +33 (0)5 46 29 44 24.

Accommodation

♥ Le Martray***: +33 (0)5 46 29 40 04. Le Sénéchal***: +33 (0)5 46 29 40 42. Le Clocher**: +33 (0)5 46 29 41 20. Le Parasol**: +33 (0)5 46 29 46 17. Thalassotherapy resorts

Le Thalacap***: +33 (0)5 46 29 10 00. Guesthouses

Au Temps Retrouvé: +33 (0)5 46 27 86 75. M. Chabassol: +33 (0)5 46 29 24 69. M. Le Teuff: +33 (0)5 46 29 22 05. Les Nuits Bleues: +33 (0)5 46 43 28 09.

Vacation rentals

Further information: +33 (0)5 46 29 46 09 www.iledere-arsenre.com

Holiday villages

La Salicorne, VVF: +33 (0)5 46 29 45 13. Campsites

Le Cormoran****: +33 (0)5 46 29 68 27. Les Dunes****: +33 (0)5 46 29 41 41. ESSI***: +33 (0)5 46 29 44 73. Le Soleil**: +33 (0)5 46 29 40 62. La Combe à l'Eau*: +33 (0)5 46 29 46 42.

T Eating Out

L'Annexe: +33 (0)5 46 34 06 71. Au Goûter Breton: +33 (0)5 46 29 41 36. Aux Frères de la Côte, brasserie: +33 (0)5 46 29 04 54. Le Bistrot de Béné: +33 (0)5 46 29 40 26. Le Bistrot du Martray: +33 (0)5 46 29 40 04.

La Cabane du Fier: +33 (0)5 46 29 64 84. Le Café du Commerce, brasserie/crêperie: +33 (0)5 46 29 41 57.

Le Clocher: +33 (0)5 46 29 41 20. Le Grenier à Sel: +33 (0)5 46 29 08 62. Le K'Ré d'Ars: +33 (0)5 46 29 94 94.

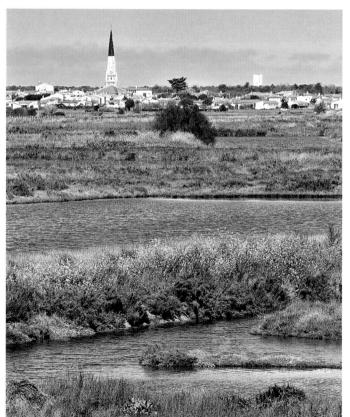

L'Océane: +33 (0)5 46 29 24 70. Ô de Mer: +33 (0)5 46 29 23 33. Le Parasol: +33 (0)5 46 29 46 17. Sans Foie ni Loix, beer and tapas bar: +33 (0)9 50 44 37 97. Le Soleil d'Ars: +33 (0)5 46 43 09 27. Le Thalacap: +33 (0)5 46 29 10 00. La Tour du Sénéchal, light meals, seafood: +33 (0)5 46 29 41 12. Le $^{\circ}$ V'': +33 (0)5 46 29 45 56. Le 20 [vingt], wine bar, world cuisine: +33 (0)5 46 29 69 52.

Local Specialties Food and Drink

Strawberries • Shrimp • Oysters • AOP early potatoes • Salt and *fleur de sel* sea salt • Wine and Pineau. Art and Crafts

Antique dealers • Artists.

🖈 Events

Markets: Daily 8 a.m.-1 p.m., Place du Marché-d'Été (April-September) or Tuesdays and Fridays 8 a.m.-1 p.m., Place Carnot (Winter).

July and August: Concerts, "Embrasement du Clocher," firework display and dance, regattas.

W Outdoor Activities

Bathing: La Grange beach • Cycling: Cycle paths across the marshes to the nature reserve at Fiers d'Ars • Walking: 3 marked trails • Sailing • Riding • Thalassotherapy.

🕊 Further Afield

- Saint-Clément-des-Baleines: Lighthouse and Parc des Incas (3 miles/5 km).
- Les Portes-en-Ré: Maison du Fier
- et de la Nature (6 miles/9.5 km).
- Loix-en-Ré: Écomusée du Marais Salant, local heritage museum (7 ½ miles/12 km).
- Saint-Martin-de-Ré: fortifications (7 ½ miles/12 km).
- *La Flotte (11 miles/18 km), see pp. 198–99.
- La Rochelle (21 miles/34 km).

I Did you know?

Producing more than 2,000 tons of salt every year, the salt marshes lie behind the development of Ars. The huge salorge, where the salt was stored, now houses the covered market, and some fine merchant houses are still visible on the Rue du Havre.

Aubeterresur-Dronne

Monolithic grandeur amid the white rocks

Charente (16) • Population: 422 • Altitude: 295 ft. (90 m)

Nestled against a chalky limestone cliff, Aubeterre overlooks the verdant valley of the Dronne river and boasts an extraordinary cultural heritage. Around its central square, a labyrinth of roofs and house fronts bedecked with wooden galleries and balconies stretches out. Facing the castle of this old fortress town, which was destroyed by the English and then by the Huguenots, and whose imposing gate still overlooks the Dronne, stands the Église Saint-Jacques, with its fine Romanesque façade. At the turn of every street and steep alley way, the visitor is reminded of Aubeterre's religious past: pilgrims on their way to Santiago de Compostela would stop at the church and three former convents, and the village also features the monolithic Église Saint-Jean, which was carved into the rock near a primitive worship site in the 12th century. For an unforgettable experience, explore the underground building and necropolis beneath its high vaults of light and shade.

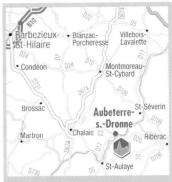

By road: Expressway A89, exit 11–Coutras (27 miles/43 km). By train: Chalais station (7 ½ miles/12 km). By air: Bergerac-Roumanière airport (43 miles/69 km).

(1) Tourist information: +33 (0)5 45 98 57 18 www.sudcharentetourisme.fr www.aubeterresurdronne.com

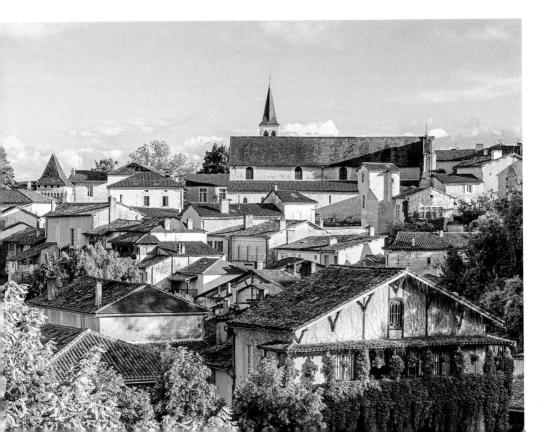

Highlights

· Église Saint-Jacques: Originally built in the 12th century but rebuilt in the 17th century; Romanesque façade with finely carved vaulted archways and Moorish ornamentation.

· Monolithic underground Église Saint-Jean: Hewn into the cliff face in the 12th century. A unique construction housing a reliquary, a central relic pit, and a necropolis containing more than 160 stone sarcophagi

 Musée-espace Ludovic-Trarieux: An exhibition focusing on human rights and on Ludovic Trarieux, the founder of the French Human Rights League.

• Village: Guided tours all year round by appointment only for groups; in the summer, possibility of individual visits: +33 (0)5 45 98 57 18 or +33 (0)6 79 85 81 26.

Accommodation Hotels

Hostellerie du Périgord**: +33 (0)5 45 98 50 46. Hôtel de France: +33 (o) 5 45 98 50 43.

Guesthouses

Aubeterre-sur-Dronne:

+33 (0)5 45 98 04 08. Gaillardon: +33 (0)6 22 13 39 40. Les Logis de la Tour: +33 (0)6 43 61 40 77. Quartier Plaisance: +33 (0)6 02 22 33 54. Gîtes

Further information: +33 (0)5 45 98 57 18 www.sudcharentetourisme.fr

Campsites

Bord de Dronne***: +33 (0)5 45 98 60 17 May-September or +33 (0)6 87 29 18 36 the rest of the year.

T Eating Out

Au Cochon Prieur: +33 (0)5 45 78 87 43. La Brasserie de la Place: +33 (0)5 45 78 38 45. Crêperie de la Source, in summer: +33 (0)5 45 98 61 78. Cupcakes, tea room: +33 (0)5 45 78 32 68. Le Garage, light meals: +33 (0)5 45 98 18 19. La Grignote, pizzeria : +33 (0)5 45 78 43 79. Hostellerie du Périgord: +33 (0)5 45 98 50 46. Hôtel de France: +33 (0)5 45 98 50 43. Restaurant de la Plage, in summer: +33 (0)5 45 78 22 91. La Ruchette, tea room: +33 (0)9 66 98 40 15. Sel et Sucre, crêperie, in summer: +33 (0)5 45 98 60 91.

La Tapazzeria: +33 (0)5 45 98 37 11. La Taverne de Pierre Véry: +33 (0)5 45 98 15 53.

Local Specialties Food and Drink

Foie gras and duck confit • Pineau • Cognac.

Art and Crafts

Antique dealer • Cabinetmaker • Potters • Wooden-toy makers • Wood turners • Glassblower • Metalworker.

* Events

May: Fête de l'Ascension; artists' festival.

July: Fête de la Saint-Jacques (last weekend).

July and August: Evening musical events in the monolithic church.

W Outdoor Activities

Swimming • Canoeing • Fishing • Walking.

🖗 Further Afield

• Romanesque churches at Pillac,

- Rouffiac, and Saint-Aulaye (5 miles/8 km).
- Chalais: medieval town (7 miles/11.5 km).
- Villebois-Lavalette: castle; covered market (12 miles/19 km).
- Cognac and Bordeaux vineyards (28 miles/45 km).
- Angoulême (30 miles/48 km).
- Périgueux (34 miles/55 km).

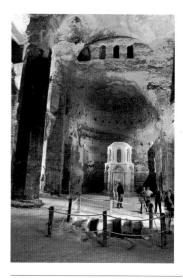

I Did you know?

Hewn into the hillside on which the castle stands, Aubeterre-sur-Dronne's subterranean church is one of the largest in Europe. The vau carved into the limestone is 56 ft. (17 m) high. A stairway cut into the rock provides access to the upper gallery, which surrounds the church three sides. In the sanctuary there is a hexago reliquary, 20 ft. (6 m) high and 10 ft. (3 m) in diameter, which was carved from a single block of stone during the Romanesque period

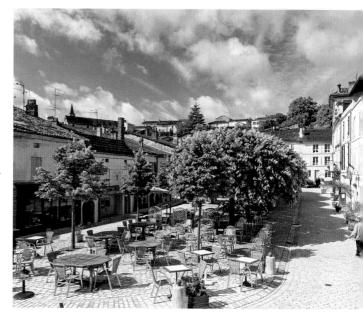

Autoire

Medieval stone and red tiles amid vines and tree-covered hills

Lot (46) • Population: 345 • Altitude: 738 ft. (225 m)

The village takes its name from the Autoire, the mountain stream that rushes down from the Causse de Gramat limestone plateau in a series of waterfalls before reaching the first ocher manor houses.

At the center of a cirque—a deep, high-walled basin—square dovecotes and the corbeled facades of rustic dwellings stand next to the turrets of manor houses. The Laroque-Delprat manor and the Château de Limargue are located downhill from the village. Higher up, the Château de Busqueille, built in the late 16th century, rises above the brown-tiled roofs. Under the dependence of successive baronages. Autoire became, in the 14th century, one of the vassal cities of the viscountcy of Turenne. However, despite promises of protection, the village was besieged by the English, who had already been victorious in the region of Haut Quercy. One of the village's castles (the Château des Anglais) served as a hideout for traveling mercenaries during the Hundred Years War. Autoire was laid waste by the Calvinists in 1562 and did not see peace again until 1588. The only remains of the village's fortified ensemble is the Église Saint-Pierre, which dates back to the 11th and 12th centuries. The square bell tower is covered with flat stone *lauzes* (schist tiles) rather than the tiles used on other roofs in the village.

Carennac Puybrun Bretenoux Loubressac Frayssinhes Do. Meyronne Autoire • St-Céré Alvignac Avnac Rocamadou Gramat Thémines Le Bastit Dago Cardaillac Assier. Fontanes- Livernon Labastidedu-Causse Murat Figea 0802

By road: Expressway A2o, exit 54– Gramat (24 miles/39 km). By train: Biarssur-Cèren station (9 ½ miles/15.5 km). By air: Brive-Vallée de la Dordogne airport (30 miles/48 km).

(i) Tourist information—Vallée de la Dordogne: +33 (0)5 65 33 22 00 www.vallee-dordogne.com

Highlights

Église Saint-Pierre (11th– 12th centuries).
Village: Guided tours in July and August: +33 (0)5 65 33 81 36.

Accommodation

Hotels Auberge de la Fontaine: +33 (0)5 65 10 85 40. Guesthouses

Mme Gauzin**: +33 (0)5 65 38 15 61. M. Sebregts: +33 (0)6 71 71 07 89. **Gîtes and vacation rentals**

- M. Blankoff: +33 (0)1 43 80 69 76. Mlle Chovanec: +33 (0)5 65 38 15 61. M. Fouilhac: +33 (0)5 65 38 12 02. M. Lemonnier: +33 (0)2 33 95 13 16. M. Magnac: +33 (0)6 10 02 53 25.
- M. Marchandet: +33 (0)5 65 38 13 50.
- M. Santolaria: +33 (0)2 33 94 22 54.
- M. Sebregts: +33 (0)6 71 71 07 89.

T Eating Out

Auberge de la Fontaine: +33 (0)5 65 10 85 40. La Cascade, crêperie: +33 (0)6 07 86 90 62 or (0)5 65 38 20 02.

Local Specialties

Food and Drink

Cabécou cheese • Mushrooms • Honey • Wine. Art and Crafts Weaving workshop.

★ Events

July: Flea market (14th); local saint's day with firework display (last weekend). August: Gourmet market.

W Outdoor Activities

Rock climbing • Fishing • Mountain-biking • Walking: Route GR 480 and 8 marked trails.

🕊 Further Afield

- Cascade d'Autoire, waterfall (½ mile/1 km).
- *Loubressac (3 miles/5 km), see p. 212.
- Saint-Céré (3 miles/5 km).
- Grotte de Presque, caves (4 ½ miles/7 km).
- Montal and Castelnau castles (4 ½ miles/7 km).
- Gouffre de Padirac, chasm (6 miles/9.5 km).
- *Carennac (8 miles/13 km), see pp. 181–82.
- Rocamadour (12 miles/19 km).
- *Curemonte (16 miles/26 km), see p. 191.
- *Collonges-la-Rouge (22 miles/35 km), see p. 186–87.
- •*Turenne (22 miles/35 km), see pp. 260–61. •*Capdenac-le-Haut (29 miles/47 km), see p. 179.

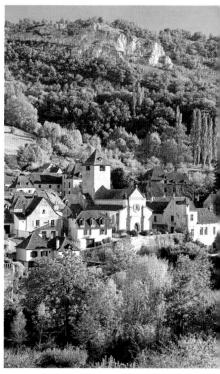

Auvillar A port on the Garonne river

Tarn-et-Garonne (82) • Population: 999 • Altitude: 377 ft. (115 m)

A stopping place on one of the pilgrimage routes to Santiago de Compostela, the former fiefdom of the kings of Navarre still watches over the Garonne river.

Located on the Via Podiensis linking Le Puy-en-Velay to the Chemin de Saint-Jacques-de-Compostelle (Saint James's Way), on the banks of the Garonne, Auvillar bears traces of its dual religious and trading role. Unique in the southwest, the covered market, built in 1824 during the city's heyday, is composed of an outer circular building-embellished with Tuscan columns-and a central structure. Inside, you can still see stone and metal grain measures, recalling the importance of the market for locally produced cereals. Serving as its setting, the magical triangular plaza, which dates from the Middle Ages, has 15th- and 17th-century half-timbered red-brick mansions. This former stronghold stands on a rocky spur and has retained traces of its fortifications, including a door crowned with a brick-and-stone clock tower dating from the late 17th century. Outside of the upper town, the former Benedictine priory attached to the Abbave de Moissac has become the Église Saint-Pierre (12th and 14th centuries), and is considered one of the finest in the diocese of Montauban. For a long time an inland shipping center, the port has retained its chapel dedicated to Saint Catherine, the patron saint of mariners.

By road: Expressway A62, exit 8–Valenced'Agen (3 miles/5 km). By train: Valenced'Agen station (3 ½ miles/5.5 km); Moissac station (12 miles/19 km). By air: Agen-La Garenne airport (21 miles/34 km); Toulouse-Blagnac airport (56 miles/90 km).

() Tourist information: +33 (0)5 63 39 89 82 www.auvillar.eu

Highlights

 Chapelle Sainte-Catherine (in summer): Murals: +33 (0)5 63 39 89 82. Église Saint-Pierre: Contains a remarkable Baroque altarpiece.

 Musée de la Faïence: Museum of popular art and traditions with a collection of 18th- and 19th-century Auvillar earthenware: +33 (o)5 63 39 89 82.

• Musée de la Batellerie: Located in the clock tower, the museum presents the history of navigation on the Garonne river in past centuries. Further information: +33 (0)5 63 39 89 82.

• Village: Guided tour for groups of 10+. Further information and bookings: +33 (0)5 63 39 89 82.

Accommodation

L'Horloge: +33 (0)5 63 39 91 61. Guesthouses

Allison Feeley***: +33 (0)5 81 11 51 26. ↓ L'Arbudet***: +33 (0)6 64 62 07 52). Stéphanie Bachir*** +33 (0)6 83 09 51 37. Patrice Cagnati**: +33 (0)6 89 29 58 08. Gisèle Chambaron***: +33 (0)5 63 29 04 31. Claude Dassonville***: +33 (0)5 63 29 07 43. Marie-Thérèse Desprez***: +33 (0)5 63 39 01 08. Claude Pouydesseau***: +33 (0)5 63 39 65 78. Jacques Sarraut***: +33 (0)5 63 39 62 45. Francis Laurens*: +33 (0)5 63 39 70 02. Jean-Pierre Wojtusiak*: +33 (0)5 63 39 73 61. Further information and other guest rooms: +33 (0)5 63 39 89 82/www.auvillar.eu

Gîtes

Gîte communal d'Étape et de Séjour*** Further information: +33 (0)5 63 39 89 82 www.auvillar.eu

T Eating Out

Al Dente, pizzeria: +33 (0)5 63 32 20 55. Alta Villa: +33 (0)5 63 29 20 09. Le Bacchus: +33 (0)5 63 29 12 20. Le Baladin, crêperie/steak house (summer only): +33 (0)5 63 39 73 61.

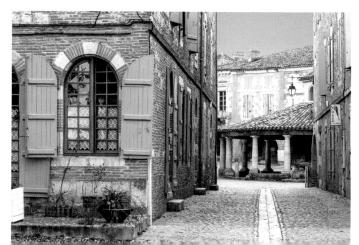

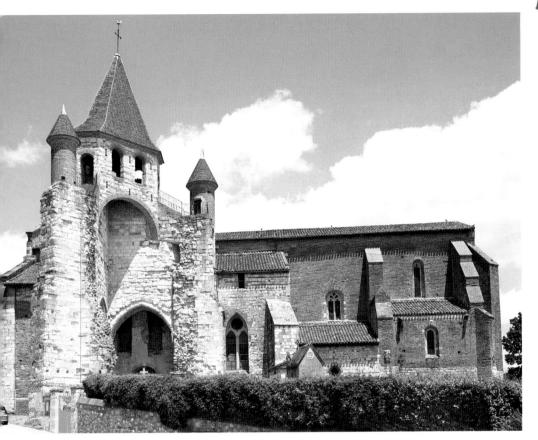

Le Bistrot des Arts (summer only): +33 (0)6 80 20 50 00. L'Horloge: +33 (0)5 63 39 91 61. Le Monde au Jardin (summer only): +33 (0)6 14 33 16 14. Le Petit Palais: +33 (0)5 63 29 13 17.

Local Specialties Food and Drink

Fruit juice, fruit produce • Brulhois wines • Jams and honey. Art and Crafts Calligrapher • Potter • Ceramicist • Art galleries • Artists • Soap-maker.

★ Events

Market: Sunday mornings, farmers' market. Palm Sunday: Dressmakers' market. May-August: Music events. Pentecost: Saint-Noé, Fête des Vignerons et des Félibres, winemakers' and Provencal poets' festival (1st weekend after Pentecost).
July: Antiques fair (July 13–14);
Craftsmen's event (last weekend).
July and August: Dramatized evening walks.
August: Dog show (2nd weekend), port festival (15th).
October: Pottery market (2nd weekend).
December: Christmas evening market (2nd Saturday).
All year round: Art and crafts exhibitions.

W Outdoor Activities

Hunting • Fishing • Walking: Route GR 65 and various trails.

🕊 Further Afield

• Voie Verte, picturesque greenway (3 miles/5 km).

• Golfech: nuclear site, "fish elevator" linking two canals (3 ½ miles/5.5 km).

- Donzac : Musée de la Ruralité (5 miles/8 km).
- Fortified towns of Dune, Castelsagrat,
- and Monjoi (8–17 miles/13–27 km).
- Moissac (12 miles/19 km).
- Agen (21 miles/34 km).
- •*Lauzerte (21 miles/34 km), see pp. 206-7.

I Did you know?

Auvillar potters have used clay and marl from the deposits found in the Garonne plains since Gallo-Roman times. Earthenware manufacture was very important here in the 18th and 19th centuries. Auvillar earthenware is distinguished by its colored—combed or sponged—edges, and predominant colors of blue and red. The Musée du Vieil Auvillar has an interesting collection of it on display.

La Bastide-Clairence

A bastide for the arts in Basque Country

Pyrénées-Atlantiques (64) • Population: 1,016 • Altitude: 164 ft. (50 m)

La Bastide-Clairence has a Basque face and a Gascon accent, with its white façades and its attractive half-timbering painted in red or green.

Bastida de Clarenza was founded in 1312 to secure a river port on the Joyeuse, and thus provide the kingdom of Navarre with a new maritime outlet. The founding charter signed by the king of Navarre, the future Louis X the Headstrong, granted land and tax benefits to the city, which developed throughout the Middle Ages and was home to the states of Navarre from 1627 to 1706. The town planning of the bastides of Aquitaine has been retained here; a grid pattern is observed with. in the center of the village, the Place des Arceaux. Characteristic spaces separate not only the houses but also the *cazalots*. These small gardens at the rear of the houses, built originally on identical plots known as *plaza*, were allocated to the first settlers, Basques, Gascons, and "Francos"-Compostela pilgrims who stayed on here. In one of the streets leading from the square, the world's oldest tringuet or jeu de paume court, dating from 1512, is still in use. The church of Notre-Dame-de-l'Assomption, built in 1315, is remarkable for its porch, the only remains of the original 14th-century building, and its lateral cloisters paved with tombstones. Next to the Christian cemetery, the Hebrew inscriptions in the Jewish cemetery, like the Hebrew names of some of the houses, are a reminder that in the 17th and 18th centuries La Bastide-Clairence welcomed an important Sephardic community fleeing the Spanish and Portuguese inquisitions. Motivated by its artisanal past, the village is currently home to more than a dozen artists and craftspeople, who combine tradition with innovation.

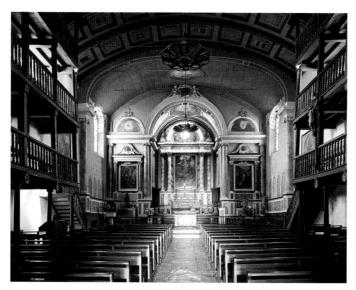

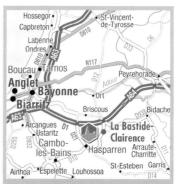

By road: Expressway A64, exit 4–Urt (3 ½ miles/5.5 km). By train: Cambo-les-Bains station (11 miles/18 km); Biarritz station (22 miles/35 km). By air: Biarritz-Bayonne-Anglet airport (23 miles/37 km).

() Tourist information: +33 (0)5 59 29 65 05. www.labastideclairence.com

Highlights

• Village: Guided tours for groups all year round by appointment only: +33 (0)5 59 29 65 05.

• Discovery trail, "Les murs vous racontent" ("the walls tell a story"; available in French only): +33 (0)5 59 29 65 05.

• MP3 audioguide: The history of the *bastide* told around the streets, with stories from locals (available in French only).

• *Trinquet*: The oldest *jeu de paume* court still in use (1512).

Accommodation Guesthouses

Maxana****: +33 (0)5 59 70 10 10. Argizagita***: +33 (0)5 59 70 15 54. Le Clos Gaxen***: +33 (0)5 59 29 16 44. ♥ La Maison Marchand***: +33 (0)5 59 29 18 27.

+33 (0)5 59 29 18 27. Gîtes and vacation rentals

Further information: +33 (0)5 59 29 65 05 www.labastideclairence.com

Aparthotels

♥ Les Collines Iduki****:
 +33 (0)5 59 70 20 81.
 Holiday villages
 Les Chalets de Pierretoun:
 +33 (0)5 59 29 68 88.

T Eating Out

Les Arceaux: +33 (0)5 59 29 66 70. Iduki Ostatua: +33 (0)5 59 56 43 04.

La Table Gourmande de Ghislaine Potentier: +33 (0)5 59 70 22 78.

Local Specialties Food and Drink

Beef and farm produce • Basque country cider • Foie gras and duck confit • Sheep cheese • Macarons • *Gâteau basque*.

Art and Crafts

Jeweler • Luthier • Picture framer • Perfumer • Wood carvers • Sculptor in stone • Lacemaker • Multimedia designer • Upholsterer-decorator • Glassblower • Potters • Cosmetics made from asses' milk • Textile designer • Leather craftsman • Artist • Floral art • Medieval art • Galleries.

★ Events

Market: July and August, farmers' market, every Friday evening 7-10 p.m. Easter: Show by the group Esperantza. May: Book fair. July and August: Sardinade, La Bastide-

Clairence festival, neighborhood festivities (La Chapelle, Pont de Port, Pessarou, La Côte). September: Pottery market

(2nd weekend).

W Outdoor Activities

Basque pelota • Fishing • Walking: 2 marked trails.

🕊 Further Afield

- Hasparren (5 miles/8 km).
- Isturitz and Oxocelhaya prehistoric caves (8 miles/13 km).
- Cambo-les-Bains (9 ½ miles/15.5 km).
- Arbéroue valley (12 miles/19 km).
- Bayonne (16 miles/26 km).
- *Ainhoa (19 miles/31 km), see p. 158.
- *Sare (24 miles/39 km), see pp. 250–51.

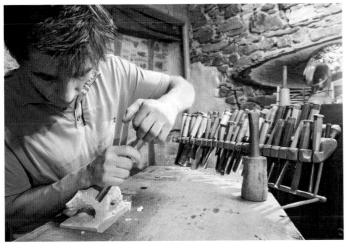

Belcastel

A medieval gem on the banks of the Aveyron

Aveyron (12) • Population: 219 • Altitude 1,335 ft. (407 m)

Clinging to vertiginous wooded slopes, Belcastel village is dominated by its spectacular fortified castle and dips its toes in the Aveyron river at its base.

In the 13th century, the fortress belonged to the lords of Belcastel, whose influence extended along both sides of the Aveyron. The castle was later gifted to the Saunhac family, who restored it, before abandoning it at the end of the 16th century: the fortress gradually fell into disrepair. It was in 1973 that the renowned architect Fernand Pouillon discovered the ruins: he bought the site and began eight years of renovation work on it, encouraging the inhabitants of Belcastel to restore their village streets and homes too. The château-fortress now looks fondly down on the renovated village with its cobbled streets, its oven, metalworking trades, and old fountain. The 15th-century church houses the tomb of its founder, Alzias de Saunhac, who built the stone bridge with its unique altar, where passersby paid for their crossing with prayers and offerings. A stone's throw from the village, the fortified site of the Roc d'Anglars dates from the 6th century.

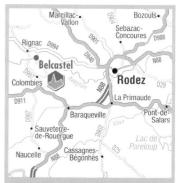

By road: Expressway A75, exit 42–Rodez (44 miles/70 km); D994 (15 miles/24 km). By train: Rodez station (15 miles/24 km). By air: Rodez-Marcillac airport (14 miles/23 km); Toulouse-Blagnac airport (103 miles/166 km).

() Tourist information: +33 (0)5 65 64 46 11 www.mairie-belcastel.fr

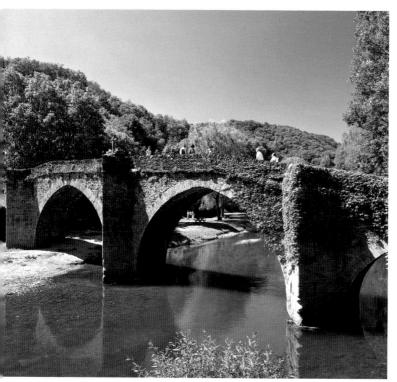

Highlights

• Castle: 11th-century fortress; 16thcentury arms and armour collection; contemporary art galleries inspired by the Animazing Gallery in Soho, New York: +33 (0)5 65 64 42 16. • Church (15th century): Way of the Cross by Casimir Ferrer, recumbent statue on the tomb of Alzias de Saunhac, 14th-16th century statues: +33 (0)5 65 64 46 11.

• Maison de la Forge et des Anciens Métiers (smithy and traditional crafts): Permanent exhibition of "sylvistructure" wood sculptures by the artist Pierre Leron-Lesur. Further information: +33 (0)5 65 64 46 11.

• Village: Guided tour and audioguide: +33 (0)5 65 64 46 11.

Accommodation

Le Vieux Pont***: +33 (o)5 65 64 52 29. **Guesthouses** Le Château: +33 (o)5 65 64 42 16. M. Rouquette: +33 (o)5 65 64 40 61. **Gîtes** www.mairie-belcastel.fr **Campsites** Camping de Belcastel**: +33 (o)5 65 63 95 61 or +33 (o)5 67 11 24 76.

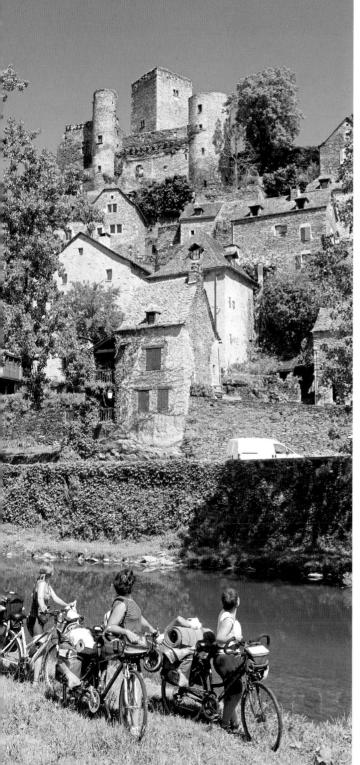

T Eating Out

Auberge Rouquette, farmhouse inn: +33 (0)5 65 64 40 61. Chez Anna, light meals: +33 (0)5 65 63 95 61 07 +33 (0)6 47 11 24 76. Le 1909 [mille neuf cent neuf]: +33 (0)5 65 64 52 26. Le Vieux Pont: +33 (0)5 65 64 52 29.

★ Events

Market: July–August, sampling and purchase of local products every Friday evening.

Throughout the summer: Art exhibition of paintings, photography, and sculpture. June: "Feu de la Saint-Jean," Saint John's Eve bonfire (last Saturday).

July: Local saint's day with village supper, fireworks, multimedia show (penultimate weekend).

September: Fête Nationale des Villages (national celebration of villages) and flea market.

W Outdoor Activities

Swimming • Fishing • Walking: Route GR 62B and 7 marked trails.

🕊 Further Afield

• Château de Bournazel (9 ½ miles/15.5 km).

- Rodez (16 miles/26 km).
- *Sauveterre-de-Rouergue (17 miles/27 km), see pp. 254–55.
- Peyrusse-le-Roc (20 miles/32 km).
- Villefranche-de-Rouergue (23 miles/ 37 km).
- *Capdenac-le-Haut (24 miles/39 km), see p. 179.
- *Conques (24 miles/39 km), see pp. 188–89.

I Did you know?

The village's most unusual feature, which affords a good view of the village and its valley, is the rock of Roquecante, which has seven seats cut into it. Probably dating to the 16th century, these "lords' seats" were traditionally used when the local lords were dispensing justice.

Belvès A papal city with a cave-dwelling past

Dordogne (24) • Population: 1,482 • Altitude: 591 ft. (180 m)

Dominating the verdant valley of the Nauze river from its hilltop position, the "town of seven bell towers" provides a sweeping panorama across the landscape of Périgord Noir.

Owing to its strategic position, Belves has had a turbulent past, despite the protection it received from both its rampart walls and from Pope Clement V, who granted Belvès the status of papal town when he was archbishop of Bordeaux (1297-1305). The town was besieged and invaded seven times by English forces during the Hundred Years War, and was later under siege again from Protestant forces during the Wars of Religion. It is miraculous that many legacies of Belvès' tumultuous past have survived: troglodyte cave dwellings. apparently occupied since prehistoric times; towers and bell towers from the Middle Ages; and residences and mansions in which Gothic flambovance blends with Renaissance artistry. In the heart of the village, a historic covered market comes to life once a week, and here you can sample the many tasty products of Périgord, which change with the seasons. Beyond the gates of the town, the marked trails of the vast Bessède forest welcome walkers, horse-riders, and mountain-bikers all year round for both competition and leisure.

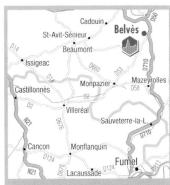

By road: Expressway A89, exit 17– Saint-Yrieix-la-Perche (33 miles/53 km); expressway A20, exit 55 (39 miles/63 km). By train: Belvès station. By air: Bergerac-Roumanière airport (30 miles/48 km); Brive-Vallée de la Dordogne airport (50 miles/80 km).

Tourist information—Périgord Noir-Vallée Dordogne: +33 (0)5 53 29 10 20 www.perigordnoir-valleedordogne.com

Highlights

• Troglodyte dwellings: Discover how peasants lived in these caves in the 13th to 18th centuries. Further information and bookings: +33 (0)5 53 29 10 20.

• Castrum: Guided tours in summer, self-guided visits and audioguides all year round. Further information: +33 (0)5 53 29 10 20.

• Église de Notre-Dame-de-l'Assomption: Renaissance painting; guided tours in summer, self-guided visits all year round. Further information: +33 (0)5 53 29 10 20.

• Castle and wall paintings (14th-16th centuries): Visit the principal furnished rooms; only wall paintings in Aquitaine representing the Nine Valiant Knights of legend, as well as a historical scene of Belvès in 1470. Further information: +33 (0)5 53 29 10 20.

• Musée Organistrum et Vielles à roue (hurdy-gurdies): Tradition and history of the stringed instruments in Périgord Noir, 12th–19th centuries; visit by appointment only: +33 (0)5 53 29 10 93.

• Village: Guided tours for groups by arrangement: +33 (0)5 53 29 10 93; self-guided family trail with puzzles

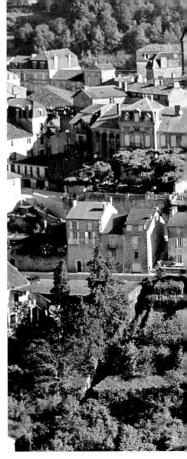

and games; trail booklet "Pêche Lune" (available in English) on sale at the tourist information center: +33 (0)5 53 29 10 93.

Accommodation

♥ Le Clément V***: +33 (0)5 53 28 68 80. Le Belvédère**: +33 (0)5 53 31 51 41. Le Home*: +33 (0)5 53 29 01 65.

Guesthouses

The Art of the Dordogne: +33 (0)5 53 29 52 16. Le Manoir de la Moissie: +33 (0)5 53 29 93 49 or +33 (0)6 85 08 80 26.

Le Petit Bonheur: +33 (0)5 53 59 67 88.

Gîtes, walkers' lodges, and vacation rentals Le Madelon: +33 (0)5 53 31 15 70. Further information: +33 (0)5 53 29 10 20 www.perigordnoir-valle-dordogne.com

Holiday villages

Domaine de la Bessède: +33 (o)5 53 31 94 60 or +33 (o)6 87 02 92 51. L'Échappée Verte: +33 (o)5 53 29 15 51 or +33 (o)6 03 01 50 99.

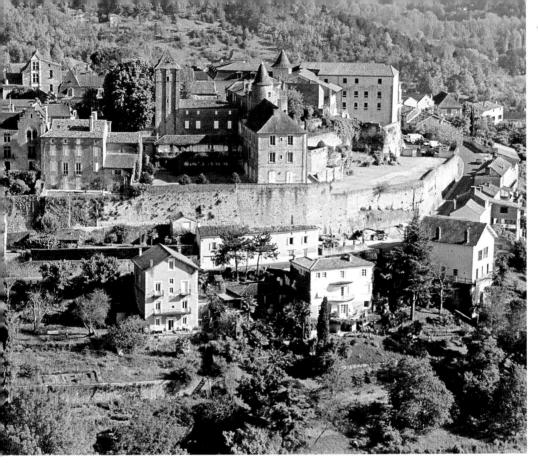

 Les Hauts de Lastours:
 Local Speci

 +33 (0)5 53 29 00 42 0r +33 (0)6 80 11 40 45.
 Food and Drink

 Campsites
 Fooi gras - Hone

 Le Moulin de la Pique****:
 Farmers' market

 +33 (0)5 53 29 01 15.
 Art and Crafts

 Les Nauves***: +33 (0)5 53 29 12 64 or
 Antique dealer

 (0)6 85 15 32 73.
 Metalworker - Particular dealer

T Eating Out

Le Belvédère: +33 (0)5 53 31 51 41. Le Café de Paris, brasserie: +33 (0)5 53 59 62 40. L'Envers: +33 (0)5 53 31 84 78. Le Home: +33 (0)5 53 30 90 165. Le Madelon, brasserie: +33 (0)5 53 31 15 70. Le Médiéval Café, brasserie: +33 (0)5 53 30 29 83. Le Pourquoi Pas, tea room: +33 (0)5 53 29 46 18. Les Sept Clochers, pizzeria: +33 (0)5 53 30 41 58. Les Terrasses de Belvès: +33 (0)5 53 28 25 48.

Local Specialities

Food and Drink Foie gras - Honey • Farm produce • Truffles • Farmers' market. Art and Crafts Antique dealer • Cutler • Cabinetmaker • Metalworker • Painters • Wool spinner • Sculptor • Stained-glass artist • Mosaic artist.

★ Events

Market: Saturday mornings, Place de la Halle. April: "Les 100 km du Périgord Noir," ultra-marathon (last Saturday). July: Flea market (1st Sunday), Republican supper (14th). July-August: Bach festival; gourmet market (Wednesday evenings). August: Medieval festival (1st Sunday), aerial meeting (15th), open-air rummage sale.

September: Pilgrimage to Notre-Damede-Capelou (start of the month). October–November: Walnut market.

W Outdoor Activities

Swimming • Horse-riding • Fishing • Walking: 75 miles (121 km) of marked trails, Route GR 36 and alternative routes in the Dordogne valley along the Saint James's Way to Santiago de Compostela • Aerial sports.

🕊 Further Afield

- Abbaye de Cadouin (8 ½ miles/14 km).
 Dordogne valley: *Castelnaud-la-Chapelle (11 miles/18 km), see p. 184;
 *Limeuil (12 miles/18 km), see pp. 210–11;
 *Beynac-et-Cazenac (14 miles/23 km), see pp. 172–73; *La Roque-Gageac (14 miles/23 km), see pp. 296–37; *Domme (15 miles/24 km), see pp. 192–93.
- Pays des Bastides (9–19 miles/ 14.5–31 km): *Monpazier (10 miles/16 km), see pp. 217–18.
- Sarlat (22 miles/35 km).
- Vézère valley (16–31 miles/26–50 km): *Saint-Léon-sur-Vézère (24 miles/39 km), see p. 246.

Beynac-et-Cazenac

Two villages, one castle, and a river

Dordogne (24) • Population: 511 • Altitude: 427 ft. (130 m)

Curled at the foot of an imposing castle that surveys the Dordogne, Beynac-et-Cazenac is a beautiful spot enhanced by both the sublime river and the food of the region.

Occupied since the Bronze Age (c. 2000 BCE) in a settlement that has been reconstructed in the current archeological park, the naturally defensive site of Bevnac became the seat of one of the four baronies of Périgord during the Middle Ages. Besieged by Richard the Lionheart in 1197. then demolished by Simon de Montfort, the castle was rebuilt before being captured and recaptured during the Hundred Years War (1337-1453) by the armies of both the English and French kings. It was then abandoned during the French Revolution. Its owner began restoration work in 1961 and opened it to the public. The impressive castle towers over the village's *lauze* (schist-tiled) rooftops and golden facades. Nestling between river and cliff, and protected by a wall in which only the Veuve gateway remains, for many years Beynac made its living from the passing trade on the Dordogne. The *gabares* (sailing barges) have abandoned the old port, which is now a park, and are today used for river trips, sharing the water with other boats and canoes. On the plateau dominating the valley, the chapel at Cazenac, a village joined to Beynac in 1827, is moving in its simplicity.

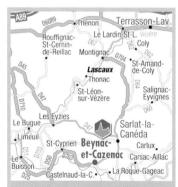

By road: Expressway A89, exit 18– Terrasson-la-Villedieu (39 miles/63 km); expressway A20, exit 55 (27 miles/43 km). By train: Sarlat-la-Canéda station (7 miles/11.5 km).

By air: Brive-Vallée de la Dordogne airport (35 miles/56 km); Bergerac-Roumanière airport (40 miles/64 km).

() Tourist information— Sarlat-Périgord Noir: +33 (0)5 53 31 45 45 www.sarlat-tourisme.com

Highlights

• Château de Beynac: Range of 12th– 17th century buildings, restored in 20th century: +33 (0)5 53 29 50 40. • Archeological park: How our ancestors lived from the Neolithic period to the Iron Age; guided tours. Educational workshops for children: +33 (0)5 53 29 51 28. • Village: Regular guided tours June– September, by appointment the rest of the year: +33 (0)5 53 31 45 42. Special event August 15: guided tour.

Accommodation

Hostellerie Maleville-Hôtel Pontet**: +33 (0)5 53 29 50 06.

Hôtel du Château**: +33 (0)5 53 29 19 20. Café de la Rivière: +33 (0)5 53 28 35 49. Guesthouses

Balcon en Forêt: +33 (0)5 53 28 24 01. Guy Gauthier: +33 (0)5 53 29 51 45. Résidence Versailles: +33 (0)5 53 29 35 06. Vacation rentals and gîtes

Further information: +33 (0)5 53 31 45 45 www.sarlat-tourisme.com Campsites

Le Capeyrou***: + 33 (0)5 53 29 54 95.

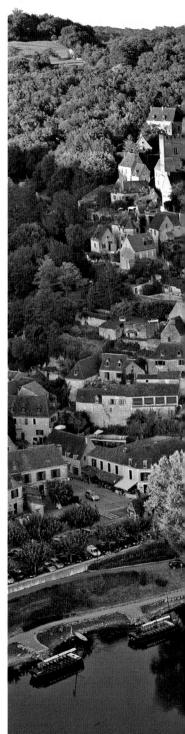

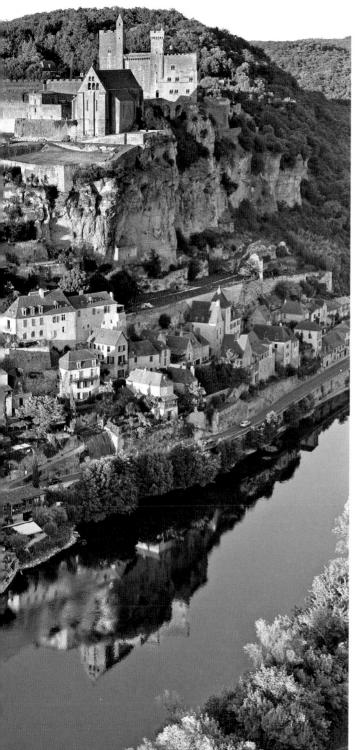

T Eating Out

Auberge Lembert: +33 (0)5 53 29 50 45. Café de la Rivière: +33 (0)5 53 28 35 49. Hostellerie Maleville-Hôtel Pontet: +33 (0)5 53 29 50 66. La Petite Tonnelle: +33 (0)5 53 29 95 18. Restaurant du Château: +33 (0)5 53 29 19 20. La Taverne des Remparts: +33 (0)5 53 29 57 76.

***** Local Specialties

Food and Drink Duck, goose • Traditional preserves. Art and Crafts Antique dealer • Painter • Painterenamelists • Potters • Metal artist.

★ Events

Mid-June to mid-September: Farmers' market every Monday morning, La Balme car park. August: Fireworks (15th).

W Outdoor Activities

Canoeing on the Dordogne • Fishing • Gabare trip on the Dordogne • Walking: 2 marked trails • Balloon flights • Mountain-biking: 5 marked trails.

🖗 Further Afield

• Dordogne valley: Château de Marqueyssac: park and hanging gardens (1 mile/1.5 km); Château de Castelnaud; Château des Milandes; *Castelnaud-la-Chapelle: Ecomusée de la Noix, walnut museum (2 ½ miles/4 km), see p. 184; *La Roque-Gageac (3 miles/5 km), see pp. 236–37; *Domme (7 miles/11.5 km), see pp. 192–93; *Belvès (14 miles/23 km), see pp. 170–71; *Limeuil (18 miles/29 km), see pp. 210–11.

• Sarlat (7 miles/11.5 km).

• Les Eyzies; Vézère valley (16–31 miles/ 26–50 km).

- *Saint-Léon-sur-Vézère (21 miles/34 km), see p. 246.
- *Saint-Amand-de-Coly (22 miles/35 km), see pp. 238–39.
- *Monpazier (24 miles/39 km), see pp. 217–18.

I Did you know?

The *gabares* sailing barges evolved from a different kind of barge that plied the waters of the Dordogne. They carried locally made wines to the port of Bordeaux. Many *gabares* used to dock at the old port of Beynac right up until the 19th century.

Blesle Benedictine memories at the gateway to the Haute-Loire

Haute-Loire (43) • Population: 653 • Altitude: 1,706 ft. (520 m)

At the end of a narrow, isolated valley that invites meditation, the echoes of Benedictine monks' prayers have for centuries blended with the murmurs of the rivers that bring life to the village of Blesle.

At the end of the 9th century, Ermengarde, countess of Auvergne, founded an abbey dedicated to Saint Peter here; then, two centuries later, the barons de Mercoeur built an impressive fortress. The village grew up under the protection of these two powers: one spiritual and the other temporal. It became one of the thirteen bonnes villes (which received privileges and protection from the king in exchange for providing a contingent of armed men) of Auvergne, and welcomed lawyers and merchants; they rubbed shoulders with tanners, weavers, and wine producers. Sheltered within its medieval surrounding wall. Blesle invites visitors to discover more than ten centuries of heritage. Several towers that were part of the old wall can still be seen on Boulevard du Vallat, itself built on the site of earlier ditches. Only the keep and a watchtower remain of the fortress, but the Église de Saint-Pierre and nearly fifty houses, many of which are halftimbered, preserve the memory of the Benedictine founders and the many trades that brought prosperity to the village.

By road: Expressway A75, exit 22– Blesle (5 miles/8 km). By train: Brioude station (14 miles/23 km). By air: Clermont-Ferrand Auvergne airport (46 miles/74 km).

() Tourist information: +33 (0)4 71 76 26 90 www.tourismeblesle.fr

Highlights

• Abbey church of Saint-Pierre: 12th-13th centuries.

• Église de Saint-Pierre: Liturgical vestments, silver plate, statues from the abbey; visits by appointment only: +33 (0)4 71 76 26 90.

• ♥ Musée de la Coiffe: Headdresses, bonnets, ribbons, hats from the region (late 18th century–early 20th century): +33 (0)4 71 76 26 90.

• Village: Guided tours in summer by appointment for individuals, all year for groups; accessible tours for visually impaired (large-print and Braille guidebooks): +33 (0)4 71 76 26 90.

Accommodation

La Bougnate***: +33 (0)4 71 76 29 30. Le Scorpion: +33 (0)4 71 76 28 98. Le Soleil d'Auvergne: +33 (0)4 71 74 15 36. **Guesthouses**

Chez Margaridou***: +33 (0)4 71 76 22 29. Aux Amis de Bacchus, M. and Mme Doremus +33 (0)4 71 76 21 38 or +33 (0)6 84 50 97 12. Le Bailli de Chazelon: +33 (0)4 71 76 21 98. Maison de Golda: +33 (0)4 71 76 40 90. **Gîtes, vacation rentals, and walkers' lodges** Further information: +33 (0)4 71 76 26 90. **Campsites**

Camping municipal de la Bessière**: +33 (0)4 71 76 25 82 or +33 (0)4 71 76 20 75 off-season.

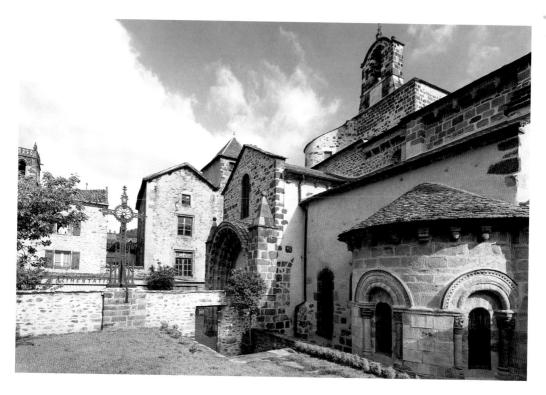

T Eating Out

La Barrière: +33 (0)4 71 74 64 22. La Bougnate: +33 (0)4 71 76 29 30. Le Scorpion: +33 (0)4 71 76 28 98. Le Soleil d'Auvergne: +33 (0)4 71 74 15 36. La Tour: +33 (0)4 71 76 22 97.

*** Local Specialties** Food and Drink

Charcuterie, salted meats, and fish • Local cheeses • Local beers • Auvergne liqueurs and wines. Art and Crafts

Antiques dealer • Potter.

★ Events

July: Painting and sketching competition in the village streets (1st Saturday); flea market and open-air rummage sale (last Sunday).

July-August: Local market (*aligot* mashed potato with garlic and cheese preserves, foie gras), Fridays from 17:30, Place de l'Église.

August: Festival of Les Apéros Musique (weekend of 15th); Fête d'Été summer fair (weekend before 15th); flea market. November: Saint-Martin Fair (11th).

W Outdoor Activities

Fishing • Walking: 17 trails, 2 mountainbiking trails.

🖗 Further Afield

• Gorges of the Alagnon: Chateaux of Montgon, Torsiac, and Léotoing (3–6 miles/5–9.5 km).

- Cézallier (4 ½–12 miles/7–19 km).
- Château de Lespinasse (6 miles/9.5 km).
- Gorges of the Sianne (6 miles/9.5 km).
- Brioude (14 miles/23 km).

• Ardes-sur-Couze: safari park (16 miles/ 26 km).

- *Lavaudieu (19 miles/31 km), see p. 110.
- Issoire (22 miles/35 km).
- Saint-Flour (24 miles/39 km).

I Did you know?

Blesle has had many famous residents: Gaspard de Chavagnac, friend of the prince of Condé (Protestant leader during the Wars of Religion); Laurent Bas, who arrested Charlotte Corday after she killed Marat in the French Revolution; the abbé de Pradt, Napoléon's chaplain; the author Maurice Barrès; the 19th-century artist Édouard Onslow; and even the holy martyr Natalène, who was beheaded by her father and then buried in a spot that became the spring that bears her name.

Brousse-le-Château

Medieval stopover at the confluence of the Tarn and the Alrance

Aveyron (12) • Population: 171 • Altitude: 787 ft. (240 m)

Brousse stands on the banks of the Alrance river, overlooked by the imposing silhouette of its medieval castle that gives the village its name. In 935, when the Château de Brousse was first mentioned in historical records, it was just a modest fort above the Tarn. Between the 10th and 17th centuries, the fort grew steadily until it filled the whole rock. Dominating the village, it also strengthened the position of the counts du Rouergue and then, from 1204 onward, the d'Arpajon family, one of whom became a duke and French dignitary in the 17th century. Restoration work started in 1963, funded by the Vallée de l'Amitié charity, and the castle opened to the public. Between the Middle Ages and the Renaissance, Brousse was a typical fortress: its keep, towers, ramparts, arrow-slits, crenellations, and machicolations indicate its military function, while the lord's apartments and the gardens reveal the level of comfort that was to be found there. Ancient winding lanes lead to the 15th-century fortified church, which sits between a graveyard and a small chapel. Crossing the 14th-century stone bridge over the Alrance brings you to the road at the bottom of the village. Stepped terraces, cut into the sloping banks of the Alrance and the Tarn, show that vines used to grow here: these, along with chestnut groves, used to be the main source of income for Brousse-le-Château.

Highlights

• Castle: Typical of the medieval Rouergue military style. Interior includes lord's apartments, well and water tank, bread oven: +33 (0)5 65 99 45 40. • Church (15th century): Dedicated to Saint James the Greater: +33 (0)5 65 99 41 14. • Illuminations of château, church, and chapel.

Accommodation

Le Relays du Chasteau**: +33 (0)5 65 99 40 15. **Gîtes** M. Miron***: +33 (0)5 65 35 48 04. M. and Mme Rolland**: +33 (0)5 65 99 47 18. M. Tuffery**: +33 (0)4 90 75 62 79. M. Daures*: +33 (0)5 65 99 41 45. M. and Mme Rugen: +33 (0)5 65 55 18 11. M. and Mme Sénégas: +33 (0)5 65 99 40 15.

I Eating Out

♥ Le Relays du Chasteau: +33 (0)5 65 99 40 15.

Local Specialties

Art and Crafts: Potter.

★ Events

July: Bonfire and fireworks at the castle (13th); flea market.

July-August: Activities, music, exhibitions. August: Local saint's day for Saint Martin de Brousse with traditional stuffed chicken (3rd weekend).

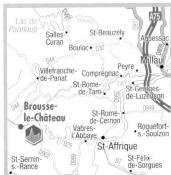

By car: Expressway A75, exit 46–Saint-Rome-de-Cernon (32 miles/51 km). By train: Albi station (32 miles/51 km); Millau or Rodez stations (37 miles/ 60 km). By air: Rodez-Marcillac airport (42 miles/68 km); Toulouse-Blagnac airport (93 miles/150 km).

(i) Town hall: +33 (0)5 65 99 41 14 www.brousselechateau.net

W Outdoor Activities

Swimming • Fishing • Canoeing • Rowing • Walks • Mountain-biking.

🕊 Further Afield

 Châteaux de Coupiac, de Saint-Izaire, and de Montaigut (9–12 miles/14.5–19 km).

 Peyrebrune tower, Saint-Louis dolmen, Ayssènes, Saint-Victor, and Melvieu (12 miles/19 km).

• Valley of Dourdou and Saint-Affrique (21 miles/34 km).

• Pays de la Muse, region; Raspes du Tarn, gorges; Lévezou lakes (22 miles/35 km).

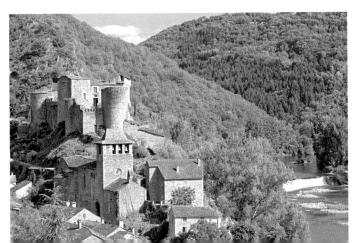

Bruniquel Defying the enemy from the cliff top

Tarn-et-Garonne (82) • Population: 583 • Altitude: 541 ft. (165 m)

Bruniquel and its two medieval castles sit atop a high rocky promontory, dominating the village and surveying the confluence of the Aveyron and Vère rivers. Bruniquel certainly shows its defensive side to approaching visitors: the high, massive façades of its 600-year-old castles perched on the escarpment are truly impressive. But the village feels completely different as you explore its flower-filled paths, pass through historic gateways opening onto the ramparts, or hear the clock in the belfry. Everything is picturesque—the sculptured figures, a pair of trefoil or mullioned windows, an arched doorway. And the byword here is stone, both grey and golden. Everything about the architecture and the heritage of the village reveals Bruniquel's past lives. It was a stronghold of the counts of Toulouse and then of Louis XIII. Later it became a center of the wine, hemp, and saffron trades; this brought it an international reputation that can still be discerned today in the Maison Payrol, built in the 12th century by monks, which became home to the governors of the town in the 15th century. After that it was an industrial town, with ores from its mines feeding forges and sawmills, right up until the middle of the 20th century. Today it is a village brought to life by its craftsmen.

Highlights

• Chateaux: Vaulted chambers, chapel, and Renaissance gallery, museum of prehistory: +33 (0)5 63 67 27 67. • Village: All-year-round audioguide tours for individuals: +33 (0)5 63 67 29 84.

Accommodation

M. Digne****: +33 (0)5 63 65 35 41. Mme Waleryszak***: +33 (0)5 63 67 25 00. Mme Artusi*: +33 (0)5 63 24 15 26. M. Caulliez: +33 (0)5 63 24 17 31. Mme Estanove: +33 (0)5 63 67 23 09. Le Moulin de Mirande: +33 (0)5 63 24 50 50. M. Rouquet: +33 (0)6 78 30 78 47. Mme Zweers: +33 (0)5 63 67 75 68. Gîtes, vacation rentals, and campsites Further information: + 33 (0)5 63 67 29 84. www.bruniguel.fr

I Eating Out

Les Bastides: +33 (0)5 63 67 21 87. Le Café Elia: +33 (0)5 63 24 19 87. Le Délice des Papilles: +33 (0)5 63 20 30 26. Les Gorges de l'Aveyron: +33 (0)5 63 24 50 50. La Taverne du Temps: +33 (0)5 63 65 35 96.

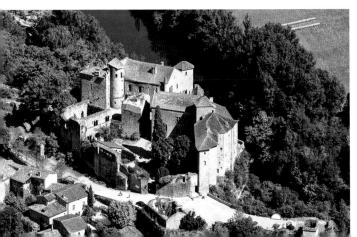

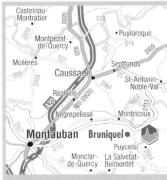

By road: Expressway A2o, exit 59–Saint-Antonin-Noble-Val (13 miles/21 km). By train: Montauban station (18 miles/ 29 km). By air: Toulouse-Blagnac airport (51 miles/82 km).

() Tourist information: +33 (0)5 63 67 29 84 www.bruniquel.fr

Local Specialties Art and Crafts

Jewelry maker • Ceramic artist • Leather engraver • Artists • Art photographer • Potter • Glassblower • Weaver.

★ Events

May: "Vert-Tige" plant market (1st Sunday).

End July-early August: Offenbach Festival. August: Feast day of the patron saint (15th).

September: Les Nuits Frappées de Bruniquel, drumming festival (3rd Saturday), harvest festival (3rd Sunday). December: À la Rencontre des Créateurs de Bruniquel, craft festival (1st weekend).

W Outdoor Activities

Walking: Route GR 46 and 5 marked trails. Trail with pack mules: L'Abri-Niquel: +33 (0)5 63 24 15 26.

🕊 Further Afield

Montricoux; Bioule; Montauban

- (3–19 miles/5–31 km).
- Gorges of the Aveyron and Caylus
- (4 ½-22 miles/7-35 km).
- *Puycelsi (8 miles/13 km), see pp. 234–35.
- *Castelnau-de-Montmiral
- (14 miles/23 km), see p. 183.

Camon The village of 100 roses

Ariège (09) • Population: 147 • Altitude: 1,148 ft. (350 m)

Nestling at the bottom of a valley in Ariège, Camon has a historic fortress-abbey within the ring of its ramparts.

The village is situated on a bend in the Hers river, on the boundary between Ariège and Aude, and grew out of an abbey that had been founded in the 10th century by Benedictine monks. The monastery became a priory belonging to the abbey at Lagrasse in 1068. but it was destroyed on 18 June 1279 by a catastrophic flood, caused when the natural barrier holding back the waters of the Lac de Puivert broke. Restored during the 14th century, the priory was again devastated in 1494 by bands of rovers and was abandoned. In the early 16th century, Philippe de Lévis, the new bishop of Mirepoix, rebuilt and fortified it, at the same time as reconstructing the church shared by the monks and local inhabitants. He guaranteed them protection by enclosing the town within a second defensive wall. At the end of the 16th century, Cardinal George d'Armagnac, then prior of Camon, strengthened the fortifications and gave the village and the priory their current appearance. Typical of the fortified villages of the Ariège département, whose houses made from local materials hunch together cheek by jowl and are covered in curved tiles, Camon is also dubbed "the village of 100 roses" and celebrates this delicate flower every May.

Highlights

• Village (abbey, church, ramparts): Guided tours. Further information: +33 (0)5 61 68 88 26.

• Cabanes (stone huts) of Camon: Themed path around the historic dry-stone winegrowers' huts; wild orchids in springtime; guided tours: +33 (0)5 61 68 88 26; "Les Bal'ânes aux Cab'ânes" trail along the cabanes path on pack mules, July–August, booking essential: +33 (0)5 61 68 88 26. • **Roseraie:** Fragrant rose garden (free entry).

Accommodation

Guestinouses L'Abbaye-Château de Camon: +33 (0)5 61 60 31 23. Gîtes Gîtes de Daurat, Mme Vercauteren: +33 (0)5 61 68 24 92. Campsites La Pibola***: +33 (0)5 61 68 12 14.

La Besse**, farm campsite: +33 (0)5 61 68 84 63.

T Eating Out

L'Abbaye-Château de Camon (evenings; booking essential): +33 (0)5 61 60 31 23. La Bergerie: +33 (0)6 95 40 28 85. La Besse, light meals and seasonal farm produce: +33 (0)5 61 68 84 63. La Camonette, light meals using local, seasonal ingredients (summer only): +33 (0)6 86 72 80 21.

*** Local Specialties** Food and Drink

Charcuterie • Croustades (flaky fruit pastries) • Grapes and grape juice. Art and Crafts Ceramics (sale and workshops).

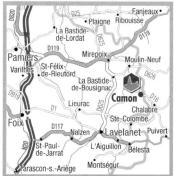

By road: Expressway A66, exit 6–Mirepoix (21 miles/34 km); expressway A61, exit 22– Foix (25 miles/40 km). By train: Foix station (29 miles/47 km). By air: Carcassonne-Salvaza airport (35 miles/56 km); Toulouse-Blagnac airport (70 miles/113 km).

() Tourist information: +33 (0)5 61 68 88 26 www.camono9.org

★ Events

May: Fête des Roses (3rd Sunday). July-August: "Des Chouettes sous les Étoiles," discovering night raptors and stars (booking essential): +33 (0)5 61 68 88 26.

W Outdoor Activities

Canoeing • Fishing (accessible fishing facilities) • Walking • Voie Verte, picturesque greenway (disused railway line, Lavelanet– Mirepoix): suitable for walking, mountainbiking, and horse-riding.

🕊 Further Afield

• Chalabre, fortified town; Lac de Montbel, lake; Puivert: castle, museum; Nébias: natural maze (6–12 miles/9.5–19 km).

- Mirepoix; Vals (7 1/2-16 miles/12-26 km).
- Lavelanet; Château de Montségur
- (10–22 miles/16–35 km).
- Carcassonne (31 miles/50 km).

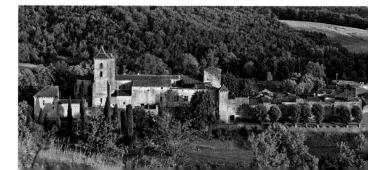

Capdenac-le-Haut

Lot (46) • Population: 1,111 • Altitude: 853 ft. (260 m)

Perched on a protruding rock, more than 360 ft. (110 m) above a meander in the Lot river, Capdenac "on high" suffered attacks by Julius Caesar and Simon de Montfort.

Shaped like the figurehead at the prow of a ship, Capdenac allegedly got its Occitan name from the configuration of the site. It was coveted for its strategic position, and what we know today as the medieval fortress was conquered in the 13th century by the count of Toulouse. However, well before that, this was the location of one of the most important Roman towns in Quercy: Uxellodunum, the site of Roman Emperor Julius Caesar's last battle against the Gauls. The Gaulish spring and Caesar's spring, fed by magnificent underground cisterns, are reminders of these ancient times. The monumental gates to the citadel, the keep, and several handsome 18th-century residences show Capdenac's second face—a place that navigated the trials and tribulations of the Middle Ages, and in which lived Maximilien de Béthune, duke of Sully (1560–1641), Henri IV's loyal minister.

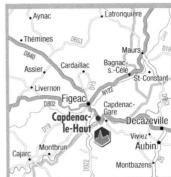

By road: Expressway A2o, exit 56–Rodez (32 miles/51 km). By train: Capdenac-Gare station (2 miles/3 km); Figeac station (3 ½ miles/5.5 km). By air: Rodez-Marcillac airport (31 miles/50 km).

(i) Tourist information—

Pays de Figeac: +33 (0)5 65 38 32 26 or +33 (0)5 65 34 06 25 www.capdenac-lot.fr

Highlights

Keep (13th and 14th centuries): Exhibition on the prehistoric, Gallo-Roman, and medieval periods: +33 (0)5 65 38 32 26.
Fontaine des Anglais: Troglodyte spring with two underground pools: +33 (0)5 65 38 32 26.

• Jardin Médiéval Cinq Sens: Plants arranged according the five senses—smell, sight, touch, taste, and a fountain to stimulate hearing; medicinal plants: +33 (0)5 65 38 32 26.

• Village: Torchlit visits in July and August: +33 (0)5 65 38 32 26.

Accommodation

Le Relais de la Tour***: +33 (0)5 65 11 06 99. **Gites and vacation rentals** M. Claude Andrieu*** and **: +33 (0)5 65 34 54 82. M. Lacarrière***: +33 (0)5 65 50 03 26. M. Couderc**: +33 (0)5 65 34 19 50. M. Tayrac**: +33 (0)5 65 34 03 81. M. Vibe: +33 (0)6 03 94 00 99.

T Eating Out

La Bonne Table: +33 (0)5 65 34 16 10. L'Oltis, crêperie: +33 (0)5 65 34 05 85. Le Relais de la Tour: +33 (0)5 65 11 06 99.

* Local Specialties Food and Drink Goat cheese • Fouaces (brioche/cake).

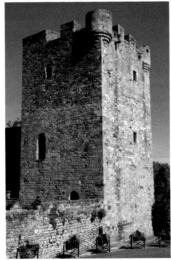

★ Events

Summer market: Wednesday mornings in July and August, Place de la Mairie. April-October: Exhibitions in the keep. April: Foire aux Chevaux, horse fair (3rd Saturday).

July-August: Evening markets, concerts, art exhibitions. September: Local saint's day (ard weekend).

W Outdoor Activities

Walking: 1 marked trail: +33 (0)5 65 38 32 26.

🕊 Further Afield

- Figeac: Musée Champollion
- (3 ½ miles/5.5 km).
- *Cardaillac (10 miles/16 km), see p. 180.
- Peyrusse-le-Roc (11 miles/18 km).
- Decazeville (14 miles/23 km).
- Villefranche-de-Rouergue (21 miles/ 34 km).
- *Belcastel (24 miles/39 km),
- see pp. 168–69.
- *Conques (26 miles/42 km),
- see pp. 188-89.
- •*Autoire (29 miles/47 km), see p. 163.

I Did you know?

In 1866, treasure consisting of 3,000 Gaulish silver coins was discovered in an earthenware jar when the mayor dug a cellar in his garden at the heart of the village. Part of the treasure was acquired by a Parisian coin collector, and the rest was melted and turned into silver plate. Today, five of these pieces are kept in the Cabinet des Médailles at the Bibliothèque Nationale in Paris.

Cardaillac

Lot (46) • Population: 614 • Altitude: 1,175 ft. (358 m)

The powerful feudal Cardaillac family founded this village on the fringes of Quercy and Ségala, and gave it its name.

When Pépin the Younger (714–768) granted Cardaillac lands to his knight Bertrand and descendants, he guaranteed a bright future for the village. The fort, completed in the 12th century, sits on a triangular spur, two cliffs providing natural fortifications. Three towers are all that survive of the ramparts: the round tower, the clock tower (which serves the prison), and the tower of Sagnes, which affords a panoramic view of the village. Cardaillac was attacked during both the Hundred Years War and the Wars of Religion; these events drove the local people to become the most fervent Protestant community in Haut Quercy, and they participated in the destruction of Saint Julian's Church. The church was restored to Catholicism by the Edict of Nantes, then rebuilt in the 17th century, when the fort passed into the hands of Protestant reformers. At the Revocation of the Edict of Nantes, the ramparts and towers were razed to the ground.

Highlights

• Fort: Ruins of 11th-century medieval fort (Sagnes and clock towers); guided visits in summer. Further information: +33 (0)5 65 34 06 25.

 Medieval kitchen garden: Medicinal plants and plants used in dyeing; selfguided visit with information boards.
 Musée Éclaté: Multisite museum; visit several sites that tell the story of the village and its people since the Middle Ages. Visit La Maison du Semalier (13th century), containing the workshop of Émile Cros—poet, inventor, and last master craftsman of the *comporte* baskets used for brining in the grape harvest; La Maison de l'Oustal, house of the Cardaillac-Thémines (fortified medieval house), collection of farming equipment and craftsman's tools; *l'étuve à pruneaux* (plum steam-room) and the bread oven, the saboterie (clogmaker), and the moulin à huile de noix (walnut mill):

+33 (0)5 65 40 10 63 or

+33 (0)5 65 40 15 65.

• Village: Signposted route with information boards; guided tours by appointment only: +33 (0)5 65 34 06 25.

✓ Accommodation Guesthouses

M. and Mme Labedie: +33 (0)5 65 34 68 75. Le Relais de Conques: +33 (0)5 65 40 17 22. **Gîtes and vacation rentals**

Isabelle de la Rosa***: +33 (0)5 65 34 18 95. Le Chalet du Ségala: +33 (0)5 65 34 56 88.

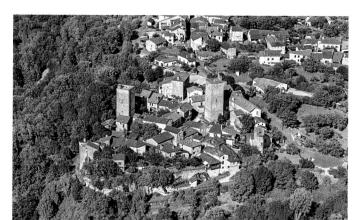

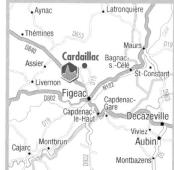

By road: Expressway A20, exit 56– Rodez (27 miles/43 km). By train: Figeac station (7 ½ miles/12 km). By air: Rodez-Marcillac airport (41 miles/66 km).

D Tourist information— Pays de Figeac: +33 (0)5 65 34 06 25 www.tourisme-figeac.com

Raymond Davet: +33 (0)5 65 40 16 39. Didier Gaubert: +33 (0)6 09 79 46 70.

T Eating Out

Le Bar du Fort: +33 (0)5 65 11 08 86.

★ Events

Market: Sunday mornings, 8.30 a.m.–1 p.m., Place du Boulodrome.

May: Foire du Renouveau, flea market, crafts, local produce.

June: National gardens day.

July-August: Ciné-village, film sceening preceded by a meal at the village hall; exhibitions; local saint's day; Fête de la Peinture, painting festival. November: Saint Martin's Fair, flea market, trees and flowers, local produce.

🕷 Outdoor Activities

Children's playground • Picnic area • Boules area (entry at any time) • Hunting • Fishing (lak Murat 1st category permit) • Mountain-biking • Walking: Route GR 6 and marked trails.

🖗 Further Afield

- Figeac (6 miles/9.5 km).
- *Capdenac-le-Haut (11 miles/18 km), see p. 179
- Lacapelle-Marival (9 ½ miles/15.5 km).
- Célé valley (16 miles/26 km).
- Rocamadour (22 miles/35 km).
- Saint-Céré (22 miles/35 km).
- *Autoire (24 miles/39 km), see p. 163.
- Gouffre de Padirac, chasm (25 miles/40 km).

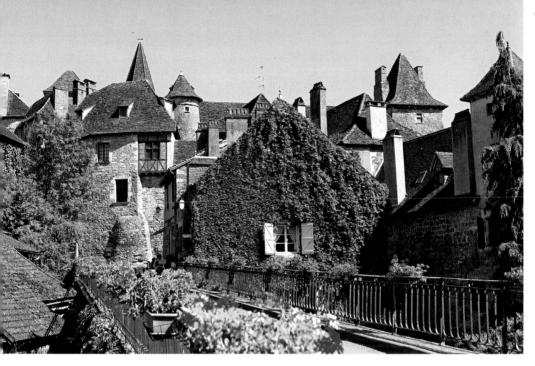

Carennac

Renaissance elegance and Quercy charm

Lot (46) • Population: 386 • Altitude: 387 ft. (118 m)

Carennac sits on the banks of the Dordogne, facing the Île de Calypso, where it shelters Renaissance houses adorned with sculptured windows.

In the days when it was called Carendenacus, the village huddled around a church that was dedicated to Saint Sernin and annexed to Beaulieu Abbey. On the orders of Cluny Abbey, the parish became a priory, and in the 11th century it built the existing Romanesque Église de Saint-Pierre, whose door is decorated with a magnificent 12th-century tympanum. The Flamboyant part-Romanesque, part-Gothic cloisters stretch out on either side of a hexagonal tower and contain a chapter house with a 16th-century sculpture of the Entombment. 15th-century bas-reliefs of Christ's life and passion. and various statues by different craftsmen. In the Château des Dovens, the heritage center hosts an exhibition staged by the Pays d'Art et d'Histoire association. of which Carennac is a member. The village houses, nestling up to this exquisite building, live up to the beauty of the church. Built in stone, some boast ornate mullioned windows, while others have watchtowers or exterior staircases, and they are covered in a patchwork of steeply sloping brown-tiled roofs, typical of this area.

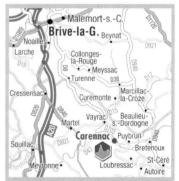

By road: Expressway A2o, exit 56– Rodez (27 miles/43 km). By train: Rocamadour station (14 miles/23 km); Gramat station (19 miles/31 km); Brive-Gaillarde station (30 miles/48 km). By air: Brive-Vallée de la Dordogne airport (21 miles/34 km).

(i) Tourist information—Vallée de la Dordogne-Rocamadour-Padirac: +33 (0)5 65 33 22 00 www.vallee-dordogne.com

Highlights

• Église de Saint-Pierre and its cloister (11th-12th centuries).

• Espace Patrimoine, heritage center (16th-century building): Permanent exhibition on the area's natural, architectural, and patrimonial wealth: +33 (0)5 65 33 81 36.

• Priory and village: Guided tours by appointment only: +33 (0)5 65 10 97 01.

Accommodation

Hostellerie Fénelon**: +33 (0)5 65 10 96 46. Guesthouses

La Farga: +33 (0)5 65 33 18 97 or +33 (0)6 73 73 56 79.

La Petite Vigne: +33 (0)5 65 50 25 84. Vacation rentals

Further information: +33 (0)5 65 33 22 00 www.vallee-dordogne.com

Campsites

L'Eau Vive**: +33 (0)5 65 10 97 39.

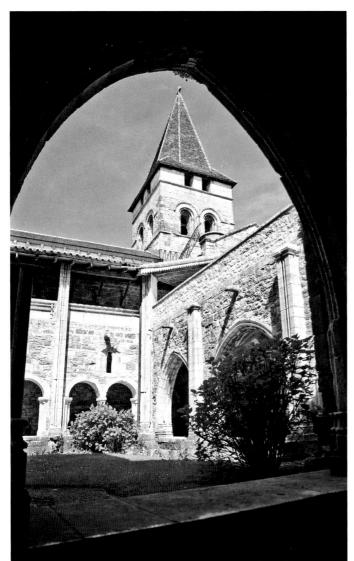

T Eating Out

La Bodega: +33 (0)5 65 39 77 77. Le Calypso: +33 (0)5 65 40 68 91. Le Fénelon: +33 (0)5 65 10 96 46. Le Prieuré: +33 (0)5 65 39 76 74.

Local Specialties Art and Crafts

Ceramic artist • Marquetry • Sculptor (summer).

★ Events

Market: July–August, local products on Tuesdays, 5–8 p.m. July–September: Painting and sculpture exhibitions.

August: Journée de la Prune Dorée de Carennac, plum market (1st Monday). November: Mois de la Pierre, "month of the stone" exhibition. December: Christmas market

W Outdoor Activities

Canoeing • Fishing • Walking: Route GR 52 • Mountain-biking.

🕊 Further Afield

• *Loubressac (6 miles/9.5 km), see p. 212. • Castelnau and Montal castles, Saint-Céré (6–10 miles/9.5–16 km).

• Gouffre de Padirac, chasm; Rocamadour (6–12 miles/9.5–19 km).

- *Autoire (8 miles/13 km), see p. 163.
- *Curemonte (9 ½ miles/15.5 km), see p. 191.
- Dordogne valley (11–22 miles/18–35 km).
- Martel (11 miles/18 km).
- *Collonges-la-Rouge (14 miles/23 km), see pp. 186–87.

•*Turenne (15 miles/24 km), see pp. 260–61.

I Did you know?

After the Wars of Religion, the 17th century saw the return of prosperity to Carennac, thanks to the peace established by Henri IV (1553–1610). The priory of Carennac became part of the fiefdom of the Salignac family of La Mothe-Fénelon, whose most famous member was François Fénelon, prior of the abbey from 1681 to 1685 and later bishop of Cambrai. He chose this "happy corner of the globe" in which to write his instructional novel *The Adventures of Telemachus*.

Castelnaude-Montmiral

The treasure of the counts of Armagnac

Tarn (81) • Population: 1,000 • Altitude: 951 ft. (290 m)

The *bastide* of Castelnau-de-Montmiral, which overlooks the forest of the Vère, contains a rich heritage bequeathed by the counts of Toulouse and Armagnac.

Proudly perched on its rocky outcrop, the village is ideally situated as a lookout and, in the Middle Ages, saw remarkable growth and the building of a seignorial castle coupled with an impregnable fortress. The castle was destroyed in the 19th century, but part of the fortifications have been preserved, along with the Porte des Garrics, dating from the 13th century. At the center of the *bastide*, founded in 1222 by the Count of Toulouse Raymond VII, 16th- and 17th-century houses surround the covered square and old well. The Eglise Notre-Dame-de-l'Assomption contains a superb Baroque altarpiece, a Pietà, and a Pensive Christ from the 15th century, as well as the reliquary cross of the consuls from the late 14th century; a masterpiece of southern religious goldsmithery, which was originally decorated with 354 precious stones.

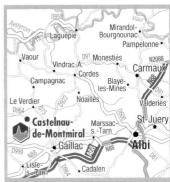

By road: Expressway A68, exit 9–Gaillac (12 miles/19 km); expressway A20, exit 59–Saint-Antonin-Noble-Val (26 miles/42 km). By train: Gaillac station (7 miles/11.5 km). By air: Toulouse-Blagnac airport (50 miles/80 km).

(i) Tourist information:

+33 (0)5 63 33 15 11 0r +33 (0)5 63 57 14 65 www.tourisme-vignoble-bastides.com

Highlights

Église Notre-Dame-de-l'Assomption
 (15th–16th centuries): 14th-century
 reliquary cross, altarpiece, Pensive Christ,
 Pietà, frescoes.

• **Permanent exhibition**: "Castelnau, Pages d'Histoire" at the tourist information center.

• Château de Mayragues (12th-17th centuries): Open for visits on Thursdays in July and August. Further information: +33 (0)5 63 33 15 11.

• Village: Guided tour for groups by appointment only; in summer also for individuals: +33 (0)5 63 33 15 11.

Accommodation

Hotels

Les Consuls***: +33 (0)5 63 33 17 44. Guesthouses

Mme Bricout***: +33 (0)5 63 33 50 41 or +33 (0)6 19 02 26 65.

M. Burd***: +33 (0)5 63 40 47 93. M. Coquillat***: +33 (0)5 63 40 17 25. Mme Geddes***: +33 (0)5 63 33 94 08. M. Janssens***: +33 (0)5 63 57 20 42. Mme Sordoillet***: +33 (0)5 63 48 83 01.

Gîtes and walkers' lodges

Further information: +33 (0)5 63 33 15 11 www.tourisme-vignoble-bastides.com Campsites

Domaine du Chêne Vert***: +33 (0)5 63 33 16 10.

T Eating Out

Les Arcades: +33 (0)5 63 33 20 88. Au Baladin de la Grésigne, light meals: +33 (0)5 63 42 78 99. Marina Pizza: +33 (0)5 63 34 47 43.

Local Specialties

Food and Drink Foie gras, duck confit, duck breast (magret) • AOC Gaillac wines. Art and Crafts Perfumer • Artists • Art gallery.

🖈 Events

Market: All year round, Tuesday mornings, Place des Arcades. Pentecost: Village festival (weekend). July and August: "Les Musicales," rock, blues, and pop festival (mid-July); "Architecture et Musique," festival of music in fine settings (late July–early August). August 15: Honey and local produce fair, village festival.

W Outdoor Activities

Base de Vère-Grésigne: Swimming, fishing, paddleboat, mountain-bike trail departure point • Walking: Routes GR 36 and 46 and 3 marked trails.

🕊 Further Afield

- Gaillac (7 ½ miles/12 km).
- *Puycelsi (8 miles/13 km), see pp. 235–36.
- •*Bruniquel (14 miles/23 km), see p. 177.
- Cordes-sur-Ciel (14 miles/23 km).
- Albi (20 miles/32 km).
- *Monestiés (20 miles/32 km), see p. 214.

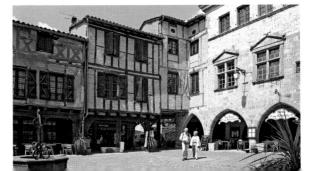

Castelnaudla-Chapelle A tale of two châteaux

Dordogne (24) • Population: 461 • Altitude: 459 ft. (140 m)

Clinging to the cliffside overlooking the confluence of the Dordogne and Céou rivers, the Château de Castelnaud and its houses, which are typical of the Périgord region, are arranged in tiers along the steep, narrow streets. Built in the 12th century on a strategic site for controlling the region's main river and land transportation routes, the Château de Castelnaud was much coveted during the many wars that marked the Middle Ages. Abandoned during the French Revolution, it was even used as a stone quarry in the 19th century, until, in 1966, it was listed as a historic monument and was thus prevented from falling into total ruin. Today, after extensive restoration, it once again casts its shadow over the valley, offering an exceptional view over the neighboring villages. It houses the Musée de la Guerre au Moyen Âge (medieval warfare museum). In the village, the characteristic houses, with their pale facades and brown sloping roofs, contrast with the green vegetation of the area. Not far from the river, the Château des Milandes preserves the memory of the French jazz entertainer Josephine Baker, who owned the property from 1947 to 1968.

Highlights

 Château de Castelnaud (12th century, restored): Musée de la Guerre au Moyen Âge in the halls of the seigneurial home, a collection of 200 items of weapons and armor, collection of furniture, scenography: +33 (0)5 53 31 30 00.
 Château des Milandes (15th century): Permanent exhibition on the life of Josephine Baker; garden:

+33 (0)5 53 59 31 21. • Écomusée de la Noix du Périgord: History and culture of the walnut in Périgord in an old restored farmhouse surrounded by a walnut grove. Museum, discovery tour, oil press: +33 (0)5 53 59 69 63.

• Gardens of the Château de Lacoste: Boxwood and rose garden, vegetable garden, park: +33 (o)5 53 29 89 37.

Accommodation Guesthouses

Le Petit Bois: +33 (0)5 53 28 29 32. La Tour de Cause: +33 (0)5 53 30 30 51. **Gîtes and vacation rentals**

Carpignac: +33 (0)5 58 74 33 81. La Chambre à Four: +33 (0)5 53 31 45 40. L'Escale: +33 (0)5 53 31 45 40. Fondaumier: +33 (0)5 53 31 45 40. La Grange au Puits: +33 (0)5 53 29 55 50.

Campsites and holiday villages

Camping Maisonneuve***: +33 (0)5 53 29 51 29. Camping-village de Vacances Lou Castel***: +33 (0)5 53 29 89 24.

T Eating Out

Bar du Château: +33 (0)5 53 29 51 16. La Cour de Récré: +33 (0)5 53 31 89 85. Les Machicoulis, crêperie: +33 (0)5 53 28 23 15. La Plage, pizzeria/snack bar: +33 (0)5 53 29 40 87. La Taverne du Château: +33 (0)5 53 31 30 00. Les Tilleuls, brasserie: +33 (0)5 53 29 58 54. Le Tornoli: +33 (0)5 53 29 31 21. Le Tournepique: +33 (0)5 53 29 51 07.

Local Specialties

Art and Crafts: Miniature models.

★ Events

July: Fête de la Plage (beach festival, weekend after the 14th).

W Outdoor Activities

Municipal canoeing center: +33 (0)5 53 29 40 07 • Walking: Route GR 64 and marked trails • Mountainbiking • Horse-riding.

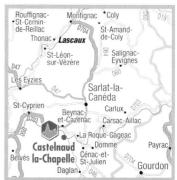

By road: Expressway A2o, exit 55– Sarlat (23 miles/37 km). By train: Sarlatla-Canéda station (7 ½ miles/12 km). By air: Brive-Vallée de la Dordogne airport (35 miles/56 km); Bergerac-Roumanière airport (42 miles/68 km).

(i) Tourist information— Vallée et Coteaux du Céou: +33 (0)5 53 29 88 84 www.tourisme-ceou.com

🕊 Further Afield

 Dordogne Valley: *La Roque-Gageac (2 miles/3 km), see pp. 236–37; *Beynac-et-Cazenac (2 ½ miles/4 km), see pp. 172–73; *Domme (6 miles/9.5 km), see pp. 192–93; *Belvès (11 miles/18 km), see pp. 170–71;

- *Limeuil (21 miles/34 km), see pp. 210–11.
- Sarlat (8 miles/13 km).
- Les Eyzies (15 miles/24 km).
- *Monpazier (21 miles/34 km), see pp. 217–18
- *Saint-Amand-de-Coly (22 miles/35 km), see pp. 238–39.

• Vézère valley: *Saint-Léon-sur-Vézère (23 miles/37 km), see p. 246.

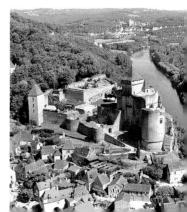

Castelnou

In the foothills of the Pyrenees

Pyrénées-Orientales (66) • Population: 365 • Altitude: 804 ft. (245 m)

Nestled in the Aspres, foothills accentuated by the magnificent Canigou mountain, Castelnou is a village that typifies Catalan rural architecture. Surrounded by two limestone plateaus-the Causse de Thuir and the Roc de Majorque-the village, founded in the 10th century, seems to have been forgotten by time after having been the capital of the viscountcy of Vallespir for more than three centuries. The castle follows the natural shape of the rock and forms a pentagon. The steepness of the rock, the castle's 10-ft. (3-m) thick walls, and the 13th-century fortified walls surrounding the village, of which eight towers remain, assured its defense. To the northeast of the village, a tower erected on a hill provided a lookout for surveying the surrounding area. The harshness of this steep, tiered, stone-built site contrasts with the intimacy of the narrow flower-filled streets lined with warm-hued houses with round-tiled roofs. To the north of the village, the Église Santa Maria del Mercadal (Saint Mary of the marketplace) is in the Catalan Romanesque style.

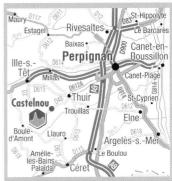

By road: Expressway A9, exit 42–Perpignan Sud (10 miles/16 km). By train: Perpignan station (12 miles/19 km). By air: Perpignan-Rivesaltes airport (17 miles/27 km).

① Tourist information— Aspres-Thuir: +33 (0)4 68 28 32 38 0r +33 (0)4 68 53 45 86 www.aspres-thuir.com

Highlights

• **Castle** (10th century): Permanent exhibitions (armor, medieval costumes, archers), film; Mediterranean gardens. Standard and dramatized tours: +33 (0)4 68 53 22 91.

• Église Santa Maria del Mercadal (12th century).

• Village: Guided tour by appointment only.

Accommodation Guesthouses

La Figuera***: +33 (0)4 68 53 18 42. Les Coricos: +33 (0)6 76 96 47 00. La Planquette: +33 (0)4 68 53 48 13. **Gîtes**

Further information: +33 (0)4 68 53 45 72 www.aspres-thuir.com

T Eating Out

Restaurants

♥ D'Ici et d'Ailleurs: +33 (0)4 68 53 23 30. L'Hostal: +33 (0)4 68 53 45 42.

Light meals

Au Pré de Carlos: +33 (0)4 34 54 18 29 or +33 (0)6 34 49 40 01. Le Coin Catalan: +33 (0)4 68 53 26 88. La Font: +33 (0)4 68 53 66 25 or +33 (0)6 87 12 73 72.

Local Specialties

Food and Drink

Foie gras, preserves • Farm produce • Honey. Art and Crafts

Artists' and craftsmen's studios and galleries • Cutler • Wirework workshop • Artist-mosaicist • Potters • Wood turner • Artworks made from eggshells • Sculptural ceramicist • Lampshades • Objects created from recycled paper.

\star Events

Market: Mid-June–mid-September, Tuesday and Friday 9 a.m.–7 p.m., at the foot of the church.

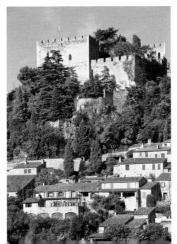

April–October: Temporary exhibitions, Carré d'Art Descossy and Carré d'Art Gili. June: Les Lucioles de Castelnou, 11-mile/ 18-km night race; "Feu de la Saint-Jean," Saint John's Eve bonfire (end of June). October: Farmers' market (2nd weekend).

W Outdoor Activities

Donkey rides.

🕊 Further Afield

• Camélas; Fontcouverte; Monastir-del-Camp; Sainte-Colombe; Serrabonne (2 ½–9 ½ miles/4–15.5 km).

- Thuir (Byrrh wine cellars), Perpignan (13 miles/21 km).
- Céret; Tech valley (18 miles/29 km).
- *Eus (18 miles/29 km), see p. 196.
- Elne; Collioure (19 miles/31 km).
- *Villefranche-de-Conflent
- (23 miles/37 km), see pp. 262–63.
- *Mosset (25 miles/40 km), see pp. 222–23.

I Did you know?

Catalonia has instilled its style in Castelnou's architecture. Keeping the ground floor for livestock and servants' quarters, the ocher-fronted houses have an outside staircase that leads to the living quarters. Bread ovens, accessible from inside the house, swell the walls.

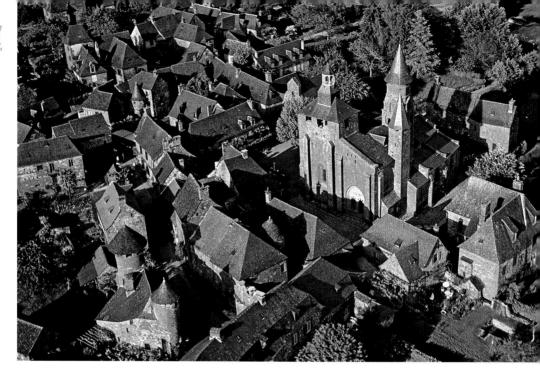

Collonges-la-Rouge Russet-colored Corrèze

Corrèze (19) • Population: 455 • Altitude: 755 ft. (230 m)

On the border between Limousin and Quercy, the red sandstone of Collonges harmonizes with the green of the vines rambling on its façades. Built up around a Benedictine priory founded in the 8th century, the village came under the lordship of the powerful neighboring viscount of Turenne in the 13th century and was the place of residence of his judicial officers. Collonges then acquired the Renaissance castles of Maussac, Vassinhac, Benge, and Beauvirie, With its imposing proportions, lauze (schist stone) roofs, towers, turrets, and watchtowers, both rural and bourgeois, robust and refined, Collonges-la-Rouge displays a rare homogeneity and has been remarkably well preserved. Every building, every monument declares the village's rich history. The Église Saint-Pierre, built in the 11th and 12th centuries, bears witness to the time when Collonges was one of the stopping places on the Saint James's Way pilgrim route via Rocamadour. The Priory gate, which is vaulted and ogival shaped, and the Flat gate (it has no tower) are the only remains of the village's former ramparts. At the center of the village, the former grain and wine market dating from the 16th century recalls the village's commercial activity and prosperous history, and still houses the communal bread oven. The Chapelle des Pénitents, which can be admired today thanks to restoration work by the Friends of Collonges, was, from 1765 to the end of the 19th century, home to the Brotherhood of Black Penitents, whose charitable missions included burying the dead free of charge.

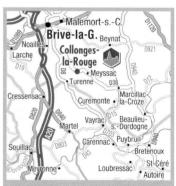

By road: Expressway A2o, exit 52– Collonges-Ia-Rouge (9 ½ miles/15.5 km). By train: Brive-Ia-Gaillarde station (12 miles/19 km). By air: Brive-Vallée de la Dordogne airport (14 miles/23 km).

(i) Tourist information—Vallée de la Dordogne: +33 (0)5 65 33 22 00 www.vallee-dordogne.com

Highlights

• Chapelle des Pénitents (15th century): Restored in 1927 by the Friends of Collonges.

• Église Saint-Pierre (11th–12th centuries): Carved tympanum.

 Maison de la Sirène (16th century): A typical Collonges house with furniture and everyday objects from the past; history of the village: +33 (0)5 55 84 08 03 or +33 (0)5 55 25 24 28.

• Village: Guided tour. Further information: 05 55 25 47 57 or +33 (0)5 55 25 32 25.

Accommodation

♥ Le Relais Saint-Jacques**:

+33 (0)5 55 25 41 02. Guesthouses

leanne Maison d'Hôte****:

+33 (0)5 55 25 42 31 or +33 (0)6 86 70 63 53. Domaine de Peyrelimouse***:

+33 (0)5 55 84 07 17 or +33 (0)6 73 57 08 99. La Douce France***: +33 (0)5 55 84 39 59 or +33 (0)6 88 65 69 95.

La Vigne Grande**: +33 (0)5 55 25 39 20. Le Jardin de la Raze: +33 (0)5 55 25 48 16 or +33 (0)6 04 18 89 91.

Gîtes and vacation rentals Further information: 05 55 25 47 57 www.ot-collonges.fr

Holiday villages Les Vignottes: +33 (0)5 55 25 30 91. Campsites Moulin de la Valane***:

+33 (0)5 55 25 40 20.

T Eating Out

L'Auberge de Benges: +33 (o)5 55 85 76 68. Lou Brasier, pizzeria: +33 (o)6 16 59 69 49. Le Cantou: +33 (o)5 55 84 25 15. Le Collongeois: +33 (o)5 55 84 59 16. La Ferme de Berle, farmhouse inn, booking essential: +33 (o)5 55 25 48 06. Le Pèlerin et la Sorcière, crêperie: +33 (o)5 55 74 23 49. Les Pierres Rouges: +33 (o)5 55 74 19 46. Le Relais Saint-Jacques: +33 (o)5 55 25 41 02.

Local Specialties

Food and Drink Duck • Purple mustard • Walnuts. Art and Crafts Leatherworkers • Hats • Cutlery • Decoration • Art galleries • Linen • Artists • Pottery • Glass.

★ Events

May: Local saint's day (3rd weekend). Mid-July-mid-August: Theater on Tuesday evenings.

August: Fête du Pain, bread festival (1st weekend); painting and visual arts festival (15th).

W Outdoor Activities

Walking: Route GR 480 and several marked trails.

🕊 Further Afield

• Ligneyrac, Noailhac, and Saillac: churches (2–6 miles/3–9.5 km).

- *Turenne (6 miles/9.5 km), see pp. 260–61.
- *Curemonte (7 ½ miles/12 km), see p. 191.
- Brive-la-Gaillarde: Jardins de Colette,
- gardens; market (12 miles/19 km).

- Dordogne valley (12 miles/19 km).
- *Carennac (15 miles/24 km), see pp. 181-82.
- *Loubressac (21 miles/34 km), see p. 212.
- Souillac (21 miles/34 km).
- *Autoire (22 miles/35 km), see p. 163.

I Did you know?

The incomparable color of this stone is due to a geological phenomenon dating back millions of years. The "Meyssac Fault," which passes through Collonges-la-Rouge, was formed by the sliding of the red sandstone of the Massif Central beneath Aquitaine's limestone plate. The oxidized iron of the sandstone of Corrèze gives the stone its dark red color, which is characteristic of the Meyssac Fault.

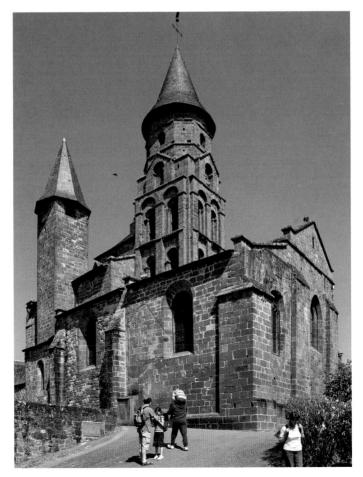

Conques Muse of Romanesque artists

Aveyron (12) • Population: 283 • Altitude: 820 ft. (250 m)

A hotspot for Romanesque art, Conques contains treasures inspired by the faith of artists in the Middle Ages.

Conques was established on the slope of a valley shaped like a shell (concha in Latin, hence its name), at the heart of a rich forested massif situated at the confluence of two rivers: the Ouche and the Dourdou. Its heyday, in the 11th and 12th centuries, coincided with the building of the abbev church, a true masterpiece of Romanesque architecture. Beneath its vaults, 250 capitals are enhanced by contemporary stained-glass windows designed by Pierre Soulages (b. 1919), and on the tympanum of its western portal 124 figures in stone illustrate the Last Judgment. Depicted in all her splendor, Saint Foy keeps watch, with an enigmatic expression, over a unique collection of reliquaries covered in gold, silver, enamelwork, and precious stones. The Barry and Vinzelle gates, remains of the ramparts built during the same period, flank a village where stone reigns. Lining the narrow cobbled streets, the village houses, the oldest of which date from the late Middle Ages, display facades that combine half-timbering, yellow limestone, and red sandstone, and are topped with splendid silver shale roofs.

Highlights

• Abbatiale Sainte-Foy: Guided tour of the tympanum, the lower level of the church, and the tribunes; for information on days and times: +33 (0)5 65 72 85 00. Evening tours of the tribunes with organ and lights daily at 9 p.m. from May to September. Guided tour for groups all year round, booking essential: +33 (0)5 65 72 85 00.

Trésor de Sainte-Foy: Abbey treasury: daily, for times: +33 (0)5 65 72 85 00; guided tour for groups all year round, booking essential: +33 (0)5 65 72 85 00.
Tour of the village: July and August: +33 (0)5 65 72 85 00; accessible tours for visually impaired (tatcile models, reliefs, guidebooks in Braille and large print).
Further information: +33 (0)5 65 72 85 00.

Accommodation

Hervé Busset—Domaine de Cambelong****: +33 (0)5 65 72 84 77. Auberge Saint-Jacques**: +33 (0)5 65 72 86 36 Sainte-Foy: +33 (0)5 65 69 84 03. Guesthouses Au Nid d'Angèle***: +33 (0)6 60 87 28 61. Le Chrismo*** and **: +33 (0)5 65 72 80 39. La Maison des Sources*** +33 (0)5 65 47 04 54 Les Chambres de Marie Scépé**: +33 (0)5 65 72 83 87. Les Chambres de Montignac**: +33 (0)5 65 69 84 29 Chez Alice et Charles**: +33 (0)5 65 72 82 10. Le Castellou: +33 (0)5 65 78 27 09.

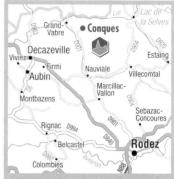

By road: Expressway A75, exit 42–Rodez, N88-Rodez, D 901 (24 miles/39 km). By train: Saint-Christophe-Vallon station (21 miles/34 km); Rodez station (28 miles/45 km). **By air:** Rodez-Aveyron airport (21 miles/34 km).

() Tourist information: +33 (0)5 65 72 85 00 www.tourisme-conques.fr

Les Grangettes de Calvignac: +33 (0)5 65 67 86 70 or +33 (0)6 75 50 59 19. Horse-drawn trailer Le Conqu'errant: +33 (0)5 65 72 90 50. Gîtes and vacation rentals Further information: 05 65 72 85 00 www.tourisme-conques.fr Bunkhouses and walkers' lodges Maison Familiale de Vacances Relais Cap France: +33 (0)5 65 69 86 18. Centre d'Accueil de l'Abbave Sainte-Foy: +33 (0)5 65 69 89 43 Communal walkers' lodge: +33 (0)5 65 72 82 98. Campsites Le Beau Rivage*** (mobile home rentals). Le Faubourg: +33 (0)5 65 69 82 23.

T Eating Out

Auberge Saint-Jacques: +33 (0)5 65 72 86 36. Au Parvis, créperie/brasserie: +33 (0)5 65 72 82 81. Le Charlemagne, créperie/ice cream parlor: +33 (0)5 65 69 81 50. Chez Dany Lo Romiu, pizzeria/snack bar: +33 (0)5 65 46 95 01. Le Conqu'errant: +33 (0)5 65 72 90 50. Hervé Busset—Domaine de Cambelong: +33 (0)5 65 72 84 77. Sainte-Foy: +33 (0)5 65 69 84 03. Sur le Chemin du Thé, tea room/organic fodd: +33 (0)9 60 oz 81 95.

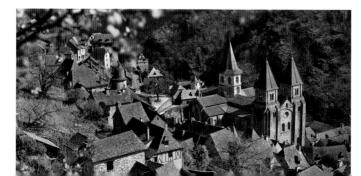

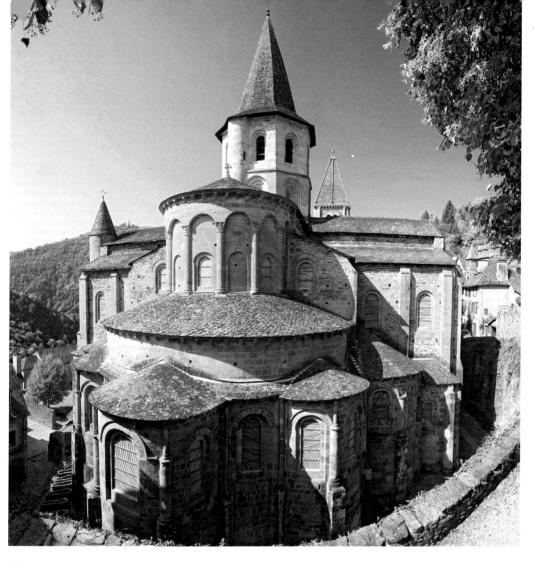

Local Specialties

Food and Drink

Conquaises (walnut shortbread) • Conques wine.

Art and Crafts

Antique dealer • Beadmaker • Art gallery • Etcher • Engraver • Leather craftsmen • Artist • Sadler • Wood-carvers • Sculptorstonemason • Low-warp tapestry.

★ Events

July and August: Classical music festival; evening market (some Thursdays). October: Procession de la Sainte-Foy (the 6th or the 1st Sunday after the 6th). All year round: Lectures, concerts, shows, workshops, etc.

W Outdoor Activities

Fishing • Walking: Routes GR 62 and 65 and 7 marked trails.

W Further Afield

- Dourdou valley and gorge: viewpoint
- at Le Bancarel (1 mile/1.5 km).
- Lot valley (4 ½ miles/7 km).
- Vallon de Marcillac, vineyards and cellar of the Vignerons du Vallon at Valady (11 miles/18 km).
- Salles-la-Source, waterfall (16 miles/26 km).

*Estaing (24 miles/39 km), see pp. 194–95.
*Belcastel (24 miles/39 km), see pp. 168–69.
Rodez: cathedral and Musée Soulages (24 miles/39 km).

I Did you know?

Along with the Pont des Pèlerins, Conques's abbey church is a UNESCO World Heritage Site, at the same rank as the Chemins de Compostelle. Situated on the Saint James's Way, the village remains a must-see stop for pilgrims traveling to Santiago de Compostela.

La Couvertoirade

In the footsteps of the Templars

Aveyron (12) • Population: 188 • Altitude: 2,546 ft. (776 m)

At the heart of the wide-open spaces of the Causse du Larzac, La Couvertoirade is the work of the Templars and Hospitallers. Built in the 12th century, the Château de La Couvertoirade formed part of the command network developed by the Templars throughout the West and in the Holy Land. After they were declared heretics in the early 14th century by Philippe le Bel, the Templars were replaced by the Hospitallers, who inherited all their assets. The latter, too, were soldier-monks and encircled the city with ramparts in the 15th century to protect it from attack and from epidemics. From the top of the ramparts, the view stretches over Larzac and the whole of the village: at the foot of the 12th-century church, a labyrinth of narrow streets lined with "Caussenard"-style houses (built of thick stone to protect the men and livestock inside) and 16th- and 17th-century mansions provides an enticing place to stroll.

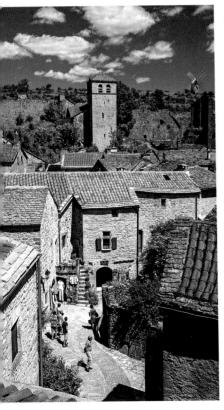

Highlights

• Village: 15th-century ramparts, 17th-century castle, Hospitallers' church, 14th-century oven. Self-guided visit (audioguide) or guided tour, evening tours in summer. Further information: +33 (0)5 65 58 55 59.

Accommodation Guesthouses

M. et Mme Augustin, La Salvetat: +33 (o)5 65 62 13 15. Gite de la Cité: +33 (o)6 01 81 94 18. Les Mourguettes: +33 (o)6 11 08 35 30 or +33 (o)6 14 57 12 31. Gites, walkers' lodges, and vacation rentals Further information: 05 65 62 23 64 www.tourisme-larzac.com Rural campsites Les Canoles, La Blaquèrerie: +33 (o)5 65 62 15 12.

T Eating Out

L'Auberge du Chat Perché: +33 (0)5 65 42 14 61. Au 20 [vingt], light meals/wine bar: +33 (0)5 65 62 19 64. Café Montes, crêperie: +33 (0)5 65 58 10 71. Café des Remparts: +33 (0)5 65 62 11 11. Les Fées des Causses, tea room: +33 (0)5 65 58 14 23. Les Gourmandises de l'Aveyron, light meals: +33 (0)6 83 03 61 31. L'Hospitalier, tea room: +33 (0)6 38 51 88 31. Le Médiéval: +33 (0)5 65 62 27 01. Tour Valette: +33 (0)5 65 62 09 69.

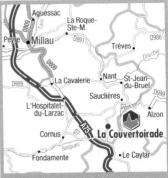

By road: Expressway A75, exit 49–Le Caylar (4 ½ miles/7 km). By train: Millau station (30 miles/48 km). By air: Montpellier-Méditerranée airport (58 miles/93 km).

Tourist information— La Couvertoirade: +33 (0)5 65 58 55 59 www.lacouvertoirade.com Tourist information—Larzac et Vallées: +33 (0)5 65 62 23 64 www.tourisme-larzac.com

Local Specialties

Food and Drink Sheep cheese • Duck produce. Art and Crafts Art gallery • Workshops in summer (potters, weavers, soap-makers, sculptors).

★ Events

July and August: "Les Mascarades," medieval village festival; country market (Thursday evenings); children's days; lectures, concerts, etc.

W Outdoor Activities

Geo-caching: Treasure-hunting with GPS • Pony rides • Trail through the rocks • Walking: Routes GR 71 C and GR 71 D and circular walks around the village • Mountain-biking.

🕊 Further Afield

• Saint-Jean-du-Bruel: Noria, Maison de l'Eau (11 miles/18 km).

• Larzac Templar and Hospitaller sites: La Cavalerie; Sainte-Eulalie-de-Cernon (reptilarium, rail bike; Viala-du-Pas-de-Jaux; Saint-Jean-d'Alcas (12–19 miles/19–31 km).

- Lodève (15 miles/24 km).
- Gorges of the Dourbie; Nant: Romanesque churches (16 miles/26 km).
- Cirque de Navacelles (21 miles/34 km).
 - Millau Viaduct (22 miles/35 km).
- Caves de Roquefort (29 miles/47 km).

Curemonte A village of lords and winegrowers

Corrèze (19) • Population: 216 • Altitude: 689 ft. (210 m)

Punctuated by the towers of its three castles, the profile of Curemonte stands out above the Sourdoire and Maumont valleys.

The village is built on a long sandstone spur. Seen from the top of the village, its medieval architecture is astonishing. Standing near the three castles (the square-towered Saint-Hilaire, the roundtowered Plas, and La Johannie), the Romanesque Église Saint-Barthélemy contains an altarpiece from 1672, and altars of Saint John the Baptist and the Virgin Mary from the 17th and 18th centuries. The late 18th-century covered market houses a Gothic cross shaft. In an enduringly simple and rural atmosphere, Renaissance mansions stand side by side with old winegrowers' houses in a harmony of pale sandstone and brown roof tiles. Outside the village, the Romanesque Église Saint-Genest, decorated with 15th-century paintings, houses a museum of religious artifacts, while the Église de La Combe is one of the oldest churches in Corrèze.

Highlights

Église Saint-Barthélemy (12th century): 17th-century wooden altarpiece.
Église de La Combe (11th century):

Exhibitions in summer.

• Église Saint-Genest: Museum of religious artifacts.

Accommodation

Guesthouses Mme Raynal***: +33 (o)5 55 25 35 01. **Gîtes and vacation rentals** Gîte de la Barbacane***: +33 (o)5 55 87 49 26. Gîte de la Mairie**: +33 (o)5 55 27 38 38. Gîte Plaisance**: +33 (o)5 55 91 08 81. Lou Pé Dé Gril: +33 (o)5 55 25 45 53. La Maison de Marguerite: +33 (o)4 42 01 77 13. Le Roc Blanc: +33 (o)5 55 25 48 02.

T Eating Out

Auberge de la Grotte, farmhouse inn: +33 (0)5 55 25 35 01. La Barbacane: +33 (0)5 55 25 43 29.

Local Specialties Food and Drink

Garlic and shallots • Aperitifs and jams made from dandelion flowers • Strawberries and jams • Artisanal beer.

★ Events

July and August: Festive market, sale of regional produce followed by a barbecue (Wednesdays at 4 p.m.).

W Outdoor Activities

Hunting • Fishing • Walking: Route GR 480 and 2 marked trails.

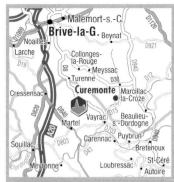

By road: Expressway A20, exit 52– Noailles (11 miles/18 km). By train: Brive-la-Gaillarde station (19 miles/31 km). By air: Brive-Vallée de la Dordogne airport (17 miles/27 km).

Tourist information Vallée de la Dordogne: +33 (0)5 65 33 22 00 www.vallee-dordogne.com

🕊 Further Afield

• La Chapelle-aux-Saints: prehistoric site; museum (2 miles/3 km).

- Dordogne valley: Beaulieu; Argentat (6–22 miles/9.5–35 km).
- *Collonges-la-Rouge (7 ½ miles/12 km), see pp. 186–87.
- *Carennac (8 ½ miles/13.5 km), see p. 181.
- *Turenne (11 miles/18 km), see pp. 260–61.
- *Loubressac (14 miles/23 km), see p. 212.
- *Autoire (16 miles/26 km), see p. 163.
- Brive-la-Gaillarde: Jardins de Colette,

gardens; market (25 miles/40 km).

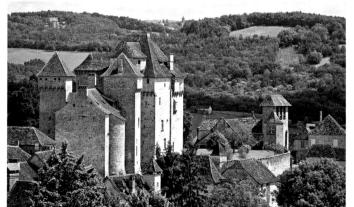

I Did you know?

During the exodus from Paris in 1940, the French novelist Colette came here to seek refuge with her daughter, Colette de Jouvenel, aka Bel-Gazou, owner of the Châteaux de Saint-Hilaire et de Plas. In the tranquillity of the village, the writer wrote part of her novel *Looking Backwards*: "With the help of the rain the seasonal mushrooms spring up in half a night. They grow so rapidly as to bring with them, over their caps, a roof of dead leaves."

Domme

A panaromic viewpoint over the Dordogne

Dordogne (24) • Population: 1,019 • Altitude: 689 ft. (210 m)

On the edge of a breathtakingly high cliff, Domme offers a remarkable view over the Dordogne valley.

Towering 492 ft. (150 m) over the meandering river, Domme's exceptional site accounts for it being one of the most beautiful bastides in the southwest of France, as well as a coveted place marked by a long and turbulent history. Its ramparts, fortified gates, and towers, which served as prisons first for the Templars in the early 14th century, then for French and English soldiers during the Hundred Years War, stand as imposing witnesses of its past. From the Place de la Rode, randomly dotted along flower-decked streets, are fine houses with golden facades and irregular roofs covered with brown tiles, such as the Maison du Batteur de Monnaie, embellished with a triple mullioned window, and the former courthouse of the seneschal, both built in the 13th century. Continuing on from the Place de la Halle, Domme offers a panoramic view of the Dordogne valley, rural landscapes, cultivated land, and a few local heritage sites, such as the Château de Monfort, the village of La Roque-Gageac, and the Jardins de Marqueyssac.

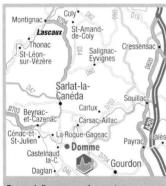

By road: Expressway A2o, exit 55– Sarlat (22 miles/35 km). By train: Sarlatla-Canéda station (7 ½ miles/12 km). By air: Brive-Vallée de la Dordogne airport (33 miles/53 km).

(i) Tourist information— Périgord Noir-Sud Dordogne: +33 (0)5 53 33 71 00 www.tourisme-domme.com

Itighlights

• Église Notre-Dame-de-l'Assomption: Open daily.

• Templar graffiti: Seven pictures linked to religious iconography engraved by the Templars on the walls of the Porte des Tours. Guided tours: +33 (0)5 53 33 71 00.

 Cave with stalactites: The largest accessible cave in the Périgord Noir.
 More than a quarter of a mile (450 m) of tunnels beneath the bastide; ascent by panoramic elevator with a view of the Dordogne valley.
 Further information: +33 (0)5 53 33 71 00.

• L'Oustal du Périgord (popular arts and traditions museum): Collection of 19th- and 20th-century farming objects. Further information: +33 (0)5 53 33 71 00.

• Village: Guided tours in July and August and by appointment only off-season: +33 (0)5 53 33 71 00; tour of the village by tourist train.

Accommodation

L'Esplanade***: +33 (0)5 53 28 31 41. Nouvel Hôtel**: +33 (0)5 53 28 36 81. Les Quatre Vents**: +33 (0)5 53 31 57 57. Guesthouses Le Manoir du Rocher***:

+33 (0)6 15 25 91 75.

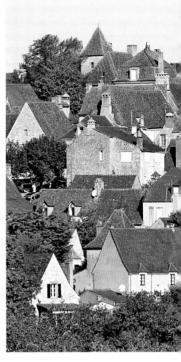

Les Cigales: +33 (0)5 53 59 25 87. Le Colombier: +33 (0)5 53 29 61 02. Ferme Auberge de Montalieu Haut: +33 (0)5 53 28 31 74.

Vacation rentals and campsites

Further information: +33 (0)5 53 31 71 00 www.tourisme-domme.com

Holiday villages

La Combe: +33 (0)5 53 29 77 42. Les Ventoulines: +33 (0)5 53 28 36 29. Village du Paillé: +33 (0)6 73 38 32 94.

T Eating Out

Auberge de la Rode: +33 (0)5 53 28 36 97. Le Belvédère: +33 (0)5 53 31 12 01. La Borie Blanche, farmhouse inn: +33 (0)5 53 28 11 24. Cabanoix et Châtaignes: +33 (0)5 53 31 07 11 Le Carreyrou: +33 (0)6 82 01 08 36. Le Chalet: +33 (0)5 53 29 32 73. L'Esplanade: +33 (0)5 53 28 31 41. Le Jacquou Gourmand: +33 (0)5 53 28 36 81. Le Médiéval: +33 (0)5 53 28 24 57. Mon Coin Resto: +33 (0)5 53 28 347. La Pizzeria des Templiers: +33 (0)6 645 15 0. La Poivrière: +33 (0)5 53 28 32 52. Les Quatre Vents: +33 (0)5 53 31 57 57.

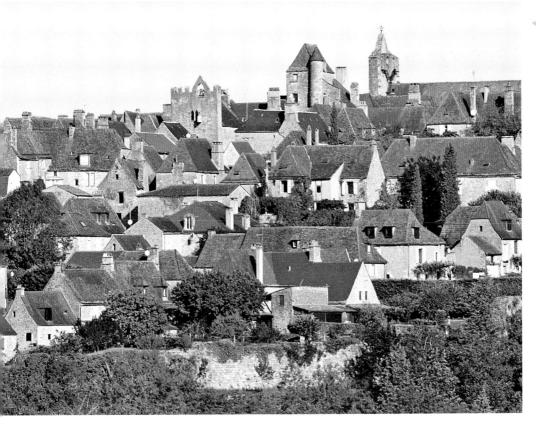

Local Specialties

Food and Drink: Geese • Walnuts. Art and Crafts: Jeweler • Potter • Artist.

★ Events

Market: Thursday morning, Place de la Halle. June: Fête de la Saint-Clair (1st weekend); "Feux de la Saint-Jean," Saint John's Eve bonfire; music festival; amateur dramatics festival.

July 14: Torchlight procession, fireworks.

July and August: Crafts market (Thursdays).

W Outdoor Activities

Canoeing • Tennis • Mountain-biking • Walking: Route GR 64 and marked trails • Air sports: Light aircraft and microlights.

W Further Afield

• Sarlat (7 ½ miles/12 km).

• Dordogne valley: *La Roque-Gageac (3 miles/5 km), see pp. 236–37; *Castelnaudla-Chapelle (6 miles/9.5 km), see p. 184; *Beynac-et-Cazenac (6 miles/9.5 km), see pp. 172– 73; *Belvès (16 miles/26 km), see pp. 170–71.

- *Gourdon (17 miles/27 km), see pp. 106–7.
- Les Eyzies (21 miles/34 km).

•*Saint-Amand-de-Coly (23 miles/37 km), see pp. 238–39.

- Vézère valley: *Saint-Léon-sur-Vézère (24 miles/39 km), see p. 246.
- *Limeuil (24 miles/39 km), see pp. 210–11.
- *Monpazier (27 miles/43 km), see pp. 217–18.

I Did you know?

At the beginning of the 14th century, Philippe Le Bel, king of France from 1285 to his death in 1314, suppressed the Christian military organization the Knights Templar. Some knights of neighboring commanderies were confined in the *bastide* of Domme. Their prison, the Porte des Tours, commemorates those years of captivity. Engraved in the stone, messages bear witness to both their distress and their faith.

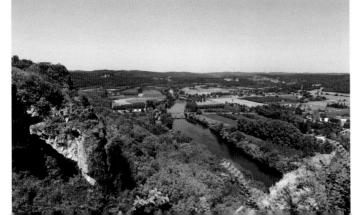

Estaing One family, one castle

Aveyron (12) • Population: 610 • Altitude: 1,050 ft. (320 m)

A short distance from the Gorges of the Lot, Estaing is distinguished by an imposing castle that overlooks the *lauze* (schist stone) roofs of the shale houses.

The illustrious Estaing family left its mark on the history of Rouergue, but also on that of France. For having saved the life of the king at Bouvines in 1214, Tristan was given the right to display the royal fleur-de-lys on his family's coat of arms. In 1368, Pierre d'Estaing was appointed cardinal and governor of the Papal States. Under Louis XVI, Vice-Admiral Charles-Henri distinguished himself overseas in the American War of Independence. The Château des Comtes d'Estaing (11th century to present) mixes Romanesque, Gothic, Flamboyant, and Renaissance styles. On the Place François Annat, the 15th-century church, which has some remarkable altarpieces and stained-glass windows, houses the relics of Saint Fleuret. The fine Renaissance houses at the heart of the village continue to draw tourists.

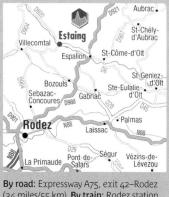

(34 miles/55 km). **By train**: Rodez station (24 miles/39 km). **By train**: Rodez-Marcillac airport (30 miles/48 km).

() Tourist information— Espalion-Estaing: +33 (0)5 65 33 03 22 www.tourisme-espalion.fr

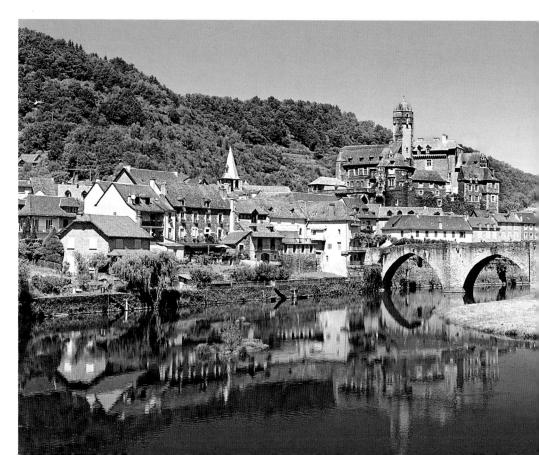

Estaing Aveyron

July: Fête de la Saint-Fleuret, traditional parade (1st Sunday). August: Nuit Lumière, illumination of

the village by candlelight, sound and light show, fireworks (15th).

September: Les Médiévales d'Estaing, Estaing celebrates its medieval past (2nd weekend).

W Outdoor Activities

Trout-fishing • Walking: Routes GR 65 and 6; topographic guide (23 circular walks), and walking tour of the village.

🕊 Further Afield

• Maison de la Vigne, du Vin, et des Paysages d'Estaing (all things wine-related) (3 miles/5 km).

- *Saint-Côme-d'Olt (8 ½ miles/13.5 km), see p. 242.
- Villecomtal (9 1/2 miles/15.5 km).
- Gorges of the Truyère (16 miles/26 km).
- Laguiole; l'Aubrac (16 miles/26 km).
- *Sainte-Eulalie-d'Olt (21 miles/34 km), see p. 243.
 Rodez (22 miles/35 km).
- *Conques (24 miles/39 km), see pp. 188–89.

I Did you know?

The first Sunday of July every year is dedicated to the patron saint of Estaing, Saint Fleuret—a former bishop of Clermont who died at Estaing in 620 cE. The villagers, including 200 actors wearing period costume and representing other historical figures associated with Estaing, celebrate with a procession across the town to the church.

Highlights

Castle (11th century to present): History of the Estaing family. Open to the public n season: self-guided visit of the restored ooms; guided tour by appointment only: #33 (0)5 65 44 72 24.

Église Saint-Fleuret (15th century): Gilded wooden altarpieces (17th and 18th centuries), elics of Saint Fleuret; contemporary stainedglass windows by Claude Baillon.

Village: Guided tour for groups by appointment only: +33 (0)5 65 44 03 22.

Accommodation

lotels

.e Manoir de la Fabrègues***: -33 (0)5 65 66 37 78. Auberge Saint-Fleuret**: +33 (0)5 65 44 01 44. ux Armes d'Estaing**: +33 (0)5 65 44 70 02. Juesthouses

.a Marelle***: +33 (0)5 65 44 66 78. .ou Bellu: +33 (0)6 80 66 77 79. .Oustal de Cervel***: +33 (0)5 65 44 09 89.

jîtes, vacation rentals, and campsites

⁻urther information: +33 (o)5 65 44 03 22 vww.tourisme-espalion.fr

T Eating Out

Auberge Saint-Fleuret: +33 (o)5 65 44 01 44. Aux Armes d'Estaing: +33 (o)5 65 44 07 02. Brasserie du Château: +33 (o)5 65 44 12 89. Chez Mon Père, pizzeria: +33 (o)5 65 44 02 70. Le Chrislou, light meals: +33 (o)5 65 44 35 56. Le Manoir de la Fabrègues: +33 (o)5 65 66 77 8. Le Plaisir du Goût, crêperie/salad bar: +33 (o)5 65 48 27 43.

Local Specialties

Food and Drink AOC and IGP Aveyron wines. Art and Crafts Bags and accessories designer • Jewelers • Cutlerv maker • Artist • Illuminator.

★ Events

Market: July and August, gourmet market, Place du Foirail, Fridays from 7 p.m. June 15–September 15: "Son et Lumière d'Estaing, 1500 ans d'histoire," sound and light show (Wednesday evenings).

EUS A feel of the South

Pyrénées-Orientales (66) • Population: 435 • Altitude: 1,270 ft. (387 m)

Eus is filled with the fragrance of orchards, old olive groves, and the *garrigue*. Built on terraces sheltered from the wind, the village takes its name from the surrounding *yeuses* (holm oaks). Designed for defense, Eus repelled the French in 1598 and, in 1793, the Spanish army, which at that time dominated the region. The 18th-century Église Saint-Vincent stands on the site of the Roman camp that kept watch over the road from Terrenera to Cerdagne, and of the former castle chapel, Notre-Dame-de-la-Volta, built in the 13th century. At the entrance to Eus, a Romanesque chapel is dedicated to the patron saint of winegrowers and to Saint Gaudérique. It opens onto a 13th-century porch made from pink marble from Villefranche-de-Conflent. Clinging to the steep, cobblestone streets, the old restored shale-stone houses give the village a harmonized feel.

Highlights

• Romanesque chapel (11th–13th centuries): Listed as a historical monument.

• Église Saint-Vincent (18th century): Altarpieces and statues.

- Musée La Solana: Popular traditions.
- Village: Guided tour by arrangement:
- +33 (0)4 68 96 22 69.

• Pépinières d'Agrumes Bachès (citrus fruit nursery): Guided tours for groups by appointment only October–February: +33 (0)4 68 96 42 91.

Accommodation Guesthouses

Casa Ilicia: +33 (0)6 95 34 15 32. **Gîtes and vacation rentals** Les Calendulas^{***}: +33 (0)6 84 35 06 11. Destination Méditerranée^{***}: +33 (0)4 68 64 42 88. Julia Marie^{**}: +33 (0)4 34 56 00 26. Amelia^{*}: +33 (0)4 34 56 00 26.

Other gîtes and vacation rentals Further information: +33 (0)4 68 68 42 88 or +33 (0)4 68 05 41 02 www.prades-tourisme.fr

I Eating Out

Des Goûts et des Couleurs, tea room: +33 (0)6 og 53 32 47. El Lluert, bar & tapas: +33 (0)4 68 o5 37 28. Le Vieux Chène d'Eus: +33 (0)4 68 96 35 29.

Local Specialties

Food and Drink Regional fruit and vegetables • Fruit juice • Honey.

Art and Crafts

Murano glass jewelry • Ceramics • Wrought ironwork • Cutlery • Paintings • Photographs • Sculptures • Stained-glass windows • Herbs, oils, and perfumes.

★ Events

January: Feast of Saint Vincent (22nd). Easter Monday: "Goig Dels Ous," Catalan Easter songs presented by the Cant'Eus choir.

June: Croisée d'Arts, contemporary art festival.

August: Festa Major festival; "Nits d'Eus," cultural festival; Course des Lézards, lizard-racing (last Sunday).

W Outdoor Activities

Walking: 5 marked trails • Adventure park (10 trails): tubing, paintball, déval'mountain (downhill course on a scooter).

By road: Expressway A9, exit 42– Perpignan Sud (25 miles/40 km). By train: Prades-Molitg-les-Bains station (3 ½ miles/5.5 km). By air: Perpignan-Rivesaltes airport (29 miles/47 km).

(i) Tourist information— Prades-Conflent: +33 (0)4 68 05 41 02 www.prades-tourisme.fr / www.eus.fr

🕊 Further Afield

• Prades; Abbaye Saint-Michel-de-Cuxa (3 ½ miles/5.5 km).

- Marcevol: priory (5 miles/8 km)
- *Villefranche-de-Conflent (7 ½ miles/
- 12 km), see pp. 262–63.
- *Mosset (8 miles/13 km), see pp. 222–23.
- Vernet-les-Bains; Abbaye Saint-Martin-
- du-Canigou (11 miles/18 km).
- Serrabone: priory (14 miles/23 km).
- *Évol (15 miles/24 km), see p. 197.
- *Castelnou (17 miles/27 km), see p. 185.
- Têt valley; Perpignan (27 miles/
- 43 km).

• Rivesaltes; Salses fort (30 miles/ 48 km).

ÉVOL "A piece of sky on the mountain"

Pyrénées-Orientales (66) • Population: 40 • Altitude: 2,625 ft. (800 m)

In the foothills of the Massif du Madrès, on the side of a valley, the hamlet of Évol emerged from the mountain.

According to Catalan bard Ludovic Massé, who was born here in 1900, Évol, "far from everything," was "a piece of the sky on the mountain whose only shade is from cloud." Invisible from the road that leads from the plain to Cerdagne, the village emerges like a jewel in its verdant setting. Overlooked by the old fortress of the viscounts of So and the bell tower of its Romanesque church, Évol remains in perfect communion with the mountain, which provides a livelihood for its shepherds and is present in the shale of its walls and the blue *lauze* (schist tiles) of its roofs, the cutting of which was one of the occupations undertaken by locals in winter. Along the winding, flower-filled streets, bread ovens, a fig-drying kiln, barns, and interior courtyards bear witness to the daily life of a bygone era.

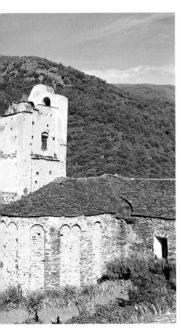

Highlights

• Cabinet Littéraire Ludovic-Massé: Literary room devoted to the Catalan writer, storyteller, and bard, born in Évol in 1900.

- Chapelle Saint-Étienne (13th century).
 Église Saint-André (11th century): Conjuratory (small religious building).
- Conjuratory (small religious building), John the Baptist altarpiece.

 Musée des Arts et Traditions Populaires: Museum of popular arts and traditions, housed in a former local school, featuring old tools. Guided tour by appointment only, Évol la Médiévale association: +33 (0)4 68 97 09 72.

- Viscounts' castle (13th century).
- Église Saint-André at Olette

(11th-13th centuries).

Accommodation

La Fontaine, Olette: +33 (0)4 68 97 03 67. Gîtes and vacation rentals

Mme]asper**: +33 (0)6 15 55 74 79. Mme Campredon: +33 (0)4 68 97 03 82. Mme Grégoire: +33 (0)3 88 35 14 63. Mme Torrejon: +33 (0)4 68 53 01 41. Communal gîtes

Further information: +33 (0)4 68 97 02 86.

T Eating Out

La Casa del Sol, Catalan bistro: +33 (0)4 68 97 10 45. L'Houstalet, local bistro: +33 (0)4 68 97 03 90.

Local Specialties Food and Drink

Homemade jams and syrups • Honey.

\star Events

Market: Traditional market at Olette, Thursdays 8 a.m.–1 p.m, Place du Village. May: Transhumance des Mérens, moving the horse herd. June: Fête de la Transhumance (ast weekend).

By road: Expressway A9, exit 42– Perpignan Sud (39 miles/63 km). By train: Prades-Molitg-les-Bains station (12 miles/19 km). By air: Perpignan-Rivesaltes airport (42 miles/68 km).

(i) Tourist information:

+33 (0)4 68 05 39 09 0r +33 (0)6 07 23 31 24 www.evol66.fr

October: Sheep, cattle, and local produce fair (3rd or 4th weekend).

W Outdoor Activities

Trout fishing (Évol river) • La Bastide lakes • Walking.

🕊 Further Afield

- Thuir-d'Évol (1 mile/1.5 km).
- Train Jaune: Olette station (1 mile/1.5 km).
- Saint-Thomas-les-Bains (6 miles/9.5 km).
- *Villefranche-de-Conflent
- (8 miles/13 km), see pp. 262–63.
- Prades (11 miles/18 km).
- Vernet-les-Bains: Abbaye Saint-Martin-
- du-Canigou (12 miles/19 km).
- Mont-Louis (14 miles/23 km).
- •*Eus (15 miles/24 km), see p. 196.
- *Mosset (19 miles/31 km), see pp. 222–23.

I Did you know?

According to local legend, the village of Évol is a haven for fairies and witches. These characters haunt the mountains as far as the *gorg nègre* (black lake). Before taking their livestock up to their summer pastures, locals used to accompany the village priest who, from the conjuratory next to the church, would exorcize evil spirits.

La Flotte Port on the Île de Ré

Charente-Maritime (17) • Population: 2,923 • Altitude: 56 ft. (17 m)

Facing the Pertuis Breton tidal estuary and the mainland, the pretty houses of La Flotte-en-Ré circle the harbour and reflect the ocean's light.

Now effectively a peninsula, located as it is at the end of a long bridge, Ré still retains its magical light, which changes with the tides; its gentle landscapes, which combine coastal flowers, vines, and salt marshes with oyster beds and fields of fruit and vegetables; and the dazzling white of its greenshuttered houses. To this "sandy, windswept

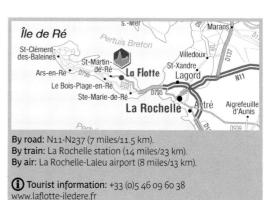

island," as Richelieu called it, in a natural environment that has been very well preserved, La Flotte adds the soulful remains of the Abbaye des Châteliers, built by Cistercian monks in the 12th century; the imposing Fort de La Prée, built in the 17th century in the face of English invasions and the Protestant La Rochelle; a maze of restored and flower-decked alleyways around the Église Sainte-Catherine, and the old round-tile-covered market; and a picturesque harbor that is enlivened year round with fishing boats and pleasure craft. The other side of its double pier, the ocean still separates the "white island" from the mainland.

Highlights

Fort de La Prée (17th century): A Vauban construction; guided tour by appointment only: +33 (0)5 46 09 61 39.
 La Maison du Platin: Museum dedicated to life on the Île de Ré, with collections on the island's traditional occupations, its relations with the

mainland, housing, and costumes; temporary exhibitions:

+33 (0)5 46 09 61 39.

• Ruins of the Cistercian Abbaye des Châteliers (12th century): Self-guided visit or guided tour.

- Village: Guided tour by arrangement:
- +33 (0)5 46 09 61 39.

Accommodation

Le Richelieu****: +33 (0)5 46 09 60 70. Le Français**: +33 (0)5 46 09 60 06. La Galiotte**: +33 (0)5 46 09 50 95. L'Hippocampe** +33 (0)5 46 09 60 68.

Aparthotels

Les Hauts de Cocraud** Odalys: +33 (0)5 46 68 29 21 or +33 (0)8 25 56 25 62.

Guesthouses

Le Château de Sable: +33 (o)5 46 01 75 60. Stéphanie Gaschet: +33 (o)5 46 09 05 78. M. Rocklin: +33 (o)5 46 09 51 28. Mme Vanoost: +33 (o)5 46 09 12 89. Mme Wyart: +33 (o)5 46 09 63 93.

$\ensuremath{\mathsf{G}}\xspace{\ensuremath{\mathsf{i}}}\xspace{\ensuremath{\mathsf{k}}}\xspace{\ensuremath{\mathsf{k}}}\xspace{\ensuremath{\mathsf{k}}}\xspace{\ensuremath{\mathsf{g}}\xspace{\ensuremath{\mathsf{k}}}\xspace{\ensuremath{\mathsf{k}}}\xspace{\ensuremath{\mathsf{k}}}\xspace{\ensuremath{\mathsf{k}}}\xspace{\ensuremath{\mathsf{k}}\xspace{\ensuremath{\mathsf{k}}}\xspace{\ensuremath{\mathsf{k}}\xspace{\ensuremath{\mathsf{k}}}\xspace{\ensuremath{\mathsf{k}}\xspace{\ensuremath{\s}}\xspace{\ensuremath{\mathsf{k}}\xspace{\ensuremath{\mathsf{k}}\xspace{\ensuremath{\mathsf{k}}\xspace{\ensuremath{\s}}\xspace{\ensuremath{\s}}\xspace{\ensuremath{\s}}\xspace{\ensuremath{\s}}\xspace{\ensuremath{\s}}\xspace{\ensuremath{\s}}\xspace{\ensuremath{\s}}\xspace{\ensuremath{\s}}\xspace{\ensuremath{\s}}\xspace{\ensuremath{\s}}\xspace{\ensuremath{\s}}\xspace{\ensuremath{\s}}\xspace{\ensuremath{\s}}\xspace{\ensuremath{\s}}\xspace$

Further information: +33 (0)5 46 09 60 38 www.laflotte-iledere.fr

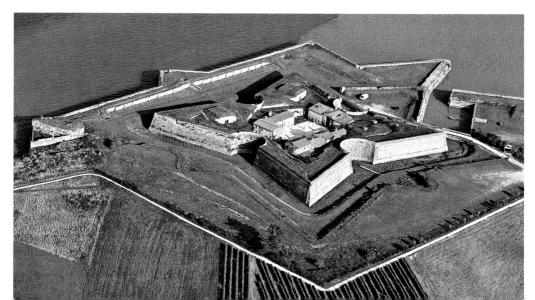

T Eating Out

À la Plancha: +33 (0)5 46 68 10 34. Chez Nous Comme Chez Vous, bistro/ wine bar: +33 (0)5 46 09 49 85. La Croisette: +33 (0)5 46 09 06 06. L'Écailler, gourmet: +33 (0)5 46 09 56 40. L'Endroit du Goinfre: +33 (0)5 46 09 50 01. L'Escale, brasserie: +33 (0)5 46 05 63 37. La Fiancée du Pirate, crêperie/pizzeria: +33 (0)5 46 09 52 46. La Fiancée du Sultan, world cuisine: +33 (0)5 46 66 58 08. Le Français: +33 (0)5 46 09 60 06. Il Gabbiano, Italian specialties: +33 (0)5 46 09 60 08. Le Nautic: +33 (0)9 67 37 31 73. Les Pieds dans l'Eau, crêperie: +33 (0)5 46 09 45 68. Le Pinocchio, pizzeria: +33 (0)5 46 09 13 13. La Poissonnerie du Port, except January and February: +33 (0)5 46 09 04 14. Le Richelieu, gourmet: +33 (0)5 46 09 60 70. Le Saint-Georges: +33 (0)5 46 09 60 18.

Local Specialties

Food and Drink

Ré oysters • Spring vegetables • Pineau, wines • Sea urchins • *Sel de Ré* (salt). Art and Crafts

Decoration • Earthenware • Art galleries • Artists • Painter-decorator.

★ Events

Market: Medieval market daily, 8 a.m.– 1 p.m., Rue du Marché. May: Fête du Port et de la Mer, sea festival.

June: Firework display; flea markets. July: Journée des Peintres, artists' day. July-August: Regattas, musical events at the harbor (every evening); evening crafts market.

July 1–September 15: Concerts in the Eglise Sainte-Catherine and tours; classical concerts at the harbor. August: Gathering of traditional sailing vessels (ast fortnight); music and firework display (mid-August).

W Outdoor Activities

Swimming (lifeguard) in July and August (Plage de l'Arnérault) • Riding • Pleasure boating • Shellfish gathering • Bike rides (rental) • Watersports: swimming, sailing, windsurfing • Thalassotherapy.

🕊 Further Afield

- La Rochelle (9 ½ miles/15.5 km).
- *Ars-en-Ré (11 miles/18 km), see pp. 159–60.
- Islands of Aix, Madame, and Oléron (19–28 miles/31–45 km).
- Marais Poitevin, region (25 miles/40 km).
- Rochefort (25 miles/40 km).

Fourcès A medieval circle in Gascogny

Gers (32) • Population: 295 • Altitude: 213 ft. (65 m)

In a loop of the Auzoue river, at the end of a bridge, Fourcès forms a circle around a central square shaded by plane trees.

Set on the banks of the Auzoue, and facing the Église Saint-Laurent on the other side of the river, Fourcès has a circular shape that is unique in Gascogny. The village developed in the 11th century under the protection of a castle, which occupied the main square, and ramparts, of which the Porte de l'Horloge remains. In 1279, Fourcès fell into the hands of Edward I of England who, ten years later, made it a *bastide* by granting it a charter of customs. Every year, in a theatrical setting of arches and half-timbered façades, the square hosts an exceptional flower market. The late 15th-century Château des Fourcès escaped ruin by becoming a hotel-restaurant; since 2010 it has been a guesthouse.

Highlights

• Arboretum: Free entry.

• Église Saint-Laurent and Église

Sainte-Quitterie.

Village.

Accommodation

✓ Le Château de Fourcès****:
 +33 (0)5 62 29 49 53.
 ✓ Du Côté de Chez Jeanne****:
 +33 (0)9 53 06 04 06.
 Solange and Pierre Mondin, Bajolle**:
 +33 (0)5 62 29 42 65.
 Gites and vacation rentals

Further information: +33 (0)5 62 28 00 80 www.tourisme-condom.com RV parks

Further information: +33 (0)5 62 29 40 13.

T Eating Out

L'Auberge: +33 (0)5 62 29 40 10. ♥ Le Carroussel Gourmand, tea room: +33 (0)9 53 06 04 06.

Local Specialties Food and Drink

Armagnac • Foie gras, duck fillet and confit • AOC Côtes de Gascogne wines. Art and Crafts

Antique dealers • Jewelry and accessories designer • Cardboard crafts • Embroidery.

🖈 Events

April: Flower market (last weekend). May–November: Flea market (2nd Sunday of each month).

June: Artists in the street.

July: Antiquarian book fair (3rd Sunday); aperitif and concert.

August: "Marciac in Fourcès," jazz concert (mid-August); village fair (3rd weekend). December: Christmas market.

W Outdoor Activities

Hunting • Fishing • Theme park, adventure playground for children • Walking • *Pétanque.*

By road: Expressway A62, exit 6– Nérac (28 miles/45 km). By train: Agen station (32 miles/51 km). By air: Agen-La Garenne airport (30 miles/48 km).

Tourist information—Ténarèze: +33 (0)5 62 28 00 80 www.tourisme-condom.com

🕊 Further Afield

- *Montréal (3 ½ miles/5.5 km), see p. 219.
- Poudenas (5 miles/8 km).
- Mézin, fortified town (5 ½ miles/9 km).
- *Larressingle (6 miles/9.5 km), see p. 203.
- Condom (8 miles/13 km).
- Château de Cassaigne (9 ½ miles/15.5 km).
- Abbaye de Flaran (11 miles/18 km).
- Trésor d'Eauze, archeological museum (13 miles/21 km).
- Nérac (15 miles/24 km).
- *Lavardens (25 miles/40 km), see pp. 208–9.

Lagrasse An abbey amid the vineyards

Aude (11) • Population: 615 • Altitude: 433 ft. (132 m)

At the heart of the Corbière mountains, where vines mingle with perfumed Mediterranean *garrigue* scrubland, Lagrasse is a rare bloom in Cathar country.

The Benedictine abbey of Lagrasse, founded in 800 CE in the valley on the left bank of the Orbieu river, is considered to have been one of the oldest and richest in France, and is still today the biggest abbey in the Aude. Its material, political, and spiritual influence extended beyond the Pyrenees. During the French Revolution, the abbey became state property, and it was split into two sections—as can be seen by the two entrance gates—before being sold. Mainly medieval, the oldest part can be visited and hosts concerts, exhibitions, and other cultural events all year round. Lagrasse is linked to this architectural jewel by a medieval bridge straddling the Orbieu. It is delightful to wander along its picturesque lanes, to share the wonderful atmosphere on its terraces or in its lively market hall, as people have been doing since the 14th century, and to appreciate the skills of its many craftspeople.

By road: Expressway A61, exit 25– Lézignan-Corbières (10 miles/16 km). By train: Lézignan-Corbières station (12 miles/19 km). By air: Carcassonne-Salvaza airport (35 miles/56 km).

() Tourist information: +33 (0)4 68 43 11 56 www.lagrasse.com

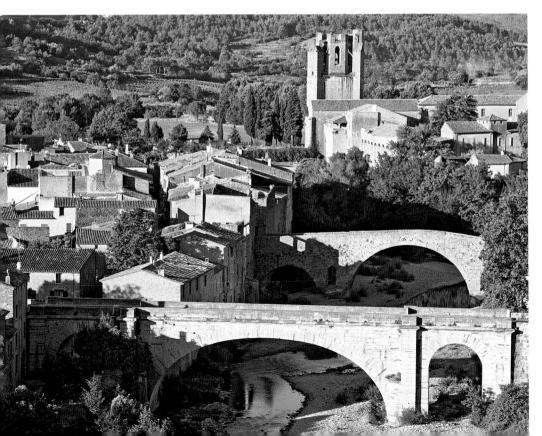

Highlights

• Abbaye Saint-Marie d'Orbieu (9th– 18th centuries): Guided tour available: +33 (0)4 68 43 15 99.

• Église Saint-Michel (14th century): Gothic style, paintings by the studio of Giuseppe Crespi (1665–1747) and by Jacques Gamelin (1738–1803), Virgin wood sculpture (13th century).

• Maison du Patrimoine, heritage center: Former presbytery, 15th-century painted ceilings; permanent exhibition on the painted ceilings of Languedoc-Roussillon; original restored works from three Renaissance painted ceilings in Lagrasse and a rare medieval painted ceiling from a mansion in Montpellier: +33 (0)4 68 43 11 56.

• "Le 1900": Over 3,000 sq. ft. (300 sq. m) exhibition with audioguide about life and traditional skills in 1900; rare-object collections; 4D show about the disused tramway: +33 (0)4 68 32 18 87.

• Village: Guided visit for groups by appointment only: +33 (0)6 81 42 79 63.

Accommodation

Hostellerie des Corbières**: +33 (0)4 68 43 15 22.

Guesthouses

Les Glycines***: +33 (0)4 68 43 14 54. Château Villemagne*: +33 (0)4 68 24 06 97. À la Porte d'Eau: +33 (0)4 68 43 10 45. À l'Ombre du Tilleul: +33 (0)4 68 43 11 17. M. Alquier: +33 (0)4 68 43 13 92. Aux Coquelicots 2: +33 (0)9 51 59 43 85. Aux 1000 [mille] Délices: +33 (0)4 68 43 59 26. Château Saint-Auriol: +33 (0)4 68 91 25 92. Chez Shona: +33 (0)4 68 65 24 33. M. Drelon: +33 (0)4 68 43 12 04. La Maison Bleue: +33 (0)6 59 12 85 30. La Maison de la Promenade: +33 (0)4 68 43 11 58 Les Trois Grâces: +33 (0)4 68 43 18 17. Mme Verplaetse-Felter: +33 (0)4 68 49 91 09. Gîtes

Further information: +33 (0)4 68 43 11 56 www.lagrasse.com

Campsites

Further information: +33 (0)4 68 43 15 18 or +33 (0)4 68 43 10 05.

T Eating Out

L'Affenage: +33 (0)4 68 43 16 59. Au Coupa Talen, pizzeria: +33 (0)4 68 43 19 36. Café de la Promenade: +33 (0)4 68 43 15 89. La Cocotte Fêlée: +33 (0)4 68 75 90 54. Hostellerie des Corbières: +33 (0)4 68 43 15 22. La Petite Maison, tea room: +33 (0)4 68 91 34 09. Les Remparts: +33 (0)4 68 43 67 49. Le Temps des Courges: +33 (0)4 68 43 10 18. Les Trois Grâces: +33 (0)4 68 43 18 17.

Local Specialties Food and Drink

Olive oil • Vinegar • Honey • AOC Corbières wines.

Art and Crafts

Antiques • Leather craftsman • Jewelry maker • Furniture designer • Wrought ironworker • Painters • Ceramic artist • Sculptor and caster • Fashion and hat designer • Upholsterer • Stained-glass artist.

★ Events

Market: Saturday mornings, Place de la Halle.

May–September: Flea markets (3rd Sunday of the month).

July: Village fête (13th); "Les Abracadagrasses, music festival (3rd weekend); piano festival (end of July).

August: Summer banquet, literature, and philosophy festival (1st fortnight); potters' mark "Les P'tibals," folk festival (end of August).

W Outdoor Activities

Fishing • Saint-Jean Lake • Walking: Route GR 36 and themed family trails.

🕊 Further Afield

- Termes and Villerouge-Termenès castles (12 miles/19 km).
- Abbaye de Fontfroide (17 miles/27 km).
- Carcassonne (22 miles/35 km).
- Narbonne (27 miles/43 km).

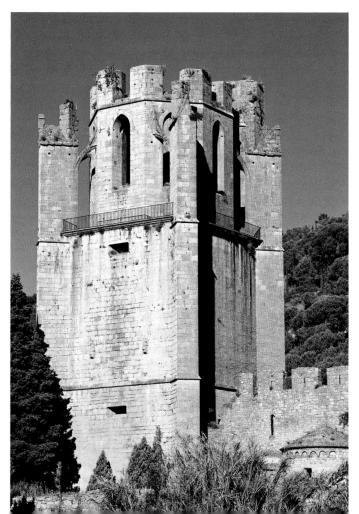

Larressingle A mini-Carcassonne in the Midi-Pyrenees

Gers (32) • Population: 217 • Altitude: 469 ft. (143 m)

Towering above the vines, the fortress-village of Larressingle cultivates the Gascon way of life.

The village lies beyond a fortified gateway, just past a bridge straddling a green moat. It backs onto a crown of ramparts encircling the castle keep (for many years the residence of the bishops of Condom) and a high church with two naves. Larressingle was saved from ruin by the enthusiastic duke de Trévise, who created a rescue committee financed by generous Americans. Today the village is a delightful collection of heritage buildings from the area's rich medieval past, including the castle, dating from the 13th, 14th, and 16th centuries, which has three floors and a pentagonal tower, a fortified gateway, and the remains of its surrounding walls: the Romanesque church of Saint-Sigismond; and the charming and finely built residences, decorated with mullioned windows and roofed with ocher tiles. Rooted to the land, Larressingle is a showcase for local Gers produce, particularly Armagnac, foie gras, and apple croustade.

• Medieval siege camp: Camp with siege engines for attack and defense, firing demonstrations of war machines: +33 (0)5 62 68 33 88.

• Église Saint-Sigismond (12th-century): Modern Madonna and Child stainedglass windows inspired by Marc Chagall paintings.

• Musée de la Halte du Pèlerin (pilgrim's rest): Representation of medieval life: 75 life-size way characters

medieval life; 75 life-size wax characters: +33 (0)5 62 28 11 58 or

+33 (0)5 62 28 08 08.

• Orchard: Series of vineyards around the village ramparts. 7-acre (3-hectare) agro-ecological site comprised of a vineyard of dessert grapes (23 varieties) and an orchard (65 varieties); historic and local collection: +33 (0)6 89 12 92 33.

• Village: Self-guided visit; guided tour (admission fee) by appointment only in summer for individuals: +33 (0)5 62 28 00 80.

✓ Accommodation Hotels

Auberge de Larressingle**: +33 (0)5 62 28 29 67. Guesthouses

Maïder Papelorey***: +33 (0)5 62 28 26 89. Martine Valeri: +33 (0)5 62 77 29 72. Gîtes

M. Teoran, "Couchet": +33 (0)5 62 28 17 50.

Walkers' lodges

Further information: +33 (0)5 62 68 82 49 or +33 (0)5 62 28 00 80. Campsites Mme Danto, la Ferme de Laillon, farm campsite: +33 (0)5 62 28 19 71 or +33 (0)6 07 69 14 19.

T Eating Out

Auberge de Larressingle: +33 (o)5 62 28 29 67. Aux: Délices de Flor, tea room: +33 (o)5 62 68 10 23. Crêperie du Château: +33 (o)5 62 68 48 93.

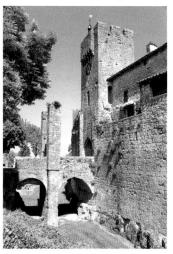

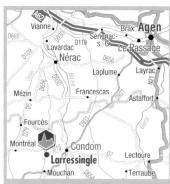

By road: Expressway A62, exit 7– Périgueux (25 miles/40 km). By train: Auch station (29 miles/47 km); Agen station (29 miles/47 km). By air: Agen-La Garenne airport (25 miles/ 40 km); Toulouse-Blagnac airport (68 miles/109 km).

(i) Tourist information—Ténarèze:

+33 (0)5 62 68 22 49 or +33 (0)5 62 28 00 80 www.tourisme-condom.com

*** Local Specialties** Food and Drink

Armagnac • Floc de Gascogne aperitif • Free-range duck preserves (confit, foie gras), and free-range pork. Art and Crafts Antiques • Painter • Glassblower.

\star Events

July–August: Theater productions; night visit to the fortified village with falconry demonstration.

W Outdoor Activities

Walking: Route GR 65 and short marked trails.

🖗 Further Afield

- Pont de l'Artigues (½ mile/1 km).
- Condom (3 miles/5 km).
- Mouchan Priory belonging to Cluny (3 ½ miles/5.5 km).
- Château de Cassaigne (4 ½ miles/7 km).
- Abbaye de Flaran (6 miles/9.5 km).
- *Fourcès (6 miles/9.5 km), see p. 200.
- *Montréal (6 miles/9.5 km), see p. 219.
- La Romieu: collegiate church (10 miles/ 16 km).
- Trésor d'Eauze, archeological museum (15 miles/24 km).
- Lectoure (16 miles/26 km).
- *Lavardens (20 miles/32 km), see pp. 208–9
- Auch (28 miles/45 km).

Lautrec Pays de Cocagne—the land of milk and honey

Tarn (81) • Population: 1,750 • Altitude: 1,033 ft. (315 m)

This medieval town in the heart of Tarn's Pays de Cocagne is the birthplace of painter Toulouse-Lautrec's family. From the top of La Salette hill there are far-reaching views over the whole Casters plain and the Montagne Noire. A castle stood here; now there is a Calvary cross and a botanical trail. For many years the village was the only fortified place between Albi and Carcassonne, and some of its ramparts remain. Its shady plane-tree promenade runs alongside them, and each year Lautrec, the center of pink garlic farming, holds garlic markets. The gateway of La Caussade leads straight from the rampart walk to the central square. The Rue de Mercadial also leads there, passing an old Benedictine convent, which became the town hall after the French Revolution. The square still holds a traditional Friday morning market under the beams of its covered hall. With its well and its lovely half-timbered and corbeled residences, it remains a delightful part of Lautrec. The Rue de l'Église leads to the collegiate church of Saint-Rémy, built in the 14th century then extended. The pastel blue walls celebrate a color that brought riches to Lautrec, earning the Pays de Cocagne its name-from the coques or cocagnes (balls of dried woad) that were ground down to produce dye—as well as its reputation as an earthly paradise.

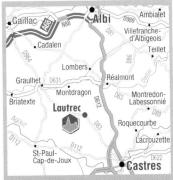

By road: Expressway A68, exit 9–Gaillac (18 miles/29 km). By train: Castres station (10 miles/16 km). By air: Castres-Mazamet airport (15 miles/24 km); Toulouse-Blagnac airport (47 miles/76 km).

Tourist information—Lautrécois-Pays d'Agout: +33 (0)5 63 75 31 40 www.lautrectourisme.com www.lautrec.fr

Highlights

• Clogmaker's workshop: Recreated workshop that existed until the 1960s, with vintage machines and tools: +33 (0)5 63 75 31 40.

• Église Collégiale Saint-Rémy (14th– 16th centuries): Marble altarpiece by Caunes-Minervois, sculpted lectern (17th century).

• La Salette windmill: For opening hours: +33 (0)5 63 75 31 40. By appointment off-season.

• La Salette botanical trail: Self-guided walk to learn about the plants of the Lautrec region, plus panoramic view of the area with viewpoint indicator.

• Village: Daily guided tours for groups of 10+ people, by reservation: +33 (0)5 63 75 31 40.

Accommodation Guesthouses

Cadalen****: +33 (0)5 63 75 30 02. La Terrasse de Lautrec****: +33 (0)5 63 75 84 22. Château de Montcuquet***: +33 (0)5 63 75 90 07. La Fontaine de Lautrec***: +33 (0)5 63 50 15 72. Temps de Pause***: +33 (0)6 37 65 92 95. Les Amis de Mes Amis: +33 (0)9 60 19 59 66. L'Auberjouille: +33 (0)6 29 73 58 02. Les Chambres de la Caussade: +33 (0)5 63 75 33 21. Château de Brametourte: +33 (0)5 63 75 01 25. Le Fraysse: +33 (0)5 63 75 35 86. **Gites and vacation rentals, bunkhouses** 16 gites (1-4*) and bunkhouse. Further information: +33 (0)5 63 75 31 40

www.lautrectourisme.com

Campsites and RV parks

Aire Naturelle de Brametourte: +33 (0)5 63 75 30 31. RV park with facilities: further information at tourist information center.

T Eating Out

Auberge Le Garde-Pile, booking essential: +33 (o)5 63 75 34 58. Au Pied du Moulin: +33 (o)6 52 72 22 29. Café Plùm: +33 (o)5 63 70 83 30. Le Clos d'Adèle: +33 (o)5 81 43 61 91. Le Coq en Pâte: +33 (o)5 63 50 32 33. Lou Lautrecois, pizzeria: +33 (o)5 63 75 10 58. Relais Loisirs de Brametourte, booking essential: +33 (o)5 63 75 30 31.

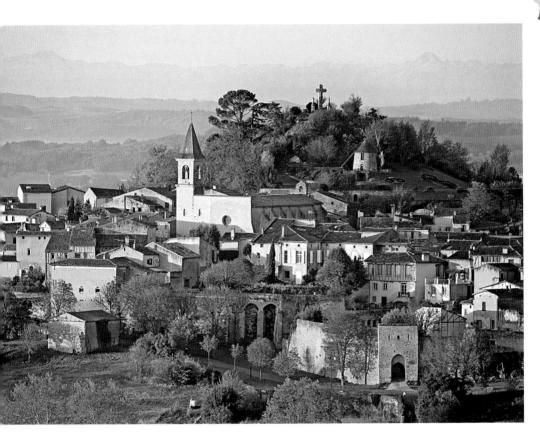

*** Local Specialties** Food and Drink

Lautrec pink garlic, garlic specialties (bread, vinegar, pâté) • Croquants aux amandes (almond cookies) • Duck foie gras • Gelée de plantes (herb and aromatic plant jellies).

Art and Crafts

Ceramic artist • Cabinetmaker • Leather craftsman • Pastel dyeing • Flutemaker • Art galleries.

★ Events

Market: Fridays 8–12 a.m., Place Centrale. Pink garlic market: Mid-July to mid-February, Fridays 8–10 a.m., on the promenade.

May: Fêtes de Lautrec (last weekend). June: Fête des Moulins, windmill festival and open-air rummage sale (3rd Sunday). July: Fête du Livre, festival of books and book craftsmanship (ast fortnight, odd-numbered years); Fête du Sabot et des Anciens Métiers, festival of clogs and traditional skills (3rd Sunday). August: Fête de l'Ail rose, pink garlic festival (1st Friday); Fête du Pain– Fête du Goût, tasting fair (15th); "Festivaoût," 3 days of concerts (around the 15th).

September: Festival of the Arts in Pays de Cocagne (1st weekend). October: "Outilautrec," traditional tool and machine festival (1st weekend).

W Outdoor Activities

Aquaval watersports (open mid-June– end August): swimming, beach volleyball, *boules* area, minigolf, model-making, fishing, field volleyball, family games • *Boules* area: Place du Mercadial (*pétanque* competition on Friday evenings in summer) • Horse-riding: marked trails • Cycling and walking: marked trails.

🖗 Further Afield

• Lombers: Écomusée du Pigeon, pigeon museum (5 ½ miles/9 km).

- Réalmont, royal walled town (7 miles/11 km).
- Castres (Musée Goya) and Le Sidobre (9 1/2-14 miles/15.5-23 km).
- Saint-Paul-Cap-de-Joux: Musée du Pastel and Château de Magrin (12 miles/19 km).
- Albi, UNESCO World Heritage Site: Musée
- Toulouse-Lautrec, museum (19 miles/31 km).
- Cascade d'Arifat, waterfall (19 miles/31 km).

I Did you know?

Pink garlic appeared in Lautrec during the Middle Ages. An itinerant merchant stopped at the place known as L'Oustallarié at Lautrec, wanting a feast. Since he had no money, he settled his bill with pretty pink garlic cloves. The hotelier planted the cloves and pink garlic began to grow in the region.

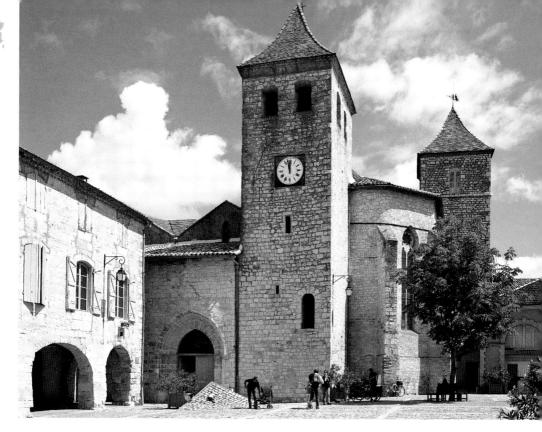

Lauzerte A walled town in Quercy Blanc

Tarn-et-Garonne (82) • Population: 1,535 • Altitude: 722 ft. (220 m)

Originally a Gaulish administrative center, Lauzerte dominates the surrouding valleys and hills from its lofty position atop a spur of land.

In the late 12th century, the count of Toulouse began construction of this fortified town. Granted an official charter in 1241, Lauzerte was simultaneously a trading town, a stronghold, and a court of appeal, dispensing justice within a 30-mile (50-km) radius until the 18th century. It also functioned as a staging post along the ancient Via Podiensis, or Saint James's Way, the pilgrims' route to Santiago de Compostela. Many buildings tell the prestigious history of this successful and wealthy town. Lauzerte produces *cocagne* dyes: its fertile farmlands and temperate climate also produce the Chasselas grape, Quercy melons, plums, peaches, pears, and nectarines, as well as poultry, foie gras, and confits.

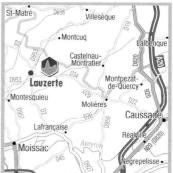

By road: Expressway A62, exit 8–Cahors (22 miles/35 km) or exit 9–Castelsarrasin (21 miles/34 km); expressway A20, exit 58–Cahors Sud (20 miles/32 km). By train: Moissac station (15 miles/24 km). By air: Toulouse-Blagnac airport (62 miles/ 100 km).

() Tourist information: +33 (0)5 63 94 61 94 www.lauzerte-tourisme.fr

Highlights

Église Saint-Barthélemy (13th-18th centuries): Stalls, paintings, Baroque altarpiece, painted paneling attributed to Joseph Ingres (1755-1814) and his pupils.
Jardin du Pèlerin (pilgrim's garden): Designed as a game of giant snakes and ladders on the theme of the pilgrimage to Santiago; history, life as a medieval pilgrim, European cultural and linguistic heritage are explored through play.
Village: Guided visits. Further

information: +33 (0)5 63 94 61 94.

Accommodation

Le Belvédère***: +33 (0)5 63 95 51 10. Le Luzerta*: +33 (0)5 63 94 64 43. Le Quercy*: +33 (0)5 63 94 66 36. **Guesthouses**

Moulin de Tauran***: +33 (0)5 63 94 60 68. Bounetis Bas: +33 (0)5 63 39 56 61. Camp Biche: +33 (0)5 63 29 23 86. Les Figuiers: +33 (0)5 63 29 53 64. Le Jardin Secret: +33 (0)5 63 94 60 01. Lavande en Quercy: +33 (0)5 63 94 68 01. Lavande en Quercy: +33 (0)5 63 94 68 01. Sainte Claire: +33 (0)5 63 95 08 62. Saint-Fort: +33 (0)5 63 95 21 90. Tuc de Saint-Paul: +33 (0)5 63 95 29 80. Villa Lucerna: +33 (0)5 63 98 03 97. Gîtes, walkers' lodges, and vacation rentals

Further information: +33 (0)5 63 94 61 94. Campsites Le Grenier des Coeurs**:

+33 (0)6 67 31 20 19.

T Eating Out

L'Auberge d'Auléry: +33 (0)5 63 04 79 13. Auberge des Carmes, brasserie: +33 (0)5 63 94 64 49. Aux Sarrazines du Faubourg, crêperie: +33 (0)5 65 20 10 12. Le Belvédère: +33 (0)5 63 95 51 10. L'Etna, pizzeria: +33 (0)5 63 94 18 60. La Forge: +33 (0)5 63 95 39 19. Le Luzerta: +33 (0)5 63 94 64 43. Le Puits de Jour, music café and light meals: +33 (0)5 63 94 70 59. Le Quercy: +33 (0)5 63 94 66 36. La Table des Trois Chevaliers: +33 (0)5 63 95 32 69.

* Local Specialties Food and Drink

Foie gras and other duck products • Fruit, Chasselas grapes AOP de Moissac • Macarons.

Art and Crafts Ceramic artists • Illuminator •

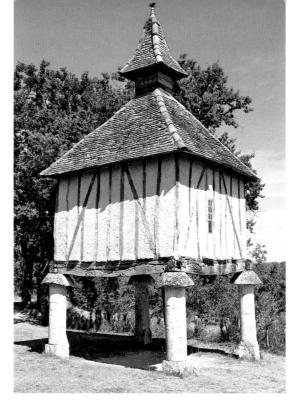

Metalworkers • Leather and wood engraver • Luthier • Essential oils.

★ Events

Markets: Wednesday mornings, Place du Foirail; Saturday mornings, Place des Cornières.

April: Flower market (3rd Sunday). June: "Rendez-Vous aux Jardins," open gardens (1st weekend); Journées Nature in the Midi-Pyrénées.

July: Pottery market (2nd weekend). July-September: exhibitions; evening food market (Thursdays). August: "Les Nuits de Lauzerte,"

contemporary art festival, with artworks exhibited in the village's courtyards and parks (1st Friday, Saturday, Sunday); professional flea market (15th). **September:** "Place aux Nouvelles," book festival (2nd weekend). **November:** "Journée de L'Arbre et du Bois," tree and wood festival (penultimate Sunday). **December:** Christmas market.

W Outdoor Activities

Horse-riding • Fishing • Walking: Route GR 65 on the Saint James's Way, and shorter walks.

🕊 Further Afield

- Saint-Sernin-du-Bosc: Romanesque
- chapel (2 ½ miles/4 km).
- Montcuq (6 miles/9.5 km).
- Moissac (16 miles/26 km).
- *Auvillar (21 miles/34 km), see pp. 164–65.

I Did you know?

During the Hundred Years War, English soldiers occupied Lauzerte. An old ladyprophetically called Gandilhonne ("she who saves")-tried to go about her daily business, but was heckled by enemy soldiers as they left the town in small groups. Although innumerate, she had the ingenious idea of counting the departing soldiers by putting one pebble (or chestnut) into her apron pocket for each soldier. She was then able to tell the town elders how many had gone, and they closed the gates to the town, keeping the enemy outside. Legend has it that this is how Lauzerte became one of the first towns in Quercy to free itself from the English.

Lavardens

A stone nave in the Gascon countryside

Gers (32) • Population: 407 • Altitude: 646 ft. (197 m)

Like a ship moored on a rocky outcrop, the imposing Château de Lavardens dominates the green crests and troughs of central Gascony.

Once the military capital of the counts of Armagnac, the medieval fortress of Lavardens was besieged and destroyed in 1496 on the order of Charles VII. The castle passed into the hands of the d'Albret and later the de Navarre families, and was granted by Henri IV to his friend Antoine de Roquelaure in 1585. De Roquelaure began rebuilding the castle out of love for his young wife, Suzanne de Bassabat. This work was interrupted several years later when he died in a plague outbreak, and was completed by the Association de Sauvegarde du Château de Lavardens (which restores and manages the castle) only in the 1970s. Its work respects all the individuality of this unique architectural site: the space, the ocher tiles and original bricks of the rooms, the exterior galleries, and the squinch towers—a unique architectural feature. At the foot of this white stone sentinel, the charming 18th-century village houses line the cobbled streets, which are bordered with hollyhocks.

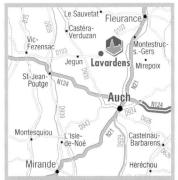

By road: Expressway A62, exit 7–Auch (36 miles/58 km); N21 (14 miles/23 km). By train: Auch station (14 miles/23 km). By air: Agen-La Garenne airport (40 miles/ 64 km); Toulouse-Blagnac airport (54 miles/87 km).

Tourist information—Cœur de Gascogne: +33 (0)2 62 68 10 66 or +33 (0)5 62 64 24 45 www.tourisme-coeurdegascogne.com

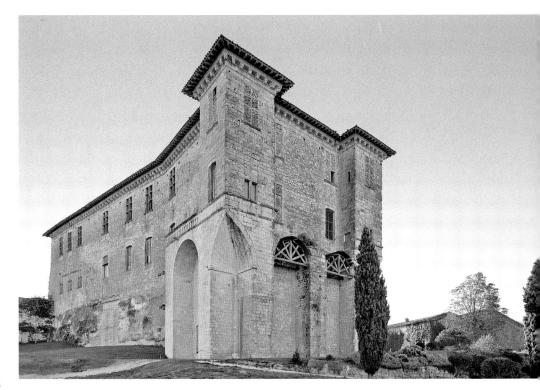

Highlights

• Castle (12th–17th centuries): Including guardroom, ballroom, games room, chapel; exhibitions: +33 (0)5 62 58 10 61. • Church (13th century): Pulpit,

wooden stalls.

 Petit Musée du Téléphone, telephone museum: By appointment only: +33 (0)5 62 64 56 61.

• Village: Guided visits in summer, and for groups all year round by appointment: +33 (0)5 62 68 10 66.

Accommodation Guesthouses

M. and Mme Chaput, Lo Campestre****: +33 (0)5 62 58 24 30. M. and Mme Delhaye, Domaine de Mascara***: +33 (0)5 62 64 52 17. Mme Ulry, at Nabat*: +33 (0)5 62 64 51 21. Gîtes and vacation rentals M. Lloyd**: +33 (0)6 62 64 57 66 or +33 (0)6 23 37 06 91. M. Monello: +33 (0)5 62 64 56 92.

T Eating Out

Le Malthus, brasserie: +33 (0)5 62 64 57 18. Le Restaurant du Château +33 (0)5 62 66 20 83.

Local Specialties Food and Drink

Gers green lentils • Gascon pain d'épice (spice cake) • AOC Côtes de Gascogne wines.

Art and Crafts Stonecutters.

★ Events

March-June: Art and crafts exhibition at the castle.

Julv-August: Evening markets. September: Village fête (3rd weekend). October-January: Santon (crib figures) exhibition at the castle. December: Christmas market.

W Outdoor Activities

Walking.

W Further Afield

 Jégun, fortified town (3 ½ miles/5.5 km). Castéra-Verduzan: spa, sports, recreation park, racetrack (6 miles/9.5 km).

• Biran: castle, church (10 miles/16 km).

- Saint-Jean-Poutge: castles; canoeing on the Baïse river (10 miles/16 km).
- Valence-sur-Baïse: Abbaye de Flaran (14 miles/23 km).
- Auch: cathedral (14 miles/23 km).
- *Larressingle (20 miles/32 km), see p. 203.
- *Montréal (24 miles/39 km), see p. 219.
- *Fourcès (25 miles/40 km), see p. 200.
- *Sarrant (27 miles/43 km), see pp. 252-53.

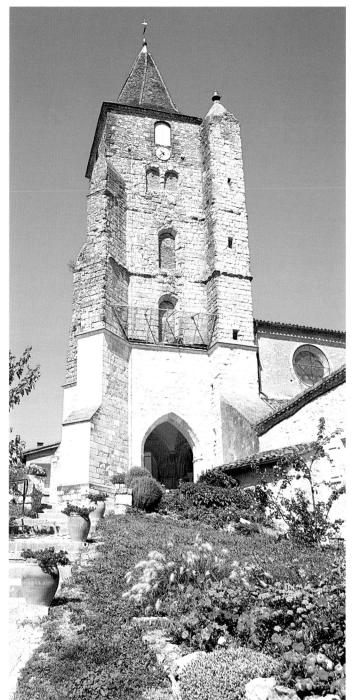

Limeuil Barges and boatmen—a bustling trading center

Dordogne (24) • Population: 334 • Altitude: 394 ft. (120 m)

Where the Dordogne and Vézère rivers meet, the once-flourishing port of Limeuil is now a welcoming and shady beach. The village knew dark days when defending itself against the Vikings and then, during the Hundred Years War, the English. Three fortified gateways remain from this time, which visitors pass through to reach the village, built on a steep slope. The houses wind along its lanes, showing their façades of golden stone decorated with coats of arms. At the top of the hill stand the old castle (now a private residence) and the Église Sainte-Catherine, whose choir dates from the 14th century. Down below, a double bridge straddles the Vézère and the Dordogne, and the Place du Port is a reminder that Limeuil was an important commercial center in the 19th century. In the valley not far from the village stands the 12th-century chapel of Saint-Martin, considered one of the most beautiful Romanesque chapels in Périgord.

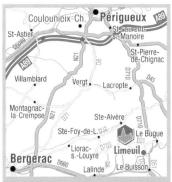

By road: Expressway A89, exit 16–Périgueux Est (25 miles/40 km); N221 (24 miles/38 km). By train: Buisson-de-Cadouin station (3 ½ miles/5,5 km); Bergerac station (29 miles/47 km). By air: Bergerac-Roumanière airport (28 miles/45 km).

(i) Tourist information: +33 (0)5 53 63 38 90 www.limeuil-en-perigord.com

Highlights

• Chapelle Saint-Martin (12th century): Frescoes: +33 (0)5 53 63 33 66. • Panoramic gardens (castle park): Gardens on the themes of colors, sorcerers, water, arboretum, landscaped garden; discovery trails on the themes of trees, landscape, river transport, and seamanship; craft workshops: +33 (0)5 53 57 52 64.

• Village and park: Self-guided visit (information panels). Further information: +33 (0)5 53 63 38 90.

Accommodation

Les Terrasses de Beauregard**: +33 (0)5 53 63 30 85. Guesthouses Au Bon Accueil: +33 (0)5 53 63 30 97. La Rolandie Haute: +33 (0)5 53 73 16 12. Gîtes and vacation rentals Further information:

+33 (0)5 53 63 38 90 www.limeuil-en-perigord.com

Aparthotels

Domaine de la Vitrolle**: +33 (0)5 53 61 58 58.

Campsites La Ferme de Perdigat***: +33 (0)5 53 63 31 54. La Ferme des Poutiroux***: +33 (0)5 53 63 31 62.

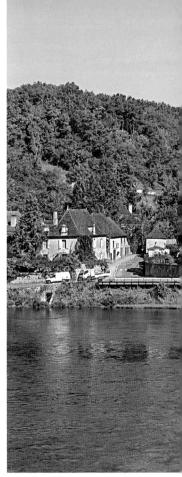

T Eating Out

À l'Ancre de Salut, bar/brasserie: +33 (o)5 53 63 39 29. Au Bon Accueil: +33 (o)5 53 63 30 97. Le Chai, crêperie/pizzeria: +33 (o)5 53 63 39 36. Garden Party: +33 (o)5 53 73 36 65. Les Terrasses de Beauregard: +33 (o)5 53 63 30 85.

Local Specialties Food and Drink

Local beer • Périgord apples and vin de pays • Organic produce.

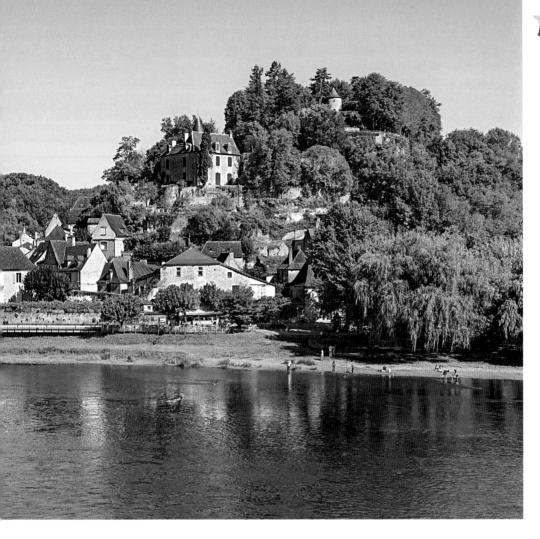

Art and Crafts

Jewelry • Art gallery • Silver/goldsmith • Painters • Potters • Glassblowers • Beadmaker • Straw-weaver.

★ Events

Market: Sunday mornings, local produce, Place du Port (last weekend in June through last weekend in August). July: Flea market, local saint's day (weekend closest to 14th); pottery market (last weekend).

July–August: Concert at Chapelle Saint-Martin; evening markets; exhibitions at the castle.

W Outdoor Activities

Swimming (no lifeguard) • Canoeing • Fishing • Walking, horse-riding, or mountain-biking: Route GR 6, Boucle de Limeuil (8 miles/13 km) and Route de Périgueux (3 miles/5 km).

🕊 Further Afield

 Vézère valley (3–25 miles/5–40 km): Le Bugue; Les Eyzies; *Saint-Léon-sur-Vézère (19 miles/31 km), see. p 246; Lascaux;
 *Saint-Amand-de-Coly (29 miles/47 km), see pp. 238–39.

• Cingle de Trémolat, meander; Bergerac (6–26 miles/9.5–42 km).

• Walled towns and medieval villages (6-25 miles/9,5-40 km): Cadouin; *Belvès (12 miles/19 km), see pp. 170-71; *Monpazier (17 miles/27 km), see pp. 217-18; Issigeac.

• Dordogne valley: *Beynac-et-Cazenac (18 miles/29 km), see pp. 172–73; *Castelnaud-la-Chapelle (21 miles/34 km), see p. 184;

*La Roque-Gageac (21 miles/34 km),

- see pp. 236–37.
- Sarlat (22 miles/35 km).

Loubressac Pointed roofs in the Dordogne valley

Lot (46) • Population: 520 • Altitude: 1,115 ft. (340 m)

From its cliff top. Loubressac commands a panoramic view of the valley of the Dordogne. Loubressac was ruined during the Hundred Years War but came back to life when the people of the Auvergne and Limousin moved back in, and it owes its current appearance to their efforts. Today, the flower-decked village lanes meet at a shady village square, where the church of Saint-Jean-Baptiste, dating from the 12th and 15th centuries, stands tall. The limestone medieval houses topped with antique tiles turn golden in the warm rays of the sun. Dominated by its castle perched on a natural promontory, the village offers far-reaching views of the Dordogne and Bave valleys. Numerous walking trails, which start in Loubressac, crisscross the area, linking the surrounding villages. Taking one of these snaking paths leads the visitor past springs or prehistoric dolmens to emerge on the limestone Causse plateau nearby.

Highlights

• La Ferme de Siran: Angora goat farm and movie on how mohair is produced: +33 (0)5 65 38 74 40.

• Cab-Ânes à Truffes: Donkey discovery farm; learn all about truffles and saffron: +33 (0)6 09 31 89 90.

• Village: Guided tour organized by local culture group Le Pays d'Art et d'Histoire de La Vallée de la Dordogne Lotoise: +33 (0)5 65 33 81 36.

Le Relais de Castelnau***: +33 (0)5 65 10 80 90. Lou Cantou**: +33 (0)5 65 38 20 58.

Guesthouses

L'Oustal de Juliette: +33 (0)5 65 10 70 44. **Gîtes and vacation rentals** Further information: +33 (0)5 65 10 82 18 www.vallee-dordogne.com **Campsites** La Garrigue: +33 (0)5 65 38 34 88.

T Eating Out

Lou Cantou: +33 (0)5 65 38 20 58. Le Relais du Castelnau: +33 (0)5 65 10 80 90). Le Vieux Pigeonnier, crêperie in Py hamlet: +33 (0)5 65 38 52 09.

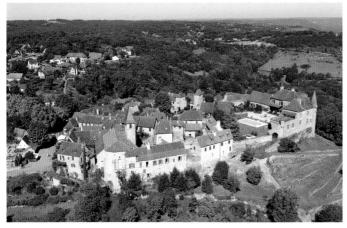

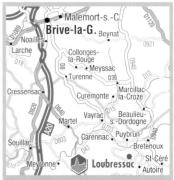

By road: Expressway A2o, exit 54-Gramat (27 miles/43 km); expressway A89, exit 21-Aurillac (40 miles/64 km). By train: Gramat station (10 miles/16 km). By air: Brive-Vallée de la Dordogne airport (34 miles/55 km).

(1) Tourist information—Vallée de la Dordogne: +33 (0)5 65 33 22 00 www.vallee-dordogne.com www.loubressac.fr

Local Specialties

Food and Drink Cabécou goat cheese • Walnut oil • Flour. Art and Crafts Handicrafts • Painters • Artist-potters • Mohair clothing

★ Events

May: Spring festival, art and crafts, flowers, local produce (1st Sunday). July: Local saint's day, book festival (2nd weekend).

August: Marché de Producteurs, farmers' market, and food-lovers' picnic (2nd Thursday); flea market (4th Sunday).

W Outdoor Activities

Walking • Mountain-biking.

🕊 Further Afield

- *Autoire (3 miles/5 km), see p. 163.
- Château de Castelnau (3 ½ miles/5.5 km).
- Gouffre de Padirac, chasm (3 ½ miles/ 5.5 km).
- *Carennac (5 ½ miles/9 km), see pp. 181-82.
- Château de Montal; Saint-Céré (5 ½ miles/ 9 km).
- Rocamadour (12 miles/19 km).
- *Curemonte (14 miles/23 km), see p. 191.
- *Collonges-la-Rouge (19 miles/31 km), see pp. 186–87.
- *Turenne (19 miles/31 km), see pp. 260–61.

Minerve

Vines and stone

Hérault (34) • Population: 122 • Altitude: 745 ft. (227 m)

Commanding a dominant position in the Languedoc landscape. Minerve is a stone ship beached in the *garrique* scrubland.

Below this wine-producing village, the Brian and Cesse rivers meet and carve out deep gorges. A viscounty in the Middle Ages, Minerve erected a Romanesque church to Saint-Étienne in the 11th century and built a ring of ramparts up against a castle. This system of defense allowed the inhabitants of the village, who had converted to the heretic Cathar religion, to resist Simon de Montfort's crusading army for seven weeks. The Rue des Martyrs and a monument near the church keep alive the memory of 180 Cathars burned at the stake after the town fell on July 22, 1210. The castle was destroyed in the 17th century; only one octagonal tower remains. A path at the bottom of the village leads from the southern postern to the Cesse river, following the course of the river underground for some 900 feet (300 meters) through impressive limestone caves.

Highlights

 Musée Archéologique et Paléontologique (Archeology and Paleonthology Museum): "3,000 Years of History" exhibition: +33 (0)4 68 91 22 92.

• Musée Hurepel: History of the Cathars and the Crusades: +33 (0)4 68 91 12 26.

• Village: Guided tour for groups only and by appointment only: +33 (0)4 68 91 81 43; videoguides for hire at Musée Archéologique.

Accommodation Hotels

Relais Chantovent: +33 (0)4 68 91 14 18. Guesthouses

La Barbacane: +33 (0)4 68 49 10 21. L'Étape Minervoise: +33 (0)4 68 75 50 54. Gîtes

Further information: +33 (0)4 68 91 81 43 www.minervois-tourisme.fr Campsites

Le Maquis: +33 (0)4 67 23 94 77.

T Eating Out

Le 1210 [mille deux cent dix], pizzeria/ salad bar: +33 (0)4 68 75 50 68. M. and Mme Poumavrac, farmhouse inn: +33 (0)4 67 97 05 92. Relais Chantovent: +33 (0)4 68 91 14 18. La Table des Troubadours, steak house: +33 (0)4 68 91 27 61. La Terrasse: +33 (0)4 68 65 11 58.

Local Specialties

Food and Drink Goat cheese • AOC Minèrve wines Art and Crafts Local crafts • Gifts • Bookshop • Paintings and sculptures.

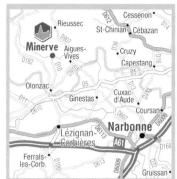

By road: Expressway A9, exit 36-Castres (29 miles/47 km); expressway A61, exit 24-Carcassonne Est (24 miles/39 km). By train: Lézignan-Corbières station (14 miles/23 km); Narbonne station (22 miles/35 km). By air: Carcassonne-Salvaza airport (30 miles/48 km); Béziers-Vias airport (40 miles/64 km): Montpellier-Méditerranée airport (75 miles/121 km).

(i) Tourist information—Minervois: +33 (0)4 68 91 81 43 www.minervois-tourisme.fr

* Events

July: Activities and commemorative concert "1210" (around 22nd).

W Outdoor Activities

Swimming • Walking: Route GR 77 and 2 marked trails.

W Further Afield

 Caunes-Minervois: Lastours: Carcassonne (16-28 miles/26-45 km).

- Montagne Noire (19 miles/31 km).
- Narbonne (20 miles/32 km).
- Oppidum d'Ensérune, archeological site; Béziers (28 miles/45 km).
- *Olargues (29 miles/47 km), see pp. 228-29.

I Did you know?

The name Minerve is an adaptation of "Menerba" in the Romance language, Occitan. In turn, this probably derives from the Celtic words men (stone or rock) and herbec (refuge, sanctuary).

Monestiés

Hispanic influences in France's southwest

Tarn (81) • Population: 1,430 • Altitude: 689 ft. (210 m)

Coiled in a loop of the Cérou river, Monestiés lies in a valley that has been occupied since the Iron Age.

The once-fortified medieval village grew up around the Église Saint-Pierre, a seat of religious and political power from the 10th century. Monestiés has retained its historic maze of streets and lanes lined with old residences. Throughout the village, half-timbered houses, doors with carved lintels, a fountain, and corbeled arcades and houses all reflect the warm colors and simple style typical of villages in southwest France. One of these buildings today houses the Bajèn-Vega museum of painting, dedicated to two artists who were political refugees from Spain. While the Chapelle Saint-Jacques, at the gates to the village, no longer welcomes the pilgrims from Santiago who used to seek refuge in the hospital, it still contains an exceptional 15th-century altarpiece. It is composed of twenty lifesize polychrome stone statues, which depict the last three Stations of the Cross: the Crucifixion, the Pièta, and the Entombment.

Highlights

• Chapelle Saint-Jacques (16th century): Group of 15th-century statues in polychrome limestone, representing the three last Stations of the Cross: +33 (0)5 63 76 19 17.

 Musée Baièn-Vega: Collection of paintings by Francisco Bajèn and Martine Vega on different themes, changing each year for an original temporary exhibition: +33 (0)5 63 76 19 17.

•♥ "Discovery Pass": Single ticket for visits to the Chapelle Saint-Jacques and the Musée Bajèn-Véga. Further information: +33 (0)5 63 76 19 17.

• Église Saint-Pierre (10th and 16th centuries): 17th-century altarpiece and 18th-century painting (Swooning Virgin Supported by Saint John).

• Village: Guided tour for groups of 15+ by appointment all year round: +33 (0)5 63 76 19 17.

Accommodation Hotels

L'Hostellerie Saint-Jacques: +33 (0)5 63 76 11 72. Guesthouses, gîtes, bunkhouses, and vacation rentals Further information: +33 (0)5 63 36 14 03 www.tourisme-monesties.fr Campsites Camping municipal Les Prunettes*,

mid-June-mid-September: +33 (0)5 63 76 19 17.

T Eating Out

L'Auberge Occitane: +33 (0)5 63 80 73 41. L'Hostellerie Saint-Jacques: +33 (0)5 63 76 11 72. Pause des Lices: +33 (0)6 83 32 85 81.

Local Specialties Food and Drink

Green lentils • Vegetable oils • Honey • Herbs and medicinal plants • AOC Gaillac wine. Art and Crafts Luthier and bow-maker.

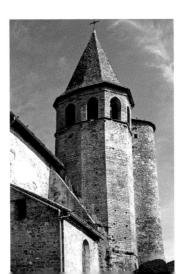

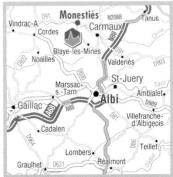

By road: Expressway A68-N88 (5 miles/ 8 km); expressway A20, exit 58-Villefranchede-Rouergue (53 miles/86 km). By train: Carmaux station (4 1/2 miles/7 km). By air: Rodez-Marcillac airport (48 miles/77 km); Toulouse-Blagnac airport (68 miles/109 km).

(1) Tourist information: +33 (0)5 63 76 19 17 www.tourisme-monesties.fr

* Events

May: Flea market (beginning of the month). June: Dressmakers' flea market; "Arts Croisés arts festival: Fête de l'Âne, donkey festival. July-August: Art exhibitions, village fêtes. September: Journées du Patrimoine, heritage festival: Fête du Cheval, horse festival. November: Flea market (beginning of the month).

December: Christmas market. All year round: "Musiques Pour Tous" concer (except July and August).

W Outdoor Activities

Horse-riding • Fishing • Tennis • Pack-donkey rides • Walking and mountain-biking: Marked trails • "Les Secrets de la Rivière" (botanical rive trail) • Watersports: La Roucarié lakeside park.

🕊 Further Afield

- Le Garric: Cap'Déecouverte, outdoor activities center (5 miles/8 km).
- Cagnac-les-Mine: Musée de la Mine, mining museum (5 miles/8 km).
- Carmaux: Musée du Verre, glasswork museum (5 miles/8 km).
- Cordes-sur-Ciel (9 1/2 miles/15.5 km).
- Albi: Gaillac (12-17 miles/19-27 km).
- *Najac (19 miles/31 km), see pp. 224-25.
- *Castelnau-de-Montmiral (22 miles/ 35 km), see p. 183.
- *Sauveterre-de-Rouergue (23 miles/
- 37 km), see pp. 254-55
- *Bruniquel (30 miles/48 km), see p. 177.

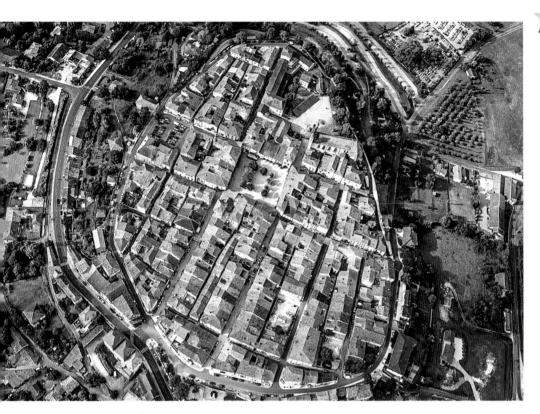

Monflanquin A Tuscan air

Lot-et-Garonne (47) • Population: 2,398 • Altitude: 594 ft. (181 m)

French writer Stendhal (1783–1842) called the landscape around Monflanquin in the southwest of France "a little Tuscany."

Founded in 1256 by Alphonse de Poitiers, brother of Louis IX (Saint Louis), Monflanquin is one of about 300 fortified towns or villages that were typically built by the kings of France and England or the counts of Toulouse, who were fighting for control of the southwest of France. At the end of the 14th century, the village became the center of a bailiwick and was enclosed within ramparts punctuated by fortified gates and topped with towers. The ramparts were destroyed in 1622 by royal proclamation after the clashes of the Wars of Religion. Monflanquin has nevertheless retained its characteristic checkerboard street plan. At the heart of the village, the Place des Arcades features a broad colonnade supported by stone pillars; it contains stunning residences, including the House of the Black Prince. From the Cap del Pech there is a spectacular view over the Lède valley.

By road: Expressway A62, exit 7– Périgueux (34 miles/55 km); expressway A89, exit 15–Agen (58 miles/93 km), N21 (8 ½ miles/13.5 km). By train: Monsempron-Libos station (11 miles/18 km); Agen station (30 miles/48 km). By air: Bergerac-Roumanière airport (31 miles/50 km); Agen-La Garenne airport (35 miles/56 km).

() Tourist information: +33 (0)5 53 36 40 19 www.monflanquin-tourisme.com

Highlights

• Musée des Bastides: Exhibition about fortified towns, the new towns of the Middle Ages; interactive family guide, calligraphy studio, and children's games: +33 (0)5 53 36 40 19.

• Village: For thrilling tales and amazing sights, take a discovery walk through the lanes of the fortified town with your jester guide Janouille la Fripouille, a medieval troubadour. Tour for individuals in July-August, by day or evening, and special events; throughout the year only for booked groups: +33 (0)5 53 36 40 49. • "Pollen," contemporary art hub and artists' residence: Exhibitions, education, and talks: +33 (0)5 53 36 54 37.

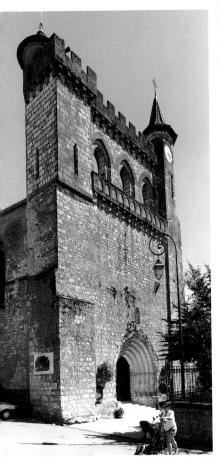

Accommodation

Monform**: +33 (0)5 53 49 85 85. La Bastide des Oliviers: +33 (0)5 53 36 40 01. Le Moulin de Boulède:

+33 (0)5 53 36 16 49.

Guesthouses

Le Nid à Nane***: +33 (0)6 82 41 26 95. Beslu: +33 (0)5 53 36 56 51.

La Cambra dé Monflanquin:

+33 (0)5 53 71 61 17.

Château Ladausse: +33 (0)5 53 36 71 63. Les Fleurs des Îles: +33 (0)5 53 40 22 38. Vignes de la Justice: +33 (0)5 53 36 32 54. Aparthotels

Résidence du Lac***, Pierre et Vacances: +33 (0)5 53 49 72 00.

Gîtes, vacation villages, and vacation rentals

Further information: +33 (0)5 53 36 40 19 www.monflanquin-tourisme.com

T Eating Out

Aldayaa: +33 (0)9 64 06 15 55. La Baldoria, pizzeria: +33 (0)5 53 49 09 35. La Bastide, crêperie: +33 (0)5 53 36 77 05. La Bastide des Oliviers: +33 (0)5 53 36 40 01. Le Bistrot du Prince Noir: +33 (0)5 53 36 63 00. La Grappe de Raisin: +33 (0)5 53 36 31 52. Le]ardin: +33 (0)5 53 36 54 15. Lou Kakou, farmhouse inn, booking essential: +33 (0)5 53 40 97 16. Le Moulin de Boulède: +33 (0)5 53 36 16 49. La Pierre Blanche: +33 (0)5 53 40 69 14. Le Restaurant du Lac: +33 (0)5 53 49 85 86. Le Temps d'Un Thé, tea room and restaurant: +33 (0)5 53 36 03 14. La Terrasse des Arts'cades, brasserie: +33 (0)5 53 36 32 18.

Local Specialties Food and Drink

Foie gras • Cheese • Organic produce • Hazelnuts • Prunes • Wine.

Art and Crafts

Flea market and antiques • Contemporary art • Bookbinding and framing workshop • Ceramic artists • Cartoonist • Wooden toys • Leather goods • Painters • Soap • Clothes and jewelry • African and Moroccan crafts • Art galleries.

★ Events

Markets: Traditional market, Thursday mornings, Place des Arcades. Little market, Sunday mornings, entrance to the fortified town, July–August.

Throughout the year: exhibitions, concerts, and theater.

April: Spring fair and horse-racing. May: Cheese and wine fair.

June: "Nuit de la Saint-Jean," Saint John's Eve ball with traditional music.

July: Antiques fair (mid-July); "Les Soirées Baroques de Monflanquin,"Baroque music (and fortnight).

July-August: Local farmers' market (Thursday evenings).

August: "Soirée des Étoiles," stargazing (early August); medieval fair (mid-August); "Les Arts'Franchis," jazz, symphony orchestra, musical theater (end August).

December: Saint André's day (1st Monday in December and preceding weekend).

W Outdoor Activities

Boules area • Horse-riding • Fishing: Lac de Coulon (1st and 2nd categories) • Walking and mountain-biking.

🕊 Further Afield

- Montagnac-sur-Lède: Moulin (5 miles/8 km).
- Castle at Gavaudun (7 miles/11.5 km).

• Fortified towns of Villeréal, Villeneuve-sur-Lot Castillonnès, and Beaumont-du-Périgord (7 ½–18 miles/12–29 km).

• Medieval towns of Cancon, Penne-d'Agenais, and Issigeac (7 ½–18 miles/12–29 km).

• Saint-Avit: Musée Bernard-Palissy, museum (7 ½ miles/12 km).

- Château de Biron (11 miles/18 km).
- *Monpazier (14 miles/23 km), see p. 217.
- Château de Bonaguil (14 miles/23 km).
- *Pujols-le-Haut (16 miles/26 km), see pp. 232-
- *Belvès (24 miles/39 km), see pp. 170–71.
- Agen (31 miles/50 km).

I Did you know?

The Black Prince was Edward of Woodstock, Prince of Wales (1330–1376), eldest son of the English king Edward III. His dark nickname perhaps has its origins in an act of revenge perpetrated by him during the sack of Limoges in 1370, where one chronicler claimed he killed more than 3,000 citizens, though other sources suggest this was much exaggerated.

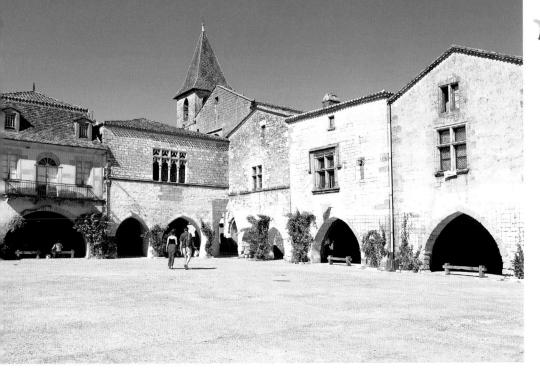

Monpazier

Dordogne (24) • Population: 522 • Altitude: 650 ft. (198 m)

Eight hundred years after its foundation, Monpazier retains its original street plan and remains an excellent example of a medieval fortified town. The town was founded in 1284 by Edward I, king of England. Given that the Hundred Years War, famine, and epidemics all hit Monpazier hard during the Middle Ages, the town is remarkably well preserved. It forms a rectangle 1,312 × 728 ft. (400 × 220 m), with straight roads 26 ft. (8 m) wide and houses of identical size. These features earned it a certain reputation: the famous 19th-century architect Viollet le Duc considered it to be the model for all fortified towns. Crisscrossed by carreyras (streets) and carreyrous (alleys), the village is laid out around the delightful Place des Cornières. Perfectly square, this is lined with 18th-century buildings and surrounded by 14th-and 18th-century arcades. Among the superb medieval structures are the 18th-century central market, which still has its grain measures; the Église Saint-Dominique (13th and 15th centuries); the square tower; the oldest (1292) and tallest chapter house in Monpazier; Dîmes barn, where the portions of harvests set aside for tax payments were kept: and also the three fortified gates. Nearby is the historic Récollets convent and the Bastideum, which houses the Centre d'Interprétation de l'Architecture et du Patrimoine (architecture and heritage center).

By road: Expressway A89, exits 16– Angoulême (41 miles/66 km) and 13– Bergerac (43 miles/69 km); N21 (17 miles/ 27 km). By train: Belvěs station (10 miles/ 16 km); Bergerac station (27 miles/43 km). By air: Bergerac-Roumanière airport (29 miles/47 km).

Tourist information: +33 (0)5 53 22 68 59 www.pays-des-bastides.com www.monpazier.fr

Highlights

• Bastideum: Centre d'Interprétation de l'Architecture et du Patrimoine. Archive documents, oral testimonies, 3D reconstruction of the fortified town and virtual flight over it: +33 (0)5 53 57 12 12.

• Église Saint-Dominique (13th and 15th centuries): Stalls.

• Village: Guided tour in French, Tuesdays at 11 a.m.; in English at 3 p.m. in July– August for individuals, throughout the year for groups by appointment only. Tours by torchlight, Mondays at 9 p.m. in July–August; accessible tours for the visually impaired (tactile models, guidebooks in Braille and large print). Further information: +33 (o)5 53 22 68 59.

Accommodation Hotels

♥ Hôtel Edward ler***:
 +33 (0)5 53 22 44 00.
 Hôtel de France*: +33 (0)5 53 22 60 06.
 Guesthouses

Les Hortensias***: +33 (o)5 53 58 18 o4.
Chantal Fleury: +33 (o)5 53 27 97 12.
Chez Janou: +33 (o)5 53 40 65 24.
Jérôme Parlange: +33 (o)6 79 34 47 68.
La Maison du Charron:
+33 (o)5 53 74 84 50.
Les Roses d'Emma: +33 (o)6 81 95 66 90. Gites and vacation rentals
Further information: +33 (o)5 53 22 68 59
www.pays-des-bastides.com

T Eating Out

Eleonore, gourmet restaurant: +33 (0)5 53 22 44 00 La Bastide: +33 (0)5 53 22 60 59. Le Bistrot 2 [deux]: +33 (0)5 53 22 60 64. Le Bonheur est dans le Pot, crêperie: +33 (0)6 18 51 29 69. Le Chêne Vert, pizzeria and light meals: +33 (0)5 53 74 17 82. Chez Minou, pizzeria: +33 (0)5 53 22 46 59. Le Croquant: +33 (0)5 53 22 62 63. Galerie M: +33 (0)9 61 67 97 14. Le Privilège du Périgord: +33 (0)5 53 22 43 98. Les Rigalous: +33 (0)5 53 22 60 06.

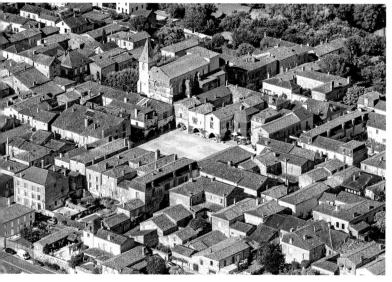

Local Specialties Food and Drink

Local Périgord specialties (foie gras etc.) • Wine.

Art and Crafts

Jewels • Turned wood • Ceramics • Dress design • Engraving on ostrich and emu eggs • Gilding on wood • Framing • Clock-maker • Leather goods • Marquetry • Painting • Glass painting • Glassblowing • Wall coverings • Soft furnishings • Ladies' fashion.

\star Events

Markets: Fair on 3rd Thursday of each month Market on Thursday mornings. Marché aux Cèpes, mushroom market (according to yield), every afternoon in autum Marché aux Truffes, truffle market, Decembe February.

April: Theater; "Printemps de Minou," concerts (2nd Saturday).

May: "Printemps des Bastides," intercultural events; Fête des Fleurs, flower festival; horse races (end of May).

June: "Rendez-vous aux Jardins," open gardens (1st weekend); flea market (2nd weekend); Journée Nationale de l'Archéologie, archeology festival.

July: Horse-racing (2nd Sunday); cycling after dark (last Thursday); Fête du Livre, book festival (last Sunday).

August: "Eté Musical en Bergerac," music festival (beginning of August); horse-racing (1st Sunday); flea market (2nd weekend); "Adoreed," endurance horse competition (last weekend).

July–August: Open-air cinema; farmers' mark-October: Flea market (2nd weekend).

W Outdoor Activities

Boules area • Horse-riding center • Walking.

🕊 Further Afield

- Château de Biron (5 miles/8 km).
- Abbaye de Cadouin (10 miles/16 km).
- *Belvès (10 miles/16 km), see pp. 170–71.
- *Monflanquin (14 miles/23 km), see pp. 215-1

• Dordogne valley: *Limeuil (17 miles/27 km), see pp. 210–11; * Castelnaud-la-Chapelle (21 miles/34 km), see p. 184; *Beynac-et-Cazenac (24 miles/39 km), see pp. 172–73; *La Roque-Gageac (24 miles/39 km), see pp. 236–37; *Domme (25 miles/40 km), see pp. 192–93.

- Château de Bonaguil (19 miles/31 km).
- Issigeac (19 miles/31 km).
- Monbazillac (27 miles/43 km).
- Bergerac (28 miles/45 km).

Montréal Ancient and medieval Gascony

Gers (32) • Population: 1,266 • Altitude: 427 ft. (130 m)

The fortified town of Montréal is surrounded by vineyards and stands proudly at the heart of Gascony in the southwest of France.

In 1255, Alphonse de Poitiers, brother of Louis IX (Saint Louis), built the first Gascon bastide (fortified town) on a rocky spur around which twists the Auzoue river. Following the classic grid pattern, roads and cobbled streets lead to the central square, which has arcades on three sides. The 13th-century Gothic church of Saint-Philippe-et-Saint-Jacques is built into the fortifications, and its flat, square tower looks down on half-timbered houses. An ogee gate survives from the fortifications. To the north, the pre-Romanesque church of Saint-Pierre-de-Genens (11th century) has a reused Roman colonnade and a Chi-Rho (symbol for Christ) carved into the antique marble. With its Flambovant Gothic plan and vaulting, the chapel of Luzanet represents an architectural style that is rare in southwest France. Just over a mile (2 km) from Montréal, the 4th-century Séviac Roman villa is an enormous palace boasting sumptuous mosaics and vast thermal baths. This luxurious wine-growing estate dominated the territory of Elusa (Eauze), capital city of the Roman province of Novempopulania.

ort-Ste-Marie 15011 Agen Seriona D665 Lavardac issage Nérac Lavra Laplume 5 Francescas Mézin Astaffort - Fourcès Montréal · Condom or Lectour Larressingle

By road: Expressway A62, exit 6–Nérac (34 miles/55 km); N124 (29 miles/47 km). By train: Auch station (33 miles/53 km); Agen station (34 miles/55 km). By air: Agen-La Garenne airport (31 miles/ 50 km); Toulouse-Blagnac airport (78 miles/126 km).

(1) Tourist information—Ténarèze: +33 (0)5 62 29 42 85 or +33 (0)5 62 28 00 80 www.tourisme-condom.com

Highlights

• Collegiate church of Saint-Philippeet-Saint-Jacques (13th century).

• Église Saint-Pierre-de-Genens (11th century): Carved portal, white marble tympanum.

• Séviac Gallo-Roman villa: Vast

multicolored mosaic floor, thermal baths. Further information: +33 (0)5 62 29 48 57/ www.elusa.fr. Repository of archeological finds from the villa at tourist information center: +33 (0)5 62 29 42 85. • Village: Guided tour of the fortified town on request: +33 (0)5 62 29 42 85.

Accommodation

Les Agapanthes***: +33 (0)5 62 29 41 44. Carpe Diem***: +33 (0)5 62 28 37 32. Le Couloumé***: +33 (0)5 62 29 47 05. Peyrouat***: +33 (0)6 86 53 82 65. Lou Prat de la Ressego***: +33 (0)5 62 29 49 55. Château de Malliac: www.vie-de-chateau.com La Pôse de Mont Royal: +33 (0)6 74 80 07 48. **Aparthotels** Résidence Hotesia***: +33 (0)5 62 68 38 93.

Gites, walkers' lodges, and vacation rentals Further information: +33 (0)5 62 29 42 85 www.tourisme-condom.com

Campsites

M. Lussagnet, farm campsite: +33 (0)5 62 29 44 78. Rose d'Armagnac, natural area and RV hire: +33 (0)5 62 29 47 70.

T Eating Out

La Bombance: +33 (0)5 62 29 28 80. Daubin: +33 (0)5 62 29 44 40. L'Escale: +33 (0)5 62 29 59 05. La Petite Escale: +33 (0)5 62 28 82 05.

*** Local Specialties** Food and Drink

Preserves (foie gras, duck confit, etc.) • Croustades • Cheese • Honey • Wine, Floc de Gascogne, and Armagnac. Art and Crafts Ceramic artist • Paintings on cardboard •

Painters • Statues in reconstituted marble

\star Events

Market: Fridays 8 a.m.-1 p.m. July: Hamlet of Arquizan's weekend festival (last weekend). July-August: Evening medieval fair; evening walk (every Thursday). August: "Courses Landaises," bullfighting, and Montréal fair (2nd Sunday). November: "Flamme de l'Armagnac," Armagnac festival (3rd weekend).

W Outdoor Activities

Recreation area • Fishing • Walking: PR and GR routes.

🕊 Further Afield

- Auzoue valley: *Fourcès (3 ½ miles/
- 5.5 km), see p. 200; Nérac (21 miles/34 km).
- *Larressingle (6 miles/9.5 km), see p. 203.
- Condom (9 ½ miles/15.5 km).
- *Lavardens (26 miles/42 km), see pp. 208–9.

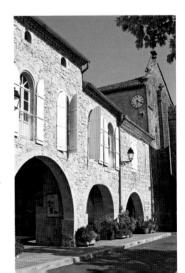

Mornac-sur-Seudre

A pearl in the marshes

Charente-Maritime (17) • Population: 840 • Altitude: 16 ft. (5 m)

Typical of Charente-Maritime, the house façades in the little port of Mornac, trimmed with hollyhocks, are bleached by the sun.

During Gallo-Roman times, the attractions of the Seudre river turned the budding village of Mornac into a small fishing town on a hill near the present castle. As commerce developed, attractive low houses began to replace modest huts. Today, Mornac-sur-Seudre is a center of oyster farming and salt production, which you can see by visiting the marshes. Brimming with medieval charm, the old town is crisscrossed by alleys leading to the port. The Romanesque church, built in the 11th century over a Merovingian shrine, is topped by a fortified square tower and has a magnificent chevet.

Highlights

- Église Saint-Pierre (11th century):
- Medieval frescoes, reliquary treasure.
- Seudre marshes: Guided biodiversity

walk: +33 (0)5 46 22 92 46. • Musée Ferroviaire (railroad museum): In

Mornac-sur-Seudre's 150-year-old disused railway station: +33 (0)7 51 66 92 36. • Village: Guided tours: +33 (0)5 46 22 92 46.

Village: Guided tours: +33 (0)5 46 22 92 46.
Salt-marsh tour: Meet salt producer Sébastien Rossignol: +33 (0)6 71 09 03 03.

Accommodation Guesthouses

Côté Chenal: +33 (0)5 46 02 14 57. M. Cougot: +33 (0)5 46 22 65 29. Marjorie: +33 (0)5 46 22 60 87. Le Mornac: +33 (0)5 46 22 63 20. Mme Pichon: +33 (0)5 46 22 63 29. **Gîtes, vacation rentals, and campsites** Further information: +33 (0)5 46 22 61 68 www.tourisme-mornac-sur-seudre.fr Michel Vinay, farm campsite:

+33 (0)5 46 22 72 25.

T Eating Out

Le Bar'Ouf: +33 (0)5 46 22 75 24. Les Basses Amarres: +33 (0)5 46 22 63 31. La Cabane de l'Ostréa: +33 (0)5 46 06 42 84. Le Café des Arts, crêperie: +33 (0)5 46 06 40 43. La Cambuse: +33 (0)9 83 27 62 24. Les Ecluses Vertes: +33 (0)6 11 77 09 53. La Gourmandine : +33 (0)5 46 23 38 47. Le Marais: +33 (0)5 46 23 16 78. Le Moulin, crêperie: +33 (0)5 46 05 59 36. Le Parc des Graves: +33 (0)5 46 22 75 14. La Planche à Sel: +33 (0)5 46 22 76 53.

Local Specialties Food and Drink

Candy • Oysters • Shrimps • Seafood preserves • Salt.

Art and Crafts

Leather crafts • Jewelry • Bag, fashion, and accessories designer • Crafts from natural materials • Salt dough • Painters and sculptors • Potters • Torch glass artist.

🖈 Events

Market: Wednesdays and Sundays, 9 a.m.–12.30 p.m. April: Romanesque fair. May: Storytelling festival. Pentecost: Journée de l'Art et des Saveurs, art and tasting fair. July–August: "Jeudis Musicaux et Nocturne des Artisans," evening music and craft fairs (every Thursday); exhibitions at the port: evening tours

exhibitions at the port; evening tours of the village. August (depending on tide): "Voiles

de Mornac," annual gathering of traditional sailboats. September: Pottery market. December: Christmas market.

W Outdoor Activities

Seudre river cruises • Horse-riding • Canoeing • Fishing • Walking: 3 marked trails • Cycling: 1 marked trail • Microlights.

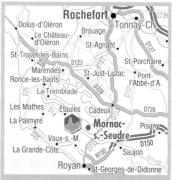

By road: Expressway A10, exit 35–Saintes (24 miles/39 km); N150, exit D14–Saujon/ La Tremblade (5 ½ miles/9 km). By train: Royan station (7 ½ miles/12 km). By air: La Rochelle-Laleu airport (45 miles/72 km); Bordeaux-Mérignac airport (100 miles/161 km).

() Tourist information: +33 (0)5 46 22 61 68 www.tourisme-mornac-sur-seudre.fr

🖗 Further Afield

• Saujon: Le Train des Mouettes, tourist steam train (6 miles/9.5 km).

- Royan (7 ½ miles/12 km).
- La Palmyre: zoo (9 ½ miles/15.5 km).
- Saint-Georges-de-Didonne: Parc de l'Estuaire nature reserve (9 ½ miles/15.5 km).
- *Talmont-sur-Gironde (18 miles/29 km), see p.
- Marennes; Isle of Oléron (19 miles/31 km).
- Brouage (20 miles/32 km).

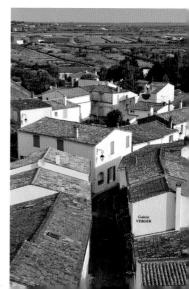

Mortemart The great and the good in Limousin

Haute-Vienne (87) • Population: 118 • Altitude: 984 ft. (300 m)

A flower-bedecked Limousin town with a glorious past. Mortemart resonates with ten centuries of history. Established on a marshy plain that gave the village its name (Morte mortuum: "dead sea"). Mortemart did not remain primitive for long. In 995, as a reward for his victorious defense of the neighboring town of Bellac against Count Guillaume de Poitiers. Abon Drut, lord of Mortemart, was authorized to build the Château des Ducs. This became the birthplace of the Rochechouart-Mortemart family: Madame de Montespan, born into the family in 1640, was a favorite of Louis XIV's. In the 10th-century castle, while the fortifications have disappeared, the keep, courtroom, and guards' room are a reminder of the perils that threatened medieval towns, as are the drawbridge, pond, and dried-up moat. The Carmelite and Augustinian convents, designed to a square grid, were begun in 1330 but were not completed until the 18th century. The Augustinian chapel, which became the parish church, contains 15th-century carved wooden stalls: their misericords, which allowed monks to rest, recall the long church services of times gone by. The historic market and the superb houses of prominent townsfolk evoke a thriving 17th-century commercial town.

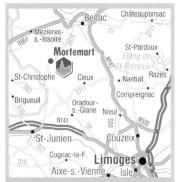

By road: Expressway A20, exit 23–Bellac (27 miles/43 km); N145 (9 ½ miles/15.5 km); N141, exit Bellac (11 miles/18 km). By train: Bellac station (8 miles/13 km); Limoges-Bénédictins station (28 miles/ 45 km). By air: Limoges-Bellegarde airport (24 miles/39 km).

() Tourist information: +33 (0)5 55 68 12 79 www.mortemarttourismelimousin.com

Highlights

 Château des Ducs (10th century): Keep, courtroom, guards' room (July–August).
 Carmelite convent (14th–17th centuries):

Monumental staircase; art and craft gallery.

• Church: 15th-century stalls, 17th-century altarpiece.

• Village: Guided visits for groups by appointment only: +33 (0)5 55 68 12 79.

Accommodation

Le Relais*: +33 (0)5 55 68 12 09.

Guesthouses

Thomas Raymond***: +33 (0)5 55 60 20 23. Philip Webb***: +33 (0)5 55 60 88 26. Gisèle Ribette: +33 (0)5 55 68 35 99.

T Eating Out

Brasserie/bar: +33 (0)5 55 68 98 61. Le Relais: +33 (0)5 55 68 12 09.

Local Specialties Art and Crafts

Poetry publisher • Artists and craftspeople at Carmelite convent.

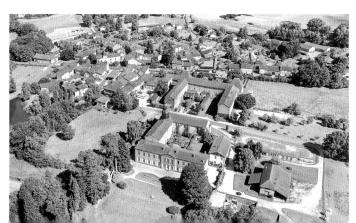

★ Events

Market: Sunday mornings, local produce, at La Halle covered market (July–August). April: Plant fair (3rd weekend, alternate years).

June: Antiques fair; concert by the Josquin des Prés vocal ensemble.

July-August: Concerts; painting and sculpture exhibitions; Haut Limousin music and heritage festival; "Peintres dans la Rue," street painting competition.

August: Exhibition and drive-past of vintage vehicles.

November: Fête des Pommes et Fruits du Terroir, local fruit festival (3rd weekend).

W Outdoor Activities

Walking: 3 marked trails • Mountain-biking • Golf Club Villars (9 holes).

🕊 Further Afield

- Monts de Blond, uplands (1–9 ½ miles/ 1.5–15.5 km).
- Bellac; Le Dorat (8–16 miles/13–26 km).
- Oradour-sur-Glane: Centre de la Mémoire.
- center for remembrance (9 ½ miles/15.5 km).
- Confolens: folklore festival (19 miles/31 km).
- Saint-Junien, Vienne valley (22 miles/35 km).
- Limoges; Site Corot, porcelain factory (25 miles/40 km).

MOSSET Between the mountains and the Mediterranean

Pyrénées-Orientales (66) • Population: 303 • Altitude: 2,297 ft. (700 m)

Surrounded by mountains, the tall façades of Mosset climb a rocky spur that towers over the Castellane valley.

Until the 13th century, Mosset consisted of a handful of houses scattered a few miles from the current village. It crept over a rocky mound 2,297 ft. (700 m) high, encircling the castle, and it became a frontier stronghold between the kingdoms of France and Aragon. The gateways in the old ramparts conserve a rich heritage behind them: the castle keep was rebuilt in the 16th century, and the Romanesque church of Saint-Julien-et-Sainte-Baselisse dates from the 13th and 17th centuries. The richness of the flora and fauna of the village's vast territory adds to its charm. At a height of over 2,000 ft. (700 m). Mosset blends Mediterranean with mountain perfumes, and gathers these scents in its Tour des Parfums perfume museum.

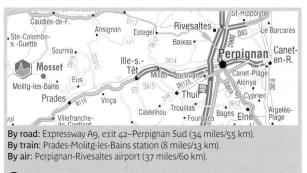

() Tourist information: +33 (0)4 68 05 38 32 / www.mosset.fr

Highlights

• **V Tour des Parfums:** Educational, interactive, and family-friendly museum on the world of scents and perfumes: +33 (0)4 68 05 38 32 or +33 (0)4 68 05 08 80.

• Église Saint-Julien-et-Sainte-Baselisse (13th and 17th centuries): Carved altarpieces: +33 (0)4 68 05 38 32.

- Village: Guided tours:
- +33 (0)4 68 05 38 32.

Accommodation

Guesthouses La Forge**: +33 (0)4 68 05 04 84. Mas Lluganas** +33 (0)4 68 05 00 37. Gîtes, vacation villages, and vacation rentals

Le Pailler**:+ 33(4) 68 68 42 88. Further information and other gîtes and vacation rentals: +33 (0)4 68 05 38 32 www.mosset.fr

Bunkhouses

Centre La Coume: +33 (0)4 68 05 01 64. Rural campsites

El Camp del Gat +33 (0)4 68 05 07 41. Moli d'Oli +33 (0)6 83 47 52 04.

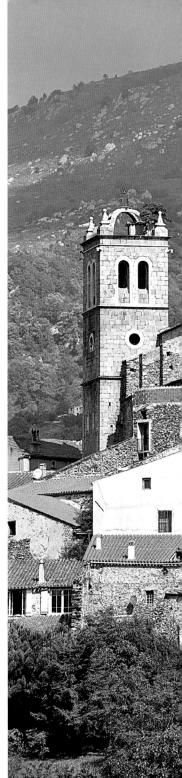

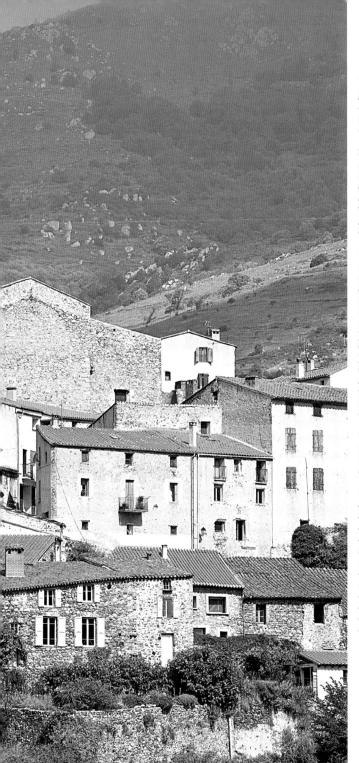

T Eating Out

Auberge de la Castellane: +33 (0)4 68 05 01 87. Mas Lluganas, farmhouse inn: +33 (0)4 68 05 00 37.

Local Specialties Food and Drink

Local goat cheese • *Coscoll* liqueur (wild angelica) • Farm produce (fattened duck, turkey, "Rosée des Pyrénées" veal) • Vegetables.

Art and Crafts Cabinetmaker • Potter • Ironworker.

★ Events

Market: Farmers' market, Sundays 10 a.m.–12 p.m., Plaça San Julia (July 15–August 31). May: Foire des Parfums et Saveurs de la Montagne, mountain scents and perfumes fair. June: "Nuit de la Saint-Jean," Saint John's (Midsummer's) Eve (23rd). July: "Lavande en Fête," lavender festival (open-air distillation, studios, etc.). August: Opera spectacle (1st fortnight), village fête (15th and 16th). December: Living Nativity scene and Catalan carols (24th).

W Outdoor Activities

Hunting • Fishing • Mushroom picking • Donkey rides • Walking • Winter sports: cross-country skiing, snowshoeing, luge.

🕊 Further Afield

- Molitg-les-Bains (3 miles/5 km).
- Prades (7 ½ miles/12 km).
- *Eus (8 miles/13 km), see p. 196.

• Abbeys of Saint-Michel-de-Cuxa and Saint-Martin-du-Canigou (9 ½– 16 miles/15.5–26 km).

- *Villefranche-de-Conflent (11 miles/ 18 km), see pp. 262–63.
- *Évol (19 miles/31 km), see p. 197.
- Serrabone: priory (24 miles/39 km).
- *Castelnou (25 miles/40 km), see p. 185.
- Perpignan (34 miles/55 km).

Najac Tumbling rooftops in the Aveyron

Aveyron (12) • Population: 754 • Altitude: 1,115 ft. (340 m)

Set on a steep hill, the fortress of Najac dominates the village and wild gorges of this southern French region.

A simple square tower in the 12th century, the Château de Najac became a fortress a century later by order of Louis IX (Saint Louis). Its strategic position made it the linchpin of the valley and earned it a turbulent history. Kings of France and England, counts of Toulouse, Protestants, and locals have all desired this "key to the whole land." From round towers, the view plunges to the valley of the Aveyron and over the village's *lauze* (schist tile) rooftops. The inhabitants converted to the "Cathar heresy" in the 1200s, and were sentenced by the Inquisition to build the Eglise Saint-Jean at their own expense. Its southern-French style of pointed arch makes it one of the first Gothic churches in the area. The village extends over the rocky crest at the foot of the castle. At its center, the Place du Barry evokes the village's role as a commercial center: its stone or halftimbered houses from the 15th and 16th centuries feature arcades to shelter merchandise.

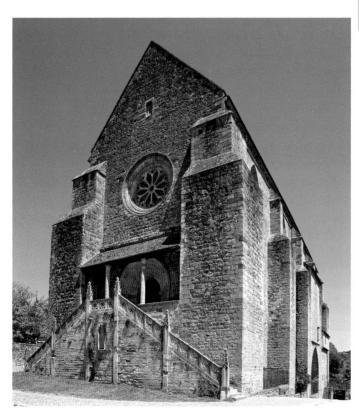

By road: Expressway A20, exit 59–Rodez (31 miles/50 km); expressway A75, exit 42– Rodez (75 miles/120 km), N88 (33 miles/ 53 km); expressway A68, exit 9–Gaillac (36 miles/58 km). By train: Najac station; Villefranche-de-Rouergue station (14 miles/ 22 km). By air: Rodez-Marcillac airport (50 miles/81 km); Toulouse-Blagnac airport (77 miles/124 km).

() Tourist information: +33 (0)5 65 29 72 05 www.tourisme-najac.com

Highlights

• Royal fortress (12th and 13th centuries): Keep, Saint-Julien's Chapel (frescoes), governor's chamber (panoramic view from the terrace): +33 (0)5 65 29 71 65.

• Église Saint-Jean (13th and 14th centuries).

• Village: Guided tours Tuesdays 10 a.m., June 15–September 15; for groups offseason by appointment; torchlit tours July–August; "Le Maître des Secrets de Najac," treasure hunt for children (age 6–12): +33 (0)5 65 29 72 05.

Accommodation

↓ Le Belle Rive***: +33 (0)5 65 29 73 90. ↓ L'Oustal del Barry**: +33 (0)5 65 29 74 32. **Guesthouses** Marie Delerue**, La Prade Haute: +33 (0)5 65 29 74 30. J.-P. Verdier**, La Prade Basse: +33 (0)5 65 29 71 51. La Bastide: +33 (0)5 65 45 08 07 07 +33 (0)6 81 92 54 93. El Camino de Najac: +33 (0)5 65 81 29 19. Sylvie Frazier, La Contie: +33 (0)5 65 29 70 79.

Gîtes, walkers' lodges, vacation rentals Further information: +33 (0)5 65 29 72 05 www.tourisme-najac.com

Vacation villages Les Hauts de Najac, VVF Villages:

+ 33 (0)5 65 29 74 31.

Campsites

Le Païsserou***, information and booking: +33 (0)5 65 29 73 96. Camping des Étoiles*: +33 (0)5 65 29 77 05. La Prade Basse, farm campsite: +33 (0)5 65 29 71 51. **RV parks**

Further information: +33 (0)5 65 29 71 34.

T Eating Out

La Belle Rive: +33 (0)5 65 29 73 90. La Cantine Pirate: +33 (0)5 65 81 59 27. Il Cappello, pizzeria: +33 (0)5 65 29 70 26. Les Hauts de Najac: +33 (0)5 65 29 74 31. L'Oustal del Barry: +33 (0)5 65 29 74 32. La Salamandre: +33 (0)5 65 29 74 09. Tartines et Compagnie: +33 (0)5 65 29 57 47.

Local Specialties Food and Drink

Ostrich and duck (confits, foie gras) • Fouace de Najac • Cheese • Gâteau à la broche (fire-baked cake) • Astet najacois (roast stuffed pork). Art and Crafts Jewelry designer • Cutler • Potter.

★ Events

Market: Sunday 8 a.m.-1 p.m., June-September. April: "Salon du Goût," tasting fair (1st weekend). June: "Nuit des Chiens Bleus," music festival. July: Open-air cinema. July-August: Contemporary art exhibitions, "Ateliers du Patrimoine" and "L'Été des 6-12 ans"; flea market (Sundays mid-July-mid-August); evening market (Wednesdays). August: "Festival en Bastides," theater

August: "Festival en Bastides," theate and street performances (1st week), village fête (3rd weekend); book fair; "Les Musicales du Rouergue," music festival.

September: Jazz festival. October: "Lame à Najac," cutlery fair.

W Outdoor Activities

Canoeing • Orienteering • Climbing • Horse-riding • Fishing • Via Ferrata • Mountain-biking (cross-country mountainbiking area) • Walking: Route GR 36 and 8 marked trails.

🕊 Further Afield

Abbaye de Beaulieu; Caylus

- (9 ½–12 miles/15.5–19 km).
- Fortified towns of Villefranche-de-Rouergue and Villeneuve (14–22 miles/ 23–35 km).
- Château de Saint-Projet (16 miles/26 km).
- Cordes-sur-Ciel (16 miles/26 km).
- Gorges of the Aveyron; Saint-Antonin-Noble-Val (17 miles/27 km).
- *Monestiés (19 miles/31 km), see p. 214.
- *Sauveterre-de-Rouergue (27 miles/
- 43 km), see pp. 254–55.
- Albi (31 miles/50 km).

I Did you know?

A local specialty, the *fouace de Najac* was originally cooked in the ashes of a fire (the word comes from the Latin *focus*, meaning hearth). Nowadays the bread is made of flour, yeast, eggs, milk, sugar, orangeblossom water, and salt, and is presented in the shape of a crown.

Navarrenx The first fortified town in France

Pyrénées-Atlantiques (64) • Population: 1,075 • Altitude: 394 ft. (120 m)

Situated at the place where the Gave d'Oloron river and the Saint James's Way meet, Navarrenx is one of the oldest towns in the old independent state of Béarn.

Navarrenx has its origins in the 1st century CE, but it was in the Middle Ages that the town had its glory days. Built as a *bastide* (walled town) in 1316, Navarrenx enjoyed a number of privileges that helped it to expand. From 1538 onward Henri II d'Albret, king of Navarre, made important alterations to it in an attempt to protect this vital commercial center and crossroads from the Spanish. The designer was Italian architect Fabricio Siciliano: his work is still visible today in the historic stronghold, and his style was copied a century later by Vauban (commissioner for fortifications in the 17th century). The impressive ramparts 33 ft. (10 m) high, from which you can see the Pyrenees, provide a magnificent view over the Gave d'Oloron, as well as over several bastions and military structures. Navarrenx, once an important stopover on the path to Santiago de Compostela, now gives a nod to the village's defensive past by welcoming pilgrims in search of peace to the historic 17th-century arsenal, partly converted into gîtes. The Gave d'Oloron, the longest salmon river in France, has also given Navarrenx its reputation as a "salmon capital," and freshwater fishermen still enjoy its bounties.

By road: Expressway A64, exit Saliesde-Béarn (17 miles/27 km) and exit 9– Mourenx (14 miles/23 km), N117 (13 miles/ 21 km). By train: Orthez station (14 miles/ 23 km); Pau station (25 miles/40 km). By air: Pau-Pyrénées airport (25 miles/ 40 km); Biarritz-Anglet-Bayonne airport (50 miles/80 km).

(i) Tourist information—Béarn des Gaves: +33 (0)5 59 38 32 85 www.tourisme-navarrenx.com

Highlights

 Centre d'Interprétation, visitor center: Museum inside the former arsenal, dedicated to the history of Navarrenx, e.g. models, plans: +33 (0)5 59 66 10 22. "La Poudrière": Permanent exhibition on gunpowder: +33 (0)5 59 38 32 85. La Porte Saint-Antoine: Musée des Vieux Outils, museum of old tools: +33 (0)5 59 38 32 85.

• La Maison du Cigare: Production site of the luxury cigar "Le Navarre," combining French and Cuban expertise; see the different stages of production of premium cigars and a cigar-rolling demonstration. Open throughout the year, Monday– Friday: +33 (o)5 59 66 51 96.

• Village: Self-guided tour using leaflet (available from tourist information center); themed tour for individuals led by tour guide from "Pays d'Art et d'Histoire"; guided group tour throughout the year by appointment; guided view of model of the fortified town at tourist information center.

Accommodation

Hôtel du Commerce**: +33 (0)5 59 66 50 16. **Guesthouses**

Monique and Jean-Pierre Lasarroques: +33 (o)5 59 66 27 36 or +33 (o)6 75 59 36 56. Le Relais du Jacquet: +33 (o)5 59 66 57 25 or +33 (o)6 75 72 89 33.

Gîtes and vacation rentals

Le Relais du Jacquet**: +33 (0)5 59 66 57 25 or +33 (0) 06 75 72 89 33. Peter French: +33 (0)5 59 66 01 18. Madeleine Laberthe: +33 (0)5 59 66 51 69. Bernadette Nargassans: +33 (0)5 59 66 08 39. Christiane Palas: +33 (0)5 59 66 50 35).

Walkers' lodges and accommodation for groups

Further information: + 33 (o)5 59 38 32 85 www.tourisme-navarrenx.com

I Eating Out

Auberge du Bois: +33 (0)5 59 66 10 40. Bar des Sports: +33 (0)5 59 66 50 63. Le Commerce: +33 (0)5 59 66 50 16. Le P'tit Bistrot: +33 (0)5 59 66 50 78. La Taverne de Saint-Jacques: +33 (0)5 59 66 25 25.

Local Specialties Food and Drink

Croquignoles de Navarrenx and *curbelets* cookies • Artisan preserves • Salted products • Jam • Artisan beers • Gave river salmon and trout.

Art and Crafts

Artist and interior designer • Jewelry designer • Photographer • Potter • Stylist and designer.

\star Events

Markets: Wednesday mornings, Place Darralde; summer market, Sunday mornings, at the town hall (June–September). January: Large agricultural and secondhand equipment fair; book fair. Easter weekend: Craft fair. June: "Feu de la Saint-Jean," Saint John's (Midsummer's) Eve bonfire. July: Fête du Saumon, salmon festival (14th). July–August: "Festival des Pierres

Lyriques," tapas evening, and "Alto" concerts in Béarn.

August: Patron saint's feast (beginning of August); medieval fête (end of August). December: Christmas markets and activities (first three Sundays).

W Outdoor Activities

Walking: several marked trails • Mountainbiking: Navarrenx mountain-biking base— 140 miles (225 km) of marked trails • Salmon and trout fishing (1st category) • Rafting, minirafts, canoeing, stand-up paddle-boarding • Le Domaine Nitot leisure complex.

🕊 Further Afield

• Gurs former internment camp (3 ½ miles/ 5.5 km).

- Laàs castle and gardens (6 miles/9.5 km).
- Église de l'Hôpital-Saint-Blaise, UNESCO
- World Heritage Site (9 ½ miles/15.5 km).
- Église Saint-Girons-de-Monein (11 miles/ 18 km)
- Sauveterre-de-Béarn, medieval town (12 miles/19 km).
- Orthez, former medieval capital (14 miles/ 23 km).
- Salies-de-Béarn, salt city (19 miles/31 km).

Olargues The natural charm of the Languedoc

Hérault (34) • Population: 600 • Altitude: 600 ft. (183 m)

Situated in a bend in the Jaur river, Olargues provides walks flavored with history at the heart of the Haut-Languedoc regional nature park. At the foot of Mont Caroux, the "mountain of light," Olargues combines the coolness of Massif Central rivers with the sunshine of the South, and its landscapes of chestnut and cherry trees with vineyards and olive groves. Although this exceptional site has been occupied since prehistoric times, it was in the 12th century that lords in the region built a castle and fortified village here. From the old bridge over the Jaur, *calades* (decorative cobblestones) invite visitors to discover stone houses, now covered with barrel tiles rather than the traditional *lauzes* (schist rooftiles); the remains of the ramparts; the covered stairway of the commandery, and the Église Saint-Laurent, built in the 17th century with stones from the original Romanesque church, whose bell tower was formerly a castle keep.

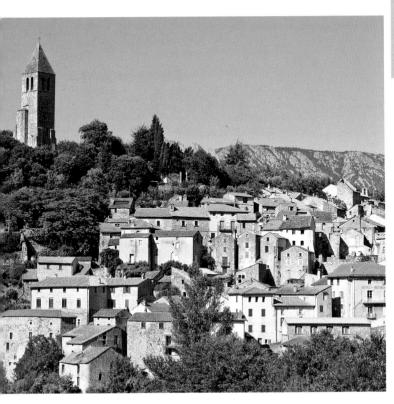

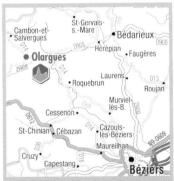

By road: Expressway A75, exit 57– Clermont-l'Hérault (34 miles/55 km); expressway A9, exit 36–Valras Plage (42 miles/68 km). By train: Bédarieux station (14 miles/23 km); Béziers station (40 miles/64 km). By air: Béziers-Capd'Agdes-en-Languedoc airport (40 miles/ 64 km); Montpellier-Méditerranée airport (73 miles/117 km); Toulouse-Blagnac airport (93 miles/150 km).

Tourist information—Caroux en Haut-Languedoc: +33 (0)4 67 23 02 21 www.ot-caroux.fr

Highlights

• Centre Cebenna: An ecosystems study and research center. Multimedia library, 3D projection, giant kaleidoscope; exhibitions, activities, and nature tours: +33 (0), 67 97 88 00.

Musée des Arts et Traditions

Populaires: Museum of village history, old tools, the geology of the region, famous people, models of life in the past, life-size reproduction of a forge, medieval hall: +33 (0)4 67 23 02 21.

• Village: Self-guided visit and guided tours every Monday at 6 p.m. in July and August; by appointment only off-season for 10+ people: +33 (0)4 67 23 02 21.

✓[★] Accommodation Hotels

Laissac-Speiser: +33 (0)4 67 97 70 89. Guesthouses

Les Quatr' Farceurs**: +33 (0)4 67 97 81 33. Fleurs d'Olargues: +33 (0)4 67 97 27 04 or +33 (0)6 80 51 96 55.

Gîtes, walkers' lodges, and vacation rentals

Further information: +33 (0)4 67 23 02 21 www.ot-caroux.fr

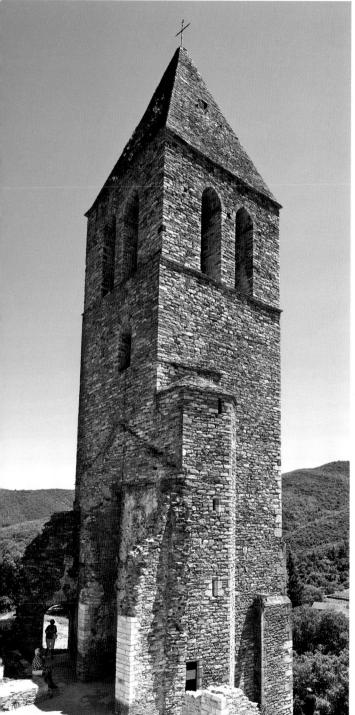

Campsites

Le Baous*: +33 (0)4 67 97 71 50 or +33 (0)6 62 28 33 64.

T Eating Out

Fleurs d'Olargues: +33 (0)4 67 97 27 04. Le Funambule: +33 (0)4 67 97 72 06. Laissac-Speiser: +33 (0)4 67 97 70 89. La Lampisterie, pizzeria: +33 (0)6 23 87 32 51.

*** Local Specialties** Food and Drink

Olargues chestnut-based specialties • Wild plants and fruits. Art and Crafts

Artists • Luthiers • Artisan potter.

★ Events

Market: Sunday mornings, Place de la Mairie.

May: Fête de la Brouette, wheelbarrow festival (mid-May).

August: "Festibaloche," contemporary music festival; "Estival de la Bio," organic produce festival; "Autour du Quatuor," classical music festival. September: Fête Médiévale d'Olargues, medieval fête (3rd weekend in September). November: Fête du Marron et du Vin Nouveau, chestnuts and wine (1st weekend after All Saints).

December: Christmas market.

W Outdoor Activities

Swimming • Boules area • Canoeing, canyoning, caving • Rock climbing • Walking • Mountain-biking and hybrid biking • "Passa Païs": Haut Languedoc greenway for walkers and cyclists from Mazamet to Bédarieux (47 miles/76 km).

🕊 Further Afield

- Le Caroux, massif; Gorges of the Héric (3 ½ miles/5.5 km).
- Gorges of the Orb; Vieussan (5 miles/8 km).
- Monts de l'Espinouse (7 ½ miles/12 km).
- Saint-Pons-de-Thomières (11 miles/18 km).
- Roquebrun (12 miles/19 km).

I Did you know?

The bridge in Olargues is called the Pont du Diable (Devil's Bridge) because legend has it that the devil agreed to its construction in exchange for the soul of the first person to cross it. So when the bridge was completed, the residents of Olargues made a cat cross it—a black one, naturally.

Peyre (commune of Comprégnac) A vertiginous viaduct

Aveyron (12) • Population: 251 • Altitude: 1,214 ft. (370 m)

Clinging to a sheer cliff where the original church was built, Peyre overlooks the Tarn downstream of Millau.

Beneath the plateau of the Causse Rouge, dotted with *caselles* (drystone shelters) whose *lauze* (schist-tiled) roofs protected shepherds and winegrowers, the lower village, crisscrossed with narrow, cobbled, stepped streets, descends steeply toward the river. The top of Peyre stretches out at the foot of a high tufa cliff, whose corbeled overhang towers above the village. Like the houses that surround it, the Église Saint-Christophe backs onto this cliff face. Fortified in the 17th century to serve as a refuge for residents of the parish, it has retained brattices and murder holes that bear witness to its defensive history. Recently restored as a venue for concerts and exhibitions, the church, which is bathed in changing light diffused by its glass and crystal stained-glass windows, now faces another symbol of modernity: the P2 pier, which, soaring upward from the Tarn, makes the Millau Viaduct the tallest bridge in the world.

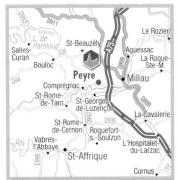

By road: Expressway A75, exit 45– Millau (7 ½ miles/12 km). By train: Millau station (5 miles/8 km). By air: Rodez-Marcillac airport (62 miles/100 km); Montpellier-Méditerranée airport (84 miles/135 km).

(i) Tourist information—Millau:

+33 (0)5 65 60 02 42 www.millau-viaduc-tourisme.fr www.compregnac12.fr

Highlights

• Église Saint-Christophe: Partially dug into the rock face, this church holds contemporary art exhibitions from June to September.

 Village: Guided tour from July 1 to National Heritage Days in September, by appointment only: +33 (0)5 65 60 02 42.
 Colombier du Capelier, Comprégnac

(14th century): Self-guided visit. • Maison de la Truffe, Comprégnac:

Presentation of truffle cultivation, and typical architecture from the Causses.

Accommodation Guesthouses

M. Espinasse: +33 (0)5 65 58 15 52 or +33 (0)6 84 90 32 07. Les Terrasses de Pérouges:

+33 (0)6 21 79 61 82.

Gîtes

M. Espinasse: +33 (0)5 65 58 15 52 or +33 (0)6 84 90 32 07.

Campsites

Le Katalpa, Comprégnac: +33 (0)5 65 62 30 05.

T Eating Out

L'Estival, July and August: +33 (0)5 65 62 39 37.

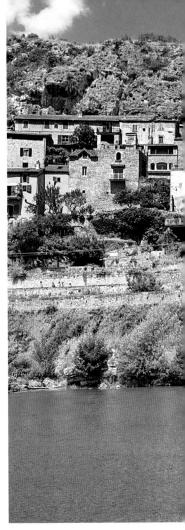

Local Specialties

Food and Drink Truffles and truffle-based produce. Art and Crafts Gifts, tableware • Potter • Atelier Terralhas, Comprégnac.

★ Events

June: Choeurs de Peyre, choirs and concerts. July: Fête de la Saint-Christophe, festival (last weekend). Mid-July-mid-August: Festival de la Vallée et des Gorges du Tarn. Late July-early August: Fête du Pain au Four Communal, bread festival.

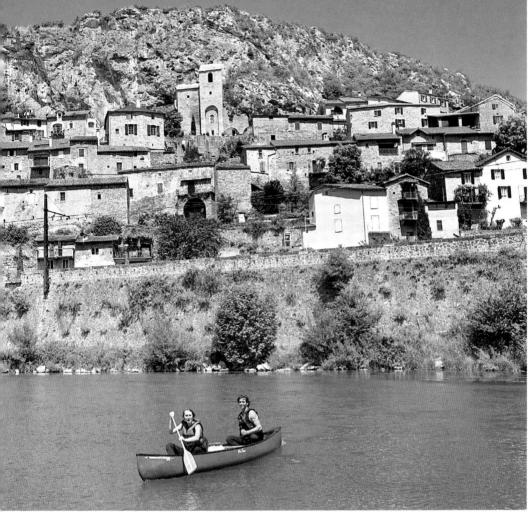

December: Truffle festival at Comprégnac and local produce market (weekend before Christmas).

W Outdoor Activities

Aire de Loisirs des Pyramides, on the banks of the Tarn: children's games, picnic area • Walking: *caselles* (drystone shelters) discovery trails, circular walks of 3 miles (5 km, 1 ½ hrs) or 4 ½ miles (7 km, 3 hrs) leaving from Peyre or Comprégnac, and (short) "Randocroquis" drawing trails around the village.

🕊 Further Afield

• Millau (5 miles/8 km)

- Millau Viaduct discovery area (9 ½ miles/15.5 km).
- Castelnau-Pégayrolles (12 miles/19 km).
- Gorges of the Dourbie (13–24 miles/
- 21-39 km).

• Saint-Léon: Micropolis, insect museum and birthplace of the entomologist Henri Fabre (16 miles/26 km).

- Chaos de Montpellier-le-Vieux (17 miles/ 27 km).
- Larzac Templars and Hospitallers
- sites (17-32 miles/27-51 km).
- Gorges of the Jonte (17–30 miles/ 27–48 km).

• Gorges of the Tarn (17–39 miles/ 27–63 km).

• *La Couvertoirade (30 miles/48 km), see p. 190.

I Did you know?

Periodically, following prolonged heavy rain, rumblings that warn of an inflow of underground water wake up some locals, and water pours down the rock overhanging the village. The water forms an impressive cascade, hurtling down the slope toward the Tarn. This phenomenon, which can last for several days, attracts a lot of local attention.

Pujols-le-Haut A former stronghold in the Albi region

Lot-et-Garonne (47) • Population: 3,844 (Pujols commune) • Altitude: 614 ft. (187 m)

A fiefdom of the heretics. Pujols was destroyed during the Albigensian Crusade then rebuilt; it has preserved its medieval character. The former stronghold of the barony of Pujols has lived through many troubled times in the course of its history, from the Hundred Years War to the French Revolution, yet most of its 13th-century architectural heritage has been preserved. In addition to part of the outer wall and the castle, there remain two fortified gates, one of which serves as the bell tower to the old seigniorial chapel of Saint-Nicolas. The Église Sainte-Foy has retained its 16th-century frescoes. On the square, the covered market, built in 1850 with materials recovered from the Église Saint-Jean-des-Rouets, faces some fine late 13thcentury half-timbered houses. The stone walls of the ground floor are topped with black oak beams interspersed with flat bricks.

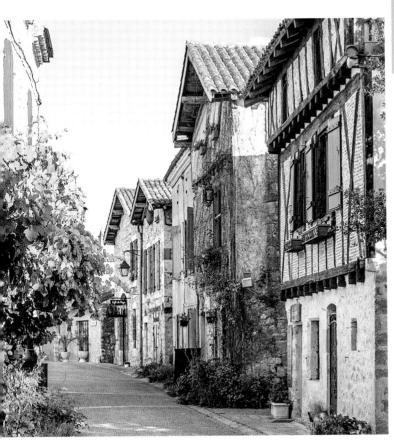

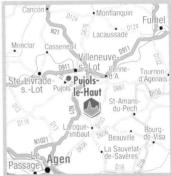

By road: Expressway A62, exit 6-Aiguillon (25 miles/40 km)/exit 7-Agen (21 miles/ 34 km), N21 (15 miles/24 km). By train: Agen station (18 miles/29 km). By air: Agen-Lagarenne airport (22 miles/ 35 km); Bordeaux-Mérignac airport (93 miles/150 km).

 Tourist information—Villeneuvois: +33 (0)5 53 36 78 69 www.tourisme-villeneuvois.fr www.pujols47.fr

Highlights

• Église Saint-Nicolas (14th and 15th centuries)

Old seigniorial chapel, city gate with bell tower. • Église Sainte-Foy (15th century): 16th-century frescoes

• Village: Guided tour for groups and by appointment; audioguides: +33 (0)5 53 36 78 69.

Accommodation

Hotels Campanile**: +33 (0)5 53 40 27 47. Bel Air: +33 (0)5 53 36 89 43. Guesthouses Pech des Renards: +33 (0)5 53 36 57 79. Gîtes and vacation rentals Les Chênes***: +33 (0)5 53 40 00 07. Gîte de la Citadelle***: +33 (0)5 53 40 66 85. Gîte des Copains et du Pigeonnier***: +33 (0)5 53 01 22 93. Gîte Plaine de Fourtou***: +33 (0)6 08 24 72 42. Le Gîte Salabert***: +33 (0)5 53 66 11 82. Le Gîte de la Petite Maison** +33 (0)5 53 70 78 14. For information on other gîtes and vacation rentals: +33 (0)5 53 36 78 69 www.tourisme-villeneuvois.fr Campsites Camping Lot & Bastides***: +33 (0)5 53 36 86 79.

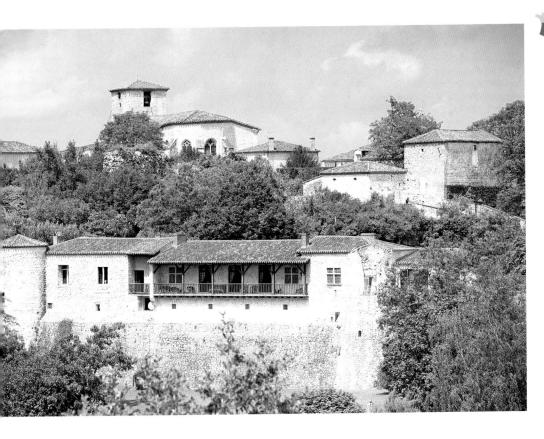

T Eating Out

Aux Délices du Puits, pizzeria: +33 (0)5 53 71 61 66. Campanile: +33 (0)5 53 40 27 47. Le Fournil de Pujols: +33 (0)5 53 70 15 55. La Toque Blanche: +33 (0)5 53 49 00 30. Villa Smeralda: +33 (0)5 53 36 72 12.

Local Specialties Food and Drink

Walnut, hazelnut, and prune-kernel oils • Walnuts, chocolate-covered walnuts • Macarons and shortbread cookies • Prunes. Art and Crafts

Artists • Potter • Toys.

★ Events

Market: Sunday mornings, farmers' market, Place Saint-Nicolas (May– September).

April–October: Painting and sculpture exhibitions at the Église Sainte-Foy and at the Salle Culturelle.

May: "Mai de la Photo" photo exhibition. July: Local produce fair (3rd Sunday). July and August: Gourmet market (Wednesday evenings); "Couleurs du Monde" festival (last week of July and first of August).

August: Book sale (1st Sunday); potters' market (3rd Sunday).

September: Fête du Sport (3rd Saturday). November: Salon des Oiseaux, bird show. December: Christmas market.

W Outdoor Activities

Hunting • Horse-riding • Fishing • Walking and mountain-biking: Route GR 652 and 3 marked trails.

🕊 Further Afield

- Villeneuve-sur-Lot (2 miles/3 km).
- Grottes de Lastournelle, caves (3 miles/ 5 km).
- Penne-d'Agenais (9 ½ miles/15.5 km).
- Le Temple-sur-Lot (11 miles/18 km).
- *Monflanquin (14 miles/23 km),
- see pp. 215–16.
- Agen (18 miles/29 km).
- Bonaguil: castle (22 miles/35 km).
- *Monpazier (29 miles/47 km), see pp. 217–18.

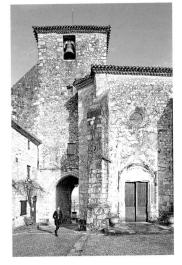

Puycelsi

Tarn (81) • Population: 484 • Altitude: 981 ft. (299 m)

At the edge of the Grésigne forest, Puycelsi watches over the Vère valley.

Occupied since prehistoric times, then besieged by the Celts and later by the Romans, Puycelsi passed, in the late 12th century, into the ownership of the counts of Toulouse, who made it one of their favorite fortified residences. Because of its strategic position and its walls, the village was able to resist many sieges: those of Simon de Montfort from 1211 to 1213 during the Albigensian Crusade: the Shepherds' Crusade in 1320; Duras's English troops in 1386; and the Huguenots during the Wars of Religion. Confined within its medieval walls, of which there remain more than 875 yards (800 meters) of ramparts and the Irissou double gate. Puycelsi offers splendid views over the Grésigne forest, the Vère valley, and the Causses du Quercy from its wall walks. At the heart of the village, the Église Saint-Corneille, with its listed altarpiece, is bordered by a medicinal-herb garden and surrounded by mostly 14th- and 15thcentury houses, which combine stone with wood and brick beneath fine hollow-tile roofs. On the horizon, the Grésigne forest can be seen, on the outskirts of which the village's master glassworkers located their workshops, in order to be close to a wood source.

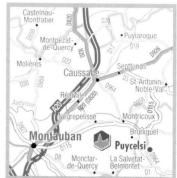

By road: Expressway A2o, exit 59–Saint-Antonin-Noble-Val (20 miles/32 km); expressway A68, exit 9–Gaillac (17 miles/ 27 km). By train: Gaillac (15 miles/24 km) station; Caussade (19 miles/31 km) station; Montauban-Ville Bourbon station (27 miles/ 43 km). By air: Toulouse-Blagnac airport (59 miles/95 km).

Tourist information— Bastides and Vignoble du Gaillac: +33 (0)5 63 33 19 25 www.tourisme-vignoble-bastides.com www.puycelsi.fr

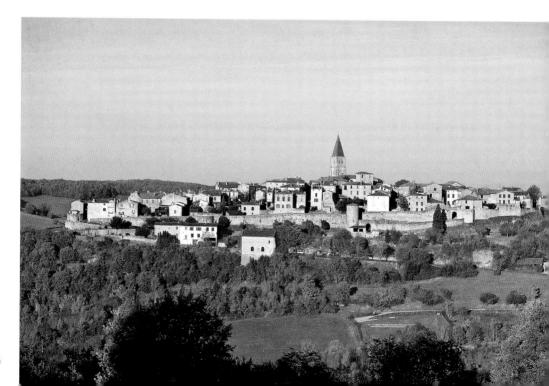

Highlights

• Église Saint-Corneille (15th and 17th centuries): Statuary, altarpiece, 18th-century bell tower.

• Institut International du Darwinisme: Further information: +33 (0)5 63 33 86 59. • Heritage walk: Free entry, guided tour by appointment only: +33 (0)5 63 33 19 25.

Research and conservation orchard: For old species of fruit trees (cherry, peach, pear, apple) and vines; option of guided tours: +33 (0)5 63 33 19 41.
Village: Guided tour, booking essential; map of the historic village available from tourist information center.

Accommodation

 L'Ancienne Auberge***:

 +33 (0)5 63 33 65 90.

 Guesthouses

 La Bâtisse Belhomme:

 +33 (0)9 53 17 53 51.

 Chez Delphine: +33 (0)5 63 33 13 65.

 La Maison de Martine:

 +33 (0)5 63 41 03 63.

 La Première Vigne: +33 (0)9 75 30 of 13.

 Gîtes, vacation rentals, and campsites

 Further information: +33 (0)5 63 33 19 25

 www.tourisme-vignoble-bastides.com

I Eating Out

Au Cabanon de Puycelsi, local bistro: +33 (0)5 63 33 11 33. Le Jardin des Lys, local bistro: +33 (0)5 63 33 15 69. Le Puycelsi Roc Café, snack bar: +33 (0)5 63 33 13 67.

Local Specialties Food and Drink

Cookies and crackers • Fruits, fruit purées, juices, and sorbets • Honey • AOC Gaillac wines.

Art and Crafts

Artists and craftsmen (Artistes Créateurs à Puycelsi) • Ceramicist • Painter-sculptor • Potters • Painting and model-making workshop.

★ Events

July: "Le Festival de Puycelsi Grésigne," choral festival (2nd fortnight). August: Village festival (end of August); exhibitions.

W Outdoor Activities

Walking: Route GR 46, heritage walks, Grésigne forest.

🕊 Further Afield

- *Bruniquel (8 miles/13 km), see p. 177.
- *Castelnau-de-Montmiral (8 miles/
- 13 km), see p. 183.
- Gorges of the Aveyron: from Bruniquel to Saint-Antonin-Noble-Val (9 ½–22 miles/ 15.5–35 km).
- Gaillac (13 miles/21 km).
- Caussade (16 miles/26 km).
- Montauban (24 miles/39 km).
- *Monestiés (27 miles/43 km), see p. 214.
- Albi (28 miles/45 km).

I Did you know?

In 1386, having been unable to take the fortress, English troops decided to reduce the villagers' resistance by besieging them. With no supplies left, the villagers walked their last squealing pig several times around the ramparts in order to make the enemy believe they still had resources despite the siege. The English eventually left. It is for this reason that a little pig can be seen carved into the stone on the church door.

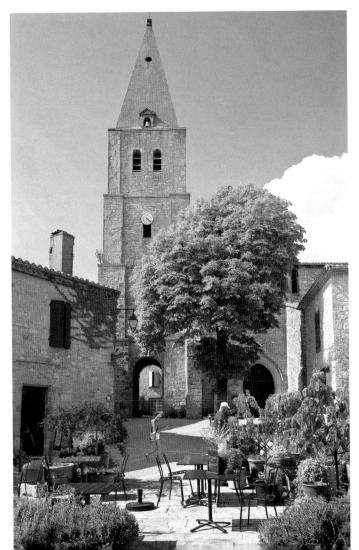

La Roque-Gageac

Dordogne (24) • Population: 430 • Altitude: 430 ft. (131 m)

Protected from the coldest weather by the cliff behind, La Roque-Gageac's golden buildings catch the sun's rays and are reflected in the Dordogne river.

An important stronghold in the Middle Ages, the village gained its fine mansions, including that of humanist Jean Tarde (1561–1636), during the Renaissance. In the 19th century, it saw heavy traffic of *gabares* (flat-bottomed boats) on the Dordogne river that transported wines from Domme to Bordeaux. Sheltered by the south-facing cliffs, and overlooked by the 16th-century church, Mediterranean and tropical plants flourish along the village's streets and in its gardens. The yellow-stone façades and pitched roofs covered with brown tiles contrast with their green setting. The beauty and character of the houses of La Roque-Gageac can also be admired from a boat on the Dordogne.

By road: Expressway A20, exit 55– Sarlat (22 miles/35 km). By train: Sarlat-la-Canéda station (8 miles/13 km). By air: Brive-Vallée de la Dordogne airport (32 miles/51 km); Bergerac-Roumanière airport (42 miles/68 km).

(i) Tourist information—Sarlat-Périgord Noir:

+33 (0)5 53 31 45 45 www.sarlat-tourisme.com

Highlights

• Jardin Exotique: Mediterranean and tropical plants. Free self-guided visit: +33 (0)5 53 29 40 29.

• Bambouseraie: Self-guided tour to discover different varieties of bamboo. Open 10 a.m.-7 p.m.: +33 (0)7 81 69 00 56.

• Jardin de la Ferme Fleurie: Terraced gardens (romantic garden, grandmother's garden, wild garden, medicinal-herb garden): +33 (0)5 53 28 33 39.

• Village: Guided tour June–September. Further information:

+33 (0)5 53 31 45 45.

Accommodation Hotels

La Belle Étoile***: +33 (0)5 53 29 51 44. Auberge des Platanes**: +33 (0)5 53 29 51 58. Le Périgord**: +33 (0)5 53 28 36 55. Guesthouses La Ferme Fleurie**: +33 (0)5 53 28 33 39. Mme Alla: +33 (0)5 53 28 33 01. Le Clos Gaillardou: +33 (o)5 53 59 53 97. Les Hauts de Gageac: +33 (0)5 47 27 51 30. La Maison d'Anne Fouquet: +33 (0)6 37 76 83 81. M. and Mme Menu: +33 (0)5 53 59 65 63. Le Pigeonnier de Labrot: +33 (0)5 53 28 37 00. Gîtes, walkers' lodges, and vacation rentals

Further information: +33 (0)5 53 31 45 45 www.sarlat-tourisme.com

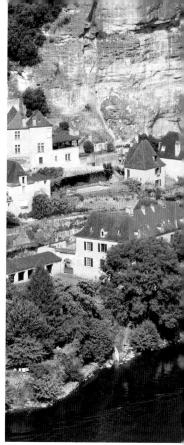

Campsites

Beau Rivage***: +33 (0)5 53 28 32 05. La Butte**: +33 (0)5 53 28 30 28. Verte Rive*: +33 (0)5 53 28 30 04.

T Eating Out

L'Ancre d'Or: +33 (0)5 53 31 27 66. Auberge des Platanes: +33 (0)5 53 29 51 58. La Belle Étoile: +33 (0)5 53 29 51 44. Le Colombier, farmhouse inn: +33 (0)5 53 28 33 97. La Ferme Fleurie, Périgord Noir country inn: +33 (0)5 53 28 33 39. Ò Plaisir des Sens: +33 (0)5 53 29 58 53. Le Palmier: +33 (0)5 53 29 24 61. Le Patio: +33 (0)5 53 29 24 61. Le Périgord: +33 (0)5 53 28 36 55. La Plume d'Oie: +33 (0)5 53 29 57 05. Les Prés Gaillardou: +33 (0)5 53 59 67 89.

Local Specialties

Food and Drink Foie gras • Périgord specialties.

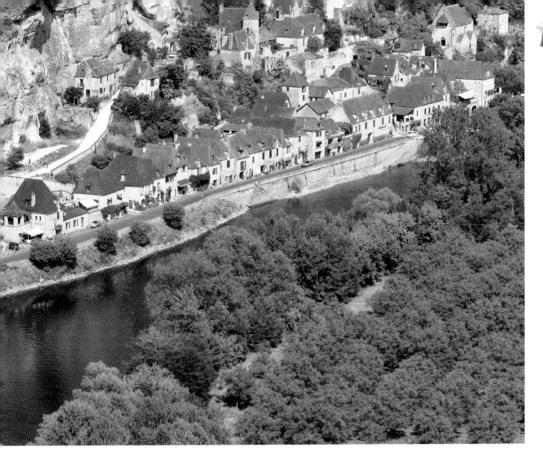

Art and Crafts

Enameler • Metalworker • Painterdecorator.

★ Events

Market: Friday mornings (May– September). August: Village festival; gourmet food market.

W Outdoor Activities

Swimming (no lifeguard) in the Dordogne • Gabare (traditional flat-bottomed boat) • Canoeing • Fishing • Boules area • Périgord hot-air balloons • Walking • Mountainbiking • Cycling.

🕊 Further Afield

• Dordogne valley: *Castelnaud-la-Chapelle (2 miles/3 km), see p. 184; *Beynac-et-Cazenac (3 miles/5 km), see pp. 172–73; *Domme (3 ½ miles/5 5 km), see pp. 192–93; *Belvès (14 miles/23 km), see pp. 170–71; *Limeuil (21 miles/34 km), see pp. 210–11.

- Marqueyssac: park and gardens (2 ½ miles/4 km).
- Sarlat (8 miles/13 km).

• Vézère valley: Les Eyzies (16 miles/ 26 km); *Saint-Amand-de-Coly (21 miles/ 34 km), see pp. 238–39; *Saint-Léon-sur-Vézère (22 miles/35 km) see p. 246.

• *Monpazier (24 miles/39 km) see pp. 217–18.

I Did you know?

The village, which faces south, enjoys an amazing microclimate and, thanks to a resident of the village, Mr. Dorin, who founded it, a Mediterranean and tropical plant garden has grown up along the narrow streets. Palms, banana trees, date palms, albizias, yuccas, bamboos, and oleanders flourish beneath the Périgord sun.

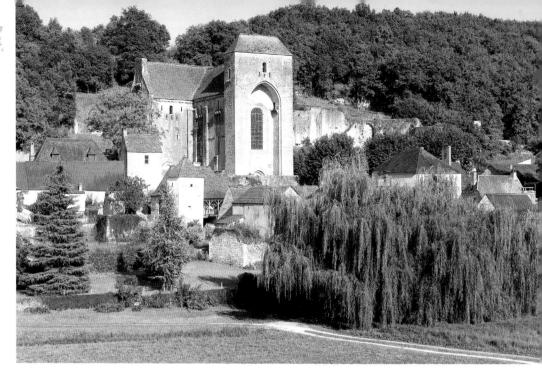

Saint-Amandde-Coly An abbey in Périgord

Dordogne (24) • Population: 405 • Altitude: 568 ft. (173 m)

Nestled at the intersection of three wooded valleys, the abbey at Saint-Amand-de-Coly watches over houses that are typical of the Périgord Noir region. The village owes both its name and its religious heritage to the monk Amand, who came to evangelize the Coly valley in the 6th century. The abbey was founded in the 12th century and ensured Saint-Amand's prosperity for two centuries. Before the Hundred Years War and the development of defense systems, the abbev church was considered the most beautiful fortified church in Périgord. The splendid 100-ft. (30-m) tall bell-tower porch, its huge Gothic arch, and its triple-arched door have a simple strength about them that is sustained inside the building. Indeed, the nave is a fine expression of the subtle balance between the sobriety of Romanesque architecture and the soaring verticality of the Gothic period. Around the church. which continues to make the village famous and which is the venue for excellent classical concerts throughout the year, are houses built in a typically Périgord style. In a harmonious contrast of ocher and gray tones, Sarlat stones and lauze (schist tile) roofs dress both grand and humble elements of the village's heritage: the abbey, houses, dovecotes, and old tobacco-drying barns.

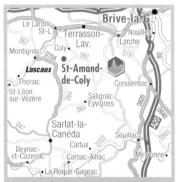

By road: Expressway A89, exit 17 (10 miles/16 km). By train: Condatle-Lardin station (6 miles/9,5 km); Sarlatla-Canéda station (15 miles/24 km); Brive-la-Gaillarde station (22 miles/35 km). By air: Brive-Vallée de la Dordogne airport (34 miles/55 km).

 Tourist information—Lascaux-Dordogne Vallée Vézère: +33 (0)5 53 51 04 56 www.lascaux-dordogne.com www.saint-amand-de-coly.org Maison du Patrimoine (July and August): +33 (0)9 64 01 46 39

Ighlights

• Guided tour of the abbey-church (12th century): In July and August: +33 (0)9 64 01 46 39; off-season by appointment only: +33 (0)5 53 51 47 85.

- Maison du Patrimoine:
- +33 (0)9 64 01 46 39.

• La Ferme du Peuch: Walnut groves, harvesting, drying, and cracking of walnuts; tour of the oil press: +33 (0)5 53 51 27 87.

• Signposted walk: Historical trail and recreational nature trail.

Accommodation

Hôtel de l'Abbaye**: +33 (0)5 53 51 68 50. Guesthouses

M. and Mme Delbos: +33 (0)5 53 51 60 48 or +33 (0)6 84 57 11 08.

La Ferme du Peuch, rooms and evening meal: +33 (0)5 53 51 27 87.

M. Lajoinie: +33 (0)5 53 51 68 76. **Gîtes**

Further information: +33 (0)9 64 01 46 39 or +33 (0)5 53 51 47 85 www.lascaux-dordogne.com

Campsites

Lascaux Vacances**: +33 (0)5 53 50 81 57.

T Eating Out

Restaurant de l'Abbaye: +33 (0)5 53 51 68 50.

Local Specialties Food and Drink

Walnut, walnut oil, Périgord *choconoiseries* (chocolate-covered walnuts), walnut preserves.

Art and Crafts

Copperwork.

★ Events

July: "Saint-Amand Fait Son Intéressant," concerts and shows in the street (Tuesday, around the 14th).

July and August: Périgord Noir classical music festival (late July–early August); local farmers' market (Tuesday). August: Village festival (Saint-Hubert Mass, drawing competition) (15th). October: Marché aux Saveurs de l'Automne, fall produce market (last weekend).

All year round: Concerts, lectures.

W Outdoor Activities

Walking, horse-riding, and mountainbiking (70 marked trails): Périgord Noir mountain-biking center.

🕊 Further Afield

- Montignac (5 ½ miles/9 km).
- Prehistoric sites at Lascaux (7 ½ miles/
- 12 km) and Eyzies (19 miles/31 km).
- *Saint-Léon-sur-Vézère (12 miles/19 km), see p. 246.
- Sarlat (14 miles/23 km).
- Dordogne valley: *La Roque-Gageac (20 miles/32 km), see pp. 236–37; *Beynac-et-Cazenac (21 miles/34 km), see pp. 172–73; *Castelnaud-la-Chapelle (21 miles/34 km), see p. 184; *Domme (22 miles/35 km), see pp. 192–93; *Limeuil (29 miles/27 km), see pp. 210–11.

I Did you know?

Here's how people greet one another in Saint-Amand-de-Coly: "Adieu soit, brave monde (homme), si vous l'êtes, et à se revoir," or, in Occitan, "Adiussatz brave monde, si sou setz, e a nous tourna veire." ("Farewell good men/man, if such you be, and until we meet again.")

Saint-Cirq-Lapopie

Lot (46) • Population: 223 • Altitude: 722 ft. (220 m)

Perched on an escarpment whose ridge is silhouetted against a background of high cliffs, Saint-Cirq-Lapopie overlooks a bend in the Lot river.

Controlling the Lot valley, which for a long time saw a flourishing trade in the transportation of goods by barge, the site of Saint-Cirq has been occupied since Gallo-Roman times. In the Middle Ages it became a powerful fortified complex that included the castles of the four dynasties that shared power here (Cardaillac, Castelnau, Gourdon, and Lapopie). Owing to its coveted strategic position, Saint-Cirq was constantly besieged. Although Richard the Lionheart failed to capture the fortress in the 12th century, it passed alternately under English and French rule during the Hundred Years War. In the late 16th century, the Huguenots twice seized it, before Henri IV-following the example set by Louis XI and Charles VIII-totally demolished it. Its castles thus vanished, and of the ramparts only the Rocamadour Gate still stands, but Saint-Cirq remains a place of rare harmony between the village, its architecture, and its landscapes. Of the numerous artists and writers who succumbed to the magic of this place in the 19th century, it is probably André Breton who paid it its finest tribute. Discovering the village one evening in 1950, like "an impossible rose in the night," he made the old Auberge des Mariniers his summer residence and ceased "wishing to be elsewhere."

By road: Expressway A2o, exit 57 (from Paris) or 58 (from Toulouse)– Cahors Centre (19 miles/31 km). By train: Cahors station (16 miles/26 km). By air: Rodez-Marcillac airport (52 miles/ 84 km); Brive-Vallée de la Dordogne airport (62 miles/100 km); Toulouse-Blagnac airport (84 miles/135 km).

() Tourist information—Saint-Cirq-Lapopie/Pech Merle: +33 (0)5 65 31 31 31 www.saint-cirqlapopie.com

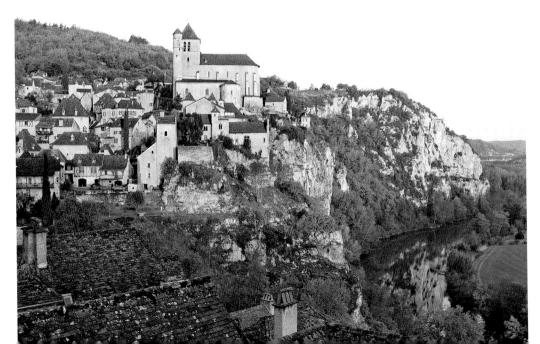

Highlights

• Musée Départemental Rignault: Permanent collections of furniture and works of art assembled by the collector Émile Joseph-Rignault; temporary exhibitions; gardens with an exceptional view of the Lot: +33 (0)5 65 31 23 22. • Village: Guided tours all year round: +33 (0)5 65 31 31 31; by appointment for groups: +33 (0)5 65 24 13 95.

Accommodation

Auberge du Sombral**: +33 (0)5 65 31 26 08. Hôtel du Causse: +33 (0)5 65 21 76 61. **Guesthouses** À la Source: +33 (0)5 65 23 56 98. M. Balmes, farmhouse guest rooms:

M. Bames, farmouse guest rooms. +33 (0)5 65 31 26 02. Chambres de Cantagrel: +33 (0)5 65 23 81 45. **Gîtes, vacation rentals, and** walkers' lodges Further information: +33 (0)5 65 31 31 31 www.saint-cirqlapopie.com **Campsites**

La Plage****: +33 (0)5 65 30 29 51. La Truffière***: +33 (0)5 65 30 20 22.

I Eating Out

Auberge du Sombral: +33 (0)5 65 31 26 08. Brasserie Lou Faouré: +33 (0)5 65 30 20 36. Le Cantou: +33 (0)5 65 35 59 03. Le Gourmet Quercynois: +33 (0)5 65 31 21 20. Hôtel du Causse: +33 (0)5 65 21 76 61. Le Lapopie: +33 (0)5 65 30 27 44. Lou Bolat: +33 (0)5 65 30 29 04. L'Oustal: +33 (0)5 65 31 20 17. La Plage, pizzeria: +33 (0)5 65 30 29 51. La Tonnelle, brasserie: +33 (0)5 65 31 21 20.

Local Specialties Food and Drink

Duck foie gras • Walnuts • Truffles • Saffron • Cahors wine.

Art and Crafts

Leather crafts • Jewelry • Hats • Ceramics • Gifts, tableware • Wooden toys • Paintings • Engraving • Sculpture • Wood turning • Clothing.

★ Events

Market: Farmers' market, Wednesdays 4–8 p.m., Place du Sombral (July and August). June-September: Cinema; dance; theater; concerts. July: Village festival (3rd weekend). All year round: Exhibitions, workshops, concerts, cultural events at the Maison de la Fourdonne, www.maisondelafourdonne.com.

W Outdoor Activities

Canoeing • Walking: Route GR 36 and 1 marked trail.

🕊 Further Afield

- Château de Cénevières (5 ½ miles/9 km).
- Célé valley: Cabrerets, Pech Merle caves,
- Marcilhac (6–16 miles/9.5–26 km). • Causse de Limogne, Villefranche-de-Rouergue (9 ½–24 miles/15.5–39 km).
- Cajarc; Figeac (12–28 miles/15.5–39 km).
- Cahors (16 miles/26 km).

Saint-Côme-d'Olt

A pilgrims' stopping place on the Lot river

Aveyron (12) • Population: 1,357 • Altitude: 1,234 ft. (376 m)

Located on the Saint James's Way in the fertile Lot valley, Saint-Côme-d'Olt is distinguished by its twisted spire and its delightful houses.

Bordered on the south side by the green hills that overlook the basaltic mass of Roquelaure, and to the north by terraces of old vineyards, the village has built up over time inside the circular ditches of the old medieval town, of which three fortified gates remain. The 16th-century church, whose twisted spire dominates the village, is of Flamboyant Gothic style. Its heavy carved-oak doors are reinforced with 365 wrought-iron nails. The 11th-century Chapelle des Pénitents, with its *ajouré* (pierced) bell tower, is topped with a hull roof. The Château des Sires de Calmont, built in the 12th century and rebuilt in the 15th, presents a Renaissance façade and has two 14th-century towers. The narrow streets retain old medieval shops and houses from the 10th and 16th centuries, such as the Consul of Rodelle's house, which has mullioned windows and is embellished with sculptures. The Ouradou, a building with an octagonal roof, was erected in memory of the victims of the 1586 plague.

Highlights

• Chapelle des Pénitents (11th century): Exhibition on Romanesque architecture and the Brotherhood of the White Penitents.

• Église Saint-Côme-et-Saint-Damien

(16th century): Twisted spire, 16th-century wooden Christ, 18th-century altarpiece. • Village: Guided tours all year round by arrangement; themed visits, discovery tour June-August: +33 (0)5 65 48 24 46 or +33 (0)5 65 44 10 63.

Accommodation Guesthouses

M. Burguière*: +33 (0)5 65 44 10 61. Les Jardins d'Éliane: +33 (0)5 65 48 28 06. Le Plateau: +33 (0)5 65 48 07 04.

Walkers' lodges

Gîte de Combes***: +33 (0)5 65 48 21 58. Espace Rencontre Angèle Mérici: +33 (0)5 65 51 03 20. Gîte Compagnon de Route: +33 (0)5 65 48 18 16. Gîte Del Roumiou: +33 (0)5 65 48 28 06. Gîte La Halte d'Olt: +33 (0)5 65 44 12 58. **Campsites** Camping Bellerive**: +33 (0)5 65 44 05 85.

T Eating Out

Brasserie du Théron: +33 (0)5 65 48 01 10. Le Passage: +33 (0)5 65 44 39 68.

*** Local Specialties** Art and Crafts

Woodcrafts • Jewelry • Potter.

★ Events

Market: Sunday mornings. May: "La Transhumance Aubrac," moving cattle to new pastures (Sunday nearest 25th). July: Evening market (14th). August: Local saint's day festivities (4th weekend); evening market (Wednesday nearest 15th).

W Outdoor Activities

Boules area • Bowling • Canoeing • Fishing • Walking: Route GR 65, Chemin de Compostelle (Saint James's Way) and 10 marked trails • Mountain-biking.

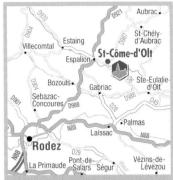

By road: Expressway A75, exit 28– Espalion (54 miles/87 km) or exit 42– Rodez (27 miles/43 km), N88 (12 miles/ 19 km). By train: Rodez station (21 miles/ 34 km). By air: Rodez-Marcillac airport (27 miles/43 km).

Tourist information—Espalion: +33 (0)5 65 44 10 63 0r +33 (0)5 65 48 24 46 www.tourisme-espalion.fr

🕊 Further Afield

• Flaujac, fortified hamlet (1 mile/1.5 km).

• Roquelaure: castle, lava flow (2–3 miles/3–5 km).

• Espalion: Musée du Scaphandre, Calmont d'Olt medieval castle, 11th-century Romanesque chapel of Perse and Pont-Vieux, Chapelle des Pénitents (2 ½ miles/4 km).

- Abbaye de Bonneval, Laguiole, and
- L'Aubrac (6–19 miles/9.5–31 km).
- *Estaing (8 miles/13 km), see pp. 194–95.
- Trou de Bozouls, horseshoe gorge (9 ½ miles/15.5 km).

• *Sainte-Eulalie-d'Olt (12 miles/19 km), see p. 243.

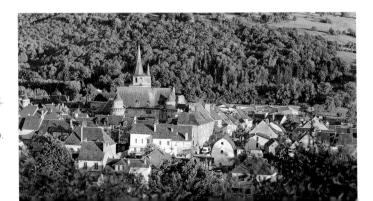

Sainte-Eulalie-d'Olt Creativity and artistry in the Lot valley

Aveyron (12) • Population: 377 • Altitude: 1,345 ft. (410 m)

Deep in the Lot valley, numerous artists and craftspeople are breathing life into the old stones of Sainte-Eulalie-d'Olt.

This typically medieval village is laid out in a series of alleyways and small squares around the Place de l'Église. Wealthy residences from the 15th and 16th centuries are reminders of the village's prosperous past, and houses built in Lot shingle up to the 18th century are architectural jewels. The large wheel of the restored flour mill rumbles away once again. The church, cited in records in 909, has a Romanesque choir surrounded by impressive cylindrical columns, while the nave and the chapel are Gothic in style. Three apsidal chapels open off the ambulatory, and a reliquary chest contains two thorns supposedly from Christ's crown. Also worth seeing in the village are the Château des Curières de Castelnau, dating from the 15th century, and a corbeled Renaissance residence, whose facade is punctuated with 14 windows. This rich heritage, and the views that Sainte-Eulalie-d'Olt commands over the Lot valley, have encouraged numerous artists to make this village their home and inspiration.

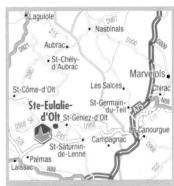

By road: Expressway A75, exit 41– Campagnac (16 miles/26 km). **By train:** Campagnac-Saint-Geniez station (12 miles/ 19 km). **By air:** Rodez-Marcillac airport (33 miles/53 km).

() Tourist information: +33 (0)5 65 47 82 68 www.sainteeulaliedolt.fr

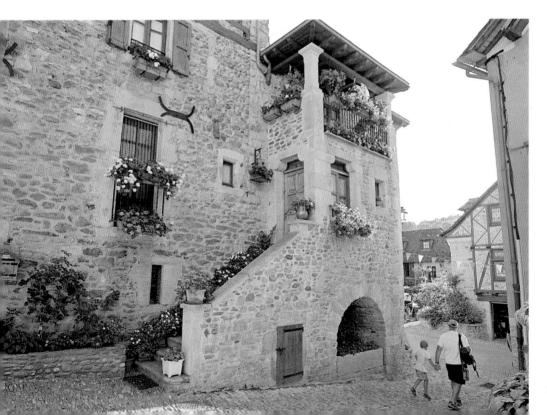

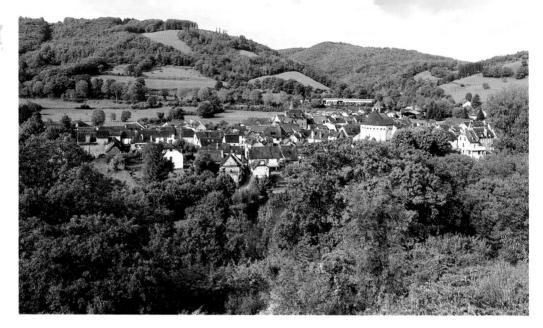

Highlights

• Romanesque and Gothic church (11th, 12th, and 16th centuries): Relics.

- "Eulalie d'Art" and various artists' studios: Art and craft studios, demonstrations, exhibitions, workshops: +33 (0)5 65 47 82 68.
- Musée-Galerie Marcel Boudou: Temporary exhibitions, July-August:

+33 (0)5 65 47 82 68. • Village: Self-guided visit (information boards and map available at tourist information center); guided tour for individuals, Mondays and Fridays 5 p.m., July-August; for groups by appointment all year round, except January 1 and May 1: +33 (0)5 65 47 82 68.

✓ Accommodation Hotels

Au Moulin d'Alexandre**: A13 (0)5 65 47 45 85. Gîtes and vacation rentals Further information: +33 (0)5 65 47 82 68. Aparthotels

La Cascade***: +33 (0)6 88 84 52 65.

Campsites and RV parks La Grave**, municipal campsite, May 15– September 15: +33 (0)5 65 47 44 59. Brise du Lac, rural campsite: +33 (0)5 65 47 55 55. RV park (open all year): +33 (0)5 65 47 44 59.

T Eating Out

Au Moulin d'Alexandre: +33 (0)5 65 47 45 85. Café de la Place, brasserie and ice-cream parlor: +33 (0)5 65 70 45 60. Caravan Kitchen, light meals using local ingredients (in summer): +33 (0)6 78 74 12 89.

Local Specialties Food and Drink

Traveling home distiller (November 1–end April) • Wood-baked *pain au levain* bread • Organic chicken • Fruit farm.

Art and Crafts

Painter and strip-cartoon illustrator • Potter • Enamel engraver • Glassblower • Wood turner • Wooden caravan builder • Jewelry designer • Artists.

★ Events

Market: Monday mornings, Place de l'Église (July–August).

May: "Marché des Senteurs et Saveurs," local produce market (1st Sunday); fishing competition (Thursday of Ascension). June: "Feu de la Saint-Jean," Saint John's (Midsummer's) Eve bonfire with fireworks. July: Historic procession of the Holy Thorn (2nd Sunday) and local saint's day; Vallée d'Olt classical music festival; Festival International Choral en Aveyron, choral concerts.

August: Fishing competition; writers' events; concerts.

September: "Trophée Cabanac," European carp fishing competition (end of September).

November 1: "Poule Un," charity auction to redeem souls in Purgatory.

🕷 Outdoor Activities

Canoeing • Stand-up paddle-boarding • Motorboats • Fishing • Walking and mountain-biking • Electric bikes.

🕊 Further Afield

• Hamlets of Cabanac, Lous, Malescombes (2–4 ½ miles/3–7 km).

- Saint-Geniez-d'Olt (2 miles/3 km).
- Parc Naturel Régional des Grands Causses, nature park (3 ½ miles/5.5 km).
- Pierrefiche; Galinières: keep (3 ½–6 miles/ 5.5–9.5 km).
- L'Aubrac (6 miles/9.5 km).
- *Saint-Côme-d'Olt (12 miles/19 km), see p. 242.
- *Estaing (19 miles/31 km), see pp. 194–95.
- Gorges of the Tarn (25 miles/40 km).

Did you know?

Legend has it that the nickname "Encaulats"—cabbage eaters—was given in jest to the local inhabitants because cabbages grew in every garden. In times of famine, however, everybody was glad to have cabbages to eat. Since then, the name "Encaulat" has been borne with pride. Almost every year since 2000, the inhabitants of Sainte-Eulalie have gathered together for a huge annual cabbage dinner.

Saint-Jean-de-Côle Architectural symphony in Périgord Vert

Dordogne (24) • Population: 359 • Altitude: 489 ft. (149 m)

Nestling in the hills, Saint-Jean-de-Côle is an inviting place to dream and meditate in an exceptional architectural setting. Overlooking the village square, the Château de la Marthonie has replaced the original fortress that was built here in the 11th century to defend the Périgord and Limousin borders. Burned during the Hundred Years War, the latter made way for a 15th- and 16th-century building that combines Renaissance elegance and classical precision in its two wings, which share a magnificent straight-flight staircase. Adjoining a priory with cloisters and ambulatory, the Romanesque-Byzantine-style church was built in the 12th century. It contains some beautiful paintings and a polychrome stone Madonna from the 17th century. At the edge of the village, near the old mill, a medieval bridge with cutwaters spans the Côle river. This prestigious architectural ensemble is completed by the village's unusual little streets and old houses, some of which are half-timbered.

Highlights

• Château de la Marthonie (12th, 15th, 16th, and 17th centuries): Castle exterior only.

• Église Saint-Jean-Baptiste (11th and 12th centuries): Wood paneling, paintings; interior sound and light show.

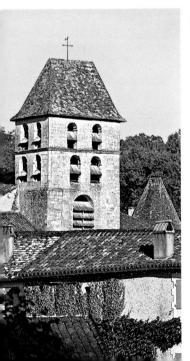

• Priory (12th century): Tour of the exterior for groups only; Braille guide available from tourist information center.

• Village: Guided tour; treasure hunt for children. Further information: +33 (0)5 53 62 14 15.

Accommodation Guesthouses

La Bouchonnerie: +33 (0)5 53 52 34 11 or +33 (0)6 23 29 38 05. Le Moulin du Pirrou: +33 (0)5 53 52 35 38. Le Relais de Montgeoffroy: +33 (0)6 37 20 85 81 or +33 (0)6 13 46 29 29. M. Wolff: +33 (0)5 53 52 53 09. **Gites and vacation rentals** Further information: +33 (0)5 53 62 14 15 www.perigordgourmand.com

T Eating Out

À Table: +33 (0)5 53 62 18 90. Chez Robert: +33 (0)5 53 52 53 09. Le Moulin du Pirrou: +33 (0)5 53 52 35 38. La Perla Café, in summer: +33 (0)5 53 52 38 11. Le Saint-Jean: +33 (0)5 53 52 23 20.

Local Specialties Art and Crafts Ceramicist • Art gallery.

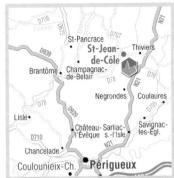

By road: Expressway A89, exit 15–Agen (31 miles/50 km); N21 (5 miles/8 km). By train: Thiviers station (5 miles/8 km). By air: Périgueux-Bassillac airport (24 miles/ 39 km); Limoges-Bellegarde airport (42 miles/68 km).

Tourist information—Périgord Gourmand: +33 (0)5 53 62 14 15 www.perigordgourmand.com www.saintieandecole.fr

★ Events

May: Flower show (weekend nearest May 8). June: "Musicôle," combining the "Fête de la Musique" music festival and the bonfires of Saint John.

July and August: Classical music concerts; street theater (Énigme du Peiregord). June-mid-September: Art and crafts exhibitions at tourist information center.

W Outdoor Activities

Fishing • Voie Verte (11 miles/18 km): greenway for walkers, riders, and mountainbikers; marked trails and railway-themed signposted walk.

🕊 Further Afield

- Thiviers: Maison du Foie Gras (4 ½ miles/7 km).
- Villars: Château de Puyguilhem; caves; Abbaye de Boschaud ruins (5–7 miles/ 8–11.5 km).
- Limousin-Périgord regional nature park (6 miles/9.5 km).
- Corgnac-sur-l'Isle: Château de Laxion (8 ½ miles/13.5 km).
- Sorges: Écomusée de la Truffe, truffle trail (9 ½ miles/15.5 km).
- Brantôme (12 miles/19 km).
- Périgueux (22 miles/35 km).
- *Ségur-le-Château (28 miles/45 km), see p. 256.

Saint-Léonsur-Vézère Treasure of the Vézère valley

Dordogne (24) • Population: 429 • Altitude: 230 ft. (70 m)

Tucked away in a bend in the Vézère river, halfway between Lascaux and Les Eyzies, Saint-Léon is at the heart of this cradle of civilization. Occupied since prehistoric times, as evidenced in the remains of dwellings at Conquil, Saint-Léon is named after one of the first bishops of Périgueux. Located near a Roman road, the village was, until the arrival of the railway, a thriving port on the Vézère river, earning itself the name Port-Léon during the French Revolution. From the cemetery's explatory chapel at the entrance to the village, the road leads past the Château de Clérans and the Manoir de La Salle, to a 12th-century Romanesque church with a *lauze* (schist-tiled) roof, which is one of the venues for the popular Périgord Noir music festival. Its plan resembles that of Byzantine churches. Near the Côte de Jor, the Château de Chabans dates from the Middle Ages to the 17th century.

Highlights

• Buddhist study and meditation center: The main European center for the preservation of the Kagyupa Buddhist tradition; meditation, Buddhist philosophy courses: +33 (0)5 53 50 70 75.

• Romanesque church (12th century): Frescoes.

• Le Conquil prehistoric theme park: Cave site, dinosaur park.

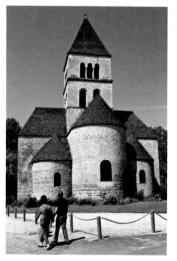

Accommodation

Le Relais de la Côte de]or**: +33 (0)5 53 50 74 47. Guesthouses Esprit Nature: +33 (0)5 53 51 35 71. Gîtes and vacation rentals Argiler: +33 (0)7 85 53 79 98. La Chênaie du Roc, eco-gîte: +33 (0)6 79 60 31 77. La Fouillousse: +33 (0)5 53 50 70 64. Les Landes-La Bugadie: +33 (0)5 53 50 70 64. Maison Rouge: +33 (0)5 53 50 70 64. Le Pigeonnier: +33 (0)5 53 50 70 64. Villa Butzelaar: +33 (0)7 85 53 79 98. Campsites and RV parks Le Paradis****: +33 (0)5 53 50 72 64.

Municipal campsite: +33 (0)5 53 51 08 42. RV park: +33 (0)5 53 51 08 42.

T Eating Out

L'Auberge du Pont: +33 (0)5 53 50 73 07. Le Déjeuner sur l'Herbe, local light meals: +33 (0)5 53 50 69 17. Le Petit Léon, July and August: +33 (0)5 53 51 18 04. Le Restaurant de la Poste: +33 (0)5 53 50 73 08.

Local Specialties Art and Crafts

Artists • Jewelry designer • Wood-carver.

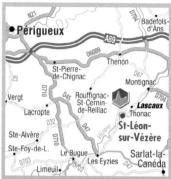

By road: Expressway A89, exit 17 (14 miles/ 23 km). By train: Condat-le-Lardin station (12 miles/39 km); Sarlat-la-Canéda station (23 miles/37 km). By air: Brive-Vallée de la Dordogne airport (40 miles/64 km); Périgueux-Bassillac airport (43 miles/69 km).

() Tourist information: +33 (0)5 53 51 08 42 www.lascaux-dordogne.com www.saint-leon-sur-vezere.fr

🖈 Events

Market: Gourmet and crafts market, Thursdays in July and August from 6 p.m. July: Flea market (1st Sunday). August: Périgord Noir music festival: concerts in the Romanesque church (mid-August); village festival (2nd weekend).

W Outdoor Activities

Canoeing • Fishing • Forest adventure park • Horse-riding • Walking: Route GR 36 (3 marked trails): Plan Départemental des Itinéraires de Promenade et de Randonnée: official map of walking and hiking routes in the Dordogne • Hang gliding • Mountain-biking • *Boules*.

🕊 Further Afield

- Côte de Jor: viewpoint (2 miles/3 km).
- Vallée de l'Homme, prehistoric sites:
- Lascaux, Les Eyzies (2-9 ½ miles/3-15.5 km).
- Montignac-sur-Vézère (6 miles/9.5 km).
- Grotte de Rouffignac, cave (11 miles/18 km).
- *Saint-Amand-de-Coly (11 miles/18 km), see pp. 238–39.

Dordogne valley: *Limeuil (19 miles/31 km), see pp. 210–11; *Beynac-et-Cazenac (21 miles/34 km), see pp. 172–73; *La Roque-Gageac (22 miles/35 km), see pp. 236–37; *Castelnaud-la-Chapelle (23 miles/37 km), see p. 184; * Belvě (24 miles/39 km), see pp. 170–71; *Domme (24 miles/39 km), see pp. 192–93.
Sarlat (22 miles/35 km).

Saint-Robert

Corrèze (19) • Population: 350 • Altitude: 1,148 ft. (350 m)

Built around a monastery founded by Saint Robert's disciples, the village was named after the founder of La Chaise-Dieu Benedictine abbev in the Auvergne.

The village stands on a hill. in landscape typical of Corrèze. on the site of an old Merovingian city. On the Saint-Robert plateau, the ruins of a curtain wall encircle the Benedictine monastery and its Romanesque abbey church. The prosperous-looking cut-stone buildings, small castles, and houses with towers were, in their time, home to noblemen. The fortified church has preserved its 12thcentury structure almost intact. The ambulatory once displayed saints' relics to pilgrims on their way to Santiago; scenes charged with biblical symbolism are engraved on the capitals, and a 13thcentury, life-size Christ, carved in wood, testifies to the religious intensity of the Middle Ages. Saint-Robert, a city-state on the borders of Périgord, was itself the scene of violent religious clashes.

Highlights

• Église Notre-Dame (12th century). • Village: Guided tour on Tuesdays at 11 a.m. and Thursdays at 4.30 p.m. in July and August; by appointment only the rest of the year: +33 (0)5 55 25 21 01.

Accommodation

Le Saint-Robert: +33 (0)5 55 25 58 09, April–October.

Guesthouses La Table d'Aline: +33 (0)5 55 84 11 07. Further information: +33 (0)5 55 24 08 80 www.brive-tourisme.com

T Eating Out

Le Saint-Robert: +33 (0)5 55 25 58 09. La Table d'Aline: +33 (0)5 55 84 11 07.

Local Specialties

Gîtes and vacation rentals

Food and Drink Foie gras and confit • Bread baked in a wood-fired oven. Art and Crafts Local crafts.

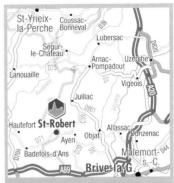

By road: Expressway A2o, exit 50– Objat (14 miles/23 km); expressway A89, exit 17–Thenon (16 miles/26 km). By train: Objat station (8 miles/13 km); Brive-la-Gaillarde station (17 miles/27 km). By air: Brive-Vallée de la Dordogne airport (24 miles/39 km).

(i) Tourist information—Brive et Son Pays: +33 (0)5 55 24 08 80 www.brive-tourisme.com

★ Events

Spring: Milk-fed veal prize-giving fair. July and August: Festive markets, classical music festival. August: Local saint's day (15th). October: Fête du Vin Nouveau, wine festival (2nd Sunday). November: Milk-fed veal prize-giving fair (2nd Monday).

W Outdoor Activities

Walking: 2 marked trails.

🕊 Further Afield

• Église de Saint-Bonnet-la-Rivière and

- Yssandon site (7 ½ miles/12 km).
- Château de Hautefort (10 miles/16 km).
- Pompadour (14 miles/23 km).
- Vézère valley; Terrasson (14 miles/23 km).
- Brive (16 miles/26 km).

• *Ségur-le-Château (17 miles/27 km), see p. 256.

I Did you know?

Filming of the French TV mini-series adapted from the novel *Firelight and Woodsmoke* by local author Claude Michelet remains etched on the memory of villagers. The story reflected the history of their village in its depiction of the Vialhe family living through the momentous changes of the 2oth century.

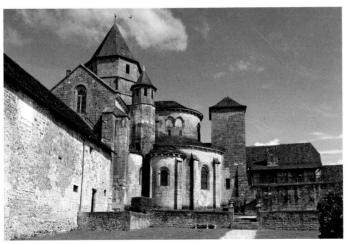

Salers Volcanic majesty and gastronomic delights

Cantal (15) • Population: 368 • Altitude: 3,117 ft. (950 m)

In the majestic scenery of the Monts du Cantal, Salers prides itself on its geological beauty and its unique regional taste sensations.

Salers stands right at the edge of an ancient lava flow, surveying the Maronne valley from a height of 3.117 ft. (950 m). The village was the seat of a baronetcy whose lords distinguished themselves in the First Crusade, and in 1428 it was granted a license by Charles VII to build ramparts, from which the Beffroi and La Martille gates survive. Here, in 1550, Henri II established the royal bailiwick of the Hautes-Montagnes d'Auvergne. On Place Tyssandier-d'Escous. the former bailiwick is surrounded by magistrates' residences, including Hôtel de Ronade, Maison de Flogeac, and Maison de Bargues. The house of commander de Mossier, Knight of Malta, has been turned into a museum celebrating the history and folklore of Salers. The Église de Saint-Mathieu boasts a Romanesque portal, five 17th-century Aubusson tapestries, and a 15th-century Entombment sculpture. At the village's eastern end, the Barrouze Esplanade overlooks the Puy Violent peak and the Monts du Cantal. Acclaimed equally for meat and cheese, from Salers's own breed of cows, the village represents the high point of gastronomy in the Auvergne.

Mauriac Chevlade _ Ally alers St-Cernin Tournemire Thiézac St-Cirgues-Jussan Polminhac Vic-s.-Cère 0120 Aurillac Ytrac . Arpajon-s.-Cère N122 ·Sansac-de-M Raulhac

By road: Expressway A75, exit 23–Massiac (50 miles/80 km), N122 (27 miles/43 km). By train: Mauriac station (12 miles/19 km); Aurillac station (26 miles/42 km). By air: Aurillac-Tronquières airport (27 miles/43 km); Brive-Vallée de la Dordogne airport (81 miles/130 km).

(i) Tourist information—Pays de Salers: +33 (0)4 71 40 70 68 www.salers-tourisme.fr / www.salers.fr

Highlights

 Le Bailliage: Renaissance residence; period furniture, tapestries, 17th-century paintings, sculptures: +33 (0/4 71 40 58 08.
 Maison de la Ronade (14th century): "Caféphilo," food and philosophy, art gallery: +33 (0/4 71 40 72 91. • Musée du Commandeur: Known as the Templars' house. Renaissance residence; historic pharmacy, novelty café/bistro. • Village: Guided tour by tourist information center, June–September; by appointment only the rest of the year: +33 (0)4 71 40 58 08.

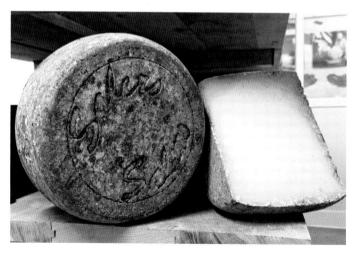

Accommodation

Le Bailliage***: +33: (0)4 71 40 71 95. Le Gerfaut***: +33 (0)4 71 40 75 75. Les Remparts**: +33 (0)4 71 40 70 33. Le Beffroi: +33 (0)4 71 40 70 11. Saluces: +33 (0)4 71 40 70 82. **Guesthouses**

Le Jardin du Haut Mouriol***: +33 (0)4 71 40 74 02. La Maison de Barrouze***: +33 (0)4 71 40 78 08. L'Asphodele: +33 (0)4 71 40 70 82. Chez Prudent: +33 (0)4 71 40 70 80. La Jourdanie: +33 (0)4 71 40 29 80. Les Sagranières: +33 (0)4 71 40 70 50. **Gîtes and vacation rentals** Further information:

+33 (0)4 71 40 58 08 www.salers-tourisme.fr

Campsites

Fruquière, farm campsite: +33 (0)4 70 40 72 26. Le Mouriol, municipal campsite: +33 (0)4 71 40 73 09. Chalets

Chalets Découverte: +33 (0)4 73 19 11 11.

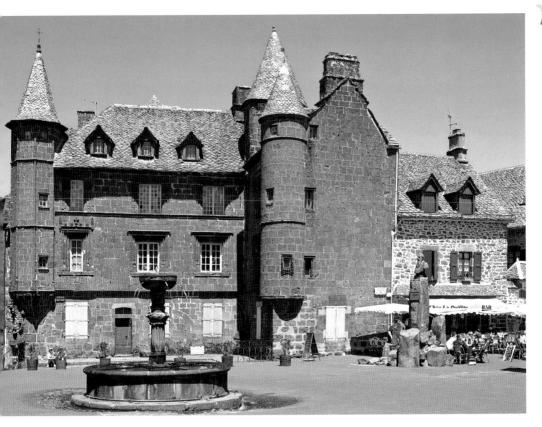

T Eating Out

Le Bailliage: +33 (0)4 71 40 71 95. Le Beffroi: +33 (0)4 71 40 70 11. La Diligence: +33 (0)4 71 40 75 39. Le Drac, crêperie: +33 (0)4 71 40 72 12. L'Evasion: +33 (0)4 71 40 74 56. La Martille: +33 (0)4 71 40 77 5. La Poterne: +33 (0)4 71 40 75 11. La Préfète, brasserie: +33 (0)4 74 40 70 55. Les Remparts: +33 (0)4 71 40 70 33. Le Rétro, crêperie: +33 (0)4 71 40 72 00. Les Templiers: +33 (0)4 74 40 71 35.

Local Specialties Food and Drink

Carré de Salers (cookie) • Salers gentian aperitif.

Art and Crafts

Jewelry • Wooden toys and furniture • Lithographs and watercolors • Mosaics • Pottery • Wood carvings • Glassworking.

🖈 Events

Market: Wednesday mornings. May: "Marché des Sites du Goût," food fair (1st); "La Pastourelle," walking and mountain-biking races (end of the month).

July: Fête Chasse et Nature, hunting and nature festival.

July-August: Concerts.

August: Folklore gala (15th); Journée de la Vache et du Fromage, cow and cheese festival; pottery market; book fair.

W Outdoor Activities

Climbing wall • Walking • Mountain-biking.

🕊 Further Afield

• Saint-Paul-de-Salers (Les Burons de Salers); Fontanges; Anglards-de-Salers; Château de La Trémolière (2–5 ½ miles/ 3–9 km).

- Maronne valley (2 ½–9 ½ miles/
- 4–15.5 km).

- Château de Saint-Chamant (9 ½ miles/ 15.5 km).
- Cirque du Falgoux; Puy Mary, volcano (12 miles/19 km).
- *Tournemire; Château d'Anjony
- (17 miles/27 km), see p. 259.

• Route des Crêtes, scenic drive; Aurillac (28 miles/45 km).

I Did you know?

Developed in the 19th century by Ernest Tyssandier d'Escous, Salers cattle rule the Auvergne pasturelands with their lyreshaped horns and mahogany coat. The breed produces a "Red Label" marbled meat, and milk that is used to make AOP Salers and Cantal cheeses. Other village specialties include an aperitif made from gentian roots, and the *carré de Salers* a thin and crispy shortbread cookie.

Sare Frontier traditions

Pyrénées-Atlantiques (64) • Population: 2,411 • Altitude: 230 ft. (70 m)

The Rhune and the Axuria, legendary mountains of the Basque Country, tower over this village, famous for both its tradition of hospitality and its festivals.

Ringed by mountains separating it from the Bay of Biscay and from Spanish Navarra, Sare honors vibrant Basque Country traditions. In particular, the tradition of the "Etxe," the Basque house, finds full expression here. Among the eleven scattered parts of this former shepherds' village, the Ihalar neighborhood is one of the oldest, and here houses date from the 16th and 17th centuries. Ortillopitz is an authentic residence from 1660, restored by a local family keen to keep their history and the significance of the Basque home alive for future generations: the house allows visitors to experience "L'Etxe où bat le cœur des hommes" ("The house where human hearts beat"). Numerous chapels and shrines contain votive offerings of thanks for survival in storms at sea—reminders that Sare inhabitants were also seafarers. A tradition of smuggling, made famous by Pierre Loti's classic novel *Ramuntcho* (1897), is also revisited each summer in a walking trail.

Highlights

• Grottes de Sare, prehistoric caves: New multimedia show tour about the geology of the site, and the origins and mythology of the Basque people: +33 (0)5 59 54 21 88. • La Maison Basque du Sare, Ortillopitz, traditional Basque house (1660): Explore the Labourd architecture of the "Etxe," its authentic furniture, and Basque family life, on a substantial estate: +33 (0)5 59 85 91 92.

• Musée du Gâteau Basque (Maison Haranea): Explore the history, flavor, and appeal of the *gâteau basque* (filled cake), and learn how it was traditionally made: +33 (0)5 59 54 22 09.

• Etxola animal park: Many different types of domestic animal from France and abroad: +33 (o)6 15 06 89 51.

• Village: Church, Basque pelota court, medieval way, oratoires, evocation of Basque traditions and customs. Guided tours June–September; all year for groups by appointment: +33 (0)5 59 54 20 14.

• Bell tower: Guided tours of the bell tower and the most ornate bell in France; tower with oak floor and beams. Guided tours June–September for individuals; all year for groups by appointment: +33 (0)5 59 54 20 14.

• La Rhune tourist train (alt. 2,969 ft./ 905 m): 35-minute climb to the top of La Rhune: +33 (0) 59 54 20 26.

Accommodation

Arraya***: +33 (0)5 59 54 20 46. Lastiry***: +33 (0)5 59 54 20 07. Baratxartea**: +33 (0)5 59 54 20 48. Pikassaria**: +33 (0)5 59 54 21 51.

Guesthouses

Further information: Gîtes de France: +33 (0)5 59 46 37 00.

Locals' guest rooms, gîtes, walkers' lodges, and vacation rentals

Further information: +33 (0)5 59 54 20 14 www.sare.fr

Vacation villages

VVF Villages Ormodia: +33 (0)5 59 54 20 95. Campsites

La Petite Rhune***, chalets for rent: +33 (0)5 59 54 23 97. Tellechea*: +33 (0)5 59 54 26 01. Goyenetche (including rural campsite): +33 (0)5 59 54 28 34.

By road: Expressway A63, exit 5– Saint-Jean-de-Luz (10 miles/16 km); expressway A64, exit 5–Bayonne-Sud (15 miles/24 km). By train: Saint-Jeande-Luz station (8 ½ miles/13.5 km). By air: Biarritz-Bayonne-Anglet station (18 miles/29 km).

() Tourist information: +33 (0)5 59 54 20 14 www.sare.fr

T Eating Out

Arraya: +33 (0)5 59 54 20 46. Baketu: +33 (0)6 37 38 01 22. Baratxartea: +33 (0)5 59 54 20 48. Berrouet: +33 (0)5 59 54 21 96. Halty: +33 (0)5 59 54 24 84. Lastiry: +33 (0)5 59 54 20 7. Olhabidea: +33 (0)5 59 54 21 51. Pikassaria: +33 (0)5 59 54 21 51. Pleka: +33 (0)5 59 54 20 11. Les Trois Fontaines: +33 (0)5 59 54 20 13.

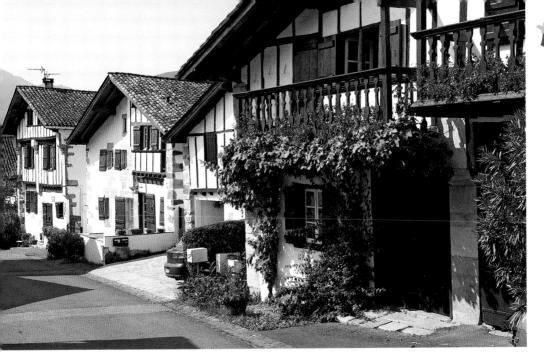

Local Specialties

Food and Drink

Gâteau basque • Farm produce • Cheese • Honey • Cider.

Art and Crafts

Bentas (border shops) • Fabric and Basque designs.

★ Events

Markets: Farmers' market and craft market, Fridays 4.30 p.m.–8 p.m. (April–October). Farmers' market, Saturdays 9 a.m.–1 p.m. (November–March).

Summer fair (craft market), Mondays 9 a.m.–1 p.m. (July–September).

February or March: Carnival.

Easter Monday: "Biltzar," Basque Country writers' fair.

June: Sare mountain-biking excursion (last Sunday).

July-August: Basque singing and dancing, trials of strength, *boules* games.

July: National Pottok horse competition (3rd Saturday).

August: "Cross des Contrebandiers," cross-country race (Sunday after 18th). September: Sare festival (2nd week, Saturday–Wednesday).

October: "Les Charbonnières," traditional charcoal fires (demonstrations, work shops, etc.); "La Palombe," wood pigeon hunt. November: Santa Katalina's day (3rd Sunday). December: La Rhune, ascent by train, descent on foot (1st Saturday).

W Outdoor Activities

Hunting wood pigeons (October– November) • Wild-salmon river fishing (tuition and guide) • Horse-riding • Basque pelota • Walking: Routes GR 8 and GR 10, and 8 marked trails; hiking across the Spanish border • Mountain-biking: 3 trails.

W Further Afield

• Old farms in Ihalar, Istilart, Lehenbiskaï, and Xarbo Erreka (1 mile/1.5 km).

• Église Saint-Martin (17th century) (1 mile/ 1.5 km).

• Xareta: *Ainhoa, see p. 158; Urdax; Zugarramurdi (5–6 miles/8–9.5 km).

• "Basque Land and Coast" tour: Ascain, Ahetze, Arbonne, Biriatou, Ciboure, Guéthary, Hendaye, Saint-Jean-de-Luz, Saint-Pée-sur-Nivelle, Urrugne (8 ½– 10 miles/13,5–16 km).

• Espelette (9 ½ miles/15.5 km).

• Cambo-les-Bains: poet and dramatist Edmond Rostand's house (12 miles/19 km).

• Biarritz, Bayonne (12–15 miles/19–24 km).

- Bidassoa valley (14–28 miles/23–45 km).
- •*La Bastide-Clairence (24 miles/39 km), see pp. 166–67.

Did you know?

Sare has a frontier 18 miles (29 km) long, which gives it the longest shared boundary with Spanish Navarra in the whole province. Smuggling began as an act of solidarity, as a means of providing basic essentials, but was equally an expression of the common values and identity the Basques shared. Among the many stories linked to this tradition, a popular one tells of a movie filmed at Sare in 1937, based on Pierre Loti's novel Ramuntcho, about a Basque smuggler. The orchestra of 120 singers and musicians was a little unusual as it included a number of smugglersas well as the popular Basque singer Luis Mariano, who was making his debut.

Sarrant A circular stronghold

Gers (32) • Population: 337 • Altitude: 410 ft. (125 m)

Sitting on the ancient Roman road between Toulouse and Lectoure, at the edges of the Lomagne, Sarrant wraps itself around the church of Saint-Vincent.

Sarrant's ancient origins are known because Roman maps include "Sarrali" along one of the five main routes out of Toulouse. The village started to expand in 1307, thanks to the "charter of customs" and the privileges it was accorded by Philippe Le Bel. Sarrant is separated from the simple chapel of Notre-Dame-de-la-Pitié and its cemetery by a wide boulevard shaded by plane trees, and its main entrance is a 14th-century vaulted gate cut into a massive square tower, a vestige of Sarrant's protective walls. While the ramparts, blocked off by the houses embedded in them, have in part disappeared, and the ditches been filled in, the village itself has kept its circular street plan. Inside the historic center, the main street is lined with tall, stone houses whose upper stories are frequently corbeled and are made from cob and half-timbering. The parish church stands in the middle of the circle; it was rebuilt and enlarged after the Wars of Religion, before being topped in the 19th century by a fine octagonal flèche that soars above the beautiful rooftops of Sarrant.

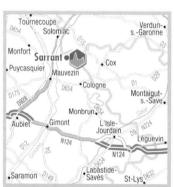

By road: Expressway A2o, exit 65–Agen (31 miles/50 km); expressway A624–N124, exit L'Isle-Jourdain (15 miles/24 km). By train: L'Isle-Jourdain station (14 miles/ 23 km); Auch station (24 miles/39 km). By air: Toulouse-Blagnac airport (35 miles/56 km).

Tourist information: +33 (0)5 62 65 00 32 / www.sarrant.com

Highlights

• Église Saint-Vincent and medieval village: Guided tours by appointment: +33 (0)5 62 06 79 70; program of children's activities exploring the Middle Ages, www.quenouille-tambourin.com.

• Tour of the town gate: Free entry July– August, Wednesday–Sunday, 3 p.m.–7 p.m.

Medieval garden: Free entry.
 Jardin des Sources: Learn about

herbs, medicinal plants, and plants used in dyeing: +33 (0)5 62 59 39 83. • Roman fountain.

Accommodation Guesthouses

Domaine Mahourat****: +33 (0)6 70 28 26 43. En Louison: +33 (0)7 85 10 34 56. **Gîtes**

Au Terrascle***: +33 (0)5 62 65 00 33. Les Clarettes***: +33 (0)5 62 65 02 89. En Gardian***: +33 (0)5 62 61 79 00. Les Gruets**: +33 (0)5 62 07 49 32. Lefèvre**: +33 (0)5 62 65 19 40. Lo Riberot**: +33 (0)6 61 21 49 04. La Clé des Champs, gypsy caravan: +33 (0)5 62 65 01 40.

RV parks

Route de Solomiac: +33 (0)5 62 65 00 34.

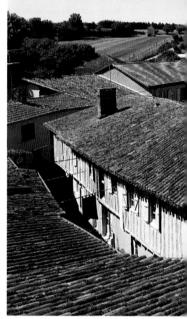

I Eating Out

Des Livres et Vous, bookshop and restaurant; 11 a.m.–6 p.m.; evening booking recommended: +33 (0)5 62 65 09 51.

Local Specialties

Food and Drink Aperitifs and homemade jams • Foie gras. Art and Crafts Pearl iewelry designer • Wood turner

and -carver.

\star Events

May: "Tatoulu," young people's literature prize: +33 (0)5 62 65 09 51. July: "Les Estivales de l'Illustration," art and illustration festival (Thursday–Sunday, after 14th).

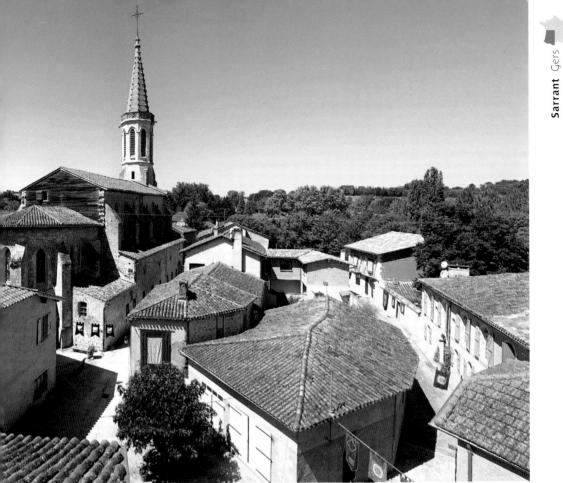

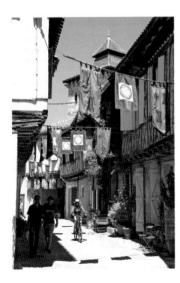

July-August: Exhibitions at the chapel. August: Local festival (last weekend). December: Christmas market (1st weekend).

W Outdoor Activities

Donkey rides and carriage rides • Walking and mountain-biking: 3 marked trails.

🕊 Further Afield

- Brignemont: mill (3 miles/5 km).
- Cologne, fortified village (4 ½ miles/7 km).
- Mauvezin, fortified village (5 miles/8 km).
- Château de Laréole (7 miles/11.5 km).
- Beaumont-de-Lomagne, fortified village (9 ½ miles/15.5 km).
- L'Isle-Jourdain (14 miles/23 km).
- Fleurance (17 miles/27 km).
- Auch: cathedral (25 miles/40 km).
- *Lavardens (27 miles/43 km), see pp. 208–9.

I Did you know?

During the French Revolution, Sarrant became an enclave of such fierce resistance to Republican abuses of power that it was dubbed "New Vendée," after the Vendée area of France that rebelled violently against the French Republic. On Palm Sunday 1793, young revolutionaries capitalized on a rainy night to cut down the tree of liberty, a symbol of the Republic, which had been planted the previous year in front of the town gate. Such a crime could only bring trouble on those who committed it: they were imprisoned at Auch, in Armagnac Tower, from whence none of them came out alive.

Sauveterrede-Rouergue Fortified village rich in arts and crafts

Aveyron (12) • Population: 803 • Altitude: 1,575 ft. (480 m)

The royal *bastide* of Sauveterre-de-Rouergue is brought alive by the passion and expertise of its craftspeople.

From its medieval past the village has kept its original 1281 street plan, the Saint-Christophe and Saint-Vital fortified gates, the rectilinear streets, and the central square complete with fortyseven arcades. The history of this centuries-old, lively site is told through its superbly corbeled stone and half-timbered houses, its 14th-century collegiate church of Saint-Christophe and its contents, and its coats of arms and stone carvings sprinkled across the façades. Proud of its illustrious past as an important center for craftsmanship, the village had new life breathed into it a few decades ago by pioneering modern artists. Now, Sauveterre calls itself the "fortified village for the arts" and showcases its cultural heritage, passion for beauty, and commitment to excellence.

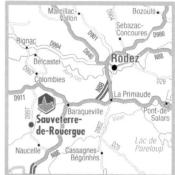

By road: Expressway A75, exit 42–Rodez (55 miles/89 km), N88 (5 ½ miles/9 km); expressway A68, then N88, exit Naucelle (5 ½ miles/9 km). By train: Naucelle station (5 ½ miles/9 km). By air: Rodez-Marcillac airport (31 miles/50 km); Toulouse-Blagnac airport (86 miles/138 km).

() Tourist information: +33 (0)5 65 72 02 52 www.sauveterre-de-rouergue.fr

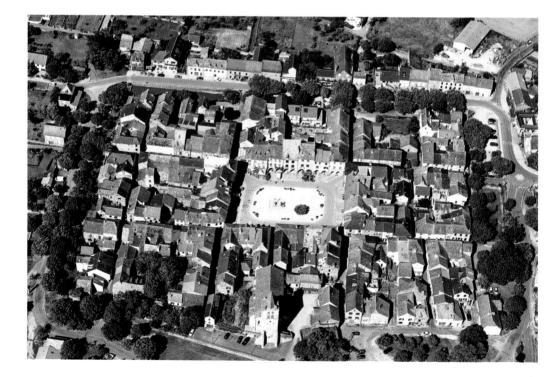

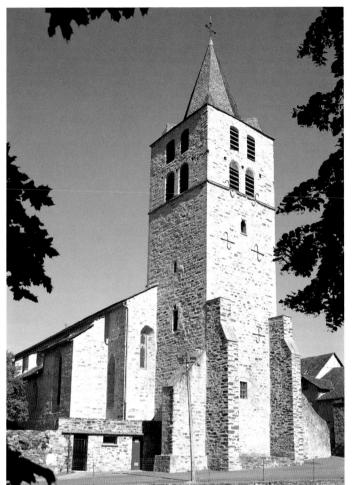

• Collegiate Church of Saint-Christophe (14th century): Southern Gothic style; 17th-century altarpiece.

• Village: Guided tours by appointment, from tourist information center.

• "La Bastide au 16e Siècle": Multimedia exhibition of life in the fortified town in the 16th century, based on the travel diary of a Swiss student who visited here.

• Espace Lapérouse: Permanent and temporary craft exhibitions; tour of art and craft studios by arrangement with tourist information center.

Accommodation

Auberge du Sénéchal***: +33 (0)5 65 71 29 00. La Grappe d'Or: +33 (0)5 65 72 00 62. **Guesthouses** Lou Cambrou***: +33 (0)7 86 68 41 87. Parrat: +33 (0)6 19 90 06 92. Villa Elia: +33 (0)6 63 98 36 60.

Gîtes

Further information: +33 (0)5 65 72 02 52 www.sauveterre-de-rouergue.fr **Chalets** Les Chalets de la Gazonne: +33 (0)5 65 72 02 46. **Campsites**

Le Sardou, rural campsite: +33 (0)5 65 72 02 52.

T Eating Out

Le Bar des Āmis, pizzeria: +33 (0)5 65 72 02 12. La Grappe d'Or: +33 (0)5 65 72 00 62. Les Quatre Saisons (in summer), light meals: +33 (0)5 65 78 49 32. Le Sénéchal: +33 (0)5 65 71 29 00. La Terrasse du Sénéchal: +33 (0)5 65 71 29 00.

*** Local Specialties** Food and Drink

Duck and foie gras • *Tripous* (sheep's tripe) and charcuterie • *Échaudés* (Aveyron cakes) • Goat cheese.

Art and Crafts

Laqueur craftsman • Jeweler • Ceramicist • Cutler • Lighting artist • Fabric bag designer • Leather bag and jewelry designer • Luthiers • Leather crafts • Painted furniture • Painters • Porcelain figures • Leather clothing • Macrophotography.

\star Events

Market: Evening market, Fridays (July– August).

May: "Soft'R," contemporary music festival. August: Fête de la Lumière, festival of lights (2nd Saturday).

September: "Fête du Melon et de l'Accordéon," festival of rock music and melon-eating (1st Sunday).

October: "Root'sergue," reggae and world music festival (last Saturday); Fête de la Châtaigne et du Cidre Doux, chestnut and cider festival (last Sunday).

W Outdoor Activities

La Gazonne recreation areas: fitness trail, trail-biking, and mountain-biking • *Boules* area • Walking: 4 marked trails.

🕊 Further Afield

- Pradinas: wildlife park (6 miles/9.5 km).
- Château du Bosc (9 ½ miles/15.5 km).
- Viaur Viaduct (11 miles/18 km).
- •*Belcastel (17 miles/27 km), see pp. 168–69.
- Rodez (22 miles/35 km).
- •*Monestiés (23 miles/37 km), see p. 214.

I Did you know?

The family of naval officer and explorer Jean-François de Galaup owned properties in and around Albi, and in Sauveterre, from where his mother and grandmother came. The family house in the village was for a long time the presbytery, but it has recently been restored, and now artists and craftspeople work and exhibit there. It is called the Espace Lapérouse and is part of the fortified village's artistic center.

Ségur-le-Château A safe haven in the depths of Limousin and Périgord

Corrèze (19) • Population: 240 • Altitude: 984 ft. (300 m)

Birthplace of the viscounts of Limoges, Ségur is lit up brightly at night, and the reflections of its fortress shimmer in the waters of the Auvezère.

Ségur comes from the French *lieu sûr*, meaning "place of safety," and it is exactly that: situated on a rocky outcrop, surrounded by forbidding hills, and encircled by a network of outpost castles. All these factors helped a village to develop here, huddling against the protective fortress walls. Then craft and commercial activities expanded. The village's reputation spread during the 15th to 18th centuries, owing to the presence of a court of appeal, responsible for dispensing justice to 36t seignorial estates between Limousin and Périgord. From this prosperous period, there remain noble houses with turrets or half-timbering, towers with spiral staircases, huge fireplaces, and carved granite mullioned windows. Among the village's other noteworthy buildings are a 15th-century granite residence topped with a tower and turrets, the Chevalier tower, the watchtower, the tower of Saint Laurent, and Maison Henri-IV.

Highlights

• Église Saint-Léger (19th century): Stained-glass window by contemporary artist Vincent Corpet, symbolizing Saint-Léger's torture.

• Village: Guided tours Fridays, 10.30 a.m., July–August; by appointment out of season for groups of 8 or more. Further information: +33 (0)5 55 73 39 92.

Accommodation

Village gîte: +33 (0)5 55 73 53 21.

T Eating Out L'Auberge Henri-IV, brasserie: +33 (0)5 55 73 38 50. La Part des Anges: +33 (0)5 55 73 35 27. Le Vert Galant, brasserie: +33 (0)5 55 73 18 02.

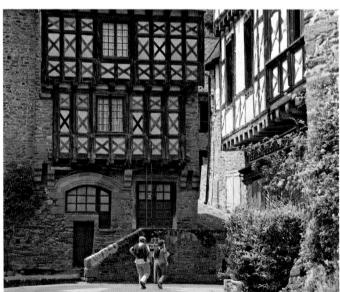

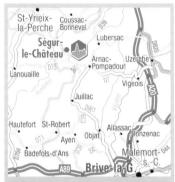

By road: Expressway A20, exit 44–Saint-Ybard (16 miles/26 km); expressway A89, exit 17–Thenon (29 miles/47 km); N21 (24 miles/39 km). By train: Saint-Yrieixla-Perche station (9 ½ miles/15.5 km). By air: Limoges-Bellegarde airport (42 miles/68 km); Brive-Vallée de la Dordogne airport (47 miles/76 km).

(i) Tourist information— Pays de Saint-Yrieix: +33 (0)5 55 73 39 92 www.tourisme-saint-yrieix.com

Local Specialties

Food and Drink Trout • Honey • Cul noir (black-bottomed) farm pigs. Art and Crafts

Terra-cotta sculptures and models • Donkeymilk beauty products.

🖈 Events

July: Jazz festival (3rd weekend). July–August: "Marché de Pays Festif," farmers market (Mondays, 4 p.m.). August: "Fête des Culs Noirs," pig festival (ast Sunday); flea market/outdoor rummage sal (2nd Sunday); street-painters' fair (close to 15th)

W Outdoor Activities

Fishing • Walking: 4 marked trails.

🕊 Further Afield

- Château de Coussac-Bonneval (6 miles/9.5 km
- Château de Pompadour; stud farm (6 miles/ 9.5 km).
- Vaux: ecomuseum of local heritage; papermaker (6 miles/9.5 km).
- Saint-Yrieix-la-Perche (9 ½ miles/15.5 km).
 - Uzerche (16 miles/26 km).
 - *Saint-Robert (17 miles/27 km), see p. 247.
 - Hautefort (25 miles/40 km).
- Brive (28 miles/45 km).
- *Saint-Jean-de-Côle (28 miles/45 km), see p. 24

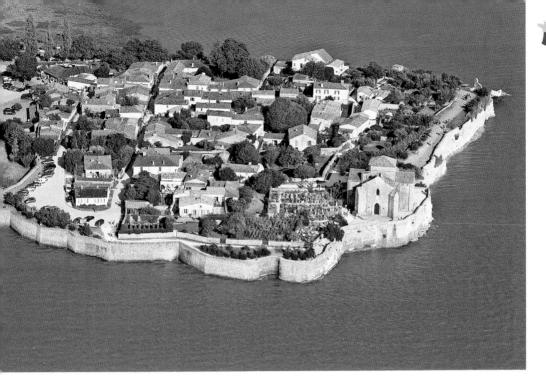

Talmontsur-Gironde Fortified village on an estuary

Charente-Maritime (17) • Population: 78 • Altitude: 16 ft. (5 m)

The Talmont promontory, girded by ramparts and crowned by its Romanesque church, seems to rise above the waves, in defiance of the waters of the Gironde.

This walled town was built in 1284 on the orders of Edward I of England, who also ruled Aquitaine. On a promontory encircled by the Gironde estuary, Talmont has kept its original medieval street plan. The streets and alleyways are punctuated by flowers, dotted with monolithic wells and sundials, and enlivened by craftspeople and traders. Streets lead to the tip of the promontory, where the 12thcentury church of Saint Radegonde watches over the largest estuary in Europe. From the Romanesque church, a stop on one of the routes to Santiago de Compostela, the rampart walk follows the cliff to the port, still used by traditional skiffs. Unmissable features of Talmont's landscape and heritage are the stunning panorama over the bay, the port, the village, the estuary, and the fishermen's huts.

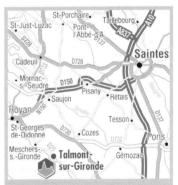

By road: Expressway A10, exit 36– Jonzac (17 miles/27 km). By train: Royan station (13 miles/21 km). By air: Angoulême-Brie-Champniers airport (70 miles/ 113 km); Bordeaux-Mérignac airport (81 miles/130 km).

(i) Tourist information:

+33 (0)5 46 90 16 25 or +33 (0)6 80 05 72 09 www.talmont-sur-gironde.fr

Itighlights

• Église Sainte-Radegonde (6th– 7th centuries).

• Musées Historique et de la Pêche: Local history museum on the site's geology; the church; the construction of the fortified town by Edward I, king of England; the American port built in 1917; and fishing in the lower Gironde estuary. Further information: +33 (0)5 46 90 16 25.

• Naval cemetery: Unique on the Atlantic coast; many memorials overflowing with hollyhocks.

• Village: Guided tour by appointment: +33 (0)5 46 90 16 25.

Accommodation

L'Estuaire**: +33 (0)5 46 90 43 85. Guesthouses

Le Portail du Bas**: +33 (0)5 46 90 44 74. La Maison de l'Armateur: +33 (0)5 46 93 68 01. La Talamo: +33 (0)5 46 91 16 66. La Vieille Maison de la Douane: +33 (0)6 79 87 44 18.

Gîtes and vacation rentals

Chantevent: +33 (0)6 02 24 03 98. L'Escale: +33 (0)5 46 02 50 97. Gîte du Puits: +33 (0)5 46 02 50 97. Mille Fleurs: +33 (0)5 46 90 26 56. L'Oubliance: +33 (0)5 46 90 26 56. Pigeonnier: +33 (0)5 46 90 24 51. Portail du Bas: +33 (0)5 46 95 58 02. Rose Trémière: +33 (0)6 34 52 34 51.

I Eating Out

L'Âne Culotté: +33 (0)5 46 90 41 58. La Brise, pizzeria: +33 (0)5 46 90 40 10. Les Délices de l'Estuaire, tea room: +33 (0)5 46 96 31 44. L'Estuaire: +33 (0)5 46 90 43 85. La Petite Cour, crêperie: +33 (0)5 46 90 16 25. Le Promontoire: +33 (0)5 46 90 40 66. Les Saveurs de Talmont, tea room: +33 (0)6 80 05 72 09. La Talmontaise: +33 (0)5 46 93 28 24.

*** Local Specialties** Food and Drink

Charente produce • Talmont wines. Art and Crafts

Jewelry and clothes • Handmade gifts • Rocks, fossils, gems • Artists • Pottery • Moroccan crafts • Soap • Leather goods • Lace.

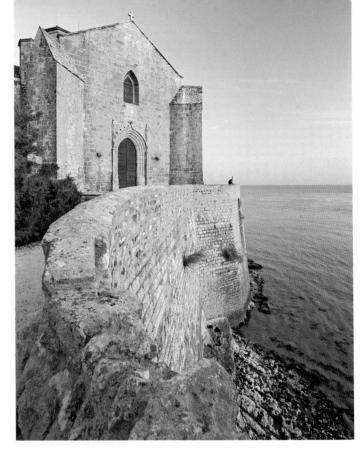

★ Events

Market: Farmers' market, Sundays 9 a.m.–5 p.m (April 1–October 31). April–October: Art exhibitions, Salle du Presbytère.

May: "Fête du Vent," kite festival. July-August: Wander the village by candlelight, shops remain open, Tuesdays from 9 p.m.; multimedia show (July 15-August 31). August: Talmont grand fair (2nd Sunday).

W Outdoor Activities

Fishing • Mountain-biking and hybrid biking • Walking: Route GR 36 and walk to Caillaud cliff • Scooter trips (in summer).

🕊 Further Afield

- Le Caillaud: vineyard activity trail (1/2 mile/1 km).
- Barzan: Fâ, Gallo-Roman site (1 mile/ 1.5 km).
- Arces-sur-Gironde: 12th-century church of Saint-Martin (2 ½ miles/4 km).

- Meschers-sur-Gironde: cave dwellings;
- beaches; estuary walks (3 miles/5 km). • Cozes: church; covered market (5 miles/
- 8 km).
- Saint-Georges-de-Didonne (6 miles/9.5 km).
- Royan (11 miles/18 km).
 - *Mornac-sur-Seudre (18 miles/29 km), see p. 220.
 - Saintes (22 miles/35 km).
 - La Palmyre: zoo (25 miles/40 km).

Did you know?

Around 1917, during the Russian Revolution, a Romanov princess was exiled to this area. When visiting Talmont-sur-Gironde, she was horrified to see sturgeon eggs being thrown to the hens and ducks. She brought in an expert, who taught the fishermen the real value of caviar; since then the little port has become an important center for its production.

Tournemire

A battle for supremacy

Cantal (15) • Population: 142 • Altitude: 2,625 ft. (800 m)

Set in the Volcans d'Auvergne regional nature park, Tournemire dominates the Doire river valley. In medieval times, two families fought for control of this village of tufa stone, which stretches down as far as the Château d'Anjony. In the Middle Ages the Tournemire family built a fortress on the tip of the Cantal massif, but a rivalry with the Aniony family, whose own castle, built in 1435, was close to the keep at Tournemire, signaled destruction for this fortressnothing but ruins remain today. However, the Château d'Anjony, with its square body and four corner towers, remains intact, as does the low wing added in the 18th century. Inside, the building still has its vaulted lower hall at basement level. The chapel and knights' hall are decorated by 16th-century murals. Flanked by 14th- and 15th-century houses, the 12th-century village church is characteristic of the Auvergne Romanesque style. It contains wood carvings and the Holv Thorn, brought back from the Crusades by Rigaud de Tournemire.

Highlights

• Château d'Anjony (15th century): Guided tours, concerts: +33 (0)4 71 47 61 67. • Church (12th century): Sculptures, reliquary.

Accommodation

Auberge de Tournemire: +33 (0)4 71 47 61 28.

Gîtes

Gîte***: +33 (0)4 71 40 70 68 or +33 (0)4 71 48 64 20.

I Eating Out

Auberge de Tournemire: +33 (0)4 71 47 61 28.

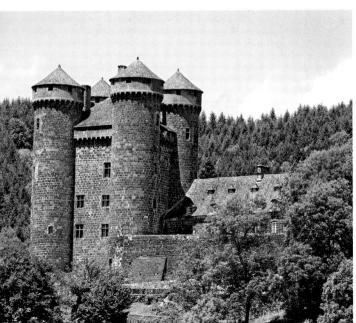

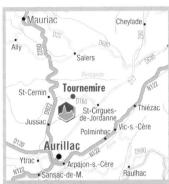

By road: Expressway A75, exit 23–Aurillac (52 miles/84 km); N122 (18 miles/29 km); expressway A89, exit 22–Egletons (54 miles/87 km). By train: Aurillac station (14 miles/23 km). By air: Aurillac-Tronquières airport (16 miles/26 km).

 Tourist information—Pays de Salers: +33 (0)4 71 40 58 08 www.salers-tourisme.fr

Local Specialties

Food and Drink Traditional Auvergne produce. Art and Crafts Painter.

★ Events

Market: Country market, Wednesdays 6 p.m. (July–August). August: Local saint's day.

W Outdoor Activities

Walking.

🕊 Further Afield

- Col de Legal (7 ½ miles/12 km).
- Aurillac (16 miles/26 km).
- *Salers (17 miles/27 km), see pp. 248–49.
- Puy Griou and Puy Mary, volcanoes
 (22 miles/35 km).

I Did you know?

The Holy Thorn, now safely housed in the church, was, according to legend, one day snatched by two burglars. However, locals from Tournemire followed them, so the thieves hid it in a tree. Tears of blood were said to have run from the tree, showing the villagers where it was hidden. The treasure was saved and the thieves arrested.

Turenne A powerful ruling family in southwest France

Corrèze (19) • Population: 811 • Altitude: 886 ft. (270 m)

Located at the foot of an old citadel bearing still-impressive remains, Turenne was for ten centuries the seat of an important viscountcy. The Caesar and Trésor towers, on top of a limestone mound (an outlier of the Causse de Martel), mark the site of the earlier fortress of the viscounts of Turenne, who ruled the Limousin, Périgord, and Quercy regions until 1738. Along its narrow streets and on its outskirts, the village has kept a remarkably homogeneous architectural heritage from this period of history. There are mansions from the 15th to 17th centuries, sporting turrets and watchtowers, and simple houses-cum-workshops too, all topped by *ardoise* (slate) tiles and presenting spotlessly white façades to the hot sun in this southern part of Limousin. They rub shoulders with the collegiate church of Saint-Pantaléon, consecrated in 1661, and the 17th-century Chapel of the Capuchins.

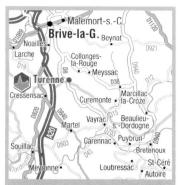

By road: Expressway A2o, exit 52–Noailles (5 ½ miles/9 km). By train: Brive-la-Gaillarde station (9 ½ miles/15.5 km). By air: Brive-Vallée de la Dordogne airport (5 miles/8 km).

Tourist information—Brive et Son Pays: + 33 (0)5 55 24 08 80 www.brive-tourisme.com www.turenne.fr

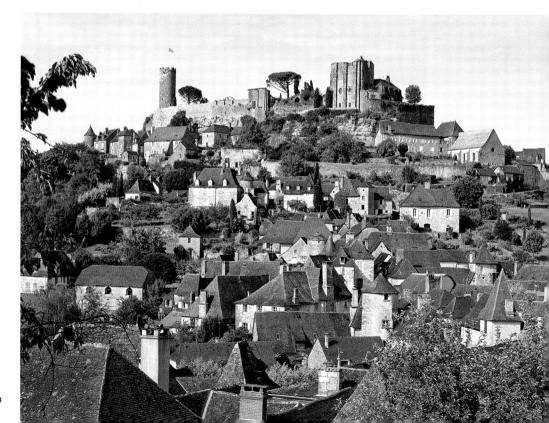

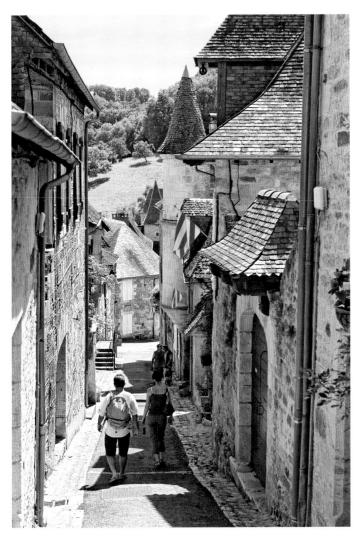

• Castle: César and Trésor towers, and garden: +33 (0)5 55 85 90 66. • Village: Historical tours, interactive costumed tours, and evening visits in summer; group tours available: +33 (0)5 55 85 59 97.

Accommodation

La Maison des Chanoines***: +33 (o)5 55 85 93 43. Guesthouses Au Bon Temps***: +33 (o)5 55 85 97 72. Le Clos Marnis***: +33 (0)5 55 22 05 28. Château de Coutinard: +33 (0)5 55 85 91 88. La Rocaille: +33 (0)5 55 22 05 73. Gites and vacation rentals Further information: +33 (0)5 55 24 08 80 www.brive-tourisme.com Vacation villages La Gironie: +33 (0)5 55 85 91 45.

I Eating Out

Au Temps Gourmand: +33 (0)9 84 34 93 06. La Maison des Chanoines: +33 (0)5 55 85 93 43. La Vicomté: +33 (0)5 55 85 91 32. Le Vieux Séchoir: +33 (0)5 55 85 90 46.

Local Specialties

Food and Drink Walnut oil • Honey • Farmhouse bread. Art and Crafts Wood turner.

\star Events

March or April (Maunday Thursday): "Foire aux Bœufs," cattle show. July: Local saint's day (1st weekend); torchlit tour (3rd weekend); "Festival de la Vézère," music festival. August: Outdoor rummage sale (3rd weekend).

W Outdoor Activities

Fishing • Walking: Routes GR 46 and GR 480, and 6 marked trails.

🕊 Further Afield

• Gouffre de la Fage, cave (4 ½ miles/7 km).

- *Collonges-la-Rouge (6 miles/9.5 km), see pp. 186–87.
- Brive-la-Gaillarde (11 miles/18 km).
- Lac du Causse, lake (11 miles/18 km).
- *Curemonte (11 miles/18 km), see p. 191.
- *Carennac (15 miles/24 km), see p. 181.
- Abbaye d'Aubazine (16 miles/26 km).
- Dordogne valley (16 miles/26 km).
- *Loubressac (19 miles/31 km), see p. 212.
- *Autoire (22 miles/35 km), see p. 163.
- Padirac; Rocamadour (22 miles/35 km).
- *Saint-Robert (25 miles/40 km), see p. 247.

Did you know?

The viscount gained substantial benefits from his advanteous geographical position. These privileges were granted by the kings of England and France. The viscount raised an army, minted coins, ennobled his faithful servants, and answered only to the king. His subjects did not pay the king's taxes, did not accommodate his soldiers, and assembled each year to vote their viscount's grant. Until the estate was purchased by Louis XV in 1738, the viscountcy was what we would today call a tax haven, practically autonomous from the authority of the kings of France, with the right even to summon the Estates (nobles, clergy, and commoners). These freedoms aroused the envy of its neighbors and the bitterness of royal functionaries. No wonder the French have the adage "as proud as a Viscount"!

Furenne Corrèze

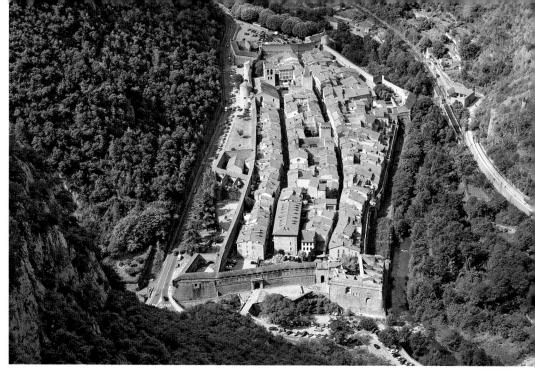

Villefranchede-Conflent

A trading center and defensive site

Pyrénées-Orientales (66) • Population: 239 • Altitude: 1,417 ft. (432 m)

Villefranche-de-Conflent owes its reputation as a commercial center to its founder, Guillaume Raymond, count of Cerdagne, and its fortifications to the works of Vauban (1633–1707), a marshal of France.

Lying in a deep valley where the Cady and Têt rivers meet, the village occupied a strategic site since its foundation at the end of the 11th century; it later became the capital of the Conflent region. The belfry tower of La Viguerie was the administrative center, and the many shops are reminders that Villefranche was a commercial center. In the 17th century, the military engineer Vauban strengthened its role as military capital of this border region by adding his fortifications to the medieval ramparts, today listed as a UNESCO World Heritage Site. The Liberia Fort, linked to the village by the Mille Marches steps built up the mountainside, is an ingenious network of galleries equipped with twenty-five cannon ports. Inside the fortifications, the buildings and the finest residences have stunning pink marble façades, and the Romanesque church of Saint-Jacques, filled with remarkable artifacts, is a reminder that Villefranche was on one of the key routes into Spain and on to Santiago.

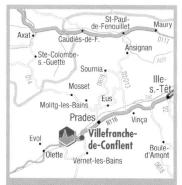

By road: Expressway A9, exit 42– Perpignan-Sud (31 miles/50 km), N116. By train: Villefranche-Vernet-les-Bains-Fuilla station (1 mile/1.5 km); Prades-Molitg-les-Bains station (5 ½ miles/9 km). By air: Perpignan-Rivesaltes airport (34 miles/55 km).

Tourist information: +33 (0)4 68 96 22 96 villefranchedeconflenttourisme.blogspot.fr

• Église Saint-Jacques (11th-14th centuries): 12th-century Romanesque carved portal, Baroque furniture (altarpiece by Joseph Sunyer, 1715). Further information: +33 (0)4 68 96 22 96.

• Ramparts. Further information: +33 (0)4 68 96 22 96.

• Fort Liberia (17th century): Tours of Vauban's site: +33 (0)4 68 96 34 01. • Petites and Grandes Canalettes grottoes, stalactites, and stalagmites: Stunning geological display and multimedia show: +33 (0)4 68 05 20 20. Cova Bastéra (prehistoric grotto): Cave fortified by Vauban, journey through time from the dinosaurs to today:

+33 (0)4 68 05 20 20.

• Village: Village, ramparts, etc; guided tour; accessible tours for visually impaired (sensory tour, audioguides, Braille, and large-print guidebooks). Further information: +33 (0)4 68 96 22 96.

Accommodation Aparthotels

Le Vauban**: +33 (0)4 68 96 18 03. Guesthouses

L'Ancienne Poste****: +33 (0)4 68 05 76 78. À l'Ombre du Fort: +33 (0)4 68 97 10 01. Casa Penalolen: +33 (0)4 68 96 52 35.

Gîtes and vacation rentals

Further information: +33 (0)4 68 96 22 96 villefranchedeconflent-tourisme.blogspot.fr

T Eating Out

Ar'Bilig, crêperie: +33 (0)6 47 73 68 57. Auberge Saint-Paul: +33 (0)4 68 96 30 95. La Barak' a' M'semen, Moroccan cuisine: +33 (0)4 68 05 30 99.

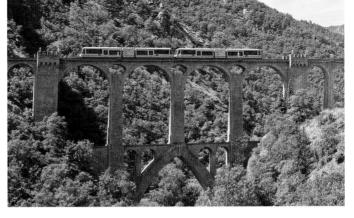

Le Bistrot Catalan: +33 (0)4 68 05 70 81. La Bonafogassa, light meals: +33 (0)4 68 96 33 52. Le Canigou, country bistro: +33 (0)4 68 05 25 87. L'Échauguette: +33 (0)4 68 96 21 58. La Forge d'Auguste, crêperie: +33 (0)4 68 05 08 65. L'Odyssée: +33 (0)4 34 52 93 51. Le Patio: +33 (0)4 68 05 01 92. La Pizzeria des Remparts: +33 (0)6 09 45 10 29. Le Relais: +33 (0)4 68 96 31 63. La Senvera: +33 (0)4 68 96 17 65. Le Vauban, light meals: +33 (0)4 68 96 18 03.

Local Specialties Food and Drink

Artisanal apple juice · Farmhouse goat cheese • Tourteaux à l'anis (aniseed cake). Art and Crafts

leweler • Leather crafts • Ceramicist • Cabinetmaker • Wrought ironworker • Lapidary studio • Wax painting • Potters • Witch doll manufacturer • Soap and candles.

* Events

Easter Sunday: "Fêtes des Géants," Easter festival. Easter Monday: "Aplec," pilgrimage to Notre-Dame-de-Vie. June: Saint-Jean's and Saint-Pierre's feast days. July: Saint-Jacques's feast day.

W Outdoor Activities

Adventure park • Canyoning, caving • Walking.

🕊 Further Afield

• Saint-Martin-du-Canigou (5 miles/ 8 km).

- Saint-Michel-de-Cuxa (5 miles/8 km).
- *Eus (7 1/2 miles/12 km), see p. 196.
- *Évol (8 miles/13 km), see p. 197.
- *Mosset (11 miles/18 km), see pp. 222–23.
- Cerdagne valley (19 miles/31 km).
- *Castelnou (23 miles/37 km), see p. 185.

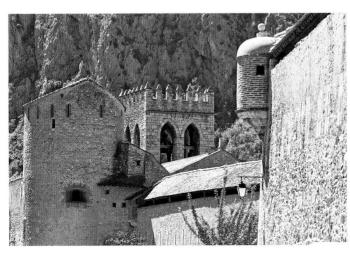

Did you know?

Each Easter, Villefranche-de-Conflent hosts the "Fête des Géants"-the festival of giants. In this traditional Catalan festival, two enormous papier-maché figures—nearly 10 ft. (3 m) high—dressed in medieval costumes and with a person inside, represent the founders of the village, Guillaume Raymond de Cerdagne and his wife, Sancia de Barcelona. They wander the streets accompanied by musicians playing traditional instruments, as well as "giants" invited from other villages or towns in France and southern Catalonia.

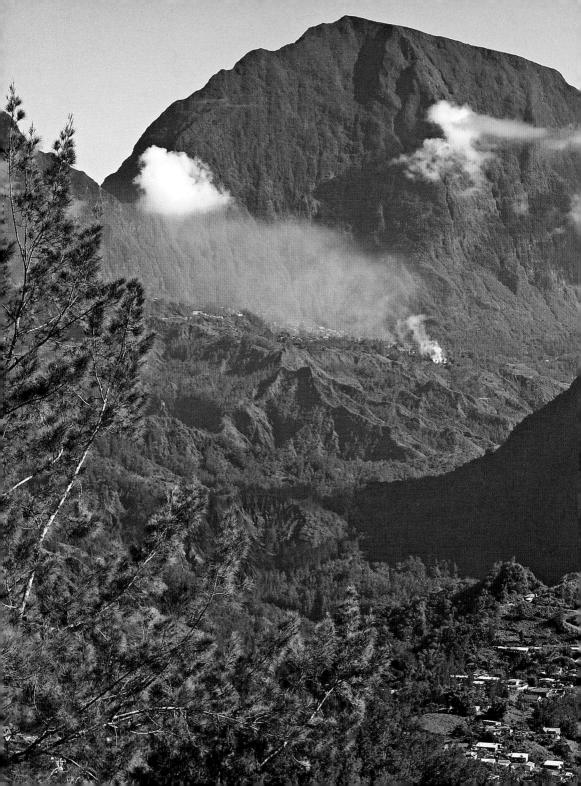

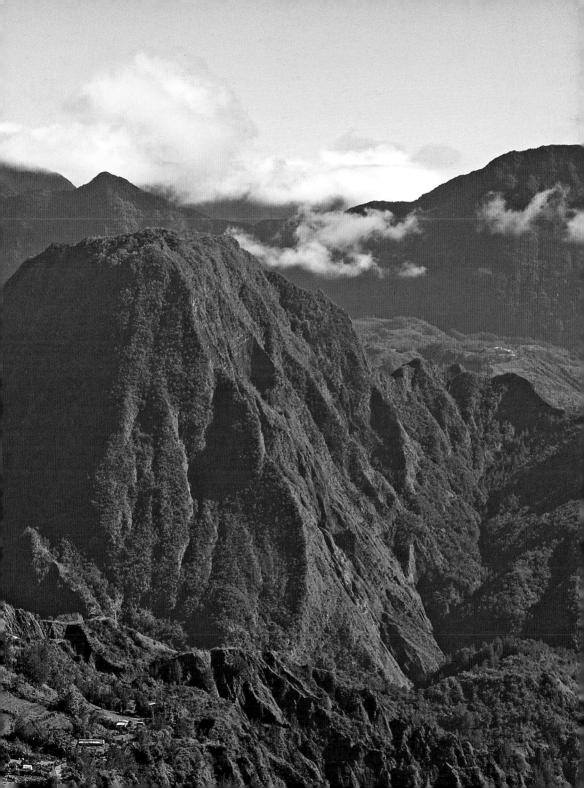

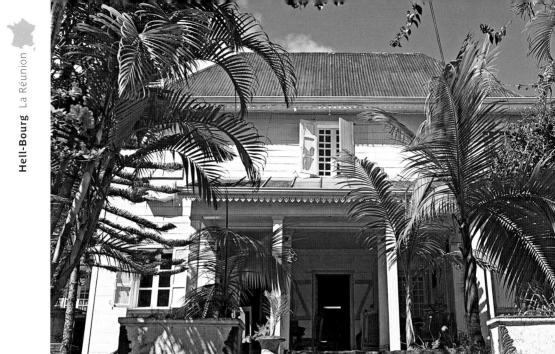

Hell-Bourg (commune of Salazie) Creole heritage at the heart of the "intense island"

La Réunion (97) • Population: 2,000 • Altitude: 886 ft. (270 m)

On the southern side of the Cirque de Salazie amphitheater, the natural entrance to the "peaks, cirques, and ramparts" designated as a UNESCO World Heritage Site, Hell-Bourg devotes itself to Creole tradition, lifestyle, and hospitality.

The Cirque de Salazie (a volcanic caldera) sets the scene for Hell-Bourg: ravines plunge into the Rivière du Mât, and waterfalls gush down the rock face, its lush vegetation maintained by the humidity of the trade winds blowing in from the Indian Ocean. For a long time the refuge of slaves fleeing from plantations on the coast, the Hell-Bourg area was colonized from 1830. With the discovery, the following year, of therapeutic springs, Hell-Bourg became a fashionable spa that was frequented by the island's well-to-do families every summer. Thatched huts gave way to villas adorned with pediments and mantling and surrounded by verandas opening onto gardens with bubbling freshwater fountains. Since the thermal springs dried up as the result of a cyclone in 1948, Hell-Bourg has maintained and perpetuated the architectural heritage of this lavish period, and has sought to return to the roots of its Creole heritage.

By road: N2 (16 miles/26 km), D48. By air: Saint-Denis airport (31 miles/50 km).

 Tourist information— Intercommunal de l'Est: +33 (0)2 62 47 89 89 est.reunion.fr / www.ville-salazie.fr

• La Case Tonton: Creole home, beliefs, and traditions. Guided tour daily from 8:30 a.m. Further information: Freddy Lafable, +33 (0) 8to 160 000 or +33 (0)6 92 15 32 32, or Guid'A Nou, +33 (0)6 92 86 32 88.

• Tour of Creole huts. Guided tour by Freddy Lafable, +33 (o)6 92 15 32 32, or Guid'A Nou, +33 (o)6 92 86 32 88; self-guided tour with audioguide, rental from tourist information center.

• Villa Folio and its garden: 19th-century Creole house, visitor interpretive center, park, garden. Guided tours for individuals and groups: +33 (o)2 62 47 80 98 or +33 (o)6 92 22 22 98.

• Old thermal spa: Explore the history of the former spa. Guided tour or selfguided tour. Further information: +33 (0)2 62 47 89 89.

• Mare à Poule d'Eau: Explore the tropical flora and fauna of one of La Réunion's most beautiful stretches of water. Guided tour with Guid'A Nou: +33 (0)6 92 86 32 88. • Landscaped cemetery.

Accommodation

Les Jardins d'Héva**: +33 (o)2 62 47 87 87. Relais des Cimes**: +33 (o)2 62 47 81 58. **Guesthouses** Le Relais des Gouverneurs***: +33 (o)2 62 47 76 21. L'Orchidée Rose: +33 (o)2 62 47 87 22. **Gîtes and vacation rentals** Further information: +33 (o)2 62 47 89 89. **Campsites** Le Relax, farm campsite: +33 (o)2 62 47 83 06.

T Eating Out

Chez Alice: +33 (o)2 62 47 86 24 or +33 (o)6 92 68 57 17. Chez Maxime's, fast-food restaurant: +33 (o)6 93 13 07 71. La Cuisine d'Héva: +33 (o)2 62 47 87 87. Le Gouléo, fast-food restaurant: +33 (o)6 92 62 36 24. L'Orchidée Rose: +33 (o)2 62 47 87 22. P'tit Koin Kréol, fast-food restaurant: +33 (o)6 92 32 61 16. Relais des Cimes: +33 (o)2 62 47 81 58. Ti Chouchou: +33 (o)2 62 47 80 93.

Local Specialties

Food and Drink Creole produce.

Art and Crafts

Local creations: basketry, pottery, paintings.

★ Events

June: Fête du Chouchou, festival devoted to the chayote fruit, the emblem of the Cirque de Salazie (tasting sessions, demonstrations, concerts, visits, etc.). August: "La Cimasalazienne" mountain race.

December 20: Abolition of slavery festival.

W Outdoor Activities

Walking (60 miles/100 km of trails) • Rock climbing • Canyoning.

🖗 Further Afield

Natural and heritage sites of Salazie:
 Bé-Maho viewpoint, Mare à Poule d'Eau,
 Voile de la Mariée (2-10 miles/3-16 km).
 Bras-Panon: vanilla cooperative (16 miles/

- 26 km). • Grand-Îlet: Église Saint-Martin, church (19 miles/31 km).
- Saint-André: Tamil temple, Parc du Colosse, Bois-Rouge sugar refinery, and Savanna rum distillery (25 miles/40 km).
 Saint Dopic (26 miles/40 km)
- Saint-Denis (31 miles/50 km).

Index of Villages

A

Aiguèze, 86 Ainhoa, 158 Angles-sur-l'Anglin, 18 Ansouis, 88 Apremont-sur-Allier, 58 Arlempdes, 90 Ars-en-Ré, 159 Aubeterre-sur-Dronne, 161 Autoire, 163 Auvillar, 164

В

Balazuc, 91 Barfleur, 20 Bargème, 92 Bastide-Clairence, La, 166 Baume-les-Messieurs, 59 Baux-de-Provence, Les, 93 Bec-Hellouin, Le, 22 Belcastel, 168 Belvès, 170 Beuvron-en-Auge, 24 Beynac-et-Cazenac, 172 Blesle, 174 Bonneval-sur-Arc, 95 Brousse-le-Château, 176 Bruniquel, 177

С

Camon, 178 Candes-Saint-Martin, 26 Capdenac-le-Haut, 179 Cardaillac. 180 Carennac, 181 Castelnau-de-Montmiral, 183 Castelnaud-la-Chapelle, 184 Castelnou, 185 Charroux, 97 Château-Chalon, 60 Châteauneuf, 61 Coaraze, 99 Collonges-la-Rouge, 186 Conques, 188 Couvertoirade, La, 190 Crissay-sur-Manse, 27 Curemonte, 191

D

Domme, 192

E

Eguisheim, 62 Estaing, 194 Eus, 196 Évol, 197

F

Flavigny-sur-Ozerain, 64 Flotte, La, 198 Fourcès, 200

G

Garde-Adhémar, La, 100 Garde-Guérin, La (commune of Prévenchères), 101 Gargilesse-Dampierre, 28 Gassin, 102 Gerberoy, 30 Gordes, 104 Gourdon, 106 Grave, La, 108

Η

Hell-Bourg (commune of Salazie), 266 Hunawihr, 66 Hunspach, 68

L

Lagrasse, 201 Larressingle, 203 Lautrec, 204 Lauzerte, 206 Lavardens, 208 Lavardin, 31 Lavaudieu, 110 Limeuil, 210 Locronan, 33 Lods, 70 Loubressac, 212 Lourmarin, 111 Lyons-la-Forêt, 35

Μ

Ménerbes, 113 Minerve, 213 Mirmande, 115 Mittelbergheim, 71 Moncontour, 37 Monestiés, 214 Monflanguin, 215 Monpazier, 217 Montbrun-les-Bains, 116 Montclus, 117 Montpeyroux, 118 Montréal, 219 Montrésor, 39 Montsoreau, 41 Mornac-sur-Seudre, 220 Mortemart, 221 Mosset, 222 Moustiers-Sainte-Marie, 119

Ν

Najac, 224 Navarrenx, 226 Noyers, 73

0

Oingt, 121 Olargues, 228

Ρ

Parfondeval, 74 Pérouges, 122 Pesmes, 75 Peyre (commune of Comprégnac), 230 Piana, 123 Poët-Laval, Le, 124 Pradelles, 125 Pujols-le-Haut, 232 Puycelsi, 234

R

Riquewihr, 76 Rochefort-en-Terre, 43 Roche-Guyon, La, 45 Rodemack, 78 Roque-Gageac, La, 236 Roque-sur-Cèze, La, 126 Roussillon, 128

S

Saint-Amand-de-Coly, 238 Saint-Antoine-l'Abbaye, 130 Saint-Benoît-du-Sault, 47 Saint-Céneri-le-Gérei, 48 Saint-Cirq-Lapopie, 240 Saint-Côme-d'Olt, 242 Sainte-Agnès, 132 Sainte-Croix-en-Jarez, 133 Sainte-Enimie, 134 Sainte-Eulalie-d'Olt, 243 Sainte-Suzanne, 50 Saint-Guilhem-le-Désert, 136 Saint-Jean-de-Côle, 245 Saint-Léon-sur-Vézère, 246 Saint-Quirin, 79 Saint-Robert, 247

Saint-Suliac, 52 Saint-Véran, 138 Salers, 248 Sant'Antonino, 140 Sare, 250 Sarrant, 252 Sauveterre-de-Rouergue, 254 Séguret, 141 Ségur-le-Château, 256 Seillans, 142 Semur-en-Brionnais 144 Sixt-Fer-à-Cheval, 146

Т

Talmont-sur-Gironde, 257 Tournemire, 259 Tourtour, 148 Turenne, 260

U

Usson, 150

V

Venasque, 151 Vézelay, 81 Villefranche-de-Conflent, 262 Vogüé, 153 Vouvant, 54

Y

Yèvre-le-Châtel (commune of Yèvre-la-Ville), 55 Yvoire, 154

Photographic Credits

All of the photographs featured in this book are published courtesy of the Hemis photographic agency.

4-5: Philippe Body; 6: P. Bernard; 7: Philippe Body; 8: P. Gilibert; 9: Philippe Body: 10-11: Pierre Jacques: 14-15: Stéphane Lemaire; 19t: Francis Leroy; 19b: Hervé Levain; 20: Jean-Daniel Sudres; 21l: John Frumm; 21r Christophe Boisvieux; 22-23: Franck Guiziou; 24: Francis Cormon; 25t: Jean-Daniel Sudres; 25b: René Mattes; 26: Francis Leroy; 27: Philippe Body; 28: Francis Leroy; 29l and r: Hervé Lenain; 30: Franck Guiziou; 31-32: Hervé Lenain; 33 and 34b: Bertrand Rieger; 34t: Emmanuel Berthier; 35-36t: Francis Cormon; 36b: Franck Guiziou; 37-38: Emmanuel Berthier; 39: Hervé Lenain; 40: Philippe Body; 41: Arnaud Chicurel; 42t: Hervé Hughes; 42b: Philippe Body; 43: René Mattes; 44: Philippe Roy; 45-46: Francis Cormon; 47: Philippe Body; 49: Hervé Lenain; 50-51: Philippe Body; 52-53: Jean-Daniel Sudres; 54: Francis Leroy; 55-59: Hervé Lenain; 60: Franck Guiziou; 61: Arnaud Chicurel: 62: Sylvain Sonnet: 63t: René Mattes; 63b: Denis Caviglia; 64: Bertrand Gardel; 65t: Denis Caviglia; 66: Bertrand Rieger; 67: René Mattes; 68: Denis Caviglia; 69t: Denis Bringard; 69m and b: Denis Caviglia; 70: Hervé Lenain; 71: René Mattes; 72: Denis Bringard; 73: Denis Caviglia; 74: Philippe Moulu; 75: Franck Guiziou; 76: Andrea Pistolesi; 77-78: René Mattes; 79: Denis Bringard; 80: Denis Caviglia; 81: Gregory Gerault; 82: Denis Caviglia; 83t: Christophe Boisvieux; 83b: Hervé Lenain; 86-87: Franck Guiziou; 88: Michel Cavalier; 89t: Camille Moirenc; 89b: Michel Renaudeau; 90: Guy Christian; 91: Franck Guiziou; 92: Sylvain Sonnet; 93-94: Franck Guiziou; 95: Pierre Jacques; 96: René Mattes; 97: Hervé Lenain; 98–99: Denis Caviglia; 100: Matthieu Colin; 101: Franck Guiziou; 102: Michel Cavalier; 103: Franck Chapus; 104–105: Jean-Pierre Degas; 105: Camille Moirenc; 106-107: Pierre Jacques; 107: Denis Caviglia; 108: Lionel Montico; 109: Franck Guiziou; 110: Hervé Lenain; 111: Franck Guiziou; 112: Michel Cavalier; 113: Jean-Pierre Degas; 114: Franck Guiziou; 115: Lionel Montico; 116: Franck Guiziou; 117: Pierre Jacques; 118: Denis Caviglia; 119: Lionel Montico; 120: Camille Moirenc; 121: Lionel Montico; 122: Franck Guiziou; 123: René Mattes; 124: Jean-Daniel Sudres; 125: Denis Caviglia; 126-127: Pierre Jacques; 128: Franck Guiziou; 129: Michel Gotin; 131: Franck Guiziou; 132: Denis Caviglia; 133: Franck Guiziou; 134: Franck Guiziou; 135t: Westend 61; 135b-137t: Pierre Jacques; 137b: Franck Guiziou; 139: Lionel Montico; 139b: Laurent Giraudou; 140: Denis Caviglia; 141: Franck Guiziou; 142–143: Michel Cavalier; 144: Christian Guy; 145: Denis Caviglia; 146–147: Franck Guiziou;

148: Denis Caviglia; 149t: Jean-Pierre Degas; 149b: Sylvain Sonnet; 150: Denis Caviglia; 151: Christian Guy; 152: José Nicolas; 153: Franck Guiziou; 154-155: Pierre Jacques; 158: Pierre Jacques; 159: Philippe Body; 160: Didier Zylberyng; 161–162: Hervé Lenain; 163: Jean-Paul Azam; 164: Hervé Lenain; 165: Jean-Paul Azam; 166–167b: Denis Caviglia; 167t: Jean-Daniel Sudres; 168–169: Pierre Jacques; 171: Bertrand Gardel; 172–173: Francis Cormon; 174–175b: Denis Caviglia; 175t: Hervé Lenain; 176: Jean-Paul Azam; 177: Francis Leroy; 178: Franck Guiziou; 179: Jean-Paul Azam; 180: Francis Leroy; 181: Christian Guy; 182-183: Jean-Paul Azam; 184: Arnaud Chicurel; 185: Franck Guiziou; 186: Bertrand Gardel; 187: Jean-Paul Azam; 188: Stéphane Lemaire; 189: Jean-Paul Azam; 190: Pierre Jacques; 191: Jean-Paul Azam; 193t: Philippe Body; 193b: Robert Harding; 194–195: Jean-Pierre Degas; 195: Jean-Paul Azam; 196: Francis Leroy: 197: Franck Guiziou: 198: Francis Leroy: 199: Franck Guiziou; 200: Jean-Daniel Sudres; 201–202: Franck Guiziou; 203: Jean-Paul Azam; 204: Didier Zylberyng; 205–207: Jean-Paul Azam; 208: Jean-Marc Barrere; 209: Jean-Paul Azam; 210–211: Francis Leroy; 212: Arnaud Chicurel; 213: Franck Guiziou; 214: Jean-Paul Azam; 215: Francis Leroy; 216: Denis Caviglia; 217: Patrick Escudero; 218t: Denis Caviglia; 218b: Francis Leroy; 219: Franck Guiziou; 220: Philippe Body; 221: Francis Leroy; 222–223: Franck Guiziou; 224: Jean-Paul Azam; 225: Jean-Pierre Degas; 227: Jean-Marc Barrere; 228–229: Franck Guiziou; 231: Pierre Jacques; 232: Hervé Lenain; 233t: Denis Caviglia; 233b: Jean-Marc Barrere; 234–235: Jean-Paul Azam; 236–237: Patrick Escudero; 237–238: Denis Caviglia; 239: Patrick Escudero; 240: Jean-Marc Barrere; 241: Jean-Paul Azam; 242-244: Hervé Lenain; 245: Jean-Daniel Sudres; 246: Philippe Roy; 247: Christian Guy; 248: Gregory Gerault; 249: Jean-Paul Azam; 250: Jean-Daniel Sudres; 251: Denis Caviglia; 252–253: Jean-Paul Azam; 254: Francis Leroy; 255: Jean-Paul Azam; 256: Christian Guy; 257: Francis Leroy; 258: Hervé Lenain; 259: Jean-Pierre Degas; 260-261: Christian Guy; 262: Jean-Paul Azam; 263t: Franck Guiziou; 263b: Jean-Daniel Sudres; 264-266: imageBROKER; 267: Gil Giuglio; 268-269: Jean-Marc Barrere.

Front cover, clockwise from top left: Hervé Lenain; Camille Moirenc; Jon Arnold; Camille Moirenc.

Back cover, clockwise from top left: Christophe Boisvieux; Hervé Lenain; Francis Cormon; René Mattes.

All maps featured in this book were produced by Éditerra.

Flammarion would like to thank the Plus Beaux Villages de France association (Anne Gouvernel, Cécile Vaillon, and Pascal Bernard) and Éditerra (Sophie Lalouette).

100 (100) 100 (1 and the should